COLLEGE BIOLOGY

Marshall D. Sundberg, Ph.D., F.L.S.

Emporia State University
Emporia, KS

Contributing Editor

William Kroll, Ph.D.
Loyola University of Chicago
Quinlan Life Sciences Education and Research Center
Chicago, IL

Collins

An Imprint of HarperCollinsPublishers

An American BookWorks Corporation Production

HarperCollins books may be purchased for educations, business, or sales promotional use. For information please write: Special Markets Department, HarperCollins Publishers, 10 East 53rd Street, New York, NY 10022.

Library of Congress Cataloging-in-Publication Data

Sundberg, Marshall David.
College biology / Marshall D. Sundberg.
 p. cm.
 ISBN: 978-0-06-088161-0
 ISBN-10: 0-06-088161-5
 1. Biology. I. Title.

QH308.2.S93 2007
570—dc22 2007018455

07 08 09 10 11 CW 10 9 8 7 6 5 4 3 2 1

Contents

Preface

Biology is the fastest growing of all the sciences and biotechnology promises to have significant impact on society in the 21st century. There is an information explosion in the biological sciences that has the potential to overwhelm even professionals in the field. The impact of this explosion can be judged by the size of introductory biology textbooks. Yet, there are relatively few basic concepts in biology that provide the foundation for all of the modern advances in the field. These concepts are accessible to the general public and provide the background necessary for us to make informed social decisions about the impact of biological science on everyday life.

This book distills the most important concepts typically covered during a year-long introductory biology course. Much of the details covered in a typical textbook are omitted. Instead the core ideas of biology are developed with enough depth to provide a solid foundation students can build upon in their future coursework.

I am thankful to my students who have challenged me to become a more effective instructor and to my undergraduate advisor, the late Professor William Muir, who taught us that science is not just a collection of facts written in a book. In fact, as scientists we should be skeptical of what is written down and demand that it be supported by evidence.

The Science of Biology

Biology is frequently described as the scientific study of living things, but it is often taught as a collection of facts about organisms. Science is a dynamic process, constantly evolving as new technologies and new information become available. In this chapter, and throughout the book, we will emphasize the process of science that leads to our current understanding of the structure, function, interrelationships, and evolution of living things.

■ BIOLOGY AS SCIENCE

Biology, which began as a descriptive science, is based on testable hypotheses and predictions, as are the other sciences such as physics and chemistry.

The Nature of Science

Science is a process, a way of knowing about the natural world. Natural phenomena have natural causes that can be discovered by observation and explained by forming and testing hypotheses. Scientific understanding of the natural world is dynamic. It continually changes, becoming richer, as we gain new insights or invent new tools to study natural processes.

Two Approaches to Scientific Study

Inductive reasoning (**induction**) is a discovery process that uses specific observations to construct general principles. If every living thing we examine microscopically is composed of cells, we can induce the general principle that all living things are composed of cells even though we haven't looked at all living things. If we accept the general principle that living things are composed of cells and observe a fossil with cellular structure, we can deduce (**deduction**) that the fossil was once alive.

Hypothesis Testing

A **hypothesis** is a tentative explanation for an observation or a prediction of what will occur. Both inductive and deductive reasoning can give rise to testable hypotheses. Scientific experiments are carefully designed to test specific hypotheses. Hypotheses are accepted if they are supported by testing, but rejected if the data are inconsistent with the predicted results.

Scientific Theories

In science an explanation that is broad in scope and well supported by a large body of evidence is called a **theory.** Scientific theories generate new hypotheses that drive discovery, and there is always the possibility that new discoveries will force us to modify or even reject our current theories. Note that this definition is virtually the opposite of the common usage of the term *theory*.

■ BIOLOGY AND LIFE

Life, which seems like such an obvious concept, is impossible to define precisely because of the great variety of living things.

The Properties of Life

Life defies simple definition, but there are a number of properties that, if taken together, describe the characteristics of living things. Among these are cellular organization, ability to grow (increase in size; increase in cell number; and/or develop specialized cells, tissues, and organs), reproductive capability, responsiveness to stimuli, utilization of chemical energy, homeostasis (ability to self-maintain the living condition), and ability to evolve.

Hierarchical Organization

Cells are composed of subcellular units, various organelles within a protoplasmic matrix, that themselves are not alive. These, in turn, are constructed from atoms and molecules. Many organisms are unicellular, but multicellular organisms are composed of specialized cells organized into tissues, organs, and organ systems. Different organisms interact with each other at different levels in their environment: with other organisms of the same species in populations; with other species in communities; and with the physical environment in ecosystems.

Emergent Properties

At each higher level in the hierarchy of life, novel properties emerge that could not be predicted based on the properties of the lower levels. These **emergent properties** are the result of the arrangement of parts and interactions between them as complexity increases. For example, chlorophyll molecules can absorb light energy but it is simply released as fluorescent light of lower energy. If the same molecules are embedded in chloroplast membranes, the same light energy can be converted into the chemical energy of ATP and NADPH that is used to synthesize sugar from CO_2.

■ CELL THEORY

A basic theory of biology is that structures called cells are the fundamental unit of living things.

Living Things Are Composed of Cells

Cells consist of one or more membrane-bound compartments that are the smallest units to exhibit the properties of life. **Organisms** are composed of one or more cells.

Prokaryotic

Cells of the smallest organisms (<10 μm diameter) consist of a single membrane-bound compartment without a nucleus or any other special membrane-bound organelles. These **prokaryotic** (that is, "before a nucleus") organisms are typically unicellular.

Eukaryotic

Larger cells (>10 μm diameter) contain multiple compartments called organelles. Each organelle has a specific function and is bound by one or two membranes. The presence of a membrane-bound nucleus defines these cells as **eukaryotic** (that is, "true nucleus"). Eukaryotic organisms may be unicellular or multicellular.

Cells Come from Preexisting Cells

Under the conditions on earth today, all cells arise from either the asexual division of existing cells or the sexual fusion of specialized reproductive cells, called **gametes.** In asexual cell division, a special process of nuclear division, called **mitosis**, ensures that each daughter cell receives exactly the same genetic information as the mother cell. In sexual reproduction, a related process, called **meiosis,** ensures that the offspring cell will receive half of its genetic information from each parent.

■ GENETIC THEORY

The condition that cells come from preexisting cells implies a hereditary relationship in which traits of one generation are passed on to the next.

Many Traits Are Inherited

The structural and functional characteristics of organisms (**phenotypes**) are frequently inherited from their parents. The unit of inheritance for any particular trait is a **gene.**

Chromosomal Basis of Inheritance

Genes are located on **chromosomes** in the nucleus of eukaryotic cells or on the bacterial chromosome of prokaryotic cells. There are hundreds of different genes on each chromosome.

Molecular Basis of Inheritance

Genes are coded in **DNA** molecules that are part of the structure of chromosomes. Each chromosome contains duplicate copies of the DNA on identical chromatids held together by a centromere so that the information can be accurately passed from one generation of cells to the next every time a cell divides. The genetic information coded by the DNA is translated into polypeptides (enzymes and other proteins) in the cytoplasm of the cell, thus giving rise to the phenotypic characteristics of that cell.

■ EVOLUTIONARY THEORY

Long before Mendel's discovery of a mechanism to explain inheritance, plant and animal breeders recognized that certain traits could be passed unerringly from one generation to the next, resulting in purebreds and true-breeding lines. Yet other traits could be changed over time, allowing breeders to develop new breeds of animals and new plant varieties.

The Unity of Life

Cell Theory and **Genetic Theory** provide powerful evidence that organisms share a succession of common ancestors. The human gene for insulin can be inserted into a bacterium and the bacterium will begin to produce human insulin. Clearly, the machinery of life in the prokaryotic bacterium follows the same commands as the eukaryotic cells in the human pancreas.

The Diversity of Life

While all organisms share a kinship through their common ancestry, species diverged as modifications evolved to better adapt species to their environmental conditions. Darwin called the evolutionary history implied by the unity and diversity of life "descent with modification." Today we call it the theory of **biological evolution.** Evolution is the basic underlying foundation for all of biology.

Natural Selection

Darwin was not the first scientist to propose a theory of evolution, but he was the first to provide a massive amount of evidence from a wide variety of scientific disciplines. More importantly, he proposed a mechanism to explain how evolution occurs——the theory of **natural selection.** Natural selection remains the most broadly supported theory to explain the unity and diversity of life. It is based on three observations and two inferences.

Individual Variation

Choose any phenotypic character in a population of individuals, and the expression of that trait will vary from individual to individual. With measurable traits, this variation frequently takes on the form of the bell curve.

Overproduction

In a favorable environment, populations have the potential to grow exponentially and many more offspring will be produced than can survive.

Competition

As the population in an area increases, individuals must compete for limited resources. The greater the overpopulation, the stronger the competition.

Unequal Reproductive Success

Given the overproduction of individuals in a population, and the heritable variation between individuals with its resulting competition, Darwin inferred that some individuals would be *more likely* to survive and breed than others. Individuals possessing favorable variations would have a *higher probability* of passing on their heritable traits to offspring; individuals having less favorable variations would be *less likely* to pass on their traits.

Evolutionary Adaptation

If the environment remains constant over many generations, the frequency of genes coding for favorable variations will increase in the population, while the frequency of less favorable traits will decrease. In other words, the population evolved through natural selection of favorable traits.

Test Yourself

1) If a person believes in a divine being;
 a) that belief cannot be tested scientifically.
 b) he or she cannot be a scientist.
 c) he or she must believe that evolution cannot occur.
 d) he or she cannot accept scientific theories.
 d) none of the above is true.

2) Is Intelligent Design (I.D.) a scientific theory opposed to the theory of evolution?

3) On a cool spring morning, you observe a yellow, slimy mass on the grass in your front yard. The next day, the mass is larger and seems to have moved toward the shade of a cedar tree. A week later, all that remains is a cluster of tiny stalked structures that release a fine powder if touched. What evidence have you observed that suggests the slimy mass was alive? What additional evidence would be useful to have?

4) Which of the following is *not* a true statement about genes?
 a) Genes are part of a DNA molecule.
 b) Both parents contribute genes to their offspring.
 c) The more complex the organism is, the more genes it will have.
 d) Genes are located on chromosomes in the cell.
 e) Genes code for the structural and functional characteristics of organisms.

5) Which of the following is *not* required by natural selection?
 a) variation among individuals
 b) survival of the fittest
 c) overproduction of offspring
 d) competition between individuals
 e) unequal reproductive success

Test Yourself Answers

1) **a.** Science is concerned with natural processes in the natural world; religion and philosophy are concerned with beliefs beyond nature (i.e., the supernatural). Because this belief is beyond nature, it cannot be studied scientifically. Many scientists hold deep religious beliefs and see no conflict with their scientific investigations. Similarly, most major religions, including mainstream Christian denominations, see no conflict with scientific theories.

2) Intelligent Design is marketed as an alternative to evolutionary theory in the science classroom. However, to be scientific, it must be concerned only with natural explanations of the natural world (that is, it cannot be a belief system) and to be a scientific theory, it must be broadly supported by evidence and testing. Neither condition is met by I.D.

3) To be alive, the slimy mass must demonstrate several of the properties of life. The observations suggest that the mass can grow (because it got larger) and perhaps can respond to stimuli, because it seems to have moved toward the shade of the tree. The powdery substance could be a means of reproduction. If a piece of the substance could be examined with a microscope it might be possible to observe cells and test for respiration—the chemical breakdown of organic molecules to obtain energy.

4) **c.** A gene is a segment of a DNA molecules that makes up a chromosome and codes for a particular structure or function in a cell. During sexual reproduction, each parent contributes genes to their offspring. There is no consistent relationship between the number of genes and the complexity of an organism.

5) **b.** "Survival of the fittest" is a phrase commonly associated with natural selection, but it is an oversimplification. *Survival* implies longevity, which is often, but not always, correlated with reproductive output. In natural selection, there must be competition between individuals, and some individuals must be more likely to reproduce than others (unequal reproductive success). However, sometimes "less fit" individuals do survive and reproduce—just not as often. In other words, chance is a factor in natural selection.

Atoms and Molecules

At the organismal level, cells are the building blocks of life. Yet cells have a chemical basis of smaller building blocks, called molecules, which themselves are composed of smaller units called atoms.

■ THE NATURE OF ATOMS

Atoms are the smallest units of a chemical element.

Subatomic Particles

While **atoms** are the smallest units that have the physical properties of an element, they are composed of a number of smaller particles. The three major subatomic particles are **protons**, **neutrons,** and **electrons.** Protons and neutrons occur together in the nucleus in the center of the atom. Electrons orbit around the nucleus.

Protons

Protons are positively charged particles that form part of the nucleus of an atom. The number of protons is constant for any element and determines the **atomic number** for that element. For example, hydrogen has a single proton, and its atomic number is 1. This is represented by $_1$H. The mass of a proton is approximately 1 Dalton.

Neutrons

Neutrons are uncharged particles that, together with protons, form the nucleus of an atom. The mass of a neutron is approximately the same as that of a proton, 1 Dalton. The number of neutrons in an atom is usually the same as the number of protons. Thus, hydrogen has a single neutron. However, some forms of an atom have one or more additional neutrons and are called **isotopes.** Many isotopes are radioactive and decay to give off particles and release energy. Different isotopes of an atom react the same way but they have different masses. The **atomic mass** of an atom is equal to the number of protons plus the number of neutrons. For example, carbon has 6 protons and usually has 6 neutrons. Most carbon atoms have an atomic mass of 12, ^{12}C. However, some carbon atoms have 7 or even 8 neutrons—the isotopes ^{13}C and ^{14}C, respectively.

Electrons

Electrons are very small positively charged particles. Although their mass is insignificant, their charge balances the charge of protons. If the charges do not balance, an **ion** is produced. If there are too few electrons, a positively charged cation is produced. Too many electrons results in a negatively charged anion.

Electron Orbitals

Electrons orbit at predictable distances from the nucleus. Although, in theory, an electron could orbit any distance from the nucleus, it is most likely to be found at a certain distance represented as an energy level or **electron shell.** Each electron shell holds a maximum number of electrons.

The energy level of an electron increases as it moves farther from the nucleus. The first shell holds two electrons; the second and third shells each hold eight. Electrons fill the lowest available energy level first, and then fill successively higher levels. For example, carbon atoms have six electrons. Two fill the first shell, and the remaining four orbit in the second shell.

Electrons Form Chemical Bonds

Atoms whose outermost electron shells are not full have a strong tendency to interact with other atoms in such a way that fill their outer shells. They may do this either by sharing electrons with other atoms or by donating or accepting an electron. In this way. two or more atoms join together to form a **molecule.**

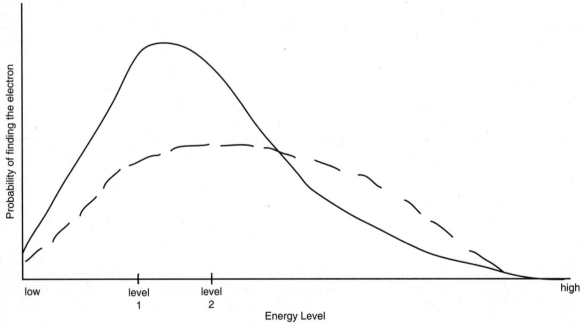

Figure 2-1. Average distances of electrons from atomic nucleus. Distance, corresponding to energy level, is plotted on the x-axis from low to high. The farther an electron orbits from the nucleus, the greater its energy. The probability of an electron being at a particular distance (energy) is plotted on the y-axis. The peaks of the two curves correspond to the average distances (amount of energy) associated with the first and second electron shells in an atom.

Covalent Bonds

In the following example of a carbon atom in Figure 2.2, four electrons orbit in the second electron shell, but there is room for eight. Hydrogen atoms have only a single electron, so a second is needed to fill its first shell. Two hydrogen atoms could interact, sharing their electrons. At any one instant, both electrons could be orbiting the first hydrogen nucleus, but at another time, they could be orbiting the second. The shared pair of electrons form a **covalent bond.** Four hydrogen atoms also could interact with our original carbon atom to form methane.

At any instant, all eight electrons could be filling carbon's second shell, but they could also be shared among the four hydrogen atoms. Two carbons could also form a covalent bond by sharing one pair of electrons. Each carbon should then share electrons with three additional hydrogen atoms. If the two carbons shared four electrons, a double bond, then only two additional hydrogen atoms can associate with each carbon atom. The **valence** of an atom is the number of covalent bonds that it can form by sharing electrons with other atoms.

The covalent bonds between two hydrogen atoms and an oxygen atom form a very special molecule: water. The three-atom molecule of water is asymmetric with the two hydrogen atoms on one side.

Because their electrons are drawn toward the more electronegative oxygen atom, at least part of the time, the positively charged protons are exposed, creating a partial positive charge on that side of the

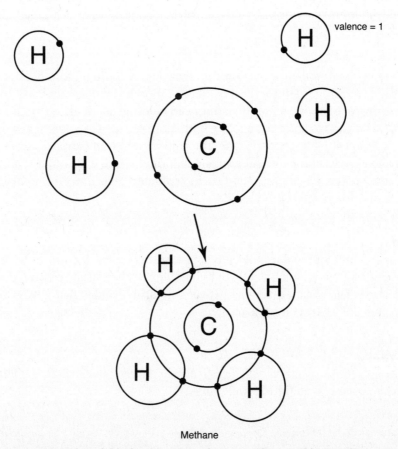

Methane

Figure 2-2. Forming a covalent bond. Hydrogen atoms have a valence of 1; a carbon atom has a valence of 4. If carbon shares its four outer electrons simultaneously with four hydrogen atoms, four covalent bonds will form to create methane, CH_4.

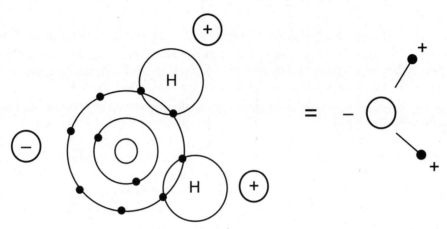

Figure 2-3. Water is a polar molecule. When water forms, the electrons shared between the two hydrogen atoms and oxygen are not shared equally because oxygen is more electronegative. As a result, water is a polar molecule. You can visualize this as the protons of hydrogen being more exposed on one side of the molecule, and the electrons in the outer shell being more exposed on the other side.

water molecule. At the same time, the cloud of exposed electrons on the opposite side of the oxygen give that side a partial negative charge. Because of these partial charges, water is a **polar** molecule.

Ionic Bonds

Some atoms are unequal in their attraction for electrons. A sodium atom fills its first two electron shells, and only a single electron is left for the third shell. Chlorine, on the other hand, has seven electrons in its third shell—with space for one more. If sodium and chlorine are in close proximity, the outer electron in sodium will be donated to chlorine, making both more stable. The sodium now has one more proton than neutron and is positively charged. The chlorine new has an extra electron and is negatively charged. The opposite charges attract the sodium and chlorine ions to each other to form an **ionic bond.** In living systems, ionic bonds are not as important as covalent bonds or as the weaker hydrogen bonds that are discussed next.

Hydrogen Bonds

The partial positive side of a polar molecule is always hydrogen. It forms a weak attraction to the partial negative side of another polar molecule. In living things, this is usually an oxygen atom, but it also may be a nitrogen atom. The weak attractions between polar molecules that always involve a partially positive hydrogen atom are **hydrogen bonds.**

Properties of Water

Because of the tendency for water molecules to form hydrogen bonds with each other, water has four emergent properties that are essential for living things.

Cohesion

Individual hydrogen bonds are weak, and they tend to constantly be forming, breaking down, and reforming. However, because there are so many hydrogen bonds between water molecules at any given time, water tends to "stick together." The mutual attractiveness of similar molecules to each other is called **cohesion.** Cohesion is what allows you to suck a drink through a straw and what allows a redwood

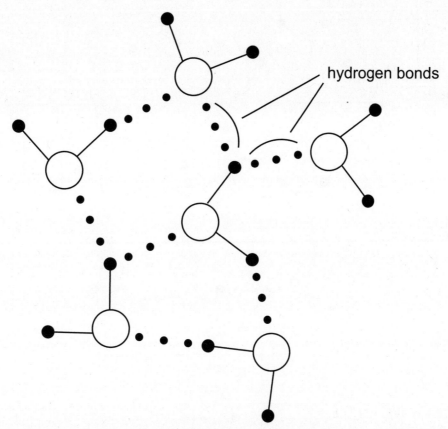

hydrogen bonds

Figure 2-4. Polar water molecules form hydrogen bonds. The negative side of one polar water molecule is attracted to the positive side of another to form a hydrogen bond, illustrated by dotted lines. Because all water molecules are polar, they tend to orient themselves to maximize hydrogen bonding.

tree to draw up water from more than 100 meters away. Cohesion is also involved in the creation of surface tension at the interface between water and air.

Temperature Moderation

When molecules are heated, they tend to move faster, and the temperature rises. The **specific heat** is the amount of heat required to raise the temperature of one gram of molecules one decree Celsius. As water is heated, hydrogen bonds slow the molecules from moving faster and, thus, it takes more heat than might be expected to raise the temperature one degree. Similarly, more heat must be given off to cool water one degree as hydrogen bonds form. For this reason, large bodies of water tend to moderate the temperature of nearby land. For example, Fargo, North Dakota, gets much colder in winter than Seattle, Washington, even though Seattle is farther north. Similarly, it gets much hotter in summer in Fargo than in New Orleans, Louisiana, although New Orleans is much farther south. Seattle and New Orleans are coastal cities, and their temperatures are moderated by the nearby ocean.

Solid Water (Ice) Floats

As most liquids cool, the distance between molecules decreases, and the liquid gets denser. This is also the case with water until the temperature reaches 4°C. As water continues to cool, the hydrogen bonds can no longer be broken, and a three-dimensional crystal lattice begins to form. Because of the reg-

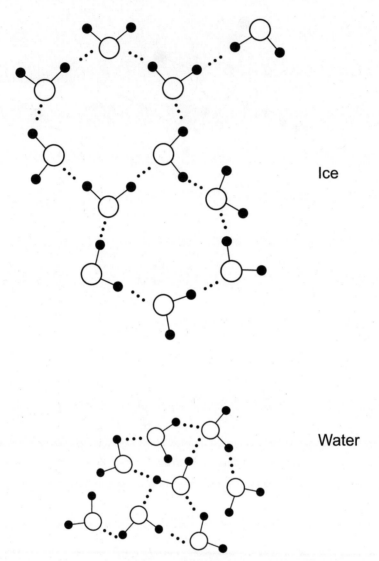

Ice

Water

Figure 2-5. Why ice floats. In ice, every water molecule hydrogen bonds with four other water molecules to form a very regular crystal lattice structure. The bonds do not break and reform, and the uniform spacing creates regular gaps in the structure. In liquid water, hydrogen bonds are constantly forming and breaking between adjacent water molecules, and a lattice structure cannot form. As a result, water molecules are closer together (therefore, more dense) in liquid water and farther apart (less dense) in ice. The less dense frozen water floats on the denser liquid.

ularity of hydrogen bonding, the space between individual water molecules is actually farther apart in ice than in liquid water and ice floats.

That ice floats is especially important in northern lakes. If ice did not float, the lakes would freeze solid every winter and nothing would survive. Instead, ice floats on the surface and provides an insulating layer to slow further cooling of deeper water and allow organisms to survive.

Water Is a Solvent

Because water is a polar molecule, it tends to be attracted to any polar molecules or charged ions that might be mixed with it. If the sodium chloride from the preceding section (ionic bonding) was dropped

$$2H_2O \quad \rightleftharpoons \quad H_3O^+ \quad + \quad OH^-$$

$$H_2O \quad \rightleftharpoons \quad H^+ \quad + \quad OH^-$$

Figure 2-6. Water dissociates to form ions. In a container of water, a certain number of water molecules spontaneously dissociate into hydrogen (H^+) and hydroxyl (OH^-) ions. Although the H^+ actually reacts with another water molecule to form hydronium ion (H_3O^-), we usually refer to the simplified form.

into water, the partial positive sides of water molecules would be attracted to chlorine ion, and the partial negative sides of other water molecules would be attracted to sodium. By surrounding both ions, water disrupts the ionic charge attraction that binds sodium to chlorine, and the salt dissolves.

Water Ionizes

Just as the hydrogen bonds in water are constantly breaking and reforming, covalent bonds between hydrogen and oxygen occasionally break. Although the resulting hydrogen ion actually associates briefly with another water molecule to form hydronium ion, we simplify this by saying the water dissociates into a hydrogen ion (H^+) and a hydroxyl ion (OH^-).

In pure water at about room temperature (25°C), the concentration of each dissociated ion is 10^{-7} molar. For convenience, we define the concentration of hydrogen ions in terms of pH, where pH = $-\log[H^+]$. If the concentration of H^+ is 10^{-7}, then log $[10^{-7}] = -7$ and pH = $-(-7) = 7$. A pH lower than 7 indicates an acidic solution with more H^+ than OH^-. Readings higher than 7 indicate a basic solution with more OH^- than H^+. Because the pH scale is based on logarithms, a change from one number to the next indicates a ten-fold difference in concentration. Most organisms have a narrow range of pH in which they can grow and reproduce.

Test Yourself

1) Helium, neon, and argon have atomic numbers 2, 10, and 18, respectively. They are three of the so-called noble gases that are inert and do not react with other atoms. Which of the following must be responsible for their inertness?

 a) The number of protons equals the number of neutrons.

 b) The number of protons equals the number of electrons.

 c) Every electron shell used in the atom is filled.

 d) Their atomic mass is twice their atomic number.

 e) The charges in their atomic nuclei balance.

2) Two atoms share a pair of electrons unequally. Which of the following statements best predicts the outcome?

 a) An ionic bond is formed.

 b) A covalent bond forms a polar molecule.

 c) The covalently bonded atoms are surrounded by a uniform electron cloud.

 d) The covalently bonded atoms form an ion.

 e) The resulting molecule is unstable and radioactive.

3) You have only hydrogen atoms ($_1$H) and carbon atoms ($_6$C). How many different molecules could be formed by these atoms using only single covalent bonds?

 a) 1

 b) 2

 c) 3

 d) any even number

 e) an indefinite number

4) Which of the following properties of water is *not* related to hydrogen bonding?

 a) cohesion

 b) temperature moderation

 c) ice flotation

 d) solvent

 e) ionization (pH)

5) An example of cohesion alone is

 a) water drawn up a narrow tube by capillary action.

 b) the formation of a meniscus in a pipette.

 c) water pumped through a garden hose.

 d) water pulled through a siphon in an aquarium tank.

 e) water diffusing into a cell.

6) When salt (NaCl) is added to water
 a) covalent bonds form between the sodium atoms of salt and the oxygen atoms of water.
 b) covalent bonds are broken in the water and ionic bonds are broken in the salt.
 c) water molecules are depolarized and the salt is deionized.
 d) water molecules become chlorinated by the chloride ions of salt.
 e) polar water molecules are attracted to both the sodium and chlorine ions of salt.

7) A solution containing a high concentration of hydrogen ions
 a) has a low pH.
 b) contains an equal number of hydroxyl ions.
 c) will have a high surface tension.
 d) is called a base.
 e) is strongly cohesive.

8) Coffee has a hydrogen ion concentration of 10^{-5} while the H^+ concentration of seawater is 10^{-8}. Which of the following statements is true?
 a) Coffee has 5/8 the number of hydrogen atoms as seawater.
 b) There is much more H^+ in seawater than in coffee.
 c) For every 100 H^+ in coffee there is 1 H^+ in seawater.
 d) Hydrogen ion is 1,000 times more concentrated in coffee than in seawater.
 e) There is no difference in H^+ between coffee and seawater; seawater is simply saltier.

Test Yourself Answers

1) **c.** Atoms react with each other by forming bonds, either by sharing, donating, or accepting electrons. This occurs only if the outer electron shell of an atom is not filled. In noble gases, there are exactly enough electrons to fill each electron shell that is used.

2) **b.** A shared pair of electrons forms a covalent bond, but if one atom is more electronegative, the pair will be shared unequally and partial charge separation creates a polar molecule.

3) **e.** The atomic number indicates the number of protons in an atom, which are balanced by an equal number of electrons. Thus hydrogen has a single electron and carbon has six. Hydrogen needs to share one electron to fill its first electron shell. Carbon fills its first shell with four in its second shell. It needs to share four additional electrons to fill its outer shell. Two hydrogen atoms can covalently bond with each other to form molecular hydrogen gas. Four hydrogen atoms can bond with a single carbon atom to form methane. Two carbons can join to each other and to three additional hydrogen atoms each. Any number of additional carbons, with two attached hydrogen atoms, can be inserted between the first two carbons and their three attached hydrogen atom.

4) **e.** Ionization is due to the dissociation of water to form hydrogen ion and hydroxide ion. Each of the other properties is due to hydrogen bonding.

5) **d.** While cohesion is involved in both the capillary tube and pipette, the driving force in each is adhesion of water to the wall of the tube. Pressure pushes water through a hose by mass flow and individual water molecules diffuse from regions of high concentration to low concentration. A siphon depends on the cohesive force of water. As water molecules are sucked from the end of the siphon, they draw additional water molecules along by cohesion.

6) **e.** The positive end of polar water molecules are attracted to Cl^- while the negative end of other water molecules are attracted to Na^+. With their charges now balanced by the bound water molecules, the opposite charged ions are no longer attracted to each other, and the ionic bonds are broken. The salt dissolves.

7) **a.** The pH of a solution is defined as minus the log of the hydrogen ion concentration. If the hydrogen ion concentration in a solution is high, the pH is low, and the solution is acidic.

8) **d.** Hydrogen ion (H^+) concentration is expressed exponentially, thus for every unit difference in the exponent there is a ten-fold difference in concentration. There is a three-unit difference in exponents between coffee and seawater so there is a 1,000-fold difference in concentration ($10 \times 10 \times 10$). The exponents are negative, however, so as the number gets larger (e.g., from 5 to 8), the value gets smaller—a ten-fold *decrease* for each unit change! For a given volume, there a 1,000 times fewer H^+ in seawater than in coffee.

Basic Biological Chemistry

A brief introduction to biological chemistry is necessary to understand the chemical basis of the structure and function of living things from the subcellular level within individual cells to the interactions between organisms and their environment in the biosphere.

■ ORGANIC MOLECULES

Organic molecules are those that contain a carbon backbone. As we saw in Chapter 2, carbon atoms contains six electrons, so their outer shell contains four electrons and their valence is four. In organic molecules, carbon atoms bond most frequently to a) other carbon atoms; b) hydrogen atoms, valence 1; c) oxygen atoms, valence 2; d) nitrogen atoms, valence 3; or e) phosphate atoms, valence 5. Which of these atoms are present, and in what proportion, are the first clues to identifying the type of organic molecule you are examining.

■ FUNCTIONAL GROUPS

Certain combinations of atoms, particularly on the end of a carbon chain, are important for determining the properties of that molecule. They tend to be involved in reactions of one molecule with another. By examining a molecule for reactive sites, you can predict where covalent bonds might form to join that molecule to others.

Hydroxyl Group

A **hydroxyl** group (Figure 3-1a) consists of a hydrogen atom bound to an oxygen atom on the end of a carbon chain. This group is polar, similar to a water molecule, so it is involved in determining the solubility of a molecule. In general, molecules with many hydroxyl groups are more soluble than those without. Alcohols are organic molecules with a hydroxyl group on the end of a short carbon chain.

Carboxyl Group

A **carboxyl** group (Figure 3-1b) is similar to a hydroxyl group, except that the carbon to which the oxygen attaches also is double bonded to another oxygen atom. A carboxyl group on the end of a carbon chain is the signature of an organic acid. The covalent bond between the terminal oxygen and hydrogen atoms is so polar that the hydrogen tends to dissociate to become a free H^+, thus lowering the pH of the solution.

a. b. c. d.

$$-OH \qquad\qquad -C \overset{\displaystyle O}{\underset{OH}{\big\langle}} \qquad\qquad -N \overset{H}{\underset{H}{\big\langle}} \qquad\qquad -O-\overset{O}{\underset{O^-}{\overset{\|}{P}}}-O^-$$

Hydroxyl Carboxyl Amino Phosphate

Figure 3-1. Important functional groups. Each of these functional groups is important in interacting to join adjacent molecules together through dehydration synthesis reactions. The hydroxyl group (a) is common in carbohydrates. A single hydroxyl on the end of a hydrocarbon chain indicates an alcohol. Carboxyl groups (b) identify acids. Amino groups (c) are characteristic of amino acids. Phosphate groups (d) occur in nucleotides.

Amino Group

Amino groups (Figure 3-1c) contain two hydrogen atoms bonded to a nitrogen atom on the end of a carbon chain. Under natural conditions, the amine frequently picks up H^+ from the surrounding solution to become a positively charged ion. As a result, amines frequently act as a base. Twenty of the most common amine-containing organic molecules also contain a carboxyl group on the opposite end of the carbon backbone. These molecules are **amino acids.**

Phosphate Group

Phosphate groups (Figure 3-1d) consist of a phosphorous atom bound to four oxygen atoms, one of which is on the end of a carbon chain. One of the terminal oxygen atoms is double bonded to phosphorous and the other two are negatively charged. As a result, the entire phosphate-containing molecule is an anion.

■ CARBOHYDRATES

Carbohydrates contain only the atoms carbon, hydrogen, and oxygen in the ratio of approximately $C(H_2O)$—carbo (C) hydro (H_2O). Although there are several ways the same carbohydrate can be diagrammed, there is no chemical difference implied between any of these structures.

Polymerizing Carbohydrates

A **polymer** is a large molecule constructed of two or more smaller molecules. For instance, glucose ($C_6H_{12}O_6$) and fructose ($C_6H_{12}O_6$) can combine to form sucrose ($C_{12}H_{24}O_{12}$). Glucose and fructose are both simple sugars called **monosaccharides.** Although glucose and fructose have the same number of atoms, they are arranged in different ways and, thus, the molecules have different properties. For example, fructose (also called fruit sugar) tastes sweeter than glucose. The formulas also suggest that sucrose is composed of two monosaccharides joined together. Thus, sucrose would be a polymer of two monosaccharides—a **disaccharide.**

For the disaccharide, sucrose, to form, the two constituent monosaccharides must be aligned in a very special way. The hydroxyl group on the number 1 carbon of glucose must be adjacent to the hydroxyl group on the number 2 carbon of fructose. When they are properly aligned, it is possible for the hydrogen atom from one to bind with the hydroxyl group of the other to form water. The oxygen left behind from the hydroxyl group on glucose now has a valence of 1. The carbon on the fructose that lost

Glucose

Figure 3-2. Representing the atoms in molecules. The 6-carbon sugar, called glucose, is represented in its two forms. The linear and ring forms occur in nature and readily convert from one to the other. In these figures, every atom in the molecule is represented. In the abbreviated ring, every corner of the ring implies a carbon atom is present. Single hydrogen atoms attached to carbons in the ring also are implied.

its complete hydroxyl group also has a valence of 1. Thus, a new covalent bond can form between the oxygen of glucose, and the carbon of fructose and sucrose is synthesized. The polymerization of two monomers by splitting off water to form a joining covalent bond is called a **dehydration synthesis.**

Sucrose, the disaccharide, can be broken down into its component monosaccharides by a reverse process called **hydrolysis.** In hydrolysis, water provides the atoms that will reform hydroxyl groups when the bond between the bridging oxygen atom and the carbon atom on one of the connected monosaccharides is broken. When the C–O bond is broken, each atom will have a valence of 1, just as do the hydrogen atom and hydroxyl group that results when water splits. Hydrogen covalently bonds with oxygen to reform a hydroxyl group on one monosaccharide, and the hydroxyl group from water covalently bonds with carbon on the other monosaccharide.

Structure Affects Properties

Maltose and lactose are both disaccharide molecules composed only of the monosaccharide glucose, but their properties are very different. Lactose is milk sugar, which is the main source of calories in an infant's diet. Yet many adults can no longer tolerate lactose in their diet. Maltose is usually obtained by allowing grain seeds to begin germination. The breakdown of long-chain starch into its component disaccharides is a process called malting. Malted grain is the source of sugars used by yeast to produce alcohol in the brewing and distilling industries. The major differences in physical properties between these two sugars are related to a subtle difference in the structure of the glucose molecules used during polymerization.

Note in Figure 3-2 that glucose can have two configurations based on whether the hydroxyl group attached to carbon 1 is "up" or "down" relative to the oxygen atom in the ring. "Down" is the alpha configuration, and "up" is the beta form. Maltose has alpha linkages while lactose has beta linkages. A similar situation can occur in the larger **polysaccharides** composed of more than two monosaccharides.

Both starch and cellulose are composed of long chains of glucose monomers. Yet cellulose, formed with beta linkages, is completely non-digestible by us, while starch, containing alpha linkages, is a major source of calories in our diet! Other polysaccharides could be formed by linking different simple sugars

a. Dehydration
 Synthesis

+ **H₂O**

b. Hydrolysis

Figure 3-3. Water in chemical reactions. a) Splitting water from the functional groups of two adjacent molecules is a dehydration synthesis. Glucose plus fructose on the left produces sucrose plus water. b) Adding water to break (hydrolyze) a bond joining two monomers is hydrolysis. Hydrolysis reforms functional groups on the two reaction products.

a.

b.

Maltose

Lactose

Figure 3-4. Alpha (α) and beta (β) linked disaccharides. Both maltose and lactose are disaccharides involving the monosaccharide glucose. In an alpha linkage (for example, maltose), the hydroxyls that undergo a dehydration synthesis are oriented on the same side of their respective monomer. In a beta linkage, the reacting hydroxyl groups are oriented in opposite directions (for example, lactose).

Starch, α linkage

Cellulose, β-linkages

Figure 3-5. Alpha (α) and beta (β) linked polysaccharides composed solely of glucose subunits.

together and/or by varying the sequence of different sugars. Another way to produce different polysaccharides is to introduce side chains as in glycogen.

■ LIPIDS

Like carbohydrates, **lipids** generally contain only C, H, and O, but not in the ratio of $C(H_2O)$. Instead there are long chains of carbon and hydrogen atoms with only a few oxygen atoms. A typical lipid consists of a glycerol molecule with three attached fatty acids. Fatty acids may differ in length of the hydrocarbon chain. They may also differ in degree of saturation. In a saturated fatty acid every carbon atom in the hydrocarbon chain bonds with at least two hydrogens. In unsaturated fatty acids, such as oleic acid, at least one pair of carbon atoms contain a double bond and, thus, bind only a single hydrogen atom each. Although lipids are large molecules, they are not polymers and unlike most carbohydrates, they have little or no affinity for water.

Glycerol

Most lipids contain two components, a glycerol foundation and two or usually three different fatty acids, hence the name **triglyceride.** Glycerol is a 3-carbon alcohol containing three hydroxyl groups that can react with other molecules through dehydration syntheses.

Fatty Acids

The backbone of a fatty acid is a hydrocarbon chain, a long carbon chain with attached hydrogen atoms. On one end of the carbon chain is a carboxyl group making the entire molecule an acid and providing a hydroxyl site for potential dehydration reactions. To form a lipid, three fatty acids must be positioned "just right," adjacent to a glycerol molecule so that three waters can be removed and the fatty acid bonds to the glycerol.

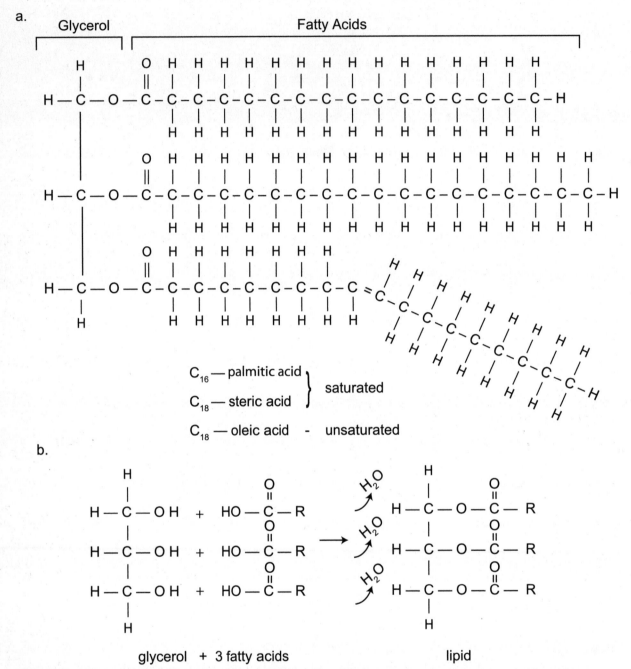

C_{16} — palmitic acid
C_{18} — steric acid } saturated

C_{18} — oleic acid - unsaturated

glycerol + 3 fatty acids lipid

Figure 3-6. Typical lipids. a) The top fatty acid, palmitic acid, contains sixteen carbon atoms, while steric and oleic acids both contain eighteen carbon atoms. Both palmitic acid and steric acids are saturated while oleic acid is unsaturated; b) Lipids are synthesized by dehydration reactions that attach the carboxyl end of three fatty acids to each of the three hydroxyl groups on glycerol.

The hydrocarbon backbone of fatty acids is sometimes abbreviated in diagrams as an "R" group. One difference between fatty acids is simply the number of hydrocarbons making up the R-group. In general, longer fatty acids contain more energy than shorter ones.

In addition to length of the hydrocarbon chain, fatty acids differ in the number of hydrogen atoms attached to each carbon atom. Note that the diagram of oleic acid appears to be bent and that a carbon-carbon double bond occurs at that point. As a result of the double bond, each carbon atom attaches only a single hydrogen atom rather than two. We say that this hydrocarbon is **unsaturated;** it does not contain the maximum number of hydrogen atoms per carbon atom. The two straight fatty acids, palmitic acid and steric acid, are **saturated.** You may recall from food labels that some products contain **polyunsaturated** fats. This means there are many double bonds in the fatty acids of the lipids in that product.

In general, lipids with saturated hydrocarbons tend to be solids at room temperature. We call them fats. Unsaturated lipids tend to be fluid oils. Animal lipids tend to be fats while plant lipids tend to be oils. Again you may recall from food labels that many processed foods contained hydrogenated plant oils such as hydrogenated soybean or corn oil in margarine or hydrogenated peanut oil in peanut butter. During processing, double bonds in these plant oils are replaced by adding hydrogen atoms, and the formerly fluid oils are converted to saturated fats. This is done primarily to improve the consistency and aesthetic appeal of the product, but it has the byproduct of converting a healthier form of lipid into a less healthy product.

Phospholipids

Phospholipids are structurally similar to triglycerides, except that one fatty acid is replaced by a phosphate group.

Figure 3-7. Phospholipids. Phospholipids substitute a phosphate-containing group for one of the three fatty acids in a lipid. The hydrocarbon chains of the two fatty acids are repelled by water (they are hydrophobic), as are typical lipids. The polar phosphate group is hydrophilic (that is, water loving) and, thus, attracted to water.

Because the phosphate group is polar, one end of the phospholipids is now **hydrophilic** while the other end, containing the two fatty acids, remains **hydrophobic** like other lipids. This makes phospholipids behave very differently than other lipids when mixed with water. For example, when olive oil is shaken with water in a salad dressing, the tiny droplets of oil quickly coalesce and float back to the surface of the water reforming separate layers of oil and water. If the same is done with phospholipids, the phospholipids droplets will spontaneously form a bilayer with the hydrophobic fatty acids tail-to-tail, and the hydrophilic phosphate groups oriented either to the external water or the water trapped within the droplet.

■ PROTEINS

Proteins are complex molecules with the greatest diversity of any biologically important class of molecules. Every protein has a unique sequence of amino acids that permits additional interactions to produce characteristic twists and folds that give each protein a unique shape. The proper shape is essential for protein function.

Amino Acids

There are twenty common **amino acids** found in living things.

Primary Structure

The sequence of amino acids in a polypeptide chain is the **primary structure.** If the hydroxyl group of one amino acid is lined up properly with the amino group of a second amino acid, the amino group can contribute a hydrogen to the hydroxyl group to form water. The remaining carbon and nitrogen atoms each have a valence of one and can join together to form a covalent **peptide bond.** As with carbohydrates where a dehydration reaction forms a disaccharide from two monosaccharides, a dehydration reaction between two amino acid **monomers** forms a **dimer**. If this process is repeated, a **polymer** is produced with a specific sequence of amino acids.

Higher Order Structure

The polypeptide formed by dehydration syntheses will have a variety of side groups coming off the polymer backbone at specific intervals. Some of these will be polar and capable of interacting with other polar side groups if the chain is twisted into a spiral or flattened into a sheet. If the polypeptide is coiled like a rope and hydrogen bonds form between the polar groups, the hydrogen bonds will hold the polypeptide in a spring-like coil, a **helix.** If the polypeptide is folded back on itself repeatedly so strands lay side-to-side, hydrogen bonds between polar groups will hold it together in a **pleated sheet.** The helix or pleated sheet is the **secondary structure** of the polypeptide.

The twisting or pleating of secondary structure may again bring different reactive side groups adjacent to each other. As a result, additional hydrogen bonds, disulfide bonds, or ionic bonds may form between side groups to hold the polypeptide in a new configuration called **tertiary** (3rd-level) structure. This is the highest order of structure than can be formed by a single polypeptide. However, two or more polypeptides with their own characteristic tertiary structure may interact with each other to form a protein with **quaternary** (4th-level) structure. Remember that proper shape is important for the structure of any protein, thus anything that changes any level of structure may change the shape of the protein and make it less functional or even non-functional. Extreme temperature and pH are two common factors that change **(denature)** protein shape and make them ineffective. Of course, sometimes we take advantage of this relationship. For example, if you have straight hair (protein) and want to make it curly, you can heat your hair with a curling iron. Heat from the iron will break some of the hydrogen bonds, allowing you to

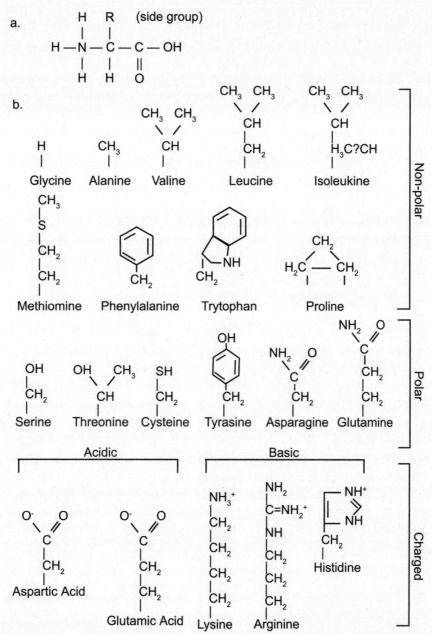

Figure 3-8. Amino acids. a) The backbone of all amino acids is a side group-attaching carbon atom with an amino group on one side and a carboxyl group on the other. b) The difference between amino acids depends on the composition of the side group. In addition to C, H, and O, every amino acid also contains at least one nitrogen atom in an amino group. Opposite the amino group is always a carboxyl group. These two groups will be involved in linking amino acids to form the polypeptide chain of a protein. The difference between most amino acids is found in the side groups. Approximately half of the amino acids have side groups that are neither polar nor charged. Six side groups are polar and, thus, may be involved in hydrogen bonding to produce higher-order structure in proteins. The side groups of five amino acids are charged. The negatively charged amino acids are acidic; positively charged side groups are basic. Two amino acids contain a fifth atom, sulphur. If two cysteine molecules happen to have their sulfur-containing side groups adjacent to each other, a covalent bond can form between them—a disulfide bond.

curl the protein, which will be held in place (at least for awhile) by forming new hydrogen bonds. Similarly, you can flatten wavy hair by ironing it on a flat board.

■ NUCLEOTIDES

The final group of major biological molecules are nucleotides. **Nucleotides** consist of a foundation of one of two sugars with one or more phosphate groups attached to one side of the sugar and one of five nitrogen-containing bases attached to the other side. As you might now expect, both phosphate groups and nitrogen-containing bases are linked to the sugar by dehydration reactions involving hydroxyl groups on the sugar, a hydroxyl group on the phosphate, and an N-H group on the nitrogenous base.

Sugars

The foundation of all nucleotides is a five-carbon monosaccharide. The only difference between the sugars is whether or not there is a hydroxyl attached to the number 2 carbon. As illustrated in Figure 3-9, **ribose** has an oxygen-containing carboxyl group at this point, while **deoxyribose** simple contains a hydrogen (a ribose without the oxygen: de-oxy).

Phosphate Groups

Various nucleotides will have one, two, or three phosphate groups. For example, adenosine monophosphate (**AMP**) has one phosphate, adenosine diphosphate (**ADP**) has two phosphates, and adenosine triphosphate (**ATP**) has three phosphates. We will see that the last is particularly important in energy transfer because attaching the third phosphate allows more chemical energy to be stored in the bonds than normally would be predicted.

Nitrogen-Containing Bases

The nitrogenous bases are carbon rings containing two or more nitrogen atoms. Three of the bases, the **pyrimidines,** contain only a single ring. Both **purines** contain a double ring. Later, we will see that it is important that the purine side chain is about twice the length of a primidine side chain. The amine groups and oxygen atoms coming off the rings are polar. We will see that it is important that guanine and cytosine both can form two hydrogen bonds, while uracil, thymine, and adenine all form three hydrogen bonds.

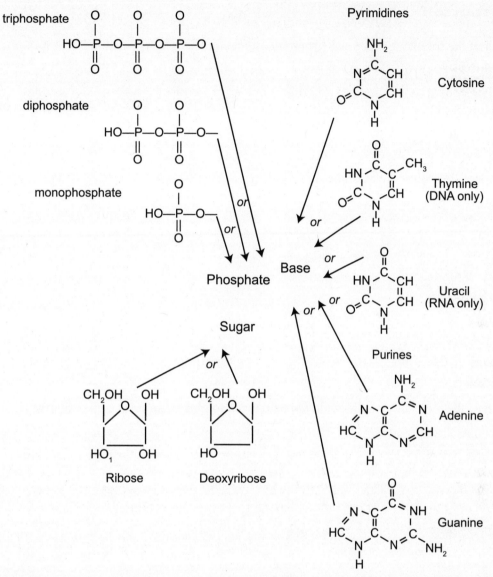

Figure 3-9. Nucleotides. A nucleotide consists of three component: sugar, phosphate, and base. One, two, or three phosphate groups attach to either ribose or deoxyribose by a dehydration synthesis. One of five nitrogen-containing bases also attaches to the sugar through a dehydration. The bases contain either a single ring, pyrimidines, or double ring, purines.

Test Yourself

1) Which of the following functional groups does not contain an oxygen atom?

 a) hydroxyl

 b) carboxyl

 c) amino

 d) phosphate

 e) All contain an oxygen atom.

2) The molecules below are examples of

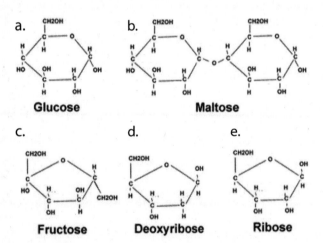

 a) carbohydrates.

 b) lipids.

 c) proteins.

 d) amino acids.

 e) nucleotides.

3) Which of the molecules below could *not* be bonded to glucose to form a disaccharide?

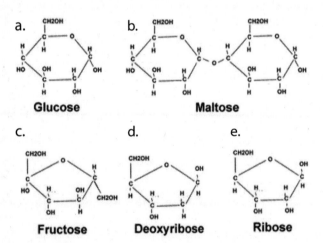

4) The factor having the greatest effect on the "fluidity" of a fatty acid is the

 a) length of the hydrocarbon chain.

 b) number of fatty acids attached to glycerol.

 c) number of phosphate groups attached to glycerol.

 d) number of double bonds in the hydrocarbon chain.

 e) position of the hydroxyl groups in the hydrocarbon chain.

5) In a complex protein, which type of bond is *least* likely to be broken when the protein is denatured by excessive heat?

 a) covalent bond between amino acids

 b) peptide bond forming a disulfide bond

 c) hydrogen bond between amino acid side chains

 d) hydrogen bond between polar amino acids

 e) ionic bond between charged amino acid side chains

6) The _____ level of structure is most critical in determining the three-dimensional shape of a protein.

 a) primary

 b) secondary

 c) tertiary

 d) quaternary

 e) They are equally important.

7) *Every* nucleotide will contain

 a) deoxyribose.

 b) phosphate.

 c) thymine.

 d) guanine.

 e) both b and c.

8) Dehydration syntheses are used to produce

 a) carbohydrates.

 b) lipids.

 c) proteins.

 d) nucleotides.

 e) all of the above.

Test Yourself Answers

1) **c.** An amino group consists of a nitrogen atom with two hydrogen atoms. The hydrogen may be donated to the hydroxyl of another atom to form both water and a bond between the nitrogen of the amino group and a carbon on the other molecule.

2) **d.** Each has a charged amino group on the left of the carbon backbone and a charged hydroxyl group on the right. They are acidic amino acids.

3) **b.** Each of these molecules is a sugar that could be attached to a glucose molecule by a dehydration synthesis. However, maltose is a disaccharide, so attaching it to glucose would produce a trisaccharide. All the other molecules are monosaccharides.

4) **d.** Unsaturated fatty acids are characteristic of liquid oils, while solid fats typically contain saturated fatty acids. Saturated hydrocarbon chains contain the maximum number of hydrogen atoms. In unsaturated hydrocarbons, pairs of hydrogen atoms on adjacent carbon atoms are replaced by a double bond. The more double bonds, the more highly unsaturated the hydrocarbon and the more fluid its consistency.

5) **a.** Hydrogen bonds have the weakest strength and are the most easily broken by any condition causing denaturation. Covalent bonds are the strongest and are the least likely to be broken. The covalent bonds between amino acids, known as peptide bonds, form the primary structure of the protein and are the least likely to be broken during denaturation. They occur only between the amino group of one amino acid and the carboxyl group of another. Disulfide bonds are covalent bonds formed between the sulfur atoms in side chains of two amino acids.

6) **a.** The primary structure, which determines the sequence of amino acids, also determines the relative positions of the various side chains that are involved in each of the higher order levels of structure. Altering the primary structure will affect the possible bonds that can form at each higher level.

7) **b.** Nucleotides contain one of two different pentose sugars, either ribose or deoxyribose. Thymine is found only in DNA. Guanine is in both DNA and RNA, but it is not the nitrogenous base in ATP. All nucleotides contain one or more phosphate groups.

8) **e.** Dehydration syntheses split water from adjacent hydroxyl groups to link carbohydrates. They are also involved in attaching fatty acids to glycerol. Peptide bonds are a special case of dehydration reaction involving an amino group as the hydrogen source for the dehydration between adjacent amino acids, and both the phosphate and nitrogenous base are attached to pentose sugars by dehydration reactions.

Membranes

Membranes are chemical boundaries that divide living "stuff," called **protoplasm,** into compartments. The simplest living things have only a single membrane, which divides the protoplasm from its environment. More complex organisms subdivide the protoplasm into smaller compartments by forming additional membranes. Understanding the nature of membranes is, therefore, critical to understanding life.

■ MEMBRANE STRUCTURE

In Chapter 3, we discussed phospholipids. Recall that phospholipids will form a bilayer with the hydrophobic tails of each layer adjacent to each other, and the hydrophilic phosphate groups oriented toward either the external water or the water trapped inside the layer. If phospholipids were the only component of membranes, they would be impermeable to anything water soluble. Water, or materials dissolved in water, could not pass through the hydrophobic internal layer of the membrane.

When cellular membranes were first examined with the electron microscope, they appeared to be simply a phospholipid sandwich, with the hydrophobic region sandwiched between two layers of phosphates. (Note that they are too thin to be seen with a light microscope. What appears to be a membrane in the light microscope is the boundary between the internal and external solutions. We see the boundary because of the different refractive indices—that is, the degree of transparency—of the solutions on each side.) We soon discovered that membranes are much more complex and more dynamic than we thought.

Embedded in the membrane are a variety of proteins. Some proteins extend all the way through the phospholipid bilayer and contact both the inner and outer solutions. Some proteins are embedded only on one side or the other. In addition, there may be carbohydrates, other lipids, or combinations of carbohydrates and lipids called glycolipids. Although the diagram makes the membrane look very rigid and fixed, in fact, many of the various components "float" relative to each other in the membrane. For this reason, our concept of the structure of membranes is called the **fluid mosaic** model.

■ MEMBRANE COMPONENT FUNCTIONS

Membrances are complex structures composed of several different biological molecules, each with a specific function.

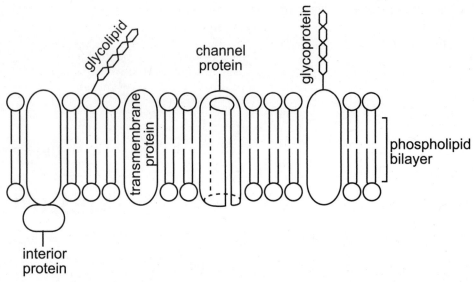

Figure 4-1. Schematic biomembrane. The most abundant component of biomembranes are the phospho-lipids that form a bilayer, with their hydrophobic tails oriented toward each other and their hydrophilic heads oriented toward the aqueous inner and outer solutions bounded by the membrane. Transmembrane proteins extend completely through the lipid bilayer. Some of these, called channel proteins, form a hol-low opening through which some materials can flow. Others may be involved in active transport or may be enzymes in various metabolic reactions. Interior proteins bind to the inside of the membrane and attach the membrane to internal structures of the cell. Short chain carbohydrates may bind either to pro-teins (glycoproteins) or lipids (glycolipids) in the membrane and extend outward.

Phospholipids

In additional to forming the basic boundary layer separating the internal and external spaces, phospholipids also provide the matrix that holds the other components within the membrane but allows them fluid movement within the layer or layers. Even the phospholipids of a single layer constantly move relative to each other.

Proteins

Different kinds of proteins are found in membranes. Transmembrane proteins extend all the way through the phospholipid bilayer, but other proteins may be embedded in the one layer of phospholipid and extend only to one side of the membrane.

Transmembrane Proteins

Proteins that extend through both layers of phospholipids are frequently involved in transport. Some provide channels or tunnels though which several different kinds of molecules can passively move. Other transport proteins will allow only specific substances to pass through passively. A third type requires energy to actively attach a specific molecule or ion on one side of the membrane and carry it across to the other side. These frequently function as pumps and are named after the substance they carry. A final type of transmembrane protein binds signaling molecules, such as hormones or neurotransmitters, on one side of the membrane. As a result, the protein changes shape, and this conformational change induces a specific activity on the inside of the membrane.

Another function of transmembrane proteins is to mediate certain reactions or reaction pathways. **Enzymes** are a special type of protein that catalyze reactions. Many enzymes, particularly in complex biochemical pathways, are integral parts of the membrane. Particularly in animal cells, special transmembrane proteins may interact with similar proteins in an adjacent membrane to bind the two membranes together in a gap junction or a tight junction.

Interior Proteins

Proteins attached only to the inner side of the membrane, often to transmembrane proteins, are **interior proteins.** These usually function in attaching the membrane to internal structural components of the compartment, such as microtubules. As such, they may be involved with changing the shape of the membrane or stabilizing the position of different proteins in the membrane. The latter is particularly important for enzyme mediated reaction pathways, where steps are arranged in a particular sequence.

Carbohydrates

Carbohydrates in the membrane are associated either with lipids (glycolipids) or proteins (glycoproteins). Both types of molecules are surface markers that are involved in recognition. Glycoproteins are particularly important for "self" recognition, such as immune response in animals or self-sterility in some plants. Glycolipids are frequently involved in tissue recognition, such as the markers that define different blood groups in humans.

■ TRANSPORT ACROSS MEMBRANES

Biological membranes are differentially permeable. That is, for a particular membrane, there is a continuum of permeability: Some substances can pass through readily; other substances cannot pass through at all; and others pass through at some intermediate rate. Different membranes have different permeabilities. Therefore, if membranes are nested—that is, a larger membrane-bound compartment surrounds one or more smaller compartments—the substances within different compartments will be different, and the chemical reactions that occur in one will be different from the chemical reactions that occur in others.

Passive Transport

Passive transport does not require an additional energy source to move substances from one side of the membrane to the other.

Diffusion

Diffusion is often defined as movement of a substance from a region of higher concentration to a region of lower concentration. A more correct definition substitutes "free energy" for "concentration," but we will talk about that later. For now, "concentration" will do. For example, if a lump of sugar is dropped into a cup of coffee, initially, all of the sugar will be in the lump (high concentration) and none will be in the coffee (low concentration). At normal temperatures, molecules are in constant random motion—even in solids. As the sugar molecules hydrate, it becomes more likely for them to move away from other sugar molecules than toward more sugar (they are less likely to bump into another sugar molecule). Thus, there will be a net movement of sugar from higher to lower concentration. Eventually, sugar molecules will be evenly distributed throughout the coffee; equilibrium will be reached, and there will be no net diffusion. Diffusion across membranes frequently occurs through channel proteins.

Facilitated Diffusion

Facilitated diffusion differs from regular diffusion because a specific transport protein is required for a specific diffusing substance. There must still be a concentration gradient from one side of the membrane to the other. The substance binds to the transport protein on the side with higher concentration and diffuses through the membrane to the side with lower concentration. Facilitated diffusion speeds the rate of diffusion but does not change its directions. Facilitated diffusion moves materials down the concentration gradient.

Osmosis

Osmosis is a special case of diffusion that involves the diffusion of water through a differentially permeable membrane. For osmosis to work, the membrane must be permeable to water but impermeable to some other substance dissolved in water on one side of the membrane, but not the other (See Figure 4-2).

Will all of the water eventually diffuse to the right side? The concentration on the left will always be 100 percent until you're down to the last drop, and the concentration of water will never be 100 percent on the right! You probably realize that as the height of solution increases on the right, the weight of fluid on that side also increases because of the force of gravity. This force is called hydrostatic pressure, and it forces water back to the left in opposition to the force of diffusion. At some point, the amount of water diffusing left to right will be equal to the amount of water moving in the other direction and equilibrium will be reached. In this example, hydrostatic pressure is another component of free energy moving in the opposite direction from the concentration component. Equilibrium occurs when the free energy is equal on both sides.

Active Transport

Active transport involves special carrier proteins in the membrane and requires energy input to move substances against the concentration gradient. This allows cells to concentrate certain substances that are rare in the environment or to set up a concentration gradient by pumping substances out of the cell.

As mentioned in Chapter 3, shape is important for the function of a protein. Carrier proteins have a shape that conforms to the shape of the substance to be carried.

Bulk Transport

The processes mentioned in the preceding section are effective for small molecules and ions, but large molecules and large particles move across the membrane through **vesicles.** Vesicles are tiny sacs bound by a membrane similar to the membrane through which transport must occur. The substance to be transported fills the vesicle. In **exocytosis,** substances produced within a living cell are packaged into vesicles, and the vesicle moves toward the cell membrane. When the two membranes come into contact, the phospholipid bilayers rearrange and join together in such a way that the substance within the vesicle is extruded to the outside of the membrane. **Endocytosis** is a reverse process, in which substances on the outside of the cell come in contact with receptor molecules on the outer membrane, and the membrane infolds at that point to enclose the substance. When phospholipids from the infolding edges come in contact with each other, they rearrange to produce a small vesicle containing the intruded substance, separate from the original membrane. The prefix *ex–* or *exo–* means "out" (think *ex*it). The prefix *en–* or *endo–* means "in" (think *en*trance).

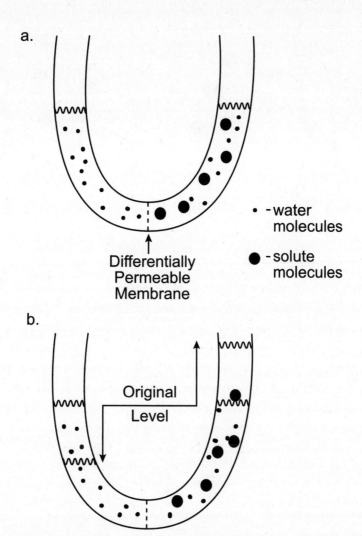

Figure 4-2. Osmosis. a) A U-shaped tube contains equal amounts of pure water and solute dissolved in water on opposite sides of a membrane. Water (small circles) can pass through the membrane in either direction but the solute (large circles) is restricted to the right side. b) The same tube some time later. The decrease in volume of water on the left is equal to the increase in volume on the right. In Figure 4-2a, a differentially permeable membrane separates one side of a U-shaped tube from the other. The left side of the tube contains pure (100 percent) water, while the right side is a solution of water and a substance that cannot pass through the membrane. On this side, the concentration of water is <100 percent. Water can pass through the membrane so it diffuses from left to right, but the substrate cannot pass through the membrane so it does not diffuse. The net result is that the height of water will decrease on the left side of the tube (and the height of solution increase on the right side) by the amount of water that diffuses (Figure 4-2b).

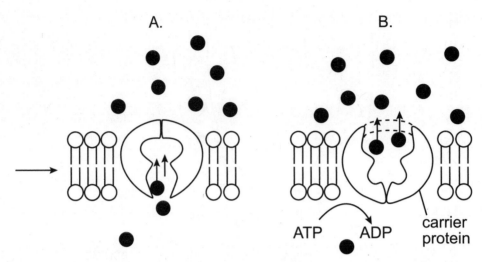

Figure 4-3. Active transport. *a) A carrier protein in the membrane has a relaxed shape that exposes a receptive surface for a specific substance (circles) on the side of the membrane with a lower concentration. b) Addition of energy from ATP causes a shape conformation in the carrier protein that transports the bound substance to the side of the membrane already containing a higher concentration of substance. In the resting condition, the receptors of the carrier protein are exposed on the side of the membrane with lower concentration of the substance to be transported. When the receptor sites are filed, energy from an ATP molecule is used to change the shape of the carrier protein so that the substance is transported across the membrane and released on the side that already has a higher concentration. This increases the concentration differential between the two sides of the membrane. In Chapter 6, we will discuss how ATP provides energy for cellular activities.*

Test Yourself

1) A substance that moved across a membrane against its concentration gradient and with the expenditure of ATP must involve
 a) simple diffusion.
 b) active transport.
 c) tunnel proteins.
 d) electron transfer proteins.
 e) osmosis.

2) Which of the following is *not* true of facilitated diffusion?
 a) It is mediated by transmembrane proteins.
 b) It is driven by concentration gradients.
 c) It requires the expenditure of ATP.
 d) It may involve a protein serving as a passageway.
 e) It may involve a protein undergoing a change in shape.

3) Proteins in membranes can affect transport of materials across membranes by
 a) serving as molecular pumps.
 b) serving as receptor molecules in endocytosis.
 c) serving as hydrophilic channels.
 d) serving as a carrier molecule in active transport.
 e) all of the above.

4) The fluid-mosaic model of a membrane
 a) contains only proteins and carbohydrates.
 b) depends on phospholipids for fluidity.
 c) requires that proteins be firmly attached to the phospholipids.
 d) implies that different components are found in different layers.
 e) refers only to how membranes regulate osmosis.

5) Which of the following molecules are the primary transporters across most cell membranes?
 a) nucleic acids
 b) cholesterol
 c) phospholipids
 d) carbohydrates
 e) proteins

6) When very specific and very large molecules are taken into the cell, this will usually be accomplished by

a) active transport.

b) facilitated diffusion.

c) endocytosis.

d) exocytosis.

e) simple diffusion.

7) The impermeability of membranes to water soluble molecules results from

a) the non-polar nature of water molecules.

b) the presence of large transmembrane proteins.

c) the presence of cholesterol in some membranes.

d) the carbohydrates on the membrane surface.

e) the presence of phospholipids in the lipid bilayer.

8) Endocytosis may be defined as

a) the secretion of molecules from a cell.

b) movement of particles from a region of greater concentration to a region of lesser concentration.

c) the intake of molecules into a cell.

d) interactions of the sodium-potassium pump.

e) the cycling of cytoplasm within the cell.

Test Yourself Answers

1) **b.** Active transport is the process that moves substances against a concentration gradient and requires energy from ATP. Both diffusion and osmosis move substances through transmembrane proteins sometimes called tunnel proteins, but in the case of osmosis the substance transported must be water. Electron transfer proteins are another type of transmembrane protein, but they are not involved with transport across the membrane.

2) **c.** Facilitated diffusion requires specific transmembrane proteins that may undergo a shape change as the substance diffuses through it. Because it is diffusion it can only move molecules down a concentration gradient and therefore does *not* require energy in the form of ATP.

3) **e.** In active transport, transmembrane proteins pump substance across membranes. Other transmembrane proteins may serve either as receptor molecules, carrier molecules, or channels for diffusion or osmosis.

4) **b.** The term *fluid* refers to the constant movement of component molecules relative to each other. *Mosaic* implies that structures with different appearance—for example, various proteins, glycolipids, and glycoproteins, are all embedded in a common matrix, the layers of phospholipid.

5) **e.** Although each of the molecules mentioned is found in membranes, only proteins are directly involved in transport across the membrane.

6) **c.** Very large molecules are moved across membranes by endocytosis or exocytosis. Endocytosis is movement into the cell. Exocytosis is movement out of the cell (*ex–* = exit).

7) **e.** The hydrophobic nature of the phospholipids tails repels water and any substances dissolved in water.

8) **c.** Endocytosis (recall *endo* means "in") is invagination of a membrane around a particle to bring it into the cell.

Cell Structure

Cells are membrane-bound structures, composed of biological molecules, that exhibit the properties of life. Maintaining this structure is essential for life.

■ ALL ORGANISMS ARE COMPOSED OF CELLS

In the late 1830s, it was proposed that all organisms are composed of one or more cells. This concept is one of three principles we now accept as the **Cell Theory.** The second principle is that cells are the smallest unit of living things. It is only when molecules organize into a cell that the emergent property of life arises. The third principle is that under the conditions found on earth today, all cells come from preexisting cells.

General Characteristics

A common feature of all cells is that they are bounded by a membrane, the **plasma membrane.** The term plasma refers to **protoplasm,** the "living stuff" of a cell. The protoplasm is a compartment separated from its environment by its outermost layer, the plasma membrane. Remember that a membrane is fluid and dynamic. It is part of the living cell.

The three-dimensional structure of a cell sets up a problem in economics. The volume of protoplasm creates certain demands. To maintain life, the cell requires a minimum amount of nutrients, water and minerals, dissolved gasses, and other substances. It also must dispose of a variety of waste materials. The larger the cell, the greater its demands will be. In the simplest case, think of a three-dimensional cell as a cube with sides of equal length. The volume of a cell 1 unit on a side will be 1 unit \times 1 unit \times 1 unit $= 1^3$ units $= 1$ cubic unit. If the dimension doubles to 2 units, the volume increases as the cube, $2^3 = 8$ cubic units. The volume of a cube 3 units on a side becomes $3^3 = 27$ cubic units.

For any living cell, the materials in demand must be transported through the plasma membrane, in one direction or the other. Nutrients and raw materials must be transported into the cell, and waste materials must be transported out. Therefore, to use an economics example, the plasma membrane determines supply. For the cell to remain alive, supply must equal demand. Unfortunately, the membrane is essentially a two-dimensional sheet whose surface area determines how much transport can occur. Surface area increases only as a square function. In a small cell (e.g., 1 unit on a side), the difference between the square and cube functions are minimal and it is easily to supply the demands of the protoplasm. As the cell increases in size, however, the difference between the cubic demand function and the squared sup-

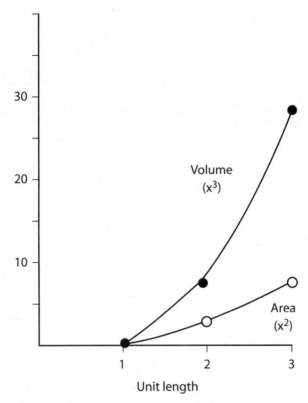

Figure 5-1. Surface/volume relationship. Volume is a cubic function (length × width × height) while area is a square function (length × width). For unit lengths 1, 2, and 3, respectively, the areas are 1, 4, and 8 units². The corresponding volumes are 1, 9, and 27 units³. As cells increase in size their volumes increase much more rapidly than their surface areas.

ply function becomes substantial and at some point, becomes limiting so that the cell will stop growing. In general, the greatest dimension of a cell will be less than 100µm.

Studying Cells

Most cells are too small to be seen with the naked eye. Some notable exceptions with which you may be familiar are unfertilized birds eggs and the individual juice sacs in each section of citrus fruits such as oranges or grapefruits. To study most cells we must use special instruments or techniques.

Microscopy

Microscopes are instruments used to visualize very small structures. Light microscopes use light of different wavelengths to illuminate cells and **magnify** the image as much as 2,000 times. Magnifying an image is only part of the function of a light microscope. It is just as important that it **resolve** the image, make it sharp and clearly visible. Think of the eye chart in a doctor's office. At some line you are unable to distinguish the difference between *e, o,* and *c.* You are unable to resolve image, and the three letters look blurrily alike. If you took that blurry image of a letter and simply magnified it without increasing the resolution, you would simply enlarge the blur. To differentiate between the three you must increase the sharpness—the resolution.

The greater the magnification of a set of lenses on a microscope, the more important it is that they have high resolution. The upper limit of effective magnification using a light microscope is actually deter-

Figure 5-2. Magnification versus resolution. The apples in both photographs are printed at the same magnification but the one on the right has lower resolution while the one on the left has greater resolution, and more detail is visible.

mined by the limits of resolution of the lenses. The magnification and resolution of the best microscopes in 1900 were as good as we have on the best regular light microscopes today! The main differences are that the image is now sharply resolved across the entire field of view (instead of just in the middle) and that color correction is better.

Although it is possible to examine living material with the light microscope, most specimens are killed and stained to better visualize small organelles and other cellular structures. A major problem to consider is the possibility of introducing artifacts during the killing or staining process. Is what you are observing in the dead cells really representative of those cells in the living condition or is it an artifact, something that you introduced as a result of the way you processed the cells? A number of special types of light microscopes were developed in the twentieth century specifically to be able to visualize subcellular details without having to kill the cells. Today, even laser light is used so that cells in thicker tissues can be examined directly without having to cut the tissue thin enough (about the thickness of one cell) for visible light to penetrate.

The major factor limiting the resolution of light microscopes is the wavelength of visible light. Blue light has the shortest visible wavelengths and, therefore, provides the best resolution. Electron microscopes use radiation of much shorter wavelength, electron beams, to produce an image of very high resolution—1,000 times greater than with visible light. As a result, effective magnifications of electron microscopes can also be 1,000 times greater than a light microscope.

Fractionation and Biochemistry

Our understanding of the structure of cells is based primarily on microscopic observations. However, our understanding of the functions of cell parts comes primarily from biochemical reactions done on individual cell components. Critical to this technique is careful disruption of the plasma membrane to release smaller components into a special solution designed to keep smaller membrane-bound components intact. The solution is then spun in a high-speed centrifuge for varying amounts of time. The heaviest components will migrate to the bottom of the tube, and the very lightest components will stay in suspension. Components of intermediate weights will separate from each other by varying amounts. This separation by relative mass is fractionation. Individual layers, containing different fractions, can then be drawn off and tested biochemically for composition or chemical activity.

■ BASIC CELL TYPES

There are many different types of cells in living organisms. You might quickly distinguish between plant cells and animal cells. Yet, plant and animal cells are fundamentally alike and distinctly different from the cells of bacteria. We recognize two fundamentally different types of cells, based primarily on the presence or absence of a nucleus. Cells without a nucleus are called prokaryotic; those with a nucleus are eukaryotic.

Prokaryotic Cells

The term *prokaryotic* literally means "before the nucleus." For the first 1.5 billion years of life on earth, life was restricted to prokaryotic cells. Many different kinds of prokaryotic cells evolved, and even today, prokaryotic organisms are the most widely distributed of any living thing.

Despite the wide diversity of prokaryotic organisms, including the bacteria and an even more primitive group, the Archaea, there are certain characteristics that allow one to readily recognize prokaryotic cells. The first indicator is simply cell size. With few exceptions, the largest prokaryotic cells are less than 10μm long. This is the short end of the size range for other cells. Being so small, prokaryotic cells typically do not contain membrane-bound organelles of any kind, including a nucleus, mitochondria, chloroplasts, or Golgi. Although we usually think of prokaryotic cells as being simple, from another perspective, they are very complex. Some prokaryotes can photosynthesize, undergo aerobic respiration, secrete substances, and pass genetic information to their offspring without the need of specialized organelles for each process. In larger cells, the membrane and compartment of organelles are involved in the special reactions for which that organelle is specialized; for example, respiration in mitochondria or photosynthesis in chloroplasts. In prokaryotic cells, the plasma membrane usually assumes all these functions. A notable exception occurs in the photosynthetic blue-green bacteria, which have an extensive system of internal sac-like photosynthetic membranes called **thylakoids.**

Because prokaryotes lack nuclei, they cannot have the special form of nuclear division required for sexual reproduction, meiosis. Although they cannot reproduce sexually, they do contain genetic material in a single circular chromosome. The genetic material in this chromosome consists of **DNA** that replicates when the cell divides in two. The division process, **binary fission,** is natural cloning. Each daughter cell produced is identical to the parent cell. Under ideal conditions, a prokaryotic cell can divide every ten to twenty minutes so that huge populations of identical cells can form virtually overnight.

Some prokaryotes also contain a **flagellum** for motility, but both the structure and function of these flagella are different from those of other cells. The flagellum has a rigid protein core that rotates within a flexible sheath. A "motor" consisting of a ring of transmembrane proteins surrounding the base of the flagellum causes it to spin like the rotor of an electric motor.

Finally, prokaryotes, like plants, fungi, and many other organisms, secrete materials to form a wall outside of the plasma membrane. The biochemistry of prokaryotic cell walls is unique, composed of a combination of carbohydrate chains side-linked with polypeptides. The chemical composition of the wall varies, depending upon the species. A simple staining test allows us to quickly classify an unknown prokaryote into one of two groups, gram positive or gram negative, depending on the staining properties of the wall. Pathogenic (disease causing) bacteria also frequently secrete a gelatinous carbohydrate **sheath** or **capsule** around the cell wall, making this a useful diagnostic feature.

Eukaryotic Cells

Eukaryotic cells are generally larger than prokaryotic cells and are characterized by the presence of numerous smaller compartments within the protoplasm. The smallest eukaryotic cells are about the same size (10 μm diameter) as the largest prokaryotic cells. The membrane-bound compartments in eukaryotic cells are **organelles.**

Organelles Visible in the Light Microscope

In the 1670s, a Dutch draper named Anthony van Leeuwenhoek began to grind simple lenses by hand and use them to observe single celled "animalicules" in pond scum, tooth scrapings, and a variety of other samples. Some of his microscopes achieved magnifications of more than 200 times. His drawings indicate that he was the first to observe individual bacteria cells as well as flagella and chloroplasts in eukaryotic cells. By 1900, all the cell structure observable with the light microscope were discovered and named. The protoplasm was divided into two basic regions, the **nucleoplasm** and the **cytoplasm.** The cytoplasm is all of the protoplasm outside of the nucleus, the nucleoplasm. While we had a good idea of basic cell structure, it took the next fifty years to understand the functions and finer structure of these organelles.

Nucleus

The nucleus is often the largest organelle in a eukaryotic cell, but it is difficult to see without staining or special microscopy. With staining, it is very conspicuous and granular in appearance. Many nuclei contained particularly dark-staining spherical structures called **nucleoli** (little nuclei). The entire contents of the nucleus was termed **nucleoplasm.** Biologists soon learned that when a cell was dividing, certain elongated structures formed within the nucleus even as the nucleus itself seemed to disappear. These structures stained particularly darkly and were given the name **chromosomes** (colored bodies). Later, specific stains demonstrated that chromosomes contained the nucleic acid **DNA;** similar staining demonstrated that nucleoli contained large amounts of the nucleic acid **RNA.** We now know that DNA is the genetic material that codes the genes responsible for the characteristics and function of the cell. We also know that nucleoli are regions where a special kind of RNA is being synthesized to form ribosomes. Ribosomes are transported out of the nucleus into the cytoplasm where the genetic information later is translated into polypeptides.

When biologists began to examine nuclear ultrastructure with the electron microscope, they discovered many new things. Even when the cell was not dividing, the chromosomes were present as thread-like chromatin. Associated with the chromatin was histone protein. This was not surprising but confirmed hypotheses based on light microscopy. What was surprising was that the **nuclear envelope** (membrane) was not a single bilayer like the plasma membrane. Instead, the nucleus was bounded by a double membrane, each of which had a bilayer structure. Furthermore, the nuclear envelope was pitted with **nuclear pores.** We later learned that the two membrane layers had different biochemical composition—they were not identical.

Mitochondria

Mitochondria are visible with the light microscope and are about the size of a typical bacterium. In living cells, they look like tiny granules that stream within the cytoplasm. Leeuwenhoek certainly saw them and recorded them as simply as part of the grainy cytoplasm of cells. Mitochondria are found in all eukaryotic cells, but they could not specifically be identified until special stains were developed that localized regions of high metabolism.

The first major discovery concerning the ultrastructure of mitochondria is that like the nucleus they are bounded by a double membrane. The outer membrane forms a capsule-like sheath around the entire organelle. It is biochemically distinct from the inner membrane, which has many invaginations that increase surface area. The inner membrane subdivides the interior of the mitochondrion into distinct compartments.

The inner compartment, the **matrix,** is the site of reactions specific to aerobic respiration. The invaginations of the inner membrane form **cristae,** which increase the membrane surface. This membrane is also critical for aerobic respiration and is actually the site for several transmembrane proteins involved with producing ATP and ultimately using oxygen gas (aerobic). The inner membrane also defines the

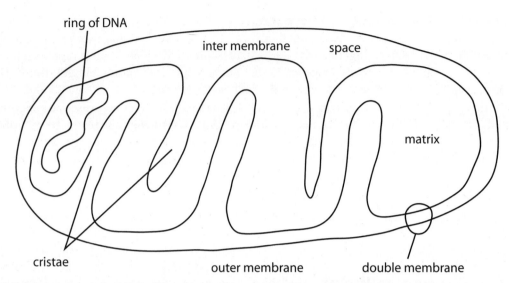

ring of DNA

inter membrane space

matrix

cristae outer membrane double membrane

Figure 5-3. Typical mitochondrion. Mitochondria are organelles with a double membrane and their own bacterial-type DNA. The inner membrane, which invaginates to form cristae, partitions the interior or the organelle into a central matrix and an intermembrane space between the two membranes.

intermembrane space, which will be an important reservoir for temporarily storing H^+ during the process of respiration.

In addition to having a double membrane, like the nucleus, mitochondria also have their own DNA in a bacteria-like chromosome. Mitochondria can reproduce and multiply in metabolically active cells as well as when the host cell divides into two daughter cells. Their DNA contains most of the genes necessary to synthesize new mitochrondria.

Chloroplasts

Chloroplasts are the most conspicuous organelle in photosynthetic cells. They are a special type of chromoplast (colored plastid) that contains their own green-colored pigment. They are easy to see without staining partially because of their color and partly because of their large size. Some chloroplasts are about the same size as large mitochondria, but usually they are considerably larger—the size of very large bacteria.

By 1900, botanists described chloroplasts as having numerous dark, grain-like **grana** within a clear green **stroma.** Fifty years later, with the invention of the electron microscope, we discovered that the grana were stacks of sac-like membranes called **thylakoids**. The stacked thylakoid membranes are so dense that they appear as dark spots when viewed with the light microscope.

These thylakoids are similar to those found in photosynthetic blue-green bacteria (see the preceding section). Some thylakoid membranes extend between grana to form an interconnecting network of membranes. The stroma is a large compartment separated by the thylakoid membranes from the sac-like inner compartment within thylakoids. Photosynthetic pigments are embedded within the thylakoid membranes. Like the inner membrane of mitochondria, thylakoid membranes also contain transmembrane proteins involved with ATP production.

Surrounding the entire chloroplast is a double membrane. Like the nucleus and mitochondria, the inner and outer chloroplast membranes are biochemically distinct. Like mitochondria, chloroplasts also contain their own bacteria-like chromosome of DNA that codes for much of its structure. Chloroplasts also can divide independent of their host cell.

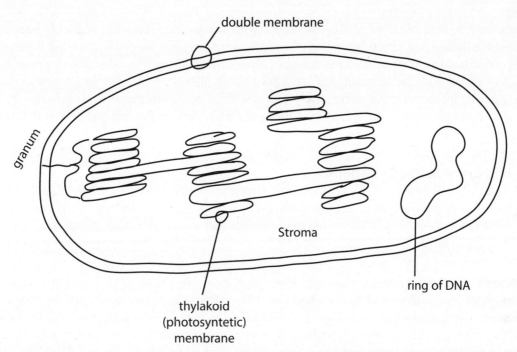

Figure 5-4. Typical chloroplast. Chloroplasts are bounded by a double membrane and have their own bacterial-type DNA. The interior space is filled with sac-like thylakoids, the photosynthetic membranes.

Golgi

Golgi bodies were described at about the same time as mitochondria and, like mitochondria, are found in all eukaryotic cells. They are generally intermediate in size between mitochondria and chloroplasts and first appeared to be larger circulating granules in eukaryotic cells. With improved staining techniques, we discovered that Golgi contained various glycoproteins and glycolipids associated with secretions of various sorts from cells.

Using the electron microscope, we learned that Golgi consist of one or more flattened sacs that stack with a consistent orientation. One side of the stack, the **cis face,** receives materials from other parts of the cell in membrane bound packages called **vesicles.** The membrane surrounding a vesicle fuses with the cis face membrane of the Golgi in a process similar to exocytosis. Vesicle contents are processed as they move through the Golgi to finally be released in new vesicles budding from the **trans face.** These secretory vesicles migrate to the plasma membrane where they fuse and release their contents, through exocytosis, to the outside of the cell. A special type of vesicle, the **lysosome,** contains digestive enzymes that are released into the cytoplasm to destroy worn out organelles and other debris. In some cases, development of a multicellular organism requires that some cells die at specific programmed times. Lysosomes are responsible for such programmed cell death.

Vacuoles

Vacuoles are membrane-bound sacs within the cytoplasm of eukaryotic cells. In many organisms, **food vacuoles** forms by endocytosis, trapping food particles and other materials outside the cell membrane and transporting them into the cytoplasm. In plants, the **central vacuole** is the largest organelle in the cell. Plant cells frequently look empty with the light microscope because the large central vacuole fills most of the cell interior and pushes the rest of the cytoplasm into a thin layer just inside of the cell wall. The vacuole is easiest to see in cells of red or purplish-colored plant parts because these pigments are stored in the central vacuole, not in special plastids.

Flagella

Flagella were first described by Leeuwenhoek, who saw motile green cells suddenly become stuck to the substrate by two fine appendages. With the electron microscope, we discovered that eukaryotic flagella (and cilia) have a complex structure. A ring of nine paired microtubules surround two central microtubules. Associated with the microtubules are cross-linking proteins and motor proteins that allow one doublet of microtubules to ratchet along an adjacent doublet. The plasma membrane ensheaths the microtubular core. Unlike prokaryotic flagella, the flagella of eukaryotes are flexible and beat with a whip-like motion to propel the cell.

Some Ultrastructural Organelles

The term *ultrastructure* refers to cytoplasmic structure too small to see with the light microscope. Although we had many clues about the ultrastructure of cells before the electron microscope, it was not until this instrument came into common use by biologists that we began to appreciate the levels of complexity in cell structure.

Ribosomes

Ribosomes are small assemblies of ribosomal RNA, rRNA, and protein that consist of a large and small subunit that function together. They are formed in the nucleolus and migrated out into the cytoplasm. Ribosomes are the site of protein synthesis. Cytoplasmic proteins are formed by ribosomes floating freely in the cytoplasm. Transmembrane proteins are formed by ribosomes attached to an extensive intracellular membrane system, the **endoplasmic reticulum.** Ribosomes are *not* bound by a membrane.

Endoplasmic Reticulum

The two largest compartments in the eukaryotic cell are defined by the membranes of the endoplasmic reticulum (E.R.). This network of tubes and sacs permeates the cytoplasm and functions in protein and lipid synthesis. The membranes separate the **cisternal space** inside the E.R. from the cytosol on the outside. All the other organelles of the cell, except the central vacuole of plant cells, are suspended in the **cytosol.**

The endoplasmic reticulum was unknown prior to the electron microscope. Early workers discovered that the appearance of the endoplasmic reticulum differed significantly, depending on how the cell was killed, preserved, and stained. In some preparations, only the extensive membrane networks were visible while in others, certain sections of E.R. were coated with granules. In these preparations there also were numerous granules throughout the cytosol. We soon discovered that the granules were ribosomes. Endoplasmic reticulum with associated ribosomes is called **rough E.R; smooth E.R.** lacks ribosomes. We also discovered that endoplasmic reticulum attaches to the nuclear envelope at a pore. This association led early workers to believe that the primary function of the E.R. simply was to transport molecules from the nucleus out into the cytoplasm. We now know that the E.R. has a much more dynamic role in the synthesis of biomolecules.

Cytoskeleton

The inner framework of cells consists of several components including microtubules and actin filaments. **Microtubules,** as their name suggests, are small protein tubules. They function either in providing structural support to the cell or in providing a pathway for transporting vesicles. Microtubules can be disassembled in one location and reconstructed in another. They may increase or decrease in length by adding or subtracting additional protein units. Many microtubules, especially those involved with cell division, form in an area near the nucleus called a centrosome. Depending on the organism, there also may be a pair of centrioles; for example, animal cells have centrioles, but plant cells do not.

Actin filaments, or **microfilaments,** are solid rods of protein subunits that provides tensile support in all cells and are involved in motility in muscle cells. The actin microfilaments form a track along which the motor protein myosin can "walk" when a muscle cell contracts.

Cell Walls

The term *cell* was first given to non-living remnants of plant cells that form cork. These distinctive structures—cell walls—are the most conspicuous component of plant cells. **Cell walls** are secreted in layers by the plasma membrane. The first layer produced is middle lamella.

The middle lamella, is shared by two adjacent cells. Its major component is pectin. Next, the cell deposits a primary wall, consisting primarily of cellulose, inside the middle lamella. In some cells an additional wall, the secondary wall, is laid down inside the primary wall. A primary component of secondary wall is lignin.

When a plant cell divides, each daughter cell contributes equally to formation of a middle lamella between them. A major component of middle lamella is the polysaccharide pectin. Ultimately, pectin acts as a glue to bind cells together.

Once the middle lamella is in place, filaments of cellulose are secreted from the plasma membrane to form a mesh-like layer of primary wall between the membrane and the middle lamella. Each daughter cell produces its own primary wall. In some specialized cells, a third layer (a secondary wall) is deposited between the plasma membrane and the primary wall. In addition to cellulose and other fibrous polysaccharides, an extremely strong polymer of lignin is deposited into the spaces between cellulose microfibers. Lignin is the substance that makes wood hard (cellulose by itself is quite rubbery).

Origin of Eukaryotic Cells

For 1.5 billion years, the only organisms on earth were prokaryotic cells. Then, about 2 billion years ago, a diversity of eukaryotic cells rapidly evolved. As we first became aware of the age of some of these fossils, it seemed that the slow and gradual process of natural selection was an adequate explanationfor the origin of eukaryotic cells. A gradual accumulation of step-wise mutations by bacterial cells could eventually have produced the membrane systems characteristic of eukaryotic cells. However, as more

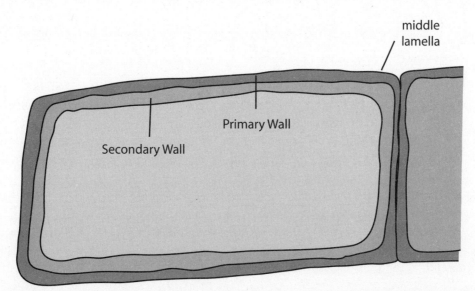

Figure 5-5. Plant cell walls. Plant cell walls have two or three distinctive layers formed in succession from the outside toward the inside of the cell.

fossils were discovered, it became clear that the transition to the eukaryotic condition was relatively rapid and occurred simultaneously to produce several divergent lines of eukaryotic cells. At the same time, we were discovering the detailed ultrastructure of eukaryotic cells and discovering many new forms of single-celled eukaryotic organisms. The time was right for a change in thinking.

Even today, there is more diversity of lifestyles among prokaryotic organisms than among any group of eukaryotes. Some are aerobic; some are anaerobic. Some are photosynthetic, and others engulf their food. Some are motile, and others attach to substrate or float freely. There was likely as much or more prokaryotic diversity when eukaryotes evolved as there is today. Perhaps eukaryotes arose through symbiotic events in which two or more different prokaryotes formed a mutually beneficial association.

This hypothesis was first proposed in the 1960s as we were becoming aware of how extensive symbioses are today. Perhaps a large anaerobic bacterium engulfed a smaller aerobic bacterium through a process of endocytosis. However, rather than digesting the smaller cell in a food vacuole, a symbiotic event would provide more energy for the host cell and protection and nutrients for the endosymbiont—a proto mitochondrion. Similarly, if a small photosynthetic bacterium also was engulfed, the new endosymbiont could function like a chloroplast in providing photosynthate directly to the host. Was there any evidence to support this hypothesis?

Recall that both mitochondria and chloroplasts are the size of typical bacteria and that each has a double membrane. In both, the outer membrane has a different biochemical makeup from the inner membrane. This is what you would predict if the inner membrane belonged to the original engulfed cell and the outer membrane originated as a food vacuole membrane of the host cell. Also recall that both organelles contain a circular ring of DNA similar to that in a bacterial chromosome and that both can reproduce independent of the host cell. Finally, we now know of several examples of extant prokaryotes that can establish symbiotic relationships or not depending on conditions. The symbiotic hypothesis has overwhelming support from a variety of fields and is now the accepted theory for the origin of eukaryotic cells.

Test Yourself

1) Cells are typically small because
 a) small cells have a favorable surface area to volume ratio.
 b) small cells have an unfavorable surface area to volume ratio.
 c) it is more difficult for adequate nutrients to diffuse into small cells, hence they remain small.
 d) the cytoskeleton cannot support large cells.
 e) b, c, and d

2) Prokaryotes
 a) contain DNA.
 b) are unicellular.
 c) produce cell walls.
 d) include bacteria.
 e) all of the above

3) Protein synthesis in the cytoplasm primarily depends upon
 a) lysosomes.
 b) ribosomes.
 c) mitochondria.
 d) centrioles.
 e) Golgi.

4) Lysosomes and other vesicles originate from the
 a) rough E.R.
 b) Golgi apparatus.
 c) cell membrane.
 d) nucleus.
 e) smooth E.R.

5) Eukaryotic chromosomes are located within which structure?
 a) cytoplasm
 b) nucleus
 c) nucleolus
 d) ribosomes
 e) mitochondria

6) Which of the following is *not* directly involved in cell support or movement?
 a) actin filament
 b) flagellum
 c) microtubule
 d) endoplasmic reticulum
 e) cell wall

7) Plant cells have _____ and _____, while animal cells do not. Animal cells have _____, while plant cells do not.

 a) nucleoli, chloroplasts, centrioles

 b) chloroplasts, cell walls, mitochondria

 c) smooth endoplasmic reticulum, chloroplasts, centrioles

 d) chloroplasts, a central vacuole, centrioles

 e) both b and d are correct

8) Membranes are *not* an essential part of the structure and function of

 a) the nucleus.

 b) mitochondria.

 c) chloroplasts.

 d) ribosomes.

 e) All of the above contain membranes.

Test Yourself Answers

1) **a.** All the materials necessary to supply the needs of the volume of cytoplasm in a cell must be supplied across the surface area of the cell membrane.

2) **e.** Prokaryotic organisms, which include bacteria, are unicellular and contain a single loop of DNA sometimes called a bacterial chromosome. Bacteria have a unique wall composition that is useful for identifying unknown species.

3) **b.** The two subunits of ribosomes, composed of protein and rRNA, are the site of protein synthesis in the cytoplasm. Lysosomes are specialized digestive vesicles that destroy damaged organelles in the cell. Mitochondria are the site of aerobic respiration and centrioles and Golgi are involved with the synthesis of microtubules and lipids, respectively.

4) **b.** Lysosomes are specialized vesicles that bud off from the trans face of Golgi. The cell membrane may form small vacuoles through endocytosis, but none of the other choices involves packaging of materials within a membrane for transport.

5) **b.** Nucleoli are also located within the nucleus, but they are the site of RNA production. Both ribosomes and mitochondria are located in the cytoplasm. Although mitochondria contain their own genetic material (DNA), it is arranged in a single ring like other prokaryotic DNA.

6) **d.** Endoplasmic reticulum is a membrane system involved in synthesizing organic molecules. Actin filaments are important in providing tensile strength within the cell and as part of a contraction mechanism. Flagella are motility organelles that in eukaryotic cells contain microtubules. The cell wall is a major structural component of prokaryotic and many eukaryotic cells.

7) **d.** Structures found in plant cells but not animal cells include chloroplasts, a central vacuole, and cell walls. The only structure listed that is specific to animal cells is centrioles. Both plant and animal cells have nucleoli, mitochondria, and smooth endoplasmic reticulum.

8) **d.** The large and small subunits of ribosomes consist of rRNA and protein. There are no membranes around or within the organelle. The nucleus, mitochondria, and chloroplasts are all bounded by a double membrane system. The extensive inner membrane systems of mitochondria and chloroplasts are essential for their functions of providing energy for their cells.

Energetics and Metabolism

In the previous chapters we have been concerned primarily with the structure of cells. To build those cells, and to allow them to function when built, requires the output of energy. The energetic processes that occur in cells is called **metabolism**.

■ ENERGY

Energy is often defined as the ability to do work or cause change. Kinetic energy is associated with motion of objects and includes the random motion of molecules which is heat or thermal energy. Energy that is related to structure position is called potential energy. The energy associated with chemical bonds, referred to in Chapters 2 and 3, is potential energy.

Intuitively, we know that energy can be converted from one form to another. For example, the potential energy in the hundreds of feet of water backed up in Lake Mead behind the Hoover Dam can be converted first into mechanical energy as it drives the turbine blades and then electrical energy as the turbines spin generators.

The branch of physics that studies such conversions is called **thermodynamics**. Two laws of thermodynamics are sufficient to explain such interactions, and they are very important for understanding the energy relationships of living things. Before defining these laws, however, it is important to distinguish between open and closed systems.

Open versus Closed Systems

A **closed system** is isolated from its surrounding, and there is no external influence on energy relationships. The universe is the usual reference for a closed system that is used to define the laws of thermodynamics. An **open system** allows for the input or dissipation of energy to or from the system. Living cells and the earth itself are open systems. For life on earth, the sun is a constant source of energy input, and cells depend ultimately on the ability of photosynthetic organisms to convert light energy into the chemical energy of organic molecules—food.

Laws of Thermodynamics

The laws of thermodynamics are physical laws that describe the relationship between heat and other forms of energy, such as mechanical energy. These laws are valid for both living and non-living things.

Figure 6-1. Energy conversions. Conversion of the potential energy (hydrostatic pressure) of water in a reservoir first to mechanical energy in a turbine, and then to electrical energy in a generator.

First Law

The first law of thermodynamics is frequently called the **Law of Conservation of Energy.** It states that in a closed system, energy cannot be created or destroyed, but it can be transferred or transformed from one form to another. The example of the potential energy stored in Lake Mead being converted into electrical energy by the turbines and generators of Hoover Dam is an example of the first law. Of course, these conversions are not completely efficient. At every step of the process, some energy is converted into heat and dissipated. Yet, if you added up all the heat generated and added it to the amount of electrical energy produced, it would equal the total amount of the potential energy that began the process.

It is intuitively obvious that for the first law of thermodynamics to be valid, you must have a closed system. If the system were open and you could either add additional energy or remove some, the total amount of energy would have to increase or decrease. The second law is not so obvious but again depends on the system being closed. Yet, some people purposely refer to the second law in an open system in an effort to confuse or mislead the public. Proponents of Intelligent Design claim that the second law of thermodynamics proves that evolution cannot occur. If the universe is constantly moving toward entropy, it would be impossible for atoms to spontaneously organize into more complex molecules, for these molecules to organize into cellular structures, for cells to organize into organisms, and for simple organisms to evolve into more complex ones. Do you now understand why this is a false and misleading argument? Hint: When we are talking about life on earth, are we talking about an open or closed system?

Second Law

The second law of thermodynamics states that as energy conversions occur in a closed system, the orderliness of the system decreases. The term *entropy* refers to the amount of disorder in the system. Furthermore, as entropy increases and the system becomes less ordered, the amount of available energy, called **Gibb's free energy** (or simply free energy), decreases. At first, this may seem to contradict the first law, that energy cannot be created or destroyed. The resolution is in the formula for the change in Gibb's free energy: $\triangle G = \triangle H - T \triangle S$, where $\triangle G$ is the change in Gibb's free energy, $\triangle H$ is the change in total energy, T is the absolute temperature (in degrees Kelvin), and $\triangle S$ is the change in entropy. Note that at a given temperature, if the system is very orderly, entropy (the amount of disorder) will be low and a small value of $T \triangle S$ will be subtracted from $\triangle H$ to determine $\triangle G$. In other words, free energy will be very nearly the same as total energy. On the other hand, if the system is highly disordered, entropy *(S)* is high, a large value of $T \triangle S$ will be subtracted from $\triangle H$ to determine $\triangle G$. Free energy will be much lower than total energy.

Recall in Chapter 4 when we discussed diffusion and osmosis, we said that a more correct definition of *diffusion* refers to free energy, not concentration. In a beaker of pure water, there is maximum hydrogen bonding of water molecules to each other, and the water is highly ordered (low entropy, high free energy). As soon as you dissolve another substance in water, the hydrogen bonding between water molecules is disrupted as some water molecules associate with the solute.

The water molecules become less ordered (entropy increases and free energy decreases). As a result water will diffuse from the region of higher free energy (concentration) to a region of lower free energy (concentration). Of course, concentration (related to entropy) is just one of several factors that can affect free energy. Regardless of the factors involved, diffusion will always be from a region of high free energy to one of lower free energy.

Also recall from Chapters 3, 4, and 5 that the molecules and cells of living organisms are highly ordered and that this ordered structure is essential to maintain life. If cells were a closed system, the second law indicates that entropy must increase and the cells must become less organized—they would die. Cells, however, are an open system and much of their metabolism is based on obtaining additional energy from external sources to overcome entropy and maintain the structural integrity of their membranes and organelles.

Figure 6-2. Free energy and diffusion. a) In pure water, there is maximum hydrogen bonding between adjacent water molecules, and the free energy of water is high. b) When solute is dissolved in water, some water molecules associate with the solute, rather than hydrogen bonding to other water molecules, and the free energy of water is reduced.

■ ENERGY AND METABOLISM

The thermodynamic principles described in the preceding section are the basis for generating and using energy within a cell.

Exergonic and Endergonic Reactions

Chemical reactions, whether in living cells or in a test tube, can be classified as one of two types, based on their free energy changes. **Spontaneous reactions** move from a reactant with a higher free energy to a product with a lower free energy. In the process, energy, in an amount equal to the difference between the initial and final free energy, is released. Reactions that release energy are called **exergonic** (*ex–* means "out of"—think *exit*). Exergonic reactions typically occur spontaneously. Because energy is given off, $\triangle G$ is negative. A common exergonic reaction in cells is the conversion of ATP into ADP + Pi (phosphate ion), $\triangle G = -7.3$ kcal/mol.

Many other chemical reactions require an input of energy for a reactant to be converted into a product. Such reactions are termed **endergonic** (*en–* means "into"— think *entrance*). In industrial or chemistry laboratories, a common source of energy to drive endergonic reactions is heat. In living cells, endergonic reactions that require energy are linked or **coupled** to exergonic reactions that give off more than the required amount of energy. The energy released from an exergonic reaction powers the coupled endergonic reaction.

Metabolic Pathways

Many of the reactions in cells follow exergonic reaction pathways, where the product of one step of the pathway becomes the reactant of the next. Suppose that three exergonic reactions can occur in a cell, A→B, B→C, and C→D, and that, initially, there are equal amounts of A, B, and C, but no D in the cell.

Neither of the first two reactions will occur because the concentrations of reactants and products are in equilibrium (there are equal amounts). However, C and D are not in equilibrium, and so C will begin to react to form D, and energy will be released. As soon as one C molecule undergoes this reaction, B and C will no longer be in equilibrium and a B molecule will react to form a new C. Again, this changes the equilibrium but, in this case, between A and B, so an A molecule will react to form a B. As long as there is disequilibrium between the initial and final molecules in the pathway, the reactions will proceed along the pathway A→B→C→D, and energy will be given off at each step.

Figure 6-3 illustrates how a metabolic pathway like respiration could have arisen in cells. As we will see in Chapter 7, respiration is a complex metabolic pathway in which a sugar molecule (with high free

Figure 6-3. Evolution of metabolic pathway. a) Initially the concentrations of A, B, and C are equal in a system where A→B, B→C, and C→D, but there is no D. b) Equilibrium between A, B, and C is lost as soon as one molecule of C reacts to form D. c) The disequilibrium establishes a pathway that will continue as long as A is provided from outside the system and D is removed from the system.

energy) is broken down through a series of step-wise reactions to form carbon dioxide and water (each with much lower free energy). As long as the final products are continually removed and the initial reactant is continually supplied, metabolism proceeds and energy is made available to the cell for all of its functions. However, if CO_2 cannot be removed or if sugar is unavailable, the pathway soon reaches equilibrium and metabolism ceases—the cell dies. Cells are open systems that require a constant input of energy (as food, or in the case of photosynthetic cells as light) and constant removal of waste products in order to stay alive.

ATP Couples Exergonic and Endergonic Reactions

Recall from Chapter 3 that adenosine triphosphate, ATP, is a nucleotide consisting of the sugar ribose, the nitrogenous base adenine, and three phosphate groups. As mentioned in the preceding section, hydrolysis can split the third phosphate group from the rest of the molecule to produce adenosine diphosphate, ADP, a free phosphate group, Pi, and 7.3kcal/mol of energy. This exergonic reaction couples to many different endergonic reactions in cells to provide the necessary energy input.

Of course, once the conversion of ATP to ADP occurs, the available energy has been released, and the ADP molecule will not be able to drive additional endergonic reactions unless it is recycled back into ATP. This is exactly what happens. ADP is coupled to a reaction pathway consisting of exergonic reactions. At least 7.3kcal/mol of energy must be available to drive a dehydration synthesis that links ADP with Pi to reform a molecule of ATP.

ATP is sometimes called the energy currency of the cell. Like money, it is earned in one location, easily transported, and spent in another location. The exergonic reaction of ATP→ADP is coupled to the endergonic reaction of ADP→ATP to continually recycle the nucleotide. This recycling, in turn, is used to couple exergonic metabolic pathways in the cell to exergonic reactions in other parts of the cell.

■ ENZYMES AND METABOLISM

Recall from Chapter 3 that chemical reactions require that reacting molecules be oriented in a very precise way relative to one another. For instance, the hydroxyl groups of two monosaccharides must be positioned in the correct orientation adjacent to each other in order to split off water and form a disaccharide. Enzymes are molecules that facilitate this process.

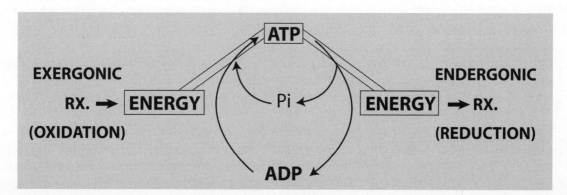

Figure 6-4. Coupling reactions. In one part of the cell, exergonic reactions provide the energy necessary to synthesize ATP from ADP. The resulting ATP can be transported to other parts of the cell where energy is necessary to drive an endergonic reaction. At this location, the exergonic reaction of ATP to ADP is coupled to the endergonic pathway, and ADP is then recycled to repeat the process.

Characteristics of Enzymes

Enzymes are special proteins with unique characteristics that make them especially suitable for controlling chemical reactions in cells.

Enzymes Are Proteins

Enzymes are a special class of proteins that function as organic catalysts. Because they are proteins, their shape is essential to proper function. As with any protein, environmental factors that alter the shape of the protein will affect its function as an enzyme. Excessive temperatures or variations from optimal pH will degrade the enzyme by disrupting hydrogen bonds, causing it to change shape and lose function.

Enzymes Are Recyclable

Enzymes are not consumed by the reactions they catalyze. Rather, they associate with substrate molecules in such a way that facilitates the reaction. Once the reaction is completed and the product is released, the enzyme is ready to form a new association with new substrate molecules. Because of this recycling, enzymes are effective in low concentration. A small amount of enzymes can function repeatedly to produce a large amount of product.

Enzymes Are Specific

For every reaction in a cell, there is a specific enzyme that catalyzes that reaction. The shape of a particular enzyme is optimized to associate with a specific substrate or substrates to produce specific products. Thus, by controlling what enzymes are present, the cell can control its metabolism.

Enzymes Function by Lowering the Activation Energy for a Reaction

Whether a reaction is exergonic or endergonic, a certain minimum amount of energy will initially be required to initiate the reaction. This minimum required energy is called the **activation energy.**

Activation Energy

In Chapter 2, we discussed the energy levels of electrons in atoms and saw that the energy level for any particular electron is not precise, but rather is predicted by a bell-shaped distribution. In the same way, the total energy of a single molecule in a population of molecules cannot be precisely determined, but rather it fits within a bell-shaped distribution. Most of the molecules in the population will have an average amount of energy, but some will have much more than average, and others will have much less. For a reaction to occur, either an exergonic or an endergonic reaction, a certain minimum amount of energy must be available. This minimum amount is called the activation energy. For an exergonic reaction, the activation energy is less than the average energy of the population. Many molecules will have enough energy to react, and the reaction will occur spontaneously. For endergonic reactions, the activation energy is more than the average energy of the population and few, if any, of the molecules will have enough energy to react spontaneously.

There are two ways to speed up a reaction for a given population of molecules, with a specific activation energy. Both relate to the curve in Figure 6-5. For most chemical reactions, you can simply heat the molecules. This raises the energy of the entire system, and the curve will shift to the right. The activation energy is not changed. However, as a result of the shift, a greater number of molecules are now to the right of the activation energy, and the reaction will speed up. This has limited use in biology, however. Can you think of why? Hint: What is the effect of heat on the structure of proteins?

An alternative to increasing the amount of energy in the entire population is to decrease the activation energy required for a reaction to occur. The result of shifting the activation energy to the left on the graph will also have more molecules to the right of the line and able to react. Chemicals that lower the

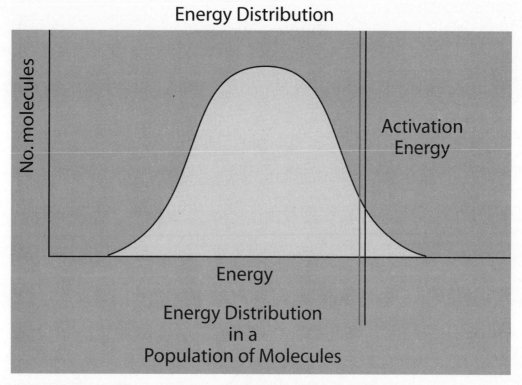

Figure 6-5. The energy levels for a population of molecules has a bell-shaped distribution. The likelihood of a reaction occurring depends on how many of the molecules have an energy level greater than the activation energy.

activation energy for a reaction are called **catalysts.** They usually act by associating with specific functional groups of the molecules that are reacting, making it easier to add or remove a water molecule for hydrolysis or dehydration synthesis. Biological catalysts are called **enzymes.**

Enzyme Functioning

Our current understanding of how enzymes function is described by the **induced fit** model.

According to this model, the initial enzyme shape presents a segment of the enzyme, the **active site,** to the environment in which substrate molecules are present. For example, in the reaction to produce the disaccharide sucrose from glucose and fructose (recall Figure 3-3), the substrates would enter the active site and interact with the enzyme by forming hydrogen or ionic bonds. The substrate molecules would fit in the active site only if they were oriented in a very specific way, thus ensuring the specificity of the enzyme.

The enzyme-substrate interaction induces a change in the configuration of the enzyme, which, in turn, lowers the activation energy for the reaction, making it more likely that the substrate molecules will react. In our example, the two monosaccharides attach to their respective positions at the reactive site. This induces a change in the shape of the enzyme molecule that brings the substrates together in the proper orientation so that a dehydration synthesis can occur to form a sucrose molecule.

The dehydration reaction further changes the enzyme/substrate complex such that the product, sucrose, is released and the enzyme returns to its original configuration ready to react again. Small amounts of enzyme are effective because the enzyme is recycled intact following each reaction it catalyzes.

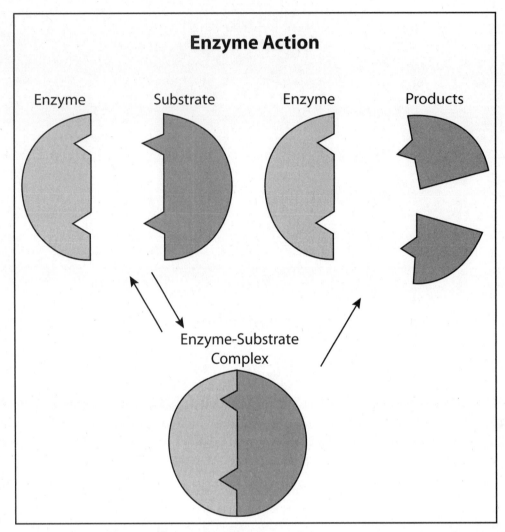

Figure 6-6. *Induced fit model of enzyme action. The shape of the enzyme permits attachment of the substrate for forming an enzyme-substrate complex, which, in turn, induces a change in enzyme shape.*

Test Yourself

1) The endergonic reaction in which inorganic phosphate is added to ADP requires what type of work to be performed?
 a) transport
 b) mechanical
 c) chemical
 d) kinetic
 e) none of the above

2) The first law of thermodynamics explains that
 a) energy is created at every conversion from one form to another.
 b) energy conversion from one form to another is 100 percent efficient.
 c) solar energy can be converted to chemical energy.
 d) energy is lost with each conversion from one form to another.
 e) energy conversion is less efficient as entropy increases.

3) Which feature of substrate molecules is important for determining an enzyme's specificity for that substrate?
 a) size
 b) shape
 c) spatial distribution of charges
 d) all of the above

4) Enzymes are efficient chemical catalysts because they
 a) provide heat for activation energy.
 b) eliminate the need for activation energy.
 c) lower the activation energy.
 d) change endergonic reactions into exergonic reactions.
 e) operate equally well under all physiological conditions.

5) In enzyme catalyzed reactions, *substrate* is a synonym for
 a) end products.
 b) enzymes.
 c) reactants.
 d) byproducts.
 e) none of the above.

6) In order for life to exist on earth, even today, entropy must be overcome. The ultimate source of energy to overcome entropy is
 a) fossil fuel.
 b) heat in the earth's core.
 c) wind energy.
 d) plant life.
 e) the sun.

7) ATP is used to
 a) code messenger RNA.
 b) couple exergonic to endergonic reactions.
 c) transport phosphorus in the cell.
 d) lower activation energy.
 e) raise activation energies.

8) Which of the following statements is true of enzymes?
 a) Enzymes are composed of ribose, phosphate, and a nitrogen-containing base.
 b) The activity of enzymes is independent of temperature and pH.
 c) An enzyme acts only once and is then destroyed.
 d) Enzymes provide the activation energy necessary to initiate a reaction.
 e) Enzymes lose some or all of their normal activity if their three-dimensional structure is disrupted.

9) The energy in ATP is stored in
 a) the adenosine.
 b) the bond between the phosphates.
 c) the base.
 d) the bond between the sugar and base.

10) When ATP breaks down to ADP and phosphate ion, energy is
 a) released.
 b) absorbed.
 c) created.
 d) destroyed.
 e) two of the above

Test Yourself Answers

1) **c.** *Energy* is defined as the ability to do work. Chemical reactions involve changes in chemical energy (work) between reactants and products.

2) **c.** The first law of thermodynamics is called the Law of Conservation of Energy. Energy is neither created nor destroyed, but it can be converted into different forms. However, no conversion from one form to another is 100 percent efficient—at least some energy is converted into heat at each step.

3) **d.** Each of these factors are involved in determining if a substrate molecule will "fit" the active site of the enzyme.

4) **c.** By forming an enzyme/substrate complex, enzymes lower the activation energy required for a reaction to occur. They are not consumed or changed in the reaction, nor do they change the type of reaction—for example, endergonic versus exergonic. Because enzymes are proteins, they are affected by any environmental factor that alters protein structure.

5) **c.** Substrates are the molecules that react in a chemical reaction—the reactants. The molecules produced by the reaction are products or end products. If the product is not used in a further metabolic reaction, it is sometimes referred to as a byproduct.

6) **e.** Fossil fuels, geothermal heat, and wind are all energy sources restricted to earth as a closed system. Both wind energy and plants depend on energy input from the sun, as did the prehistoric plants that became the fossil fuels we now use. In terms of solar energy, the earth is an open system and, thus, the sun ultimately provides the energy required for living things to overcome entropy.

7) **b.** The conversion of ATP to ADP + Pi is exergonic, while the reverse reaction, ADP + Pi forms ATP is endergonic. ATP can thus be coupled to exergonic reactions where it is formed to endergonic reactions where it gives off energy while becoming ADP + Pi.

8) **e.** Like other proteins, anything that changes the three-dimensional structure of enzymes, such as high temperature or pH, may diminish their activity. Enzymes are reusable and lower the activation energy required for a reaction to occur.

9) **b.** The so-called high energy bond is the covalent bond between the second and third phosphates of ATP that is broken when ATP becomes ADP + Pi.

10) **a.** The conversion of ATP to ADP + Pi is exergonic, and energy is released.

Respiration

Cellular respiration is the process of extracting chemical energy from food molecules that can be used to do work. It consists of one or more pathways of primarily exergonic reactions that eventually produce ATP.

Although many organic molecule can be used to fuel respiration (e.g., fats, proteins, and carbohydrates), it is simplest to view the process as the breakdown of glucose, a monosaccharide. The pathway of reactions used by a cell depends in part on the environment of the cell. In an anaerobic environment—that is, one without oxygen—sugar molecules are partially broken down to alcohol or an organic acid. Although some ATP is produced, considerable chemical energy remains in the alcohol or acid. The most efficient form of respiration, aerobic respiration, requires oxygen gas to break down the sugar more completely into carbon dioxide and water. The overall reaction for aerobic respiration may be summarized by the formula $C_6H_{12}O_6 + 6\,O_2 \rightarrow 6CO_2 + 6H_2O$ + energy (36 to 38 ATPs).

■ REDOX REACTIONS: REDUCTION AND OXIDATION

Why is the reaction pathway a series of small steps, each with a small energy change, and how are these small steps accomplished? Recall from Chapter 6 that ATP/ADP is used to couple exergonic with endergonic reactions in the cell. In order to efficiently produce ATP, as is indicated in the overall equation for respiration, ATP synthesis must be coupled to an exergonic reaction that produces slightly more energy than is required. With 36 to 38 ATPs produced, the overall reaction must be broken down into a series of small steps. A common solution is to use a pathway of oxidation reactions.

Many chemical reactions involve a transfer of electrons from one molecule to another. Because electrons have a negative charge, the molecule receiving an electron is said to be **reduced** (it is now more negatively charged), while the molecule donating the electron is said to be **oxidized.** Recall from Chapter 2 that electrons are involved in forming covalent bonds between atoms. If an electron is transferred from one molecule to another, covalent bonds must be affected. One way this is evident in a pathway is if a small molecule is given off at one step. For example, a CO_2 molecule could be released if an electron in the C–C bond holding CO_2 to the rest of the sugar was broken to provide the reducing electron. However, atoms do not have to be released from a molecule when oxidation occurs. The arrangement of bonds may simply be altered from a more electronegative configuration in the reduced form to a less electronegative configuration in the oxidized form.

Oxidation and reduction are always coupled; an electron donor must have an electron acceptor. The acceptor, in turn, becomes the donor for the next step in the pathway. With each transfer of electrons, the

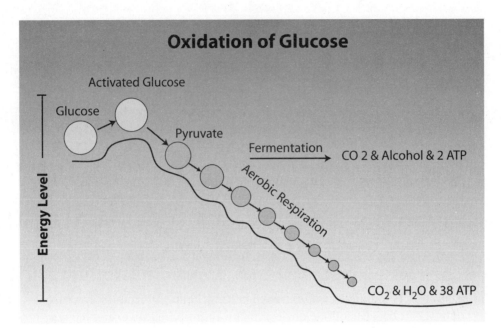

Figure 7-1. *Energetics of the respiratory pathway. The energy level is plotted along the distance down the pathway of metabolic respiration. The initial step of the pathway, from glucose to activated glucose, requires an input of energy to raise the energy level. Subsequent steps involve a series of exergonic reactions that lower the energy level in small steps. Pyruvate, the end product of glycolysis, contains only slightly less energy than the initial glucose. If no oxygen is available, fermentation will occur; with oxygen present, additional energy is released, and CO_2 and H_2O are produced.*

energy level is slightly lowered as covalent bonds are broken or rearranged. The overall pathway of cellular respiration is an oxidation. We say that sugar is oxidized to produce carbon dioxide and water.

■ GLYCOLYSIS

The first stage of cellular respiration, called **glycolysis,** occurs in *all* living cells, whether prokaryotic or eukaryotic. This should be a clue as to where in the cell glycolysis occurs. It cannot be inside a specialized organelle because these are lacking in prokaryotes. Glycolysis, a reaction pathway that occurs in the cytoplasm, can be subdivided into three major steps: phosphorylation, sugar cleavage, and oxidation.

Phosphyorylation

Reexamine Figure 7-1 to observe the energy levels. Before any energy can be released from the oxidative breakdown of glucose, an endergonic reaction must occur to raise the energy level of the sugar (activated glucose). An analogy to this is priming an old-fashioned hand water pump. If the pump has not been used recently, you must actually pour some water into the pump before you start pumping ("prime the pump") in order to get any water out. The cell must expend some energy to activate glucose before it can get any energy out of the glucose molecule.

The source of energy for phosphorylation is ATP. ATP undergoes an exergonic reaction to form ADP and Pi. The energy released is used to bond the phosphate group to glucose, forming glucose-6-phosphate, which has slightly more energy than the original glucose molecule. The atoms of this molecule are

GLYCOLYSIS

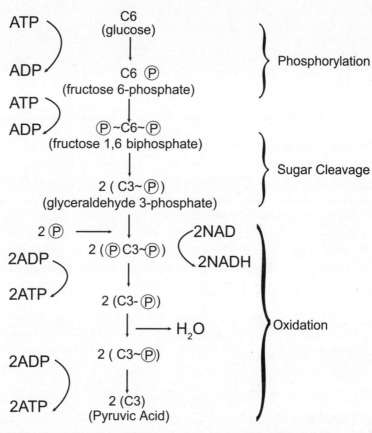

Figure 7-2. Gylcolysis. Glycolysis consists of three major steps: phosphorylation, sugar cleavage, and oxidation. Two ATPs provide energy and donate phosphate groups to produce fructose 1,6-bisphosphate. This more-or-less symmetrical molecule is split into two similar 3-carbon phosphorylated molecules during sugar cleavage. Oxidation of these two products results in two pyruvic acid, four ATP, and two NADH molecules.

then rearranged to form its isomer, fructose-6-phosphate, which can accept a second phosphate group from a second ATP to form fructose 1,6 bisphosphate. Fructose, a 6-carbon sugar, now has a phosphate group on its first and last carbon atoms, forming a more-or-less symmetrical molecule with phosphate on each end. Phosphate has been added to the original glucose—it has been phosphorylated. As a result, the phosphorylated glucose contains more energy than the original sugar molecule—it has been activated.

Sugar Cleavage

This step is the namesake for glycolysis. Glucose is lysed—that is, it is split in two. As mentioned in the preceding section, fructose 1,6 bisphosphate is a nearly symmetric 6-carbon molecule. During sugar cleavage, the central C–C bond undergoes hydrolysis to form two 3-carbon molecules with a phosphate on the end. Although not identical, the two molecules are isomers and can convert from one form to the other. Only one of these, glyceraldehyde-3-phosphate, proceeds through the oxidation step, but as it does so, its isomer will convert to a second glyceraldehyde-3-phosphate, which can then follow through

the oxidation pathway. For our purposes, the activated glucose is split into two identical 3-carbon molecules, each of which is further oxidized. As a result, each of the oxidative reactions that completes glycolysis will occur twice, once for the first 3-carbon phosphorylated molecule and again for the second. This explains the "2" in front of each molecule represented in Figure 7-2.

Oxidation

The remaining steps of glycolysis are an oxidation pathway. Each step is an exergonic reaction involving either the loss or rearrangement of electrons. As a result, some high energy molecules are produced.

In the first step, sugar is oxidized by transferring H^+ and an electron to an NAD^+ molecule, which is reduced to form NADH. This provides a site on the sugar molecule with an unpaired electron to which a phosphate group can covalently bond. The 3-carbon sugar now has a phosphate group on each end of the molecule.

During the subsequent reactions of the oxidation step, each of these phosphate groups is transferred to an ADP in a redox reaction to form ATP. The end products of glycolysis are two 3-carbon pyruvate molecules, two NADH molecules, and four ATPs. At this point, it may be useful to begin a table keeping track of energy production during respiration. During glycolysis, there is a net gain of two ATP (although four ATP are produced by oxidation, two were required during phosphorylation) and two NADH molecules.

Depending on the conditions, aerobic or anaerobic, and the kind of organism involved, the pyruvate produced during glycolysis will be further processed through one of several pathways. Each of these will be considered in the following sections.

■ ANAEROBIC PATHWAYS

If oxygen is not available, the cell can obtain additional energy by fermenting the pyruvic acid produced by glycolysis. Some organisms produce alcohol, while others produce lactic acid. In either case, the NADH produced during glycolysis is used to power the reactions.

Alcoholic Fermentation

Some bacteria and fungi, notably yeast, ferment alcohol when grown under anaerobic conditions.

The first step of this process is to convert the 3-carbon pyruvate into a 2-carbon molecule. The third carbon atom, along with two oxygens, is released as CO_2. You may be familiar with some of the commercial applications of this step. For example, yeast is added to bread dough to make it rise. The yeast cells trapped within the dough undergo fermentation to produce CO_2 gas that remains trapped in small pockets. As more gas is produced, the pockets enlarge and the dough expands (it rises). The air holes in baked bread are the pockets where CO_2 gas was trapped. Another example is the "head" of beer or the effervescence of sparkling wine. As the final fermentation occurs within a capped bottle, CO_2 is released and dissolves in the liquid building up pressure. When the bottle is opened, pressure is released and the dissolved CO_2 begins to bubble out of the liquid.

The final step of the process is to produce the 2-carbon molecule ethanol. NADH from glycolysis undergoes oxidation to NAD^+ and provides an electron and hydrogen to reduce the 2-carbon acetaldehyde molecule into ethanol. Why does Figure 7-3 show two CO_2s and two ethanols produced (and two NADHs used)? This is because there were two molecules of pyruvic acid produced in glycolysis from the original glucose molecule. Each one undergoes fermentation.

$$
\begin{array}{ccc}
 & 2\ \text{NADH} & \\
\text{H} & +2\text{H}^+\ \ 2\ \text{NAD}^+ & \text{H} \\
\text{C}=\text{O} & \longrightarrow & \text{H}-\text{C}-\text{OH} \\
\text{CH}_3 & & \text{CH}_3 \\
\text{2 Acetaldehyde} & & \text{2 Ethanol}
\end{array}
$$

Figure showing Glucose → 2 Pyruvic acid with 2 ADP → 2 ATP, 2 NAD$^+$ → 2 NADH + 2H$^+$; then to 2 Acetaldehyde (+ 2 CO$_2$) → 2 Ethanol, and to 2 Lactic acid (via 2 NADH + 2H$^+$ → 2 NAD$^+$).

2 Pyruvic acid

2 Lactic acid

Figure 7-3. Fermentation. If oxygen is not present, the two pyruvic acid molecules produced by glycolysis undergo fermentation. In alcoholic fermentation, a CO$_2$ is released and NADH is used to produce ethanol. In lactic acid fermentation, NADH is used to produce lactic acid directly from pyruvate.

Lactic Acid Fermentation

Other bacteria and fungi, as well as the skeletal muscle tissue in animals, produce lactic acid under anaerobic conditions. During this process, the 3-carbon pyruvic acid produced by glycolysis is converted into 3-carbon lactic acid. The energy for this reduction reaction is provided by NADH as it is oxidized to form NAD$^+$. You might be familiar with this process from the muscle cramps that develop when inadequate oxygen reaches muscles during heavy exertion and the cells must metabolize anaerobically.

Under anaerobic conditions, the net gain of chemical energy is 2ATP from glycolysis. Both alcoholic and lactic acid fermentation use the NADH produced during glycolysis to reduce pyruvate or a product of pyruvate.

■ AEROBIC RESPIRATION

If oxygen is present, the pyruvate product of glycolysis may be shunted through an alternative pathway that is much more efficient at producing chemical energy in the form of ATP. In eukaryotic cells this pathway is localized within a specialized organelle, the mitochondrion. Recall from Chapter 5 that the mitochondrion has a double membrane, and the inner membrane forms projections, called cristae, that increase the internal surface area. The inner membrane also partitions the internal area of the organelle into an intermembrane space and an internal matrix. The inner membrane and the bounded spaces are structurally essential for the aerobic pathways.

Krebs (Citric Acid) Cycle

The Krebs Cycle, named after its discoverer, Hans Krebs, is a cyclic metabolic pathway that begins and ends with the 6-carbon molecule, citric acid.

The enzymes involved in the pathway occur on the inner membrane or within the matrix of the mitochondrion. As you can see in Figure 7-4, the pathway consists of a number of 6-, 5-, and 4-carbon compounds. As we saw in alcoholic fermentation, each time a carbon is lost it is released as a CO$_2$ molecule. Each time the Krebs Cycle works, two CO$_2$ molecules are produced. You also may realize that each step

KREBS (CITRIC ACID) CYCLE

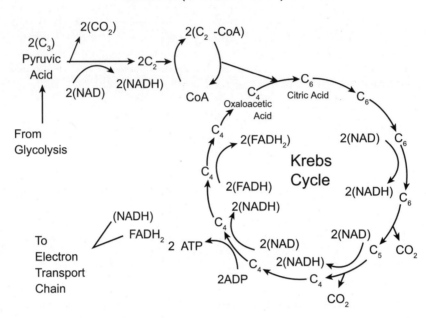

Figure 7-4. Krebs Cycle. The Krebs Cycle, also know as the Citric Acid Cycle, is a series of oxidation reactions that converts the 6-carbon citric acid into a 4-carbon oxaloacetic acid molecule, releasing two CO_2s and producing one ATP, three NADHs, and one $FADH_2$ molecules. A 2-carbon molecule, produced by removing CO_2 from pyruvic acid (and producing an additional NADH) is used to convert oxaloacetic acid back into citric acid to complete the cycle. The cycle runs twice for each glucose that is respired.

of the pathway, from citric acid to oxaloacetic acid, is exergonic and that the energy given off is used either to produce ATP or to reduce NAD^+ to NADH or FADH to $FADH_2$. For each run of the Krebs Cycle, one ATP, three NADHs, and one $FADH_2$ are produced.

For the cycle to be completed, two things must happen. First, the last 4-carbon molecule, oxaloacetic acid, must gain two carbons to have the six necessary to make a citric acid molecule. Second, because this is an oxidation pathway, the free energy of oxaloacetic acid at the end is considerably lower than that of citric acid at the beginning. There must be an input of energy.

The pyruvate produced by glycolysis provides both the carbon backbone and chemical energy required to convert oxaloacetic acid into citric acid and thus complete the cycle. This requires an intermediate reaction involving the enzyme CoA. To begin the process, a carbon is removed from pyruvic acid (in the form of CO_2) to provide a 2-carbon molecule that associates with CoA to form acetyl CoA. This is an exergonic reaction that reduces NAD^+ to NADH. Acetyl CoA, in turn, associates with oxaloacetic acid to form citric acid and complete the Krebs Cycle. In terms of chemical energy, we can add an additional NADH to those produced in the Krebs Cycle itself.

Each pyruvate molecule that is passed into the Krebs Cycle results in the release of three CO_2 molecules. Glycolysis produces two pyruvate molecules for each glucose molecule metabolized, thus the Krebs Cycle can run twice and a total of six CO_2s are released. Note that this accounts for the glucose and $6CO_2$ molecules in the overall reaction for respiration. But, so far, we have only mentioned oxygen as being necessary and have said nothing about the water in the overall equation. Although we can account for two additional ATPs, beyond the net gain of two ATPs in glycolysis, this is far short of the total energy expected from the equation. However, in addition to ATP, both NADH and $FADH_2$ were produced. These can be added to your tally sheet of energy produce by glycolysis. For each glucose molecule, the

CoA pathway and Krebs Cycle add an additional eight NADHs and two $FADH_2$s. The final pathway of aerobic respiration is used to convert chemical energy from these two molecules into ATPs.

Electron Transport Chain

The components of the electron transport chain are a series of molecules embedded in the inner mitochondrial membrane. Each molecule has a reduced and an oxidized form, and there is a gradual drop in free energy as we proceed from one molecule to the next.

NADH donates an electron to reduce the first electron carrier molecule and, in the process, is oxidized to NAD^+. At the same time, an H^+ is released into the intermembrane space. The reduced receptor molecule undergoes an oxidation and passes the electron on to the second molecule in the chain, which becomes reduced. This process is repeated through successive carrier molecules until the electron reaches the final electron acceptor—oxygen. The electron is used to bond H^+ to oxygen to form H_2O. During this process, two additional H^+ are released into the intermembrane space.

If $FADH_2$ donates an electron, a different electron acceptor at a slightly lower free energy is used. This receptor also undergoes an oxidation to feed the electron into the electron transport chain. In this case, only two H^+ are released to the intermembrane space during electron transport, but oxygen is still the ultimate electron acceptor and water is produced. For every glucose molecule that began respiration, a total of six O_2 molecules are required as final electron acceptors in the electron transport chain and six H_2O molecules are produced.

Chemiosmosis

The inner membrane not only provides a physical location for the components of the electron transport chain, but also contains the enzyme complex ATP synthetase, and provides an essential barrier to diffusion for H^+.

During the redox reactions of the electron transport chain, H^+ ions are released into the intermembrane space. If the membrane were permeable to H^+, these ions simply would diffuse across the mem-

ELECTRON TRANSPORT CHAIN

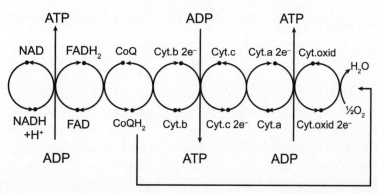

Figure 7-5. Electron transport chain. The electron transport chain consists of a series of membrane bound molecules that undergo sequential redox reactions. As a molecule to the left is oxidized to a lower energy level, it passes an electron to the molecule immediately to its right, thereby reducing that molecule. This process is repeated sequentially, beginning either with NADH or FADH$_2$ on the far left and ending with O$_2$ on the far right. Approximately three ATPs can be produce for every NADH that provides an electron; approximately two ATPs are produced for every FADH$_2$ electron donor.

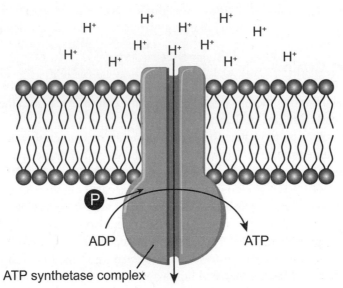

Figure 7-6. ATP synthetase. ATP synthetase is a complex of transmembrane and membrane bound proteins that channel hydrogen ions from the intermembrane space to the matrix and use the energy of the concentration gradient to synthesize ATP from ADP and Pi.

brane back into the matrix, which has a lower concentration. However, most of the membrane is impermeable. As a result, an H^+ concentration gradient develops between the two sides of the membrane.

The only areas of the membrane that are permeable to H^+ are ATP synthetase channels. These assemblies of transmembrane proteins that allow H^+ to pass from the inter membrane space into the matrix, driven by the concentration gradient. This channeled diffusion of hydrogen ions provides the energy necessary to convert ADP + Pi into ATP in a process called **chemiosmosis.**

The number of ATPs produced depends on the H^+ gradient, which, in turn, depends on which electron donor is used by the electron transport chain. If NADH is used, about three ATPs are produced. $FADH_2$ produces about two ATPs.

Net Energy Production

Aerobic respiration is a considerably more efficient ATP production pathway than anaerobic respiration. However, before summarizing net ATP production from the aerobic pathways, it is useful to consider how the pathway is determined at the end of glycolysis. We have said that at the end of glycolysis, fermentation will occur if no oxygen is present and that Krebs Cycle and electron transport will occur in the presence of oxygen. Yet oxygen does not appear in the process until the *very last step* of the electron transport chain. How can the very last step of a process affect what occurs much earlier in the pathway?

For an analogy, think of an assembly line in which someone has the job of removing the finished product from the end of the line. If the finished product were not removed, how would that affect the next person up the line who assembles the last piece? And the person up line from him, and up line from her, and so on, until the entire assembly line is shut down? What would happen to electron transport if there were no electron acceptor at the end? What would happen to the Krebs Cycle if the NADH and $FADH_2$ produced were not oxidized back to NAD^+ and FADH?

The net production of ATP in aerobic respiration is summarized in Figure 7-7.

Two ATPs are produced directly by glycolysis and another two directly by the Krebs Cycle. Two NADHs are produced by glycolysis, another two by the acetyl CoA pathway into Krebs Cycle, and six more in the Krebs Cycle itself for a total of ten. For each NADH fed into the electron transport chain, an

ATP YIELD FROM OXIDATION OF GLUCOSE

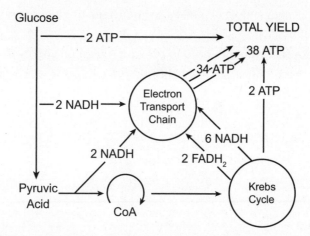

Figure 7-7. Summary of ATP production in aerobic respiration. Glycolysis and Krebs Cycle each produce two ATPs directly. A total of ten NADHs and two FADH₂s are fed into the electron transport chair to produce an additional 34 ATPs for a net yield of approximately 38 ATPs.

average of three ATPs are produced, thus a total of about thirty ATPs result from NADH production. Similarly, two ATPs are normally produced from each of the two FADH₂s generated by the Krebs Cycle, for an additional four ATPs. The net yield of ATP thus should be about 38; it is actually between 36 and 38. This is partially due to rounding error. ATP production is not precisely correlated to the number of NADH or FADH₂ molecules used in electron transport. It is also partially due to the fact that two NADHs are produced by glycolysis in the cytoplasm and they must be transported into the mitochondrion for their electrons to be used in the electron transport chain.

Test Yourself

1) Why must you refer to a "net gain" of two ATPs per molecule of glucose undergoing glycolysis when four ATPs are actually produced?

 a) in order to account for the two ATPs used to provide activation energy during phosphorylation

 b) because ATPs produced by substrate-level phosphorylation are less energized than those produced by oxidative phosphorylation

 c) in order to account for the two NAD^+s used

 d) in order to account for the two inorganic phosphates added in the middle steps of the process

2) Where are the enzymes of the Citric Acid Cycle located?

 a) cytoplasm

 b) outer mitochondrial membrane

 c) mitochondrial matrix

 d) inner mitochondrial membrane

 e) intermembrane space of mitochondrion

3) The art of making bread and wine is thousands of years old. What energy-releasing pathway is responsible for both these legacies of human culture?

 a) aerobic respiration

 b) alcoholic fermentation

 c) lactate fermentation

 d) glycolysis

 e) none of the above

4) Which of the following statements about glycolysis is *not* correct?

 a) Glycolysis occurs in the absence of oxygen.

 b) Glycolysis produces ATP by substrate phosphorylation.

 c) Glycolysis degrades and oxidizes glucose.

 d) This is an ancient pathway found in all cells.

 e) Glycolysis occurs in the mitochondria.

5) In aerobic respiration, oxygen (O_2) is required

 a) at the end of glycolysis to carry pyruvic acid into the Krebs Cycle.

 b) during the oxidation portion of glycolysis.

 c) during the oxidation portion of the Krebs Cycle.

 d) as the ultimate electron acceptor at the end of the electron transport chain.

 e) Both b and c are correct.

6) At the end of glycolysis, the 3-carbon product diffuses into the mitochondria and the first carbon is split off as
 a) carbon monoxide.
 b) carbon dioxide.
 c) a precipitate.
 d) a carbon crystal.
 e) none of the above.

7) How many turns of the Krebs Cycle are required for one molecule of glucose?
 a) 1
 b) 2
 c) 3
 d) 6
 e) none of the above

8) In humans, fermentation results in
 a) pyruvic acid being converted to ethanol.
 b) pyruvic acid being converted to lactic acid.
 c) lactic acid being converted to ethanol.
 d) ethanol being converted to pyruvic acid.

9) Given that complete oxidation of glucose to CO_2 and H_2O yields 686 kcals energy, what is the percentage efficiency of energy conversion of aerobic respiration (including inputs from glycolysis) if the breakdown of ATP produces –7.3 kcals energy?
 a) 100 percent
 b) 50 percent
 c) 40 percent
 d) 25 percent
 e) 2 percent

10) Which metabolic pathway is common to both the aerobic and anaerobic catabolism of sugar?
 a) Krebs Cycle
 b) electron transport chain
 c) glycolysis
 d) synthesis of acetyl CoA from pyruvic acid
 e) reduction of pyruvic acid to lactic acid

Test Yourself Answers

1) **a.** Although four ATPs are produced during the oxidation phase of glycolysis, two are needed to provide phosphate groups and additional energy to glucose—phosphorylation. The energy level of ATP is the same regardless of how it was formed. The production of NADH from NAD^+ is a redox reaction unrelated to ATP. The Pi added to the 3-carbon phosphorylated compound after sugar cleavage is unrelated to ATP.

2) **c.** The Krebs Cycle (also known as the Citric Acid Cycle) occurs primarily in the matrix of mitochondria. Gylcolysis occurs in the cytoplasm, while the inner membrane and the intermembrane space of mitochondria are involved in electron transport and ATP synthetase. The pyruvate and NADH produced by glycolysis in the cytoplasm must be transported across the outer membrane to get into the mitochondrion.

3) **b.** Alcoholic fermentation releases CO2 (for breadmaking) and produces ethanol (for wine and beer). This is an anaerobic process that is an alternative to lactate fermentation that occurs in oxygen stressed muscle cells. Glycolysis normally precedes fermentation.

4) **e.** Glycolysis, which occurs in the cytoplasm, can occur with or without oxygen present. It is found in all cells, both prokaryotic and eukaryotic and, therefore, must be an ancient process that arose before aerobic pathways. During glycolysis, energy is produced by oxidation, some of which is used to produce ATP by transferring phosphate from another phosphorylated molecule—substrate level phosphorylation.

5) **d.** Oxygen is used for the very last step of the electron transport chain, which occurs after glycolysis and Krebs Cycle during aerobic respiration.

6) **b.** Pyruvic acid is the 3-carbon compound produced by glycolysis. A carbon must be removed, as CO_2, to convert it into acetate, which associates with CoA to convert oxaloacetic acid into citric acid.

7) **b.** Each glucose molecule produces two pyruvates during glycolysis. A CO_2 is stripped from pyruvate to form a 2-carbon molecule that can be added to oxaloacetic acid to complete one turn of the Krebs Cycle. Because two pyruvates were available, the Krebs Cycle can complete two revolutions for each glucose molecule that is oxidized.

8) **b.** In muscle tissue under anaerobic conditions, pyruvic acid is converted into lactic acid. In fungi, ethanol is produced from pyruvate.

9) **b.** Each ATP molecule contains 7.3 kcal energy. A total of 36 to 38 ATPs are formed by complete oxidation of glucose. Thus ATP accounts for a total of 263 (36×7.3) to 277 (38×7.3) kcal. If the total yield from glucose is 686 kcal and ATP accounts for approximately 270 kcal, the percent yield is $270 \div 686 \times 100 \approx 39$ percent.

10) **c.** Glycolysis is the first step of cellular respiration, regardless of whether or not oxygen is present. Krebs Cycle, electron transport, and synthesis of acetyl CoA occur only in aerobic respiration. Reduction of pyruvic acid to lactic acid occurs only during anaerobic fermentation.

Photosynthesis

Photosynthesis is the most critical metabolic process on earth. It is the mechanism by which solar energy is converted to chemical energy that allows organisms to overcome entropy in an open system (recall Chapter 6). Not only does photosynthesis trap an external source of energy that is used to produce food for plants and animals, but it also releases the O_2 necessary to act as an electron acceptor at the end of aerobic respiration. Aerobic respiration could not evolve until atmospheric levels of O_2 were raised by photosynthesis.

The overall equation for photosynthesis can be summarized as $6CO_2 + 6H_2O + \text{light energy} \rightarrow C_6H_{12}O_6 + 6O_2$. Note that this formula is the reverse of the general formula for aerobic respiration. We will see later that this relationship is significant because respiration and photosynthesis together drive essential nutrient cycling in the biosphere.

■ THE NATURE OF LIGHT

Visible light is a small portion of the **electromagnetic spectrum.**

Solar radiation consists of a broad spectrum of energy from very weak to very strong. The energy level of light is inversely related to its wavelength. Radio waves, with a wavelength longer than one meter, contain the least energy and generally are not harmful to organisms. Slightly shorter wavelengths produce infrared radiation, otherwise known as heat. Infrared has shorter wavelengths than radio waves and, therefore, contains higher energy levels. Excessive heat can certainly injure organisms.

The visible spectrum ranges from about 750 nm (red) down to 380 nm (violet) light. The different colors of visible light are due to their different wavelengths. Again, as the wavelengths shorten, the amount of energy increases. We should note that "visible" is with reference to human vision. Bees and other insects, for example, do not see red, but they do see in the near ultraviolet! Their visible spectrum is shifted slightly to shorter wavelengths.

Ultraviolet and shorter wavelengths are successively more powerful and more dangerous to living things. Today, for example, we are becoming more concerned with the increasing amount of ultraviolet radiation reaching the surface of the earth because the ozone layer is thinning due to human perturbation. The incidence of skin cancer, due to UV exposure, is increasing. Of course, when we do tissue culture in the laboratory, the way we sterilize the interior of a transfer cabinet is to expose it to UV for about twenty minutes.

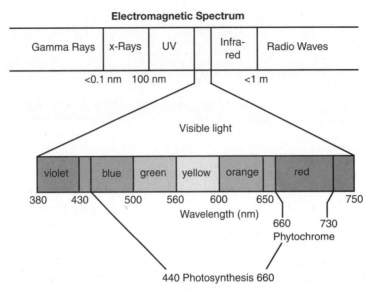

Figure 8-1. Electromagnetic spectrum. Visible light, with wavelengths between 380 and 750 nm, is a small portion of the electromagnetic spectrum radiating from the sun. Energy level is inversely proportional to wavelength: Longer wavelengths have less energy than shorter wavelengths.

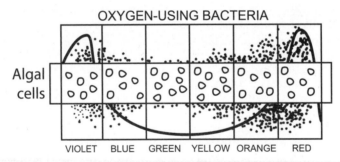

Figure 8-2. Light and photosynthesis. A crude actions spectrum for photosynthesis was demonstrated by irradiating an algal filament with the spectrum of visible light. More oxygen was produced under those colors of light that were most effective in promoting photosynthesis. Aerobic bacteria in the culture migrated to the areas of greatest oxygen production.

■ ABSORPTION AND ACTION SPECTRA

The first evidence that different wavelengths of light, rather than the full visible spectrum, are involved in photosynthesis was an experiment done by Theodor Engelmann in 1883.

At that time, microscopes used a mirror to reflect sunlight to illuminate the object. Engelmann inserted a prism into the light path so the rainbow spectrum of light illuminated the algal filaments he examined. By that time, it was already known that the amount of CO_2 consumed during photosynthesis was equal to the amount of O_2 produced. By placing motile aerobic bacteria in the water with his alga, he could predict the colors of light active in photosynthesis by where the O_2 requiring bacteria migrated. Most bacteria tended to accumulate in either the blue or red parts of the spectrum. A plot of the rate of photosynthesis, which is usually measured by the rate of oxygen production, against the wavelength of incident light is called the **action spectrum.**

Scientists could now begin to look for the photosynthetic **pigment** molecules that absorb light energy. Pigments are molecules that absorb light of certain colors and reflect other wavelengths. The color we see is the color *not* absorbed by the pigment—the reflected light. Any plant pigment involved in photosynthesis must absorb light in an active region of the spectrum. Ideally, the absorption spectrum of the pigment will parallel the action spectrum of photosynthesis.

Dozens of pigments are found in different plant species. Which ones are involved in photosynthesis? There are five different **chlorophyll** pigments that have absorption peaks in both the blue and red regions of the spectrum. Chlorophyll a is found in all photosynthetic organisms, and chlorophyll b is found in all land plants and green algae.

Why are the absorption spectra for these two chlorophylls different? Will more or less of the available light energy be absorbed if pigments absorb at different maxima? In addition to the chlorophylls, there is another large class of pigments, the **carotenoids,** that absorb in the blue end of the spectrum. Again there are many different carotenoids, and a given plant will have five or more along with its chlorophylls. Each one absorbs preferentially at slightly different wavelengths so that, when combined with the absorption of other pigments, much of the available light energy is trapped.

■ PHOTOSYNTHETIC UNITS

What happens when a pigment molecule absorbs light? In part, this depends on what molecules surround the pigment. If leaf tissue is ground up in a blender and the pigments and other molecules are placed in a suspension and illuminated with bright light, each photosynthetic pigment will absorb light energy and one or two electrons from the outermost electron orbital of a constituent atom will be raised out of its electron shell (recall Chapter 2). Unless another nearby molecule accepts these excited electrons, they will fall back into their original orbit, giving off the excess energy as a flash of light. This

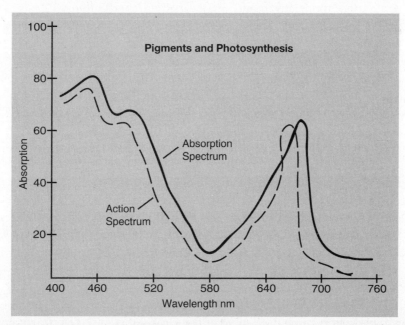

Figure 8-3. Action and absorption spectra. Once the action spectrum for a photosynthesis was determined, the rate of photosynthesis at a given wavelength, various pigments could be examined for their potential role in the process. A high absorption spectrum at wavelengths, correlating with high rates of photosynthesis, implicate involvement of that pigment in the process.

fluorescent light is always of lower energy and longer wavelength than the original exciting light. In our plant extract, most of the fluorescent energy is infrared and invisible. The shortest fluorescent light will be red.

If the tissue is intact, however, the photosynthetic pigments are embedded in the internal photosynthetic membranes of the chloroplasts, thylakoids, and associated in groups of 200 or more molecules called **photosynthetic units.** At the center of each photosynthetic unit is a special chlorophyll a molecule, and surrounding it in a regular array are the other pigment molecules. Adjacent to the central chlorophyll a is a special electron acceptor molecule. The thylakoid surfaces are covered with adjacent photosynthetic units.

When light hits an intact photosynthetic unit in a thylakoid membrane, each pigment absorbs light energy from that portion of the spectrum for which it is optimized. This energy is transferred inward to the central chlorophyll a molecule, which also absorbed light energy. The cumulative energy funneled in to the central chlorophyll a molecule excites electrons out of their shell far enough to be picked up by the electron acceptor molecule. As a result of this electron transfer, light energy is converted into chemical energy.

There are two types of photosynthetic units embedded in the thylakoid membranes. The first, called **photosystem I,** has a central chlorophyll a molecule maximized for absorption of red light at 700 nm. It is called **P700.** The rest of the photosynthetic unit consists of other chlorophyll a molecules and carotenoids optimized for absorbing shorter wavelength, higher energy light. **Photosystem II** units have a central chlorophyll a molecule optimized for 680 nm **(P680).** Its accessory pigments include chlorophyll b and phycobilin pigments that absorb longer wavelengths of lower energy.

■ CYCLIC PHOTOPHOSPHORYLATION

In addition to two types of photosystems embedded in the thylakoid membranes, there are two different reaction pathways that ultimately produce convert light energy into ATP, a process called **photophosphorylation.** The simplest and most ancient is the cyclic pathway that uses photosystem 1 to recycle electrons back to P700.

In cyclic photophosphorylation, carrier molecules of an electron transport chain are embedded in the thylakoid membrane along with the photosynthetic pigment. The excited electrons trapped by the receptor molecule are used to reduce cytochrome B, the first step in the chain. Oxidation of this cytochrome passes the electron to the next transport molecule and provides the energy to produce ATP.

The electron transport chain in thylakoid membranes is linked to ATP production in the same way as the electron transport chain in the inner membrane of mitochondria. During the redox reactions of electron transport, H^+ are released into the intrathylakoid space to produce a concentration gradient. ATP synthetase units are embedded in the thylakoid membranes to channel hydrogen flow out of the thylakoids and drive ATP production.

Eventually electrons are passed back to the original P700, and the process can be repeated. As long as light is available, chemical energy in the form of ATP will be produced. This is not a very efficient system but it is simple and, even today, it is adequate to sustain some photosynthetic bacteria.

■ NON-CYCLIC PHOTOPHOSPHORYLATION

Non-cyclic photophosphorylation uses some of the same pathways as cyclic photophosphorylation but additional pathways have evolved to make the overall process much more efficient at trapping light energy and converting it to chemical energy.

Photosystem I is still used, but the electrons trapped by the accepter molecule are not passed on to an electron transport chain. Instead, they are used to reduce NADP to form NADPH. NADPH is trans-

Photosynthesis, Light Reaction

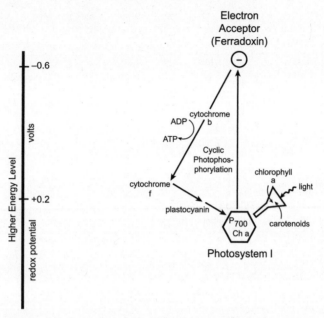

Figure 8-4. Cyclic photophosphorylation. The figure labeled P700 represents the reaction center of a photosystem I photosynthetic unit in a thylakoid membrane. The funnel represents the associated accessory pigments that absorb light at different wavelengths and funnel that energy in to the reaction center. This excites an electron from P700, which is trapped by an electron acceptor molecule and fed into an electron transport chair that drives ATP synthesis and ultimately returns the electron to P700 so that the process can be repeated. Energy level is represented on the y-axis.

ported away from the membrane to power another process and with it goes the electron that was formerly part of P700. As a result, P700, and that entire photosystem, is non-functional until a new electron can be found to fill the electron "hole" produced after NADPH formed.

Photosystem II, located in the same membrane adjacent to photosystem I, functions in a similar way. The accessory pigments absorb light of different wavelengths, and generally lower energy, than was absorbed by photosystem I. This energy is funneled into the central chlorophyll a molecule, P680 and electrons are exited. The excited electrons are absorbed by an electron acceptor molecule that initiates an electron transport chain down to P700. As in cyclic photophosphorylation, the redox transfer of electrons by the electron transport chain creates a concentration gradient of H^+ that is used to produce ATP. In fact, some of the molecules of the original electron chain have a new role in the non-cyclic process of transferring electrons from P680 to fill the electron hole in P700, and the same ATP synthetase complexes are employed. Photosystem I is now ready to function again.

So far we have described only a limited solution to the problem of filling the electron hole in P700, because a new electron hole is created in P680 that must be filled before photosystem II can react again. At this point, a new source of electrons is employed.

Embedded into the photosystem II complex are enzymes that split water into H^+, electrons, and oxygen. The released electrons are used to fill the electron hole in P680. As long as water is split, there is a continuous supply of electrons that pass through the non-cyclic pathway to end up in NADPH. The oxygen from water is the source of O_2 produced during photosynthesis. The O_2 produced does *not* come from CO_2!

Photosynthesis, Light Reaction

Figure 8-5. Non-cyclic photophosphorylation. Photosystem I is the same as in cyclic photophosphorylation except that the electron is used to reduce $NADP^+$ instead of being recycled back to P700 by an electron transport chain. A second photosystem, photosystem II, has P680 as its reaction center and an array of different accessory pigments, absorbing light at lower energy levels than those of photosystem I. The electron excited from P680 is passed down an electron transport chain to replace the electron lost by P700. The resulting electron "hole" in P680 is replaced by electrons resulting from the enzymatic splitting of water. The oxygen from water is released as oxygen gas. Energy level is represented on the y-axis.

In land plants and green alga, both the cyclic and non-cyclic pathways of photophosphorylation occur simultaneously to produce ATP and NADPH.

■ LIGHT-INDEPENDENT REACTIONS

The energy-trapping reactions associated with the thylakoid membranes account for the water consumed and oxygen produced in the overall equation for photosynthesis. But we have not yet seen how CO_2 is fixed into carbohydrate. These biochemical reactions occur in the stroma of the chloroplast and depend on the ATP and NADPH produced in the light reactions. Like the Krebs Cycle in respiration, carbon fixation in photosynthesis is a cyclic process that depends on regeneration of the starting molecule. However, it is much more complex and could not be worked out until after radioactive isotopes became available following World War II. We now know that the cycle has three main components: carbon fixation, reduction, and regeneration.

Carbon Fixation

Melvin Calvin and his coworkers reasoned that CO_2 molecules with a radioactive carbon label could be used to track the pathway of carbon as CO_2 is converted into sugar. Photosynthetic algae were grown in a flask exposed to light and bubbled with labeled CO_2. After a short period of time, a small sample was removed, the cells ground up, and the molecules containing the labeled carbon were identified. After only

a single-minute exposure there were many different labeled molecules. Which molecule was formed first? What came next? By shortening the exposure time, they reached a point where only a single molecule was labeled, **3-phosphogylcerate (PGA),** a 3-carbon molecule that also occurs in the glycolysis pathway. The PGA formed also gives the cycle one of its names, C_3 **Cycle.** It is more commonly known as the **Calvin Cycle** or **Calvin-Benson Cycle.**

But where did the other two carbons in the final product, glucose, come from? Originally, it was thought that three CO_2 molecules must be involved, but later is was discovered that only a single carbon, from CO_2, was labeled. How could this be? One of Calvin's insights was to realize that the 5-carbon molecule, **ribulose bisphosphate (RuBP),** has an affinity for CO_2 and reacts to form a 6-carbon molecule. Calvin never saw this molecule, however, because as soon as it is formed, the hugely abundant enzyme, **ribulose bisphosphate carboxylase (rubisco),** hydrolyzed it into two 3-carbon molecules (PGA), one of which contained the labeled carbon.

Reduction

With a slightly longer exposure a second molecule, **glyceraldehyde-3 phosphate (G3P)** was also present. From the biochemistry of the molecules, Calvin's group knew that if energy and a reducing agent were supplied, PGA could be converted into G3P. In fact, a single ATP and a single NADPH are

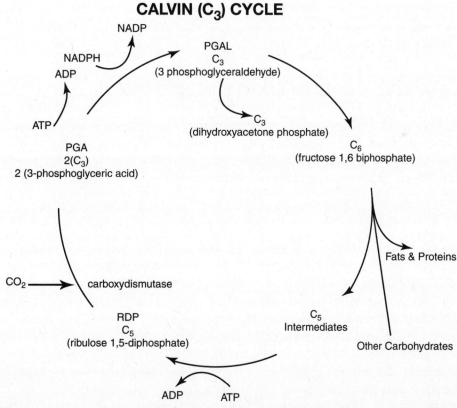

CALVIN (C_3) CYCLE

Figure 8-6. Calvin (C_3) Cycle. Carbon dioxide is fixed by the 5-carbon acceptor molecule RuBP, which is immediately split by the enzyme rubisco to produce two 3-carbon PGA molecules. ATP and NADPH are needed to convert PGA into G3P, also a 3-carbon molecule. Three CO_2 molecules processed simultaneously allows one 3-carbon sugar to be stored and three 5-carbon intermediates to be recycled into three RuBPs to repeat the process.

necessary to drive the synthesis of G3P from PGA. What is the source of these two molecules? Non-cyclic photophosphorylation occurring on the adjacent membranes. Fixing CO_2 into a molecule of G3P is the link between the light-dependent and light-independent reactions of photosynthesis.

But G3P is not glucose. What was the next step of the process? By increasing the time further, not one but several different molecules could be the "third" one produced. At this point, the cycle gets complex and alternative pathways can be followed, both to produce organic molecules and to complete the cycle.

Regeneration

It is easiest to visualize what happens in the Calvin Cycle if the carbon atom of one CO_2 is followed at a time (although this is not exactly how it happens). For each CO_2 added during the carbon fixation phase, two GP3s are produced. Two of these could combine to form a 6-carbon intermediate. If one carbon is temporarily "stored," the remaining 5-carbon molecule could be regenerated to an RuBP molecule if the energy of one ATP was provided. This ATP comes from cyclic photophosphorylation in the adjacent thylakoid membranes. RuBP is now ready to accept a second CO_2 and the Calvin Cycle can turn a second time—temporarily "storing" a second carbon. To fix six CO2 molecules, the Calvin Cycle must turn six times and enough carbon has been brought in to produce a 6-carbon sugar.

In actuality, three CO_2 molecules are fixed simultaneously and reduced to six GP3s. One of these is stored (3-carbons simultaneously) and the remaining five 3-carbon molecules move through the pathways to ultimately produce three 5-carbon RuBPs. These processes are repeated a second time to account for the six CO_2 molecules consumed and the $C_6H_{12}O_6$ (from combining the two 3-carbon "stored" sugars) produced in the overall reaction.

■ ALTERNATIVE CARBON FIXATION PATHWAYS

Unfortunately, Rubisco also has an affinity for O_2, which competes for room on the active site with CO_2. If O_2 is attached, the oxygenated RuPB is shunted into an alternative energy-requiring pathway called **photorespiration**. Rather than producing chemical energy, photorespiration uses chemical energy. Under some conditions, as much of 50 percent of the carbon fixed during photosynthesis is shunted off in photorespiration. An alternative carbon fixation pathway evolved to eliminate photorespiration.

Hatch-Slack (C_4) Pathway

Particularly in hot, dry areas, many plants have evolved an alternative pathway to fix carbon. These plants have structural modifications in the leaves so that the cells undergoing the Calvin Cycle are not exposed to high levels of O_2. These cells are tightly compacted, usually around major veins in a leaf.

In the spongy cells filling most of the interior of the leaf, CO_2 is fixed by the enzyme **PEP carboxylase** into a four-carbon acid; hence the name, C_4 pathway. PEP carboxylase is more efficient than RuBP at trapping CO_2, and it is not affected by O_2.

The acid is transported into the bundle sheath cells where they release CO_2 to be used in the C_3 pathway. The three-carbon pyruvate that remains returns to the spongy tissue to be converted into PEP to repeat the process. Because the C_4 pathway is much more efficient at fixing atmospheric CO_2 than is RuBP alone, C_4 plants are more productive than their C_3 counterparts, particularly under extreme conditions.

CAM Pathway

Certain desert plants take advantage not only of the higher efficiency of the C_4 pathway, but they also take advantage of the fact that production of chemical energy during the light reactions of photosynthe-

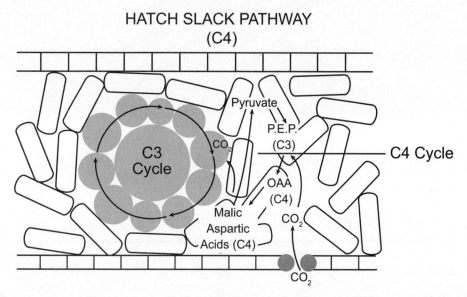

HATCH SLACK PATHWAY
(C4)

C3 Cycle

Pyruvate

P.E.P. (C3)

CO₂

OAA (C4)

Malic
Aspartic
Acids (C4)

CO₂

CO₂

C4 Cycle

Figure 8-7. Hatch-Slack (C₄) pathway. To minimize photorespiration, Calvin Cycle reactions are limited to bundle sheath cells surrounding major veins inside the leaf. CO₂ from the air is fixed by PEP into a four-carbon (C₄) acid, which can be transported to the bundle sheath cells. There, CO₂ is released to be used in the Calvin Cycle, leaving a three-carbon pyruvate, which returns to the spongy mesophyll cells to be reconverted into PEP to repeat the process.

sis is a separate process from fixing CO_2 to form organic molecules. Although in most plants the two reactions occur simultaneously in the light, this is not necessary.

In order to fix carbon, CO_2 from the atmosphere must be able to diffuse into the leaf and reach the chloroplasts. There are microscopic pores in the leaf surface, called **stomata,** that can open or close to permit gas exchange to occur. However, this raises a problem in desert conditions. The stomata must be open to allow CO_2 in, but a consequence is that water vapor from the inside of the leaf then can diffuse out. The plant has to balance water loss with need for CO_2.

CAM plants have evolved an elegant solution to this dilemma.

During the day, the stomata remain closed so that no water is lost. In the high light intensity cyclic and noncyclic photophosphorylation occur rapidly so that much ATP and NADPH are generated. But how can this be used if no CO_2 can get into the plant for the Calvin Cycle to occur? Won't this just back up the process and stop it the way lack of O_2 stops aerobic respiration?

Actually, there will be plenty of CO_2 available for the Calvin Cycle because all during the night before, stomata were open and CO_2 was being fixed into organic acids by the C_4 pathway. These acids were stored in the large central vacuoles of the photosynthetic cells. When the light reactions begin, CO_2 is released from the acids to regenerate PEP to be used the next night to fix more CO_2.

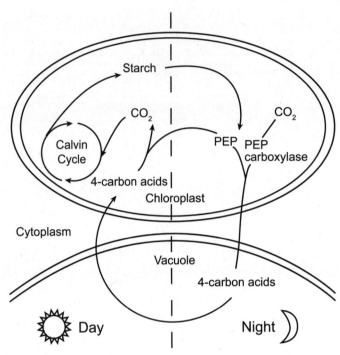

Figure 8-8. CAM pathway. The CAM pathway takes advantage of the fact that carbon fixation and conversion of light energy to chemical energy are independent processes in photosynthesis. During the night, CO_2 is brought into the plant and fixed into 4-carbon acids via the C_4 pathway. The following day, the acids release CO_2 in the chloroplast to be used in the Calvin Cycle without having to open stomata and expose the plant to possible desiccation.

Test Yourself

1) What are the light-independent reactions of photosynthesis *directly* dependent upon for energy?

 a) chlorophyll

 b) oxygen

 c) sunlight

 d) non-cyclic photophosphorylation

 e) ATP and NADPH

2) O_2 that is produced as a byproduct of photosynthesis is derived from

 a) H_2O.

 b) CO_2.

 c) $C_6H_{12}O_6$.

 d) H_2S.

 e) ATP.

3) The final electron acceptor in noncyclic photophosphorylation is

 a) NAD^+.

 b) FADH.

 c) G3P.

 d) RuDP.

 e) $NADP^+$.

4) In the visible spectrum, the light of highest energy

 a) has the shortest wavelengths.

 b) is invisible to insects.

 c) produces the most heat.

 d) travels the fastest.

 e) all of the preceding

5) One of the important results of the light-dependent reactions is

 a) the addition of phosphate to sugar to form sugar phosphate.

 b) the chemiosmotic formation of ATP.

 c) the change of chlorophyll from green to colorless.

 d) the transfer of electrons to glucose molecules.

 e) the rearrangement of sugar molecules to form O_2 from H_2O.

6) Which of the following occurs during the light-dependent reactions of photosynthesis?

 a) ATP is used, and NADPH loses its hydrogen.

 b) ATP is produced to form the enzyme CoA.

 c) ATP is split and phosphorylates glucose.

 d) CoA is synthesized into a complete vitamin.

 e) ATP is formed and $NADP^+$ gains a hydrogen and becomes NADPH.

7) The Calvin Cycle occurs in

 a) chloroplast stroma.

 b) mitochondrial matrix.

 c) inner mitochondrial membrane.

 d) inner chloroplast membrane.

 e) chloroplast grana.

8) In photosynthesis,

 a) carbon dioxide and water are used to produce sugar and oxygen.

 b) sugar and oxygen are combined to produce carbon dioxide and water.

 c) light energy is turned into motion energy.

 d) chemical energy is turned into thermal energy.

 e) plants produce their own energy so they do not need respiration.

9) Which of the following is a correct statement?

 a) The light reactions convert light energy to chemical energy in the form of sugars.

 b) The light independent reactions convert chemical energy in the form of sugars to ATP.

 c) The light reactions convert light energy to chemical energy in the form of ATP and NADPH.

 d) The light-independent reactions must occur in the dark.

 e) The light-independent reactions must occur in the light.

10) Plants are green because

 a) chlorophyll absorbs green light.

 b) chlorophyll does not absorb green light.

 c) chlorophyll reflects red and blue light.

 d) carotenoids absorb green light.

 e) Both a and d are correct.

Test Yourself Answers

1) **e.** The light-independent reactions of photosynthesis, the Calvin Cycle, are powered by the ATP and NADPH produced in the light reactions. The ultimate source of energy is sunlight, which is trapped by photosynthetic pigments in the light-dependent reactions, cyclic and non-cyclic photophosphorylation. Oxygen is released during non-cyclic photophosphorylation.

2) **a.** As a result of water splitting to provide electrons for non-cyclic photophosphorylation, oxygen is released. Carbon fixation during the light-independent reactions incorporates the carbon and oxygen atoms from CO_2 into organic intermediate molecules.

3) **e.** Electrons excited from photosystem I at the end of non-cyclic photophosphorylation are used to reduce $NADP^+$ to NADPH. NAD^+ and FADH are electron acceptors used during respiration. GeP and RuDP are components of the Calvin Cycle.

4) **a.** The energy level of light is inversely proportional to wavelength. In the (human) visible spectrum, violet is the color of highest energy and shortest wavelength. Violet is also within the visible spectrum of insects. Heat, infrared radiation, is of wavelengths longer than the visible spectrum.

5) **b.** ATP synthetase molecules are components of the thylakoid membranes involved in ATP production by the process of chemiosmosis. Sugar phosphorylation, which requires transfer of electrons and Pi, is the first step of glycolysis during respiration. Splitting of water to form oxygen does not involve sugar molecules and the color of pigment molecules does not change as they absorb light energy.

6) **e.** The chemical energy produced during the light reactions is ATP and NADPH. These molecules, once produced in the light reactions, are used to power the light-independent reactions of the Calvin Cycle. Sugar phosphorylation and the CoA enzyme are involved in respiration.

7) **a.** The enzymes of the Calvin Cycle occur in the stroma of chloroplasts. The grana, which includes the inner mitochondrial membranes, thylakoids, are the site of the light reactions. The mitochondria are involved in respiration.

8) **a.** In the overall equation for photosynthesis, $6CO_2 + 6H_2O + \text{light energy} \rightarrow C_6H_{12}O_6 + 6O_2$. The reverse process is respiration. During photosynthesis, light energy is converted into chemical energy. Although some heat is produced as a byproduct of reactions, most of the chemical energy produced in the light reactions is converted into the chemical energy of the ultimate product, sugar.

9) **c.** The chemical energy produced during the light reactions is ATP and NADPH. These molecules provide the energy necessary to synthesize sugar molecules in the light-independent reactions, which normally occur simultaneously during the day. However, in CAM plants, the light-independent reactions that fix CO_2 occur at night in the dark.

10) **b.** The color we see is the color of light not absorbed by a pigment. It is either reflected or transmitted.

Cell Cycle

You have learned about the structure of cells and some of the basic physiological processes necessary to overcome entropy and remain alive. However, even in unicellular organisms, it must be possible to reproduce to provide succeeding generations of cells. In multicellular organisms, the first cell must be able to divide and proliferate to produce a population of cells that can differentiate into the different cell types, tissues, and organs of the organism. In this chapter, we examine the cellular processes involved in cycling from one generation to the next—the cell cycle.

■ CELL DIVISION

Cell division requires that the protoplasm of the parent cell be divided into two daughter cells. The implication is that division is equal, but this is not always the case. In many circumstances where a special cell type is being formed, the division may be unequal so that one daughter cell is larger than the other. Similarly, the implication is that all the protoplasm divides in synchrony. Again, this is not necessarily the case. Nuclear division and cytoplasmic division are separate processes that are usually linked, but in some cases, they are unlinked and proceed separately, if at all.

■ NUCLEAR DIVISION: MITOSIS

Mitosis is a type of nuclear division in which the daughter cells contain chromosomal information identical to that of the parent cell. Recall from Chapter 5 that the nucleus contains chromosomes consisting of DNA and associated proteins. At the beginning of mitosis, each chromosome consists of two **chromatids** bound together at some point by a **centromere.**

It is important to note that the two chromatids are identical to each other—they carry identical strands of DNA. You can think of each chromosome as having an original and backup copy of a music file on separate CDs in a single jewel case. In many organisms, the length of the chromatids and the position of the centromere are characteristic enough that individual chromosomes can be identified and numbered.

During most of the cell cycle, the chromosomes are not visible because the DNA in the chromosomes is not highly coiled. The nucleoplasm appears granular, and nucleoli (concentrations of RNA) may be visible. This stage, called **interphase,** is described in more detail at the end of this section.

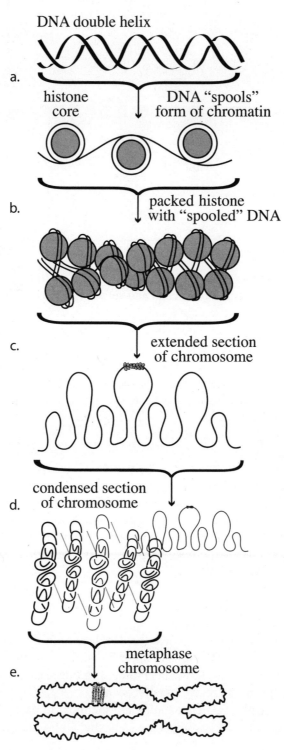

DNA double helix

a.

histone core DNA "spools" form of chromatin

b. packed histone with "spooled" DNA

c. extended section of chromosome

condensed section of chromosome

d. metaphase chromosome

e.

Figure 9-1. Cell cycle. The cell cycle is a continuous process that is divided into named stages to make description more convenient. The stages of mitosis are a) prophase, b) metaphase, c) anaphase, and d) telophase, during which each the two chromatids of each chromosome divide from each other. This is followed by interphase (e) during which DNA is replicated to return the chromosome to a two-chromatid condition.

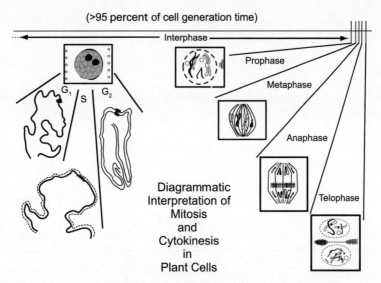

(>95 percent of cell generation time)

Interphase

Prophase

Metaphase

Anaphase

Telophase

Diagrammatic
Interpretation of
Mitosis
and
Cytokinesis
in
Plant Cells

Figure 9-2. Structure of chromosomes. Each chromatid consists of a coiled and condensed strand of DNA.

Prophase

As the nucleus begins to prepare for division, it moves into **prophase** (Figure 9-2a). During this prolonged phase, the chromosomes begin to condense, first by coiling DNA around individual spool-like histone proteins. The spooled DNA further coils due to hydrogen bonding and other molecular interactions. As the degree of coiling increases, the overall diameter of the chromosome increases while its length decreases. At some point early in this process, the chromosomes are thick enough to be visible with the light microscope, and we recognize the cell as being in prophase. As the chromosomes continue to condense, the chromatids and position of the centromere become more apparent. The earliest stages of prophase are difficult to distinguish from an undividing cell in interphase. As a result, students studying the stages of mitosis microscopically usually underestimate the number of cells in this stage.

At the same time that the chromosomes condense, the nucleoli begin to disassemble. On the outside of the membrane, two microtubule organizing centers, the **centrosomes,** begin to migrate away from each other and toward the poles of the cell. Microtubules begin to extend from the centrosomes as they migrate. Longer microtubules extend toward the middle of the cell. The extending microtubules moving toward each other begin to form a **spindle apparatus** that will eventually aid in chromosomal movements. Some of these microtubules, extending from each pole, attach to the chromosomes near the centromere so that the chromosome appears to be suspended by microtubules between the poles of the spindle. Other microtubules from one pole attach to corresponding microtubules from the other pole without contacting a chromosome.

Once microtubules attach to each side of the chromosome, the chromosomes are moved toward the metaphase plane, the region between the poles where the cell eventually will separate in two.

Throughout the process of prophase, the nuclear envelope is breaking down so that it will not interfere with the movement of chromosomes as the cell divides.

Metaphase

At some point of this gradual process, the nucleus is described as being in **metaphase** (Figure 9-2b). There is not a distinct demarcation between any of these stages. They are simply names of convenience to describe characteristic stages during a continuous process. Metaphase is recognized by the orderly arrangement of chromosomes at the **metaphase plate,** the three-dimensional plane in the dividing cell

that is equidistant between the two spindle poles. The spindle is well formed and microtubules attach to each side of the chromosome at the centromere. The nuclear envelope is gone.

Anaphase

Metaphase is a relatively long stage. In time-lapse films, the chromosomes seem to jostle about for position like sailboats lining up for the start of a race. Then, quite suddenly, the chromatids move apart from each other as the centromere divides in two. The cell is in **anaphase** (Figure 9-2c). Each chromatid was attached, at its side of the centromere, to a spindle fiber running to opposite poles of the spindle. When the centromere divides, the chomotids are no longer held to each other but are free to migrate independently.

Migration of the chromosomes appears to be the result of two complementary processes occurring simultaneously in the spindle apparatus. Those microtubules attached to chromatids shorten by disassociating near the attachment point. At the same time those spindle microtubules extending from pole to pole extend, pushing the poles farther apart and elongating the cell. The next result of these two processes is that each chromatid migrates toward it pole, led by the centromere with the chromatid arms trailing. At this point, the former chromatid can be referred to as a new chromosome for the nucleus that will form.

Telophase

Anaphase occurs quickly. Only a few minutes are required for the chromatids to reach opposite poles of the spindle. At each pole will be a complete set of chromosomes from the parent nucleus, and they will be identical to each other. The only difference is that now, each chromosome has a single copy of the genetic information, while in the parent nucleus, each chromosome had paired copies immediately before the onset of mitosis.

At this stage, the cells are in **telophase** (Figure 9-2). During telophase, a nucleus reforms at each pole. The chromosomes become less condensed as they uncoil and the microtubules of the spindle apparatus disassociate. A nuclear envelope reforms around the chromosomal material and nucleoli reform. The daughter nuclei are moving back to the interphase condition that characterized the parent nucleus at the start of mitosis. However, there is one significant difference. Each chromosome consists of a single chromatid instead of paired chromatids. This discrepancy is resolved during interphase.

Interphase

Interphase means between (inter) phases of mitosis. It is the period of time between successive cell divisions during the cell cycle. At one time, interphase was called the resting phase. Nothing could be further from the truth. It is during interphase that most of the metabolic activity of the cell occurs. It is also during this time that DNA synthesis occurs to produce two identical chromatids from each single chromosome received during telophase.

Interphase is divided into three substages, G1, S, and G2 (Figure 9-2e). In terms of nuclear division, S (synthesis) is the significant stage. During this time, DNA synthesis occurs to produce a chromosome with duplicate chromatids. The actual process of DNA replication will be covered in Chapter 12. The important thing is that after synthesis, each chromosome will consist of two identical chromatids held together at the centromere, and the nucleus will be capable of repeating the mitotic cycle.

G1 and *G2* refer to the "gap" in the cell cycle before (G1) and after (G2) synthesis. Metabolism is active during both gap phases, but during G1, it is critical that the molecules necessary for DNA synthesis are prepared.

We tend to emphasize the distinct, named phases of the cell cycle and observe the stages of mitosis on slides of cells that were prepared at a specific moment in time. For many dividing cells, it will be easy to identify in which stage of mitosis they were caught. There will be some, however, for which it will be

difficult to tell whether this is an early prophase or a later interphase, a late anaphase or an early telophase, and so on. It is important to remember that mitosis and the cell cycle are continuous, dynamic processes.

■ CYTOPLASMIC DIVISION CYTOKINESIS

Cytoplasmic division, **cytokinesis,** typically occurs simultaneously with mitosis. Because of the presence of a cell wall in plants, the mechanisms of cytokinesis will be much different in animals and plants.

Animal Cells

In animal cells, cytokinesis occurs by a process called **cleavage.**

As mitosis proceeds through telophase, a ring of microfilaments form around the periphery of the cytoplasm in the plane of the old metaphase plate. These microfilaments consist of the proteins actin and myosin that also are involved in muscle contraction. In this case, as contraction occurs, a furrow forms that constricts the cytoplasm and eventually pinches it in two. As adjacent membrane surfaces compress toward each other, the molecules reassociate to form two distinct, but appressed, membranes.

Plant Cells

Constriction of plant cells is not possible because of the cell wall. Once the daughter chromosomes have divided during late anaphase, Golgi from each side of the dividing cell migrate toward the old

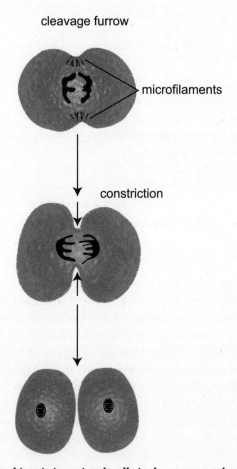

Figure 9-3. Cytokinesis in animal cells is due to cytoplasmic constriction.

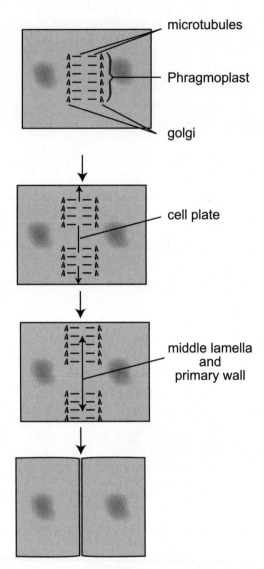

microtubules

Phragmoplast

golgi

cell plate

middle lamella
and
primary wall

Figure 9-4. Cytokinesis in plant cells is complicated by the presence of a cell wall. Not only must the cytoplasm divide, but a new wall must form to separate the daughter cells.

metaphase plate, and microtubules form from the Golgi on each side toward the center of the cell. In the light microscope, this concentration of Golgi and their associated microtubules appear as an elliptical denser staining area, the **phragmoplast,** between the developing daughter nuclei.

As the phragmoplast expands laterally toward the cell walls, a darker line, **the cell plate,** becomes visible running down the center. New cell wall material is produced in the Golgi and transported along the microtubules from both sides of the phragmoplast until they coalesce at the center. The cell plate is the new cell wall being laid down between the daughter nuclei. Middle lamella is produced, starting in the center and developing centrifugally as the phragmoplast expands toward the periphery. Primary wall material follows, from each side and, finally, new cell membrane is synthesized. As each layer reaches the original cell periphery, it fuses with the existing layer. Rather than pinching in two, plant cells build a partition between the daughter cells, from the inside out.

Test Yourself

1) Of the following, a cell spends the longest time in
 a) prophase.
 b) metaphase.
 c) anaphase.
 d) telophase.
 e) interphase.

2) Each of the chromosomes in a cell each consists of only a single chromatid. The cell must be in which portion of the cell cycle?
 a) S-phase
 b) prophase
 c) G-2 phase
 d) anaphase
 e) both a and c

3) Which of the following could happen if mitosis and cytokinesis were not linked?
 a) A daughter cell could be produced that has two identical nuclei.
 b) A multinucleate cell could be produced.
 c) A multinucleate cell could become a multicellular tissue.
 d) Choices a, b, or c could occur.
 e) None of the above could occur. Mitosis and cytokinesis are always linked.

4) Chromosomes will be least condensed during which of the following stages of mitosis?
 a) prophase
 b) metaphase
 c) anaphase
 d) either a or b
 e) They are equally condensed at all stages of mitosis.

5) If a cell has six chromosomes at the beginning of mitosis, how many chromosomes will be in each daughter cell?
 a) three
 b) six
 c) twelve

6) Which of the following cells could undergo mitosis? A cell with ___ chromosomes.
 a) five
 b) six
 c) eight
 d) b and c only
 e) a, b, or c

7) Which of the following statements is always true of cytokinesis?

 a) The cytoplasm pinches in to form two equal cells.

 b) The organelles in the cytoplasm are distributed between daughter cells.

 c) Actin and myosin microfilaments are involved.

 d) Each daughter cell receives one centriole.

 e) All of the above are true of cytokinesis.

8) You are examining a prepared microscope slide that was made from growing tissue. In some of the cells, it is evident that mitosis is occurring. Which stage of mitosis should you expect to see most frequently?

 a) prophase

 b) metaphase

 c) anaphase

 d) telophase

 e) Each of the above should be equally represented.

Test Yourself Answers

1) **e.** Most of the cell cycle is spend in interphase, where most of the metabolism of the cell occurs. The other phases are subdivisions of the short period during which the nuclear material divides.

2) **d.** From the S-phase of interphase through the end of metaphase, each chromosome consists of two chromatids held together at the centromere. From anaphase through the beginning of the S-phase, each chromosome consists of a single chromatid.

3) **d.** There are many instances in both plants and animals where mitosis can occur repeatedly without cytokinesis, resulting in a multinucleate cell. In some cases, particularly in plants, such a multinucleate cell can undergo cytokinesis repeatedly to partition the cytoplasm around each nucleus to form a tissue of uninucleate cells.

4) **a.** At the beginning of what we recognize as prophase, the chromosomes are elongated and barely visible as discrete structures. Throughout this phase, the chromosomes continue to shorten and condense. They are fully condensed from the end of prophase through the completion of anaphase.

5) **b.** During mitosis, the number of chromosomes in each daughter cell is the same as the number in the parent cell.

6) **e.** During mitosis, the number of chromosomes in each daughter cell, is the same as the number in the parent cell. Although we usually think of mitosis occurring only in body cells of organisms such as animals or flowering plants with pairs of chromosomes (thus an even number), this is not necessary. Whatever number of chromosomes occur in the parent cell, the daughter cells will have the same number after mitosis.

7) **b.** All the other choices are true for animal cells, but not for plant cells.

8) **a.** Prophase has the longest duration of the listed stages of mitosis and anaphase has the shortest. In a sample of dividing cells taken at any moment in time, the number of cells in a given stage should be proportional to how long that stage takes. Longer stages should appear more frequently; shorter stages should be more rare.

Sexual Reproduction

Two things are absolutely necessary for sexual reproduction to occur in any organism—but is it not necessarily to have males and females. First, there must be fusion of sex cells, **gametes,** in a process called **syngamy** or fertilization. In animals and most plants, the gametes are differentiated into larger, non-motile female gametes **(eggs)** and smaller, motile male **sperm.** In some organisms, however, both gametes are motile, and they may or may not be the same size.

During sexual reproduction, each parent contributes a copy of its genetic information, via its gamete, to the offspring. When the gametes fuse, the genes from both parents are combined in the offspring. This raises a potential problem. If each parent had ten chromosomes and gametes were produced by mitosis, each gamete would also have ten chromosomes. The offspring resulting from syngamy would end up with twenty chromosomes. A generation later, there would be forty, then eighty, and so on, and quickly there wouldn't be enough room in a cell nucleus for all the chromosomes. The solution to this dilemma is to start with pairs of chromosomes and to modify nuclear division so that only one of each chromosome pair is contained in each gamete. This method of nuclear division is called **meiosis.** Meiosis reduces the number of chromosomes in a daughter cell to half that of the mother cell. More importantly, it ensures that the daughter cells receive one of *each type* of chromosome—one of each pair possessed by the mother cell.

■ SEXUAL LIFE CYCLE

Sexual reproduction may be diagrammed as a four-part process with fertilization and meiosis driving the process.

We can begin anywhere in the cycle. For example, each gamete has one of each type of chromosome. This condition is called **haploid** and is designated $1n$, where n is the number of different chromosomes characteristic of that species. When fertilization occurs, two gametes (each $1n$) fuse so that the resulting cell is **diploid** ($2n$), containing a pair of each type of chromosome. The original diploid cell is called a **zygote.** A diploid cell is capable of undergoing meiosis to reduce the number of chromosomes back to $1n$ and complete the cycle.

The significance of the sexual cycle is that every zygote produced will have a unique combination of genetic information. Half of its genes came from one parent (paternal) and half from the other (maternal). Furthermore, when the diploid cell undergoes meiosis, further mixing occurs. Meiosis ensures that each daughter nucleus receives one of each pair of chromosomes from the diploid nucleus. But it is a coin toss as to which of each pair a particular daughter nucleus receives. It may receive paternal chromosomes

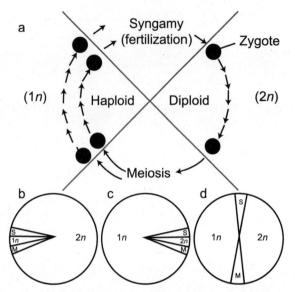

Figure 10-1. Diagramatic life cycles. a) A generalized four-part life cycle involving meiosis and syngamy. b) Diploid dominant life cycle, with gametes as the only haploid cells. c) Alternation of generations, with mitosis occurring in both the haploid and diploid generations producing both haploid and diploid bodies. d) Haploid dominant life cycle, with zygotes as the only diploid cells.

1 and 2 but maternal chromosomes 3, 4, and 5. For each homologous pair of chromosomes, there is a fifty-fifty chance that the paternal or maternal chromosome will segregate to a particular daughter nucleus. As a result, virtually every daughter nucleus produced by meiosis carries a unique combination of genetic material.

This basic life cycle is characteristic of all sexually reproducing organisms, whether unicellular or multicellular, plant or animal. The only difference is where mitosis might occur. For example, in animals, the zygote undergoes mitotic cell division repeatedly to form a multicellular diploid body. When the animal becomes reproductively mature, specialized cells in the sex organs begin to reproduce meiotically to directly produce haploid gametes, either eggs or sperms. Two gametes to produce a new zygote and the cycle is complete. The gametes are the only haploid cells in the life cycle of the animal (Figure 10-1b).

Not all organisms have the diploid dominant life cycle of animals. For example, many algae have exactly the opposite life cycle (Figure 10-1d). In these organisms, the zygote is the only diploid cell, and it immediately undergoes meiosis to produce haploid cells. The daughter cells are not gametes, they are haploid **spores.** Each spore is capable of undergoing mitotic division which may produce a multicellular haploid body. When the organism is reproductively mature, sex organs differentiate to produce gametes by mitotic division. Two gametes fuse to produce a new zygote to repeat the process.

The life cycles mentioned above are the two extreme conditions but land plants and many other organisms are intermediate and have the best of both—a process called **alternation of generations.** The zygote undergoes mitotic cell division to produce a multicellular diploid plant body that produces reproductive organs when it is mature. Meiosis occurs in these organs to produce haploid spores, which also undergo mitotic cell division to produce multicellular (or at least two-celled) haploid bodies. The haploid bodies produce gametes that fuse to produce a new zygote to complete the cycle (Figure 10-1c).

■ MEIOSIS

The key to sexual reproduction is meiosis, the special form of nuclear division that converts diploid cells into haploid cells. At one time, meiosis was referred to as reduction/division, and this old terminol-

ogy has the advantage of emphasizing that meiosis has two parts. During meiosis I, the number of chromosomes is reduced; the diploid nucleus divides to form haploid daughter nuclei. During meiosis II, the already haploid daughter cells essentially divide mitotically.

Meiosis I: Reduction

Organisms with diploid cells have pairs of chromosomes, one derived from each parent. During meiosis I not only is the number of chromosomes reduced in half, but the daughter cells receive one of each pair.

Prophase I

In most respects, prophase I is similar to prophase in mitosis. It is by far the longest stage of meiosis and, during this stage, the chromosomes condense, the spindle apparatus forms, and the nuclear membrane breaks down. The most significant difference is that as the chromosomes condense, they align in homologous pairs, a process called **synapsis.** They are homologous pairs because this must be a diploid cell. Each homologue contains the same set of genes (although the chromosomes may have different forms of those genes—see Chapter 11) as its pair; they are visibly alike, having the same size and shape.

The homologous pairs of chromosomes typically intertwine during early prophase I, and segments of one chromosome may exchange places with a corresponding segment of its pair. Such **crossing over** produces otherwise unexpected variability in the cells that eventually are produced. Without crossing over, each daughter cell would receive a set of chromosomes in which every chromosome would be identical to one or the other of the original homologous pairs in the parent cell. Crossing over produces unique variations in the offspring.

By the end of prophase I, the homologous pairs of chromosomes are closely associated with each other and are referred to as a **tetrad**—the four chromatids of the paired chromosomes appear almost as a unit. As the spindle forms, microtubules from one pole attach only to the centromere of the chromosome pair nearest that pole. Thus the paired chromosomes of the tetrad connect to spindle microtubules from opposite poles.

Metaphase I

During metaphase I, the tetrads align at the metaphase plate. Both chromatids of a chromosome attach to microtubules from the same pole. Homologous chromosomes are connected to opposite poles.

Anaphase I

Anaphase I of meiosis is similar to mitotic anaphase except that the centromeres to not divide. Instead, an entire chromosome, composed of sister chromatids, draws toward one pole as its homologous pair moves to the opposite pole. Pairs of chromosomes in the diploid parent nucleus are reduced to one of each pair in the forming haploid daughter nuclei.

Telophase I and Interphase

Telophase I varies considerably, depending on the organism undergoing division. The spindle apparatus disassembles and chromosomes frequently decondense. The nuclear membrane may reform and, typically, cytokinesis occurs in the same manner as a cell undergoing mitosis. There may be a pause, called **interphase,** before proceeding with meiosis II, or division may proceed promptly.

Meiosis II

Mechanically, the processes of meiosis II are identical to those of mitosis. Remember that mitosis can occur in either a diploid or a haploid cell. The number of chromosomes is not changed, and the two daughter nuclei each receive one of the sister chromatids from each chromosome of the parent nucleus.

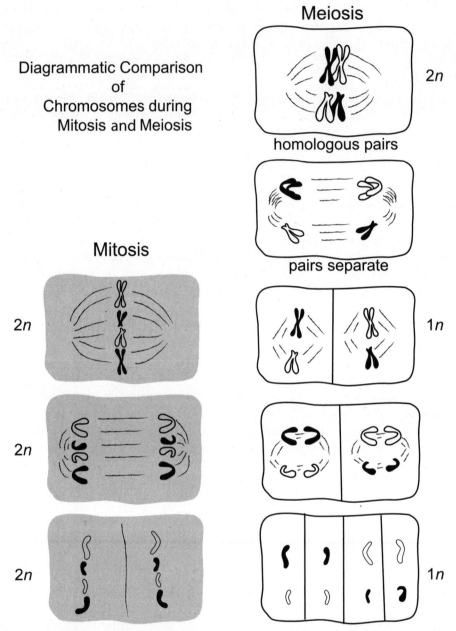

Figure 10-2. Comparison of mitosis and meiosis. A cell with four chromosomes, two homologous pairs, is diagrammed. The homologues are solid or open. One pair is large; the other small. In meiosis, homologous chromosomes pair during prophase I, and the homologous chromosomes move to opposite poles in anaphase I to produce haploid daughter cells, each with one of the original pair of homologues. In mitosis, homologues do not pair, and the daughter chromatids of every chromosome divide during anaphase. Exactly the same process can occur whether the cell begins as haploid or diploid. Meiosis II is essentially the same as mitosis.

Here there is a subtle, but significant, difference. In mitosis, the chromatids of each chromosome are identical, so each daughter cell receives identical genetic information. Because of crossing over during prophase I, the sister chromatids on each chromosome are unique at the beginning of meiosis II. Although each daughter nucleus receives a chromatid from each parent chromosome, the genetic information they contain will be unique.

During prophase II, a new spindle arises, oriented at right angles to the former meiosis I spindle. The chromosomes recondense and the nuclear membrane breaks down. Spindle fibers from each pole attach to the chromosomes on opposite sides of the centromere and help to align the chromosomes at the metaphase plate during metaphase II. The centromeres divide, and the sister chromatids draw apart during anaphase II. Telophase II completes meiosis as the newly forming haploid nuclei move into interphase, where sister chromatids are synthesized from the chromosome template. A second round of cytokinesis typically accompanies telophase II.

Test Yourself

1) Sister chromatids are formed during
 a) prophase I of meiosis.
 b) telophase of meiosis II or mitosis.
 c) anaphase of mitosis or meiosis.
 d) interphase following either mitosis or meiosis.
 e) mitosis only.

2) In plants that produce eggs and sperm, female gametes have (an equal number of; fewer of; more of) chromosomes than male gametes, and female gametes have (equal; more; less) cytoplasm as male gametes.
 a) equal number of, equal
 b) equal number of, more
 c) more of, more
 d) less of, more
 e) equal number of, less

3) A parent cell has sixteen chromosomes. Following *mitosis,* each daughter cell will have (thirty-two, sixteen, eight) chromosomes, and following *meiosis,* the number chromosomes will be (thirty-two, sixteen, eight).
 a) thirty-two, sixteen
 b) sixteen, eight
 c) eight, eight
 d) thirty-two, eight
 e) sixteen, sixteen

4) During the life cycle of flowering plants, either a triploid ($3n$) or pentaploid ($5n$) cell always is produced. By what process can this cell divide to form a $3n$ (or $5n$) tissue?
 a) mitosis only
 b) meiosis only
 c) mitosis or meiosis
 d) neither mitosis nor meiosis (It must be a unique process.)

5) Which of the following is a true statement?
 a) Meiosis always produces egg or sperm cells.
 b) Sexual reproduction is an animal characteristic.
 c) A cell must be diploid to undergo meiosis.
 d) Gametes are always motile cells.
 e) All of the above are true.

6) Which of the following always follows syngamy in a sexual life cycle?

 a) gametes

 b) diploid cells

 c) meiosis

 d) spore

 e) haploid cells

7) A diploid cell becomes haploid during

 a) prophase I.

 b) mitosis.

 c) anaphase I.

 d) prophase II.

 e) telophase II.

8) Which of the following is a true statement?

 a) Sister chromatids divide during anaphase I.

 b) During metaphase I, sister chromatids contain identical genetic information.

 c) Tetrads consist of four independent chromatids.

 d) During metaphase II, sister chromatids contain identical genetic information.

 e) None of the above is true.

9) Which of the following is *not* an actual chromosome count from a diploid cell?

 a) six

 b) ten

 c) twelve

 d) twenty-five

 e) two hundred and twelve

10) Which of the following contributes to the genetic variability of a species?

 a) crossing over during prophase I

 b) separation of homologous chromosomes during anaphase I

 c) division of sister chromatids during anaphase II

 d) fusion of gametes during syngamy

 e) all of the above

Test Yourself Answers

1) **d.** Sister chromatids are formed during the S-phase of the cell cycle, which occurs during interphase following nuclear division, either mitosis or meiosis.

2) **b.** The gametes of any species contain the same number of chromosomes regardless of whether they are differentiated into large, sessile eggs and small, motile sperm, or both cells motile, and of similar size or not.

3) **b.** Following mitosis, the number of chromosomes in the daughter cells will be the same as in the parent cell; meiosis reduces the number of chromosomes by half.

4) **a.** Mitosis always produces two daughter nuclei identical to the parent nucleus, regardless of the original ploidy.

5) **c.** In animals, meiosis directly produces egg or sperm cells, but in plants and other sexually reproducing organisms, spores are the direct product of meiosis. Gametes may be motile or not; an egg cell is non-motile.

6) **b.** Syngamy is the fusion of haploid gametes to form a diploid cell. Meiosis produces haploid cells, which may be spores or gametes, from a diploid cell.

7) **c.** The homologous pairs of chromosomes of the diploid parent cell separate during anaphase I of meiosis; the resulting daughter nuclei that form during telophase I are haploid.

8) **e.** Crossing over occurs during early prophase I. As a result, every chromatid carries a unique combination of genetic information the rest of the way through meiosis. The tetrads visible at the end of prophase I consist of the homologous pair of chromosomes, each of which consists of two chromatids. Homologous chromosomes separate during anaphase I; sister chromatids divide during anaphase II.

9) **d.** A diploid cell must have an even number of chromosomes to have homologous pairs. A surprising number of plants have chromosome counts in the hundreds.

10) **e.** As a result of crossing over during prophase I, each sister chromatid of every homologous pair of chromosomes will be unique. During anaphase II, there is an equal probability that any paternally derived chromosome will segregate with either the paternal or maternal member of every other homologous pair. Fusion of gametes creates unique pairs of homologous chromosomes derived from the two parents.

Mendelian Genetics

Gregor Mendel, an Augustinian monk living 150 years ago in the Moravian city of Brno, made some elegant discoveries that form the basis of our understanding of heredity in sexually reproducing organisms. Yet, even today, Mendel would be unusual for a biologist because of his background and training in mathematics and physical science. However, it was precisely this training that allowed him to recognize basic repeating patterns in his breeding experiments, to deduce a mechanism that explained the patterns, and to test the validity of his hypotheses.

■ CHOOSING EXPERIMENTAL MATERIALS

Mendel began his experiments with garden peas in 1856 because they fit three criteria he considered to be essential.

First, inbred lines were available that had constant differentiating characters.

The fourteen inbred lines represented seven traits each with two distinctive phenotypes. The first five traits refer to characteristics visible in the seed produced following a cross. The last two traits are characters not visible until the seeds germinate the following season to produce the mature plant body.

Second, pollination could be controlled; and third, the hybrids and their offspring should remain vigorous. Although he used a total of thirty-four varieties, only twenty-two proved to have constant characters and, of these, only fourteen supplied the data reported in his published paper.

■ CONTROLLING THE EXPERIMENTS

Mendel kept meticulous notes, recording individual plants and flowers that either provided or received pollen in a hybridization experiment. This was important because his analyses involved more than one generation, and each experiment was performed in replicate. He manually pollinated flowers and prevented self-pollination by surgically removing stamens from receptive flowers before the pollen was mature. During the next eight years, he designed, repeated, and systematically recorded the results of his experiments.

■ MONOHYBRID EXPERIMENTS

Many earlier breeding experiments done by others observed that hybrids, as a rule, are somewhat intermediate between the parents. Size and form of leaves, for example, often behave this way. With the

Round vs Wrinkled seed
Yellow vs green seed
Colored vs white seed coat
Smooth vs wrinkled pod
Green vs yellow pod
Axillary vs terminal flowers
Tall vs short stems

Figure 11-1. Inbred lines used by Mendel were only some of the many varieties commercially available to him.

characters Mendel chose, however, one character was always maintained in the hybrid (F1) generation, while the other seemed to disappear. To describe this he coined the terms **dominant** and **recessive** and established the convention of representing the dominant with a capital letter and the recessive with a lower case letter. He also determined that it did not make a difference whether the pollen-bearing or seed-bearing parent expressed the dominant character. It worked the same in either case.

Note that for five of his characters relating to color or shape of the seeds, he could score the results of his cross the same year it was made. For the last two characters, however, he had to plant the resulting seeds the next year to grow out the plants and score their characters—tall or dwarf and position of the flowers. Good record keeping was essential.

At first, there was some question as to what happened to the recessive character. Was it gone or simply hidden by the dominant character? To determine this, he grew out the hybrid seeds and produced a second generation (F2). His cumulative results for two experiments are illustrated in Figure 11-2.

The general pattern Mendel observed in all of his monohybrid experiments was a 3:1 ratio of dominant to recessive characters for the trait examined. The recessive characters reappear "with their peculiarities fully developed," and there were no intermediate forms. Furthermore, he immediately noticed a mathematical trend. The F2 offspring were always in a ratio of about three dominant to one recessive. What is the simplest logical way to explain the results of his monohybrid crosses?

First, he knew that both parents contributed equally to the offspring because the same results occurred regardless of which plant was the pollen donor or the seed producer. Second, he knew that a minimum of two factors must be involved, one from each parent. Because the offspring of one generation becomes the parent of the next, each parent must contain two factors, although only one is contributed to the next generation. (In essence, he predicted that meiosis must be involved in gamete production decades before meiosis was discovered.)

The true-breeding dominant and recessive parents must contain two dominant (AA) and two recessive (aa) factors, respectively. The dominant parent can contribute only a dominant factor (A) to the F1

	Experiment 1. Form of Seed.		Experiment 2. Color of Albumen.	
Plants	Round	Angular	Yellow	Green
1	45	12	25	11
2	27	8	32	7
3	24	7	14	5
4	19	10	70	27
5	32	11	24	13
6	26	6	20	6
7	88	24	32	13
8	22	10	44	9
9	28	6	50	14
10	25	7	44	18

Figure 11-2. Mendel's cumulative monohybrid results. Second generation (F2) results from two of Mendel's monohybrid experiments. In both, a total of ten plants were examined and all of the seeds on each plant were scored.

Tall Dwarf P1

Parental Cross
(both inbred)

X self F1

1st Filial (Daughter)

F1

2nd Filial

Figure 11-3. Monohybrid cross. Inbred lines are chosen for the initial cross to produce an F1 offspring gen-eration that shows only the dominant trait. The F1 is a hybrid of the two parents and is heterozygous for this trait. A monohybrid cross is one between two hybrid (heterozygous) individuals that typically produces an F2 generation with a phenotype ratio of three dominant, one recessive.

offspring and, likewise, the recessive parent can contribute only a recessive factor (a). The F1 must have one of each factor (Aa) and show the dominant character.

Producing the second generation is more interesting. The F1 offspring (Aa) now becomes a parent producing the F2. What are the probabilities that one parent could donate a dominant or recessive factor to its offspring? Of course, it is fifty-fifty; half of the offspring could receive A and half could receive a. The other parent carries the same factors, so the probabilities are the same. Given these probabilities, what factors would you expect in the offspring? To Mendel, this was a simple algebra problem: $(1/2A + 1/2a) \times (1/2A + 1/2a) = 1/4AA + 1/2Aa + 1/4aa$. One-quarter of the offspring should be identical to the original dominant parent, one half should be identical to the F1, and one quarter should be identical to the recessive parent. In other words, three out of four should show the dominant characteristic, and the rest show recessive. Using his formulas, Mendel predicted what should appear in the F3 through F6 genera-tions, and then did the experiments to verify his hypotheses. His results confirmed the mechanism.

How do we understand Mendel's results? The characters we observe, the **phenotype,** are the expres-sion of genes, located on chromosomes, the **genotype.** In the simplest case, a gene will have two forms, or **alleles,** a dominant allele and a recessive allele. Each of the two homologous chromosomes carries one allele for a gene. If both chromosomes of a homologous pair carry the same allele, we say it is **homozy-gous.** *Homo* means "the same" and *zygous* refers to the zygote from which the individual developed. True

breeding genotypes may be homozygous dominant (AA) or homozygous recessive (aa). Meiosis ensures that one or the other homologous chromosome, carrying its allele for the gene, is passed on to the next generation. The F1 zygote has two different alleles (Aa); it is **heterozygous.** What kinds of gametes will this plant produce when it reproduces? Meiosis ensures that one-half of the gametes will contain A, and one-half will contain a.

Most students find it easiest to visualize these processes using a Punnett Square. The critical factor in setting up a Punnett Square is determining how many different possible gametes each parent could produce as a result of meiosis. A heterozygous parent, as in a monohybrid cross, could produce two possible gametes; one dominant and the other recessive. The square must have a row for each possible gamete from that parent. If the other parent is also heterozygous, the square also must have two rows; one for the dominant, the other for the recessive.

The key to setting up a Punnett Square is to determine what gametes each parent can produce through meiosis. The possible gametes from one parent go across the top axis, while the possible gametes produced by the second parent go down the left side. Once the gametes are determined, it is simply a matter of filling in the squares, one gamete contributed by each parent, to determine the possible offspring. By convention, the dominant letter is always written first if an offspring is heterozygous. This makes it easier to compare and count possible genotypes and phenotypes in the offspring population.

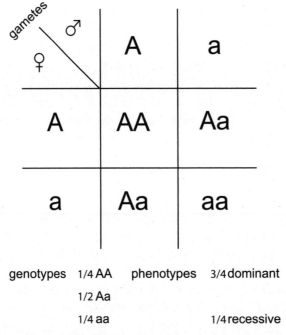

Figure 11-4. Monohybrid Punnett Square. The Punnett Square for a monohybrid cross must be a 2 x 2 square with a total of four boxes to hold the four possible genotype combinations resulting from syngamy of two gametes. Genotype and phenotype ratios are given.

■TEST CROSS

For Mendel's purpose, working with probabilities to determine the hereditary mechanism, it did not matter that both the homozygous dominant and heterozygous have the same phenotype. But a breeder today often must be able to distinguish between the two. The traditional way to do this is a **test cross** or back cross. We know for sure that our dominant offspring has at least one dominant allele, but we don't know the second alleles (A?). If we use the unknown as one parent and cross it back to the original homozygous recessive parent, we can figure it out. If our unknown is homozygous (AA), then all the offspring will have a dominant phenotype: AA × aa → all Aa. However, if our unknown is Aa, then half of the offspring should have the recessive phenotype: Aa × aa → 1/2 Aa, 1/2 aa.

■ DIHYBRID EXPERIMENTS

Armed with his understanding of monohybrid inheritance, Mendel next set out to examine how two or more characters are associated. For example, what if round yellow seed parents (AABB) were crossed with wrinkled and green seed parents (aabb)? The only kind of gamete the homozygous dominant parent can produce is AB; the homozygous recessive parent produces only ab. All of the offspring must be heterozygous for both genes (AaBb) and have a round yellow seed phenotype. What about the F2 generation? Figure 11-5 shows the results of Mendel's first dihybrid experiment, which happened to examine these characters.

Of the 556 seeds produced in the F2, approximately 9/16 (313) plants were dominant for both traits, approximately 3/16 (104) plants were dominant for one trait but recessive for the other, and approximately 1/16 (35) plants were recessive for both characteristics.

Based on these results, he could say that his proposed mechanism was supported *if* the two traits behaved independently. If 3/4 of the offspring of a monohybrid round/wrinkled cross were round, and 3/4 of a yellow/green cross were yellow, then 9/16 of his dihybrid offspring should be round and yellow. By the same reasoning, 3/16 should be wrinkled/yellow; 3/16, round/green; and 1/16, wrinkled green. His experimental results fit the expected proportions.

How do we set up this Punnett Square? The first thing to determine is the possible gametes that could be produced by meiosis. Every gamete must have one of each homologous chromosome. Assuming the A and B genes are on separate chromosomes, every gamete should have one of the As and one of the Bs. The possible gametes are 1/4AB, 1/4Ab, 1/4aB, and 1/4ab for each parent. We must have a 4 x 4-celled Punnett Square, and the four possible gametes should be placed on the two sides.

The possible offspring are determined by filling in the square. By convention, the homologous alleles are paired, the dominant allele is written first, and the order of genes is consistent—As first, then Bs, and so on. From the completed square, both the genotype and phenotype ratios can be determined.

Could you determine the possible genotype and phenotype ratios of a trihybrid cross—AaBbCc? Mendel did, and his experimental results supported the hypothesis of independent assortment.

315 round and yellow
101 wrinkled and yellow
108 round and green
32 wrinkled and green

Figure 11-5. Phenotypes for the F2 generation of Mendel's first dihybrid experiment.

Figure 11-6. Dihybrid Punnett Square. *As in the monohybrid cross, the key is to determine the possible combinations of alleles that could occur in the gametes. A dihybrid individual could produce four possible combinations of two traits, each heterozygous. The Punnett Square for a dihybrid cross must be a 4 × 4, defining sixteen boxes. Genotype and phenotype ratios are given.*

Test Yourself

1) Assume tall (T) is dominant to dwarf (t). If a homozygous tall individual is crossed with a homozygous dwarf, offspring will be:

 a) all intermediate in height.

 b) all tall.

 c) 1/2 tall and 1/2 dwarf.

 d) 3/4 tall and 1/4 dwarf.

2) The results of a test cross (that is, the offspring of this cross) was 50 percent phenotypically dominant offspring and 50 percent phenotypically recessive offspring. The *genotype* of the phenotypically dominant parent in this cross

 a) was homozygous dominant.

 b) was homozygous recessive.

 c) was heterozygous.

 d) was a and b, but not c.

 e) cannot be determined from the information.

3) If all offspring of a cross are heterozygous, the parents' genotypes would most likely be

 a) AA × aa.

 b) Aa × Aa.

 c) Aa × aa.

4) In the cross AaDD × AADd, which of the following would *not* be represented in the offspring?

 a) AaDd

 b) AADd

 c) AaDD

 d) AADD

 e) AAdd

5) Pea flowers may be purple (W) or white (w). Pea seeds may be round (R) or wrinkled (r). What proportion of the progeny (offspring) from the cross WwRr × WwRr will have white flowers and wrinkled seeds?

 a) 1/16

 b) 3/16

 c) 8/16

 d) 9/16

 e) all of them

6) Mendel drew four conclusions from his work. Which of the following was *not* one of his conclusions?

 a) There are alternative forms of factors (genes), the units that determine heritable characteristics.

 b) Each characteristic of an organism is determined by two factors (alleles), one inherited from each parent.

 c) A sperm or egg carries only one factor (allele) for each characteristic.

 d) When two different factors (alleles) of a trait are present, one may show incomplete dominance over the other.

 e) Factors (alleles) may be dominant or recessive.

7) Flower color in snapdragons is an example of incomplete dominance. If a true-breeding red flowered plant (homozygous RR) is crossed with a true-breeding white flowered plant (also homozygous, but rr), all of the F1 generation has pink flowers, a color intermediate between red and white. If a pink flowered plant was crossed with another pink flowered plant, the progeny plants would be.

 a) 100 percent pink.

 b) 100 percent red.

 c) 25 percent red, 50 percent pink, and 25 percent white.

 d) 50 percent pink and 50 percent red.

 e) 25 percent pink and 75 percent red.

8) Sickle-cell anemia is caused by the homozygous condition of a single gene. If two individuals heterozygous for sickle-cell marry, what fraction of their children, on average, will be homozygous for sickle-cell anemia?

 a) 0 percent

 b) 25 percent

 c) 50 percent

 d) 75 percent

 e) 100 percent

9) Each of Mendel's true breeding varieties of peas

 a) was homozygous for one of the traits he studied.

 b) was heterozygous for one of the traits he studied.

 c) had only dominant alleles for one of the traits he studied.

 d) had only recessive alleles for one of traits he studied.

 e) Two of the above are correct.

10) A is dominant to a. The phenotypic ratios of a cross between an Aa individual and an Aa individual will be

 a) 1:2:1.

 b) 3:1.

 c) 1:1.

 d) 1:1:1:1.

 e) 9:3:3:1.

Test Yourself Answers

1) **b.** The homozygous tall individual must contribute a tall allele to each offspring (and the homozygous dwarf individual must contribute a recessive dwarf allele); therefore, all of the offspring will have the heterozygous genotype and be tall.

2) **c.** A test cross is used to determine whether a phenotypically dominant individual is homozygous or heterozygous. The unknown is crossed with a homozygous recessive. If the unknown was homozygous dominant, all of the offspring of the test cross will be heterozygous and phenotypically dominant. If any recessive offspring are produced (typically 50 percent), the unknown must have been heterozygous and able to contribute a recessive allele to the offspring.

3) **a.** The only way that all offspring can be heterozygous is if each parent can contribute only one type of allele, and the alleles of the two parents are different. That is, one must be homozygous dominant and the other homozygous recessive.

4) **e.** For the A gene, the only possible genotypic combinations in the offspring are AA or Aa because the second parent can only contribute a dominant allele. Similarly, the only possible genotypes of the D allele are DD or Dd because the first parent can only contribute a dominant D. Neither an aa nor a dd genotype can be produced; therefore, AAdd is not a possible offspring.

5) **a.** The genotype of white flowers and wrinkled seeds is wwrr, homozygous recessive for both traits. Each parent has a 50 percent probability of contributing the recessive w allele; therefore, the probability of the offspring being white (homozygous recessive) is $1/2 \times 1/2 = 1/4$. Similarly, the probability of each parent contributing a r allele is also 50 percent, and the probability of the offspring having wrinkled seeds is $1/2 \times 1/2 = 1/4$. Therefore, the probability of the offspring having *both* white flowers and wrinkled seeds is $1/2 \times 1/4 = 1/16$. You could also set up a Punnett Square to see that 1 square out of 16 is homozygous recessive for both traits.

6) **d.** None of the traits examined by Mendel showed incomplete dominance, but he was able to demonstrate that heritable characteristics are the result of a combination of two factors, one derived from each parent. We now call these factors different alleles of a gene.

7) **c.** The F1 offspring must be heterozygous (Rr); therefore, the genotypic ratios of the cross Rr × Rr would be 1/4 RR (red), 1/2 Rr (pink) and 1/4 rr (white). You could also work this out with a Punnett Square.

8) **b.** If the mother and father are both heterozygous for the sickle-cell gene, each has a 50 percent probability of passing it on to offspring. As a result, the possibility of having a child with sickle cell (homozygous) is $1/2 \times 1/2 = 1/4$, or 25 percent. You may also work this out with a Punnett Square.

9) **a.** The true-breeding varieties were homozygous for a particular trait, either dominant or recessive.

10) **b.** Although the genotype ratio for this cross will be 1(AA):2(Aa):1(aa), the phenotype ratio will be 3 (showing dominant trait):1 (showing recessive trait).

DNA

Mendel discovered the basic mechanisms of inheritance (see Chapter 11) with little understanding of how this was actually accomplished in the cell. Scientists of his time did not know about chromosomes (see Chapter 5), much less the process of meiosis in which the chromosomes are divided in a special way that is essential for sexual reproduction (see Chapter 10). Even after the role of chromosomes was apparent, however, scientists did not understand which of the two major molecular components, DNA or protein, contained the genetic information. Recall from Chapter 5 that DNA is a rather simple molecule constructed of only four different nucleotides that can be used to compose a molecular message. Imagine designing a vocabulary with an alphabet of only four letters. Proteins, on the other hand, are built of twenty different amino acids so there would be many different possible combinations with which to build a code. For biologists, much of the mid-twentieth century was devoted to determining what constituted the genetic code and how it works.

■ IS THE CODE PROTEIN- OR DNA-BASED?

The logic outlined in the introductory paragraph suggested that the sequence of amino acids in proteins was the most likely candidate for the genetic code. The availability of radioactive isotopes for biological research, following World War II, provided the tools necessary for a series of elegant experiments to answer a previously intractable question. In this case, radioactively labeled phosphorous and radioactively labeled sulfur, not carbon, were the critical ingredients.

Recall from Chapter 2 that phosphorous, one of five atoms found in all nucleotides, is unique in that it does not also occur in amino acids. Sulfur, while not found in all amino acids, occurs in several and is the only atom of amino acids not also found in nucleotides. By the mid 1940s, it was well known that viruses consist of a nucleotide core, either DNA or RNA, surrounded by a protein sheath. Alfred Hershey and Martha Chase realized that viruses provided a means of using labeled isotopes to determine whether DNA or protein was being passed from generation to generation.

They first produced populations of labeled bacterial viruses by growing them in medium containing either labeled phosphorous (^{32}P) or labeled sulfur (^{35}S). They then inoculated fresh bacteria in non-labeled medium with the labeled viruses. When the medium was centrifuged, ^{35}S was found in the rinse solution, while ^{32}P was detected inside the infected bacteria. Figure 12-1 illustrates their experiment.

Clearly, DNA was the prime candidate to be the genetic material.

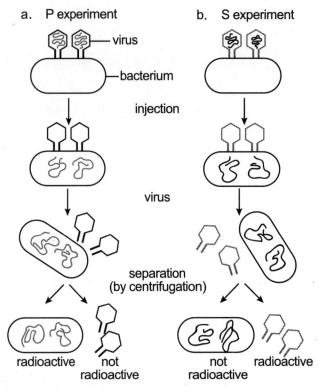

a. P experiment b. S experiment

virus

bacterium

injection

virus

separation
(by centrifugation)

radioactive not not radioactive
 radioactive radioactive

Figure 12-1. Hershey-Chase experiment. Bacterial viruses were produced with either ^{32}P labeled DNA or ^{35}S labeled protein coat. These viruses were allowed to infect new bacterial cells, which were then checked to determine which component was transferred to the next generation.

■ STRUCTURE OF DNA

The chemical composition of DNA was well understood, but how was the molecule actually constructed? Several different laboratories around the world were investigating this problem, and a handful provided useful clues to solving the problem.

Erwin Chagaff discerned that, regardless of the organism being examined, there were several commonalities in their DNA.

The most interesting feature was that, whether you were looking at a bacterium, a fungus, a plant, or an animal, the proportion of adenine (A) was always similar to the proportion of thiamine (T), and guanine (G) was proportional to cytosine (C). Recall from Chapter 3 that both A and G are purines whose nitrogenous base has a double-ring structure, while T and C are pyrimidines with a single-ringed base. Not only were the proportions of pyrimidines and purines equal, but they also appeared to be in matched pairs. The ingredients were now there, and we knew, at least in a relative way, how much of some of the ingredients to use, but the exact amounts and how to mix them together were still missing.

At the University of London, two groups, the Wilkins laboratory and the Franklin laboratory, were working on this problem. Rosalind Franklin was using a new tool to visualize the structure of the intact molecule. Franklin was already a world authority on using X-ray diffraction to interpret the structure of organic molecules. When molecular samples are bombarded with electrons from an X-ray source, the atoms of the molecule deflect the electrons in a particular way, depending on their relationship to other atoms in the molecule. As a result, the electrons produce a characteristic pattern on a sheet of X-ray film.

Based on her X-ray photographs, Franklin knew that DNA formed a double helix and could predict the distance between the sugar-phosphate helical backbones. She could also predict the distance between

COMPONENT NUCLEOTIDE BASES (PERCENT)					
Organism	Cells Analyzed	Adenine	Thymine	Guanine	Cytosine
E. coli	—	26.0	23.9	24.9	25.2
Diplococcus	—	29.8	31.6	20.5	18.0
Yeast	—	31.3	32.9	18.7	17.1
Wheat germ	—	27.3	27.1	22.7	22.8
Sea urchin	Sperm	32.8	32.1	17.7	18.4
Herring	Sperm	27.8	27.5	22.2	22.6
Rat	Bone marrow	28.6	28.4	21.4	21.5
Human	Thumus	30.9	29.4	19.9	19.8
	Liver	30.3	390.3	19.5	19.9
	Sperm	30.7	31.2	19.3	18.8

Figure 12-2. Chagaff's table. DNA from bacteria, a fungus (yeast), a plant, and various animals were analyzed for their percentage composition of each component nucleotide base. The percentages of adenine and thymine were always similar, as were the percentages of guanine and cytosine.

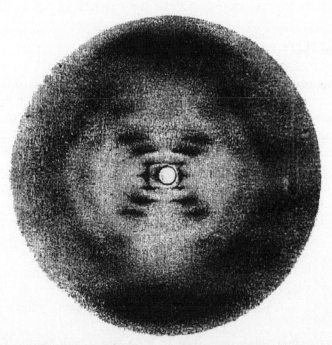

Figure 12-3. Franklin's X-ray diffraction image from the B form of DNA. Her analysis of the structure suggested it was "not inconsistent with the model proposed by Watson and Crick," two pages earlier in the same issue of Nature.

successive nucleotides along the backbone. Unfortunately, depending on how the sample was prepared, two different structures were implied—which one represented the structure of functional DNA in a cell?

James Watson and Francis Crick, two students at Cambridge University, managed to put all the pieces together. Watson, an American post-doctoral student trained in biochemistry, and Crick, whose prior training was in physics, had a mutual interest in using modeling to elucidate the structure of DNA. They constructed metal models of the various nucleotide molecules, scaled to size, and then tried to arrange them in such a way that satisfied the available evidence. Franklin's measurements exactly fit the pairing of a purine ring pair with a pyrimidine ring, and Erwin Chagaff's pairing could be explained by the fact that the rings of AT, when lined up ring-to-ring, form two hydrogen bonds, while CG form three hydrogen bonds. Furthermore, the vertical spacing of nucleotides was exactly as Franklin's photo's predicted if sugar-phosphate units formed the backbone. Finally, if the sugar-phosphate backbones ran in opposite directions, one with the phosphate attached to the #5 carbon of sugar on top and the #3 carbon of sugar toward the bottom, and the other from #5 on the bottom to #3 on top, they would fit naturally into a double helix, held together by the hydrogen bonds between bases. The sugar-phosphate chains are said to run antiparallel. The first is said to run from 5′ (five-prime) to 3′ (three-prime) while the other runs from 3′ to 5′.

Watson and Crick's paper in *Nature,* describing their model of DNA, filled a single page, but it included an important sentence: "It has not escaped our notice that the specific pairing we have postulated immediately suggests a possible copying mechanism for the genetic material."

The structure they proposed for DNA suggested a simple way that DNA could be replicated exactly. Here was a mechanism to explain how a chromosome consisting of a single chromatid at the end of nuclear division could create an identical copy during the S-phase of interphase so that by the beginning of the next round of division, each chromosome would have two chromatids (refer to Chapter 9).

■ DNA REPLICATION

Watson and Crick's model suggested that the double-stranded DNA could easily be divided by breaking hydrogen bonds between the ring structures of complementary bases. If this was done, each strand could serve as a template to reconstruct the opposite strand. The question remained: Would the two new strands then unite to form a completely new double helix in parallel with the original DNA (that is, would the original strand be conserved)? or would each original strand now be paired with a new complementary strand (semiconservative)? How could you test which of these possibilities actually occurs?

Isotopes again were critical to finding the answer to a difficult question. Cells were allowed to complete their cell cycle in a culture medium containing labeled nitrogen nucleotides (in this case the nitrogen isotopes were not radioactive, but they had different weights). If replication was conservative, half of the resulting DNA would be heavier and the other half would be lighter. With **semiconservative** replication, every DNA strand would contain half of the heavier and half of the lighter nucleotides, and they would weigh an intermediate amount. The latter was the case.

Among the functions that occur during G1 of the cell cycle is the production of new nucleotide molecules within the nucleus. When the synthesis phase begins, the double helix "unzips" at the origin of replication. The hydrogen bonds between complementary bases break, allowing the bases to separate from each other.

As a result, the hydrogen bonding sites from an A on one strand and the T on the complementary strand are now available to form new hydrogen bonds with free nucleotides in the nucleoplasm.

The enzyme, **DNA polymerase,** associates with the newly single original DNA strand to begin synthesis of a new complementary strand. If A is the first base exposed, only a free T will hydrogen bond to it. If C is the next base, only G will match and DNA polymerase joins the phosphate group of T to the sugar of G to begin a new backbone. As new nucleotides are brought in sequentially to complement the

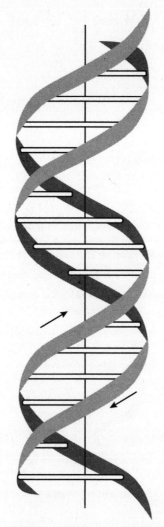

Figure 12-4. Watson and Crick's model. Model of DNA as a double helix with sugar-phosphate chains running antiparallel and held together by pairs of bases.

exposed bases on the original strand, DNA polymerase joins them to create a new complementary strand. Because this occurs simultaneously on both original strands of DNA, each becomes incorporated into one of the chromatids, and each contains a complementary strand of new nucleotides.

Watson and Crick's original model assumed that when the DNA "unzipped," DNA replication would proceed down both strands in the same way. However, shortly after DNA polymerase was discovered scientists realized that it can only add nucleotides to the 3′ end of a DNA chain. In other words, DNA replication occurs from the 5′ to 3′ direction. One strand, the 5′ to 3′, replicates in continuous fashion. DNA polymerase attaches to the terminal exposed base and proceeds to synthesize the complementary strand moving sequentially forward toward the replication fork where the original strand is "unzipping." This strand is called the **leading strand.** But what about the complementary strand that is running from 3′ to 5′? Because DNA is synthesized only in the 5′ to 3′ direction, DNA polymerase must work away from the replication fork. Enough of the original DNA must "unzip" so that a small segment of new strand can be replicated in the 5′ to 3′ direction. As the original DNA continues to "unzip," additional small segments, **Okazaki segments,** of complementary bases are synthesized in succession. As they are produced successive segments are linked using **DNA ligase** enzyme to complete the so-called **lagging strand.**

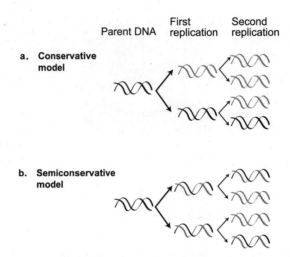

Figure 12-5. Conservative versus semiconservative replication. With conservative replication, the original double helix remains intact after being used as a template to form a new double helix. In semiconservative replication, each strand of the original helix serves as a template for a new strand, so the replicated DNA contains one original strand and one new strand.

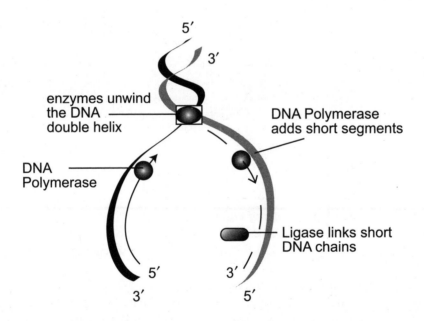

DNA synthesis at a replication fork

Figure 12-6. DNA replication. A replication fork forms where DNA is unwound by breaking the hydrogen bonds between bases. On the 3′ to 5′ template, DNA polymerase catalyzes continuous formation of the leading strand toward the replication fork. On the 5′ to 3′ template, DNA polymerase catalyzes short segments of trailing strand DNA, which must be spliced together by ligase enzyme.

Test Yourself

1) The two sugar-phosphate backbones (legs of the ladder) of a DNA molecule are joined to each other through
 a) 5′ to 3′ deoxyribose and phosphate bonds.
 b) hydrogen bonds between nucleotide bases.
 c) covalent bonds between nitrogen atoms in adenine and nitrogen atoms in thymine.
 d) covalent bonds between carbon atoms in deoxyribose molecules.

2) Replication of DNA is described as semiconservative. This means
 a) only one of the double helices is replicated.
 b) only half of the chromosomes are replicated.
 c) each new chromosome has one parent strand and one new strand.
 d) DNA is halved during meiosis.
 e) replication results in the production of haploids.

3) The two strands of double-stranded DNA are most accurately described as being oriented _____ to one another.
 a) parallel
 b) perpendicular
 c) antiparallel
 d) counterclockwise

4) DNA
 a) has deoxyribose sugar covalently bonded to a phosphate group.
 b) can move out of the nucleus for protein synthesis.
 c) contains a single-stranded backbone.
 d) is a sheet-like folded molecule.
 e) contains two chains of deoxyribose sugars covalently bonded to each other.

5) Which of the following observations explains Chagaff's rule for the observed proportion of nucleotides in DNA?
 a) Either two or three hydrogen bonds form between bases of nucleotides.
 b) DNA consists of double strands of nucleotides.
 c) Half the nucleotides are purines; half are pyrimidines.
 d) Purines bond with purines, and pyrimidines bond with pyrimidines.
 e) Both c and d are correct.

6) DNA replication occurs
 a) in the prophase of both mitosis and meiosis.
 b) in the metaphase of meiosis only.
 c) in the S phase of interphase following mitosis or meiosis.
 d) in the G1 phase of interphase in germ cells only.
 e) in the cytokinesis portion of the cell's life cycle.

7) Which of the following lines of evidence confirmed that DNA must consist of a double helix?

 a) Chagaff's rule: A-T, C-G confirms this.

 b) Labeled phosphate, not labeled sulfur, is passed to succeeding generations of bacterial viruses.

 c) Labeled sulfur, not labeled phosphate, is passed to succeeding generations of bacterial viruses.

 d) DNA replication is semiconservative.

 e) The X-ray diffraction pattern of DNA forms a cross-pattern.

8) When DNA replicates,

 a) each new double helix has half of the original strand and half of a new strand.

 b) one double helix produced is entirely original; the second double helix is an entirely new strand.

 c) both new strands of DNA are produced in the same way in the same direction.

 d) one new strand is produced in a continuous sequence while the other is constructed in segments, but both go in the same direction.

 e) the new DNA strands are produced continuously in opposite directions.

9) Okazaki segments

 a) are formed whenever DNA replicates.

 b) are associated with formation of the leading strand of replicating DNA.

 c) form DNA from the 5′ toward the 3′ end of DNA.

 d) code for the formation of DNA polymerase.

 e) synthesize new nucleotides for use in DNA replication.

10) Which of the following statements is true about DNA polymerase?

 a) Only a small amount is necessary for proper function of the cell.

 b) High temperature or extreme pH can disrupt proper function.

 c) It is coded for by a gene in the DNA.

 d) It is specific for replicating double-stranded DNA.

 e) All of the above are true.

Test Yourself Answers

1) **b.** The bases of each nucleotide chain extend toward each other in a double helix and are held together by hydrogen bonds. Individual nucleotides in the chain are held together by covalent bonds between the #3 carbon of one sugar and a phosphate group attached to the #6 carbon of the next nucleotide.

2) **c.** During replication, hydrogen bonds holding the double strands of DNA are broken so the strands separate. Each original strand remains intact and serves as a template to form a new complementary strand. This occurs during the S-phase of interphase following either mitosis or meiosis. It does not change the ploidy of cells. It simply makes two identical copies of an original double heli—that is, two identical chromatids are produced where originally there was one.

3) **c.** The two strands of a DNA molecule do run parallel to each other, but in opposite directions, antiparallel. If one strand runs from 3′ on top to 5′ below, the complementary strand has its 5′end on top and its 3′end below.

4) **a.** The chain of nucleotides forming the backbone of each of the double helices of DNA are covalently bonded between the sugar of one nucleotide and the phosphate group of the next. DNA does not move out of the organelle where it is produced. It has a double helical structure with each strand of the backbone held to the other by hydrogen bonds between complementary bases.

5) **a.** The purine adenine always binds with the pyrimidine thymine by forming two hydrogen bonds between them. The purine guanine forms three hydrogen bonds with the pyrimidine cytosine.

6) **c.** DNA replication is the "synthesis" that occurs during the S phase of interphase.

7) **e.** Franklin's X-ray diffraction images confirmed that DNA must be a double helix. Chagaff's pairings helped to elucidate which were the complementary bases of the antiparallel strands of DNA and also helped to explain the precision of semiconservative DNA replication. Labeling of P and S confirmed that DNA, not protein, was the hereditary material.

8) **a.** Replication is semiconservative; each half of the original DNA double helix serves as a template to synthesize a new second half.

9) **c.** DNA is always synthesized from 5′ toward 3′. Because DNA is antiparallel, only one strand, the leading strand, can be replicated in a continuous process toward the replication fork. The other (trailing) strand must be replicated in short segments away from the replication form, and then spliced together. These short fragments are Okasaki segments.

10) **e.** DNA polymerase is an enzyme responsible for DNA replication and has all of the general properties of enzymes: protein structure, affected by temperature and pH, reusable and active in small amounts, and specific for a particular substrate.

Protein Synthesis

Watson and Crick provided a structural model for DNA that suggested a means of exact replication to ensure that genetic material could be passed on from generation to generation without change. However, it remained to be shown how the DNA molecule coded hereditary information or how the genetic code was translated into phenotypic traits.

■ DNA TRANSCRIPTION

DNA is restricted to the nucleus (or to a specific organelle such as a chloroplast or mitochondrion that has its own unique DNA). RNA can be found throughout the cell—in the nucleus, the organelles, and in the cytoplasm. Furthermore, the structure of RNA is very similar to that of DNA. It seemed reasonable, then, that RNA must somehow be involved in getting the genetic information from the nucleus, where it is stored, into the cytoplasm, where cell differentiation occurs. The process of converting the stored code of DNA into the functional code of RNA is called **transcription.**

RNA transcription occurs in a manner analogous to DNA replication. When a particular gene must be expressed, the portion of DNA containing that gene is "unzipped" by the enzyme **RNA polymerase.**

Although both strands of DNA are exposed, only the 3′ to 5′ "sense" strand is transcribed. For each base, in succession on the DNA strand, its RNA complement is linked together by RNA polymerase to form a single-stranded transcript. The transcript is an exact copy of the original complementary strand of DNA except that ribose is the sugar and uracil (U) replaces T as the complement for A. In bacteria, this transcript is messenger RNA (mRNA), the RNA that transfers the genetic information from the DNA to the cytoplasm.

■ RNA PROCESSING

We originally assumed that the process of eukaryotic transcription proceeded in the same way as in prokaryotic cells. However, we now know that the primary transcript is processed in a variety of ways before it can be used in the cytoplasm.

The initial processing modifies the two ends of the RNA in a way that helps it to migrate through the nuclear envelope. On the 5′ end of the transcript, the first portion produced, a special guanine nucleotide containing 3-phosphate groups, is added once transcription has begun. This is called the **5′cap.** Once transcription is completed, a series of 50 or more adenine nucleotides attach to the 3′end, forming a **poly-A tail.** In addition to facilitating transport out of the nucleus, these modified ends protect the transcript from

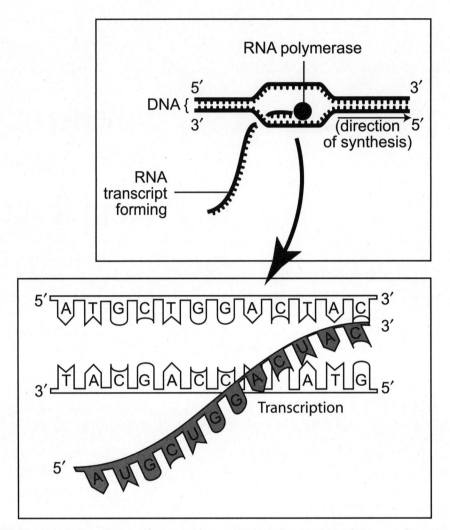

Figure 13-1. RNA transcription. Transcription is the rewriting of something from one language to another. In this case, the DNA code is rewritten into RNA. RNA polymerase unwinds the DNA at the gene to be transcribed and a RNA transcript is formed using the 3′ to 5′ strand of DNA as a template. Complementary RNA nucleotides associate with the exposed DNA base and are sequentially linked to form the single-stranded transcript.

enzymatic degradation. They also are involved with attaching the processed RNA to ribosomes in the cytoplasm.

A more complex form of processing occurs within the transcript itself. The primary RNA transcript is divided into two types of regions. **Exons** are regions of the RNA transcript that ultimately form a mRNA molecule. **Introns** are intervening regions between exons that must be excised from the transcript before it passes through the nuclear envelope into the cytoplasm. When an intron is excised from the primary transcript, exons on either side of it must be spliced together. This processing of cutting and splicing occurs in a special structure within the nucleus called a **spliceosome.**

RNA processing is unique to eukaryotic cells. It is an essential step in genetic control and allows the same segment of DNA to be used in different ways, depending upon which parts of the original transcript remain in the mRNA after processing.

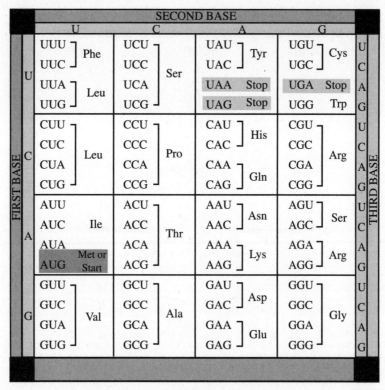

Figure 13-2. Genetic code. The genetic code is a triple of bases, the codon, that codes for a particular amino acid. The first base is indicated on the left-hand axis, the second base across the top, and the third base on the right hand axis. Most amino acids are coded for my more than one codon. A single codon, AUG, codes for methionine and is the start codon. Three codons, UAA, UAG, and UGA, are stop codons.

■ THE GENETIC CODE

As mentioned early in this section, it was originally believed that amino acids must contain the genetic code because there are only four different nucleotides in DNA, while proteins are composed of 20 different amino acids. If a single nucleotide were the code, only four amino acids could be coded for, 4^1. If a pair of nucleotides functioned as a code, a total of 16 different codes would be possible, 4^2. This is still not enough even to code for each amino acid. If the code consists of a triplet of bases, however, there would be 64 different combinations, 4^3. This is more than enough unique codes to account for every amino acid. The code does, indeed, consist of triplets of nucleotides known as **codons.**

There is built in redundancy in the system. Most amino acids are coded for by more than one codon. As a result, one or even two base mutations can have negligible effect on the protein produced. Methionine is exceptional in that it has a unique codon, AUG. This triplet also serves as the "start" codon, the equivalent of a capital letter in our language system. Three triplets serve as "stop" codons and do not code for any amino acid. These serve as punctuation marking the end of a code.

■ RNA TRANSLATION

Messenger RNA is translated into protein in the cytoplasm, but before this happens, two other types of RNA must be transcribed by the DNA. The first of these is ribosomal RNA (rRNA). Recall from Chapter 5 that ribosomes are composed to two subunits of rRNA, a large and a small subunit. These sub-

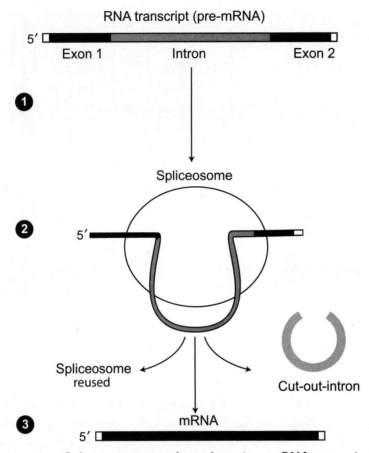

RNA transcript (pre-mRNA)

5′ Exon 1 Intron Exon 2

1

Spliceosome

2 5′

Spliceosome
reused Cut-out-intron

3 mRNA
5′

Figure 13-3. RNA processing. Spliceosomes attach to the primary RNA transcript in such a way that both boundaries of a particular intron are contacted, and the corresponding ends of adjacent exons are in proximity. DNA is cut at each exon-intron boundary, the exons are spliced together, and the intron is released.

units must be transcribed from DNA and transported to the cytoplasm to provide the ribosomes necessary for protein synthesis. Similarly, individual amino acids must be transported to the ribosomes and arranged in the correct sequence in order to construct a specific protein. A third type of RNA, transfer RNA (tRNA) is responsible for this task. They, too, must be transcribed from DNA and transported to the cytoplasm before protein synthesis can begin.

When mRNA moves to the cytoplasm, it attaches near its 5′ leading end to a small ribosomal subunit. The mRNA moves along the subunit until an AUG start codon is reached.

The AUG codon of the mRNA exposes hydrogen bonding sites that uniquely fit the complementary bases UAC on a tRNA. These happen to be the bases exposed on one end of the tRNA molecule attached to the amino acid methionine. UAC is the **anticodon** to the codon AUG. The association of tRNA to mRNA triggers attachment of the large ribosome subunit, and translation of the genetic code into a polypeptide is ready to begin.

The structural configuration of the complete ribosome defines three adjacent sites labeled E, P, and A. Each site can accommodate a single tRNA, with or without its attached amino acid. The first site accepts an incoming tRNA bearing its amino acid (A). At the second site, a peptide bond (P) links the amino acid to a growing polypeptide chain. As the peptide bond forms, the amino acid is released from its tRNA, which prepares to exit the ribosomal complex at the E-site.

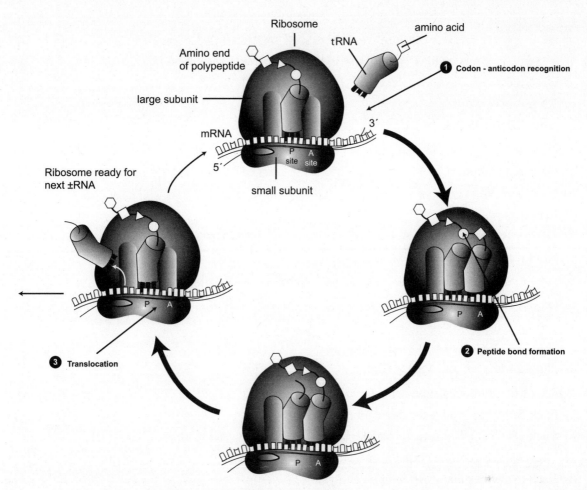

Figure 13-4. Protein synthesis. Messenger RNA associates with the small ribosomal unit so that the start codon is in place. This triggers attachment of the large ribosomal unit, leaving the UAC tRNA in the A-position. The ribosome shift along mRNA, moving the UAC-tRNA to the P-position and allowing the second t-RNA to attach in the A-position. The ribosome catalyzes formation of a peptide bond between the first two amino acids, and then shifts UAC-tRNA to the E-position where it is released. The second tRNA shifts to the P-position and a third tRNA enters the A-position. This sequence is repeated until a stop codon is reached.

The methionine tRNA attached to the mRNA by the codon/anticodon association, initially occupies the A-site on the ribosome. Methionine will be the first amino acid of the new polypeptide. The ribosome now moves along the mRNA in the 3′ direction and in doing so translocates the methionine-bearing tRNA to the P-site. This opens the A-site for the next t-RNA whose anticodon compliments the second codon. The large subunit catalyzes the formation of a peptide bond between the two adjacent amino acids. As a result, the original methionine is released from its tRNA, and the ribosome translocates both tRNAs and their complementary mRNA forward until the next codon is exposed. The original tRNA, now in the E-site, is released. The second tRNA occupies the P-site, where a second peptide bond will form with the third amino acid, now arriving at the A-site. This process is repeated until a stop codon is reached on the mRNA. At that point, the ribosome detaches from the mRNA and the newly formed polypeptide is released.

Test Yourself

1) This segment of nucleotides, AGACGAUGA, may represent a segment of
 a) DNA only.
 b) RNA only.
 c) either DNA or RNA.

2) Nucleotide base pairing is associated with
 a) DNA replication.
 b) tRNA-mRNA.
 c) transcription.
 d) DNA-mRNA.
 e) all of the above.

3) Which of the following is the correct sequence of largest to smallest?
 a) chromosome→gene→codon→exon
 b) chromosome→gene→exon→codon
 c) chromosom→exon→codon→gene
 d) chromosome→exon→gene→codon

4) Which of the following statements is true for DNA?
 a) Each DNA base codes for three amino acids.
 b) Each gene codes for three proteins.
 c) It takes three genes to code for one protein.
 d) Each triplet has many different meanings.
 e) Each amino acid in a protein is coded for by three bases in the DNA.

5) The tRNA that transfers the amino acid, valine, has the anticodon CAG. What is the mRNA codon?
 a) CAG
 b) GAC
 c) GTC
 d) TUG
 e) GUC

6) Noncoding regions of eukaryotic primary RNA transcripts that must be removed before translation are
 a) exons.
 b) introns.
 c) 5′ caps.
 d) poly-A tails.
 e) trailers.

7) Which of the following is (are) true for prokaryotes but not eukaryotes?

 a) After transcription, mRNA requires little or no modification.

 b) mRNA must become associated with a ribosome before it can be used to synthesize protein.

 c) tRNA is required to supply amino acids for the growing polypeptide.

 d) Translation can begin while transcription is still in progress.

 e) Both a and d are true.

8) Which of the following do pro- and eukaryotes have in common?

 a) double-stranded DNA

 b) introns

 c) spliceosomes

 d) exons

9) Transcription takes place

 a) on the cell membrane.

 b) in the rough E.R.

 c) in the cytoplasm.

 d) on free ribosomes.

 e) on the DNA.

10) The function of tRNA is to

 a) bring amino acids to the growing polypeptide chain.

 b) transcribe the genetic code on mRNA.

 c) provide a binding site for amino acids to join together.

 d) transfer the genetic code to DNA.

Test Yourself Answers

1) **b.** Uracil, U, is found only in RNA. The corresponding nucleotide found only in DNA is thymine, T. The nucleotides represented by G, A, and C are found in both DNA and RNA.

2) **e.** During DNA replication, the bases of the original strand pair with complementary bases of nucleotides forming the new strands. During protein synthesis, tRNA anticodons pair with mRNA codons. Transcription is the formation of a primary RNA transcript (either mRNA or its precursor) formed by pairing RNA nucleotide bases with the complementary strand of DNA.

3) **b.** A codon consists of only three bases, a small segment of a single exon of the primary RNA transcript. The complete RNA transcript complements a single gene on the chromosome.

4) **e.** The codon for an amino acid is a triplet of RNA bases, which complement a triplet of bases in the DNA.

5) **e.** GC and AU are the complementary bases of RNA; therefore, GUC must be the codon for CAG. A complementary DNA segment would be GTC.

6) **b.** Introns and the intervening segments between exons, the coding regions that are expressed. The introns must be removed and the sequential exons spliced together to form a mRNA. The 5′cap and poly-A tail must be attached to opposite ends of the mRNA for it to move out of the nucleus and attach to a ribosome in the cytoplasm.

7) **e.** Protein synthesis always occurs in a ribosome and requires tRNA to supply appropriate amino acids for protein synthesis. Eukaryotic cells require that the primary RNA transcript be processed in the nucleus to form a mRNA, which must then be transported to the cytoplasm before it can be translated into polypeptide. In prokaryotes, the primary transcript is mRNA, which can begin to function in translation as soon as it is produced because it is produced in the cytoplasm where ribosomes already are present.

8) **a.** All DNA is a double-stranded helix. Introns, exons, and spliceosomes are associated with primary RNA transcript processing and are, thus, found only in eukaryotes.

9) **e.** Transcription is the production of a strand of RNA from a DNA template. It occurs in all cells, even prokaryotic cells that lack E.R. Ribosomes in the cytoplasm are the site of translation of RNA into polypeptides.

10) **a.** The anticodon of tRNA associates with the codon of mRNA to ensure that the proper sequence of amino acids is formed. Each tRNA brings a specific amino acid to the site of polypeptide synthesis.

Genetic Engineering

Since the dawn of civilization, humans have tried to improve their lot by selectively breeding the plants and animals they use. The original approach was very simple; save your best seed or breed your best animals, and the likelihood was that many of their desirable characteristics would be passed on to their offspring. This was obviously a successful approach because it produced all of the domesticated species of agriculture.

Mendel's discovery of the genetic basis of inheritance promised a more efficient way to improve domesticated species and dominated agricultural efforts through most of the twentieth century. Genetic inheritance, after all, is the foundation of traditional breeding. An understanding of the mechanisms of genetic inheritance increases the probability that desirable combinations of genes can be produced. Our understanding of the genetic basis of many diseases also stimulated breakthroughs in diagnosis and medical treatment.

The past three decades have seen a shift in emphasis to understanding and manipulating the underlying molecular basis of genetics. The goals have not changed. Can we improved domesticated species? Can we improve human health? And can we do it more efficiently and predictably by going directly to the molecules involved?

■ DISCOVERING THE NATURAL TOOLKIT

As scientists learned more about the molecular nature of the gene and how its code is translated into molecules responsible for particular phenotypes, scientists began to realize that many of these molecular processes could be manipulated if we had the right tools. Furthermore, the tools were already invented by nature. We had only to find them and learn to use them. Several earlier discoveries now promised new significance.

Transformation

One of the earliest clues that the genetic material could be manipulated came from medical experiments in 1928. Frederick Griffith noticed that the bacterium responsible for causing pneumonia has two recognizably different strains.

The encapsulated form was lethal when injected into mice, but the non-encapsulated form was harmless. (It turns out that the presence of a capsule is a good predictor of pathogenicity.) Heat-killed encapsulated bacteria were also harmless when injected into mice. What would happen if the harmless non-encapsulated form and heat-killed encapsulated bacteria were both injected into the same mouse?

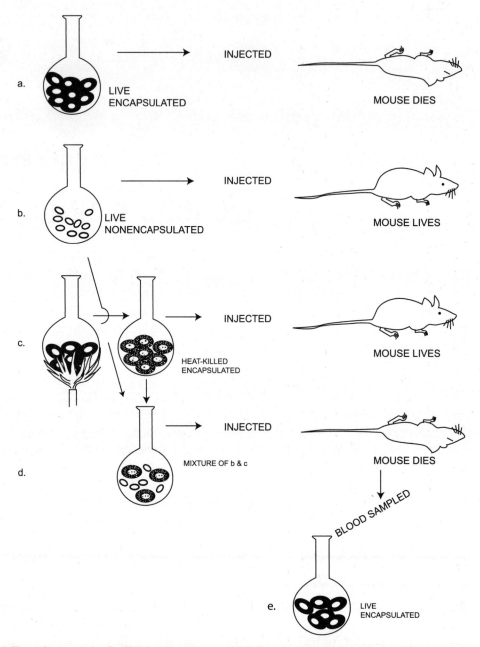

Figure 14-1. Transformation. Griffith's experiments with Streptococcus pneumoniae. ***Non-encapsulated bacteria can be transformed into encapsulated forms by dead encapsulated bacteria.***

Griffith expected that the mouse would be unharmed. After all, neither of the cells injected caused disease on their own. Not only did the mouse die, but living encapsulated bacteria also were recovered from this dead mouse.

Griffith concluded that genetic material from the heat-killed cells must somehow enter the harmless living cells and transform them into the capsulated pathogen. It is not necessary to have a living cell donate the genetic information. Some, but not all, bacteria are capable of undergoing transformation. However, by altering membrane permeability with chemical treatment or electrical shock, most cells can

be induced to incorporate foreign DNA from their environment, resulting in transformation of the host cell.

Conjugation

When microbiologists began to study bacteria with the electron microscope, they discovered that some cells of a species may form elongated extensions, called **pili,** that form a cytoplasmic bridge with non-pilated cells.

It was soon discovered that the ability to form pili was correlated with the presence of small rings of DNA separate from the larger ring of bacterial DNA. The small ring, which codes for the pili, is a **plasmid,** which confers a kind of bacterial fertility to the cell.

Plasmid containing cells are designated as F^+ because they have the fertility factor. Plasmid-less cells are F^-. Once pili form a cytoplasmic bridge between the two cells, the plasmid DNA undergoes replication to form an identical copy. The copy migrates across the pili into the F^- cell. If the duration of connection is long enough, the entire plasmid is transferred and the F^- cell becomes a F^+ cell. This one-way transfer of genetic information from the F^+ donor to the F^- receptor is sometimes referred to as bacterial sex.

Plasmids turn out to be useful vectors for carrying genetic information from one cell to another. Desirable genes or markers can be incorporated into the plasmid, which then acts as a carrier or vector to transfer that gene into a new host cell.

Transduction

In Chapter 12, we discussed the work of Hershey and Case using bacterial viruses, or **phage,** to determine the nature of the genetic material. A phage infection may lead to lysis of the host bacterium.

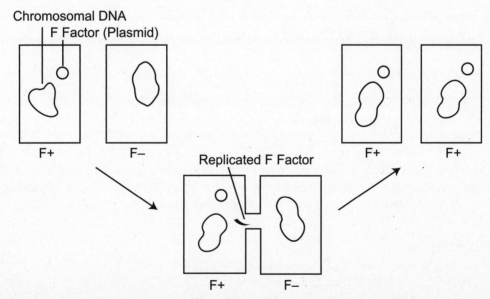

Figure 14-2. Conjugation. Conjugation between a plasmid-containing F^+ bacterium and an F^- bacterium. A cytoplasmic bridge extends from the F^+ cell and joins it to the F^- cell. The plasmid replicates, and once copied, migrates to the F^- cell. If the cells are in contact for a long enough period that the entire plasmid copy is transferred, the former F^- cell is converted into an F^+ cell.

Transduction

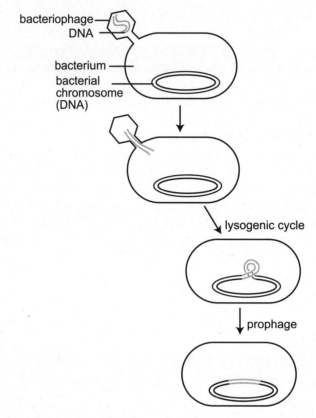

bacteriophage DNA

bacterium

bacterial chromosome (DNA)

lysogenic cycle

prophage

Figure 14-3. Transduction. Viral DNA is inserted into a host bacterial cell where it may incorporate into the host DNA. When this cells divides, the DNA, including that portion derived from the virus, replicates.

The viral DNA replicates repeatedly within the host cell. During this process, the bacterial host DNA is fragmented and new coat protein is synthesized.

In this way, a new generation of virus particles are produced within the host cell that eventually bursts, releasing the newly formed phage. Occasionally, segments of host DNA are incorporated into the viral DNA as a new phage particle is formed. When this phage infects a new bacterial host, the bacterial DNA segment it carries may be transferred to the new bacterial DNA, creating a **recombinant** cell. Recombinant DNA combines DNA from two or more original strands.

Restriction Enzymes

What do transformation, conjugation, and transduction have in common? In each case, foreign DNA is introduced into a bacterial cell, resulting in a genetic change. Bacteria have evolved a mechanism to resist this change by enzymatically attacking the foreign DNA. These enzymes are called **restriction** enzymes. Hundreds of naturally occurring restriction enzymes have been isolated and identified from different bacteria. Although each one is unique, they share a common mechanism.

The first restriction enzyme isolated from the bacterium *Eschericia coli* (*E. coli*) is called *Eco*RI. Restriction enzymes are named in sequential order (I, II, III, and so on), based on the species from which

Action of a restriction enzyme on DNA

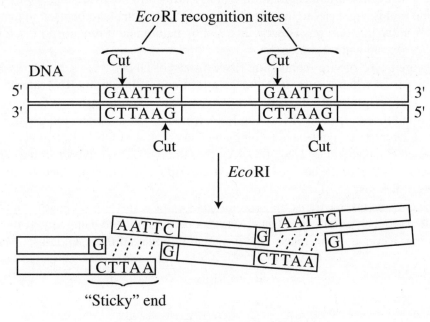

Restriction fragments of DNA

Figure 14-4. Restriction enzymes. The restriction enzyme EcoRI recognizes the specific palendromic sequence GAATTC; the sequence of bases on one strand is exactly the same as the sequence of complementary bases on the antiparallel strand. The enzyme then cuts between two specific bases on the opposing strands. For example, ecoRI cuts between the G and A on both strands, producing segments with identical "sticky ends."

it was isolated. Each restriction enzyme recognizes a specific **restriction site,** a segment of DNA where the sequence of bases, 5′ to 3′, on one strand is identical to the sequence of complementary bases on the antiparallel strand.

It is possible for more than one restriction enzyme to recognize a particular restriction site; however, each has a unique method of attack. For example, *RsrI* has the same recognition site as *Eco*RI , but only the latter cuts DNA in the restriction site between G and A at the beginning of the sequence. As a result, the original strand is cut into two fragments, each with a so-called **sticky end,** where the protruding bases on one strand complements the protruding bases of the other. The restriction enzyme recognizes and attacks every restriction site for that enzyme along the DNA. Thus, if a segment of foreign DNA contains the specific restriction site, the bacteria's restriction enzymes will inactivate it by cutting it into pieces. The bacterium protects itself by adding methyl groups to recognition site bases of its own DNA— a process called **methylation.**

If two segments of DNA are treated with the same restriction enzyme, each segment will be cut the same way at every recognition site along its length. Every piece will be terminated by identical sticky ends. Recall from Chapter 12 that DNA ligase joins segments of DNA. When DNA ligase is added to fragmented DNA, the sticky ends are joined back together. Which segment attaches to which is a matter of chance. If the two original segments were each cut into two pieces, there is a fifty-fifty chance that ligation will rejoin the original segments of form a recombination between the two.

Retroviruses

For most genetic engineering techniques, the tools outlined in the preceding section are sufficient. But one additional tool is necessary to be able to design DNA segments to be used in genetic engineering. As with other tools, this one was already invented by nature and it remained only for biologists to identify and isolate it from natural sources.

Retroviruses are a type of virus containing RNA instead of DNA.

HIV is a retrovirus. When a retrovirus attacks a host cell, it inserts its RNA along with a special enzyme, **reverse transcriptase.** As its name suggests, reverse transcriptase functions by reversing the normal transcription process. Instead of forming RNA from a DNA template, reverse transcriptase uses the viral RNA as a template to synthesize a complementary strand of DNA. It then catalyzes formation of a double-stranded complementary DNA (cDNA) from the RNA/DNA hybrid strand. The new cDNA is incorporated into the DNA of the host cell. Normal transcription will now produce virally coded mRNA as well as mRNA of the host.

By using the enzyme reverse transcriptase, biologists can use mRNA to construct a cDNA segment that directly codes for a particular gene. The cDNA can be manipulated using any of the techniques of genetic engineering. Reverse transcriptase also has another potential therapeutic use. Many hereditary

Retro Virus

Figure 14-5. Retrovirus. The genetic material of retroviruses consists of a single-stranded RNA instead of a double-stranded DNA. The RNA inserts into the cytoplasm, where the enzyme reverse transcriptase synthesizes a single complementary DNA strand to produce a hybrid DNA/RNA complex. The enzyme then catalyzes a replication-like reaction to produce a new double-stranded cDNA segment, which can incorporate into the host DNA.

diseases are due to the lack of a particular gene and, thus, its gene product. By inserting mRNA for the gene of concern into a retrovirus, it may be possible to use insert a cDNA segment for the deficient gene into DNA of the host cell. As a result, the deficient gene product will now be produced.

■ OTHER USEFUL TOOLS

In addition to the naturally occurring enzymes that are essential for genetic engineering, two other laboratory techniques had to be developed before routine work in molecular genetics was possible. One technique was an elaboration of a procedure already developed for identifying proteins. The others provide novel ways to mass produce segments of DNA.

Gene Cloning

Cloning is a method of making identical copies of a gene. The original method of **gene cloning** used several of the tools outlined earlier in this chapter.

The gene of interest and a bacterial plasmid are both cut with the same restriction enzyme so that they have the same sticky ends. The two are mixed, along with ligase enzyme. As a result of this process, any two sticky ends may join but only those in which the selected gene is incorporated into a reformed plasmid is useful. The transformed plasmid is then reintroduced into a bacterial cell. Every time the bacterium divides it replicates its DNA, including that of the plasmid. With each replication cycle, the number of copies of the gene of interest is doubled.

Polymerase Chain Reaction

The **polymerase chain reaction** (PCR) is a more rapid and specific technique developed in the late 1980s that uses only enzymes, not living bacteria. A key discovery was a form of DNA polymerase from hot springs bacteria that remain functional after exposure to high temperature. To initiate the process, the DNA of interest is heated to separate the antiparallel strands.

After cooling, a short segment of DNA primer, complementary to each end of the sequence to be cloned is added, along with DNA polymerase. A primer is necessary because the enzyme can only add nucleotides to the 3′end of an existing strand. Polymerase proceeds to replicate both strands of the original DNA.

When replication is completed, the mixture is reheated, both DNA segments separate into their constituent strands, and the process is repeated. Each time a PCR cycle is completed, the number of copies of the DNA sample doubles. Consequently, small amounts of DNA can be rapidly cloned to be further processed. This is especially important when only small amounts are initially available, such as cDNA, DNA from early stages of infection, or when little tissue is available from which DNA can be extracted.

Gel Electrophoresis

Electrophoresis is a process that separates molecules based on their size.

DNA samples, treated with restriction enzymes, are placed in wells on one end of a semisolid carrier gel and an electric current is applied from one end to the other. DNA segments in each well migrate down the gel in response to the applied current. The smaller the segment, the farther it will migrate. An organisms DNA, when treated with a specific restriction enzyme, will produce a specific migration pattern—its genetic fingerprint.

Gel electrophoresis also can be used to determine the nucleotide sequence of DNA. A batch of DNA is divided into four tubes and careful heated to separate the two double strands. A small sample of a special dideoxynucleotide (ddn) is added to each tube along with excess nucleotides and DNA polymerase. Dideoxynucleotide competes with a normal nucleotide during DNA replication. If ddn is added to the

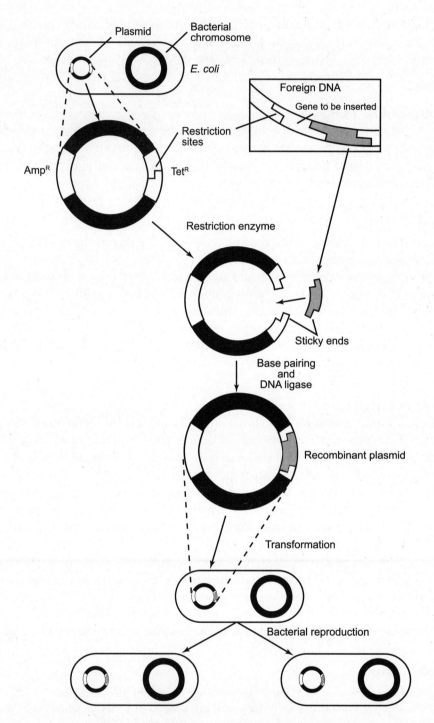

Bacterial clone carrying many copies of the foreign gene

Figure 14-6. Gene cloning. A gene of interest and a bacterial DNA molecule are both cut with the same restriction enzyme, and then mixed together with ligase to reanneal the DNA. At least some segments will combine to form a bacterial chromosomal ring containing the desired gene. Every time this engineered bacterium divides, the desired gene will also be replicated.

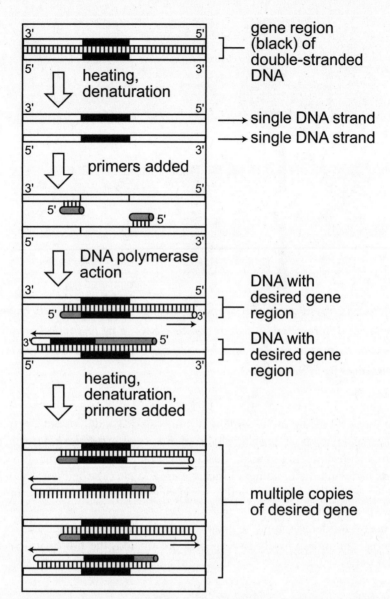

Figure 14-7. Polymerase Chain Reaction (PCR). Polymerase Chain Reaction (PCR) produces multiple clones of a DNA segment using heat and chemicals, not bacteria. The DNA of interest is heated to separate the strands, and a primer segment and a special heat-resistant DNA polymerase is added to initiate replication. Each strand replicates to form two identical segments of DNA. These are then both reheated to begin the process anew. The cycle is repeated until sufficient DNA is obtained.

growing DNA chain, further replication is blocked. For example, in one tube, dideoxyadenine (ddA) is added in small amounts. When the first T is reached on a template strand, A will be the complement, and replication continues. On a few strands, however, ddA will be added, and replication of that strand stops. A few more strands will be stopped at the next T, a few more after that, and so on, until the entire length of at least some DNA has been replicated. That tube will now contain a variety of segments of different length, each terminated by a ddA that corresponds to where the complementary T occurred in the template strand.

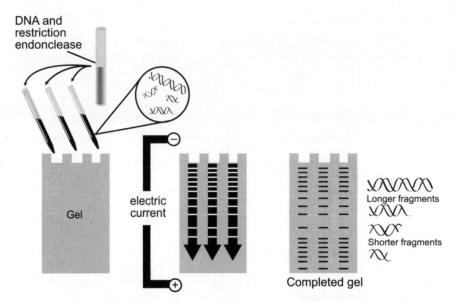

Figure 14-8. Electrophoresis. A semisolid gel is prepared through which an electric current can be passed. Prepared DNA samples of different length (often due to cleavage by restriction enzymes) added to one end of the gel migrate as current is applied. Smaller molecules migrate farther than larger ones, forming bands at different distances from the source.

The three other tubes are set up in the same way, but with ddT, ddG, or ddC, respectively. A sample from each tube is put into adjacent wells on an electrophoresis gel. After the gel is run, the bases are read from the longest run (smallest piece) to the shortest (largest piece). For example, if a G band ran the farthest, the T band was next, and the three next longest were Cs, etc., the sequence would be GTCCC.... Originally, the gels were read by hand but today, sequences are automatically scanned, digitized, and uploaded to computers.

Sequencing is useful for determining the genetic code for particular genes and for determining evolutionary relationships. The more closely two species are related, the more similar will be their base sequences for similar genes.

■ TRANSGENIC ORGANISMS

For several years, scientists have been successful in producing a number of transgenic plants, particularly of economic crops such as rice, soybeans, and corn. Frequently, this involved inserting a gene for herbicide resistance so that herbicide can be sprayed on the crop field without damage to the crop. Researchers have also been successful at incorporating genes for improved nutritional quality of a crop, such as increased iron and vitamin B in rice.

The first step is to prepare cell cultures of the host plant. An already established plant containing many previously selected desirable characteristics is chosen as the host. Individual cells of this plant are cultured in sterile growth medium using standard tissue culture techniques. Meanwhile, the gene of interest is cloned into a viral or bacterial vector.

The vector is inoculated into the plant cell culture medium, and at least some cells take up the vector DNA and incorporate it into a plant chromosome. If the gene is for herbicide resistance, the cell culture is exposed to concentrations of the herbicide, and most cells will be killed. Only transgenic cells that have incorporated the resistance gene into their DNA will survive. For other traits, an additional marker

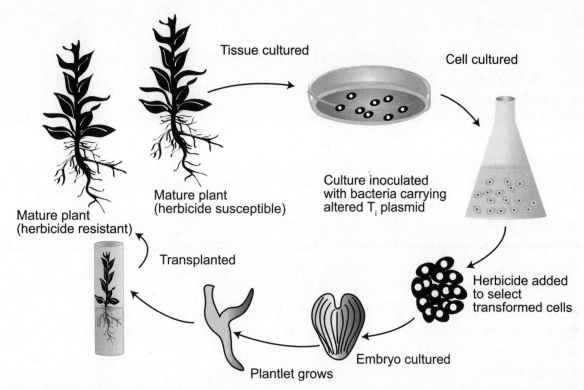

Figure 14-9. Transgenic organisms. Host plant cells are established in tissue culture to which genetically modified bacteria are added. The bacteria carry the gene of interest inserted in a plasmid. Bacteria invade host cells, and some of the plasmid DNA is successfully incorporated into host cell DNA. The genetically modified cells are grown to the embryo stage, transplanted to differentiation medium, and eventually, transplanted to soil.

is included in the vector DNA segment that can be used to determine whether the vector DNA was incorporated into a host chromosome.

Transgenic cells are then moved to culture medium that supports growth and differentiation to produce a transgenic embryo. The embryo may need to be transferred to a new medium to promote vegetative growth of the transgenic plant. Once it is large enough, the plantlet is transplanted to soil medium and may be grown as a normal plant. The only difference is that it contains a segment of introduced DNA from another organism.

Test Yourself

1) Normal human genes may soon be introduced into patients who have defective genes by using
 a) bacteriophage.
 b) cauliflower mosaic viruses.
 c) tobacco mosaic viruses.
 d) retroviruses.
 e) smallpox viruses.

2) *Eco*R1 and *Hind*III are two different restriction enzymes. If the DNAs of different organisms are cut as described below, which DNAs could *not* be spliced together?
 a) human DNA cut with *Eco*R1/chimp DNA cut with *Eco*R1
 b) prokaryotic DNA cut with *Hind*III/eukaryotic DNA cut with *Hind*III
 c) mouse liver DNA cut with *Eco*R1/mouse kidney DNA cut with *Eco*R1
 d) mouse DNA cut with *Hind*III/chimp DNA cut with *Hind*III
 e) bacterial DNA cut with *Eco*R1/mouse DNA cut with *Hind*III

3) RNA viruses that integrate their genetic information into the chromosome of a host must first use _____ to convert RNA to DNA.
 a) ATP synthase
 b) RNA polymerase
 c) DNA polymerase
 d) reverse transcriptase
 e) none of the above

4) In recombinant methods, the term *vector* refers to
 a) the enzyme that cuts DNA into restriction fragments.
 b) the sticky ends of a DNA fragment.
 c) a RFLP marker.
 d) a plasmid or other agent used to transfer DNA into a living cell.
 e) a DNA probe used to locate a particular gene.

5) A restriction enzyme will cut bacterial DNA as diagrammed below. If the same enzyme is added to a test tube containing cockroach DNA, how will the latter be cut?
 a) c \c u a g g
 g g t u c\ c
 b) c \c t a g g
 g g a t c\ c
 c) c c t t g/ g
 g/ g t t c c
 d) c\ c t t g g
 g g u u c \c
 e) either a, b, or c

6) DNA used in recombinant DNA techniques is first cut into fragments by

 a) enzymes called ligases.

 b) restriction enzymes.

 c) treatment with DNA polymerase.

 d) treatment with a strong acid or base.

 e) X-rays.

7) Rejoining DNA fragments from two organisms is best known as

 a) gene sequencing.

 b) mapping genes.

 c) recombinant DNA technology.

 d) conjugating DNA.

8) A mRNA message is AUGCCCGGGUUU. Which sequence below would be the corresponding cDNA?

 a) AUGCCCGGGUUU

 b) ATGCCCGGGTTT

 c) CTCGGGCCCTTT

 d) TACGGGCCCTTT

 e) UACGGGCCCAAA

9) DNA is extracted from the pathogenic S strain of *Diplococcus pneumoniae,* mixed with living cells of the non-pathogenic R strain, and this mixture is injected into mice. What will happen?

 a) The mice will die, and the bacteria taken from the dead mice will look like the S strain.

 b) The mice will die, and the bacteria taken from the dead mice will look like the R strain.

 c) The mice will live, and any surviving bacteria will look like the S strain.

 d) The mice will live, and any surviving bacteria will look like the R strain.

10) The AIDS virus uses which of the following to read RNA and synthesize the corresponding DNA?

 a) transcription

 b) reverse transcription

 c) translation

 d) reverse translation

Test Yourself Answers

1) **d.** Of the viruses listed, only retroviruses and smallpox viruses attack animal cells, including humans. Retroviruses have the ability to convert RNA into DNA. mRNA for the normal gene product can be used to synthesize a cDNA gene for that product. Inserting the engineered cDNA into a defective host cell will enable it to produce the missing gene product.

2) **e.** The DNA source is irrelevant to restriction enzymes. Any DNA cut with the same restriction enzyme will produce multiple segments with the same sticky ends, which could be reannealed.

3) **d.** Reverse transcriptase reverses the normal process of DNA coding for an RNA sequence using RNA polymerase. Rather, it transcribed RNA into cDNA. DNA polymerase is used in replication, while ATP synthase converts ADP to ATP.

4) **d.** A vector carries something from one organism to another. In genetic engineering, plasmids are commonly used vectors for transferring DNA from one organism to another. Restriction enzymes cut DNA in a way that may form "sticky ends." Markers and probes are used to locate specific regions of DNA because of complementary base pairing.

5) **b.** For the same restriction enzyme to cut DNA from two different sources, both must have exactly the same recognition site and the cut will be made in exactly the same location.

6) **b.** Restriction enzymes cut DNA into as many segments as there are recognition sites—plus one. Ligases are used to splice segments back together. DNA polymerase is used to catalyze DNA replication. Strong acids or bases, or X-rays will disrupt bonds along the length of the DNA.

7) **c.** Combining DNA from two or more sources is recombination. Gene sequencing determines the sequences of bases that code for a gene. Mapping genes locates their position on a chromosome. Conjugation is a form of bacterial "sex" with a one-way transfer of DNA from one bacterium to another.

8) **d.** The sequence of bases in cDNA must be the complementary to the mRNA template, including substitution of T as the complement of A.

9) **a.** S strain DNA will transform the R strain bacteria into the pathogenic form, which will then kill the mice. Bacteria isolated from the mice will be the transformed type.

10) **b.** The AIDS virus, HIV, is a retrovirus that uses reverse transcriptase to synthesize DNA from an RNA template.

Genes and Development

Every cell of an organism contains a complete set of the hereditary information for that organism, yet only a few genes, so called **constitutive** genes, are active at all times. The activity of most genes is regulated and in multicellular organisms, only certain genes are expressed in a particular cell. Even in unicellular organisms, not all genes are expressed simultaneously. The external environment and the cell itself have roles in controlling when and where gene expression occurs. Development is controlled by controlling gene expression.

The preceding chapters have described a variety of molecular processes involved in replicating and expressing the genetic information. Virtually every one of these steps presents a control point for development.

■ TRANSCRIPTIONAL REGULATION

The terms *turning on* and *turning off* a gene refer to transcriptional control mechanisms. Transcription is the most common point of control for all organisms, usually in response to external signals.

Chromosomal Changes

Recall from Chapter 9 that during prophase, the chromosomal material begins to condense by coiling the DNA strand. The first level of coiling is associated with histone proteins called nucleosomes. Even during interphase, most of the DNA is in a partial form of contraction looped around nucleosomes or even higher orders of association. Genes within such loops are not accessible to RNA polymerase and, thus, cannot produce RNA transcripts. These genes are turned off.

Two mechanisms are known to affect the histone/DNA association. Each histone molecule has an elongated tail region that extends out from the loop. These tails can be chemically modified to be either charged or neutral. When charged, the nucleosomes clump together; when neutral, they slip apart. DNA within clumps or associated with a nucleosome cannot be transcribed, so that gene is turned off.

Segments of DNA also can be modified. A methyl group can be added to certain bases, usually cytosine, which inhibits transcription. Degree of methylation, thus, regulates transcription; heavily methylated genes are turned off. Demethylation permits transcription to occur, and the gene may be turned on.

Control Points for Gene Regulation

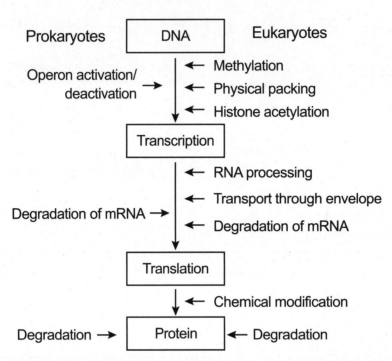

Figure 15-1. *Control points for regulating gene expression. In both prokaryotes and eukaryotes, primary gene regulation is pretranscriptional. Post transcriptional control is more elaborate in eukaryotic cells and is primarily associated with processing the primary RNA transcript.*

Control of Initiation

The earliest form of gene regulation recognized involved the enzymes required for lactose digestion by the bacterium *E. coli*. Genes for enzymes involved in metabolic pathways are often packaged together on a chromosome in a region called an **operon.**

In addition to the three enzymes required for lactose digestion, the *lac* operon consists of a promoter region containing an operator. The *lac* operon is a system of inducible enzymes. In the absence of lactose, no enzyme is present. With lactose present, the genes are induced to produce the necessary enzymes for digestion to occur.

Outside of the operon is a regulatory gene, *lac*1, that codes for a repressor protein. In the absence of lactose, the repressor binds to the operator site and prevents transcription of any of the genes of the operon. This is the usual condition of the cell, and the genes are turned off. When lactose is present, it binds with the repressor, causing it to change shape and release from the operator. RNA polymerase can now transcribe the sequence of genes necessary to produce the enzymes that digest lactose. This is an example of an inducible operon because the presence of a particular chemical causes the genes of the operon to be turned on.

An alternative type of operon works on the opposite principle. Instead of turning a gene on by inducing transcription, it turns a gene off by repressing transcription. The *trp* operon is an example of such a repressor. The *trp* operon consists of an operator and a series of genes required to synthesize the essential amino acid tryptophan.

The *trp* operon also has a promoter outside of the codon that codes for a repressor protein. In this case, however, the promoter is inactive and does not bind to the operator gene. As a result, in the normal

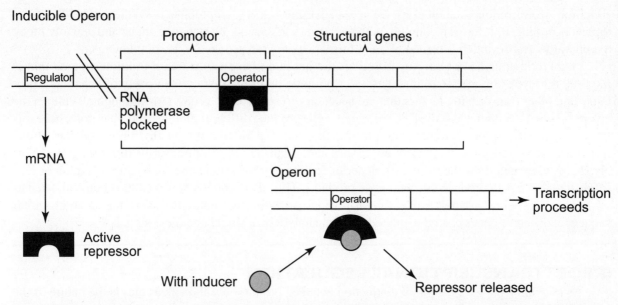

Figure 15-2. Inducible operon. *An operon consists of a series of structural genes preceded by a promoter region, which includes an operator segment. A promoter region of DNA on another part of the chromosome codes for repressor protein that may interact with the operator. With inducible enzymes, the repressor is normally associated with the operator, preventing transcription. An inducer molecule associates with the repressor, causing it to change shape and release from the operator. At this point, transcript can begin.*

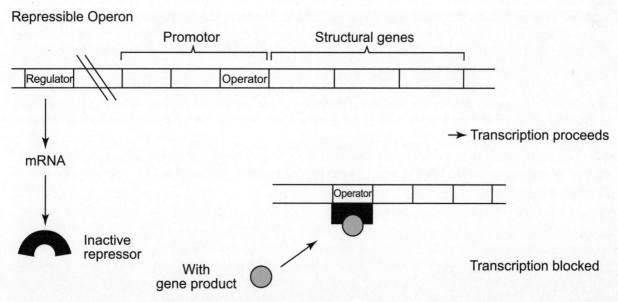

Figure 15-3. Repressible operon. *With repressible enzymes, the repressor does not normally associate with the operator and transcription proceeds. The gene produced may associate with the repressor, activating it and causing it to bind to the operator, thereby shutting down further transcription.*

condition, transcription is not blocked, the genes are turned on, and tryptophan is synthesized. When tryptophan is produced, it forms a complex with the repressor, causing it to change shape and actively block the operator. Transcription is turned off, and further tryptophan production is shut down.

Eukaryotic cells do not have operons, but the genes do have an upstream promoter region that is required for RNA polymerase to initiate transcription. In addition, there are a variety of enhancers, proteins, and other transcription factors that are necessary to activate the promoter. Although all cells in the eukaryotic body contain the same DNA, different cells produce different proteins and, therefore, have different sets of enhancers and transcription factors that can respond to different environmental cues at different times. As a result, cells in different tissues and organs necessarily transcribe different genes. This also helps to explain how the same cell, under different environmental conditions, might turn on or turn off different genes to produce different gene products. This also explains how a single chemical, such as a hormone, can elicit a number of different responses in different cells. By using the same promoter sequence, different genes can be regulated simultaneously by a single chemical signal.

■ POSTTRANSCRIPTIONAL REGULATION

As noted in Chapter 13, a major distinction between prokaryotes and eukaryotes is the nature of the primary RNA transcript. In prokaryotes, mRNA is produced directly. In eukaryotes, the transcript consists of a series of exons and introns that must be processed to produce the functional mRNA. This posttranscriptional processing is a second major control point in regulating gene function.

The same primary RNA transcript can produce multiple different mRNAs, depending on which exons are spliced together. The difference of a single exon being spliced into the mRNA or not will affect the polypeptide that is ultimately produced.

Once mRNA is synthesized and moved to the cytoplasm, it can still be regulated by controlling degradation. The lifetime of a particular mRNA may vary from minutes to weeks, depending on how quickly enzymes are produced to degrade the mRNA.

Another form of regulation is to control attachment of mRNA to the ribosome. In Chapter 13, we described the 5′cap and poly-A tail on a mRNA that is necessary for transport across the nuclear envelope. We also mentioned that these regions are necessary for attachment to the small subunit of the ribosome. If the cap is covered or there are too few adenines in the tail, the mRNA cannot attach and translation will not occur. Various cytoplasmic proteins can block the 5′cap and, in some cases, additional A-units must be added to the tail in the cytoplasm.

Finally, the gene products themselves may be modified or degraded after translation occurs on the ribosome. Polypeptides may be cleaved in various ways or chemically modified, such as by methylation, to produce different results. The lifetime of the gene product will also depend on the subsequent production of degradation enzymes.

The genetic control of cellular differentiation is a complex field that is only beginning to be elucidated. But application of the tools of genetic engineering promise that rapid advancements in our understanding will continue to be made.

Test Yourself

1) Which of the following do eukaryotic and prokaryotic cells have in common?

 a) double-stranded DNA

 b) nucleosomes

 c) introns

 d) operons

2) A bacterial gene that is normally turned off is called

 a) inducible.

 b) constitutive.

 c) repressible.

 d) polycistronic.

 e) facultative.

3) An operon contains

 a) an operator.

 b) a promoter.

 c) structural genes.

 d) regulatory genes.

 e) a, b, and c.

4) Your muscle cells and nerve cells contain the same DNA, yet they are different because

 a) they express different genes.

 b) they contain different genes.

 c) they use different genetic codes.

 d) they have unique ribosomes.

 e) they have different chromosomes.

5) Gene expression is controlled by

 a) control sites built in the DNA.

 b) regulatory proteins.

 c) enzymes.

 d) hormones.

 e) All of the above may have control functions.

6) In bacteria, (prokaryotes) _____ have the most important roles in the negative control of transcription.

 a) repressor proteins

 b) activator proteins

 c) RNA polymerase

 d) DNA polymerase

 e) hormones

7) The lactose operon (*lac* operon) in the bacterium *E. coli* is turned on in the presence of
 a) glucose.
 b) lactose.
 c) sucrose.
 d) none of the above.

8) You have inserted the gene for human growth factor into the *E. coli* lactose operon, replacing the structural genes with the gene for human growth factor. What substance must you add to your culture of bacteria to cause them to produce human growth factor for you?
 a) repressor protein
 b) operator protein
 c) human growth factor
 d) lactose

9) Pretranscriptional control of gene expression would include
 a) acetylation of polypeptide gene product on the ribosomes.
 b) degradation of mRNA.
 c) splicing of exons from primary RNA transcript.
 d) methylation of DNA.
 e) cleavage of polypeptide gene products.

10) At which of the following control points could environmental factors have an impact on gene regulation?
 a) histone acetylation
 b) derepression of a repressor protein
 c) activation of a repressor protein
 d) activation of enhancer elements
 e) all of the above

Test Yourself Answers

1) **a.** All organisms contain double-stranded DNA. Nucleosomes and introns are characteristic of eukaryotic DNA and primary transcript RNA, respectively. Operons are characteristic genetic control mechanisms of prokaryotic cells.

2) **a.** An inducible operon produces an active repressor that binds to the operator preventing transcription. Presence of an inducer molecule will inactivate the repressor, causing it to release from the repressor and permit RNA synthesis. Constituitive genes are always turned on, and repressible genes are normally on until they are turned off by a repressor.

3) **e.** Operons contain one or more structural genes and a promoter region containing an operator. The regulator gene is outside of the operon.

4) **a.** Although all somatic cells (non-gametes) of your body contain the same DNA on identical chromosomes, different genes are expressed in cells of different tissues. The genetic code is the same for all organisms, and all ribosomes are basically alike.

5) **e.** Enzymes and hormones may interact with regulatory proteins to provide pretranscriptional control of eukaryotic cells. A variety of promoters, enhancers, and other control elements are built into the DNA of eukaryotic cells.

6) **a.** Repressors provide negative control by binding to the operator and turning off transcription of an operon under usual conditions.

7) **b.** Lactose is the substrate that inactivates the repressor by binding to it. As the repressor's shape changes, it is released from the operator permitting RNA polymerase to transcribe the structural genes of the operon.

8) **d.** To deactivate the *lac* operon repressor, you must add lactose. Once repression is released, RNA polymerase can transcribe the downstream structural genes—in this case, the genes for human growth factor.

9) **d.** Pretranscriptional control must involve the DNA before RNA synthesis occurs. Methylation of DNA nucleotides prevents transcription from occurring.

10) **e.** Environmental factors can impact each of the control points of gene regulation.

Populations

Most of us have a general understanding of the term *population,* particularly with humans. For an ecologist, population has a more specific definition. A **population** is all the individuals of a particular species living in a defined area. When studying populations, we must define both the species of interest and the area concerned.

■ HUMAN POPULATION GROWTH

On 28 September, 2005, at 18:39 Greenwich Mean Time (1:39 p.m. Eastern Time), the world population was 6,469,365,409 according to the U.S. Census Bureau. (You might want to check www.census.gov to see what the current estimate is at the time you read this.) What does this mean? Did the Census Bureau really have an estimate accurate to within 9 people? The number it reported implies 9 **significant figures.** It is only the last digit, 9, that is not significant—it could be anywhere between 0 and 10, although it is probably closer to 10.

What might make you think that this is not an accurate estimate? For example, in the United States, arguably the most advanced country on earth, how do we estimate our population? If you said we take a census every ten years, you'd be right. But how is it done? The Census Bureau sends out a census form to every household in the country with an address. What happens if you don't return the form? What happens if you're homeless and don't have an address? What happens if an elderly couple dies the day after they return their form? What about the young couple that has their first babies (triplets) a week after they returned their form? If there is some uncertainty in our census data, how accurate do you think our estimate is for the world? 6.47 billion (6,470,000,000) is a better estimate. We're sure of that number within 10 million!

■ EXPONENTIAL GROWTH

Human population during historic time is represented in Figure 16-1.

At first glance, it appears that the growth of the human population can be divided into three stages. Until about 1,000 years ago, growth increased very slowly. Then, for about 800 years, growth seems to have gradually increased, only to have taken off during the past 100 to 200 years. In fact, this J-shaped pattern is best described by a simple equation in which the rate of growth is constant, $G = rN$, where G is the growth incurred, r is the growth rate, and N is the initial population size. This equation, sometimes called the compound interest law, describes **exponential growth.**

Figure 16-1. Human population growth since the dawn of civilization. Estimated human population, in billions, from B.C. 14,000 through the present.

To understand how it works, think of a savings account. Suppose you have one dollar to invest at 10 percent annual interest. At the end of the first year, the interest earned, *G*, will be 10 percent × $1.00 = $0.10. This gets added to your initial investment, so *N* for year two is $1.10. The second year, you earn $0.11, which is added to $1.10 to become *N* for year three, and so on. When *N* is small, the change from year to year is also small and may seem trivial. But eventually, *N* becomes larger and as it does so, the increment earned per year becomes substantial. What would be the interest earned on $1 million at this rate?

Exponential growth is typical of all organisms that begin with a small population and have adequate resources. What factors affect the rate of growth, *r?* Ultimately it comes down to two things. For a given population, what are the number of births per unit time (the birth rate) and the number of deaths per unit time (the death rate). For a given population, the birth rate *(b)* – the death rate *(m)* = **intrinsic rate of growth** *(r),* assuming there is no migration into (that is, immigration) or out of (that is, emigration) the area of study.

■ LOGISTIC GROWTH

Figure 16-2 shows a portion of the data from Figure 16-1, but at a different scale. What seems to be happening to population growth in the past decade? What might be responsible for the apparent slow down? Consider a more limited population, perhaps your home state. Within these limits (no imports or exports, no immigration or emigration), are there any factors that might limit increased population growth? Of course there are a variety of factors directly related to population size that eventually may limit growth. Competition for resources increases as more people depend on finite food, water, space, and so on. Health problems increase with accumulation of wastes, toxins, and simply closer contact among

Human Population

Figure 16-2. Human population growth since 1650. Expansion of the data from Figure 16-1. The dotted line and open circle represent exponential growth projection of earlier data. The double open circle to right of line indicates 2005 estimate of 6.4 \times 10^9.

individuals that increases the probability of disease transmission. Territoriality and aggressive behavior become more severe as population density increases, and so on. Such **density dependent** factors automatically increase proportional to population size.

Virtually all populations that have been examined experimentally follow a growth curve similar to that in Figure 16-3.

This S-shaped curve describes **logistic growth.** Initially, the increase appears exponential, but as population size increases, it begins to slow and eventually levels off. This later slowdown is due to the effect of density-dependent factors that eventually limit population size at a maximum sustainable level, the **carrying capacity.** The formula for logistic growth is $G = rN[(K - N) \div K]$. Note that the first part of the equation is the equation for exponential growth. The difference is the addition of the factor $[(K - N) \div K]$. K is the carrying capacity for the population, and N is still the current size of the population. What is the value of $[(K - N) \div K]$ if N is very small compared to K? For example, if N is 10 and K is 1 million (10^6), the factor is approximately 1 (999,990 \div 1,000,000). The formula approximates exponential growth. If N is very large, however, only a small fraction of exponential growth occurs. For example,

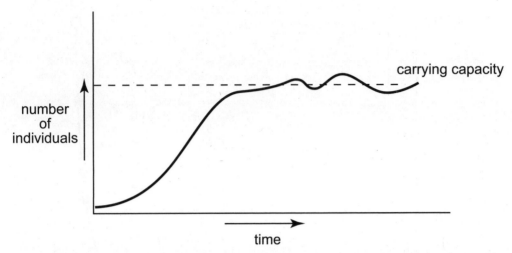

Figure 16-3. Logistic growth. The S-shaped curve of logistic growth slows as it approaches the carrying capacity.

if the population size in the preceding example was already 999,990, the factor becomes $10 \div 1,000,000 = 0.00001$, so $G = rN(0.00001)$, and that's approximately 0.

■ PATTERNS OF POPULATION GROWTH

When the growth of populations is examined, a number of patterns emerge that are useful not only in describing the growth, but also in being able to make predictions about the future of that population and the kinds of interactions it might have with other populations. Some of the more useful patterns are described in the following sections.

Survivorship Curves

Individuals have a finite life span that may last from minutes to decades, depending on the species. But there is a maximum age typical for any species. One way to compare species is to standardize life-span by converting the survivorship of an individual to its percent of the maximum. For example, if the maximum lifespan for a species was 100 years, and one individual lived to be 80, its lifespan would be 80 percent. Figure 16-4 illustrates the range of survivorship patterns that occur in different populations.

Consider the human population of the United States, where the average lifespan for both men and women is in the 70s. Of 1,000 children born, most survive into adulthood and, on average, live into their 70s. Mortality then picks up rapidly. Humans have a Type I survivorship curve. On the other hand, consider a maple or an ash tree. A single tree can produce thousands of seeds per year over a lifespan of a century or more. Some, but not many, of the seeds will germinate, but most will be eaten or will land in a poor location for growth. Few will, themselves, become a mature old tree. This is an example of a Type III curve.

Life History Traits

The survivorship examples in the preceding section also serve to illustrate several of a suite of characters that define basic life history patterns. Some species reproduce prolifically with many offspring produced each generation. Individuals often begin reproducing at a young age and do so throughout their

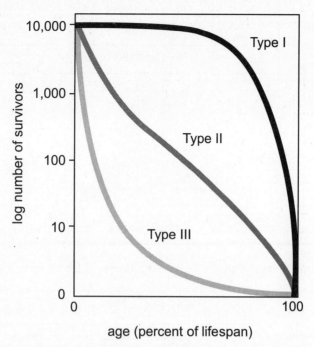

Figure 16-4. Survivorship curves. Survivorship curves plot the number of survivors logarithmically on the y-axis against age as a percent of the maximum lifespan. In a Type I curve, most individuals born survive into middle to late age when mortality increases rapidly. In Type II, the mortality rate is essentially constant at all ages. In Type III, there is high mortality shortly after birth, but individuals who manage to live to middle age tend to live into old age.

lifespan, which is usually quite short. Individuals tend to be small. Species exhibiting many or all of these traits are called **r-selected.** Their life history tends to maximize r, the intrinsic growth rate, and they tend to occur in environments well below carrying capacity for that species.

Other organisms follow a different strategy. They frequently have few offspring, one or two at a time and at infrequent intervals. It may take a decade or more before an individual even reaches reproductive maturity. Individuals tend to be large and long-lived. Such populations are termed **K-selected** because they tend to maximize traits that are advantageous when a population is at or near carrying capacity. (Recall that K is the carrying capacity for the population.)

Age Structure

When considering growth of the human population, it is useful to break down the total population by gender and age class. Such a representation is an age-structure analysis, which is shown in Figure 16-5.

By convention, the male population is represented on the left side of the graph and females on the right with the distance from 0 indicating population size. Age is represented on the *y*-axis in equal-sized increments or cohorts.

Note that each of the curves is approximately symmetrical, but there are some biologically interesting trends. Look in the youngest age cohort. It's true that more males than females are born, and we're not sure why. At the other end, it is also true that more women than men live into old age. Again, we are not sure of the biological basis for this.

Population Pyramids for Nigeria 1.29 x 10^8

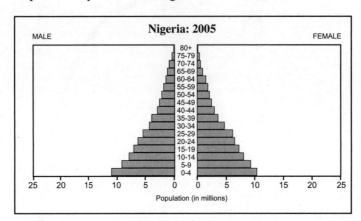

Population Pyramids for United States 2.96 x 10^8

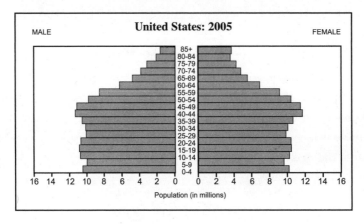

Population Pyramids for Austria 8.2 x 10^6

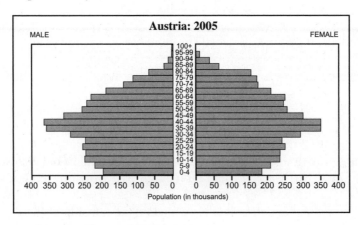

Source: U.S. Census Bureau, International Database
Extract data from IDB Online Aggregation

Figure 16-5. Age-structure analysis. Age-structure pyramids for Nigeria, the United States, and Austria. Successive age cohorts are plotted on the y-axis, males on the left and females on the right. (Note that population size on the x-axis is plotted at a different scale for Austria.) The population of Nigeria is increasing exponentially, the United States is almost stable, and Austria is decreasing.

The age cohorts are frequently differentiated into three regions. The lower-most indicates pre-reproductive. These individuals are not yet reproductively mature. The upper-most region is post-reproductive, when at least one sex of that population no longer is able to reproduce.

Of what significance is the shape of the curves? Consider what will happen in the next five years. In Austria, the cohort moving out of the reproductive phase will be replaced by a smaller cohort becoming reproductive. The size of the new cohort added at the bottom will probably be smaller than the current youngest cohort. At the same time, the oldest cohort will decrease significantly because of higher mortality at old age. The total population of Austria will continue to decrease. Declining population is currently considered to be a problem in many western European countries. Nigeria has a much different situation. The cohort moving post-reproductive is much smaller than the cohort moving into reproductive maturity. The new cohort added to the bottom will probably be considerably larger than the present one, and the total population will increase significantly. The United States is approaching zero population growth (zpg), where birth rate equals death rate. The number of children in the lowest cohort is currently about the same as Nigeria's. How will they compare in five years?

■ POPULATION PROJECTIONS

Consider the age structures for the three countries depicted in Figure 16-5. Which one suggests that population is nowhere near carrying capacity? Which one suggests that we might already be above carrying capacity? The problem, of course, is that we don't know the human carrying capacity of earth. Carrying capacity is usually determined empirically either by doing an experiment or replicate sampling from nature. Neither approach is possible with people. Furthermore, humans are an exceptional species in that we purposely modify our environment to artificially increase obvious factors that may limit carrying capacity—for example, food production. It's unclear if any or all of these modifications are sustainable, although evidence is accumulating that it may not be.

A further complication is implied by the age-structure analysis of populations. Depending on the shape of the curve, there may be a built-in lag between when individual families restrict their size to two children (two children to exactly replace the two parents is required for zero population growth) and the time the country as a whole reaches zero population growth.

For example, the United States and Nigeria are predicted to achieve the goal of two-child families within five years of each other, but when that happens in the United States, it will have achieved zpg. Nigeria's population is projected to continue increasing for more than 100 years.

We are early in the twenty-first century, and human population is somewhere along a sigmoid curve. We may be near carrying capacity, we may already have overshot it, or we could still have a long way to go. The extent of this uncertainty is reflected in the population projections provided by international agencies (Figure 16-7).

Within your lifetime, we should have a better idea of where we are and where we are heading.

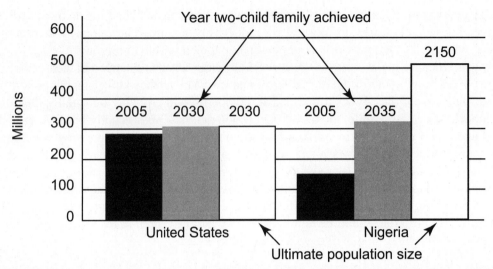

Figure 16-6. National population projections. Population projections for the United States and Nigeria. The current U.S. population is slightly more than double that of Nigeria, but both are projected to achieve a two-child family level within thirty years. At that time, the populations will be approximately equal, but the United States will have reached zpg, and Nigeria's population will continue to increase for more than a century.

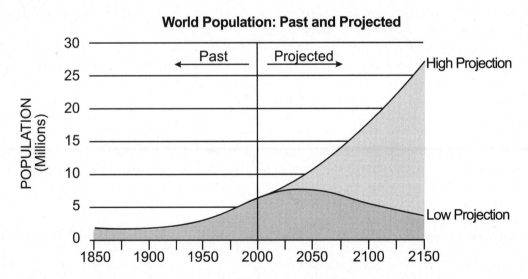

Figure 16-7. World population projections. Based on 1998 projections, the human population of earth will be somewhere between 4 billion and 27 billion, depending of the actual carrying capacity of earth.

Test Yourself

1) What is the best example of a factor responsible for increases in r, the intrinsic rate of increase?

 a) better medical care for premature infants

 b) the invention of the cotton gin

 c) widespread use of fertilizers

 d) the invention of the flush toilet

 e) the domestication of cattle

2) As N approaches K for a certain population, which of the following is predicted by the logistic equation?

 a) The population increase will get larger.

 b) The population increase will approach zero.

 c) The population will show an Allee effect.

 d) The population will increase logarithmically.

 e) The carrying capacity of the environment will increase.

3) Given K of 200 individuals and an initial population of 150, how many individuals could be added before the population overburdens the system?

 a) 75

 b) 25

 c) 350

 d) 50

 e) 150

4) If there is no immigration or emigration in a population, the birth rate is 40 per 1,000 individuals, and the death rate is 30 per 1,000 individuals, what will be the effect upon the initial population after one generation? Assume unlimited growth (K is not a factor).

 a) The population will increase by 5 percent each generation.

 b) The population will decrease by 70 percent each generation.

 c) The population will increase by 10 percent each generation.

 d) The population will increase by 1 percent each generation.

5) The age-structure diagram of a human population in a country such as Sweden, which has a population growth rate near zero, has the shape of a(n)

 a) hourglass.

 b) triangle.

 c) rectangle.

 d) funnel.

 e) upside-down triangle.

6) What is a survivorship curve?

 a) a graph illustrating the number of individuals of a population that dies over time

 b) a graph illustrating the proportion of individuals of a population that survives over time

 c) a graph illustrating the rate at which individuals of a prey species survive predation over time

 d) a population growth curve limited by carrying capacity

 e) a population growth curve in which carrying capacity is ignored

7) Compare the growth rates of the following pair of bacterial cell cultures.

 I. The population of culture A increases from 2×10^9 cells/ml to 8×10^9 cells/ml in two hours.

 II. The population of culture B increases from 50 cells/ml to 200 cells/ml in two hours.

 a) I is greater than II.

 b) I is less than II.

 c) I is equal to II.

 d) Insufficient information is given to answer this question.

8) Which of the following is most clearly a density-dependent factor?

 a) date of the first frost

 b) communicable disease

 c) light intensity

 d) proximity of a toxic waste dump

 e) amount of annual rainfall

9) All of the following are characteristics of *r*-selected populations *except*

 a) high mortality rates.

 b) high intrinsic rate of growth.

 c) onset of reproduction at early age.

 d) extensive parental care of offspring.

 e) population control by density-independent factors.

10) The age distribution of a population that had achieved zpg.

 a) is unequal with more people in the post-reproductive category.

 b) is unequal with more people in the pre-puberty category.

 c) is unequal with more people in the reproductive age category.

 d) is equal with approximately the same number of people in each age category.

Test Yourself Answers

1) **a.** Intrinsic rate of growth is the difference between the birth rate and death rate; therefore, factors affecting r must affect directly either births or deaths. Medical intervention increases birth rates and decreases death rates. Each of the other factors listed can affect the carrying capacity of a population.

2) **b.** As N approaches K, the factor $[(K - N) \div K]$ approaches 0 and, therefore, G approaches 0 in the logistic equation.

3) **d.** The stated carrying capacity, K, is 200 and the initial population, N, is 150. With the addition of 50 individuals, carrying capacity will be reached and addition of new individuals will be matched by deaths. If more than 50 individuals are added, G will be negative and there will be a decrease in number.

4) **d.** A birth rate of 40/1,000 is 4/100 or 4 percent. The death rate is 30/1,000 (3/100) = 3 percent. The intrinsic rate of growth, r, is birth rate – death rate = 1 percent.

5) **c.** A stable population with zero population growth will have about the same number of individuals in each age class of an age-structure graph and will appear rectangular with the y-axis elongated.

6) **b.** The x-axis of a survivorship curve is calibrated in percent of maximum age for a species. So that species with different life histories can be compared. The y-axis is plotted logarithmically so that different population sizes can be compared.

7) **c.** Both cultures are growing exponentially at a rate that doubles every hour and quadruples every two hours. For example, in II: $G = rN = 2 \times 50 = 100$ after 1 hour. Then $rN = 2 \times 100 = 200$ after two hours. Similarly, in I, G increases to 4×10^9 after 1 hour, and then 8×10^9 after two hours.

8) **b.** As population density increases, the probability of transmitting a communicable disease from one individual to the next increases. This is true for any species. Light intensity could be a density-dependent factor for plants. As a plant population increases in size, the amount of shade beneath them increases so that there may be insufficient light for some seedlings to grow. Similarly, if a toxic waste dump is located within the defined area of the population, increasing population density would increase the likelihood that some individuals would be affected by the dump. First frost and annual rainfall are environmental factors independent of density.

9) **d.** r-selected individuals have both high reproductive and high mortality rates—they are short-lived. They reproduce rapidly beginning at an early age and frequently produce many offspring at a time. Carrying capacity is not usually a factor in their growth. For a parent to provide extensive care to its young, the number of young must be small—often a single offspring. This would be characteristic of a K-selected individual.

10) **d.** When a population reaches zpg, the number of births equals the number of deaths. This is achieved when all age cohorts, up through and beyond the reproductive years, are approximately the same size.

Communities

In our examination of populations, we defined a population as all the individuals of a species in a defined area. A community consists of all the populations in that defined area. Individual populations will still grow and be affected by a variety of factors, both density-dependent and independent of population size. Individuals will still compete with each other, particularly as population size approaches carrying capacity. But now we will also consider the interactions of one species with others.

■ NICHE

As you might expect, many of the earliest studies of community interactions were done in relatively simple communities where relatively few different species were involved. One of the earliest examined the distribution of two genera of barnacles in the intertidal zone along a rocky coastline. Recently, New Orleans made the news because of the fact that much of the city is below sea level. But what does this mean? In a given location, sea level changes throughout the day, often twice a day, with the tides. An organism living in the middle of the intertidal zone has some unique challenges. During high tide, water level is high and our organism will be submerged. During low tide, water level is lower and our organism will be exposed to desiccating air. Furthermore, there is an approximately monthly cycle of the most extreme high and low daily tide, spring tide, and the least extreme tide, neap tide. As a result, organisms living in the highest zone may only be covered with water once a month, while organisms in the lowest zone may only be exposed to air once a month with a continuum of different exposures in-between.

In northern waters along the rocky coastline, two general types of barnacles are commonly found living in the intertidal zone. *Chthamalus* forms a distinct high tide zone. Its shell is frequently bleached white so at low tide, it almost looks like someone painted a white stripe at the high tide line. *Balanus*, a dark-shelled genus, occurs in the middle and lower intertidal zones. What is the reason for this distinct distribution that represents the **realized niches** for these species?

There are several possible explanations. Perhaps *Balanus* cannot survive excessive exposure to air, or *Chthamalus* cannot survive excessive submersion. Or perhaps there is competition between the two species. How could you test these possibilities?

Study sites were marked off on the coastline. On some, all the *Balanus* were removed; on others, all the *Chthamalu*s were scraped off. Under these conditions, *Chthamalus* colonized the entire intertidal zone, but *Balanus* remained only in the area below high neap tide. Physiologically, *Chthamalus* could survive under a broad range of environmental conditions, but *Balanus* was restricted to area below high neap. The distribution range of a species in the absence of competition is its **fundamental niche.** It appears that

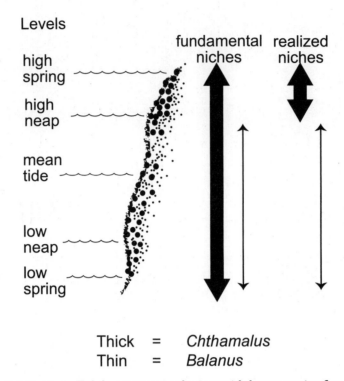

Levels

fundamental realized
niches niches

high
spring

high
neap

mean
tide

low
neap

low
spring

Thick = *Chthamalus*
Thin = *Balanus*

Figure 17-1. Barnacle distributions. Tidal variation in the intertidal zone varies from the lowest spring tide of the month to the highest spring tide. An organism's exposure to water and air varies according to the intertidal zone level it inhabits. Distribution of Chthamalus *is indicated by the thick line;* Balanus, *by the thin line. The realized niche represents the natural distribution. The fundamental niche represents the distribution when other barnacle is removed.*

the realized niche of *Balanus* is an interaction of its physiological ability to grow in the lower intertidal zone and its ability to out-compete *Chthamalus* in that zone. The realized niche for *Chthamalus,* however, is primarily a function of its ability to survive in the high intertidal zone.

Niche is a term used to describe the entire role of an organism in its community. It is not only the location where it is found, but also includes the resources it uses and what it puts back. If the niches of two species are different, they will not have much of an effect on each other, even if they occur in close proximity. If their niches are very similar, however, they will compete in the community. The more similar the niches, the greater the competition between species. In the mid- to lower-intertidal zone, the niches of *Chthamalus* and *Balanus* must be very similar because competition is completely dominated by *Balanus.* The exclusion of one species by another when they are in competition in a community is called **competitive exclusion.**

■ RESOURCE PARTITIONING

Because of competitive exclusion, one does not expect to find many similar species in the same community. It was surprising to find five different species of warblers living in the same spruce community in northern New England. The forest was almost a monoculture of the same tree species, yet all five bird species flourished. This suggested that each bird must be occupying a different niche. But how could this be?

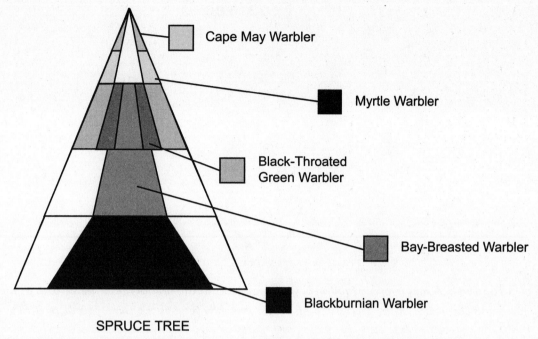

Figure 17-2. Resource partitioning. A single tree species provides the resources to support several related bird species, if those resources can be divided in such a way as to minimize competition.

A close study of the birds nesting behaviors suggested the answer.

The birds occupied different parts of the trees. One lived only in the tree tops; a second was restricted to the outer branches of the top half of the trees; another nested near the trunk at the base of the tree. Two species shared the middle zone, but one near the trunk, and the other in the outer branches. A single spruce tree was providing a complex habitat that was divided among species in such a way that minimized competition. This **resource partitioning** enables many species, each with a different niche, to be close neighbors in the community.

■ FOOD WEB

Competition is a natural result of having a high demand on a limited supply of some resource. There is an even more basic interaction between organisms found in communities, however, and this was also first studied in the far north. We all know that some animals eat other animals, and some animals eat plants. How do these different organisms interact in the community?

Some of the earliest studies done to answer this question were conducted in the Alaskan tundra. Relatively few species are found here, making it easier to work out relationships.

At the base of this web are the plants that synthesize their own food. They are the primary trophic level, the **producers.** The secondary trophic level consists of herbivorous animals that feed directly on plants. They are the **primary consumers.** At the third trophic level are carnivores—animals that eat other animals. Those that eat herbivores are **secondary consumers.** But some carnivores eat other carnivores. For example, in Figure 17-3, the fox eat sandpipers and buntings, and sea birds eat fish. In this case, the fox and sea birds are feeding at the fourth trophic level, and if the fox eats sea birds, it is feeding at the fifth level.

Another interesting relationship soon became apparent. As you move to higher trophic levels in the food web, the number of individuals at that level decreases significantly.

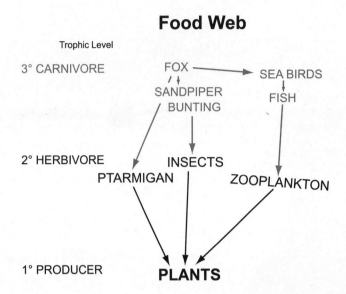

Food Web

Figure 17-3. Food web. A simple arctic food web, with producers at the primary level, herbivores at the secondary level, and carnivores at the tertiary level. Carnivores may feed at the third, fourth, or fifth trophic level.

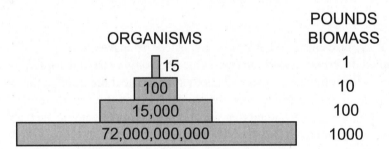

Figure 17-4. Pyramid of numbers. Number of organisms of each trophic level in Figure 17-3 in the area of study. Conversion to pounds biomass suggests a rule of 10s relationship. Biomass decreases by a factor of 10 at each successively higher trophic level.

For example, to support fifteen fox in this community, there were some 72 billion plants. Every step up in trophic levels results in a drastic reduction in the number of individuals at the higher level. In Chapter 18, we will examine the underlying principle.

■ SPECIFIC INTERACTIONS BETWEEN SPECIES

The earliest community studies suggested that competition was a key interaction between species at the same trophic level and that "who eats whom" is important between levels. Further studies revealed more specific interactions between species.

Predator-Prey

The classic examination of predator-prey interactions, first published in the late 1930s, examined the relationship between lynx and hare populations in Canada. These studies were based on the well docu-

mented accounts of pelts sold to the Hudson's Bay Company. The primary assumption was that the abundance of trapped animals is directly proportional to the population size that season. Hares are herbivores (primary consumers), while lynx are carnivores that prey heavily on hares. An initial surprise was that the hare population was not always larger than the lynx population.

Both populations fluctuated at approximately regular intervals of ten years, but they were not perfectly synchronized. The hare population usually peaked and began a sudden drop before the lynx population peaked. As a result, the lynx predator population frequently was larger than the prey population. Shortly after the hare population began to fall, there was a corresponding drop in the lynx population. The conclusion seemed obvious. The lynx must be driving the cycle. When the lynx population is low, there is little predation and the hares can "reproduce like rabbits," increasing rapidly. As the prey population increases, more food is available to the predator, and the lynx population begins to increase. In a few years, the lynx population is large enough to decimate the hare population, and there is a sudden population crash. With food supply suddenly limited, a lynx population crash must follow, and the cycle will be repeated.

This explanation seemed perfectly reasonable, but it was not tested until the late 1970s. What were some alternative explanations? Perhaps the hares were driving the cycle. As the hare population increased, they would place heavier browsing pressure on the plant cover. Perhaps the hares were overeating the producers, and this caused the crash in the hare population. A crash in the lynx population would necessarily follow. A long-term experiment was set up in which lynx were excluded from the community, and extra food was provided in the winter. As might be expected, the hare population increased dramatically. Food supply in winter was limiting the natural carrying capacity, so by supplementing food, the carrying capacity was raised. What was unexpected is that the boom/bust cycle continued with the same ten-year period. As a result of these studies, there has been renewed interest during the past decade in examining these cycles. We do not yet have the answer.

Parasitism

One hypothesis being examined to explain the predator-prey oscillation involves the buildup of parasites in the hare population. **Parasitism** is a relationship between two organisms in which one, the par-

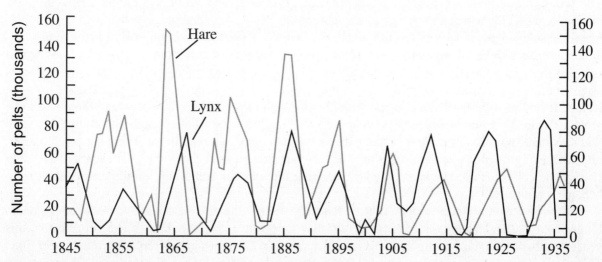

Figure 17-5. Predator-prey. The lynx, a large cat, is a predator on hares, a large relative of rabbits. Both populations show a periodic increase in population size followed by a sudden decrease with the lynx cycle occurring slightly later than the corresponding hare cycle.

asite, benefits, and the host is harmed. Parasites that live within the body are endoparasites. A large buildup of endoparasites weakens or even kills the host. Some endoparasites with which you may be familiar are heart worms in dogs, and malaria and tapeworm in humans. Parasites living on the outside of the host are ectoparasites. Fleas, ticks, and lice are examples you may know. Although parasitism can be lethal to the host, this is not a good strategy from an ecological point of view. Well adapted parasites do not usually kill their host, but simply weaken it. Parasitism is usually considered to be one extreme of a continuum of relationships known as symbiosis. **Symbiosis** is an intimate interrelationship between two organisms that is beneficial for at least one of the participants.

Mutualism

Mutualism is the type of relationship most commonly thought of as symbiotic. In a mutualistic symbiosis both organisms benefit from the relationship. The classic example of mutualism occur in lichens. Lichens are an association between a fungus and an alga species that are very widespread. In much of the south, the black or gray "dirt" that seems to cover concrete overpasses or stone buildings is frequently a layer of lichens. The multi-colored patches on stones and tree bark in the northern states are also lichens. Lichens are especially interesting because they form special chemicals that neither the fungus nor alga can produce on their own. Some of these lichen substances have antibiotic properties.

Mutualistic symbioses turn out to be much more common and important than we once realized. The vast majority of plants depend on mutualistic fungi associated with their roots. We depend for protection on a natural flora of mutualistic bacteria in and on our bodies to protect us from pathogens.

Commensalism

Commensalism is an intermediate type of symbiotic association. One organism is benefited with seemingly no effect on the other. The key word is "seemingly." For example, Spanish moss drapes from oak and cypress trees in the south. The "moss" (actually a member of the pineapple family) benefits from its aerial perch with good light exposure and periodic drying. The supporting tree apparently is not affected one way or the other, but further study may show otherwise.

Succession

We have described a number of processes acting on populations in the community. How do these interact to affect the actual appearance of the community? Imaging a defined area that contained no living organisms—perhaps a newly formed volcanic island. What kind of organism is most likely to first colonize that new habitat? In general, it will be an *r*-selected species that is small, reproduces rapidly, and can withstand extreme environmental conditions. Suppose species A meets these criteria and becomes established on our island. How will it affect the island as the population grows and expands over the island? It will provide nutrients as some individuals die and a small bit of shade where there was none previously. In short, the presence of population A will slightly modify the conditions on the island and that may make it more favorable for a second species, B, to become established. There is now a community with two growing populations that may or may not interact with each other, but each will certainly change the conditions on the island slightly, opening the way for additional immigrant populations to become established.

If this process continues, a point may be reached where some of the earliest founded species can no longer compete under the new conditions, and they drop out of the population. The net effect of this process is that community composition gradually changes with some species replacing others over time. This process is termed **succession.** Species that appear at the earliest stages of succession are sometimes called pioneer species. In established communities, the populations already present are well adapted to the existing conditions and are able to continually self-replace in the community. These tend to be *K*-selected species. A community at this stage is sometimes called a **climax community.**

This example, beginning with new habitat, is **primary succession.** The more usual occurrence is for some disturbance to suddenly modify a more-or-less established community, thereby opening the possibility to begin the process anew. Succession resulting from disturbance is called **secondary succession.** It is interesting that the sequence of communities in secondary succession is usually different from that of primary succession. Secondary succession is a common natural occurrence following from fires, hurricanes, landslides, and so on. Increasingly, secondary succession is driven by human impacts on the environment.

Test Yourself

1) According to the competitive exclusion principle, two species cannot continue to occupy the same
 a) environmental habitat.
 b) ecological niche.
 c) territory.
 d) range.
 e) biosphere.

2) In a food web where consecutive trophic levels contain grass, grasshoppers, sparrows, and hawks, the grasshoppers are
 a) primary consumers.
 b) primary producers.
 c) secondary consumers.
 d) secondary producers.
 e) detritivores.

3) During ecological succession, the species composition of a plant community generally
 a) decreases until all but one species goes extinct.
 b) remains constant over long periods of time.
 c) changes abruptly because environmental factors change abruptly.
 d) changes gradually because each species responds differently to changes in environmental factors.

4) Predation by human hunters differs from natural predation in that hunters
 a) do not regulate the size of the prey population.
 b) often selects prey from the healthy portion of a population.
 c) help to increase the fitness of the prey population.
 d) have a more serious influence on the age structure of the prey population.

5) Mosses living at the bases of large trees, frequently on the north side, demonstrate which relationship?
 a) parasitism
 b) commensalism
 c) mutualism
 d) competitive exclusion
 e) none of the above

6) Assume that the predators in a community consist of foxes, whose diet is 80 percent mice and 20 percent birds; weasels, whose diet is 50 percent mice and 50 percent birds; and bobcats, whose diet is 20 percent mice and 80 percent birds. Which predator species is the most likely to disappear from the community as a result of competition from the other two?

 a) the foxes

 b) the weasels

 c) the bobcats

 d) both a and c

 e) They are equally likely to go extinct.

7) Which of the following are usually found at the greatest densities?

 a) primary producers

 b) primary consumers

 c) secondary consumers

 d) tertiary consumers

 e) herbivores

8) If you watch sandpipers on a beach, the different species of sandpipers will tend to spend most of their time foraging in water of different depths—they don't tend to forage in the same places. This is because of

 a) resource partitioning.

 b) different fundamental niches.

 c) facilitation.

 d) differential predation.

 e) chance.

9) A flea living in the fur of a cat and feeding on the cat is an example of

 a) commensalism.

 b) predation.

 c) parasitism.

 d) mutualism.

 e) competition.

Test Yourself Answers

1) **b.** Niche is the role of a species in its community; two coexisting species cannot have the same role. More than two species can share the same habitat and even have overlapping territories or ranges, as long as they do not compete.

2) **a.** Grass is the producer. Grasshoppers, which are herbivores, are the primary consumers, although they are at the secondary level of the food web. Sparrows, the secondary consumers, are the first level of carnivores. They occupy the third trophic level. Hawks are also carnivores, but are tertiary consumers at the fourth trophic level.

3) **d.** The term *succession* implies change. Community composition changes over time, in part because the presence of any species has some effect on the local environment, which may be advantageous for a subsequent species. In general, species diversity increases during succession.

4) **b.** In nature, predators frequently attack old or weak prey because of the greater ease and probability of success. Human hunters, at least sport hunters, tend to hunt the largest and most vigorous prey. All predation tends to limit the size of the prey population. By consciously hunting the healthiest, most vigorous animals, human hunters tend to decrease the overall fitness of the prey population and have undue effect on future reproduction of the prey species.

5) **b.** Mosses benefit from the shade, protection, and water channeling of the bark of large trees with no apparent effect on the tree. This is an example of commensalisms, where one species benefits and the other is seemingly not affected.

6) **b.** Foxes and bobcats specialize on mice and birds, respectively, and are, therefore, in little competition with each other, but both compete with weasels. Weasels do not specialize for either mice or birds and, therefore, are not as strong a competitor for either as are the specialists. Weasels will, therefore, be the most susceptible to extinction.

7) **a.** Producers have by far the greatest biomass and largest numbers of individuals of any trophic level. The individuals must, therefore, be found at the greatest densities.

8) **a.** By specializing on feeding in different water depths, these shorebirds minimize competition by partitioning the resources between them, thereby having different realized niches, although they may have the same fundamental niche.

9) **c.** The flea benefits from this symbiotic relationship, but the cat is harmed. The flea is an ectoparasite, and this is an example of parasitism.

Ecosystems

Recall from Chapter 17 that there is a dramatic difference in number of organisms from one trophic level to the next. What is the underlying basis for this relationship? To begin to answer this question, the first thing was to try to standardize the organisms at each level. Although the population of fifteen fox were all about the same size, the 72 billion plants varied considerably. Some were tiny algae, many were mosses, and some were woody. Should a single-celled alga count as much as a woody shrub? To solve this problem, pounds of biomass, living tissue, was estimated for each trophic level. When this was done, a simple pattern emerged. There is about a ten-fold reduction in biomass from one level to the next, whether it is between the first and second or fourth and fifth. There must be an underlying biological basis. Furthermore, the number of trophic levels in a community did not vary greatly regardless of whether you were studying the arctic tundra or tropical rain forest? How can this be?

■ ENERGY FLOW

Recall from Chapter 6 that the sun is an external source of energy that allows living things on earth to overcome entropy. For practical purposes, we live in an open system and do not have to worry about the second law of thermodynamics. About 2 percent of the sunlight reaching earth is converted into chemical energy by plants. This determines the size of the primary trophic level.

Some of this energy is used by the plants themselves, in respiration, to support growth and development. In the process, heat is generated. Some of the energy remains locked up in the organic molecules of the plant when it dies, only to be released by decomposers, again generating heat. Only a fraction of the total energy fixed by plants is passed to the herbivores that eat them—about one-tenth. The same pattern hold true at each trophic level. Much of the energy obtained from the previous level is utilized in respiration just to keep the animals alive. Some animals die off and become food for decomposers. Only about one-tenth is passed to the next higher level. With plant production limited at the base, there is enough energy to pass through about five levels before it is completely used up. Energy flows through the system beginning with the plant producers that absorb a fraction of the sun's energy and ultimately ending up as radiated heat.

■ BIOGEOCHEMICAL CYCLES

Although energy flow is one way, the matter from which living things are built must be recycled. Although there is a constant input of "space dust," the amount is insignificant relative to the volume of atoms circulated in biogeochemical cycles. Certain of these atoms are particularly important in living

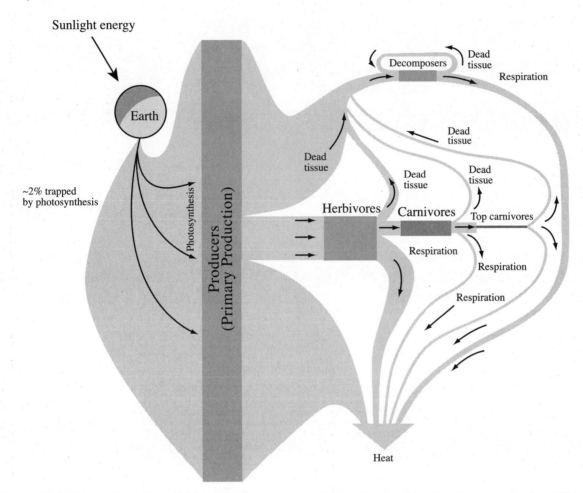

Figure 18-1. Energy flow. The width of the primary trophic level is fixed by the photosynthetic ability of the plants. At each trophic level, the majority of energy is utilized in the metabolism of the organisms at that level or is stored in dead tissue for later decomposition. Only about one-tenth is passed on to the next generation through predation by organisms on the next higher level.

things. Recall the atoms involved in the basic biological molecules examined in Chapter 2. All of them contain carbon, hydrogen, and oxygen. Amino acids and nucleotides also contain nitrogen and phosphorous. In fact, there are ten atoms that are essential for all living things. For nine of these, it is because that atom is a constituent of some essential molecule. Although all of these elements are essential, three have particular importance in terms of ecosystem functioning: carbon, oxygen, and nitrogen.

Carbon Cycle

The largest reservoir of carbon on earth is CO_2, in the atmosphere or dissolved in water, yet it is the backbone of all organic molecules. You already know the process by which CO_2 is transformed into organic molecules: photosynthesis (see Chapter 8).

Net photosynthetic activity determines the size of the primary trophic level by fixing the amount of energy that can be passed through the system. Much of the fixed carbon is returned to the atmosphere in a relatively short time by the respiration of plants and animals. A large amount is also recycled through bacteria or fungi as dead plants and animals decay. There is a further process that until recently was insignificant in terms of carbon balance in the ecosystem. Occasionally, an organism will die that does not

Carbon Cycle

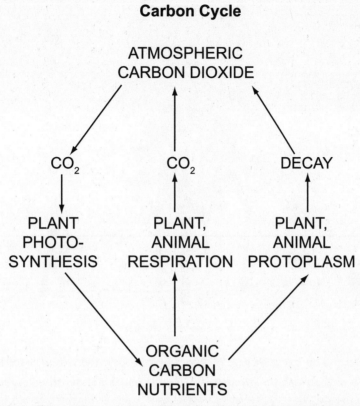

ATMOSPHERIC
CARBON DIOXIDE

CO_2 CO_2 DECAY

PLANT
PHOTO-
SYNTHESIS

PLANT,
ANIMAL
RESPIRATION

PLANT,
ANIMAL
PROTOPLASM

ORGANIC
CARBON
NUTRIENTS

Figure 18-2. Carbon cycle. The carbon cycle is driven by photosynthesis and respiration. Photosynthesis fixes atmospheric CO_2 into organic carbon compounds. Respiration oxidizes organic compounds, releasing CO_2 back to the atmosphere.

decay. In historic time, we know of organisms that were frozen or preserved in peat bogs. In geological time, fossilization may occur. Today's fossil fuels are the carbon remains of organisms that were part of earths carbon cycle millions of years ago, but have been out of the system since then. Burning those fossil fuels oxidizes the organic molecules and releases substantial amounts of additional CO_2 back into the cycle. Fossilization over geological time drew a small trickle of carbon out of the cycle; for the past century and a half, fuel combustion has provided a massive flood of carbon back into the cycle within each generation.

Oxygen Cycle

Photosynthesis and respiration also drive the oxygen cycle.

Recall from Chapter 8 that during the light-dependent reactions of photosynthesis, water is split to provide electrons for non-cyclic photophosphorylation. A byproduct of this process is the release of oxygen gas. As a result, the input of energy from the sun has a direct impact on determining the amount of oxygen cycled. Some of the oxygen produced is immediately used by the plant for its own aerobic respiration. Fortunately, plants produce much more oxygen than they consume, and the excess is released to the atmosphere. During geological time, there has been a gradual increase in atmospheric O_2. Prior to the evolution of photosynthesis, there was no free oxygen available. Today, the atmosphere contains about 20 percent oxygen, and this has been stable during historic time. The total aerobic respiration of all living things balances the photosynthetic production of oxygen by plants.

Oxygen Cycle

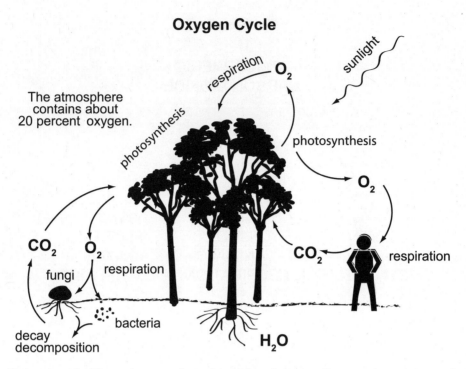

Figure 18-3. Oxygen cycle. The oxygen cycle is driven by photosynthesis and respiration. During photosynthesis, plants release oxygen into the atmosphere. During aerobic respiration, organisms utilize the oxygen as a final electron acceptor.

Nitrogen Cycle

Like carbon and oxygen, a major reservoir of nitrogen is the atmosphere where nitrogen gas, N_2, makes up about 78 percent of the volume. Unlike CO_2 or O_2, however, N_2 cannot be fixed into organic molecules by either plants or animals. Nitrogen cycling has no direct link to either photosynthesis or respiration. The keys to the nitrogen cycle are several different groups of bacteria.

The only organisms on earth capable of using N_2 are the nitrogen-fixing bacteria, including the cyanobacteria in aquatic systems. Some are free-living in the soil, but many are symbiotic with plant tissue, particularly the roots of legumes and some other plants. Nitrogen-fixing bacteria convert molecular nitrogen into ammonia, NH_3 which is converted into ammonium, NH_4^+, which can be used by some plants directly. Nitrifying bacteria in the soil convert NH_4^+ into first nitrite, NO_2^-, and then nitrate, NO_3^- which is the form most readily absorbed by plants. Some plants can use NH_4^+ to produce amino acids, but most use NO_3^-. Again, the volume of plants producing plant protein limits nitrogen availability to the rest of the community. When organisms die, two additional types of bacteria come into play. Ammonification bacteria break down proteins into NH_4^+, which can be recycled back into plants. Denitrifying bacteria break down proteins, releasing N_2 back into the atmosphere to complete the cycle.

■ HUMAN PERTURBATIONS

As mentioned in Chapter 17, humans have a major impact on community succession. Not surprisingly, humans also have drastic influences on other aspects of the ecosystem.

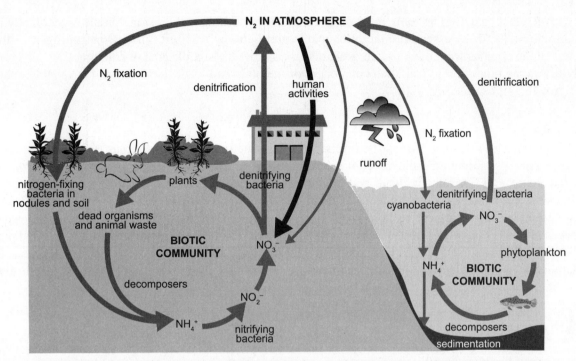

Figure 18-4. Nitrogen cycle. The nitrogen cycle depends on several different groups of bacteria to cycle molecular nitrogen into forms that can be absorbed by plants, and to recycle nitrogen-containing wastes back into forms that can be reabsorbed by plants or released back into the atmosphere.

CO_2

In the discussion of the carbon cycle, we mentioned the recent impact of burning fossil fuels. The carbon that has been locked up in fossil form for millions of years has been rapidly returned to the atmosphere since the beginning of the industrial revolution. There is no doubt that CO_2 levels have been rising. Since the 1950s, direct measures of CO_2 concentration have been made on top of Mauna Loa, one of the volcanic peaks on the big island of Hawaii. Since measurements began, CO_2 concentration has steadily increased and is now about 21 percent higher (375ppm) than it was initially (315ppm). Does not this increased CO_2 simply stimulate increased photosynthesis? After all, atmospheric levels of CO_2 are not optimal for photosynthesis, and commercial greenhouse operators sometimes speed plant growth by supplementing CO_2. Experiments are being done to see whether that is happening. So far, the results are inconclusive but, obviously, plants are not able to "keep up." The vast majority of climate scientists believe the rising levels of CO_2 are linked directly to global warming in what is called the **greenhouse effect.** A greenhouse, or your car with its windows closed, allows light in, which produces heat when the light is absorbed by objects inside. The heat radiates away from the objects, but is trapped by the glass so that the temperature inside the greenhouse increases more rapidly than the outside air. Like the greenhouse glass, CO_2 allows light to penetrate but limits the radiation of heat away from the earth.

Deforestation

If plant photosynthesis is a driving force in both the carbon and oxygen cycles, it is not surprising that deforestation impacts ecosystems. The extent of that impact, however, is greater than you might first expect. Long-term studies at Hubbard Brook Experimental Forest in New Hampshire demonstrate the

direct role plant cover has not only in holding water and preventing soil erosion, but also specifically in minimizing loss of the essential mineral elements nitrogen and calcium. The role of nitrogen in the ecosystem is obvious from the nitrogen cycle discussion, but the significance of calcium, Ca^{2+}, is more subtle. Among other things, Ca^{2+} is a component of the plant cell wall. If calcium is unavailable, plant cell growth will be reduced.

Acid Rain

The first clues that Ca^{2+} might be limiting plant growth were a serendipitous discovery during a larger experiment monitoring the effect of acid rain on the forest. In the 1960s, people in the northeast United States and Canada, England, and Scandinavia all began to notice that fish populations were decreasing, particularly in lakes. Scientists quickly realized that the pH of these waters was much lower than normal and that burning fossil fuels was again the culprit. Certainly, added CO_2 acidifies the water because of the formation of carbonic acid. A bigger problem was the emission of sulfur dioxide. Acid precipitation can have direct harm to plant tissue, but the biggest concern is that when it penetrates the soil, a number of minerals, including Ca^{2+}, become more soluble and easily washed away. Toxic metals also become more soluble and are released into streams and lakes.

Toxin Accumulation

Toxins are not good for any organism in the ecosystem, but certain toxins are particularly deadly because they become naturally concentrated. Fat-soluble toxins are in this category. Such chemicals are taken into the organism from the environment and are frequently not metabolized. Instead, they accumulate in the lipids of the body. Ecosystems, however, consist of food webs with organisms at higher trophic levels feeding on organisms at lower levels. In the same way that available energy decreases from one level to the next, by a factor of ten, immobile toxins in the lipids accumulate from one level to the next, also by a factor of ten. This **biological magnification** can have severe consequences for organisms at the top of the trophic pyramid. Of course, this can have an impact on humans who often feed at top levels. Have you seen warnings about eating fish from certain lakes or rivers more than once a week, especially if you're pregnant?

Nutrient Enrichment

It may seem contradictory, but nutrient enrichment is a serious problem in many ecosystems. In agricultural regions fertilizers, particularly those that are nitrogen- and phosphorous-based, can be a problem if there is excessive application and/or excessive runoff into nearby lakes and streams. Feedlot runoff also contributes excessive amounts of nitrogen to open water. This problem is not restricted to agricultural regions. Runoff from lawn fertilizers in urban areas is an equally large contributor. The problem with nutrient loads in open water arises as populations of algae increase in response to the added nutrients. Such algal blooms can literally form floating mats on the water surface. Light penetration decreases and, eventually, deeper-growing plants die and decompose. The bacteria responsible for decomposition deplete dissolved oxygen in the water, causing fish kills that add to the problem. The result is **eutrophication,** massive die off in the lake as a result of anaerobic conditions brought on by nutrient enrichment.

Test Yourself

1) Increased atmospheric CO_2 from the combustion of organic materials leads to
 a) global warming.
 b) atmospheric ozone depletion.
 c) the greenhouse effect.
 d) a and b only.
 e) a and c only.

2) Which of the following levels of organization is arranged in the correct sequence, from most to least inclusive?
 a) community, ecosystem, individual, population
 b) ecosystem, community, population, individual
 c) population, ecosystem, individual, community
 d) individual, population, community, ecosystem
 e) individual, community, population, ecosystem

3) In ecosystems, energy _____, whereas nutrients _____.
 a) flows, accumulates
 b) cycles, flow
 c) cycles, accumulate
 d) flows, cycle
 e) accumulates, cycle

4) Which ecological unit incorporates non-living factors?
 a) community
 b) ecosystem
 c) population
 d) species
 e) symbioses

5) In experimental studies conducted at the Hubbard Brook Experimental Forest in the White Mountain National Forest, New Hampshire, it was found that water and minerals (nutrients) were retained most efficiently by
 a) areas where trees were cut and allowed to rot on the ground.
 b) experimental plantings of ground cover plants.
 c) plots inoculated with genetically engineered bacteria.
 d) plots where artificial fertilizer was added.
 e) undisturbed forests.

6) Which of the following is *not* true of the nitrogen cycle?

 a) It requires different types of bacteria.

 b) Plants can take in and utilize atmospheric nitrogen using their leaves.

 c) Nitrogen needs to be cycled through living organisms.

 d) When plants and animals die, their nitrogen is recycled.

7) The build-up of toxic substances such as pesticide DDT and strontium-90 in food chains is known as

 a) upwelling.

 b) eutrophication.

 c) biosynthesis.

 d) biological magnification.

8) The form of nitrogen most likely to be absorbed from the soil by plant roots is

 a) ammonia gas, NH_3.

 b) atmospheric nitrogen, N_2.

 c) nitrates, NO_3.

 d) nitrites, NO_2.

9) Which of the following is an ecological problem caused by adding phosphorus-rich fertilizer to crops?

 a) Too much phosphorus can kill the crop.

 b) Too much phosphorus will promote the growth of weeds.

 c) Much of the phosphorus in fertilizer will be washed away and end up polluting lakes and rivers.

 d) Phosphorus can accumulate to toxic levels in animals in the vicinity, especially those higher on the food chain.

 e) Phosphorus is in short supply worldwide, and using it on cropland is wasteful.

10) Eutrophication of a lake could occur if

 a) phosphate-rich detergents are dumped into the lake.

 b) fertilizers from farms are washed into the lake.

 c) raw sewage is dumped into the lake.

 d) all of the above occurred.

Test Yourself Answers

1) **e.** Burning of organic material, including fossil fuels, releases CO_2 into the atmosphere. This is related to global warming and is known as the greenhouse effect.

2) **b.** Ecosystems consist of all the communities in a region and the non-living factors that affect them. Communities consist of all the populations in a defined area and populations consist of all the individuals of a single species in a defined area.

3) **d.** In terms of energy, the earth is an open system. Energy from the sun is a constant input, some of which is absorbed by plants. Plants form the base of the food web and determine the total amount of energy than can be passed on from one trophic level to the next. In terms of nutrients, the earth is a closed system and nutrients must be recycled.

4) **b.** Species, populations, and communities deal only with individual organisms living in a defined space. Symbioses are close associations between two or more species. Only the ecosystem incorporates both living and non-living factors.

5) **e.** When experimental plots were cut, more precipitation ran off, and mineral nutrients in the soil were depleted.

6) **b.** The nitrogen cycle requires several different types of bacteria, including nitrogen-fixing bacteria, ammonification bacteria, nitrifying bacteria, and denitrifying bacteria. Once incorporated by plants into proteins, they are available to organisms in the rest of the food web. Decomposers recycle nitrogen and other nutrients when organisms die.

7) **d.** Fat-soluble chemicals tend to build up in food chains in a manner similar to energy usage. Toxic substances at each level accumulate approximately ten-fold compared to the next lowest level. Upwelling of ocean waters tend to bring nutrients from the bottom sediments toward the surface. Eutrophication describes the development of anaerobic conditions in open waters due to excessive nutrient buildup and the resulting bloom of algae.

8) **c.** Although anhydrous ammonia is the most commonly used nitrogen fertilizer in agriculture, it must be applied weeks before seeds are planted. The ammonia itself is toxic to plants, but it is converted by bacteria into nitrates that can be absorbed. Nitrogen gas can only be utilized by nitrogen-fixing bacteria. Nitrites must be converted to nitrates before plants can absorb and use the nitrogen.

9) **c.** Phosphorus and nitrogen are the two main nutrients that are associated with eutrophication when they run off cropland into open water. Excessive amounts of any chemical applied to crops can be lethal. Fertilizing crops will also fertilize the adjoining weeds in the field. Phosphorus does not accumulate in the body and is not in short supply.

10) **d.** Phosphate containing detergents, farm runoff, and untreated sewerage are all sources of excess nutrients that can cause eutrophication.

Biosphere

The **biosphere** is the total of all organisms on earth and the abiotic factors that affect them. Figure 19-1 illustrates the subdivision of the terrestrial biosphere into major regions.

Focusing just on the shading patterns, it should be apparent that there is a tendency for regions to run horizontally from east to west along parallels of latitude. Even patterns that appear more localized, such as around the Mediterranean Sea, tend to reappear at other places at the same latitude such as southern California, or along a parallel latitude, such as Southern Australia and South Africa. What is responsible for such broad patterns of life?

■ABIOTIC FACTORS

Abiotic factors are critical in determining the distribution of life on earth. Most critical is the climate, specifically the temperature and precipitation. Which of these two factors is most likely responsible for the horizontal bands of Figure 19-1?

Temperature

Just as sunlight is the ultimate source of energy necessary for organisms to overcome the tendency toward entropy, it is also the source of energy that drives major climatic and weather patterns on earth. The earth's rotation, relative to the sun, is at a constant tilt of about 23.5°.

Twice a year, on the spring and fall equinoxes, the sun will be directly over the equator and the intensity of sunlight per unit area will be maximum at that point. High light intensity produces high heat. The farther you move from the equator, the less direct will be the light and the less heat will be generated. The horizontal bands primarily reflect regions of similar temperatures at corresponding latitudes (parallel distances) equidistant from the equator.

The equinoxes are also the two days of the year when day length equals night length anywhere on earth. For a person in the northern hemisphere, halfway between the spring and fall equinox will be the summer solstice. At noon on this day, the longest in the north, the sun will be exactly over the Tropic of Cancer, 23.5° north of the equator, because the earth's normal tilt is now directed with the north pole toward the sun. This is the shortest day of the southern hemisphere. Six months later, the earth has rotated to the opposite side of the sun and the northern hemisphere is now directed away from the sun. The winter solstice is the shortest day of the northern year; the sun is directly over the Tropic of Capricorn and it

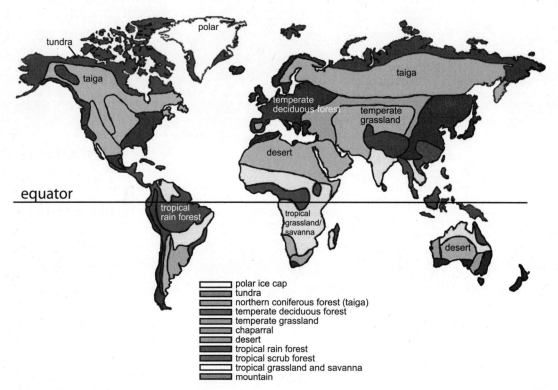

Figure 19-1. Terrestrial biomes. Most of the major terrestrial biomes have an east-west orientation between certain latitudes, indicating that temperature is a major determining factor. Similar latitudes north or south of the equator have similar temperatures.

is the middle of the southern summer. The tropics are defined as the region between the Tropic of Cancer and the Tropic of Capricorn.

Precipitation

Precipitation patterns are directly related to solar heating of the earth. People living on the Gulf Coast of the United States experience in the summer what occurs daily in much of the tropics. Once the sun rises and begins heating vegetation or open water, evaporation increases. As air heats, it rises and can hold more water vapor. As a result, warm, moist air begins to rise and continues to do so during the heat of the day. If you've driven over a mountain pass in the Rockies, you know that as you increase in elevation, temperature decreases. The same thing happens to the warm, moist air rising in the tropics. At some point, it cools enough to begin to condense, forming clouds that soon contain enough moisture that precipitation begins. The result is an afternoon shower. When day length is nearly constant year-round, as in the tropics, you can almost set your watch by the afternoon showers.

The generally rising air in the tropics also drives global patterns of precipitation.

As a mass of air rises, it displaces the higher air already present toward the north or south. As the higher air cools, it becomes denser and sinks back toward the earth. In cooling, the air lost moisture to precipitation, so the sinking air is already dry. As it sinks, it warms, which causes the air to absorb any humidity from the surrounding air to further dry the surface. As a result, two large convection currents form, north and south of the equator. The rising and cooling air produces heavy precipitation in the tropics. The falling, warming air results in bands of deserts and arid conditions at approximately 30° north or south of the equator.

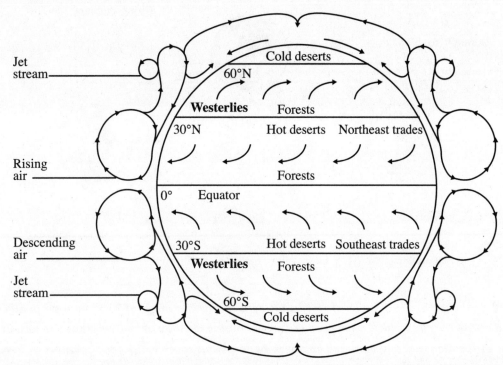

Figure 19-2. Global air circulation. Air circulation patterns are directly related to solar heating of the earth's surface. The tropics receive the most direct sunlight and are heated the most. Warm air masses rise and displace higher, colder air to the north or south. Cold air descends at about 30° north or 30° south latitudes and either returns toward the tropics, repeating the cycle, or disperses toward the poles, establishing a second set of convection cycles. Deserts occur where dry air descends.

At the same time the convection currents circulate air vertically over the surface of the earth, the earth itself is spinning on its axis from west to east. This effect is most pronounced at earth's widest part, the equator. The rising air is deflected toward the west—the so-called trade winds that powered sailing ships from Europe to the Caribbean and southern United States. The falling air is deflected toward the east—the prevailing westerlies that influence most of the contiguous forty-eight states of the United States.

Montane Effects

Although the prevailing pattern in Figure 19-1 is one of horizontal bands, there are some notable exceptions, such as on the western sides of both North and South America and in the region between China and India. These anomalies are associated with mountainous areas that have local influence on precipitation patterns. A good example is the coast range of the Pacific states.

The prevailing westerlies pick up water vapor over the Pacific and then are forced to rise to pass over the coast range. As it rises, the air cools, water condenses, and there is heavy precipitation. As the air mass continues over the mountains, it descends, warming in the process and absorbing any local moisture. The warm, drying air on the leeward side of the mountain creates a rain shadow. The rain shadow effect of the Cascade Range and Sierra Nevada mountains allows the desert region of the western United States to extend far north of 30° into the Great Basin. The Himalayas between India and China create a rain shadow of the Gobi Desert. The Andes separate the Amazon rain forest from the Atacama Desert of Chile.

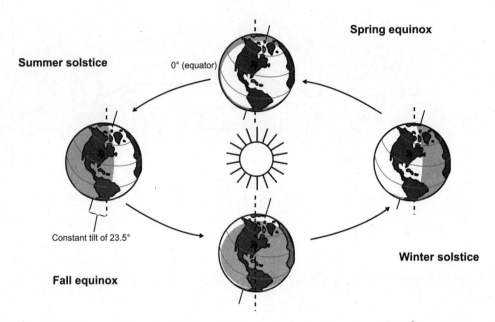

Figure 19-3. Sunlight. The earth's axis of daily rotation is a constant angle of 23.5° from perpendicular. An equal area of the earth's surface is exposed to the sun during any day of the year, but because of the tilt in the axis of rotation, the northern and southern hemispheres receive different amounts of coverage in the summer and winter. Days are longer in the summer and shorter in the winter. The solstices are the longest and shortest days of the year in that hemisphere.

■ TERRESTRIAL BIOMES

Climatic factors determine the dominant vegetation type for a region which, in turn, affects the animals living in that region. Such major ecological associations that cover broad expanses of land are called **biomes.**

Knowledge of the temperature and precipitation of a location allows you to accurately predict the type of terrestrial biome that will be present.

For example, Las Vegas is one of the fasting growing cities in the United States. In what biome is it located? The average temperature for Las Vegas is 63° F, and the average precipitation is five inches. In general, deserts are defined as areas having less than ten inches of precipitation per year, so it is not surprising that a plot of Las Vegas' climatic factors puts it in the desert region. What about Juneau, the capital of Alaska? Its average temperature is 37° F, and precipitation is eighty-three inches. Juneau is in the temperate rain forest.

Fire

A local effect with major impact on several biomes is natural fire. Particularly in areas with seasonal drying, wild fires ignited by lightning strikes can be a major factor in determining biomes. There are three notable examples in the United States, and two of these regularly make the news. Chaparral vegetation consists of intermixed grassland and shrubby plants adapted to high temperatures and relatively low, seasonal rainfall. This biome dominates the Mediterranean region and also southern California. The shrubby plants are well adapted to fire. In fact, many produce flammable oils and resins that increase the probability that if a fire starts, it will rapidly spread. Fire burns rapidly and the heat destroys only the aboveground portion of native plants. The roots are undisturbed, and new shoots quickly reappear.

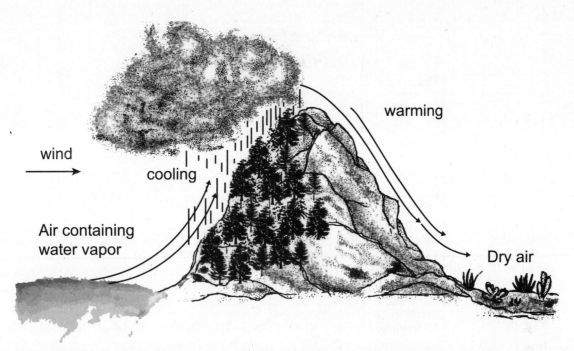

Figure 19-4. Effect of mountains. Mountains affect precipitation patterns when they block moisture-laden prevailing winds. As air rises to pass over a mountain it cools, and water condenses, causing heavy precipitation on the windward side. Dry air passes over the mountain and warms as it descends. Warm air holds more moisture, so these winds tend to be drying and create a rain shadow on the leeward side of the mountain.

The piney woods of the southeast and the grasslands of the central states are also prone to burning. In both of these cases, there is adequate rainfall to promote temperate forests, but the periodic wildfires maintain the dominant vegetation. Fire suppression allows deciduous woody plants to invade.

■ AQUATIC BIOMES

Aquatic life is also divided into zones but the major limiting factor is light. As in terrestrial systems, light is necessary to power photosynthesis for producers in the food web. However, water absorbs light and does so differentially.

Shorter-wavelength, higher-energy light penetrates to greater depth than does light of longer wavelengths. Nevertheless, virtually no light penetrates below 200 meters. The water column can thus be divided into the shallower **photic** zone and the deeper **aphotic** zone. Aquatic environments are also divided based on whether organisms are in contact with the substrate (**benthic** zone) or in the water column (**pelagic** zone). The benthic zone may be either photic or aphotic. Organisms living between the shoreline and the distance from shore where the benthic zone transitions from photic to aphotic live in the **littoral** zone if freshwater or the **neritic** zone if marine (saltwater). The deeper freshwater biome is the **limnetic** zone; the corresponding marine biome is the **oceanic.** The intertidal zone, described in Chapter 17, is at the interface between marine and terrestrial biomes. **Estuaries,** where rivers flow into the ocean, are the interface between freshwater and marine biomes. Estuaries are especially productive zones because of the constant inflow of nutrient runoff from the upstream watershed that is carried downstream by the rivers.

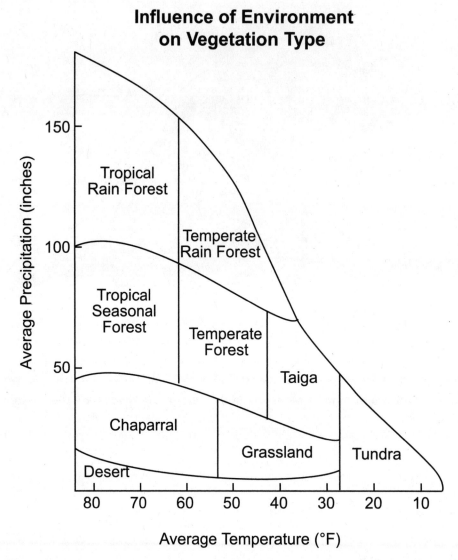

Figure 19-5. Climograph. Average temperature and precipitation are plotted on the x- and y-axes, respectively. By plotting those two climatic factors for any location, the local biome can be predicted.

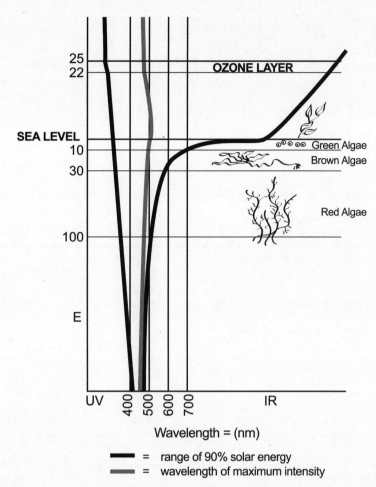

Figure 19-6. Absorption of various colors of light at different depths. Shorter wavelengths have greater energy and can penetrate to greater depths.

Test Yourself

1) Generally speaking, deserts are located in places where air masses are usually
 a) cold.
 b) humid.
 c) falling.
 d) rising.
 e) expanding.

2) Compared to the open ocean, marine life is especially abundant and diverse near the shore because
 a) the open ocean is too salty.
 b) the water is calm near the shore.
 c) the water is warmer near the shore.
 d) there are fewer large predators near the shore.
 e) nutrients are more plentiful near the shore.

3) The sum of all earth's ecosystems is called the
 a) stratosphere.
 b) biome.
 c) biosphere.
 d) landscape.
 e) terrestrial community.

4) Terrestrial communities that occur over wide areas, easily recognized on the basis of their overall appearance, are known as
 a) biomes.
 b) climatic zones.
 c) ecosystems.
 d) land forms.
 e) vegetation types.

5) Which of the following is incorrectly paired?
 a) temperate deciduous forest—a warm summer-cold winter climate with moderate to high rainfall
 b) temperate grasslands—a warm summer-cold winter climate with occasional drought and frequent fires
 c) chaparral—mild and somewhat wet winters, hot and dry summers with frequent summer fires
 d) temperate rain forest—long and extremely cold winters, cool wet summers

6) Historically, in the North American interior, grasslands were protected from the encroachment of forests by

 a) fires.

 b) heavy rainfall.

 c) winter snow.

 d) periodic flooding.

7) Timberline occurs at certain levels in the Rocky Mountains, measurable in distance above sea level. A similar timberline marks the boundary between taiga and tundra and occurs on a horizontal land surface, measurable in

 a) distance inland from the seashore.

 b) British thermal units.

 c) isobars.

 d) isochrones.

 e) degrees of latitude.

8) Seattle is about 75 miles due east of Quinault, Washington. Quinault receives more than 150 inches of precipitation per year, but Seattle receives less than 30 inches. This is because

 a) Seattle is farther south, slightly warmer, and, therefore, drier.

 b) Quinault is closer to the ocean and more affected by storms.

 c) Quinault receives more runoff from the nearby snow-capped peaks.

 d) Seattle is in the rain shadow of the Olympic Mountains.

 e) Seattle has a higher population and, therefore, uses more water.

9) In the northern hemisphere, the days are longer in the summer because

 a) the earth is closer to the sun in summer than in winter.

 b) the earth's axis of rotation shifts more toward the sun in summer.

 c) the speed of earth's rotation slows when earth is closer to the sun.

 d) the earth's axis of rotation stays the same, but the sun is directly over the Tropic of Cancer in summer.

Test Yourself Answers

1) **c.** Major convection currents of warm, moist air rising in the tropics, lose their moisture through condensation at high elevation and descend at about 30° north or south of the equator. As these air masses descend, they warm and begin to absorb moisture from their surroundings.

2) **e.** Near the shore there is a constant source of nutrients that arrive as runoff. The nutrient-rich substrate is also within the photic zone, so plants will prosper at the base of the food web. The temperature of water is often dependent on the currents, which may be cool or warm near the shore.

3) **c.** The broadest scale of biotic and abiotic interactions, the sum total of all the ecosystems, is the biosphere.

4) **a.** Terrestrial biomes are determined primarily by climatic factors and are recognized by their general plant cover. They occur over wide areas.

5) **d.** A temperate rain forest may be cool, but not extremely cold for long durations.

6) **a.** Like chaparral plants, the roots and crown of grasses grow beneath the soil surface and are protected from fierce rapid burns that destroy young trees and seedlings.

7) **e.** The tundra is a circumpolar band of treeless biome at the highest northern latitudes. It is bounded on the south by taiga, which also occurs in a broad band around the northern hemisphere. The boundary between the two is measured in degrees of latitude above the equator.

8) **d.** Quinault is on the windward side of the Olympic Mountains and receives heavy rainfall as the prevailing westerlies drive moist air masses up and over the mountains. The drier air coming down the leeward side moves on to Seattle.

9) **d.** The tilt of the earth's axis of rotation stays constant at 23.5° throughout the year, but the earth cycles around the sun. In the summer, the northern hemisphere receives more direct light from the sun, and the day's length is of longer duration, because more of the hemisphere is exposed at any one time.

Behavior

Behavior is traditionally defined as the reaction of an animal to environmental stimuli or to other individuals. It is an observable response often associated with muscular activity. Behavioral questions fall into two categories, and they should not be confused. **Proximal** questions relate to immediate causes of a behavior. They are usually associated with direct environmental stimuli and an immediate response that might be anatomically or physiologically based. Much current interest is in the genetic basis of the response. **Ultimate** questions relate to the evolutionary significance of the behavior. It is critical that such questions be addressed in testable experiments.

■ BEHAVIOR OF INDIVIDUALS

The earliest work in behavioral ecology studied the response of individual animals in their natural environment. What different mechanisms could be identified? When are these behaviors important during the lifetime of the animal? How does the behavior effect survival and reproductive fitness?

Fixed Action Patterns

Fixed action patterns (FAPs) are innate behaviors that show little variation from one individual to the next. Innate implies that they are genetically controlled, not learned. Within a species, this type of behavior is stereotypical. For example, a certain species of spider builds a certain type of web that is distinguishable from that of other species. Finally, the behavior consists of a specific sequence of action. Once begun, it will proceed to completion, even if the original stimulus is removed.

What is the stimulus that triggers FAPs? The particular stimulus can be quite variable, but it is always simple. A particular color patch, such as a red underside on a stickleback fish, can provoke a response, as can a particular occurrence such as an egg rolling out of a goose nest.

Learning

Learning occurs when behavior changes in response to a particular event experienced by the individual. Physiologically, it involves changes in the cells of the nervous system.

One of the simplest types of learning is called **imprinting.** The classic example of imprinting occurs with some species of newly hatched birds. During a short critical period immediately after hatching, the first moving object the hatchling sees is imprinted as its mother. Conservation biologists take advantage of this in captive breeding programs for rare and endangered birds. Hand puppets have been successfully used to feed hatchlings of a number of species including the California condor. Perhaps the most elabo-

rate example is "crane-suited" biologists flying ultralite planes to guide the migration of captive-bred whooping cranes. Even more remarkable is the fact that, later in life, male birds that were imprinted to humans exhibited courtship displays toward humans in preference to female birds! Imprinting occurs only during a brief period shortly after birth but lasts throughout the animal's life.

A fascinating aspect of learning concerns how animals learn to recognize landmarks in their environment—**spatial learning.** Some of the simplest experiments involve solitary insects that learn patterns of landmarks that mark nest locations. Both shape and pattern can be important cues. In one case, it may be smooth stones, in another, rough pinecones. The spatial position of the landmarks with respect to one another may be important as well as the number of landmarks. If the pattern is repositioned by the researcher away from the nest, the insect will home in on the pattern rather than on the nest itself.

A more complex pattern of learning occurs when an animal associates one aspect of the environment with another feature. An example of this **associative learning** is when a bird learns to associate a particular bright color pattern, such as that of a monarch butterfly, with a noxious taste. After one or two encounters, the bird learns to avoid potential prey that look like the offender. A special case of associative learning is **classical conditioning.** In this behavior, the animal learns to associate an arbitrary stimulus, such as a sound or chemical, with a particular reward or punishment. The animals are trained by experience to give the same response to two or more stimuli that are presented simultaneously. After several exposures to the stimuli, followed by the reward or punishment that elicits a response, the animal will continue to respond to a stimulus even if no reward or punishment is given. A second special case is a type of trial and error learning. In **operant conditioning,** the animal learns to associate one of its behaviors with a reward or punishment. It then tends to either repeat or avoid that behavior to gain the reward or avoid the punishment.

Cognition

Unlike the various forms of learning, **cognition** cannot be observed directly. Instead, experiments must be designed that require animals to manipulate information is a way that infers conscious thinking. The animal must form new associations or insights. In many instances, this involves the use of tools to perform a task. For example, chimpanzees and several species of birds fashion tools out of twigs or sticks that are used to "fish" for insects in nests or crevasses. During cognition, the nervous system must perceive and store information, process it, and then elicit a complex response.

Orientation

The simplest form or orientation behavior is **kinesis,** which resembles the activity of some simple toys.

With **kinesis,** movement is random but rapid until an obstacle is encountered or the organism reaches a region with optimal conditions. Hitting an obstacle elicits a change in direction. Reaching a favorable environment causes the organism to slow or stop its movement.

Taxis is movement in a particular orientation relative to the direction of a stimulus. Taxis may be positive or negative. For example, many organisms show negative taxis toward light, moving from light toward dark. Others are positively phototactic, moving toward light. A common positive taxis is toward a chemical source along a chemical gradient.

The most intriguing orientation behavior is **migration.** Birds, in particular, are known for their long-distance seasonal migration routes, but other animals—from butterflies to whales—also migrate. The ultimate question, why animals migrate, is relatively straightforward: to feed and breed. The temperate and polar regions are characterized by seasonal environmental changes. Summers have long days with optimal growing conditions for many organisms. Winters bring severe conditions with reduced productivity. Animals migrate to avoid severe conditions and maximize the utilization of their resources.

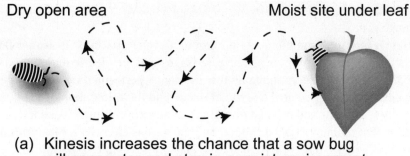

Dry open area Moist site under leaf

(a) Kinesis increases the chance that a sow bug
will encounter and stay in a moist environment.

Direction
of river
current

(b) Positive rheotaxis keeps trout facing into the current,
the direction from which most food comes.

Figure 20-1. Simple orientation. Simple orientation to the environment may be random movement (kinesis) or in reference to a directional gradient (taxis).

More difficult to understand is the proximal question of how animals orient during their migration. In most specific cases, we simply do not know. However, several different mechanisms have been demonstrated in particular species. Many birds seem to depend on **piloting,** a long-distance type of spatial recognition. Offspring learn migration routes by following parents. Other animals essentially **compass orient.** Like sailors, they are able to determine their position relative to the sun, the stars, magnetic flux, or a combination of these. Any sailor knows that it is not enough to simply know the position of the sun or stars. You must also know the time. Eukaryotic organisms have a built-in physiological clock that determines circadian rhythms. Migratory animals somehow combine their physiological clocks and physiological compasses to accurately determine their location. How they do this is mostly unknown, but we do know that it is under genetic control.

■ GROUP BEHAVIOR

The behaviors described in the preceding section are mostly individual, but several suggest interaction between individuals. For example, during migratory piloting, the young are positively influenced by parents. But many behaviors show strong group interaction or social behavior. For this to occur, there must be some kind of communication between individuals.

Communication

Communication is transmission of some kind of signal from one organism to another that causes a behavioral change in the recipient. We are most familiar with **auditory** communication such as human speech. Bird songs and insect calls are among the most widely studied non-human auditory modes of

communication. Such communication is frequently associated with mating, but it is also common as a method for warning.

Less well known is **visual** communication, although even here, most of us are familiar with body language. Without speaking, we are often sending messages that are clearly understood by those who see us. The classic example of visual communication is the dance performed by a honey bee upon returning to its nest from a new source of nectar. The type of dance and the orientation of the bee during its dance tells the rest of the hive how far and in what direction the new food source is located.

The most subtle, but often most powerful, communication is **chemical. Pheromones,** chemical substances often involved with sexual attraction, are the classical example. Pheromones are odors that may seem imperceptible when they are released in low concentration by an animal. Nevertheless, they can have dramatic impact on the behavior of the animal receiving the stimulus. Other common pheromones involve alarm substances released when an animal is injured. These substances elicit a fright response in all other animals of that species in the vicinity.

Altruism

All the behaviors discussed so far can be thought of as selfish—that is, an individual animal benefits from the behavior, regardless of what happens to the rest of its population. It is easy to understand the ultimate advantage of this type of behavior. The individual that benefits will more likely be successful in reproducing and passing on its genes to the next generation. This then makes unselfish behavior that benefits the group despite possible harm to the individual (called **altruism**) difficult to understand.

This seeming discrepancy—behavior that sacrifices individual good for the good of the group—is best explained genetically by a process proposed by William Hamilton. Altruistic behavior has a benefit to the group and cost to the individual, both of which can be measured in terms of offspring produced. The benefit is the *extra* offspring produced because of the altruistic behavior. The cost is the *decrease* in

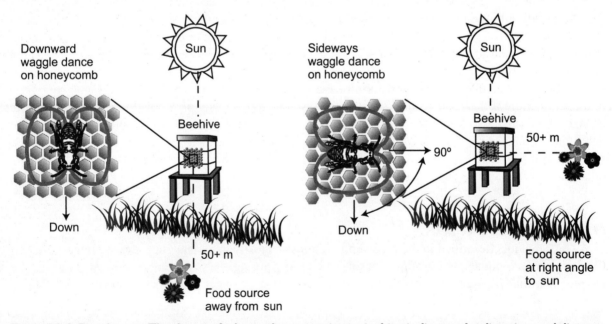

Figure 20-2. Bee dances. The dance of a honey bee returning to its hive indicates the direction and distance of a food source from the hive. Orientation of the straight line of the dance indicates directional angle from the sun. Down is away from the sun, up is toward the sun. A waggle during the straight line portion indicates a distance of greater than 50 meters from the hive.

offspring from what is normally expected. The third factor that comes into play is the coefficient of relatedness between individuals in the population. The more closely related the individuals in the group are, the greater the coefficient of relatedness and the more likely some of an individuals genes will be passed on despite the fact that the individual may die or have reduced reproductive output. This type of behavior that increases the probability of reproductive success by the relatives of an individual is now known as **kin selection.**

Test Yourself

1) A male turkey was imprinted to humans and subsequently reared with a flock of "normal" turkeys. When sexually mature, it directed its courtship preferentially to

 a) other turkeys in preference to humans.

 b) inanimate objects in preference to other turkeys.

 c) humans in preference to turkeys.

 d) only female turkeys but not males.

 e) only male turkeys but not females.

 The next two questions are concerned with the following situation. In the Chimpomat experiment, chimpanzees were shown how to insert coins in a machine and obtain grapes. After they had learned this, coins of different kinds were introduced, some of which would deliver more grapes than others. The chimpanzees soon learned to prefer the coins that produced more grapes. Then a work machine was installed. If the chimpanzee would work on the machine for a time, it would deliver a coin. In the second part of the experiment, chimpanzees were permitted at the work machine only occasionally. Between times, they got no food. When exposed to the machine, some chimpanzees would work vigorously for coins, go immediately to the grape machine and use them all. Others would take their coins and hide some of them. During the intervals when not permitted at the work machine, they would return and get their hidden coins to obtain grapes.

2) The *most significant* conclusion to be drawn from the first part of this experiment is that chimpanzees

 a) can copy human procedures.

 b) like to work.

 c) can distinguish one coin from another if the coins are observably different.

 d) can recognize different values of coins.

 e) realize that work is essential for survival.

3) The *most significant* conclusion to be drawn from the second part of the experiment is that

 a) all chimpanzees will work if they must.

 b) some chimpanzees are loafers while others are diligent.

 c) chimpanzees have an instinct for hoarding.

 d) some chimpanzees have a more intense hunger drive than others.

 e) some chimpanzees can plan for the future.

4) When nest building, a Fisher's lovebird cuts long strips of vegetation and carries them to the nest site one at a time in its beak. The peach-faced lovebird cuts short strips and carries them to the nest tucked under back feathers. A hybrid offspring cuts intermediate sized strips and attempts to tuck them under back feathers before carrying them in its beak. What does this demonstrate about behavior?

 a) Behavior can be learned from parents.

 b) There is a genetic basis to behavior.

 c) Environment is important in forming behaviors.

 d) Lovebirds can be trained easily.

 e) The smaller the strip, the easier it is to carry.

5) What do we call the type of learning in which an arbitrary stimulus is associated with a reward or punishment?

 a) classical conditioning

 b) trial-and-error learning

 c) positive or negative rewarding

 d) programmed learning

 e) imitation

6) Several primates have been taught to communicate with humans using sign language. This supports the view that animals other than humans undergo what process?

 a) imitation

 b) cognition

 c) association

 d) trial and error

 e) classical conditioning

7) Anthropomorphism is the tendency for people to ascribe human emotions to other animals, for example, a dog is "happy" when it wags its tail. What form of learning would be most likely to incorrectly reinforce anthropomorphism?

 a) association

 b) classical conditioning

 c) habituation

 d) imitation

 e) cognition

8) Altruistic behavior enhances the evolutionary fitness of a population through kin selection. This means

 a) an individual benefits through selfish behavior.

 b) the altruistic individual is more likely to reproduce.

 c) close relatives of the altruistic individual are more likely to reproduce.

 d) more complex behaviors will evolve.

 e) the altruistic individual mates only with close relatives.

9) Which of the following terms broadly describes any kind of interaction between two or more animals?

 a) fixed action pattern

 b) migration

 c) imprinting

 d) taxis

 e) social behavior

10) Which of the following is *not* a navigational component for successful long-distance migration to occur?

 a) observation of sun or stars

 b) internal timekeeping

 c) spatial recognition

 d) group or social behavior

 e) All of the above are necessary.

Test Yourself Answers

1) **c.** With imprinting, the "mother" image is fixed immediately after birth or hatching. For the male turkey, the implanted image of female is a human.

2) **d.** The chimpanzees can distinguish one coin from another, but more significant is that they can learn that different coins have different values.

3) **e.** Both parts of this experiment demonstrate cognition by the chimps, but the second part is more sophisticated because it demonstrates the ability for long-term planning.

4) **b.** Nest building is an example of a fixed action pattern. Offspring do not observe parental nest building, so they cannot learn this behavior from parents. The intermediate nature of the offspring behavior between that of two parents with markedly different behaviors is a strong indicator of a genetic basis.

5) **a.** Associative learning occurs when one stimulus is associated with another sensation. A special condition, classical conditioning, occurs when the sensation is a reward or punishment.

6) **b.** Communication involves the association of abstract ideas with particular behaviors—a high order level of cognition.

7) **e.** Cognition was once thought to occur exclusively in humans. Thus, the attribution of particularly human emotion to other animals, anthropomorphism, may easily, but incorrectly, be associated with cognition.

8) **c.** An altruistic individual sacrifices its personal reproductive ability, but in doing so, increases the likelihood that close relatives will reproduce and pass on some of the genes shared with the altruist.

9) **e.** Interaction between two or more animals is group or social behavior.

10) **d.** Although most obvious migrations are by groups, individual animals are also capable of successful migration. Orientation during migration depends to varying degrees on visual observation of landmarks, the sun, and/or stars, as well as the internal physiological clock of circadian rhythms.

Conservation

I f you surveyed the general public to find out what is perceived as the most serious threat to the biosphere, you would come up with a list headed by such things as toxic wastes, air or water pollution, or perhaps global warming. A survey of ecologists would place loss of biodiversity at the top of the list. What is biodiversity and why is it so important?

■ BIODIVERSITY

In its broadest terms, *biodiversity* is the total variation of all living things. It includes genetic variation within a species, variation between species, and variations in specific ecosystems.

Genetic Diversity

Within a population of organisms, the total of all the alleles of all the genes found within that population is the **gene pool.** The larger the gene pool, the greater the genetic diversity. In general, large populations with many individuals tend to have greater genetic diversity.

For widespread species, there may be more than one recognizable population. For example, leopard frogs are found throughout the United States, but populations in New England are different from those in the Midwest or in western states. The genetic diversity for the species includes that of all populations of the species.

Genetic diversity may be difficult to ascertain based simply on population size. Some populations, even if they are of reasonable size today, have gone through genetic bottlenecks that limit genetic diversity. If a population was reduced to a few individuals, but later is protected and begins to grow, the genetic diversity is limited to that which was present in the original bottleneck population. For example, many of the large cats fall into this category, including the Florida panther in the United States.

Species Diversity

How many species are there? The numbers vary considerably. Not quite 2 million species of all organisms have been named out of an expected total of from 10 million to 200 million total. Why is there such a discrepancy in the estimates? Ask ten people to name a living thing and nine of ten responses will probably be something furry (mammal) or feathered (birds). These include the most conspicuous organisms around us, but they are also some of the least diverse. For example, fewer than 5,000 mammal species are known worldwide and fewer than 10,000 birds. We are confident of these numbers because

Counting Earth's Species

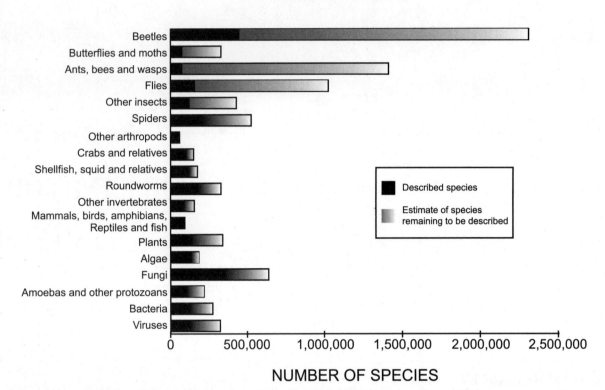

NUMBER OF SPECIES

Figure 21-1. Numbers of species. Estimates of the number of described species (dark bar) and additional undescribed species (light bar) for various taxa. The top five categories are all insects. All vertebrate species are lumped into a single (smallest) category.

they are conspicuous animals, easily observable not only by scientists, but also by the general public. Most have probably already been discovered and named.

It is possible for one person to know all the names of all the birds or mammals in many small countries, states, or regions. But how about the fungi? Few specialists study fungi, yet more than 100,000 species have been named, mostly from temperate regions. If fungi are like birds or mammals, there are more than ten times this many in the tropics, mostly unnamed and undiscovered. And then there are the insects. The top five rows in Figure 21-1 are all insect species!

There are some species we know from recorded history that no longer exist on earth, they are **extinct.** Extinction is not a newly described concept. Fossils are evidence of previous life forms that no longer exist—they are extinct. What is relatively recent is the realization that some plants and animals that were well known in the past can no longer be found. For example, based on collections made during the past 500 years, we know of approximately 20,000 plant species native to the United States. We know that more than 200 of these are now extinct because they no longer grow where they were originally collected and a living specimen has not been seen for more than fifty years. Based on the record of known extinctions, we can project an inverse relationship between human population growth and total species diversity on earth.

Since the late 1960s, there has been a growing concern about the loss of species diversity, particularly in the United States. This led to the passage of the Endangered Species Act. According to this law, an **endangered species** is ". . . in danger of extinction throughout all or a significance portion of its

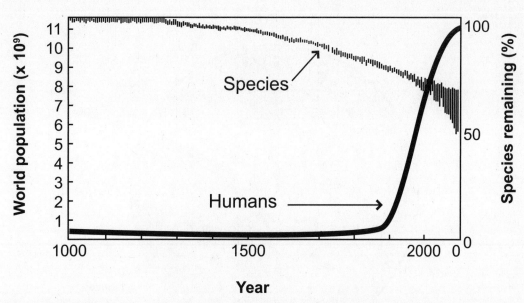

Figure 21-2. Species diversity versus human population growth. Inverse relationship between human population and estimated percent of extant (living) species since 1,000 A.D.

range." This law also recognized **threatened species** that are considered likely to become endangered in the near future. Threatened and endangered species are protected by law in an effort to prevent their extinction. More than 1,400 species in the United States are listed as threatened or endangered or have been proposed for listing. Worldwide, the number is greater than 3,500.

Ecosystem

Although ecosystems are large-scale units, even they can be threatened or lost. The interconnectedness of food webs (see Chapters 17 and 18) suggests how an entire ecosystem can become vulnerable to loss. Organisms at every trophic level are interconnected to many other organisms. Removing one species will have some effect, often unforeseen, at every other level.

■ WHY IS BIODIVERSITY IMPORTANT?

The importance of biodiversity can be explained at many levels, but in terms of the general public, the most effective approach is to provide concrete examples of direct benefit.

Direct Benefits of Biodiversity

The obvious importance of biodiversity is in providing food and shelter for humans. The source of genes for improving productivity, nutritional value, disease resistance, structural properties, and so on, are in those wild plants and animals related to the species we have domesticated. If we lose the wild relatives, we lose the opportunity to continue to improve the species upon which we depend.

A less obvious direct benefit to humans is medicine. More than half of the drugs listed in the *U.S. Pharmocopea* (a listing of all drugs approved for use in the United States) were originally derived from plants or based on plant extracts. Several of our most potent anti-cancer drugs are still derived from plant extracts, including taxol from the bark of the western yew tree and vinblastine from rosy periwinkle. Bacteria are the single largest source of antibiotics, and a variety of animal toxins are now being investigated for potential use in treating a variety of nervous disorders. Bacterial drug resistance is a growing

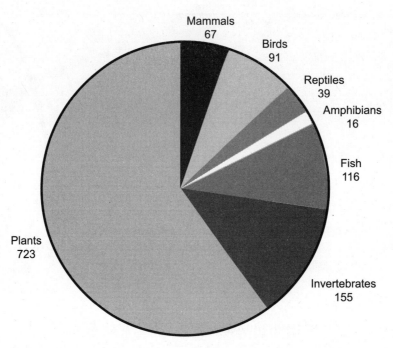

Figure 21-3. U.S. threatened and endangered species. Listed threatened and endangered species in the United States, grouped by major taxa. Only plants and animals are considered for listing.

Threatened Species

Taxon	# Listed as Threatened	% of Total
Vascular Plants	33,798	12.5
Mammals	1,096	25.0
Birds	970	11.0
Reptiles	253	20.0
Amphibians	124	25.0
Fishes	734	34.0

IUCN-World Conservation Union 1996 (animals), 1998 (plants)

Figure 21-4. Worldwide threatened and endangered species. Number of worldwide species listed as threatened by major taxonomic group. The percentage of the total is for named species. One-third of all known fish species and one-quarter of all known mammals and amphibians are considered threatened.

problem, and some bacterial infections are now at least partially resistant to virtually all of our known antibiotics. Who knows what potential cures for human diseases we will lose as more species go extinct?

Indirect Benefits of Biodiversity

The indirect benefits can be seen only by those educated about the interactions and interdependency of organisms in an ecosystem. For example, plant coverage determines the size of the base of the food web. It does not matter what species of plant is photosynthesizing, it may frequently be weedy or inconspicuous. Yet it is filling a niche in its community that would be unfilled if it were lost. Decreasing plant biodiversity will automatically decrease the overall efficiency of photosynthesis in a community, which, in turn, will decrease overall productivity.

Symbiotic interactions, often unrecognized, are essential for the simultaneous survival of two species. If a pollinator is lost, the plant it pollinates will not reproduce. During the past two decades, populations of colonial bees have decreased dramatically to the point where it is affecting agricultural production in many parts of the country.

■ THREATS TO BIODIVERSITY

Unfortunately, all the major threats to biodiversity are tied to a single species—humans—and this helps to explain the relationship in Figure 21-2. The four greatest threats to biodiversity are habitat destruction, introduced species, pollution, and overexploitation of species.

Habitat Destruction

It is not surprising that **habitat destruction** is the primary threat to biodiversity, and it is also not surprising that increasing land use for agriculture (affecting 38 percent of threatened species) and commer-

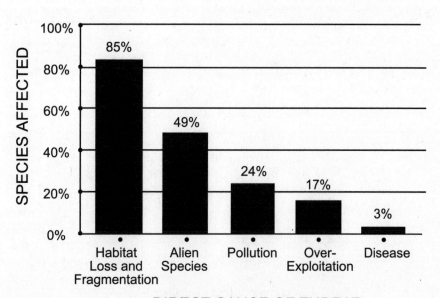

Figure 21-5. Threats to biodiversity. Habitat loss and fragmentation is the single largest threat to species diversity in the United States, followed by alien species, pollution, and overexploitation.

cial development (affecting 35 percent of threatened species) are the two leading causes. The best farmland in the world, the corn and wheat belts of the United States, cover most of the original prairie ecosystem. Some of the major urban areas in the country (Indianapolis, Minneapolis/St. Paul, Kansas City, Omaha, and so on) are spreading on top of prime cropland. Water development or wetland loss is nearly as great (30 percent). Most prairie wetlands have been drained and water development, particularly dams and impoundments, have had a significant effect on aquatic species. Outdoor recreation, particularly the use of off-road vehicles, affects 27 percent of threatened species, mostly plants, while extractive land use, such as grazing, logging, mining, has an impact on 45 percent of threatened species. To most people, habitat destruction seems innocuous. Diverting a stream, building a new road, or even building a new subdivision seems to have a minor impact. Yet, many minor alterations can produce a major impact. The relationship between habitat loss and loss of species diversity is not linear. As habitat declines, the greater proportions of species are threatened with extinction.

Introduced Species

Alien species are species not native to an ecosystem that have been introduced from another area. If well adapted to their new home, they may spread unchecked because they have no natural predators to hold their population in check. Such an alien species earns the moniker **invasive species.** Many invasive species are exotic plants or animals that people purposely bring to an area because of their attractive flowers or other desirable features. Kudzu, for example, was introduced into the United States because of its

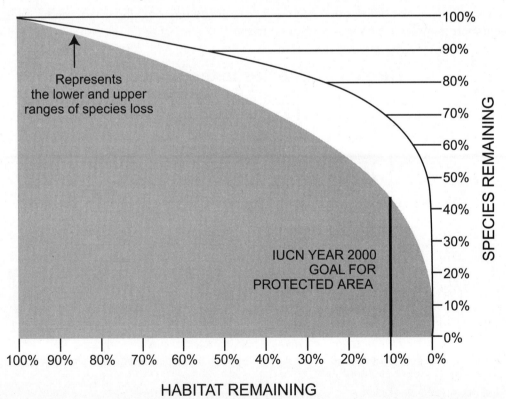

Figure 21-6. Habitat loss and species numbers. High (light) and low (dark) estimates of the percentage of species loss versus the percentage of habitat remaining. Species loss increases exponentially as habitat decreases.

potential for managing soil erosion. Others are "volunteers" that were introduced by accident. A classic example is the zebra mussel that has spread throughout the Great Lakes and Mississippi River system during the past two decades. Humans may introduce alien species on purpose or accidentally, but regardless of the method of introduction, the consequences can be disastrous.

Plants, birds, and fish species are especially susceptible to competition from alien species. Especially sensitive are small areas containing large numbers of **endemic** species, species unique to an area and found no where else on earth. The State of Hawaii is a clear example. A high proportion of all species in Hawaii are endemic; most of the threatened species in the United States occur in Hawaii.

The Office of Technology Assessment estimates that there are more than 4,500 alien species now established in the United States, and the number is increasing.

Pollution

Pollutants, including agricultural and urban run off, siltation, and mining pollution, are the single greatest threat to aquatic species, especially in the eastern United States. In the west, dams and impoundments are equally important. Traditionally, running water was viewed as a convenient method for waste disposal, moving it away from sites of human habitation. Even today, there is resistance to increasing treatment levels at point sources such as sewerage treatment plants and industrial plants. Non-point sources (runoff) are difficult to control.

Overexploitation of Species

The impact of **overexploitation** is difficult to determine. The relatively large numbers of species affected include many animals that were formerly hunted, such as wolves, whooping cranes, and the

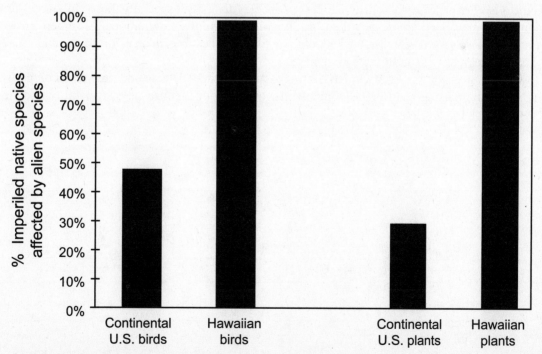

Figure 21-7. Imperiled U.S. bird and plant species. Comparison of the impact of alien species on bird and plant species in the continental United States and the State of Hawaii. Nearly all the populations of these taxa are threatened in Hawaii.

California condor. Of particular concern today are the depletion of fish stocks. Ecologist Stuart Pimm suggests a practical demonstration of this problem. *The Joy of Cooking* cookbook has gone through more than a dozen editions since it was first published in 1931. Compare the number of recipes for various fish species. For example, in the 1943 edition, there were four for red snapper and five for halibut. By 1975, this was reduced to one and zero, respectively. As fish stocks are depleted, the number of recipes for that species decline and are replaced by recipes for formerly less desirable species.

■ CONSERVATION STRATEGIES

The first step in any conservation strategy is to recognize the problem. Scientists have been aware of this for decades, but only recently has the general public begun to take notice. Further public education will be required to develop the political will to implement any strategy.

Population Conservation

The most successful strategies deal with efforts to rescue individual species from possible extinction. These usually involve celebrity species—birds or large mammals to which humans can easily relate. The efforts are to first determine the **effective population size,** the minimum number of individuals that will be self-sustaining. Once this is determined, the next step is to bring the population to that size by controlled breeding. Simply breeding to increase the number of individuals is not sufficient. Efforts must be made to increase genetic diversity by carefully selecting mates. Zoos have taken a leading role in this program, particularly for large mammals, and regular exchanges of captive animals are made specifically to widen the gene pool of rare species.

Landscape Conservation

Some areas are particularly sensitive to loss of species diversity, especially those with large numbers of endemic species. Such areas are called **biodiversity hot spots.** International biosphere **preserves** and/or national parks have been established in many of these locations in an effort to maintain the habitat diversity necessary to support the communities.

How large an area is necessary to have a successful preserve? This is one time when bigger is better. Plants and animals have different requirements, but none of them respect artificial boundaries, so

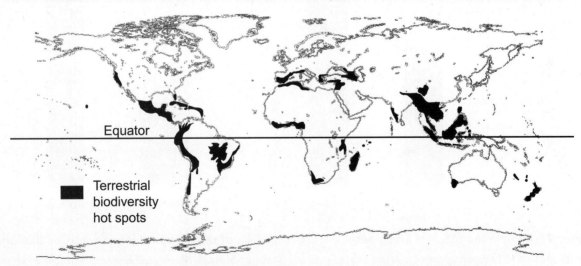

Figure 21-8. Locations of biodiversity hot spots throughout the world.

compromises must be made. One solution is to provide **corridors** between established preserves or to bypass human perturbations such as roads. An interesting example is in the Canadian Rockies where wide grassy overpasses have been constructed over the Trans-Canada Highway to allow animals to cross from one side to the other. Extended **buffer zones** around parks is a strategy being tested at Yellowstone.

Restoration

Restoration attempts to return a degraded ecosystem to a more natural state. Restoration of lost habitat first involves removal of any man-made structures. During the past decade, for example, we have begun to remove many small dams that were constructed in the past, and even some large dams are being considered for removal.

Eradication of alien species, once established, is not possible. However, it may be possible to control their growth and spread. In some cases, this involves physical or chemical means, such as herbicides or pesticides but, increasingly, it involves **biological control.** Natural predators can be imported and established to control the original alien. Of course, there is always the potential of introducing a worse problem than the one that was being corrected, so extensive studies must be done in advance.

Bioremediation, the use of organisms to detoxify pollutants, is increasingly used to clean up pollutants. Bacteria are particularly useful because of their ability to evolve rapidly. Toxic sites naturally selected for resistant bacteria can then be used to detoxify other areas.

Test Yourself

1) The lowest species diversity would be found among
 a) fungi.
 b) flowering plants.
 c) insects.
 d) birds.
 e) mammals.

2) Which of the following is not a direct benefit of biodiversity for humans?
 a) source of germplasm for plant and animal breeding
 b) source of pollinators for crop plants
 c) source of potential drugs
 d) source of potential new food crops
 e) source of potential antibiotics

3) Habitat destruction is the primary threat to biodiversity in the world. The greatest cause of habitat destruction is
 a) wildfires.
 b) floods.
 c) hurricanes.
 d) earthquakes.
 e) humans.

4) The most endemic species would be found in the state of
 a) Alaska, because it is the largest state.
 b) Rhode Island, because it is the smallest state.
 c) California, because it is the most populous state.
 d) Hawaii, because it is an island state.
 e) Kansas, because it is in the middle of the country (lower forty-eight states).

5) An alien species is
 a) an animal that migrates over long distances.
 b) a microbe introduced from outer space.
 c) a non-native organism introduced from another ecosystem.
 d) a species that is unique to an area.
 e) any carnivorous plant that eats animals.

6) Zoos cooperate to conserve endangered animal species. Why is it impossible for a single zoo to breed a sustainable, diverse population on its own?

 a) Genetic diversity requires a large gene pool contributed to by many individuals.

 b) Males and females may not be receptive at the same time.

 c) Zoos could not afford to feed the large herds that would result from a continual breeding program.

 d) Zoos do not have the space necessary for the large herds that would result from a continual breeding program.

7) Which of the following would most likely be a strategy to establish a successful biodiversity preserve?

 a) Set aside a large national park, such as Yellowstone National Park.

 b) Set aside a smaller national park in an extreme environment, such as Death Valley National Park.

 c) Protect a large area around an existing national park, as well as the park, such as the wetlands around Everglades National Park.

 d) Choose an area that is continually changing, such as Hawaii Volcanoes National Park.

8) Which of the following is *not* a significant contributor to water pollution?

 a) agricultural chemicals

 b) urban lawn fertilizers

 c) animal waste from sewerage lagoons

 d) industrial chemicals from chemical plants and storage tanks

 e) All of the preceding are significant contributors.

9) Extinction

 a) does not occur in modern times.

 b) is restricted to tropical forests in Third-World countries.

 c) occurs at a faster rate today than it did 100 years ago.

 d) occurs only to fossil organisms.

 e) Choices a and d are correct.

10) Of the items listed below, the most serious threat to the biosphere is

 a) toxic wastes.

 b) air pollution.

 c) water pollution.

 d) loss of biodiversity.

Test Yourself Answers

1) **e.** Although most of the animals we usually think of are mammals, there are fewer than 5,000 known mammal species in the world. There are twice as many bird species and more than 20 times as many fungi, flowering plants, and insects.

2) **b.** Each of the items listed is a benefit of biodiversity for humans, but pollinators are an indirect benefit that promotes food production.

3) **e.** The greatest impacts on habitat destruction are due to agriculture, commercial development, urbanization, and wetland loss—all caused by humans.

4) **d.** Hawaii, an oceanic island far from any other land is least likely to share species with other states and, therefore, most likely to contain large numbers of endemic species.

5) **c.** An alien species may be a plant, an animal, or any other type of organism that is not native to an ecosystem, but has been introduced from another area.

6) **a.** Genetic diversity requires a large gene pool. To maintain genetic diversity in a captive breeding program, you do not want close relatives to mate; rather, you want to promote mating between unrelated individuals. A zoo population of any animal species will become more and more inbred over time unless a breeding program is established with animals from another population.

7) **c.** In general, the larger the area, the more biodiversity will be supported. Because wild organisms do not recognize political boundaries, a buffer zone should be provided around the most highly protected areas.

8) **e.** Each of the sources listed contributes either to surface water or ground water pollution to a significant degree.

9) **c.** Extinction is occurring at a faster rate today than at any time since the last major extinction event more than 60 million years ago. The rate of species extinction is directly related to human population growth.

10) **d.** Loss of biodiversity is considered the greatest threat to the biosphere.

Evolution

Descent with modification was Charles Darwin's term for what we now know as evolution. The idea that organisms evolved was not a new concept with Darwin. Several earlier scientists, including his grandfather, Erasmus Darwin, had proposed mechanisms to explain how species change and new species arise. Biology was ripe for discovery. But this, too, was not unique. Although physics and chemistry entered the modern age of science a century earlier, geology and biology were just beginning to challenge old theories and test new ones. Charles Darwin, with training both in geology and biology, was receptive to new ideas and recognized the importance of hypothesis testing.

■ PRIOR PERCEPTIONS IN WESTERN CULTURE

Prior to the beginning of European exploration in the late 1400s, western perception of the world was limited to the Mediterranean, Northern Europe, and Western Asia.

The geography of this area continues to have a major effect on the local ecosystems, but it has even greater significance in geologic history. During the glacial period, as mile-thick ice masses extended south, plants and animals from those areas were forced to migrate farther south. In North America, for example, species of pine now growing around the Great Lakes migrated as far south as Florida, as evidenced by their fossil pollen left behind. There was no east-west barrier to migration. In Europe, however, southern migration routes were, for the most part, blocked. Relatively few plant and animal species survived to migrate north as the glaciers retreated (recall genetic bottlenecks discussed in Chapter 21). From the dawn of civilization, there were relatively few large (easily recognizable) plants and animals, and it was easily possible to know the names of all the dominant plants and animals of an area. Furthermore, with a few exceptions (the volcanoes Vesuvius and Etna in Italy, and occasional earthquakes in Asia Minor), the earth was considered to be *terra firma*—solid and unchanging. Sudden creation, and subsequent fixity, of plants and animals and the earth itself was a logical induction.

European explorations to other parts of the world opened new possibilities. Thousands of never-before-described species began to pour back to European museums, and strange new lands were described. Darwin was fortunate to be instructed in geology as Hutton's theory of gradualism supplanted the previously held theory of catastrophism. Rather than a single origin followed by a cataclysmic flood, earth's geology was viewed as undergoing continuous physical change through erosion, sedimentation, and mountain building. Similarly, the diversity of new organisms, evident both from comparative anatomy and developmental studies, as well as plant and animal breeding, had biologists searching for an underlying mechanism to explain the similarities and differences.

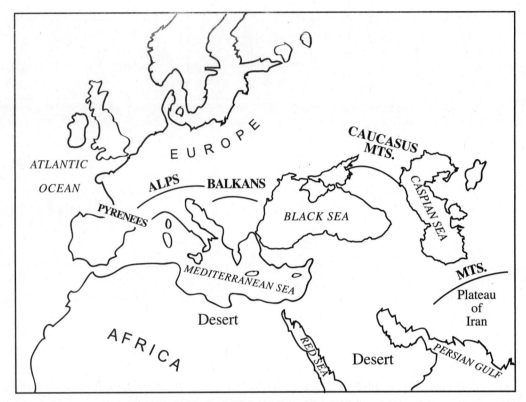

Figure 22-1. Known (western) world before 1500. East-west mountain ranges divided the northern plains of Europe and western Asia from desert lands south of the Mediterranean Sea.

■ DARWIN'S VOYAGE

Darwin graduated from college with the expectation that he would join the ministry. Instead, he had the opportunity to accompany Captain Fitzroy on a five-year voyage around the world on the ship *Beagle*. The *Beagle*'s task was to chart the coast of South America, so for weeks at a time, Darwin could be traveling and collecting specimens inland from where the ship was working. His diary notes were published in a popular account, "The Voyage of the *Beagle*," which is still in print. It is clear from reading this account that several events on the journey made a profound impact on Darwin's thinking.

The first of these was the impact of the tremendous diversity of plants and animals that are found along the Amazon River. The Amazon rain forest is among the most diverse ecosystems on earth. Being a trained collector, particularly of insects, Darwin was quick to notice not only the variety of different species, but also the variation among individuals of a species. Most of us will probably recognize that there can be different numbers of spots on lady bird beetles (ladybugs), but for the most part, a beetle is a beetle. Careful observation reveals a multitude of subtle differences among individuals to the same degree that we recognize among individual people.

Two animals that Darwin took particular note of were the armadillo and the common sloth. Both of these are very distinctive species—once you have seen one, you will not forget it. Later in the voyage, in what is now southern Argentina, some stunning fossils were uncovered along a river bank. Fossils were well known in England and Europe, but these were different. First, they were very large, but more importantly, they closely resembled some of the distinctive animals Darwin had just seen in the Amazon. One was of an armadillo-like animal the size of a farm animal, and the other was obviously a sloth, but taller than a man. The resemblance was too striking to be accidental. They were surely related, although one of

each was long extinct. Also, on the Pampas, Darwin noticed that variation in ostriches, another large and unique animal, had a geographic pattern that was so distinctive that ostriches from one end of the spectrum could not interbreed with those on the other extreme. This suggested a pattern of divergence among living species.

The third event was actually a series of incidents during a transect of Chile. When Darwin left England, he had a copy of the first volume of a new geology text by Charles Lyell. He received a copy of the second volume before the *Beagle* rounded the southern tip of South America. Lyell, the founder of modern geology, proposed a theory of uniformitarianism—that the earth is constantly changing its appearance under the influence of natural forces such as erosion and uplift. More importantly, the changes that could be observed in nature were the same since prehistory and could be predicted to continue into the future. On the coast of Chile, Darwin had an opportunity to make extensive collections of barnacles, mussels, and other invertebrates. Shortly afterward, he had the opportunity to take a pack trip to a pass over the Andes. High in the mountains were fossil shells almost identical to the specimens he had just collected at sea level, embedded in the rocks. Lyell's suggestion would be that the rocks were once below sea level, receiving sediment from above, and that later a series of uplifts raised them thousands of feet. Supporting evidence soon followed when Darwin and his party experienced an earthquake and one side of the street raised above the other. Not only did this support Lyell's theory, it also allowed an estimate for how old the mountains were. According to Lyell, the fossil-bearing rocks were once at sea level. For simplicity, assume that each earthquake causes a fault of ten feet. If the pass was now at 10,000 ft elevation, then there must have been 1,000 earthquakes to cause that much of a rise. If such a strong earthquake occurs once in 100 years, then it must have taken 100,000 years for the mountain to get that high. Even with this simplified example, it is clear that the earth must be much older than the 6,000 years implied by the Bible.

The final event, and the most well known, was Darwin's visit to the Galapagos Islands.

Like Hawaii, the Galapagos Islands are a small group of volcanic islands that have never been connected to the mainland. There are relatively few species, but many are endemic to a single island.

For example, of the seventy-one species of legumes (relatives of peas and beans) found on James Island, thirty were endemic to that island and found no where else in the world. Eight others could be found only on other nearby islands of the group. Only thirty-three occur naturally anywhere else in the world, mostly in South America. This pattern was true for virtually all of the species collected, not just the finches with different-shaped beaks or the tortoises with different-shaped shells that are usually illustrated. But Darwin had not yet noticed this.

The *Beagle* was in the Galapagos Island for only a few weeks, so Darwin's days were busy collecting specimens and his evenings were busy preserving and labeling them and preparing his notes. He did not have time to study the specimens carefully. One day, when he and the ships officers were dining at the governor's house, the governor mentioned that simply by looking at a specimen of one of the giant tortoises Darwin collected, he could tell from which island it was taken. Later, as the ship sailed west across the Pacific, Darwin could examine the specimens and found that, indeed, there were geographic variations from island to island with many of the plants and animals. How could these organisms be so similar from island to island, yet so distinctive? This was a puzzle that he did not solve until later.

■ DESCENT WITH MODIFICATION

The year after returning from his voyage, Darwin began the first of several notebooks recording his thoughts, experiments, and other notes that might help to explain this puzzle. He was soon convinced that in order to remain adapted to their constantly changing environment, species must have altered in the past and were probably continuing to do so. Lyell's geological unformatarianism must have a biological counterpart, which Darwin called descent with modification. But how did this happen?

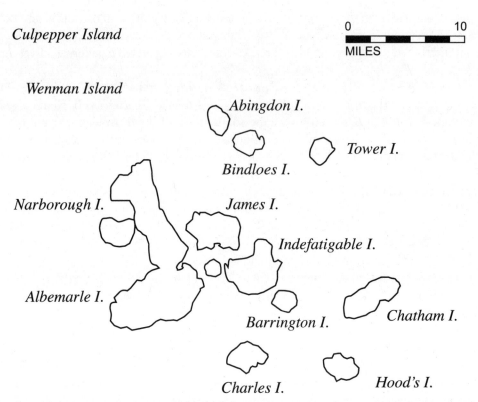

Figure 22-2. Galapagos Islands. The Galapagos are a group of small volcanic island about 600 miles off the coast of Ecuador. The name Galapagos refers to the giant tortoises that are found there.

Name of Island.	Total No. of Species.	No. of Species found in other parts of the world.	No. of Species confined to the Gala-pagos Archi-pelago.	No. confined to the one Island.
James Island	71	33	38	30
Albemarle Island	46	18	26	22
Chatham Island	32	16	16	12
Charles	68	39	29	21

Figure 22-3. Endemic species. The number of species of leguminous plants (relatives of peas and beans) are given for four of the islands. These are broken down into the number of species that are unique to a single island (called indigenous species), and the number found only in the Galapagos Islands but on more than one island.

By 1839, it was clear that Darwin recognized both the importance of sexual reproduction and **random novelties** (mutations) in producing variation within populations (recall Chapters 10 and 11). He had also just read Thomas Malthus's book on population, in which Malthus demonstrated exponential growth in the population of England. From breeding experiments and discussions with farmers, Darwin was aware of how artificial selection was used to improve domesticated species. If populations increased exponentially, competition must soon arise, and some variations would be more favorable than others in

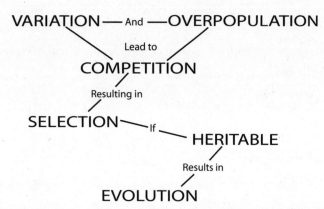

Figure 22-4. Mechanism of evolution by means of natural selection. For natural selection to occur, there must be variation between individuals of a population and rapid growth such that competition for resources develops between individuals. Natural selection ensures that individuals with favorable traits are more likely to survive and reproduce than those who lack such traits. If the favorable traits are heritable and can be passed on to offspring, evolution occurs.

a particular environment. Natural selection would result. Darwin wrote, ". . . it at once struck me that under these circumstances favorable variations would tend to be preserved, and unfavorable ones to be destroyed . . . the result of this would be the formation of new species."

In 1842, he had a summary sketch of his hypothesis that he circulated to some of his friends and by 1844, this was expanded into a 250-page paper. For more than a dozen years, Darwin continued to gather information in support of his thesis and he began to compile it into a book. Then, in 1858, he received a letter from a young naturalist working in the islands of what is now Indonesia. In a few short pages, Alfred Russell Wallace summarized Darwin's thesis exactly. ". . . those which year by year, survived this terrible destruction must be, on the whole, those which have some little superiority enabling them to escape each special form of death to which the great majority succumbed. . . ." That summer, Wallace's letter and Darwin's summary sketch were read jointly at a meeting of the Linnean Society of London. The two shared priority for the idea of descent with modification by means of natural selection. The mechanism of natural selection is summarized in Figure 22-4.

If a population grows exponentially and variation exists between individuals, competition will naturally arise. Those individuals possessing more favorable traits will likely be selected for and survive. If those favorable traits are heritable, they will be passed on to the next generation, and the population will have evolved. Darwin realized that their biggest problem was that they did not have an explanation for how heritability works; nevertheless, the following year, he published *The Origin of Species.*

Test Yourself

1) Which of the following factors is *not* a necessary component of natural selection?

 a) rapid population growth

 b) variation among individuals

 c) competition

 d) human selection

 e) All of the above are necessary.

2) Which of the following assumptions was *not* part of Darwin's theory of natural selection?

 a) Traits are inherited as discrete particles.

 b) The earth is very old.

 c) Populations overproduce offspring.

 d) Organisms compete for limited resources.

3) The major weakness in Darwin's theory was that

 a) there was no explanation of how characteristics are transmitted from parents to their offspring.

 b) the concept of survival of the fittest was omitted.

 c) the concept of natural selection was omitted.

 d) he did not explain how the theory of special creation supported his observations on the Galapagos Islands.

 e) there was no weakness in his theory.

4) All of the following are sources of genetic variation related to sexual reproduction, *except*

 a) crossing over.

 b) production of offspring by two parents.

 c) independent assortment of homologous chromosomes.

 d) mutation.

 e) random fertilization.

5) Evidence that directly supported Darwin's development of the idea that organisms change over time was

 a) the huge number of species he saw in the tropics.

 b) his discovery of large fossil animals in Argentina.

 c) the discovery of fossil seashells high in the Andes.

 d) the general similarity of organisms on the Galapagos Islands to those on the mainland.

6) Species of Darwin's finches differ from one another primarily in

 a) the coloration of their plumage.

 b) the anatomy of the genitalia.

 c) their flying abilities.

 d) the shape and length of their beaks.

 e) their perching behavior.

7) Which of the following ideas was first put forward by Darwin?

a) The earth is much older than 6,000 years.

b) Organisms inherit modifications that the previous generation acquired.

c) Organisms can be arranged by similarities of parts.

d) The unequal ability to survive and reproduce causes gradual changes in a population.

e) All of the above were postulated by Darwin.

8) Natural selection is sometimes described as "survival of the fittest" (although this was not Darwin's terminology). Which of the following measures the "fitness" of an organism?

a) how many offspring it has that survive to reproduce

b) how much food it is able to obtain or make

c) how long it lives

d) how strong it is when competing with others of its species

e) the number of mates it attracts

9) Which of the following was *not* important to Darwin's thinking when he came up with his idea of how evolution works?

a) the geographic distribution of plants and animals

b) artificial selection

c) geographic variation of plants and animals

d) genetics

e) oceanic islands

10) Which of the following is the correct explanation for Darwin's fame today?

a) He was the first scientist to claim that evolution occurs.

b) He demonstrated that only the most fierce animals survive.

c) He provided a viable mechanism to explain how evolution occurs.

d) He was the first to claim that God did not create all the species.

e) All of the above are true.

Test Yourself Answers

1) **d.** Human selection was an example used by Darwin to model how natural selection occurs, but nature replaces humans in natural selection.

2) **a.** Darwin was unaware of Mendelian genetics and that inheritance was due to genes passed from parents to offspring. His Andes' observations confirmed the prevailing geological view that the earth was very old. His studies of barnacles confirmed that organisms can produce many more offspring than survive, and his observations of plants and animals in the wild confirmed that competition for limited resources can be fierce.

3) **a.** Darwin realized that the biggest problem with his theory was the lack of a mechanism to explain inheritance.

4) **d.** Recall from Chapter 10 that crossing over is associate with meiosis and that meiosis and syngamy are the requirements for sexual reproduction, and remember from Chapter 11 that an independent assortment of chromosomes produces random combinations of genes in alleles.

5) **b.** The discovery of giant armadillo-like and sloth fossils on the continent where much smaller armadillos and sloths currently lived suggested that the living animals changed over time from their fossil ancestors. The fossil shells in the Andes suggested that the duration of time was long.

6) **d.** The most distinguishing feature of the different species of finches is the shape and size of their beaks, related to their different diets on different islands.

7) **d.** Lyell's idea of uniformitarianism predicted an old earth, and Lamarck's evolutionary mechanism depended on inherited modifications. Linnaeus grouped organisms based on similarity of parts. Each of these ideas preceded Darwin, whose theory of natural selection depended on unequal survival of individuals and gradual change in the population.

8) **a.** "Fitness," in terms of natural selection, depends on how successful an organism is in reproducing and passing on its favorable characteristics to the next generation. It is not necessarily related to any of the features we tend to associate with human physical fitness, such as strength, endurance, sexual attractiveness, or lifespan.

9) **d.** Although Mendel published his work three years before Darwin published *The Origin of Species* (see Chapter 11), Darwin was never aware of its significance. He did make use of geographic distributions, variation within species, artificial selection (breeding), and the special condition of oceanic islands.

10) **c.** Darwin provided a mechanism, natural selection, that could account for the evolution of new species. Several scientists before him claimed that not all species were created by God, but that natural processes resulted in the evolution of new species. His theory requires that some species are more likely to survive and reproduce than others, but the competition that drives natural selection results from many factors, not just an individual's strength or ferocity.

Supporting Evidence

Charles Darwin understood that his hypothesis would be controversial, not only among the public, but also among scientists. He knew that it would be important to provide strong supporting evidence from as many different perspectives as possible to overcome the natural resistance there would be to such a dramatic change in our understanding of how species, especially the human species, came to be.

■ BREEDING

The first evidence Darwin presented in *The Origin of Species* concerned changes in domesticated species as a result of human breeding. Breeds of animals and varieties of plants were something that most people could relate to, and they understood how human selection during the breeding process maintained breeds and could be used to develop new ones.

Breeds of dogs are something that most of us can relate to. To begin with, there are many different breeds of dogs, from the tiny Chihuahua to the large Great Dane or Saint Bernard. In addition to the physical differences, there are also behavioral differences. Sheep Dogs are good herders, and Hounds have a particularly keen sense of smell. Labradors and other Retrievers are good hunters, while Greyhounds are bred for speed. Furthermore, a breeder wants the "papers" to trace the bloodlines of potential breeding stock. Desirable traits are best maintained through inbreeding.

By breeding varieties of plants and animals, humans have selected certain characteristics as desirable. Plants or animals expressing those traits are chosen to parent the next generation. By selecting for different traits in different populations, those populations begin to differentiate from each other over time. As a result, over time, traits can become fixed in a population, resulting in distinctive breeds within the species. Darwin suggested that man, in utilizing artificial selection to fix traits of interest, was simply controlling the process of natural selection.

■ PLATE TECTONICS

Did you ever look at a map of the world and wonder how the shape of eastern South America seems to fit that of Western Africa?

It was not until the early twentieth century that a hypothesis of continental drift was proposed that would suggest that these two great land masses were once joined. However, it was not until the last half of the century that this idea became generally accepted as the **theory of plate tectonics.** This theory rec-

a. ☐ ~5,700,000 years ago
b. ▨ ~100,000,000 years ago

Figure. 23-1. a) Positions of the continents today. b) Positions of the continents 100 million years ago. Today's North America and Eurasia were connected to form the continent Laurasia. South America, Africa, India, and Antarctica formed the continent Gondwana.

ognizes that the earth's crust is divided into large plates floating over the deeper mantle. These plates are in motion relative to one another. Two hundred million years ago, the continents we know today were joined as a single large land mass, Pangea, that began to split apart, so that by 100 million years ago there was a northern supercontinent of Laurasia and a southern supercontinent of Gondwana (Figure 23-1b). In some areas, like the Atlantic Basin, the plates began moving apart as new crust was formed between them. The age of such rocks can be measured radiometrically. The youngest occur near the ridge, with older rocks extending both east and west. The Atlantic, ridge today is a line of submerged volcanic activity running between Europe and North America, and Africa and South America that is constantly extruding molten rock and spreading the continents apart. Iceland, with its famous hot springs and geysers is one of the few places this ridge reaches the surface. With today's satellites it is possible to measure the continuing spread—centimeters per year.

In other places, plates crash into each other, and the leading edge of one is forced deeper (subduction) under the other, which raises the upper plate higher. The Indian subcontinent, once attached to Africa, is crashing north into the Asian plate, raising the Himalayan Mountains, the world's tallest, to ever greater heights. Again, today's technology allows us to measure this increase on an annual basis—about 5 centimeters per year. Both the Sumatran tsunami of 2004 and the Kashmir/Pakistan earthquake of 2005 occurred at this boundary. Plate tectonics is Lyell's uniformitarianism on a much larger scale than he could have imagined.

■ BIOGEOGRAPHY

Although continental drift and plate tectonics were not established as theories in Darwin's day, he and other naturalists recognized patterns of organisms that suggested possible connections of the conti-

nents different from their present configurations. For example, certain plant species, like quaking aspens, occur around the world in the northern latitudes—Asia, Europe, and North America. Some families, such as the Proteas, occur naturally only in Australia, South Africa, and the southern part of South America. Other organisms have much more restricted ranges. Cacti occur naturally only in the Americas, while cactus-like succulents are found in the deserts of the old world. With few exceptions, marsupials (mammals that carry their young in pouches) are restricted to Australia. What could explain such distributions? One possibility is that ancient species would show a broader distribution of lands formerly connected, while more recently evolved species would be restricted to smaller, more localized areas.

That this is a continuing process is illustrated by one of the animals mentioned by Darwin during his voyage. The armadillo is one example. The range of this curious animal continues to spread north in the United States. Armadillos originated in South America, where Darwin first observed them, but once the tip of Central America joined northern South America, there was a land bridge over which armadillos could migrate. Today they have reached as far north as Kansas.

Special cases are oceanic islands such as the Galapagos Islands. These islands have never been connected to a mainland, so there was no bridge over which plants or animals could migrate. Only rare immigrants could have reached these lands and become established. Recall from Chapter 17 the characteristics of pioneer species that increase their likelihood for survival in extreme habitats. Darwin noticed the plants and animals on the Galapagos Islands were all species related to forms that occurred on the mainland of South America. They were in the same genera or families. Chance migration from this continental pool of species would explain why only certain groups were present on the islands. But how could distinctive species arise only on certain islands? From his breeding experiments, Darwin realized that variation exists between individuals of a species. If only a few individual migrants originally arrived on a particular island, they would introduce a limited amount of variation. The environment of that island would naturally select for those traits that were most advantageous under the conditions on that island. The conditions would include both the physical environment and any other population of organisms already living there. With different migrants of the same species arriving on different islands, one would expect that selection would cause the resulting populations to diverge from each other. Given enough time, the result would be the evolution of new species. Here was an explanation that answered the questions raised in Darwin's mind years before after sailing from the Galapagos Islands toward home.

■ COMPARATIVE ANATOMY: HOMOLOGY

Structural **homology** refers to similarities in structure due to a genetic relationship between the organisms being compared. This differs from **analogous** structure, in which a structural similarity is due to adaptation of unrelated organisms to similar selection pressures. For example, the wing of a bird and the wing of a butterfly are both structures that adapt an animal to flight, but the animals are not closely related, and these wings develop in very different ways. These wings are analogous structures.

The classic example of homology is the forelimbs of terrestrial vertebrate animals.

The homologous bone structure of the arm and hand (leg and foot) of amphibians, reptiles, birds, and mammals already was well established in European biology before Darwin, and it was some of the strongest evidence that evolution of species must occur. Elaboration of certain bones, and the corresponding diminution of others, produced a variety of specialized structures from the same basic ground plan. In bats, for example, the finger bones are much elongated to form a framework over which tissue is stretched to form a wing. These same bones may be shortened and thickened to extend the length of the leg in ungulate mammals. This homology also served to link the study of fossils with the study of extant organisms.

WARBLER FINCH

CACTUS GROUND FINCH

WOODPECKER FINCH

SHARP-BEAKED GROUND FINCH

SMALL INSECTIVOROUS TREE FINCH

SMALL GROUND FINCH

LARGE INSECTIVOROUS TREE FINCH

MEDIUM GROUND FINCH

VEGETARIAN TREE FINCH

LARGE GROUND FINCH

WARBLER FINCH

PROBING BILLS

CACTUS EATERS

GROUND FINCHES

TREE FINCHES

GRASPING BILL

CRUSHING BILLS

INSECT EATERS

SEED EATERS

PARROTLIKE BILL

Figure 23-2. Darwin's finches. Beak size and shape in the Galapagos finches varies considerably and is associated with the food source used by each species on particular islands.

ALLIGATOR BIRD BAT HUMAN

Figure 23-3. Vertebrate homologies. Homologous bones in the limb of a variety of vertebrates are indicated by similar colors. The bones that make up the human hand (metacarpals and carpels) show particular modification in these species.

■ FOSSILS

Fossils were also well known long before Darwin, and the occurrence of particular types of marine fossils, layered in beds, was crucial in developing the idea of uniformitarianism in geology. We tend to think only of bones (for example, dinosaur bones) when thinking of fossils, but by far the most numerous fossils are the shells of invertebrate animals, especially marine forms. As these animals die, their shells sink to the bottom and become covered with sediment. Over time, pressure and temperature transform these layered deposits into sedimentary rock. The sequence of layers generally conforms to the age of the deposit, younger layers on top of older layers. When these sediments are thrust up above sea level, erosion begins to exposes these layers from the top down. It is only in the younger layers of sedimentary rock that fossils of bony fish and other vertebrate animals appear.

The same comparative techniques used to analyze homologies between living organisms are used to compare living organisms with fossil forms and fossil forms with each other. In theory, it should be possible to follow changes in particular structures through the fossil record to link between different species of related organisms. Certainly, a goal of paleobiology is to identify intermediate forms that link forms already well known. To the lay public, there is the impression that one should always be able to find the "missing links" between species. Given the special conditions that are necessary for fossilization to occur at all, it is surprising how detailed a record of speciation we have for some species. A well documented example is the evolution of the horse.

Notice that this is not a linear sequence with one species transforming into a new species over and over. Rather, the fossil evidence suggests that multiple species frequently arise and persist for varying degrees of time. Some species go extinct and are no longer found in the fossil record, while others give rise to new species radiations. A line can be drawn from the modern horse through its fossil ancestors, but it is a line passing through many branching points.

Of particular concern is the criticism often directed at evolutionists about their inability to demonstrate this missing link between humans and other primates. This is a pseudo-criticism in that it will never be possible to satisfy the naysayer. For any two fossils in a sequence, there will always be an unknown intermediate form. As soon as an intermediate is found, it automatically creates two new missing links, one on either side of it and between the original two specimens.

■ VESTIGAL STRUCTURE

Darwin realized that the fossil record in his day was very incomplete but that, with time and study, many of the gaps between species would be filled in—this might help to explain some of the anomalies that comparative anatomy was uncovering. Why, for example, do humans have a "tailbone" (actually a group of small bones, the coccyx, fused together at the base of the spine)? This was one of several **vestigial** structures found in humans; structures that have no apparent function.

In the light of descent with modification, the occurrence of such structures became clear. They were relics of organs that functioned in ancestral species but that were no longer useful. In once sense, it is like a muscle that atrophies from disuse when an arm or leg is in a cast. The vestigial structure is a small reminder of a structure that was once more significant in an ancestral species.

■ GROWTH

One of the clues to interpreting vestigial structures comes from a comparative study of development. Early on biologists realized that **embryology,** the study of growth and development of early embryos, provided considerable information about the relationships between organisms.

Although we now realize that some of the early work was overstated, it is clear, for example, that vertebrate animals share many developmental features.

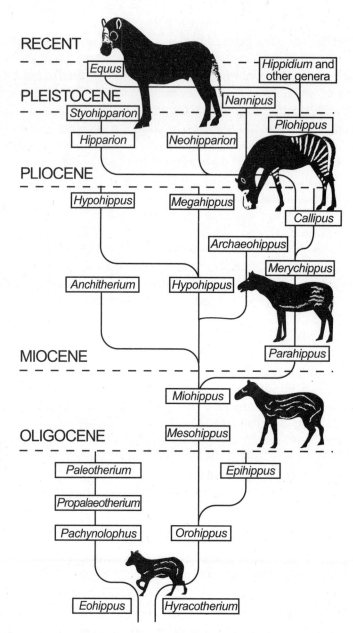

RECENT

Equus

Hippidium and other genera

PLEISTOCENE

Styohipparion

Nannipus

Pliohippus

Hipparion

Neohipparion

PLIOCENE

Hypohippus

Megahippus

Callipus

Archaeohippus

Merychippus

Anchitherium

Hypohippus

Parahippus

MIOCENE

Miohippus

Mesohippus

OLIGOCENE

Paleotherium

Epihippus

Propalaeotherium

Pachynolophus

Orohippus

Eohippus

Hyracotherium

Figure 23-4. Horse phylogeny. Although frequently represented as a single line, the ancestry of the modern horse passes through several branch points where multiple related species were present; most lines went extinct.

The early work concentrated on descriptive comparisons between taxa, but by the 1930s, biologists were quantifying growth patterns. Studies of **allometric growth** turned out to be a particularly powerful tool.

In allometry, the growth of one structure or dimension is plotted logarithmically against that of a second structure or against total growth of the organism. This is a useful tool for identifying when growth patterns change and for demonstrating how similar early stages can produce much different results because of differential growth.

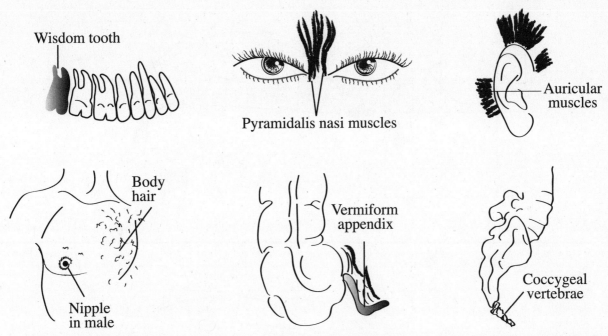

Figure 23-5. *Vestigial structures. Some of the common vestigial structures found in humans include the appendix, "tailbone," body hair, muscles to wiggle the ears, and so on.*

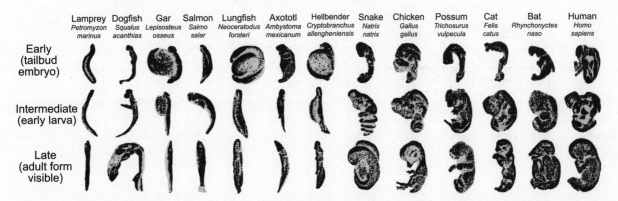

Figure 23-6. *Embryonic development of vertebrate animals. Early vertebrate embryos are remarkably similar in appearance across a variety of species. During later development, distinctive adult forms become more evident.*

■ MOLECULAR EVIDENCE

The strongest supporting evidence today was unimagined by Darwin and his contemporaries: the molecules that compose living cells. Recall from Chapters 5 and 6 that the basic structure and metabolic function of cells is similar in all organisms. Shortly after the discovery of the structure of DNA, the biochemical tools became available to compare the structure of commonly shared molecules in different organisms.

The first molecules studied were the amino acid sequences of common proteins such as cytochrome C from the electron transport chain. All aerobic organisms have this molecule, so a simple comparison was done to determine the similarity of amino acid sequences. The more similar the proteins between two

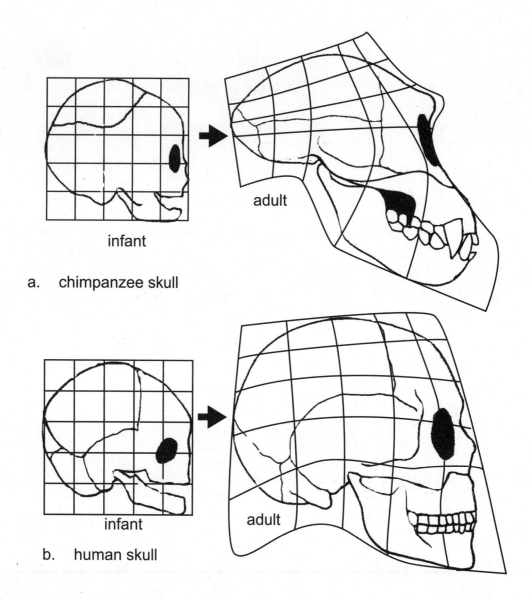

CHIMPANZEE SKULL VERSUS HUMAN SKULL DEVELOPMENT

Figure 23-7. Allometric growth during development. Different patterns of growth during development can produce very different adult structures from a common juvenile ground plan.

species, the more closely related they must be. Today, this work is much more sophisticated and focuses on changes in the sequence of nucleotides in common RNA or DNA sequences.

Darwin went to great lengths to provide evidence in support of natural selection from a variety of fields before proposing this mechanism to explain how evolution occurs. From the beginning, there was controversy among scientists and the public. Public skepticism was driven by popular belief in a Biblical origin and constancy of species. Scientists on both sides of the issue set out to test the predictions of natural selection from the viewpoint of their own particular expertise. Today, the supporting evidence is overwhelming. The theory of evolution by means of natural selection is among the most strongly supported theories in all of science.

AMINO ACIDS IN CYTOCHROME C
SHARED WITH HUMANS BY:

Chimpanzee 104

Rhesus monkey 103

Kangaroo 92

Rabbit 92

Dog 91

Donkey 88

Horse 87

Duck 87

Chicken 86

Turtle 85

Rattlesnake 84

Tuna 73

Moth 68

Yeast 38

Figure 23-8. Similarity in cytochrome C amino acid sequences. Cytochrome C is a molecule found in all eukaryotic organisms. The greater the similarity in amino acid sequences for this molecule between two species, the closer the relationship between those species.

Test Yourself

1) No ocean basin on earth is older than about 200 million years. What would be the best evidence in support of this claim?

 a) radiometric dating of seawater

 b) radiometric dating of living marine plankton

 c) radiometric dating of undersea rocks at the seafloor farthest from the mid-ocean ridge

 d) radiometric dating of undersea rocks at the mid-ocean ridge

2) Structures that are derived from a common ancestor, but may have different functions in different species, are referred to as

 a) analogous structures.

 b) acquired traits.

 c) allometric structures.

 d) homologous structures.

3) The best test to establish the ancestral relationships of two living species is to compare their

 a) fossils records.

 b) embryo development.

 c) DNA.

 d) structures (anatomy).

4) Geophysicists of the early 1900s claimed to have disproved the hypothesis of continental drift when their tests of all known mechanisms came up negative. Where did they go wrong?

 a) Their instruments were not accurate enough to measure these changes.

 b) They were incorrect in assuming they knew all the possible mechanisms.

 c) They made conclusions based on observations and tests, rather than on intuition.

 d) They "fudged" the data to support their preconceived notions.

 e) They did not use all of the information available to them at the time.

5) Snakes have a simpler body plan than other reptiles and, thus, might be considered the ancestral condition. What evidence would suggest that snakes are derived from legged reptile ancestors?

 a) the presence of vestigial leg bones in some species

 b) the absence of snakes on oceanic islands

 c) differences in the DNA of snakes and lizards

 d) the presence of scales on the skin of all reptiles

 e) differences in the allometric growth patterns of their leg bones

6) Gymnosperms are found naturally on all continents (except Antarctica), but cacti are native only to the Americas. Proteaceous species occur in South America, South Africa, and Australia, but Franklinia is native only to North America. Based on this biogeography, which must be the most recently evolved group?

 a) gymnosperms

 b) cacti

 c) proteas

 d) Franklinia

 e) cannot be determined from this evidence

7) The best evidence that can be used to compare living and fossil species is

 a) molecular similarities.

 b) allometric growth patterns.

 c) embryonic growth patterns.

 d) comparative anatomy.

 e) biogeography.

8) Which of the following structure(s) could *not* be found in a human embryo?

 a) tail

 b) eye

 c) legs

 d) heart

 e) All would be present.

9) The amino acid sequences of five species were compared with humans. The rabbit has twelve differences from humans, dogs have seven differences, horses have eleven differences, donkeys have ten differences, and pigs have six differences. Based on this data, which animal is most closely related to humans?

 a) rabbits

 b) dogs

 c) horses

 d) donkeys

 e) pigs

10) Which of the following is/are analogous structures?

 a) fin of a fish and flipper of a dolphin

 b) flipper of a dolphin and wing of a penguin

 c) wing of a penguin and wing of a bat

 d) wing of a bat and wing of a bird.

 e) all of the above

Test Yourself Answers

1) **c.** Radiometric dating is used to determine the age of rocks. The oldest rocks in an ocean basin must be far from a current ridge-forming zone where new rock material is still being produced.

2) **d.** Homologous structures are derived from a common ancestor. Analogous structures have similar function but are derived from unrelated ancestors. Acquired traits are an individual's response to environmental factors but are not passed on. Allometry refers to differential growth rates of structures, regardless of their origin.

3) **c.** DNA codes for genotypes that produce a specific phenotype under certain environmental conditions. The phenotypes, such as structure or embryonic development, may vary depending on the environment. Fossil records may or may not be available for comparison.

4) **b.** The reason scientists cannot prove hypotheses is that they can never be sure they have considered all possible explanations. Based on their understanding at the time, they could not support any of the mechanisms proposed for continental drift and, therefore, had to reject this hypothesis.

5) **a.** The presence of vestigial structures is evidence of an ancestral condition. Such structures would have to be present for an allometric study of growth to be done. None of the other examples have a necessary correlation with the presence of limbs.

6) **d.** Biogeographic patterns are based on the origin of specific groups relative to the connectedness of land masses. More widespread groups arose when current land masses were connected; more restricted species arose after continents separated. The most restrictive distribution, Franklinia, must be the most recently evolved.

7) **d.** Comparison of homologous structures preserved in fossils and present in extant forms provides the most evidence for such comparisons. Growth studies, either allometric or embryological, requires sequential stages that are uncommon in the fossil record. Some more recent fossils contain organic molecules that can be compared using molecular techniques, but this also is uncommon and restricted to relatively recent fossil materials.

8) **e.** Each of these structures, found in human adults, arises in the embryo. Of the structures listed, the tail is a vestigial structure in adults, but is prominent in embryos.

9) **e.** Based on this data, the amino acid sequence of rabbits is most distant from humans with twelve differences, while the pig has the fewest differences and must, therefore, be most closely related to humans.

10) **a.** Although the fin of a fish and flipper of a dolphin are both used for swimming, they arise from different ancestral structures and are analogous. The dolphin flipper and wings of all the other organisms listed are homologous, based on the same basic plan as the human arm and hand.

Population Genetics

In Chapter 11, we discussed Gregor Mendel and the discovery of the genetic mechanism of inheritance. Mendel published his results three years prior to Darwin's publication of *The Origin of Species,* but Mendel's work was virtually unnoticed for forty years. In 1900, the principles of genetics were independently rediscovered by three biologists working in three different countries. Hugo DeVries, Erich von Tschermak, and Carl Correns confirmed Mendel's theory of particulate inheritance. Discrete characters were controlled by genes and the offspring of crosses could be predicted to occur in known ratios. Changes from the predicted ratios were due to mutations that introduced new discrete characters. This was much different from the more or less continuous spectrum of variation proposed by Darwin's theory. For about twenty years, there was vigorous debate between geneticists and Darwinists as to which view of evolution was correct. Was evolution a slow and gradual process in which selection acted on variation present within the species, or was evolution due to rapid changes as a result of mutation? It is important to note that these biologists, nearly 100 years ago, were not arguing over whether or not evolution occurs; they were arguing over what are the processes and mechanisms by which evolution occurs. Similarly, today's biologists do not argue over whether or not evolution occurs—it does. But there is still considerable discussion over the mechanisms involved.

■ A NEW SYNTHESIS

In the late 1920s and early 1930s, a new group of biologists began to realize that the apparent dichotomy between genetics and Darwinian evolution was not real; in fact, in most cases, genetics would predict a uniform distribution of traits. How could this be?

Recall that Mendel specifically chose traits with distinct phenotypes that were dominant or recessive and due to a single pair of alleles. This is not the usual case. For example, for some characters, dominance is incomplete. The heterozygous genotype as a distinctive phenotype that is intermediate between the homozygous dominant and homozygous recessive. Red (RR), Pink (Rr), and white (rr) flower color in snapdragons is an example.

Another common situation is the occurrence of more than two alleles for a given trait. An example of this is the genetics of blood types in humans. There are two different co-dominant blood type alleles, I^A and I^B, and a single recessive.

A person with type A blood will be either homozygous $I^A I^A$ or heterozygous $I^A i$. Similarly, a person with type B blood will be either homozygous $I^B I^B$ or heterozygous $I^B i$. Type AB has the genotype $I^A I^B$ while type O is homozygous recessive, ii.

Genotype	Phenotype (Blood Group)
$I^A I^A$ or $I^A i$	A
$I^B I^B$ or $I^B i$	B
$I^A I^B$	AB
ii	O

Figure 24-1. Multiple alleles: human blood types. Human blood type results from co-dominance of two alleles, I^A and I^B, along with a single recessive i.

More common still is the situation where two or more genes control a single character. In the simplest situation the number of dominant alleles have an additive effect. With one gene, we expect three phenotypic classes in the normal Mendelian monohybrid ratio of 1AA, 2Aa, and 1aa.

If two genes are involved, there are five phenotypic classes, with the number of dominant alleles ranging from 0 to 4 in the ratio of 1 (0 dominant), 4 (1 dominant), 6 (2 dominant), 4 (3 dominant), and 1 (4 dominant). With three genes, there are seven phenotypic classes with the number of dominant alleles range from 0 to 6 in the ratio of 1 (0 dominant), 6 (1dominant), 15 (2 dominant), 20 (3 dominant), 15 (4 dominant), 6 (5 dominant), and 1 (6 dominant). As the number of genes involved in a trait increase, the distribution of genotypes begins to approach the normal distribution (a bell-shaped curve) that Darwin's variation within a population predicted. A common example of such quantitative inheritance is skin color in humans. At least four major genes are involved with the pigmentation for human skin color. The presence of eight dominants produce the darkest shades, while 0 dominants produce the lightest. These are examples of **polygenic** inheritance.

A final factor are the number of minor, modifier genes that provide additional gradation to the phenotype caused by major genes. Human eye color, for example, is due to a single major gene with several additional modifiers. Homozygous recessive produces blue-eyed individuals and dominant produces non-blue, but a variety of modifier genes work in consort to produce the various shades of green, hazel, brown, and so on that we find so attractive.

■ HARDY-WEINBERG EQUILIBRIUM

The realization that genetics did not contradict Darwin's ideas, but rather provided additional supporting evidence, led to the development of the field of population genetics. Godfrey Hardy and Wilhelm Weinberg, an English mathematician and a German physician, respectively, independently determined that if certain assumptions are met, the frequency of alleles and genotypes in a population (the gene pool; recall Chapter 21) must stay constant from one generation to the next. Consider a population of students in a classroom. If 4 out of 100 students have blue eyes, the homozygous recessive (bb), then the frequency

Number of Gene Pairs	Number of Phenotypic Classes	Histogram of F2 Phenotypes
1	3	
2	5	
3	7	
4	9	
5	11	

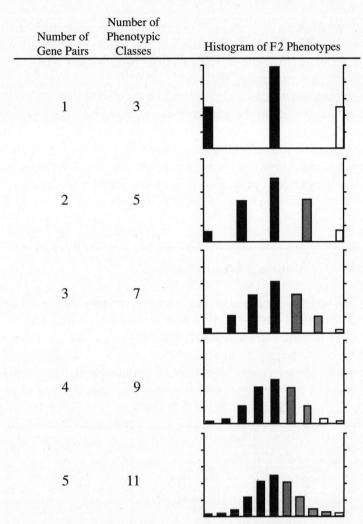

Figure 24-2. Polygenic inheritance. Many phenotypes result for the interaction of more than one gene. If the effects are additive, the result approaches a normal distribution of phenotypes as the number of involved genes increases.

of the homozygous recessive in the population is 0.04. If the frequency of the homozygous recessive (bb) is 0.04, the frequency of the recessive allele (b) must be $\sqrt{0.04} = 0.2$. If the frequency of the recessive allele, b, is 0.2, then the frequency of the dominant allele, B, must be $1 - 0.2 = 0.8$ because all of the dominants plus all of the recessives must equal 1.0 (100%). This is the first equality of the Hardy-Weinberg Equilibrium: $p + q = 1$, where p is the frequency of the dominant allele and q is the frequency of the recessive allele.

Knowing p and q, one can calculate the frequencies of each of the possible genotypes. If the frequency of dominant and recessive alleles in the population as a whole are 0.8 and 0.2, respectively, then any randomly chosen male has a 80 percent probability of donating a B and 20 percent probability of donating a b, respectively. In other words, the possible male gametes could be represented as $(p + q) = (0.8B + 0.2b)$. A randomly chosen female would have the same probabilities of donating a dominant or recessive allele, $(0.8B + 0.2b)$. Hardy and Weinberg realized that if this were the situation, one could easily determine the frequency of all offspring genotypes by mating a random male with a random female

from the population $(p + q) \times (p + q) = 1$. This is the second equality of the Hardy-Weinberg Equilibrium, $(p + q)^2 = \mathbf{1 = p^2 + 2pq + q^2}$. The frequency of the homozygous dominant genotype, BB, must be p^2. In this case, $(0.8)^2$ is 0.64. The frequency of the heterozygous, $2pq$, is $2(0.8 \times 0.2) = 0.32$. The frequency of the homozygous recessive, q^2, is $0.2^2 = 0.04$.

To visualize this relationship, we can set up a modified Punnett Square (see Figure 24-3), where the frequency of each allele is included on the axes and the frequency of each genotype is shown in the boxes.

As expected, the genotype frequencies of the new generation are exactly what was predicted. More important, it is clear that the frequency of homozygous recessive in the offspring population is exactly the same that was observed in the previous generation! Hardy and Weinberg were correct that the allele and genotype frequencies should not change from one generation to the next, providing their assumptions are met.

Assumptions of Hardy-Weinberg Equilibrium

What are the assumptions required by the Hardy-Weinberg Equilibrium? There are five. a) The population must be large. Probabilities are based on statistics and random samples. The population must be large enough for these criteria to be met. b) Mating must be random. In this way, the probability of alleles carried by the mates in any particular cross will most likely reflect the allele frequencies in the population as a whole. c) There can be no migration of individuals into or out of the population. Any migration will automatically change the allele frequencies within the population. d) There can be no selection. Any allele in the population must be equally advantageous so that natural selection cannot occur. e) There can

♀ \ ♂	0.8B	0.2b
0.8B	0.64BB	0.16Bb
0.2b	0.16Bb	0.04bb

Figure 24-3. Hardy-Weinberg Punnett Square. The assumption is that a randomly chosen individual from a population will have the likelihood of contributing a dominant or recessive allele that is proportional to the frequency of that allele in the population. Allele frequencies are included on the axes, indicating possible male and female gametes. Genotype frequencies fill in the boxes for possible crosses.

be no mutation. Mutations, by definition, change alleles that would change the frequencies of alleles in the population.

How Often Are These Assumptions Met?

Assume all but one of the assumptions are being met. What would be the effect of that one exception? We talked in Chapter 21 about the loss of genetic diversity in small populations. This loss is called a **genetic bottleneck.** Even though the number of individuals may increase in the population, the diversity will be no larger than that of the bottleneck populations. A similar situation occurs with a **founder population,** when a few individuals colonize a new area (recall oceanic islands in Chapter 23). Finally, if the population is small, a chance event could significantly alter the allele frequencies in a population. A small population, restricted to a narrow range, could easily be devastated by a single catastrophic event such as a flood, wildfire, or human disturbance. Random changes that occur in a population because of small population size are called **genetic drift.**

Random mating occurs in some organisms, particularly when large numbers of gametes are produced that rely on wind or water for dispersal. Particularly in animals, however, mate choice is a significant behavior, and the criterion of random mating is not met. For example, if only a few dominant males mate with all of the females, the alleles the dominant males carry will be over-represented in the offspring population.

The significance of migration varies, depending upon the organism concerned. Given the international movement of humans today and the purposeful or accidental transport of other species by humans (recall Chapter 23), it is difficult to exclude migration as a possibility. Migration of individuals (and the alleles they carry) into or out of a population is called **gene flow.**

If the population is large and growing, competition between individuals will develop (Chapter 16). Because there is variation in any population that is not clonal, competition between individuals will result in natural selection (Chapter 22).

Finally, although sexual reproduction increases variability within a population, the ultimately the source of variation is mutation. Mutations are a natural process that occurs all the time (Chapter 13). The assumption of no mutations is never met. Some of the five assumptions might be met some of the time, but all the assumptions are never met in a natural population.

Why Is Hardy-Weinberg Important?

If the assumptions for the Hardy-Weinberg Equilibrium are rarely, if ever, met, why is the equilibrium important? First, if we can identify one of the five variables involved in either equation, p, q, p^2, q^2, or $2pq$, we can calculate all the others. Furthermore, if we can determine the Hardy-Weinberg frequencies at one time, and then recalculate them at a later date, we will have an indication of how rapidly change must be occurring. If measurable change is occurring, we can examine the assumptions to see which are not being met, and then form hypotheses to this change. What is this change? Evolution! Calculating the Hardy-Weinberg Equilibrium allows us to study the rate of evolution and determine what factors are driving evolution at a particular time and in a particular place.

Test Yourself

1) The ultimate source of all genetic variation is
 a) mutations.
 b) crossing over.
 c) meiosis.
 d) polyploidy.

2) Genetic equilibrium in the Hardy-Weinberg Equilibrium refers to
 a) equal numbers of dominant and recessive alleles in a population.
 b) equal numbers of males and females in a population.
 c) unchanging allele frequencies in successive generations of a sexually reproducing population.
 d) lack of mutations that affect the phenotypes observed in the population.

3) Genetic drift as an evolutionary factor is
 a) a greater force in a population with small numbers than a population with large numbers.
 b) a greater force in a population with much genetic variation than in a population with little genetic variation.
 c) a force because it is responsible for the selection of mutations.
 d) a force because it involves the movements of alleles between populations of a single species.

4) The changes in allele frequencies that lead to evolutionary change can be observed in
 a) gametes.
 b) somatic cells.
 c) individuals.
 d) organelles.
 e) populations.

5) If the women (or men) of a class were lined up according to height, there would be a wide variation from the tallest to the shortest, with most individuals of about average height. This type of genetic trait is due to
 a) polygenic inheritance.
 b) incomplete dominance.
 c) environmental interaction.
 d) multiple alleles.
 e) sex-linkage.

6) Ten people, shipwrecked on a remote island, established a new population. When the population was discovered 150 years later, 50 of the 420 members were found to have six toes on each foot. What is the most likely agent at work in this population?

a) gene flow

b) natural selection

c) the Hardy-Weinberg Equilibrium

d) nonrandom mating

e) the founder effect

7) In a large population, the frequency of the recessive allele is initially 0.1. There is no migration and no selection. What is the frequency of the dominant allele in this population?

a) 0.1

b) 0.2

c) 50 percent

d) 90 percent

e) 99 percent

8) If the frequency of the homozygous recessive genotype in a population is 0.81, the frequency of the recessive allele is

a) 0.9.

b) 0.8.

c) 0.5.

d) 0.2.

e) 0.1.

9) To calculate the Hardy-Weinberg Equilibrium, which factor can be directly measured in the population?

a) p

b) q

c) p^2

d) $2pq$

e) q^2

10) Which situation would most likely result in a change in the genetic makeup of a population?

a) There is no immigration from the population.

b) The population is large.

c) No mutations have occurred.

d) Non-random mating occurs in the population.

Test Yourself Answers

1) **a.** Mutations in genes are what ultimately produce new alleles and, therefore, are the ultimate source of genetic variation. Crossing over, meiosis, and polyploidy all produce additional variation as a result of sexual reproduction.

2) **c.** The Hardy-Weinberg Equilibrium demonstrates that if certain assumptions are met, the allele and genotype frequencies will remain constant in a population from one generation to the next.

3) **a.** Genetic drift, such as founder effect or population bottleneck, occurs when a population becomes very small. As a result of the decrease in population size, genetic variation is much reduced. This is independent of mutations, migration, or gene flow.

4) **e.** Evolution does not occur in individuals or parts of an individual; it is a species-level process that occurs in populations of organisms over time.

5) **a.** Polygenic inheritance, with additive effect, results in a normal distribution of phenotypes; the larger the number of genes, the smoother the curve.

6) **e.** A small founder population randomly chosen from a large population will frequently have allele frequencies that are much different from those found in the larger population. Rare genes in the original population could be over-represented in the founder population so that rare phenotypes could become common in the offspring population.

7) **d.** According to the Hardy-Weinberg Equilibrium, $p + q = 1$ where p and q are the frequencies of the dominant and recessive allele, respectively. If $q = 0.1$, then $p = 1 - 0.1 = 0.9 = 90$ percent.

8) **a.** According to the Hardy-Weinberg Equilibrium, the frequency of the homozygous recessive genotype is q^2, while the frequency of the recessive allele is q. If q^2 is 0.81, then $q = \sqrt{0.81} = 0.9$.

9) **e.** In a population of individuals, only phenotypes can be observed. In many cases, it is impossible to distinguish between the homozygous dominant and the heterozygous genotypes because they appear the same. The homozygous recessive phenotype, q^2, is visible.

10) **d.** The Hardy-Weinberg Equilibrium requires that mating be random. If mating is non-random, one of the assumptions of Hardy-Weinberg is not met and equilibrium will be upset—change will occur. Each of the other choices fulfills one of the other assumptions to maintain equilibrium.

Speciation

Although Darwin titled his most famous book *The Origin of Species,* he used that phrase only four times in the entire book—all in the introduction. Perhaps this was because he intended this book to be only a short abstract of a larger work that would be more comprehensive in explaining the details of his mechanism to explain descent with modification (unfortunately, that larger book was never was published). But perhaps it was related to the difficulty in precisely defining what a species is.

■ SPECIES CONCEPT

The most widely used definition of species is the **biological species concept** that was first proposed by the ornithologist Ernst Mayr. According to this concept, a species is a population of organisms that is capable of interbreeding in nature to produce viable offspring. It fits the idea of a gene pool, where random breeding can occur between any two compatible members of the population. It is possible for a species to evolve gradually over time into a new species, but if this happens, one cannot choose a point in the transitional series where the original species stopped and a new species began. The more usual situation is that subpopulations become isolated from each other and subsequently begin to diverge. At the point where an individual from one subpopulation can no longer interbreed with a member from another subpopulation, new species have formed.

■ MODES OF SELECTION

If the phenotypic range of a species can be represented as a bell-shaped curve, how can selection create new species? Three different modes of selection are recognized.

One of these, stabilizing selection, does not result in the formation of new species, but directional selection and disruptive selection could result in speciation.

Stabilizing Selection

If the population occurs in a stable habitat, there is a tendency for extreme phenotypes to be selected against, and the population becomes more and more uniform. An example of such **stabilizing selection** is the birth weight of human infants. Too low a birth weight, often associated with premature delivery, is usually fatal unless extensive medical treatment is available. Similarly, too high a birth weight is often associated with the inability of the infant to pass through the mother's birth canal, resulting in the death of both the mother and infant, again unless medical intervention is possible. As a result, most human infants are born in the range of six to nine pounds.

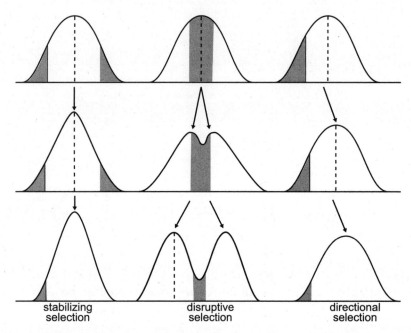

Figure 25-1. Modes of selection. The range of phenotypic variability of a species normally follows a bell curve. In a stabilizing selection, the extremes are selected against (darker) and more individuals fall near the mean. Directional selection selects against one extreme, and the entire population shifts toward the other extreme. Disruptive selection removed the average phenotypes, resulting in a bimodal curve.

Directional Selection

Environments undergoing gradual change over long periods of time result in **directional selection.** As this occurs, one extreme of the phenotypic range may be better adapted than the other, and the entire population will tend to shift in the direction of the favored phenotype from one generation to the next. Over time, the phenotypic distribution of the current population may have shifted enough that it no longer overlaps with that of the original population. The original species is now extinct, and the current population is a new species. Similar selection is seen along an ecological gradient, such as increasing elevation up a mountainside. For some plant species, individuals growing at high elevation are unable to breed with those from lower elevation, even if brought together in a common garden. If there are no intermediate forms, these would now be separate species. It is a more difficult problem when there is an intermediate that could breed with individuals from either extreme. In this case, gene flow is still possible from one extreme to the other of the gene pool.

Disruptive Selection

Disruptive selection is often associated with sudden changes in the environment that removes most of the average members of the population, but allows individuals on either extreme to survive. Disruptive selection is often associated with human activities, such as mining.

■ ISOLATING MECHANISMS

The biological species concept requires that some individuals of a population must become reproductively isolated from others. In a sense, this can be likened to methods of human birth control. Some methods prevent syngamy from occurring either by physical or behavioral methods. Such methods of

reproductive isolation are called **prezygotic** because they occur before, and thus prevent, fusion of gametes to form a zygote. Alternatively, some methods of birth control occur after a zygote is formed; they prevent the zygote from developing to term. **Postzygotic** isolation mechanisms ensure that any off-spring produced are not reproductively viable.

Prezygotic Isolating Mechanisms

The simplest form of isolation is to have **physical isolation** between parts of the population. This separation may be due to geographical factors such as mountain ranges, deserts, or rivers. A classic example is the Kaibab squirrel that inhabits the North Rim of the Grand Canyon and the related Abert squirrel that is found on the South Rim. Physical isolation may be due to habitat differences within a geographic range, such as moisture or temperature gradients along the slope of a mountain range.

In order for reproduction to occur, two individuals must be capable of mating at the same time. Morning glories get their name because the flowers open in the morning, and then close later in the day. Evening primroses, as their name suggests, do not open their flowers until later in the day. Even if other factors did not block reproduction between members of these species, they are **temporally isolated** because they are receptive to reproduction at different times.

Behavioral isolation is most readily observed in animals that have specific mating rituals. Birds are particularly noted for courtship displays or other mating rituals during which the member of one sex attracts a mate. The spectacular tail feather display of peacocks to attract peahens is a classic example.

Mechanical isolation physically prevents successful reproduction. An obvious example in animals is if the sex organs are not compatible. In plants, this frequently involves an association between a flower and its animal pollinator. Bees, for example, can learn to recognize flower shape and color. If it is rewarded with nectar and picks up pollen on one species of flower, it will visit another flower of that species rather than a nearby flower of a different species with a different shape or color.

Finally, there may be **gametic isolation.** Although the gametes may be brought into contact with each other, physiologically they are incompatible, and syngamy will not occur. Recognition factors on cell membranes (recall Chapter 4) are usually involved.

Postzygotic Isolating Mechanisms

Postzygotic isolating mechanisms prevent a hybrid zygote from developing into a mature, sexually viable adult. They are broken down into types, depending on the relative viability of the hybrid offspring.

Some species occasionally hybridize, but the hybrid offspring are few, weak, and often do not complete development. Such offspring exhibit **reduced hybrid viability.** In other instances, the hybrid off-spring reach maturity and may be vigorous and robust individuals, but they are sterile. Mules are hybrid offspring of horses and donkeys that exhibit **reduced hybrid** fertility. With some species, the initial hybrid offspring are fertile, but their viability is reduced in successive generations, either crossing with one another or back to either parent. Over several generations, there is eventual **hybrid breakdown.** From an evolutionary viewpoint, postzygotic isolating mechanisms are not very efficient mechanisms because considerable energy is wasted on the growth of offspring that ultimately cannot contribute to the gene pool of future generations. As a result, species that exhibit postzygotic isolating mechanisms frequently evolve earlier-acting prezygotic mechanisms.

■ ALLOPATRIC SPECIATION

Allopatric speciation occurs when a population becomes divided geographically so that gene flow cannot occur between the subpopulations.

As a result, the gene pool of each subpopulation comes under the effect of different environments. They may have different initial allele frequencies and different mutation rates. Different selective pres-

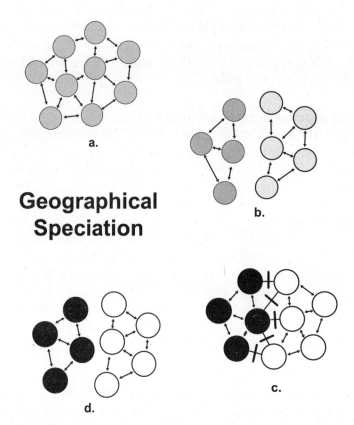

Geographical Speciation

Figure 25-2. Allopatric speciation. a) Allopatric speciation involves a geographic barrier that blocks gene flow between halves of the population. b) Each isolated population continues to evolve through natural selection and will diverge from each other. At some point, this divergence will be great enough that the two populations will have produced additional isolating mechanisms c) and become distinct species; they will be incapable of interbreeding even if the original barrier is removed d).

sures may be involved, both sexual and otherwise. Under these influences, the subpopulations will diverge from each other enough so that even if they are allowed to come back into contact with one another, they will no longer be able to interbreed. At this point, they have formed new species. In cases where several different subpopulations diverge from a common ancestral population, we recognize **adaptive radiation** as the more-or-less simultaneous origin of multiple species.

■ SYMPATRIC SPECIATION

It is easy to visualize how geographic separation of an ancestral population can lead to allopatric speciation. It is not as easy to how a interbreeding population can remain intact and still have new species arise, a phenomenon known as **sympatric speciation.**

Polyploidy

The most common form of sympatric speciation is **polyploidy,** a systematic increase in the number of sets of chromosomes. More than half of all plant species arose from polyploidy, and this process can be observed occurring in certain populations today.

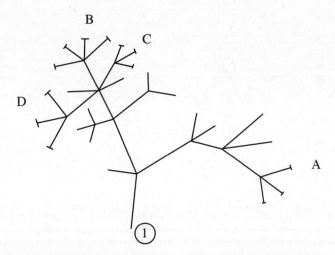

Figure 25-3. Adaptive radiation. A tree from Darwin's notebook illustrating several adaptive radiations at A, B, C, and D, where three or four species diverge from a single common ancestor in response to the availability of different habitats and different selective pressures. The crossed tips of each branch represent extant species; blind-ending tips represent extinctions.

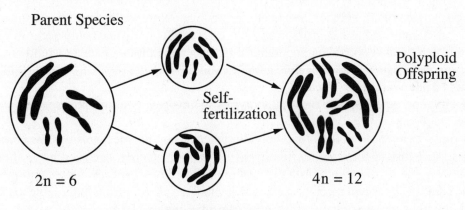

Figure 25-4. Autopolyploidy. A single species doubles its chromosome number from 2n to 4n due to non-disjunction. Instantly, the polyploidy becomes a new species.

The simplest form of polyploidy involves increasing the number of sets of chromosomes of a single species, called **autopolyploidy.**

In Chapter 10, we discussed the role of meiosis in producing haploid gametes. However, if the chromosomes fail to separate during meiosis, a process called non-disjunction, the gamete would be a diploid cell. Because most plants are bisexual, if a condition arose that caused non-disjunction during the production of one set of gametes, it is quite likely that a similar situation occurred during the production of the other gamete. A diploid gamete that fused with a haploid gamete would have unmatched chromosomes and not be able to undergo meiosis at a later date. A hybrid offspring of such a cross, if it survived,

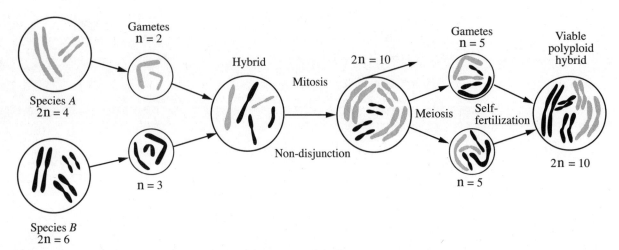

Figure 25-5. Allopolyploidy. Two different species hybridize to form a zygote with a complement of chromosomes from each parent. If both parental species undergo non-disjunction prior to gamete formation, the hybrid will be fertile and instantly produce a new species distinct from either parent.

would be sterile. That would not be a problem with two diploid gametes, however, and the tetraploid offspring would instantly become a unique new species with four of every type of chromosome.

The 4*n* cell would still be able to undergo meiosis and form gametes because each chromosome will still have a homolog; it is just that there will be pairs of homologous chromosomes. A resulting 2*n* gamete could undergo syngamy with another 2*n* gamete to produce a second 4*n* generation (remember, many plants produce both male and female parts in each flower, so polyploidy need only occur in a single plant to give rise to a new sexually breeding population). However, the diploid gamete would not be viable if it underwent syngamy with a normal haploid gamete from the original population. The resulting triploid cell would not be able to undergo meiosis.

A more common type of polyploidy, allopolyploidy, involves two different species with different numbers of chromosomes.

There is more than one way for allopolyploidy to occur, but one mechanism is for normal gametes to be produced that fuse to form an infertile hybrid. If non-disjunction occurred when the hybrid cell underwent mitosis, the hybrid would instantly become a new diploid species with a chromosome number that is the additive of the two parental species. The plant developing from this zygote may be self-fertile and if so, it will be a new species, distinctive from either parent.

Habitat Differentiation and Sexual Selection

Polyploidy also occurs in animals, but less commonly than in plants. A more common means of sympatric speciation occurs when subpopulations specialize for a particular habitat or undergo sexual selection. Parasites are a good example of the former, when a particular parasite species specializes on a specific host. Any variation that would allow a subpopulation to adapt to a new host would facilitate speciation.

Test Yourself

1) Two birds are members of the same biological species if they
 a) possess the same number of chromosomes.
 b) breed at the same time.
 c) are phenotypically indistinguishable.
 d) can mate and produce viable, fertile offspring.
 e) can meet any of the above criteria.

2) Failure of homologous pair of chromosomes to separate during meiosis I can lead to
 a) polyploidy.
 b) diploidy.
 c) extranuclear inheritance.
 d) epistasis.

3) Pre-zygotic reproduction isolation is an important aspect of
 a) natural selection.
 b) genetic drift.
 c) speciation.
 d) extinction.

4) From a normal distribution of phenotypes, directional selection eliminates
 a) all phenotypes.
 b) both extremes.
 c) heterozygotes.
 d) no phenotypes.
 e) one extreme.

5) Which of the following might be expected to change gene frequencies in a population?
 a) stabilizing selection
 b) directional selection
 c) disruptive selection
 d) mutation
 e) all of the above

6) The term *reproductive isolation* mechanism refers to
 a) specific areas where males compete or display for females.
 b) the process by which sexual selection evolves within a population.
 c) a blockage of gene flow between populations.
 d) the inability of a species to continue reproduction.

7) Allopatric speciation requires
 a) geographic isolation.
 b) gradual evolutionary changes.
 c) polyploidy.
 d) adaptive radiation.

8) Birds with average-sized wings survived a severe storm more successfully than other birds in the same population with longer or shorter wings. This illustrates
 a) conservative selection.
 b) reverse selection.
 c) artificial selection.
 d) directional selection.
 e) stabilizing selection.

9) Salamanders react strongly to chemical cues in their courtship behavior and different species of salamanders have different chemical cues. This is an example of
 a) a prezygotic isolation mechanism.
 b) a postzygotic isolation mechanism.
 c) ecological isolation.
 d) a chemical preadaptation.
 e) mechanical isolation.

10) Horses and donkeys are distinct biological species. What keeps them distinct?
 a) polyploidy
 b) a prezygotic isolation mechanism
 c) an allopatric isolation mechanism
 d) a postzygotic isolation mechanism
 e) a geopolitical isolation mechanism

Test Yourself Answers

1) **d.** The biological species concept requires that individual members of the population can mate successfully to produce viable, fertile offspring. They will have the same number of chromosomes, but many other organisms may have the same chromosome number. Similarly, more than one species can breed at the same time. Individuals within a species are frequently phenotypically indistinguishable, but this is not necessarily the case. For example, the many breeds of dogs look very different, although all belong to the same species.

2) **a.** Failure of homologous pairs of chromosomes to separate during meiosis is non-disjunction that may lead to polyploidy.

3) **c.** According to the biological species concept, reproductive isolation, either pre-zygotic or post-zygotic, is necessary for speciation to occur. Once isolation occurs, natural selection may cause isolated subpopulations to diverge. If a small subpopulation is isolated, genetic drift may occur.

4) **e.** Directional selection eliminates one extreme of the phenotypic distribution, causing the entire curve to shift toward the other extreme.

5) **e.** Mutation, or any type of selection, negates an assumption of the Hardy-Weinberg Equilibrium; thus, there will be a change in the frequency of alleles in the gene pool of a population.

6) **c.** The biological species concept requires that individuals in a population are capable of interbreeding to produce fertile offspring. Reproductive isolation mechanisms prevent some individuals from mating with others, effectively dividing the original population in two and blocking transfer of genes between the two isolated populations.

7) **a.** Allopatric speciation requires that a population becomes physically separated into two or more subpopulations. In nature, this requires introduction of some geographic barrier. Polyploidy is specifically associated with sympatric speciation. Adaptive radiation and gradual evolutionary change may be associated with either sympatric or allopatric speciation.

8) **e.** In this example, both extremes of a phenotypic distribution are selected against, and stabilizing selection results.

9) **a.** Courtship behavior occurs before fertilization produces a zygote; thus, it is an example of a prezygotic isolation mechanism. Although chemicals are involved in this courtship behavior, there is no evidence that preadaptation occurred.

10) **d.** Horses and donkeys can produce viable offspring (mules), but the mules are sterile. This is an example of the postzygotic isolation mechanism of hybrid infertility.

Phylogeny and Systematics

D arwin's theory of descent with modification, illustrated by a branching tree (recall Figure 25-3), provided a model that both explained the observable sequence of the fossil record and provided a rationale for the hierarchical classification of living things. As the tree grows through time, the tips of branches always represent extant organisms living on earth in the present. Proceeding downward, the trunk moves through successively older periods of earth history and the organisms of those times; if fossilized, they will appear in successively older layers of the fossil record. Each branching point in the tree represents a common ancestor that gave rise to two or more divergent lines. Thus, the tree maps a pattern of genealogical relationships, culminating with the species alive today. This pattern is called a **phylogeny.**

■ TAXONOMY AND CLASSIFICATION

Humans have always been interested in classification for the most practical of purposes. Primitive societies classify organisms based on utility: those that provide food, those that provide shelter, those with medicinal properties, and those that are harmful. In aboriginal societies today, the names used for organisms usually relate to their classification.

In science, we also classify living things, but since the early 1700s, our classification has been based on similarities and differences among organisms. It was at this time that scientists began to differentiate between homologies and analogies (recall Chapter 23), and organisms began to be grouped based on the basis of homologous structures. A hierarchical system developed in which organisms with many similarities were grouped into species, the morphological species concept. Species that shared common features were nested into a genus. Similar genera were grouped into families, families grouped into orders, orders into classes, classes into phyla, phyla into kingdoms and, today, kingdoms are grouped into domains.

This systematic classification of organisms is known as **taxonomy.** *Taxon* is a general term used to refer to any natural group of organisms, so taxonomy is the study of how organisms group together. In 1748, Carl Linnaeus, a Swedish botanist, linked the naming of organisms to the taxonomic classification system by establishing **binomial nomenclature.** Every species should be referred to with a name consisting of two parts. The first name indicates the genus to which the organism belongs. It is equivalent to our last name we share with all of the members of our family. The second name, or specific epithet, indicates the specific species to which that individual belongs. For us that would be equivalent to our first name. The corn plant, *Zea mays*, is the species *mays* in the genus *Zea*.

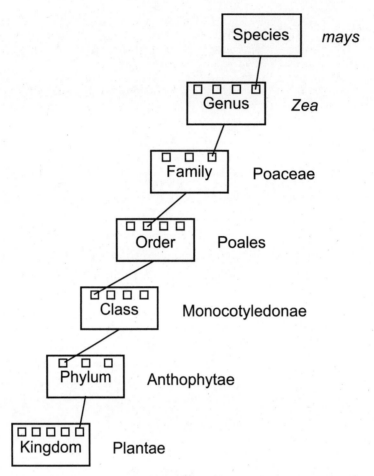

Figure 26-1. Hierarchical classification of living things. The traditional classification system that nests species into increasingly larger and more inmclusive taxa: species, genus, family, order, class, phylum, and kingdom.

The phylogenetic tree represented by taxonomic classification is a hypothesis about the relationships between different organisms based on similarities of homologous parts. It has been developed and refined over hundreds of years and every year, new species must be added as they are discovered and described. Until recently, the methods of taxonomy had not changed significantly since the time of Linnaeus, however, beginning in the 1960s, new tools became available and new concepts were developed that permitted us to begin rigorous testing of these taxonomic hypotheses.

Phenetic Analysis

In the 1960s, a new tool, the computer, began to be used to help resolve phylogenetic trees. The descriptive data for all species being analyzed were digitized, and then the computer could be used to create a phylogenetic tree by maximizing similarities. The philosophy of grouping by overall similarity was known as phenetics (as in phenotype). There were three great advantages to this approach. First, huge amounts of data could be considered because the analysis was done by a computer. Second, data was not restricted to morphology, but could include biochemical information, first amino acid sequences, then DNA similarities, and ultimately, base sequences in DNA or RNA. Third, because the analysis was done

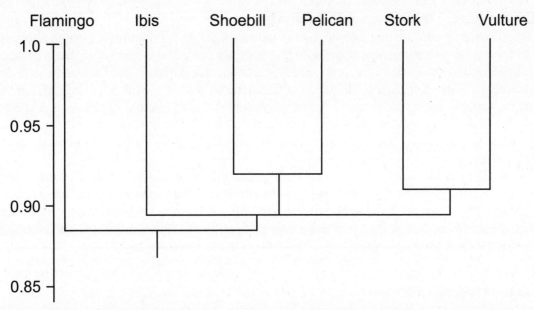

Figure 26-2. Phenogram. A tree illustrating relative similarities between different species. More similar species occur closer together than less similar species.

by machine, the potential for human bias by the investigator was minimized. The computer simply generated a statistic: the coefficient of similarity. The greater the coefficient of similarity between two species, the closer together they must appear on a tree.

The lower the similarity, the farther apart they must appear, and the lower on the tree they must have diverged. The great disadvantage was that the similarities between species did not have to be related to each other; both analogies and homologies count as similarities.

■ CLADISTIC ANALYSIS

At about the same time that phenetic analysis began to be employed, a new philosophy of classification was devised by the German entomologist Willi Hennig. His approach was based on the fact that extant species must have a common ancestor. Some of those ancestral traits, even today, would be shared by at least some species. Such ancestral character states are called **plesiomorphies.** During the course of evolution, ultimately through mutation, some characters changed state. The newly derived characters are called **apomorphies.** Species sharing a specific apomorphy must be derived from the same common ancestor that also had that character state. By comparing character states, primitive or derived, for a number of different characters, a new type of tree is formed based on shared, derived characters rather than simply overall similarities. This tree is a **cladogram,** and each branch is a **clade.** Clades are nested in the same way that different levels of taxa nest in traditional taxonomy. If all the species of a genus have a common ancestor, they will fall within the same clade, and the genus is **monophyletic.** If species fall into different clades, the group is **polyphyletic,** and the genus is not considered to be a natural group.

Cladistic analysis has the same advantages as phenetic analysis. Because the data are digitized, computers can be used to analyze huge amounts of data, and molecular, as well as morphological, data can be used. Finally, the computer algorithm constructs trees that are not biased by an investigator's preconceptions. The added advantage, however, is that because the cladogram maps shared, derived characters, it also shows genealogical relationships.

■ CONSTRUCTING A CLADOGRAM

The principle of constructing a cladogram is rather simple, but it requires a great deal of effort to select an appropriate **outgroup** for comparison. An **outgroup** is a related sister taxon that is not included in the group being investigated. A character state found in both the outgroup and the taxa being examined is considered plesiomorphic. Any modification of the character state is considered to be apomorphic. For example, in constructing a cladogram of terrestrial vertebrates with internal fertilization, a salamander (amphibian) would be an appropriate outgroup for turtles, blackbirds, and cats. Only the three ingroups form an amniotic egg, so this trait must have arisen after amphibians but before the common ancestor of the other groups.

Cats, turtles, and blackbirds all have amniotic eggs, so this must be a trait of their common ancestor. Hair is a characteristic of mammals, so it must have evolved after the evolutionary line toward mammals diverged from the line toward birds and reptiles. In practice, cladograms are much more complicated and are done by computers. Figure 26-3 provides a simple algorithm to demonstrate how computers use the data provided to generate a cladogram.

Character Description

Morphology is the traditional basis for phylogenetic classifications, and it continues to provide strong evidence. Begin by listing the recognizable traits and their character states for all of the taxa being

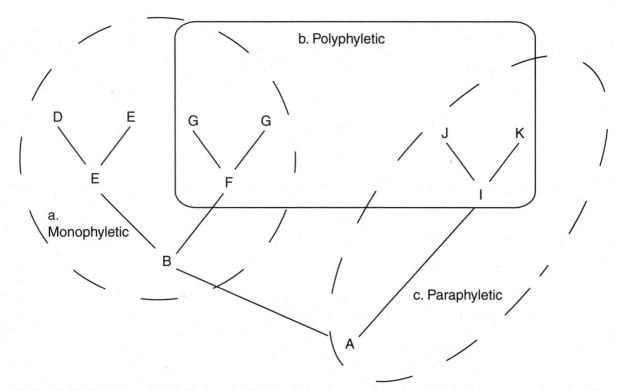

Figure 26-3. Cladogram. A phylogenetic tree based on shared, derived characters illustrates genetic ancestry. a) In this clade, all members share a single common ancestor, B, and the clade is monophyletic. b) Species that occur in two or more clades are polyphyletic. c) A clade that contains some, but not all, of the descendents of a common ancestor is paraphyletic.

classified. For example, salamanders, turtles, blackbirds, and cats all produce an egg, either amniotic or not. During the past thirty years, biochemical traits have become increasingly important in determining phylogenies. The data are much less prone to interpretational bias by the investigator and the results are easily quantifiable. An added benefit is that only small bits of tissue are required, and in some cases, even fossil material may be used.

To use biochemical data, similar molecules (for example, cytochrome C or specific segments of DNA or RNA) are extracted from many different species. The sequences are then compared, position by position, from one end of the molecule to the other. The resulting data can be displayed in tabular form that shows only those positions where a difference occurs. For example, a comparison of our four taxa might show five positions in the cytochrome C molecule where there was a difference in amino acids.

Building a Data Matrix

To build a data matrix, numerical values are substituted for character descriptions. Pleiomorphic states are assigned the value 0; apomorphies are assigned sequential whole numbers. Score the first apomorphic state, if any, for a character as 1. All taxa sharing this state should also be scored 1. If a second apomorphic state was found in the taxa surveyed, score it 2, and so on. The data matrix for the cytochrome C data are presented in Figure 26-5.

Position	Salamander	Turtle	Blackbird	Cat
8	Proline	Proline	Alanine	Alanine
22	Lysine	Aspartic Acid	Lysine	Threonine
41	Alanine	Valine	Alanine	Threonine
66	Aspartic Acid	Histidine	Aspartic Acid	Aspartic Acid
108	Glutamic Acid	Aspartic Acid	Alanine	Threonine

Figure 26-4. Hypothetical molecular character states for a particular molecule. The amino acids in a particular polypeptide were sequenced for the outgroup (salamander) and three ingroup taxa: turtle, blackbird, and cat. The sequences were identical except at the five positions indicated. The variable site amino acids for each species are listed.

Position	Salamander	Turtle	Blackbird	Cat
8	0	0	1	1
22	0	1	0	2
41	0	1	0	2
66	0	1	0	0
108	0	1	2	3

Figure 26-5. Data matrix for the information presented in Figure 26-4. Character states from Figure 26-4 are assigned numerical values. By definition, the outgroup (pleisiomorphic) character is assigned the value 0. Apomorphic character states are assigned successive whole numbers. Apomorphies shared between taxa receive the same number.

Constructing the Cladogram

Like any good tree, a cladogram must have a root, the origin from which the branches of the tree grew. The outgroup is used to root a cladogram. Taxa are added sequentially to the root to provide the most parsimonious tree; that is, the simplest tree that explains the data. The method described below illustrates how a computer can be programmed to construct a tree using the data in the data matrix.

Begin by sketching the outgroup and any two additional taxa, joined together in a diagram as illustrated in Figure 26-6a.

In the parentheses, list, in order, the character state scores from the data matrix. This three-taxon statement is called a **Wagner Neighborhood,** with the three taxa joined at a single point, the node, which represents the common ancestor of the two derived taxa.

The next step is to determine the character states of the node. If a character is binary, the node character state is defined as the majority state of three taxa in the neighborhood. If all taxa in the neighborhood have a different value for that character state, the node should be scored as the median state of the neighborhood taxa (Figure 26-6b).

Additional taxa are added one at a time by placing each in the neighborhood with the greatest parsimony. There are three possible positions, indicated with "?," where the blackbird could be added to the tree: between the root (salamander) and the node; between the node and the turtle; or between the node and the cat (Figure 26-6c). Each of the three possible trees must be constructed, including a calculation of the new node characteristics of each tree. The three possible trees are combined in Figure 26-6d.

Examine the three possible branches. The preferred one provides a node for a **unique** shared ancestor between the taxon being added and one neighbor already on the tree. In other words, the score for the new node should be different from any other, and the number of changes between the new node and the newly added taxon should be minimal.

In this case, we should plot the blackbird in the first position between the salamander and the original node. The new node requires only one change from the character states of the salamander. In position 2, the new node is exactly the same as the original node. To avoid the ambiguity of having three taxa

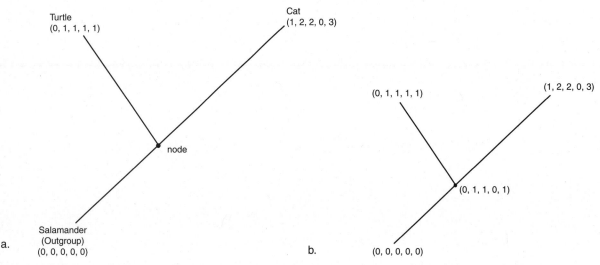

Figure 26-6(a,b). Constructing a nearest-neighbor cladogram. a) The outgroup and any two taxa from the study are connected to form a base tree. For each taxon, the character-state values are listed in order. The node represents the hypothetical common ancestor of the two outgroup taxa. b) Character states of outgroup are either the majority or median value of the three nearest neighbors.

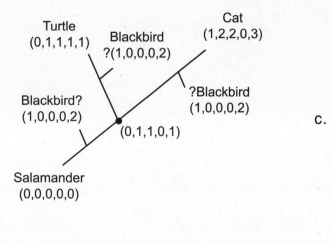

Figure 26-6(c, d). Constructing a nearest-neighbor cladogram. c) Three possible positions to add the fourth taxon, the blackbird. d) Nodal character states calculated for each possible position.

diverge from the same point, we must reject this alternative. In position 3, there are three changes from the original node, so this alternative is not as likely as a single change.

If more taxa were present in the data matrix, they would be added in the same fashion: Each possible cladogram would be constructed and examined for parsimony. Although this may be done rather quickly for small numbers of characters and taxa, it rapidly becomes laborious as numbers increase. Fortunately, there are computer programs that perform the necessary calculations and comparisons to generate cladograms for large data sets.

■ SOME DIFFICULTIES IN PHYLOGENETIC ANALYSIS

Any classification system depends on data, interpretation of the data, and an underlying philosophy of classification. Gathering and scoring character state data is difficult. Sometimes, characters from one species do not match characters from another, and sometimes, character states are related—a change in one will automatically change the other. Is this one character or two? Furthermore, not all characters in an organism evolve at the same rate. For example, in some genes, mutations occur frequently, while in others, mutations are rare. A tree based on sequences of one gene will most likely be different from a tree based on another gene. A variety of techniques have been developed to deal with such problems to reach a consensus tree. This is a vigorous and exciting area of modern biology.

Test Yourself

1) The binomial system of classification names every kind of organism according to
 a) kingdom, species.
 b) genus, species.
 c) class, kingdom.
 d) family, genus.
 e) a or b, but neither c nor d.

2) Classification systems that reflect the evolutionary history of a group are called
 a) categorical.
 b) hierarchical.
 c) historical.
 d) phylogenetic.
 e) phenetic.

3) The characteristics defining a genus are more general than those defining a
 a) family.
 b) species.
 c) order.
 d) phylum.
 e) class.

4) Two experts are given exactly the same data about a collection of living organisms and are asked to form a "natural" classification reflecting the degree of relationship between each individual. How could you explain different results by these two experts?
 a) One or both did not use all the data that they were given.
 b) The experts had different philosophies about what are the most important characteristics of the organisms.
 c) One expert treated all data equally, the other "weighted" some evidence more heavily than others.
 d) What the data meant was interpreted differently by one expert than by the other.
 e) All of the above happened.

5) Which of the following is true?
 a) Phenetic classifications are base primarily on genotypes.
 b) Phenetic classifications are base primarily on phenotypic similarities and genotypic differences.
 c) Cladistic classifications depend on shared, derived characters.
 d) Cladistic classifications are based solely on molecular data.
 e) A natural classification, showing genealogical relationships, may be either phenetic or cladistic.

6) The modern method of biological taxonomy was devised by
 a) Darwin.
 b) Lamarck.
 c) Linnaeus.
 d) Mayr.
 e) Cuvier.

7) A group of species that includes an ancestor and some, but not all, of its descendants is called
 a) monophyletic.
 b) semiphyletic.
 c) polyphyletic.
 d) paraphyletic.
 e) epiphyletic.

Test Yourself Answers

1) **b.** Genus and species provides the scientific binomial (name) for any organism. These are the two most specific levels at the base of the hierarchical system of classification.

2) **d.** A phylogenetic classification represents the genetic relationships between organisms, their evolutionary history.

3) **b.** The most specific characteristics defining an organism are at the species level. More general are characteristics shared by all species in the genus. The characteristics at higher levels of the classification are successively more general.

4) **e.** Each of the situations listed would result in different classifications being formed by two different experts.

5) **c.** Cladograms, used to form hypotheses about classification, are based on shared, derived characters. Phenetic classifications are based on similarities between individual taxa with no special regard for genetic relationship.

6) **c.** The hierarchical system of classification, and the system of binomial nomenclature, were developed by Linnaeus.

7) **c.** A clade containing all species derived from a common ancestor is monophyletic. If some species fall into a different clade, the genus naming those species is polyphyletic.

Prokaryotes

In Chapter 5, the unique characteristics of prokaryotic cells were described and compared to eukaryotic cells. While most living things you can name are eukaryotic organisms, by far the most numerous and diverse organisms are prokaryotic. The distribution of prokaryotes is cosmopolitan; anywhere there is life there are prokaryotic organisms. They are the most ancient group of organisms with fossil evidence in rocks that are three billion years old. Since their origin, prokaryotes evolved a variety of metabolic pathways in addition to the typical anaerobic, aerobic, and photosynthetic pathways we discussed. These include several different chemosynthetic pathways as well as metabolic adaptations to extreme conditions of heat, cold, salinity, and pH. Although members of this group are almost entirely unicellular and microscopic, the total biomass of prokaryotic organisms is more than ten times the biomass of all the plants and animals on earth combined.

■ STRUCTURE

Prokaryotes are mostly small unicellular organisms, less than 10μm long. Three different cell shapes are common. Spherical cells are called **cocci,** rod-shaped cells are **bacilli,** and spiral cells are **spirilla.** Frequently, the cells are paired (**diplo–**), in chains (**strepto–**) or in clumps (**staphlo–**). Many bacterial genera are named based on their cell shape—for example, *Staphlococcus* (as in "staph infections") form clumps of spherical cells, while *Streptococcus* (as in "strep throat") form chains of spheres. Cyanobacteria are unusual in that they frequently form colonial chains of cells in which some cell specialization may occur.

A characteristic feature of prokaryotic cells is their cell wall that is built with a combination of carbohydrates and polypeptides. Two basic types of cell walls can be detected based on their affinity for certain stains; **gram positive** cells stain purple, while **gram negative** cells stain pink when treated with the gram stain procedure. In addition to the wall itself, some bacteria extrude an additional layer of gelatinous material that forms a sheath or **capsule** around the entire cell. Presence of a capsule is frequently associated with pathogenicity.

With a few notable exceptions, there are no internal membranes other than the cell membrane itself. The cytoplasm of most cyanobacteria cells are packed with photosynthetic membranes, thylakoids, that function similarly to the thylakoids of chloroplasts in plant cells. Some bacilli form a thick-walled endospore within the cytoplasm, particularly as growing conditions deteriorate following a period of active growth. The endospore is metabolically inactive and highly resistant to drought and temperature

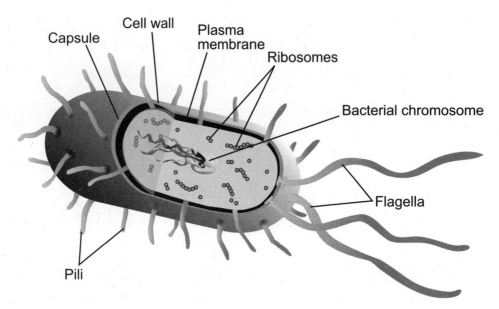

Capsule Cell wall Plasma membrane Ribosomes Bacterial chromosome Flagella Pili

Figure 27-1. Generalized prokaryotic cell. All prokaryotes produce a cell wall external to the plasma membrane. In addition, many secrete an additional capsule layer around the outside of the cell wall. Motile cells produce one or more bacterial flagella, which are rigid proteinaceous rods with a helical structure. The flagellum penetrates the cell wall and rotates in place. Strands of cytoplasm may also extrude through pores in the wall forming fimbriae. Internally, there is a single ring-shaped bacterial chromosome; there may be one or more small rings of DNA, called plasmids.

change. Such a resting spore allows the species to survive inclement conditions, such as a cold winter, and then resume growth as conditions later improve.

A number of prokaryotic organisms are motile with one or more flagella. The bacterial flagellum is structurally and functionally different from eukaryotic flagella and cilia. The axis of the flagellum is composed of helical protein chains (recall the helical secondary structure of proteins from Chapter 3). This fixed shape allows the flagellum to function like a propeller on a boat motor. At the base of the flagellum, embedded in the wall and the adjacent cell membrane, is a basal apparatus. The wall acts like a bushing in an electric motor to allow the shaft of the basal apparatus to spin. The power to spin the motor is related to the ATP synthetase complexes in electron transport chains (Chapters 7 and 8). ATP driven pumps transport protons across the cell membrane into the space under the cell wall. [Diffusion of protons back into the cell, powers the basal apparatus, causing it to spin and rotate the attached flagellum like a screw propeller, to drive the cell through the medium]. In addition to the flagellum, there are frequently numerous threads of cytoplasm, **pili** or **fimbriae,** that extend through the cell wall and serve to attach the cell to substrate or other cells.

The single loop of DNA is more or less diffuse in the cell. In the true bacteria, there are no histone proteins associated with the DNA; however, the archaea, like eukaryotic cells, have associated histones. In addition to the single bacterial chromosome, many prokaryotic cells contain one or more small rings of DNA, plasmids (recall Chapter 14).

■ REPRODUCTION

Under optimum growth conditions, prokaryotes are capable of astronomical growth rates, doubling every 20 minutes or less. Recall from Chapter 16 that if you started with one cell, growing exponentially,

it would double to two in 20 minutes, four in 40 minutes, and eight in 1 hour. After one day, you would have 4.7×10^{21} individuals. Of course, a variety of factors will limit the rate of growth as the population increases.

Prokaryotic cells, which lack a nucleus, undergo a unique type of cell division called **binary fission.**

DNA replication occurs, and each strand attaches to the cell membrane. As the cell elongates, a new membrane is synthesized between the attachment points and the two bacterial chromosomes begin to separate. The cell membrane begins to invaginate between the chromosomes to divide the cytoplasm in two. Soon after, a new wall begins to form by centripetal deposition of glycoprotein, eventually cutting off two identical daughter cells.

True sexual reproduction cannot occur in prokaryotes, again because they lack a nucleus and, therefore, cannot undergo meiosis. However, as shown in Chapter 14, they are capable of one-way transfer of genetic information. In addition to transduction, using a virus vector to transfer bacterial DNA from one cell to another, and conjugation involving transfer of plasmids, a second type of conjugation occurs in some prokaryotic cells

As before, a cytoplasmic bridge (a reproductive pilus) forms between compatible cells, and DNA replication occurs in the donor cell. In this case, it is an entire replicated bacterial chromosome, rather than a plasmid, that migrates through the pilus from the donor cell to the receptor cell. Successful transfer of the entire chromosome depends on the duration of connection

■ METABOLISM

Prokaryotic organisms possess a wide variety of metabolic pathways. Normally, when we think of autotrophic organisms (organisms capable of producing their own food), we think of photosynthesis (recall Chapter 8). There are many photosynthetic prokaryotes, including some with unique photosynthetic pathways. There are also many autotrophic prokaryotes that obtain their energy not from sunlight

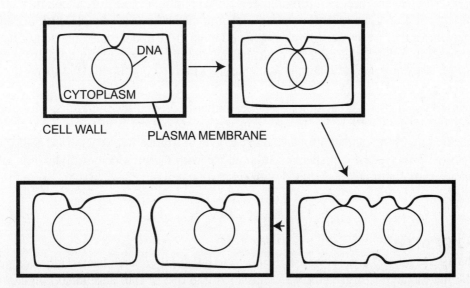

Figure 27-2. Binary fission. Vegetative reproduction is by splitting the cell in two, called binary fission. Prior to division, the bacterial chromosome replicates and each ring attaches to the plasma membrane. Growth of the membrane separates the chromosomes and initiates an infolding, which ultimately divides the cytoplasm in two. New wall growth is centripetal, from the original wall toward the center.

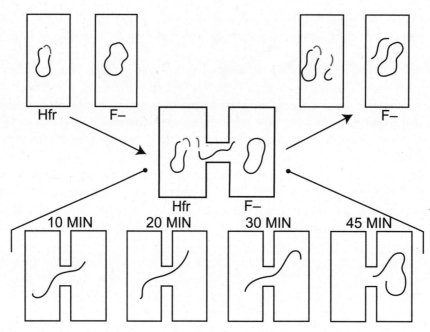

Figure 27-3. Conjugation. *Conjugation is one method of one-way transfer of genetic information from one cell to another. A cytoplasmic bridge forms between participating cells, and part or all of a replicated chromosome passes from the donor cell to the receptor cell.*

but by oxidizing chemicals such as hydrogen sulfide, ammonia, or iron. Many of these chemosynthetic organisms live in extreme environments such as deep sea thermal vents or hot springs.

In terms of respiration (recall Chapter 7), there is also more variety in prokaryotes. While many prokaryotes are obligate aerobes, requiring oxygen for respiration, others are facultative anaerobes. If oxygen is present, they undergo aerobic respiration, but in the absence of oxygen, they undergo fermentation. Obligate anaerobes are poisoned by oxygen and must grow under anaerobic conditions. But even here there is variation. While some undergo typical fermentation, others have unique pathways similar to aerobic respiration that use nitrate or sulfate ions, instead of oxygen, as the final electron acceptor at the end of the electron transport chain.

As discussed in Chapter 18, bacteria also are essential in driving the nitrogen cycle. Certain bacteria, including the cyanobacteria, are involved in fixing atmospheric nitrogen into ammonia. The cyanobacteria are interesting in that nitrogen fixers carry on this process in specialized cells of the colony called heterocysts. This type of cell specialization, along with the presence of thylakoids in vegetative cells, are characteristics normally associated with eukaryotic cells.

■ PHYLOGENY

Until the 1970s, all prokaryotes were considered to be closely related bacteria in a single kingdom, Monera. All other eukaryotic organisms were classified into one of four additional kingdoms. With the onset of cladistic analysis of molecular characters (recall Chapter 26), a surprising pattern emerged. A group of prokaryotes, the Archaea, have cells that are intermediate between prokaryotes and eukaryotes. There are actually three major types of cells, two of which are prokaryotic. With the acceptance of this discovery, a new level of classification was introduced into the classification system, the domain. Two

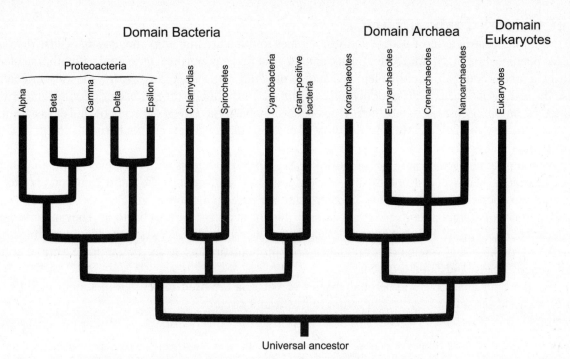

Figure 27-4. Prokaryotic phylogeny. Current classification divides all living things into three domains, two of which consist of prokaryotic organisms, domain Bacteria and domain Archaea. There are numerous subdivisions of each of these domains into clades that are equivalent to the four kingdoms of the Eukaryotic domain.

domains, Bacteria and Archaea, have prokaryotic cells, and all other organisms are grouped into a single domain, Eukaryota.

Although prokaryotic, members of the Archaea share several characteristics with eukaryotes, such as more than one kind of RNA polymerase, having methionine as the first amino acid during protein synthesis, having introns in the primary RNA transcript, not responding to antibiotics, and having histone proteins associate with their DNA. A major difference of Archaea from both bacteria and eukaryotes is their ability to survive in extreme environments, including high salt (halophiles) and high heat (thermophiles). Some thermophiles can withstand temperatures above 100°C.

In Chapter 8, the symbiotic theory for the origin of eukaryotic cells was described. The extreme variability in pathways used by prokaryotes to obtain energy, as well as their propensity to form symbiotic relationships with other organisms, support the likelihood of this now-accepted theory.

■ ECOLOGICAL IMPORTANCE

The nitrogen cycle depends exclusively on the participation of several different types of prokaryotic organisms to fix and cycle nitrogen in the ecosystem (recall Chapter 18). In extreme environments, prokaryotes are frequently the primary producers. Normal decay and decomposition depends in large part on bacterial species that recycle organic and inorganic nutrients through the ecosystem.

Prokaryotes are also important symbionts associating with a variety of eukaryotic organisms. Many of the nitrogen fixers are plant symbionts living within specialized groups of cells in roots or leaves. Many lichen species have a cyanobacterium algal partner associated with the fungus. Even humans have internal and external symbiotic bacteria that are essential to our health.

■ ECONOMIC IMPORTANCE

Mention bacteria to most people and what comes to mind are human pathogens that cause diseases such as plague, cholera, typhoid fever, pneumonia, scarlet fever, gonorrhea, meningitis, diphtheria, tuberculosis, tetanus, botulism, syphilis, leprosy, and so on. Billions of dollars are spent annually to control these diseases. And bacteria do not only attack animals. Fire blight, soft rot, bacterial wilts, and crown gall are common diseases of agricultural crops caused by bacteria. Given the scale of this devastation, it may be difficult to believe that the vast majority of prokaryotic organisms are not harmful, and in fact, the majority are beneficial.

Although some bacteria are the agents of disease, others provide us with the means of treating infection. Bacitracin, neomycin, streptomycin, and polymyxin B are some of the more common antibiotics derived from bacteria that are effective in controlling the pathogenic forms.

A number of common foods owe their existence to the action of various bacteria. They include dairy products such as yogurt, butter, buttermilk, and some cheeses such as Swiss, cheddar, and limburger. Sauerkraut, pickles, and vinegar depend on bacterial fermentation, as do the initial processing of coffee beans, cocoa beans, and cured tobacco.

Finally, both anaerobic and aerobic species of bacteria are used in sewage treatment facilities to purify waste water before recycling or return to freshwater streams.

Test Yourself

1) Bacteria that oxidize ammonia to nitrate as a source of energy are
 a) photoautotrophic.
 b) chemoautotrophic.
 c) chemoheterotrophic.
 d) saprophytic.
 e) both c and d.

2) Metabolic diversity is greatest in which group?
 a) prokaryotes
 b) protists
 c) fungi
 d) animalia
 e) plantae

3) Bacteria that are poisoned by oxygen are known as
 a) aerobes.
 b) obligate anaerobes.
 c) facultative anaerobes.
 d) obligate aerobes.
 e) facultative aerobes.

4) Heterocysts are structures characteristic of some
 a) spore-forming bacteria.
 b) cyanobacteria.
 c) archaebacteria.
 d) nitrogen-fixing bacteria in root nodules of legumes.
 e) heterotrophic cyst-forming archaebacteria.

5) The methane-producing bacteria (methanogens), salt-tolerant species (halophiles), and heat tolerant species (thermophiles) belong to the
 a) archaebacteria.
 b) prokaryotes.
 c) eukaryotes.
 d) urkaryotes.
 e) eubacteria.

6) What benefit goes to bacterial species that produce endospores?
 a) They can perform sexual reproduction.
 b) They can move.
 c) They are resistant to antibiotics.
 d) They are resistant to freezing, drying, and heating.
 e) They can evade host immune systems.

7) The actions of nitrogen-fixing bacteria that live in the soil are most like those of a farmer
 a) turning over the soil.
 b) spraying a pesticide on the crops.
 c) spraying an herbicide on the fields.
 d) applying fertilizer to the field.
 e) gathering plant refuse to be used as silage.

8) All of the following are examples of the benefits of bacteria to humans *except*
 a) vitamin manufacture in the large intestine.
 b) bacterial action in the processing of sewage.
 c) bacterial production of toxins.
 d) production of drugs such as streptomycin.
 e) production of acids that flavor cheese.

9) Which of the following is a characteristic of prokaryotes?
 a) a nucleus containing only DNA
 b) small mitochondria
 c) chloroplasts with thylakoids
 d) a capsule or slime sheath
 e) cellulose cell walls

10) Bacterial cells divide by
 a) mitosis.
 b) meiosis.
 c) binary fission.
 d) all of the above.
 e) a and b only.

Test Yourself Answers

1) **b.** Bacteria that oxidize molecules to obtain energy are chemosynthetic, using a chemical source of energy to produce their own food. Therefore, they must be chemoautotrophic. Heterotrophs and saprophytes utilize organic molecules as a food source.

2) **a.** The prokaryotes, formerly the kingdom Monera, are so diverse that today they are classified into two great domains, equivalent to the third domain of all eukaryotic organisms, including all plants and animals.

3) **b.** Bacteria that are poisoned by oxygen cannot survive if oxygen is present. Therefore, they are obligate anaerobes.

4) **b.** Heterocysts are cells specialized for nitrogen fixation found in cyanobacteria.

5) **a.** The archaebacteria include extremophiles, those prokaryotes adapted to extreme environmental conditions, as well as the methane-producing bacteria that are obligate anaerobes.

6) **d.** Endospores are thick-walled resistant structures that allow the species to resist unfavorable conditions, such as freezing, drying, and heating. Once favorable conditions return, the endospore germinates to produce a new generation of reproducing cells.

7) **d.** Nitrogen-fixing bacteria add nitrogen to the soil in the form of ammonium, which can then be converted into nitrate by other bacteria. The nitrate is the form most readily taken up by plants to form amino acids. The most common methods used by farmers to add nitrogen fertilizer to their fields are to inject ammonia or broadcast nitrate.

8) **c.** Most bacteria are beneficial to humans, as suggested by all of the choices except c, the production of toxins by the few pathogenic species.

9) **d.** Some prokaryotes, especially pathogenic forms, produce a gelatinous capsule or sheath around the cell. Nuclei, mitochondria, and chloroplasts are found only in eukaryotic cells. Plants have cellulose walls; prokaryotes have glycoprotein walls.

10) **c.** Binary fission is a form of cell division unique to prokaryotes, which lack a nucleus. Mitosis and meiosis are both forms of nuclear division.

Protists

At the time that Lynn Margulis proposed the symbiotic theory for the origin of the eukaryotic cell (see Chapter 5), it was also proposed that living things be classified into five kingdoms (prior to that, there was a three-kingdom approach). In addition to prokaryotic organisms in kingdom Monera, there were plants, animals, fungi, and a fifth group, the kingdom Protista. This kingdom, in a sense, served as a default. If an organism was one-celled and not clearly a member of one of the other kingdoms, it must be a protist. With this approach, there were clearly some protists that were animal-like, fungal-like, or plant-like, and it was assumed that these three kingdoms arose from unicellular members of the protista that shared similar characteristics.

The advent of molecular data and cladistic analysis clarified relationships and brought order to what was previously simply a grouping of convenience.

One of the first striking relationships was that, despite their cell walls, the fungi are more closely related to animals than they are to plants. A second striking relationship was that most of the algal groups do not have close affinities to the land plants, but instead fall into several different clades. Finally, there is a great diversity of protistan organisms, but the multicellular groups of fungi, plants, and animals are related to specific predominantly unicellular groups.

Several traditional features still serve to characterize major groups of protists. The presence and composition of the cell wall serves to differentiate between several groups. A chitinous cell wall in all of the true fungi was an early clue of a relationship to animals; insects and crustaceans also produce chitin. Storage products and pigments are also defining characteristics. While all photosynthetic eukaryotes have chlorophyll a, only land plants and green algae have chlorophyll b, brown algae, diatoms, and dinoflagellates have chlorophyll c, and some red algae have chlorophyll d. The presence, number, and type of flagella are also useful traditional characters. For example, all eukaryotic flagella have a whip-like axis containing microtubules in a 9 + 2 pattern (see Chapter 5), but many species have so-called tinsel flagella where bristle-like lateral ornamentation extends from the axis. The characteristics of the major groups of protistans are outlined in the following sections.

■ ALVEOLATA

The alveolate clade consists of unicellular organisms that may or may not contain two or more flagella, but that always have one or more small sac-like structures, called an alveoli. These tiny structures are visible only with an electron microscope.

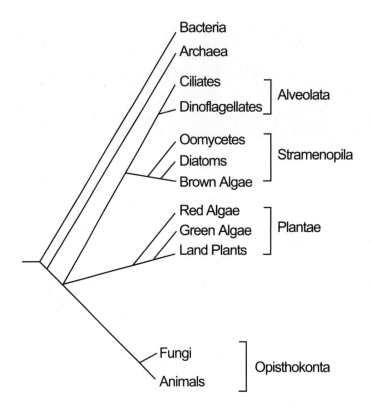

Figure 28-1. Phylogenetic relationships of eukaryotic organisms. Cladogram of the major clades of living things, with the two prokaryotic domains as outgroups to the eukaryotes. The Alaveolata, Stramenopila, and Amoeozoa are major protistan clades.

Ciliates

Ciliates are among the largest unicellular organisms and some can be seen with the naked eye. They have many short, flagella-like structures, called **cilia,** protruding from the cell.

At the base of each cilium is a **basal body,** and these are interconnected by fibrous strands. As a result, the cilia beat in a coordinated fashion that permits the ciliate to respond to stimuli. They are free-living organisms that occur in either fresh- or salt water. Most ciliates have a funnel-shaped groove that traps food particles as the organism swims through the water and channels them to a special part of the cell membrane where **phagocytosis** occurs. The membrane invaginates to form a food vacuole around the trapped particles

There is no cell wall, and the fresh water forms live in a hypoosmotic environment, where water is in higher concentration outside of the cell, so it tends to move into the cell by osmosis (recall Chapter 4). The constant inflow of water might cause the cell to swell and burst, except that a special **contractile vacuole** accumulates water from the cytoplasm and periodically pumps it back out of the cell.

A unique feature of ciliate cells is the presence of two nuclei of different sizes. The **macronucleus** contains multiple copies of common genes whose function is unknown. The **micronucleus** undergoes meiosis and is involved in a special type of sexual reproduction. The life cycle is complex, but during most of the cycle, the micronucleus is in the diploid condition (recall Chapter 10).

Ciliates are important consumers in aquatic food webs, and many are endosymbionts in the gut of grazing mammals. These ciliates, along with various bacteria, assist in the digestion of plant material that the herbivore cannot break down with only its enzyme complement.

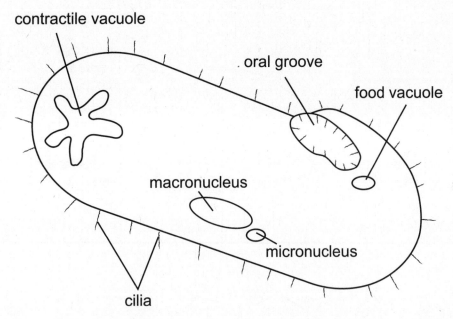

Figure 28-2. Diagrammatic ciliate. Ciliates are characterized by numerous cilia covering their membrane. An oral groove serves to funnel food materials to an inner portion of the membrane that functions as a mouth, forming food vacuoles that move through the cytoplasm. Two distinctive nuclei are present, a macronucleus and a micronucleus. A contractile vacuole removes excess water from the cytoplasm.

Dinoflagellates

The dinoflagellates, or "spinning flagellates," occur mostly in warm marine waters. Most common forms are called "armored" because of the cellulose plates they produce beneath the cell membrane.

The cellulose plates give the cell somewhat of a helmet shape. A characteristic feature is a transverse furrow that forms a groove around the equator of the cell. A shorter furrow extends from the transverse furrow toward the posterior end of the cell. A unique, belt-shaped flagellum lies within the transverse furrow. One edge is attached to the cell membrane, while the free side extends outward and flaps in an undulating motion. This undulation causes the cell to spin on its axis. The second flagellum emerges from the cell membrane where the two furrows join, and it extends backward through the posterior groove. This is a whiplash-type flagellum.

Approximately half of the species are photosynthetic containing chlorophylls a and c and accessory pigments identical to those of diatoms. Many dinoflagellates are symbiotic with animals, such as the corals, and others contain symbiotic cyanobacteria. Sexual reproduction has rarely been reported, but it appears that most cells are haploid, and meiosis occurs immediately after the zygote is formed (see Chapter 10).

While many dinoflagellates are important primary producers in the marine ecosystem, several are responsible for the notorious red tides that occur in coastal waters. Red tide is a bloom of dinoflagellates in which the concentration of protists is so abundant that the water is colored by the organisms. The algae produce a nerve toxin that does not harm shellfish or other invertebrates but is lethal to vertebrates, including humans who eat contaminated shellfish. Some dinoflagellates are interesting because they produce a bioilluminescence when oxygenated, for example by churning propellers of a ship. The algae undergo the same reaction as fireflies do to produce a glow. When they number in the thousands per liter, a ship's wake can easily be tracked by satellite.

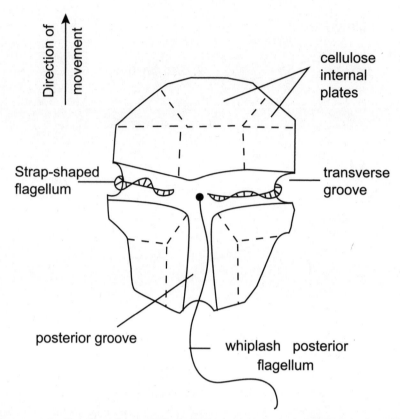

Figure 28-3. *Diagrammatic dinoflagellate. Dinoflagellates have two distinctive grooves, one around the equator and a second moving at right angles from the equator toward the posterior end. A belt-shaped flagellem traverses the transverse groove. A whiplash flagellum lies in the posterior groove and extends toward the rear. Many dinoflagellates possess distinctive cellulose plates beneath the cell membrane.*

Ampicomplexa

The ampicomplexa consist entirely of parasitic organisms, which contain a complex apical structure specialized for penetrating the cytoplasm of host cells. They lack any specialized structure for motility and, thus, depend entirely on their host for movement. The parasite often depends on two hosts to complete its life cycle.

Perhaps the most familiar ampicomplexans are the malarial parasites, plasmodium. Plasmodium spends most of the vegetative part of its life cycle in humans, where it reproduces asexually, building up large numbers of haploid parasite cells in the blood. The sexual part of the life cycle, fertilization and meiosis, occurs in a secondary host, the *Anopheles* mosquito. In recent years, the parasite has evolved immunity to most commonly used treatment drugs, and the mosquito has evolved resistance to common insecticides so that malaria is reemerging as a major tropical disease. In 2005, more than 6,000 African children died every day from malaria.

■ STRAMENOPHILA

The characteristic feature of all stramenophiles is the presence of tinsel-type flagella on at least some cells during the life cycle, either vegetative or sexual reproductive cells.

Oomycetes

Oomycetes were originally considered to be fungi because of their filamentous bodies, called **mycelia.** Unlike most fungi, whose filaments consist of chains of cells, the mycelium of oomycetes consists of elongated, multinucleate cells.

If you examine a filament microscopically, there are no crosswalls except where reproductive structures form; the cells are long, narrow tubes through which multinucleate cytoplasm flows. Like fungi, the cells produce cell walls, but rather than being composed of chitin, the cell wall of oomycetes is made of cellulose.

The characteristic feature of oomycetes, for which they are named, is the production of enlarged female reproductive structures, oogonia, in which meiosis occurs to produce egg cells. These begin as a short branch off the side of a filament, which forms a wall to separate its nuclei and cytoplasm from the rest of the mycelium. In the tip of another filament, a male reproductive structure, an antheridium, is formed by walling off cytoplasm and nuclei. The antheridium and oogonium join, and haploid nuclei fuse to form a diploid oospore. When this spore germinates, it produced a new diploid mycelium. Unlike true fungi, oomycetes have a 2n dominant life cycle.

None of the sexual reproductive cells are motile, but prolific asexual reproduction occurs by means of spores. Aquatic forms produce two types of zoospores, both having two, unequal-length flagella, the longer tinsel and the shorter whiplash. Terrestrial forms usually produce wind-blown spores lacking flagella, but under certain conditions, they may also produce typical zoospores.

Although most species are saprophytic and help to decompose dead organisms, there are several important parasites. If you have fish in an aquarium, you may be familiar with "ick." This is a water mold

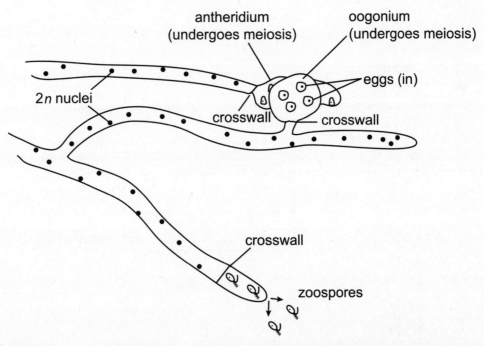

Figure 28-4. Oomycete. The body of oomycetes is composed of multicellular filamentous cells. The only crosswalls that divide the filament into smaller segments occur at the base of reproductive organs. Biflagellate zoospores are produced in terminal sporangia. Oogonial cells undergo meiosis to produce egg cells. The nuclei in antheridia undergo meiosis to produce male gametes. Fusion of an egg and male gamete produces an oospore.

that forms white fuzzy patches, beginning in small patches between scales, but quickly killing the host and spreading throughout the aquarium. More significant are several terrestrial forms that parasitize plants. Downy mildew of grapes first attacks grape leaves. The spores germinate on the leaf surface and grow their filaments into the leaf tissue, where they proliferate and spread, soon killing the leaves and, eventually, the entire plant. It was first introduced into France, by accident, on infected roots brought from America. The roots stocks were imported because they were resistant to attack by root nematodes that were attacking the native French grape roots. Although one problem was solved, the grape industry was almost destroyed as the mildew killed the tops. This led to the discovery of the first commercial fungicide: Bordeaux mixture, which is still used. Of greater social impact was the introduction of the potato blight mold from America to Northern Europe in the mid 1800s. At that time, an average peasant in Holland or Ireland consumed more than eight pounds of potatoes per day—all three meals. Within a two-year span, the population of Ireland fell from more than 4 million people to less than 2 million. Approximately half of the loss was due to starvation after the blight killed nearly all the potato plants in the fields. The other million Irish embarked on a great migration—to America and Australia.

Diatoms

Diatoms are widespread and abundant, both in freshwater and marine ecosystems. They may be free-floating in the water column, but are often epiphytic or form slimy layers on the substrate. It has been argued that they are the single most important photosynthesizers on earth, producing more oxygen and fixing more carbon than the flowering plants on land.

The characteristic feature of diatoms is their glassy cell wall. The wall consists of two halves that fit together like a Petri dish, with one half slightly larger and overlapping the second.

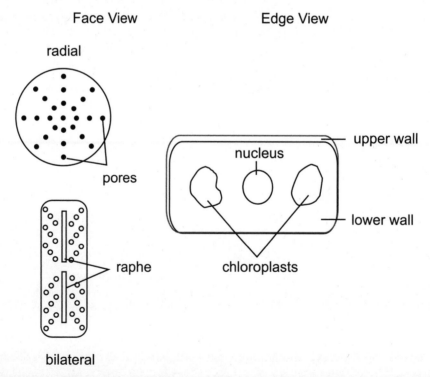

Figure 28-5. Diatom. In a face view, diatoms are either radially or bilaterally symmetric, with numerous pores on the surface in distinctive patterns. Bilateral diatoms have a groove, called the raphe, running down the center of the wall. In an edge view, the overlapping upper and lower walls are evident.

Marine forms are mostly radially symmetric or triangular, while freshwater forms are mostly bilaterally symmetric. Although the walls contain cellulose, they are impregnated with silica (the same mineral in sand grains that are fused together to form glass) and are, therefore, very hard, abrasive, and reflective. The wall also contains numerous pores that are very uniform in size and in a characteristic pattern. The pattern of pores is so precise that certain species of diatoms are used to test the resolving power of research-quality microscope lenses.

Diatoms contain the same photosynthetic pigments as dinoflagellates and brown algae (see the following section), and also produce a lipid storage product similar to that of brown algae. The bilaterally symmetric diatoms also have a groove—the raphe—running lengthwise down the middle of the cell. The cell membrane protrudes into these gaps, and the action of motor proteins on microtubules in this area allow the diatom to glide along the substrate.

Diatoms are diploid cells that have a unique method of cell division. Every time the cell divides, one of the original cell walls becomes the larger side of the newly formed daughter cell, which goes on to synthesize a new smaller wall. As a result, one daughter cell remains the same size as the parent cell, while the other cell will be slightly smaller. After a period of growth, the population of diatoms will consist of individuals of a spectrum of sizes, from the size of the original cell down to a cell approximately 70 percent smaller.

Under appropriate environmental conditions, when a cell reaches a certain (small) critical size, it will undergo meiosis to produce gametes. In the bilateral forms, the gametes appear identical and are amoeboid. In radially symmetric forms, one type of cell typically undergoes meiosis to produce one or two egg cells, while a second type produces four or more flagellated sperms. The sperm have only a single flagellum, but it is a specialized tinsel type.

In addition to their role as primary producers in aquatic ecosystems, diatoms are a useful tool for monitoring water pollution. In general, non-polluted water contain small populations of many different diatom species while only a few species increase to great numbers and dominate polluted water. This is useful for long-term monitoring of water quality. For example, a baseline is established for a river or stream before construction of an industrial plant, allowing changes to be monitored over time once the plant is completed.

The most important economic role of diatoms makes use of deposits of fossilized remains, called diatomaceous earth. These deposits are mined and used for fine filtering, producing mildly abrasive polishes, producing reflective surfaces (such as in paints and signs), or producing high-temperature insulation.

Brown Algae

Brown algae, frequently known as kelp, are almost exclusively multicellular marine organisms. They are most dominant in colder waters, where some can grow to enormous size. In the kelp forests off southern California, individuals can grow to be 50 to 70 meters long. They are differentiated into a root-like holdfast, a stem-like stalk, and leaf-like blades. There are often gas-filled floats associated with the base of blades.

The photosynthetic cells contain many of the same pigments as diatoms and dinoflagellates and, like diatoms, they produce a liquid storage product. The cell walls contain cellulose and pectin, but also a unique hydrophilic compound, algin.

Unlike animals, or even land plants, the many brown algae produce two, large, multicellular bodies at different parts of their life cycle. One body is composed of diploid cells, the other of haploid cells. These two bodies may look similar (making identification easy) or completely different (making identification of one or the other of the body forms difficult). The diploid body type of some species produce zoospores that will germinate to form new diploid individuals. The diploid body can also produce a meiotic sporangium that produces either haploid zoospores or gametes. The zoospores and gametes (except

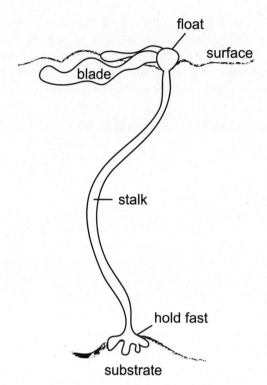

Figure 28-6. Brown algae. The morphology of large kelps is analogous to that of land plants. A root-like holdfast attaches the alga to the substrate. A more-or-less elongated stalk functions like a stem. One or more hollow floats hold the photosynthetic, leaf-like blades near the water surface.

an egg, if formed) contain one or two flagella. One is always a tinsel type. The second flagellum, if present, is whiplash.

The kelps grow in relatively shallow water and firmly attach to the substrate by means of a holdfast. They frequently have a stem-like stalk and one or more leaf-like blades that are buoyed near the surface by gas-filled floats. Kelp forests form a distinct ecosystem. The genus *Sargassum* typically grows attached in shallow waters on the flanks of tropical reefs. Wave action breaks off pieces, which then drift in the currents, buoyed by their floats. The Sargasso Sea in the mid-North Atlantic is an ecosystem dependent upon flotsam of floating sargassum.

Brown algae are an important food source in some cultures, especially in the orient. If you've eaten sushi, the "wrapper" is frequently a brown alga. Brown algae have also been used as animal fodder and fertilizer, but by far the most common use in developed countries is the extraction of algin. More than half a million tons of brown algae are harvested in the United States alone to extract algin for the food-processing industry. Algin is used as an emulsifier and stabilizer in a variety of food products, including dressings, ice cream, chocolate milk, and many other products (look for "alginate" on the label). It is also used to produce drug capsules, latex paint, cosmetics, plastics, and a variety of other products.

Test Yourself

1) Diatom cell walls contain the same material used to form
 a) plastic.
 b) salt.
 c) diamonds.
 d) coal.
 e) glass.

2) Ciliates possess
 a) macronuclei, micronuclei, and flagella.
 b) macronuclei, cilia, and micronuclei.
 c) micronuclei, pellicle, apical complex.
 d) macronuclei, cilia, and cell walls.
 e) all of the above.

3) Which of the following do *not* have a swimming cell in at least part of its life cycle?
 a) ciliates
 b) dinoflagellates
 c) brown algae
 d) ampicomplexans
 e) diatoms

4) What is the vector of malaria that is caused by *Plasmodium falciparum?*
 a) fleas
 b) *Anopheles* mosquitoes
 c) stable flies
 d) ticks
 e) tsetse flies

5) What is the chief benefit to humans provided by diatoms?
 a) They can make our footprints on the beach sparkle at night.
 b) They produce a lot of the atmosphere's oxygen.
 c) They make it easier to harvest fish by causing red tides.
 d) They produce an oil used in cosmetics.
 e) They are an ingredient in silver polish.

6) Contractile vacuoles are most active in which environment(s)?
 a) marine
 b) brackish
 c) freshwater
 d) terrestrial
 e) parasitic

7) Diatoms obtain food by
 a) photosynthesis.
 b) absorbing externally digested food.
 c) engulfing its prey.
 d) ingesting its food.
 e) decomposing organic material.

8) Late blight of potato, which destroyed the Irish potato crops in 1845–1847 (and which still occurs today), is caused by a member of the
 a) oomycetes.
 b) dinoflagellates.
 c) amphicomplexans.
 d) ciliates.
 e) diatoms.

9) Photosynthetic pigments suggest a close evolutionary relationship between
 a) blue-green bacteria and dinoflagellates.
 b) diatoms and ampicomplexans.
 c) diatoms and euglenoids.
 d) oomycetes and ciliates.
 e) dinoflagellates and brown algae.

10) A marine biologist examines a sample of seawater and finds many unicellular photosynthetic organisms with plates made of cellulose and having two flagella. Further testing of the water determines the presence of a toxin that is deadly to fish and humans. This organism is most likely a
 a) diatom.
 b) ciliate.
 c) dinoflagellate.
 d) brown alga.
 e) There is not enough information to answer this question.

Test Yourself Answers

1) **e.** Diatom walls are impregnated with silica, the same material found in sand from which glass is made. Plastics, diamonds, and coal are carbon-based, and salt contains sodium and chloride ions.

2) **b.** Ciliates are unique in having cells containing one or more micronucleus and a macronucleus. As their name suggests, they also contain cilia.

3) **d.** Ampicomplexans are parasites that lack any motile cells. Each of the other taxa listed are either entirely motile or have motile reproductive cells in their life cycles.

4) **b.** Plasmodium, the malaria parasite, is an amplicomplexan that spends the sexual portion of its life cycle in the mosquito and most of its asexual stages in the human host.

5) **b.** Diatoms are the major primary producers of the oceans, fixing carbon and releasing oxygen during photosynthesis.

6) **c.** Contractile vacuoles, found in many aquatic protists, are important for removing excess water from the cells that diffuses into the cells by osmosis. The higher the water concentration in the environment, the greater the concentration gradient into the cell and the more water will diffuse into the cell. Of the aquatic environments listed, freshwater contains the fewest dissolved minerals and is, therefore, of the highest water concentration.

7) **a.** Diatoms are photosynthetic organisms with chlorophylls a and c and several characteristic accessory pigments.

8) **a.** Late blight of potato and downy mildew of grape are two important plant diseases caused by members of the oomycetes.

9) **e.** Dinoflagellates, brown algae, and diatoms all contain the photosynthetic pigments chlorophyll a, chlorophyll c, betacarotene, and fucoxanthin. Ampicomplexans and ciliates are not photosynthetic.

10) **c.** Ciliates are not photosynthetic and brown algae are not unicellular, so both of these choices must be eliminated. Both diatoms and dinoflagellates contain cellulose, but only dinoflagellates have cellulose in intracellular plates and have flagella. Red tide producing dinoflagellates produce a nerve toxin that is deadly to vertebrates.

Non-Vascular Plants

The **plant kingdom** is a term that, at various times, has included some or all of the non-animal organisms on earth. Molecular phylogenies indicate a monophyletic clade including red algae, green algae, and all land plants. The single unifying feature is a chloroplast derived from a primary symbiosis involving a blue-green bacterium. The chloroplasts of photosynthetic protistans were all derived by secondary symbioses.

Many features of red and green algae are similar to those of some protists, especially brown algae. These features relate to their common aquatic habitat. Land plants evolved to deal with very different environmental constraints and, basically, two different approaches were employed. To better understand these similarities and differences, the environments themselves should be considered.

■ AQUATIC ENVIRONMENT

The intertidal zone was described in Chapter17. Brown and red algae are particularly abundant in this zone; browns predominantly in colder waters and reds predominantly in warmer regions. The phycocolloids in their cell walls, such as algin (see Chapter 28), help to resist drying during the time the algae are exposed to air. However, even in the subtidal zone, the aquatic environment provides some unique challenges for photosynthetic organisms.

You are probably familiar with the fact that when you are swimming underwater, everything tends to look bluish. To see a bright red swimsuit as red, you have to be very close to the person wearing it. Recall from Chapter 8 that visible light is composed of a spectrum of colors, each of different wavelength and different energy. Water is an effective filter. It first absorbs the longer, low-energy light waves, and as you go deeper, shorter and shorter wavelengths are absorbed.

Plants with photosynthetic pigments similar to land plants can live only in the most shallow water, because the red wavelengths are soon lost. Plants growing in deeper waters will not have red-absorbing pigments, but will concentrate on shorter wavelengths. The plants growing in the deepest waters will have only blue light available. As you might expect, these plants are very good at reflecting red light. In general, red algae grow at the greatest depths, with green algae in the shallower water. Brown algae tend to be intermediate.

range of 90 percent solar energy
wavelength of maximum intensity

Figure 29-1. Light transmission and water depth. Water is a differential light filter. The lower-energy, long wavelengths are absorbed more quickly than the higher-energy, short wavelengths. Red light is absorbed within a few meters, while blue light can penetrate more than 100 meters.

■ TERRESTRIAL ENVIRONMENT

It has long been known that land plants arose from algal ancestors. The transition from the aquatic to the terrestrial environment involved significant adaptations to the physical challenges of the new habitat.

Water

The most obvious challenge is water. Cells are composed of 90 percent water or more, so to move from an aquatic to a terrestrial environment required the evolution of mechanisms to acquire and retain water.

The simplest solution is to avoid the problem. Land plants that stay small, grow in clumps, and live only in moist habitats can avoid many of the problems of obtaining and retaining water. The alternative is to develop a variety of special structures whose function is to solve a particular problem. Roots or root-like organs can facilitate water absorption. Certain groups of cells can specialize to retain water in large vacuoles or transport water from one part of the plant to another. Some cells can minimize or regulate water loss while permitting gas exchange to occur.

Nutrients

In the aquatic environment, cells are bathed in a nutrient solution. On land, nutrient availability is more limited, and this limitation increases with distance from the source.

Again, the easiest solution is to avoid the problem. Plants can stay small so that no cell is far removed from nutrients. Alternatively, specialized organs, cells, and tissues can evolve to absorb nutrients from one location and move them throughout the plant body to where they are needed.

Support

Not only does water keep cells of aquatic plants hydrated and bathed in nutrients, but it also supports the plant so that individuals can increase in size without synthesizing extensive amounts of structurally supporting tissue. Brown algae can extend their blades more than 100 feet above the attached holdfast, but if uprooted in a storm and washed ashore, the stem-like stalk resembles a thick rubber hose. Only a few specialized algae, such as the sea palm, *Postelsia,* produce a stalk rigid enough to hold the blades upright when the tide is out. Again, the easiest solution is to avoid the problem by staying small and growing in clumps. To stand upright, a plant must evolve specialized cells to provide the necessary support.

Reproduction

Perhaps the greatest challenge associated with the move to land involved reproduction. Most algae and other protists produce motile gametes that can swim through the water, or at least be carried by water, for syngamy to occur. Not only does water provide a transport medium, but it also keeps the fragile unicellular gametes hydrated during the reproductive process. To avoid the problem of limited free water, land plants could stay small and live only in moist places so that free water is available for swimming gametes. To overcome the problem, specialized structures and/or processes must evolve to ensure the survival of gametes once they are produced and to facilitate their movement between parents.

■ RED ALGAE

Red algae, commonly called seaweeds, are predominantly marine organisms common in the intertidal zone of warmer waters and that are predominant at depths of 200 meters. Because of their reddish pigments, they are capable of efficiently absorbing the blue light that penetrates to the greatest depths. In addition to chlorophylls a and d, several accessory pigments, especially phycoerythrin, characterize the group. Also, like brown algae, the cells of red algae contain specialized phycocolloid molecules that help to resist dessication. Two different molecules predominate: **agar** and **carrageenin.**

Like brown algae, red algae have very complex life cycles that include both multicellular haploid gametophyte and diploid sporophyte plant bodies, but there are no motile cells. Nevertheless, most red algae form specialized sex cells that produce either small, non-motile sperm or a single large egg cell. Fertilization depends on the sperm being carried by water currents to the egg.

Several genera of red algae secrete calcium carbonate that forms a crust-like covering over the plant body. In tropical areas, these corraline algae contribute to the formation of coral reefs by cementing the reef together.

Agar and carrageenin are commercially important products derived from red algae. Agar is best known as the jelly on which bacteria and other organisms are grown in culture. Agar is useful because it is indigestible and, because of its high water content, is a good carrier for minerals, nutrients, and other molecules. In addition to its uses in medicine and research, you can find agar in a variety of industrial products such as paper coatings, shoe polish, photographic film, and cosmetics. The food-processing industry uses agar as an emulsifier and stabilizing agent in ice cream and other milk products. Carrageenin is the most widely used of the phycocolloids in food processing. Check some labels. The

genus *Porphyra* is an important commercial food product, called Nori, that is used in cooking and is the seaweed commonly wrapped around rice or fish in sushi.

■ GREEN ALGAE

Green algae are a diverse group of plants that have long been considered ancestral to the land plants. They have cellulose walls, and their chloroplasts contain the same pigments as land plants: chlorophylls a and b; β-carotene; and other accessory pigments. Starch is their primary storage product. Green algae are common in marine ecosystems but are particularly abundant in fresh water. A few live on moist soil, and some are epiphytic on terrestrial plants.

Chlorophytes

The unicellular genus, *Chlamydomonas,* was once considered to be the ancestral form of green algae. Molecular evidence now suggests that it is a derived form, but its structure is still prototypical for green algae, particularly the motile gametes and spores of multicellular forms.

Most members of the genus are biflagellate with two anterior whiplash flagella that pull the cell thorough the water. An **eyespot** associated with the chloroplast is photosensitive, and the cells can move in response to light and chemical gradients as well as physical contact. The nucleus is centrally located in the cytoplasm and partially surrounded by a cup-shaped chloroplast. Associated with the chloroplast is a specialized structure, the **pyrenoid,** which is the site of starch production. Within the green algae as a whole, the size, shape, and number of chloroplasts in the cell is a distinguishing characteristic.

Vegetative cells are haploid, they have a gametophyte dominant life cycle. Under adverse environmental conditions, diploid cells undergo meiosis to differentiate into gametes. While physically similar,

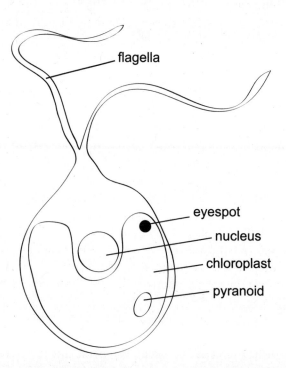

Figure 29-2. Chlamydomonas. Chlamydomonas has two anterior flagella and a cup-shaped chloroplast that surrounds the nucleus. A pyrenoid in the chloroplast is the site of starch production. An eyespot, also in the chloroplast, senses light for tropic responses.

genetic differences are expressed physiologically to produce mating strains. Sexual reproduction in which two similar appearing gametes fuse is called **isogamy.** Cells of compatible mating strains have complementary proteins on their flagella that bind together to facilitate syngamy. The resulting **zygospore** forms a thick, resistant wall that protects the dormant cell until growth conditions improve. The sexual condition of other green algae may be isogamous; the two sex cells may differ in size **(anisogamy);** or a large non-motile egg is fertilized by a smaller, motile sperm **(oogamy),** but in each case, the motile gamete is morphologically similar to *Chlamydomonas.*

Charophytes

The charophyte line of green algae are particularly interesting because of their close molecular affinity to land plants, their multicellular body form, and the presence of multicellular reproductive organs that foreshadow a necessary adaptation for reproduction on land—protection of the developing gametes.

The *Charales* (or stoneworts), are freshwater charophytes that produce a "plant-like" gametophyte body; that is, the axis consists of a thick, tissue-like column of cells segmented by whorls of leaf-like appendages.

Individuals look like little plants growing in shallow water. Later in the growing season, sex organs differentiate in the axils of the appendages. These structures consist of a sheath of protective vegetative cells surrounding the reproductive cells, either a single egg in a female gametangium or multiple sperm in a complex male gametangium. When the sperm cells are mature, the wall of the male gametangium breaks open, and the sperm are released. The biflagellate sperm is spiral-shaped, similar to mosses. A pore

Chara

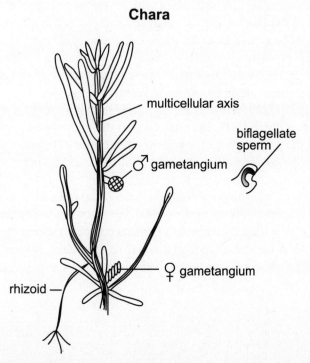

Figure 29-3. Chara. The stonewort, Chara, has a multicellular axis composed of columns of elongated cells. Conspicuous whorls of elongated unicells resemble leaves at a node. Multicellular gametangia occur at the nodes. The female structure has a jacket of sterile cells spiraling around the egg. The male structure is complex but produces biflagellate sperm.

remains at the tip of the oogonium to allow entry of the swimming sperm to fertilize the egg. As in other green algae, the oospore is a thick-walled, resting spore that survives through inclement conditions on the bottom. When growth conditions improve, the zygospore undergoes meiosis and germinates to form a new haploid multicellular body.

The *Coleochaetales* have the closest affinity to land plants. Some extant species have adapted to a specialized terrestrial environment, living primarily as epiphytes on the leaves of vascular plants growing in humid areas. At first glance, they appear to be crust-like growths, similar to lichens, growing in small symmetric patches on the leaves. They are, in fact, radial colonies of small cells, tightly packed together and appressed to their leafy substrate. They have adapted to the terrestrial habitat by avoiding most of the problems associated with living on land.

■ BRYOPHYTES

The most familiar non-vascular plants are the bryophytes, the mosses, and their relatives. Like *Coleochaete,* they have generally avoided the problems associated with living on land by staying small, growing in clumps, and living in moist habitats. The vegetative body is a gametophyte composed of haploid cells and, although their body plans may vary considerably, they share common adaptations for sexual reproduction.

All bryophytes have complex sex organs with a lining of sterile cells surrounding the reproductive cells.

The antheridium is a sac-like structure that produces motile sperm within a lining of sterile jacket cells. The archegonium is a more complex structure with several recognizable parts. The base, embedded within the gametophyte, is a swollen venter that produces a single, nonmotile egg cell. The venter extends into a neck, which protrudes beak-like from the gametophyte body. The neck consists of four contiguous columns of cells that are temporarily plugged by a series of neck canal cells. Between the neck canal cells and the egg is a ventral canal cell. When the egg is mature, the ventral canal cells break down, providing a tubular pathway through which sperm can swim to reach the egg.

Unlike their green algal relatives, however, the fertilized egg undergoes repeated mitotic activity to produce a multicellular sporophyte body that grows out of the archegonium, but remains attached at the base and is dependent on the gametophyte for water and nutrients. The sporophyte is differentiated into a **foot, seta,** and **capsule,** whose structure is useful in differentiating between the different groups of bryophytes. The foot attaches the sporophyte to the gametophyte cells of the former archegonium. Elaboration of the cell walls at the boundary between these two tissues increases surface area to facilitate transport. The seta is an elongated stalk that raises the sporogenous tissue of the capsule above the gametophyte body. Meiosis occurs within the capsule to produce haploid spores that germinate upon release to form a new gametophyte, if the spore lands in a moist environment. Not surprisingly, early growth of the gametophyte resembles that of a filamentous green alga.

Liverworts

The most primitive bryophytes are the liverworts. Liverworts have two basic body plans. The most familiar are the **thallose** liverworts. A liverwort thallus is a relatively undifferentiated body that is flattened in the dorsiventral plane.

Multicellular rhizoids extend from the lower epidermis. They function in attachment, presumably absorption, and effectively trap a film of water over the substrate surface. The upper epidermis frequently contains a complex pore consisting of chimney cells that permit gas exchange while reducing water loss from the interior of the thallus. The epidermal cells lack chloroplasts so they function like a window,

Antheridium

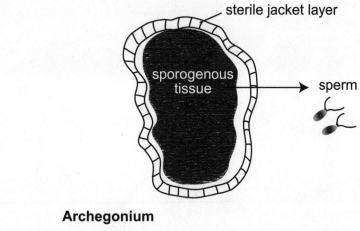

Archegonium

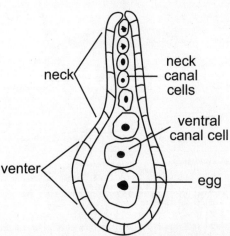

Figure 29-4. Antheridium and archegonium. Antheridia and archegonia are reproductive structures of the gametophyte containing a sterile jacket layer of cells around the reproductive cells. The antheridum produces multiple sperm; each archegonium produces an egg. The archegonium has a distinctive neck and venter, each with central cells that degenerate when the egg matures to form a canal, through which sperm may swim.

letting light in while minimizing water loss. Internally, the photosynthetic tissue is organized either into thin partitions of cells that divide the internal space into separate cavities, or into short algal-like filaments branching up from the bottom of the cavity. Below the photosynthetic layer is storage tissue consisting of cells with enlarged central vacuoles.

Both the antheridia and archegonia are embedded in the gametophyte. In many thallose forms, this may be in a central groove of tissue; in the genus *Marchantia,* they are on specialized stalked organs. In either case, there must be a film of water connecting the antheridia to archegonia when the gametes are mature, because the sperm must swim to fertilize the egg.

Less frequently recognized, but more common, are the leafy liverworts. Superficially, these resemble mosses, but their leaf-like organs tend to be broader and they have a distinctive liverwort sporophyte. In all bryophytes, the foot of the sporophyte has close attachment to the gametophyte tissue of the old

BRYOPHYTA-MARCHANTIA

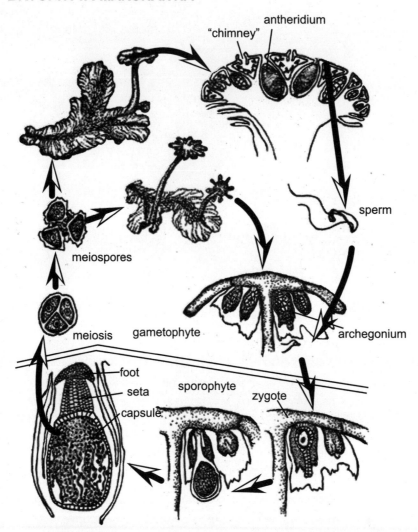

Figure 29-5. Liverwort. Marchantia is a thallus-type liverwort. The gametophyte generation is dominant; the sporophyte is attached to and dependent on the gametophyte. The thallus contains large air cavities, with chimney-like pores, on the upper surface and produces rhizoids from the lower surface. In Marchantia, antheridia and archegonia are borne on separate specialized structures, but a film of water is necessary for the sperm to swim to fertilize the egg. The sporophyte has a distinctive foot, seta, and capsule. Meiosis occurs in the capsule to produce haploid spores.

archegonium, and the cells specialize for transport from gametophyte to sporophyte. In liverworts, growth of the seta is limited and the capsule is only slightly raised above the gametophyte tissue. The capsule is exposed directly to the environment and releases its spores simply by breaking open.

Mosses

The germinating moss spore produces a filamentous gametophyte that soon undergoes cell proliferation at intervals along its length to produce tiny buds. Each bud develops into an upright stem-like axis bearing leaf-like appendages.

BRYOPHYTA

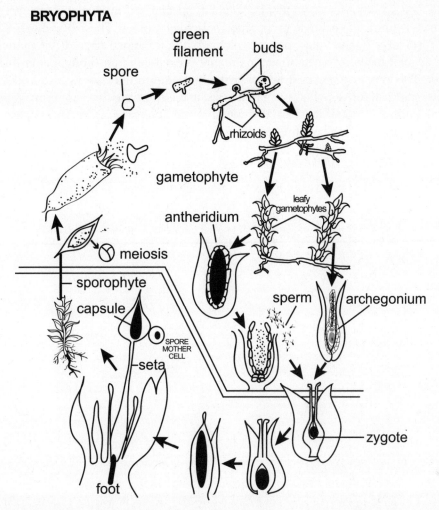

Figure 29-6. Moss. The leafy gametophyte generation is dominant; the sporophyte is attached to and dependent on the gametophyte. A germinating spore produces a filament that forms rhizoids and buds. The leafy gametophyte grows from a bud. Either antheridia or archegonia terminate the leafy gameto- phytes. A film of water is necessary for the sperm to swim to fertilize the egg. The sporophyte has a dis- tinctive foot, seta, and capsule. Meiosis occurs in the capsule to produce haploid spores.

The clonal upright gametophytes pack more or less tightly together, providing enough collective sup- port so that in some species they may be 10 centimeters or more tall.

In many species, the terminal appendages form a miniature flower-like rosette in which sex organs are produced. An individual axis usually produces either antheridia or archegonia, and again a film of water must be present between the two so that spiral-shaped biflagellate sperm may swim to fertilize the egg.

The seta of moss sporophytes is more elongated that than of liverworts, and the capsule is raised con- spicuously. The tip of the capsule is initially covered by a hair-like covering that originates from the orig- inal neck cells of the archegonium. A specialized dispersal mechanism forms at the tip of the capsule. A disk of cells differentiates as a cap that breaks off when the spores are mature. Beneath the cap is an elab- orate ring of finger-like teeth that flex in or out, depending on moisture. This flexing aids in dispersing spores from within the capsule.

Bryophytes are an important component of small, specialized microenvironments, but their economic importance is limited to a single group, the *Sphagnum* mosses. These bog dwellers have specialized cells that form large intercellular spaces, which provide flotation; mats of *Sphagnum* may literally float along the edge of the bog. When dried, *Sphagnum* is capable of absorbing better than ten times its weight in water. This property makes it useful in the horticulture industry as a soil additive in potting mixes, a packing material for shipping living materials, and a substrate for plant propagation. *Sphagnum* also has natural antibiotic properties. Partially decomposed *Sphagnum* is known as peat, which is also used in horticulture and, in some countries, as a fuel source.

Test Yourself

1) Which group of algae is most closely related to land plants?
 a) brown algae
 b) charophytes
 c) red algae
 d) liverworts
 e) mosses

2) What are the reproductive cells of moss gametophytes?
 a) spores
 b) sperm
 c) zygotes
 d) eggs
 e) two of the above

3) Which of the following is *not* a phycocolloid, a special cell wall chemical that gives the cell a rubbery flexibility?
 a) algin
 b) cellulose
 c) agar
 d) carrageenin
 e) All of the above are phycocolloids.

4) The largest and most long-lived multicellular body of a moss is its
 a) sporophyte.
 b) gametophyte.
 c) pollen.
 d) rhizoid.
 e) embryo.

5) One line of support for the theory that land plants evolved from green algae is that
 a) both transport water and nutrients using xylem and phloem.
 b) neither produces motile sperm and non-motile eggs.
 c) both contain carotenoids and chlorophylls a and b.
 d) neither produces specialized sex organs.
 e) both contain phycocolloid molecules that resist drying.

6) A characteristic of the red algae is that they
 a) produce pigments that make them particularly efficient at absorbing light at deep depths.
 b) are used to produce carrageenin, a food additive used as a stabilizer in ice cream, cosmetics, and paint.
 c) include the kelps and *Sargassum.*
 d) contain special conducting cells that are very similar to the xylem and phloem found in land plants.
 e) both a and b

7) Which organisms have sex organs composed of jackets of sterile cells that protect developing gametes and embryos?
 a) mosses
 b) charophytes
 c) liverworts
 d) red algae
 e) all except d

8) Which of the following is *not* a problem associated with the transition from the aquatic to the terrestrial habitat?
 a) availability of CO_2 for photosynthesis
 b) availability of mineral nutrients
 c) support for upright growth
 d) transport of water to cells
 e) exposure to wavelengths of light not filtered by water

9) Which one of the following features is shared by mosses and liverworts?
 a) flattened thallus for a gametophyte body
 b) vascular tissue in the sporophyte
 c) sporophyte that is dependent on the gametophyte
 d) vascular tissue in the gametophyte
 e) meiosis produces gametes directly

10) Which part of the bryophyte body is most similar to the ancestral algal body plan of the green algae?
 a) the leafy gametophyte of mosses
 b) the foot and seta of liverworts
 c) the germinating spore of mosses and liverworts
 d) the flattened sporophyte thallus of liverworts
 e) the leafy sporophyte of mosses

Test Yourself Answers

1) **b.** Charophytes are the group of green algae most likely ancestral to the land plants. Liverworts and mosses are land plants. Both brown and red algae are separate evolutionary lines.

2) **e.** Sperm form in moss antheridia and eggs form in moss archegonia. Antheridia and archegonia are the sex organs of moss gametophytes. Spores are reproductive cells formed by meiosis in the sporophyte, which develops from the zygote.

3) **b.** Algin is a phycocolloid from brown algae; agar and carrageenin are both phycocolloids in red algae.

4) **b.** The leafy gametophyte is the plant body normally recognized as a moss. The sporophyte is the elongated, capsule-tipped structure that is present only after fertilization of the egg occurs within the gametophyte body. The sporophyte remains attached and dependent on the gametophyte for survival. Pollen and an embryo does not occur in mosses. Rhizoids are inconspicuous structures on the underside of the gametophyte.

5) **c.** Green algae and the land plants have the same photosynthetic pigments and at least some members produce motile sperm in specialized sex organs, antheridia, and non-motile eggs in specialized sex organs. The algae and non-vascular land plants lack vascular tissue. Neither have cell walls containing phycocolloids.

6) **e.** Red algae, which live at the deepest depths of any algae, contain special photosynthetic pigments that efficiently absorb the blue light that reaches the greatest depths. The cell walls of red algae also contain agar and carrageenin, two phycocolloids that bind water molecules. *Sargassum* and the kelps are brown algae, the largest of which contain specialized conducting cells.

7) **e.** Mosses and liverworts both have antheridia and archegonia, and the charophytes have male and female reproductive cells with sterile jacket layers of cells. Of the groups listed, only red algae have unicellular sex organs without a sterile jacket layer.

8) **a.** Atmospheric concentrations of CO_2 would have been higher than dissolved CO_2 even before plants moved onto land. However, the plant would no longer be bathed in a mineral-rich solution, so mineral nutrients and water would have been limiting. Plants would also lack the buoyancy of water for support. Green algae in shallow waters and the intertidal zone already evolved the pigment systems that also are used by land plants for photosynthesis.

9) **c.** In all bryophytes, the sporophyte is dependent on the gametophyte for water and nutrients. Only some of the liverworts have a flattened thallus, and none of the bryophytes has vascular tissues in any part of the plant. Meiosis does not directly produce gametes in plants.

10) **c.** The germinating spore of all bryophytes initially produces a multicellular filament similar in appearance to many green algae. The gametophyte, not the sporophyte, of mosses is leafy, but this is a more complex body plan than any green alga. The foot and seta are complex sporophyte tissues that do not occur in green algae, and the gametophyte, not sporophyte, is the flattened thallus, which is more complex than that found in green algae.

Vascular Plants

In Chapter 29, some of the major problems associated with the terrestrial habitat were described. For each of the problems listed, there were two basic solutions. The simplest was to avoid the problem by staying small and living only in suitably moist habitats. This was the solution of the occasional terrestrial algae and the bryophytes. Alternative solutions were generally adopted by vascular plants, which can grow to tremendous size and occupy a variety of habitats on land. The single most important adaptation was the evolution of vascular tissues, xylem and phloem.

■ VASCULAR TISSUES

All vascular tissue in plants consists of strands of elongated cells that are specialized for conducting water and dissolved substances. In addition, some cells in the vascular tissue are specialized for mechanical support, and some have a combination of functions. The vascular tissues are of two distinct types, xylem and phloem, that associate with each other in specific patterns in different parts of the plant.

Xylem

Xylem is composed of thick-walled cells containing a very tough molecule, called lignin. Fiberglass provides a good analogy to the cell walls of xylem. Recall from Chapter 5 that the framework of the cell wall is composed of cellulose microfibrils that weave together to form an open meshwork like the fiber mat of fiberglass. It provides tremendous strength against tension—it is difficult to pull apart. But it provides little support on its own—it can easily be crushed or wrinkled and it is porous. Cellulose cell walls provide virtually no impediment to water movement. Lignin is like the resin of fiberglass. It fills the spaces between fibers, and then hardens around and between them to form a tough and rigid structure, impermeable to water. Some places in the wall do not become lignified. These **pits** join adjacent xylem cells, allowing water and dissolved materials to pass from cell to cell thorough the pits. (Note that pits are not holes; the cellulose cell wall is still present.)

Some xylem transport cells, **tracheids,** connect end-to-end through pitted endwalls. More specialized transport cells completely dissolve their endwalls between adjacent cells to form thin, segmented tubes. These cells are **vessel elements,** and the tubes are **vessels.** Once the cell walls are completely formed, the cytoplasm of xylem cells autodigests, so that a series of hollow tubes remain. These function in the one-way transport of water and dissolved minerals from the soil substrate up and through the rest of the plant (see Chapter 36).

XYLEM

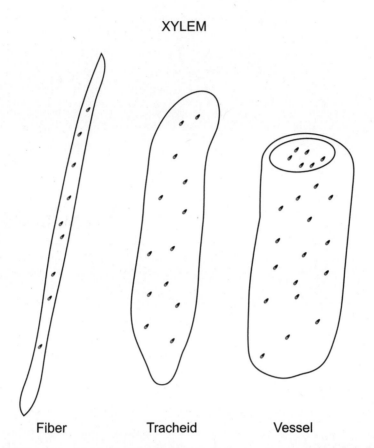

Fiber Tracheid Vessel

Figure 30-1. Xylem. Xylem is composed of lignified cells that are dead at maturity. Fibers are narrow and elongated cells that provide mechanical support. The walls of tracheids have thin spots, called pits, where no secondary wall develops. Vessels have pitted side walls and open ends to form a hollow tube.

The lignified strands of xylem cells also provide tremendous support to the plant. Some xylem cells specialize only for support. These long and narrow xylem **fibers** have very thick cells walls and pack tightly together around and between the conducting cells. In smaller plants, the xylem bundles concentrate around the periphery of the upright axis, similar to the reinforcing steel bars in a pillar of concrete. This provides maximum support per mass of material. In larger plants, the strands unite into a continuous ring that grows in width as the plant grows taller. This xylem, containing both conducting cells and fibers, is known as wood (see Chapter 34).

Phloem

The second type of vascular tissue is **phloem.**

The elongated, conducting cells of phloem also form strands that connect end-to-end, but unlike the xylem, these cell walls do not thicken, and at least some cytoplasm remains when the cell becomes functional. As phloem develops, an elongated mother cell undergoes an unequal lengthwise division to produce a pair of cells that maintain tight protoplasmic connections. The larger cell forms specialized endwalls, called sieve plates, where cytoplasmic bridges form between adjacent cells. Special transport proteins are associated with the sieve pores. Once the sieve structure is formed, the nucleus and most cytoplasmic organelles degenerate, and the mature **sieve tube element** is ready to function in transport-

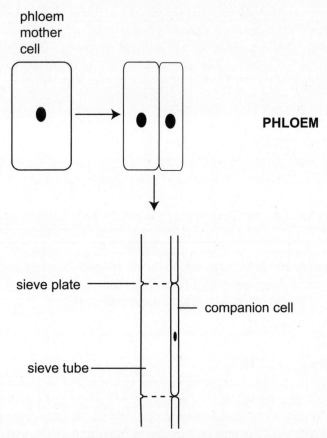

phloem
mother
cell

PHLOEM

sieve plate

companion cell

sieve tube

Figure 30-2. Phloem. Sieve tubes and companion cells are derived from a common, elongated mother cell that undergoes an uneven cell division. The cytoplasm of the two are connected, and the companion cell controls the metabolism of both after the sieve tube nucleus degenerates. Sieve plates form on the end-walls of sieve tubes, through which the cytoplasm of adjacent cells connects.

ing sugars and other metabolites through the plant. The smaller adjacent **companion cell** is packed with mitochondria and provides the energy and cellular regulation necessary for the sieve cell to function.

Unlike the xylem, the conducting cells of phloem are living when they become functional. This is important because they must be able to react to different conditions and change the direction and rate of flow of materials upon demand. An area of nutrient demand is called a **sink.** When a seedling germinates or a bud begins to grow in the spring, the growing tip is a sink for nutrients. Later in the year, a growing fruit produces a greater demand and at the end of the season, nutrients may flow to the roots for storage overwinter. The transported nutrients are primarily sugars produced in the leaves. The producing leaf is the **source.** In a perennial plant, a storage root may be the source as the plant resumes growth in the spring. Whereas xylem transport is always up from the soil, phloem transport can be either up or down, but is always from the source to the sink.

■ PLANT ORGANS

Vascular tissue permitted land plants to grow larger and still supply water and nutrients to all of the tissues. This also facilitated the organization of tissues into organs specialized for specific functions. Vascular plants have three major organ systems: roots, stems, and leaves. **Roots** typically form a subter-

ranean branching axis that supports the above-ground parts of the plant and specialize for absorption of water and nutrients. **Stems** are the above-ground axes that specialize in support of the photosynthetic tissues of **leaves** and transport of water, minerals, and nutrients between the roots and the leaves. The patterns of vascular tissues within roots, stems, and leaves are key distinguishing characteristics of the various groups of vascular plants.

■ REPRODUCTIVE ORGANS

The evolution of vascular tissues and their associated organs allowed the vascular plants to grow in increasingly drier parts of the terrestrial habitat, but before successful colonization could be established, reproductive structures had to evolve that were also suitable for this habitat. A general strategy was to minimize and, ultimately, miniaturize the gametophyte portion of the life cycle. In the earliest vascular plants, the gametophytes, bearing archegonia and antheridia, are quite similar to those of bryophytes and still dependent on a moist habitat. It is the sporophyte plant that grows free of its parental archegonium and develops vascular tissues and organ systems. In the more specialized vascular plants, gametophytes are miniaturized (to as few as three cells) and are either protected within a thick-walled, easily transportable structure or are retained and protected within sporophyte tissue.

■ FERNS AND FERN ALLIES

The earliest vascular plants had simple stem axes that branched infrequently below ground and above ground. A horizontal stem, growing at or below the soil surface, is called a **rhizome.** They lacked leaf-like appendages, or if they were present, they resembled the simple leaves found today on some of the fern relatives. The upright axes had terminal sporangia, also similar to some of today's fern relatives. It is likely that the extant lycophytes, the club mosses and ground pines, are their direct descendents. Although their sporophyte morphologies are distinctive, the life cycles of ferns and club mosses are virtually identical. In all of these non-seed vascular plants, the gametophyte and sporophyte bodies grow independently of each other. The lycophytes are often referred to as **fern allies,** a name that also is applied to a third group, the horsetails.

Lycophytes

The most primitive vascular plants living today are the club mosses and ground pines. Their common names are very suggestive of their appearance. Club moss sporophytes have a general body plan that looks like an overgrown moss with a club-shaped terminal cone containing sporangia.

Ground pines can easily be mistaken for pine seedlings. These plants have an underground rhizome that is frequently short, but in some species can be several meters long. Along the rhizome, upright branches develop. The vascular bundles of stems form a solid core in the center of the axis, but the pattern of xylem and phloem varies depending on the group. Thread-like roots grow out of the rhizome at nodes, the attachment point of leaves. The leaves of lycophytes are often scale-like or needle-like and contain a single vascular bundle that branches out of the main vascular bundle in the stem and form a midrib in the leaf.

Branching is usually dichotomous; that is, a stem divides into two equal branches. Some species have few branches, others branch repeatedly. Near the tip of the stem, a sporangium forms in the axil of each leaf. In many cases, these sporangia and their subtending leaves form a distinctive cone. Meiosis occurs within each sporangium to produce a multitude of haploid spores that germinate upon release if they land in a suitably moist habitat. Like the bryophytes, the early gametophyte is algal-like and even-

LYCOPODIUM

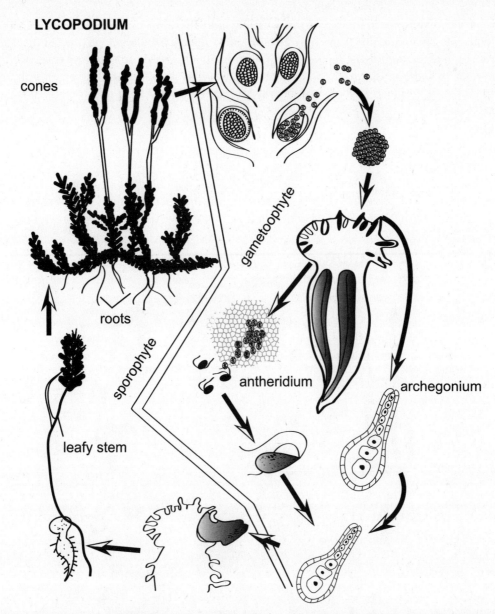

cones

gametoophyte

sporophyte

roots

antheridium

archegonium

leafy stem

Figure 30-3. Lycophytes. Lycophytes are fern allies whose sporophyte body is leafy with a terminal cone. The underground stem is a rhizome. Roots branch from the nodes of rhizomes, and the upright stem produces leaves. Roots, stems, and leaves have vascular tissues. Meiosis occurs in the sporangia to produce haploid spores that germinate to form a thallus-like gametophyte containing archegonia and antheridia.

tually forms antheridia and archegonia, similar in appearance to those of mosses. The gametophyte is small and inconspicuous and is restricted to moist habitats. The sperm are released into a film of water and swim down the neck of an archegonium to fertilize an egg.

In some club mosses, the sporophyte may produce distinctively different sized spores. The smaller **microspores** produce a tiny male gametophyte whose main function is to produce sperms. The larger **megaspores** produce female gametophytes with egg-bearing archegonia. The production of two different types of spores, called **heterospory,** is a prerequisite to the development of seeds and pollen.

Seeds have evolved several times and, in fact, some of the fossil lycophytes were seed plants that also formed wood. The age of the dinosaurs may also be called the age of the lycophytes. At that time, lycophytes were some of the dominant plants on earth, forming thick, woody forests with trees twenty meters tall and a meter or more in diameter. A common place to find fossils of such plants are in coal fields because, in fact, coal is primarily the fossil remains of lycophytes and their relatives, the horsetails.

Horsetails

The horsetails, also fern allies, have a distinctive sporophyte morphology and extant species may grow up to two meters tall.

Their rhizomes and upright stems are distinctly jointed, with alternating nodes and internodes. At each node, is a whorl of scale-like leaves. Depending on the species, there may also be a whorl of branches alternating with the leaves. Embedded in the outer cell walls of the stems are silica grains that

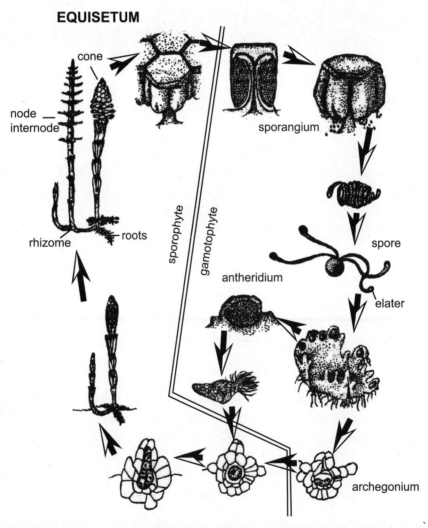

Figure 30-4. Horsetails. The distinctive sporophyte is segmented into nodes and internodes with whorls of scale-like leaves at each node. Roots are produced at nodes along the rhizome. The upright axis is terminated by a specialized cone with numerous sporangia. Meiosis occurs in the sporangia to produce haploid spores that germinate to form a thallus-like gametophyte containing archegonia and antheridia.

give the stem a sandpapery texture. Another common name for horsetails is scouring rushes because they were used like scouring pads by pioneers to clean pots and kettles.

Within the rhizome and stem are distinctive canals and a hollow, central **pith.** This characteristic makes it easy to distinguish fossil forms. While today, only two genera survive, during the coal ages, relatives of horsetails also were abundant forest trees, co-dominant with the lycophytes. Terminating the upright axis is a distinctive cone that produces abundant spores. The spores have unique wing-like projections that unwrap from around the spore as they dry. This helps to separate the spores from one another and aids in wind dispersal. The powdery spores are explosive when ignited. In the early days of photography, a flash was produced by igniting a bed of horsetail pollen in the flash gun.

Spores germinate to form independent gametophytes containing archegonia and antheridia. Sperms swim from the antheridia to fertilize the egg.

Ferns

Ferns are the most abundant non-seed vascular plants today. Some are tiny, floating, heterosporous species; some are tree-like and grow to the size of palms; most are the typical ferns we find in woods and as houseplants. The sporophyte has large leaves that are usually deeply lobed or compound with numerous leaflets.

The leaf stalk, or stipe, is frequently misidentified as the stem. It contains one or more vascular bundles, and the bundles branch repeatedly in the blade. These are the veins, which may undergo repeated dichotomous branching and end blindly near the leaf margin or may form an interconnecting network.

The rhizome is inconspicuous and may be either upright or horizontal. If the rhizome is upright, the leaves of the fern appear to be whorled. If the rhizome is horizontal, the leaves are solitary in a line.

In most ferns, the spores are borne in sporangia that are clustered into **sori** on the underside of leaves. The shape, position, and arrangement of sori are useful characteristics for identifying species. They are often associated with leaf veins and may have a specialized protective covering.

Regardless of the size of the sporophyte, once the spores are released, they require a moist habitat to form a tiny, gametophyte-bearing antheridia and archegonia. The sperm still require a film of water to swim to the archegonium and down the neck to fertilize the egg.

Because of their attractive foliage, ferns have considerable horticultural importance for landscaping and interior decoration. They can be important understory species in wet forest environments growing on the forest floor under a canopy of trees.

■ SEED PLANTS

Evolution of the seed was the ultimate plant adaptation to the land. Seed plants are heterosporous, undergoing meiosis in two separate structures and producing two distinctively different types of spores. The smaller microspores undergo one or two cell divisions to produce a two- or three-celled male gametophyte within a protective cell wall. This gametophyte is called a **pollen grain.**

The pollen is adapted to survive exposure to air and be carried—by wind, water, or an animal—to the female. Upon germination, one of the pollen grain cells will undergo an additional mitotic division to produce two sperms.

The larger megaspore undergoes three or more mitotic divisions to form a female gametophyte with as few as eight or as many as several hundred cells. The female gametophyte is retained within the parental tissue, which ultimately forms a protective **seed coat.** The female gametophyte may produce one or more archegonia, but there will always be at least one egg.

Pollination occurs when pollen is transferred from its sporangium to the vicinity of the female gametophyte. The pollen germinates and typically forms a tube that grows toward the egg. Within the tube, a

DRYOPTERIS

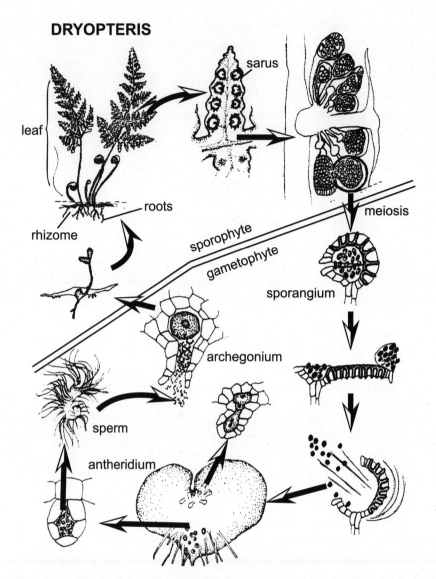

Figure 30-5. Ferns. The stem of ferns is an underground rhizome; the compound leaves have an elongated stalk that is frequently mistaken for a stem. Spores are produced by meiosis in sporangia that are clustered into a sorus on the underside of leaves. The independent gametophyte produces antheridia and archegonia.

final mitotic division occurs to produce two sperm. Syngamy of sperm and egg produces a new diploid zygote that grows to form a new sporophyte embryo retained within the female gametophyte, which itself is surrounded by the seed coat. In angiosperms, the second sperm has a special function.

Gymnosperms

The gymnosperms are a diverse group whose unifying feature is producing seeds directly exposed to the air. Conifers, such as pines, spruces, firs, and cedars, are the most common group. All gymnosperms are woody, and the conifers include some of our most important timber species including the tallest (redwoods), most massive (sequoia), and oldest (bristlecone pine) living things. The conifers are

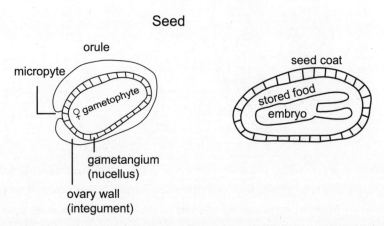

Figure 30-6. Generalized pollen and seed. Pollen grains are initiated by meiosis of a pollen mother cell to produce four microspores. Each microspore undergoes one or two mitotic divisions so that at the time of release, the pollen grain is a two- or three-celled microgametophyte surrounded by a thick, resistant pollen wall. The seed is a reproductive structure that develops from an ovule. The sporophyte embryo of the new generation is surrounded by a food reserve and protected by a thick-walled seed coat.

softwoods, which means their xylem contains tracheids but no vessels. With few exceptions, gymnosperms produce scale-like or needle-like leaves that persist for more than one growing season (that is, they are evergreen). The most distinctive feature of conifers is their cones.

The woody pine cone is a complex structure derived from a fertile branching system. Each scale is a flattened branch in the axil of a scale-like bract. On the upper surface of each scale, near the base, are two seeds.

During its first year of growth, the cone is much smaller and inconspicuous. In place of seeds are two ovules, each containing a sporangium. Meiosis occurs in each sporangium to produce a megaspore that undergoes repeated mitotic divisions to become a gametophyte within the surrounding megasporangium wall. Scale tissue grows most of the way around the sporangium, leaving a tiny pore, the **micropyle,** on the back side. The entire swollen structure is called an **ovule.** Simultaneously, one or more archegonia form in the gametophyte within the ovule, adjacent to the pore.

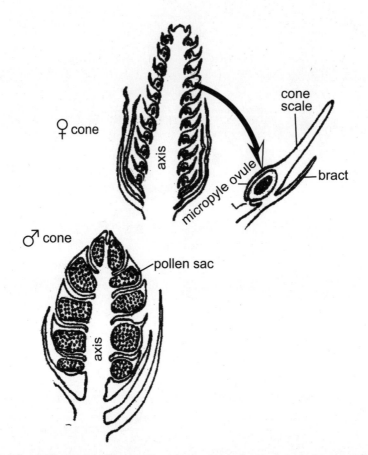

Figure 30-7. Generalized conifer cones. The male cone is a simple stem axis, bearing lateral scales. On the lower side of each scale is a microsporangium, or pollen sac, where meiosis occurs to produce pollen. The female cone is a miniature branching system with bracts produced along the main axis. In the axil of each bract is a woody scale, bearing two ovules on the upper surface near its base.

While the female gametophytes are developing in the larger cones, much smaller male cones are forming on a different part of the tree. The male cones form in clusters and survive for only a few weeks. Each cone is a short shoot, and each bract is a modified leaf with one or more sporangia on its lower surface. Meiosis occurs within the sporangia to produce pollen grains. At the same time that pollen matures and is released, a tiny drop of fluid, a pollination drop, is exuded from the pore of each ovule. The massive release of yellow pollen occurs over a one- or two-week period in the spring. Some pollen grains are trapped by the sticky pollination droplets, and the pollen grains are drawn into the pore as the fluid is reabsorbed. Once inside, the pollen germinates and produces sperm. Ovule tissue between the pollen and archegonium is enzymatically digested, and a sperm can fertilize the egg. Fertilization is accomplished without the need for free water for a sperm cell to swim to the egg.

The mature seed of a gymnosperm consists of a multicellular diploid embryo retained within the female gametophyte. This gametophyte tissue functions as a stored food reserve to nourish the embryo, sometimes for years, until the seed germinates. Surrounding the female gametophyte is the ovule wall that hardens and dries to form the seed coat.

Ginkgo and the cycads are other familiar gymnosperms. Ginkgo is considered a living fossil. There is a single species of a single genus in the phylum Ginkgophyta, although there were several different fossil forms. Ginkgo is commonly planted as an urban tree because of its resistance to disease and pollution

and its overall hardiness. The cycads superficially resemble small palm trees, but once they reach maturity, they produce large cones every year. Both cycads and ginkgo retain swimming sperms that rely on fluid from the pollination droplets and breakdown of cells in the ovule to provide a medium to swim through to fertilize the egg.

Gymnosperms have obvious ecological importance as they are the dominant trees of several forest ecosystems. In addition to timber and wood products, gymnosperms are an important source of resins and chemicals and a niche source of food products.

Angiosperms

The angiosperms, or flowering plants, are the dominant land plants today. Their characteristic feature is the specialized reproductive shoot called a flower. A typical flower consists of four types of modified leaves along a stem. **Sepals** form the bud scales and protect the developing flower.

Petals are showy structures with elaborate shapes and colors that attract pollinators. **Stamens** have sac-like anthers on the end of an elongated filament. Within the anther are sporangia that undergo meiosis to produce pollen grains that typically contain only two cells. The **carpel** has a swollen ovary containing one or more ovules, each producing an eight-celled female gametophyte containing a single egg. A receptive stigma forms on the end of a tubular style above the ovary to trap pollen grains and guide the pollen tube toward the ovules. Like gymnosperms, the angiosperm ovule will eventually become the seed, but instead of being exposed to the air, the angiosperm ovule is enclosed within an ovary. The ovary will eventually form a **fruit.**

A distinguishing feature of angiosperms is double fertilization, a process that requires two sperms. During pollination, pollen is transferred from the anther to the stigma. When the pollen germinates, one of the cells divides to form two sperms. In the ovule, the eight cells migrate so that an egg and two **synergid** cells are adjacent to the fertilization pore, the micropyle. Three cells migrate to the opposite end of the embryo sac, while two, the **polar nuclei,** remain near the center of the embryo sac. During fertiliza-

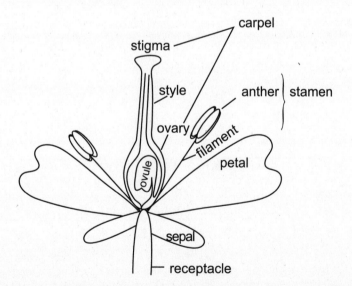

Figure 30-8. Generalized flowers. Sepals, petals, stamens, and carpels are modified leaves along a specialized stem, the receptacle. The stamen, consisting of a filament bearing an anther with four sporangia, is the male reproductive organ that produces pollen. The carpel, with a stigma, style, and ovary, bears one or more ovules that develop into seeds.

tion, one sperm unites with the egg to form a zygote, and the second sperm unites with both polar nuclei to form **endosperm.** The endosperm will be $3n$ (or $5n$ in lilies) and undergoes mitosis to produce a multicellular food storage tissue that nourishes the embryo during development.

A second distinguishing feature of angiosperms is the occurrence of vessels in their xylem. Of extant plants, only gymnosperms and angiosperms produce wood, but only the angiosperms produce hardwoods, which is wood that contains vessels.

Angiosperms are divided into two major groups, the monocots and the dicots. The embryo in monocot seeds contains a single cotyledon (monocotyledon), while a dicot embryo has two cotyledons (dicotyledons). There are other recognizable characteristics. Monocot leaves have parallel veins; dicot leaves have branching veins producing networks. Monocot flowers have parts in multiples of three; dicot flowers have parts in multiples of four or five. Monocots are herbaceous; many dicots are woody.

Test Yourself

1) A land plant produces a reproductive structure that contains diploid and triploid cells. It is a(n)
 a) bryophyte.
 b) fern.
 c) horsetail.
 d) conifer.
 e) angiosperm.

2) A land plant has xylem containing vessels. It must be a(n)
 a) conifer.
 b) angiosperm.
 c) club moss.
 d) fern.
 e) bryophyte.

3) An example of a derived character shared between gymnosperms and angiosperms is
 a) double fertilization.
 b) a seed.
 c) a flower.
 d) vascular tissue.
 e) flagellated sperm.

4) The sperm-producing gametangium of a fern gametophyte is called its
 a) archegonium.
 b) antheridium.
 c) oogonium.
 d) sporangium.
 e) sporophyte.

5) Germinating pollen of an angiosperm is the
 a) male gametophyte.
 b) female gametophyte.
 c) male sporophyte.
 d) female sporophyte.
 e) antheridium.

6) Which of the following groups is characterized by gametophyte and sporophyte generations that are capable of growing independently?

 a) bryophytes

 b) ferns

 c) conifers

 d) gymnosperms

 e) angiosperms

7) Swimming sperms will *not* be found in

 a) red algae.

 b) green algae.

 c) liverworts.

 d) mosses.

 e) ferns.

8) The gametophyte generation is most reduced in which of the following groups?

 a) mosses

 b) ferns

 c) charophytes

 d) horsetails

 e) angiosperms

9) Which of the following groups had members whose economic importance was in the formation of major reserves of fossil fuels?

 a) angiosperms

 b) ferns

 c) horsetails

 d) mosses

 e) gymnosperms

10) Heterospory will *not* be found in

 a) angiosperms.

 b) gymnosperms.

 c) lycophytes.

 d) ferns.

 e) All of the above have some heterosporous members.

Test Yourself Answers

1) **e.** The seed of flowering plants contains a diploid embryo surrounded by triploid endosperm, which is stored food. The triploid endosperm is unique to flowering plants

2) **b.** A characteristic of angiosperm xylem is the presence of vessels along with fibers and tracheids. The xylem of all other vascular plants contains tracheids.

3) **b.** Gymnosperms and angiosperms are the seed plants. All other plants reproduce by spores. Double fertilization and the flower are unique to angiosperms. The vascular tissue of angiosperms contains vessels; gymnosperm vascular tissue lacks vessels. Some unusual gymnosperms, Gingko and cycads, have flagellated sperm.

4) **b.** In mosses, ferns, and fern allies, sperm (male gametes) are produced in an antheridium, the sperm-producing gametangium. Eggs are produced in archegonia if there is a sterile jacket of cells or in oogonia if there is no sterile jacket. In ferns, meiosis occurs in a sporangium to produce haploid spores from which a gametophyte grows.

5) **a.** In both gymnosperms and angiosperms, pollen is the male gametophyte, although it consists of only four or three cells, respectively.

6) **b.** The ferns and fern allies have independent sporophyte and gametophyte generations. In bryophytes, the sporophyte grows out of and is dependent on the gametophyte for water and nutrients. In seed plants, the gametophyte generations (both the microgametophyte and megagametophyte) grow within sporophyte tissues.

7) **a.** The red algae lack motile sperms and depend on water currents to transport the sperm cells to fertilize the egg. All land plants through some of the gymnosperms produce motile sperms and depend on a film of water for sperms to swim to fertilize the egg.

8) **e.** Angiosperm gametophytes are very reduced—as few as three cells in a pollen grain and eight cells in an embryo sac. They are retained in the sporophyte tissues until mature.

9) **c.** Many fossil horsetails (and lycophytes) were woody trees during the coal-forming ages and contributed to the formation of coal, an abundant fossil fuel.

10) **e.** Heterospory, formation of microspores and megaspores, is a prerequisite for producing seeds; thus, it must be present in angiosperms and gymnosperms, the seed plants. Fossil members of lycophytes and ferns formed seeds and even today, some members of each group are still heterosporous.

Fungi

The fungi traditionally were classified with plants because although they are not photosynthetic, their cells have cell walls, and their body forms resemble the filamentous body forms of algae or tissue-forming bodies of land plants. Like plants, they also reproduce using spores. Unlike plants, however, the cell walls of fungi are composed of chitin, the same molecule used to construct the exoskeleton of insects and other arthropods. Recent molecular evidence confirms that fungi are actually more closely related to animals than to plants. Like animals, fungi are heterotrophic. Many fungi are saprophytic, helping to decay and decompose dead organisms to help recycle nutrients. As the fungus grows, it secretes digestive enzymes to externally digest the substrate through which it is growing. It then absorbs the released nutrients. Many fungi form symbiotic relationships, and some are parasites.

Fungi have a filamentous growth plan with individual filaments, **hyphae,** organized into a collective **mycelium.** Some hyphae are not divided into individual cells, with crosswalls forming only in association with reproductive structures. This type of multinucleate filament is analogous to the growth form of water molds (recall Chapter 28). Most fungi, like mushrooms, have cellular hyphae that weave together, more or less tightly, to form a tissue-like mycelium.

Fungal classification is traditionally based on sexual reproduction, particularly the sporangium where meiosis occurs. In two groups, these cells are located in specialized fruiting bodies of the mycelium, again characteristic of the group. A large number of species were traditionally relegated to the artificial group of imperfect fungi. This consisted of fungi for which no sexual stage had yet been observed. In some cases, this simply was a matter of the sexual stage not yet having been discovered. Once sexuality was observed, that species could be reassigned to one of the sexual groups. There are enough anatomical differences between phyla that one could predict to which phylum an imperfect was probably related, even though, in many cases, we believe sexuality was lost altogether during the course of evolution. Molecular evidence supports reclassifying the traditional imperfect fungi with their sexually reproducing relatives.

Fungi are an old group and were already established when plants moved onto land. The earliest fossils of vascular plants contain presumably symbiotic fungal cells. There is a close relationship between fungi and plants, ranging from mutualistic symbiosis through parasitism (recall Chapter 17).

■ ZYGOMYCETES

Zygomycetes, which include the common black bread mold, are named after the characteristic large and ornamented zygospores produced after gametes fuse. A single spore germinates to form an elongated,

multinucleate filament that can grow 1 centimeter or more each day. The multinucleate hyphae lack crosswalls except to separate reproductive structures from the vegetative mycelium. The hyphae branch as they grow with some forming rhizoid-like branches into the substrate. After a few days, some of the branches grow upright to form sporangia.

The tip of the upright hypha begins to swell and forms a cup-shaped interior crosswall that separates the terminal sporangium from its upright stalk. As the sporangium swells, the many nuclei undergo repeated mitosis and, eventually, each nucleus, surrounded by a thin layer of cytoplasm, is enclosed by a resistant spore wall. As the thousands of spores mature, the entire sporangium takes on a black color. A single mycelium can produce thousands of sporangia. The total number of spores produced within a week of initial germination is astronomical—and each spore can begin the process anew. Asexual reproduction by spores is extremely prolific and allows the mold to quickly cover its substrate.

Although all mycelia appear the same, physiologically, they are differentiated into genetically distinct mating strains. When the hyphae of compatible mating strains come in contact, crosswalls form to separate the respective tips from the remainder of the hyphae. The contacting cell walls are digested, and the cytoplasm fuses, allowing compatible nuclei to fuse. This process is called **gametangial copulation**—compatible gametangia fuse. The fused cytoplasm, now containing diploid nuclei, continues to swell and eventually forms a thick-walled zygospore, which can persist for years before undergoing meiosis and germinating to form new hyphae.

In addition to black bread mold, other common zygomycetes include the down mildews that infect plant leaves; the dung fungus, *Pilobolus*, that can shoot a mass of spores more than two meters; a variety of insect parasites; and soil parasites that capture and parasitize protozoa and small animals.

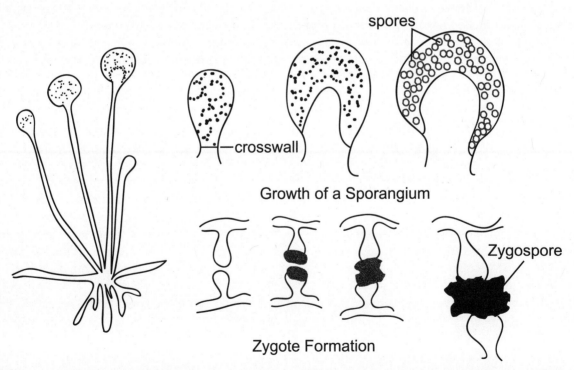

spores

crosswall

Growth of a Sporangium

Zygospore

Zygote Formation

Figure 31-1. Bread mold. Hyphal branching produces upright sporangia that contain thousands of spores. When the tips of compatible mating types come into contact, they merge and the compatible nuclei fuse to become 2n. The entire fusion structure develops a thick, sculptured zygospore wall.

■ GLOMEROMYCETES

Glomeromycetes are a special group of fungi, formerly considered to be zygomycetes but now separated into their own phylum. All members of the group form mutualistic symbiotic relationships with the roots of flowering plants. The fungal hyphae penetrated into host cells branch prolifically into bush-like structures called arbuscules. These **endomycorrhizae** are called the **arbuscular mycorrhizae.** The fungus aids in absorption of water and minerals—they are more effective than root hairs. The host plant cells provide nutrients for the fungus. Most flowering plants have such partnerships, and fossils of the oldest angiosperms show evidence of endomycorrhizae.

■ DIKARYOTIC CELLS

Most multicellular organisms are composed of uninucleate cells that are either haploid or diploid. Two groups of fungi, the ascomycetes and basidiomycetes, have a distinctive stage in their life cycle in which each cell has two nuclei. During the sexual reproductive cycle, a multicellular, tissue-like fruiting body is produced—for example, a mushroom or bracket fungus. Within this fruiting body, specialized hyphae are formed in which cytoplasmic fusion, **plasmogamy,** is separated from nuclear fusion, **karyogamy.** Compatible haploid hyphae fuse so that the resulting cell contains haploid nuclei from both parents. This **dikaryotic** (two-nuclei) cell undergoes repeated cell division, with each nucleus undergoing simultaneous mitosis. As a result, a dikaryotic hypha is formed that grows to the surface of the fruiting body. Upon reaching the surface, nuclear fusion is triggered to produce a diploid terminal cell that immediately undergoes meiosis to produce haploid spores. The method of forming dikaryotic cells, and the extent of dikaryotic cell growth, are unique to the ascomycetes and basidiomycetes, respectively.

■ ASCOMYCETES

The simplest ascomycetes are unicellular yeasts, but most form cellular hyphae that organize into a multicellular mycelium. Haploid mycelia grow through the substrate absorbing nutrients. Under appropriate conditions, the mycelium organizes into a densely-woven fruiting body, the **ascocarp**. Within the ascocarp, some hyphae form a receptive reproductive organ the **ascogonium**. Cells from a compatible mating strain fuse with the ascogonium and paired, compatible hyphae establish a dikaryotic hyphae that grows up through the ascocarp until it reaches the reproductive surface. In the terminal dikaryotic cell, nuclei fuse to become a diploid **ascus**. Meiosis occurs within the ascus to produce four **ascospores**.

The ascus resembles a small sac, and the ascomycetes are frequently called the sac fungi.

The life cycle of ascomycetes begins with the germination of a haploid spore to form a filament. Repeated branching produces a haploid mycelium, which penetrates the substrate, absorbing nutrients from decomposing organic material. As in the zygomycetes, upright branches produce astronomical numbers of vegetative spores called **conidiospores.** These spores are frequently colored and easily visible when densely packed in great numbers. For example, the green molds that grow on fruits and other food stored for long periods of time in the refrigerator, are ascomycetes. Each conidiospore is capable of generating an entirely separate haploid mycelium so that a species can quickly spread over appropriate substrate. The shape of the upright **conidiophore,** the conidiospore-bearing hypha, is often distinctive and a useful identification feature. For example, the green molds mentioned above belong to one of two genera: *Penicillium,* which includes the species from which the first antibiotic was isolated, has a distinctive swelling at the tip of the condiphore; or *Aspergillus*, which includes several pathogens, is dichotomously branched at the tip.

Under appropriate environmental conditions, the mycelium of ascomycetes begin to form a fruiting body, the ascocarp. Ascocarps have distinctive shapes and colors, and these are useful features in identi-

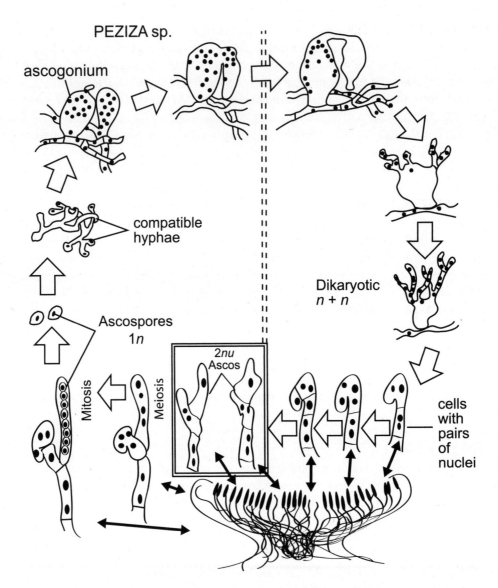

PEZIZA sp.

ascogonium

compatible hyphae

Dikaryotic
n + n

Ascospores
1n

Mitosis

Meiosis

2nu
Ascos

cells
with
pairs
of
nuclei

Figure 31-2. Ascomycete. Under appropriate conditions, the haploid mycelium of an ascomycete forms a fruiting structure, the ascocarp. Specialized hyphae in or on the ascocarp terminate in a unique reproductive cell, an ascus, in which meiosis occurs to produce ascospores.

fying species. There are three basic shapes. Commonly, a mushroom-like cup is formed that appears shiny on the outside and velvety on the inside. The velvety layer, called the **hymenium,** contains the asci that produce ascospores. A second common appearance is like a flask embedded in a rough covering. It is as if the cup were folded near the top, leaving only a small pore through which spores can be projected. The third form is tennis ball-shaped (but much smaller), with the spores produced within a hollow cavity completely surrounded by tough, resistant tissues. Ascocarps appear to be made of fleshy tissue, but they are simply densely woven hyphae like a three-dimensional knitting project.

Most of the ascocarp is composed of haploid hyphae of two different mating strains. One of these produces an enlarged ascogonium that attracts cells of the compatible mating type. The cytoplasm fuses, and compatible nuclei pair and divide in synchrony to form dikaryotic hyphae. These hyphae grow through the fruiting body until they reach the hymenium, where karyogamy is triggered. The resulting

diploid ascus produced four haploid spores, lined up within the ascus wall. In many species, each meiospore undergoes a mitotic division so that a total of eight spores are present. In species where the ascocarp is open, the spores "puff" out of the asci like tiny artillery shells. Asci completely enclosed by the ascocarp depend on the ascocarp being fractured so that spores can be released.

Arguably, the most economically important of the ascomycetes are the yeasts. Most yeasts are single celled, except when going through sexual reproduction, when they produce a four- or eight-celled ascus. Yeasts are the backbone of the brewing and baking industries. They undergo anaerobic fermentation (recall Chapter 7) that produces alcohol and releases CO_2. In addition to wine, beer, and distilled spirits, commercial alcohol is produced (laboratory alcohol, ethanol, and so on). Although CO_2 is considered a metabolic waste product, it is also of commercial importance. In an aqueous medium, the released CO_2 goes into solution and builds up pressure. When the pressure is released by opening a bottle, sparking wine sparkles and beer forms a "head." In the baking industry, CO_2 produced by yeast in the dough is trapped and forms gas pockets, which causes the dough to rise. The tiny holes in baked bread are the gas pockets where CO_2 accumulated.

Not many ascomycetes are food products, but several are particularly noteworthy. The morels produce an above-ground ascocarp, the size of a medium mushroom, that has a characteristic reticulate appearance. The concave surfaces of the reticulum are hymenial layers. It is one of the easiest wild fungi to positively identify—and also one of the best tasting. An unusual edible fungus is the truffle. Truffles grow underground, and the best tasting and largest are from France. They are hunted by individual collectors who use pigs to locate the delicacy. In New York, truffles (the fungus, not the chocolate candies) sell for more than $1,000 per pound. Finally, you may be familiar with the distinctive flavor of Roquefort, Stilton, or other bleu cheeses. The blue veins in the cheese that give them their distinct flavors are the sporangia of ascomycetes growing in the cheese.

As previously mentioned, penicillin, the first antibiotic, was originally isolated from an ascomycete. Some ascomycetes, however, can be serious pathogens, particularly of plants. Dutch elm disease and chestnut blight nearly eliminated two of the dominant forest trees of the eastern United States, and oak blight is devastating oak forests in the west. Ergot of rye and other grains are particularly noteworthy examples of the social effects of plant disease. Ergot, an ascomycete pathogen of grain, is the natural source of the hallucinogen LSD as well as medicinal vasoconstrictors. Ergot-contaminated grain causes seizures and delirium and, in severe cases, leads to gangrene and loss of extremities and death. Ergot-grain contamination has been implicated in the peculiarities associated with the Salem witch trials in colonial New England.

■ BASIDIOMYCETES

Mushrooms and shelf fungi of the basidiomycetes are the most recognizable of the fungi, but the group also contains less familiar rusts and smuts of virtually all our cereal grain crops. Haploid hyphae grow through the substrate, and compatible cells fuse to form a dikaryotic hypha. Dikaryotic hyphae are even more significant in the life cycle of basidiomycetes than in the ascomycetes; in fact, the fruiting body of basidiomycetes is composed entirely of tightly-woven dikaryotic hyphae.

The distinctive feature is the production of a specialized diploid cell, the **basidium,** that forms on the hymenial layer of the **basidiocarp.** Just as the ascus is the only diploid cell of the ascomycete, the basidium is the only diploid cell of the basidiomycete, and it undergoes meiosis to produce four **basidiospores.** The basidiospores develop on the outside of the basidium, like four little clubs. This gives the group their common name, the club fungi.

The life cycle of basidiomycetes begins with a germinating haploid spore that produces a haploid mycelium. In the rusts and smuts, haploid mycelia produce prolific numbers of spores that spread the fungal pathogen rapidly though a field of grain. In the mushrooms and shelf fungi, no asexual spores are

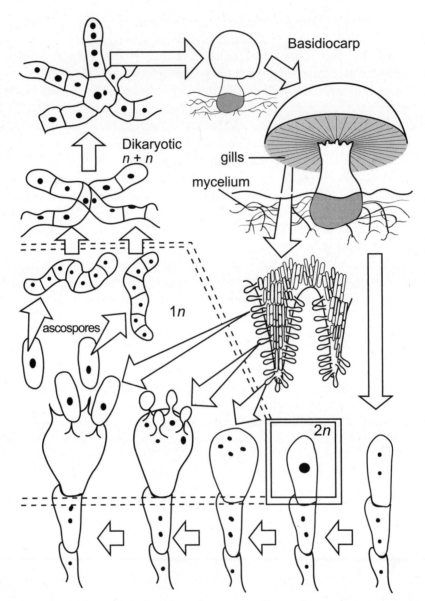

Figure 31-3. *The mushroom basidiocarp has a complex structure with spore-bearing surfaces covering either pores or gills on the underside of the mushroom cap. Fusion of nuclei in the terminal cells of some dikaryotic hyphae form diploid basidia. Meiosis occurs within the basidium to produce four basidiospores.*

formed. Like other fungi, basidiomycetes have mating strains, and if two compatible types come into contact, fusion will occur. There are no specialized fusion organs; instead, the cells of two compatible hyphae fuse their cytoplasm to establish the dikaryotic condition. Growth of the dikaryotic mycelium is very rapid and involves a unique structure called a **clamp connection** that looks like a small bulge, a cytoplasmic bridge connecting one cell to the cell behind it. The presence of clamp connections is an easy way to identify basidiomycete mycelia growing thorough the substrate.

Dikaryotic cells reaching the surface of the basidiomycete hymenium undergo karyogamy to become a diploid basidium. The nucleus undergoes meiosis and each of the four basidiospore nuclei migrate into a swelling bud on the outer surface. Each of these four buds becomes a basidiospore.

The mushroom is an interesting example of adaptation for spore dispersal. Long before it is visible on the surface, the mycelium of the future organizes all of its complex tissue layers within a compact ovoid mass underground. This is called the egg stage because it looks like a small egg or a small puffball. If you cut it open, however, it will not be a solid mass of tissue but you can recognize a miniature cap, stalk, gills, and so on of a mushroom. A single mycelium may form many egg stage basidiocarps that remain condensed underground. Almost overnight, following a soaking rain, all the egg stage basidiocarp cells engorge with water so that every mushroom rapidly expands.

A broad **cap** has a fleshy top layer that covers and protects the hymenial layers lining the gills or pores on the underside. The entire cap is raised by an elongated stalk. The spacing of the gills, or diameter of the pores, is precisely correlated to the ballistic capability of the basidiospores lining their surface. When the basidiospores are mature, they are gently shot from the surface of the basidium. The force is sufficient to propel the spore to the center of the pore or gap between gills, where it can free fall out of the cap to be caught by air currents and carried away from the parent basidiocarp. The basidiospores, particularly in the rusts and smuts, are thick walled and capable of overwintering to begin a new generation of growth the next growing season.

In Europe, a wide variety of tasty wild edible mushrooms are available for sale in markets. In the United States, however, we are familiar with only a few species of commercially produced mushrooms, and very few wild mushrooms are eaten. Wild mushrooms are generally considered to be tastier; however, it is critical that a sure identification is made. Several species are poisonous and even toxic. There is no sure-fire test for toxicity—you have to know what you are eating.

By far, the most significant economic importance of basidiomycetes is the destruction they cause to grain crops. Hundreds of millions of dollars are lost per year due to reduced harvest and post-harvest contamination.

■ LICHENS

Lichens are the classic example of symbiotic association in which unicellular or filamentous green algae or cyanobacterial cells are associated with an ascomycete or basidiomycete host.

The tightly woven outer layer of fungus protects against dessication and the loose interior meshwork provides a medium to support algal growth. The alga produces nutrients for both partners. Lichens are usually classified with the fungi because the shape and reproductive structures are determined by the fungal partner.

The basic shape of the lichen is due to the fungus, but the morphology and physiology of the lichen symbiosis is unique and is the product of the association. It is possible to separately culture the algal and fungal components of some lichens. The fungus forms an amorphous mycelium, and the algae form a simple mass of cells. When the lichen symbiosis is reestablished, however, the unique lichen form is reconstituted. Lichens have three basic shapes: fruticose (shrub-like), foliose (leaf-like), and crustose (crust-like).

Vegetative reproduction of the lichen is by a special process of fragmentation. Localized regions of the thallus, including both algal and fungal components, round up and break off to spread the lichen to new locations. These asexual propagules may be tightly woven **isidia** or loosely woven **soridia** (Figure 31-4). Sexual reproduction is apparently limited to the fungal component.

Lichens are often brightly colored and are a source of pigment for natural dyes. Lichens produce unique chemical compounds that neither component organism can produce on its own. Several of these lichen compounds have antibiotic properties, such as usnic acid, which is commonly used in burn treatment.

LICHENS

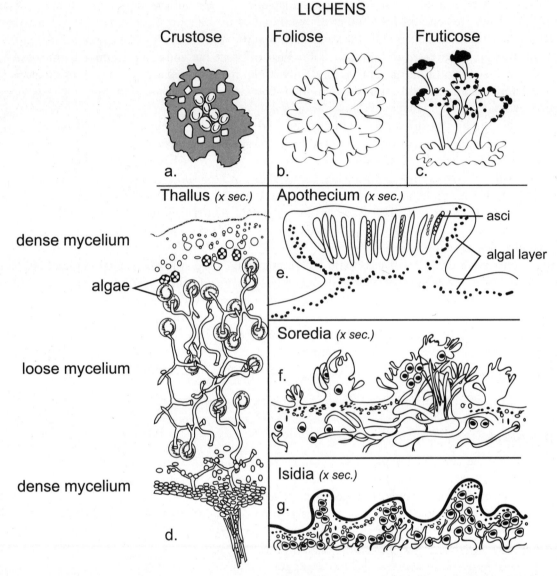

Crustose a.

Foliose b.

Fruticose c.

Thallus *(x sec.)*

dense mycelium

algae

loose mycelium

dense mycelium

d.

Apothecium *(x sec.)*

asci

algal layer

e.

Soredia *(x sec.)*

f.

Isidia *(x sec.)*

g.

Figure 31-4. Lichens. The structure of lichens is due primarily to the interwoven mycelium of the fungal partner surrounding the algal symbiont. In an established symbiosis, the overall form and color of the lichen is unique. The three common shapes are crustose, foliose, and fruticose. In each, asexual propagules, containing both partners, can bud off from the original lichen. Sexual reproduction occurs in small asco-carps or basidiocarps, depending on the nature of the fungal partner.

Test Yourself

1) Which of the following is *not* an economically useful aspect of fungi? Some species
 a) are used to flavor foods.
 b) are edible.
 c) produce alcohol via fermentation.
 d) produce oxygen via fermentation.
 e) produce antibiotics.

2) An unknown fungus was examined microscopically and found to lack crosswalls in its hyphae. It must belong to the
 a) zygomycetes.
 b) ascomycetes.
 c) basidiomycetes.
 d) lichens.

3) The fruiting body of an unknown fungus was examined microscopically and was found to consist entirely of dikaryotic hyphae. It must belong to the
 a) zygomycetes.
 b) ascomycetes.
 c) basidiomycetes.
 d) lichens.

4) Dikaryotic cells
 a) have two identical nuclei per cell.
 b) contain pairs of homologous chromosomes.
 c) divide only by meiosis.
 d) contain two genetically different nuclei per cell.
 e) contain diploid nuclei.

5) Once a dikaryotic cell is formed, in either ascomycetes or basidiomycetes, it continues to grow to form a dikaryotic hypha. In order to maintain the heterokaryotic condition,
 a) only one of the two nuclei per cell divides.
 b) both nuclei divide but no cell walls form.
 c) two nuclei must divide and migrate in synchrony before crosswalls form.
 d) only one of each pair of homologous chromosomes divides.
 e) dikaryotic cells do not divide; their nuclei must fuse and undergo meiosis.

6) The gills of a mushroom (*Basidiomycetes*) are specialized for
 a) respiration.
 b) food production.
 c) defense.
 d) reproduction.
 e) water storage.

7) Which of the following statements is sufficient by itself to identify an unknown organism as belonging to the kingdom fungi?

 a) It is multicellular and non-photosynthetic.

 b) It has cell walls and reproduces by spores.

 c) It has filamentous growth and digests its food externally.

 d) It has prokaryotic cells and cell walls made of chitin.

 e) It is unicellular and eukaryotic.

8) Lichens obtain organic nutrients by

 a) photosynthesis.

 b) engulfing other organisms.

 c) absorbing nutrients from the environment.

 d) decaying organic material.

 e) parasitizing flowering plants.

9) The names of fungal phyla are based on important and characteristic structures associated with

 a) reproduction.

 b) nutrition.

 c) ecology.

 d) vegetative growth.

 e) cell division.

10) The symbiotic associations called mycorrhizae are considered to be

 a) parasitic.

 b) mutualistic.

 c) commensal.

 d) harmful to the plant partner.

 e) both a and d.

Test Yourself Answers

1) **d.** Ascomycetes are used to flavor cheese, and both ascomycetes and basidiomycetes have edible species. Yeasts produce oxygen and lichens and ascomycetes produce antibiotics. Carbon dioxide, not oxygen, is produced during fermentation.

2) **a.** Zygomycetes have multinucleate hyphae that form crosswalls only in association with reproductive structures. All other fungi produce hyphae with one nucleus per cell or that are dikaryotic.

3) **c.** Although both ascomycetes and basidiomycetes have dikaryotic cells in their fruiting bodies, the basidiocarp is composed entirely of dikaryotic cells, while most hyphae of the ascocarp are composed of haploid cells. Only those hyphae that terminate in an ascus are dikaryotic.

4) **d.** Plasmogamy to establish the dikaryotic condition requires that hyphae of two different mating strains join. As a result, each dikaryotic cell contains two genetically distinct nuclei.

5) **c.** Both nuclei must divide in synchrony and migrate in such a way that one of each lies in both daughter cells after the new cell wall forms.

6) **d.** The gills on the underside of the mushroom cap space the layers of basidia far enough apart that basidiospores can be shot into the space between the gills, and then drop by gravity out of the mushroom.

7) **c.** The filamentous fungi secrete enzymes into their substrate, where digestion occurs externally. This mode of nutrition is unique to fungi. Although fungi are multicellular and non-photosynthetic, so are animals. Plants also have cell walls and reproduce by spores. Fungal cell walls do contain chitin, but the cells are eukaryotic.

8) **a.** The algal component of lichens photosynthesize to provide food for both symbiotic partners.

9) **a.** Traditional classification of fungi, supported by molecular evidence, groups phyla based on characteristic reproductive structures: zygospores (zygomycetes); asci and ascospores (ascomycetes); basidia and basidiospores (basidiomycetes).

10) **b.** Mycorrhizal fungi, like the arbuscular mycorrhize, establish a mutually beneficial relationship with their host plant roots. The fungus aids in uptake of water and minerals; the root provides nourishment for the fungus.

Invertebrate Animals

Animals are multicellular heterotrophic organisms composed of diploid eukaryotic cells. Unlike fungi, they ingest their food and digest it internally. Most are capable of movement by contractile cells with specialized proteins. Meiosis typically occurs in specialized sex organs and produces gametes directly. The gametes are the only haploid cells in the life cycle.

■ TISSUES AND SYMMETRY

During development, the zygote undergoes a series of cell divisions, called cleavage, that forms a hollow ball of cells, the **blastula.** Further growth produces an infurrowing of cells on one side of the blastula to form a two-layered hollow **gastrula** with a blastopore opening. The inner layer, **endoderm,** and outer layer, **ectoderm,** are fated to develop into specialized tissue layers. For this reason, they are called germ layers. The endoderm forms the digestive tube or cavity, and the ectoderm forms the body covering and, in some cases, the central nervous tissue. Although some animals have only two germ layers, in most animals, a third germ layer, the **mesoderm,** differentiates between the others and is fated to produce muscles and connective tissues.

The pathway of embryonic development follows one of two basic plans: protostomic or deuterostomic.

In **protostomic** development, the mouth forms first from the blastopore of the gastrula. When the zygote cell begins to divide, daughter cells form in a spiral (spiral cleavage) and, ultimately, a body cavity, the **coelom,** forms by a splitting within the mesoderm. In **deuterostomic** development, the anus forms from the blastopore and the mouth forms later at the other end of the digestive tube. In deuterostomes, the daughter cells formed from the zygote divide radially (radial cleavage) and, ultimately, the coelom develops from outpockets of the developing digestive tube into the mesoderm. Further development of the embryo establishes either a **radial symmetry,** where any lengthwise slice through the center of the axis produces mirror images, or **bilateral symmetry,** where there is a distinct top and bottom, right and left.

■ BODY CAVITY

The simplest animals, **acoelomates,** have no body cavity.

In **pseudocoelomate** animals, a space forms between the mesoderm and endoderm. Organs differentiating from the germ layers can fill this cavity, and it may provide a hydrostatic skeleton for internal support or provide an internal transport pathway. Most animals are **coelomates** and have a true body

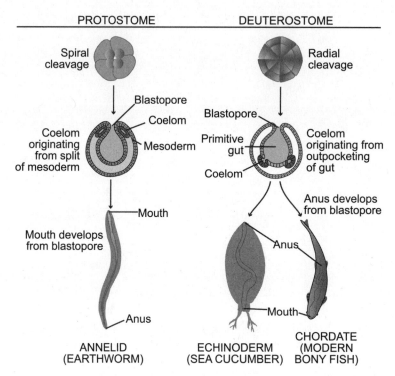

Figure 32-1. Embryo development. Coelomic animals follow one of two basic plans of embryo development. In protostomic development, the mouth forms from the blastopore before development of the anus. The early embryo undergoes spiral cleavage, and the mesoderm splits to form the coelom. In deuterostomic development, the anus forms from the blastopore before development of the mouth. The early embryo undergoes radial cleavage, and the coelom develops as outpocketings of the gut.

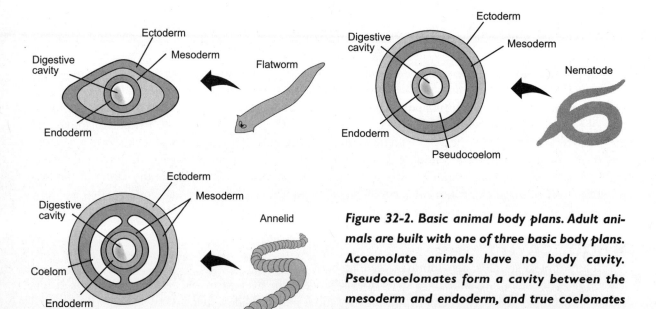

Figure 32-2. Basic animal body plans. Adult animals are built with one of three basic body plans. Acoemolate animals have no body cavity. Pseudocoelomates form a cavity between the mesoderm and endoderm, and true coelomates form a body cavity within the mesoderm.

cavity that forms secondarily within the mesoderm. A true coelom shares the same functions as a pseudocoelom.

■ SPONGES (PORIFERA)

Sponges are mostly radially symmetric marine animals, although there are a few freshwater forms. The adult animals are sessile (non-motile), but the juveniles are motile. They have no definite tissues, but they do have specialized cells that form coverings, canals, and chambers. A lining of **epithelial cells** forms an outer covering. The central body cavity is often chimney-like, with numerous pores in the sides. Each pore is lined by **pore cells.**

Specialized cells, **collar cells,** with a collar of cilia line the pores. The beating motion of the cilia set up currents of water passing through the sponge, which carries plankton and organic materials. The collar cells filter the water, trapping prey and passing nutrients on to other cells in the body.

Sponges have relatively little economic importance today, now that synthetic sponges can be manufactured. However, a natural bath sponge is a luxury for some. A few sponges parasitize shellfish by

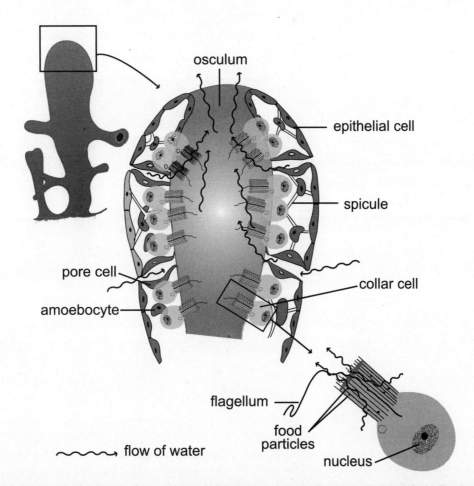

Figure 32-3. Sponge. Sponges have no tissue organization but do have specialized cells. Epithelial cells form an outer lining connected to the interior space through pore cells. Collar cells, with beating flagella, set up water currents that pass water through the sponge, allowing the collars to filter feed from the water passing though the organism.

boring holes through their shells and a few are poisonous, causing skin irritation to swimmers who touch them.

■ JELLY FISH AND CORALS (CNIDERIA)

Cnidarians are mostly marine animals with radial symmetry. They have a sac-like gut and well defined tissue systems. Their most distinguishing feature is a specialized cell type, **cnidocytes,** that contain a stinging hair **(nematocyst)** that resembles a spring-loaded harpoon.

The body has two distinctive layers, the endodermis and ectodermis, with a jelly-like layer between them. The mouth is a two-way opening into the gut. A whorl of tentacles typically surrounds the mouth. The tentacles are lined with cnidocytes to sting and paralyze prey that then can be drawn to the mouth opening.

There are two forms of cnidarians: **medusa** forms are free swimming and **polyps** are attached. Jellyfish are typical medusans. Jellies can grow to great size, more than two meters in diameter, with thirty-six-meter-long tentacles in the South Pacific, but mostly, they are softball size or smaller. On the

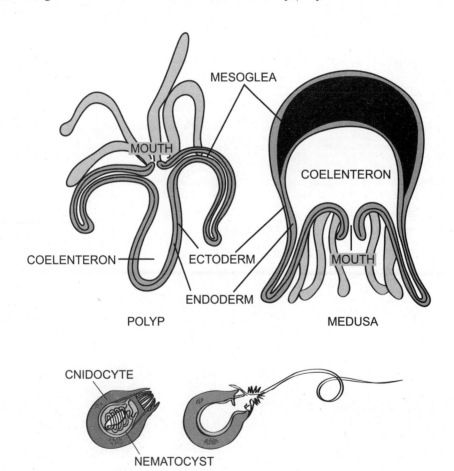

Figure 32-4. Cnidarian. Cnidarians are radially symmetrical animals with a distinct outer ectoderm and inner endoderm joining through a single mouth opening into the gut. Tentacles are embedded with specialized stinging cells, cnidocytes, which project a harpoon-like nematocyst to paralyze and catch prey. Floating adults are called medusa; attached adults are polyps.

margin of the "umbrella" are sensory cells that can detect light and chemicals; rhythmic contractions of the umbrella allows the animal to swim directionally.

A typical polyp is the coral animal. Corals are frequently colonial animals, and the individual polyp secretes a cup-shaped skeleton around itself so that its mouth and tentacles are upright and it attaches to the base of its cup. Hard corals depend on symbiotic dinoflagellates (recall Chapter 28) to produce their hard calcium carbonate case. The muscular system of corals are capable of rapid contraction to quickly move the animal into its stone cup when threatened. The nervous system consists of interconnected sensory and motor nerves to coordinate response.

Coral reefs are important ecologically as major fish nurseries in the oceans. They have among the highest rates of productivity of any ecosystem on earth (recall Chapter 17). A highly specialized polyp-type is the Portuguese man-of-war, which is a colony of specialized polyps attached to a common gas-filled float. Some polyps are specialized for food capture, trailing sixty feet or more below the colony. Others specialize in digestion of captured prey, and a third type are specialized for reproduction.

■ FLATWORMS (PLATYHELMINTHS)

Flatworms include marine, freshwater, and parasitic forms. They have bilateral symmetry and an acoelomate body developed from three germ layers.

Cephalization is evident; that is, sensory cells and nerve cell bodies are aggregated into clusters or **ganglia** at the anterior end of the animal. The animals are sensitive to light, chemicals, and touch. This is the first indication toward the development of a brain. The animals have well developed organ systems.

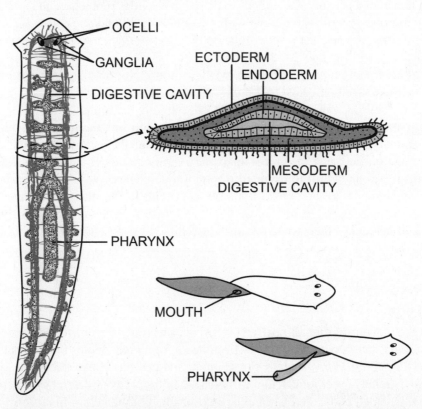

Figure 32-5. Flatworms. Flatworms are bilaterally symmetric, and they are the earliest evolved forms to have three tissue layers. There is a single mouth opening into the much-branched gut. Two major nerve cords run the length of the body and concentrate in ganglia associated with sensory organs.

The digestive system is a highly branched sac within the body with a single opening to the outside. Specialized excretory cells collect and remove excess water from the body. Two ventral nerve cords run the length of the body that permits coordinated movement. Ciliated cells on the ventral surface cause the animal to glide along the substrate.

Among the economically important flatworms are tapeworms and flukes that parasitize animals, including humans. Tapeworms are intestinal parasites that deprive the host of nutrition and, thus, weaken the host. (In the Victorian era, tapeworms were sold to induce weight loss.) Worldwide, one in ten humans is infected. Flukes can be both ectoparasites of the skin or endoparasites of internal organs. For example, "swimmers itch" occurs when individuals swim in infected water. The flukes burrow into the skin and stimulate an inflammation response. Liver flukes arise when humans eat infected fish that have been undercooked. The flukes penetrate the intestinal walls and are taken up by the blood stream. As blood passes through the liver, the flukes migrate out of the blood vessels and establish themselves in the liver.

■ ROUNDWORMS (NEMATODES)

Nematodes are especially abundant in the soil and in aquatic habitats. They are characterized by having a **pseudocoelom,** a body cavity between the endoderm and mesoderm.

This fluid-filled cavity functions as a hydrostatic skeleton against which muscles can contract to provide motility. The fluid-filled cavity also assists internal circulation of dissolved materials. The pseudocoelom also provides a space for the well developed sex organs—nematodes are prolific reproducers.

Covering the animal is a tough, chitinous cuticle that provides protection and additional mechanical support. There is a one-way digestive canal with a distinct mouth and anus. Two large nerve cords, one dorsal and one ventral, traverse the length of the body. This primitive nervous system can be taught conditioned responses (recall Chapter 20) that persist for hours.

Nematodes are important plant parasites, mostly of roots. Not only do they do direct damage to the host root, but their damage to the host root provides entry for secondary parasites.

There also are several widespread human parasites among the roundworms. *Ascaris* is an intestinal parasite that produces toxic chemicals. Approximately one-third of the human population is infected. Hookworm is another intestinal parasite that is picked up through the feet by walking barefoot on infected soil. A severe infection can cause the loss of up to one quart of blood per day, which results in severe anemia. *Trichinella* is a roundworm transmitted through undercooked pork. The parasite moves into the blood stream and throughout the body, ultimately encysting in the muscles. At the least, this causes inflammation of the muscles, but severe infestations can impair muscle function. Finally, pinworms affect approximately 50 percent of the population of industrialized nations. These are the "worms" that often infect infants.

■ MOLLUSCS

Molluscs are a diverse group of nearly 100,000 species (only the arthropods, including the insects, are more numerous). They occur in marine environments from great depths to the surface, in fresh water, and in terrestrial systems. Many, such as slugs, squid, and octopus, have soft bodies, while others, like snails and clams, secrete a shell of calcium carbonate. Molluscs have bilateral symmetry. Although they do not have a segmented body, there are three recognizable body zones: a **head/foot; visceral mass** of internal organs; and **mantle,** which secretes a shell if one is present.

Molluscs have a well developed, three-chambered heart that pumps blood through an open circulatory system, except in the cephalopods (squids and octopus), which have a network of blood vessels

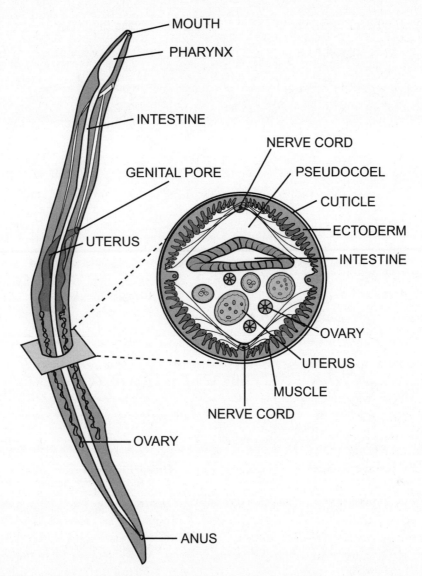

Figure 32-6. Roundworms. Roundworms have three tissue layers in which a pseudocoelom forms between the endoderm and mesoderm. The pseudocoelom becomes filled with reproductive organs as well as fluid under pressure to form a rigid tube. Roundworms are the earliest organisms to evolve a one-way digestive system with specialized organs along its length.

forming a closed circulatory system. Most mollusks have a toothed tongue with chitinous teeth that rasps prey like a file. Molluscs have specialized organs, **nephridia,** for excretion. There are three distinctive classes of molluscs.

Bivalves

The bivalves, such as clams, mussels, and oysters, have two (bi) shells (valves). They are mostly marine bottom dwellers, but there are also many freshwater forms. The Mississippi River drainage has the world's greatest diversity of freshwater bivalves. Bivalves are all filter-feeding herbivores that draw in

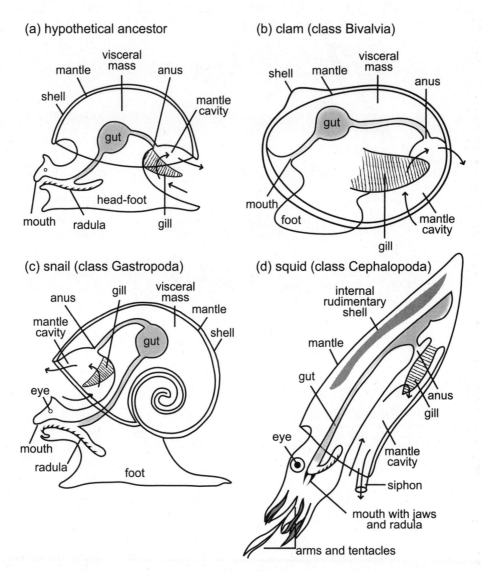

(a) hypothetical ancestor

(b) clam (class Bivalvia)

(c) snail (class Gastropoda)

(d) squid (class Cephalopoda)

Figure 32-7. Molluscs. The basic body plan of molluscs has a head/foot region, a visceral mass, and a mantle, which may or may not secrete a shell. The mouth contains a rasp-like radula, and a gill is used for respiration. Bivalves are the class most similar to the basic mollusc type. The mouth is less well developed and lacks a radula. Gastropods twist the internal organs so that the gill and anus are located above the head. Cephalopods have multiple tentacles associated with the head and an internal shell to provide support.

water through a tubular incurrent **siphon,** filter it over a gill where gas is exchanged and food particles are trapped and transferred to the mouth by ciliary action, and return the water through an excurrent siphon.

Gastropods

The gastropods include slugs and snails. They may be marine, freshwater, or terrestrial organisms. The head is cephalized; that is, sense organs and nerve fibers are concentrated in the head region. The ani-

mals can sense chemical and light gradients. In terrestrial forms, the mantle cavity forms a lung-like humid cavity where the gill exchanges gases.

Cephalopods

The cephalopods include squid and octopus. These are marine organisms that can reach great size. Giant squid can extend more than fifty feet. Numerous arms, with suction disks, are associated with the head. In the center is a mouth with beak-like jaws.

Cephalopods are characterized by a large brain; they are capable of learning. The giant nerve axons of squid are easy to manipulate, so they were the test cells for the first studies of how nerve cells function. The eyes are large, complex, and remarkably similar to the eyes of vertebrate animals.

Cephalopods are active predators with varied locomotion. The octopus can move along the ocean floor, "walking" with its arms. Squids have lateral fins, allowing it to swim gracefully. Both are capable of rapid movement by forcefully ejecting water from the mantle cavity through a hose-like siphon—a form of jet propulsion. If alarmed, they can simultaneously release an inky substance that clouds that water, making them more difficult to see. Even under normal circumstances, however, they are difficult to see. Their skin cells contain numerous **chromatophores** filled with different colored pigments. Muscle contractions expose or cover various chromatophores to produce varying color patterns on the skin that allow the animal to blend into its background. An octopus on the bottom can be so well camouflaged as to be invisible. A spectacular sight is to follow a pod of squids swimming slowly over a coral reef as they change their body colors in a moving pattern to match the background.

The obvious economic importance of molluscs to seafood lovers is the variety of shellfish commercially available: oysters, clams, mussels, scallops, and so on. Then there are squid (calamari), snails, and even octopus. Unfortunately, because shellfish are such good filter feeders, they also tend to accumulate toxins in the water (recall red algae from Chapter 29). They also accumulate organic and inorganic pollutants in contaminated water. (You may recall hearing about the oyster beds that had to be closed around New Orleans following hurricane Katrina.) On the other hand, this tendency to accumulate industrial and human-caused pollution makes shellfish useful organisms for biomonitoring the heath of aquatic systems.

A minor, but noteworthy, point of economic significance is the production of pearls by many bivalves. The mantle secretes the "mother of pearl" inner lining of bivalve shells. If an irritating particle lodges in the muscles that close the shell, the mantle deposits layers of pearl around the particle to form a smooth, ovoid pearl of commerce.

There are also detrimental effects of molluscs. These include the slugs that attack crop plants and the shipworms that bore holes in wooden structures. Snails are the alternate host of the trematode parasites (blood flukes), and some snails (the drills) parasitize shellfish by boring a hole through the shell to attack the internal organs.

■ SEGMENTED WORMS (ANNELIDA)

Segmented worms occur in marine and fresh water and in moist terrestrial ecosystems. The segmented body plan, which is both evident externally and redundant internally, is their distinguishing feature.

Each segment has its own paired nephridia, which are specialized excretory organs. The digestive system is tubular with an anterior mouth and posterior anus. There are specialized sections of the digestive tract that specialize in grinding, enzymatic digestion, and absorption.

These animals have a closed circulatory system with a main dorsal blood vessel that contracts by peristalsis (rhythmic contractions) to produce an anterior flow. Valves prevent backflow. Five aortic arches regulate blood pressure and connect to four smaller ventral vessels that distribute blood at a constant pressure. A capillary network interconnects the vessels. Gas exchange occurs at the body wall, and hemo-

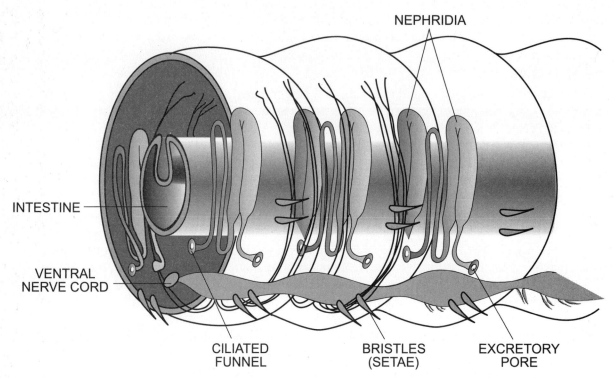

NEPHRIDIA

INTESTINE

VENTRAL
NERVE CORD

CILIATED
FUNNEL

BRISTLES
(SETAE)

EXCRETORY
PORE

Figure 32-8. Segmented worms. Segmented worms are bilaterally symmetric coelomic animals with a basic structure repeated in each segment. Of particular note are various types of bristles (chaetae) growing out of each segment. The number and specialization of chaetae distinguish the classes of segmented worms. The worms have a one-way digestive tract and specialized excretory organs (nephridia) in each segment. The nervous system has a major ventral nerve connecting each segment to the head end.

globin, the oxygen binding molecule, is free in the blood plasma rather than carried in specialized blood cells.

A ventral nerve cord, with ganglia at each segment, runs the length of the animal. A concentration of ganglia dorsal to the mouth opening functions as a primitive brain. Segmented worms respond to light, chemicals, touch, and moisture. Some have demonstrated simple learning.

Polychaetes

On each segment of the worm are variously modified bristles (chaetae) that have different functions. The worms are divided into three main classes based on the relative number of bristles per segment. Polychaetes have many bristles. These include marine animals such as tubeworms and fire worms. There is frequently a distinct head and trunk region and fleshy, paddle-like **parapodia** arise from each segment of the trunk. Numerous chaetae line the parapodia, which can function like gills in gas exchange or like feet for locomotion.

Oligochaetes

The oligochaetes have few bristles per segment. They are mostly terrestrial or occur in freshwater. The earthworm is a common example. The chaetae have a ratcheting action. When a segment is drawn forward by contraction in anterior segments, the chaetae fold flush to the surface like little skids. When that segment contracts, the chaetae extend into the soil to anchor the segment firmly in place so that posterior segments can be drawn forward.

Leeches

The leeches lack bristles and have reduced segmentation. They are mostly freshwater organisms although there are a few marine and terrestrial species, especially in tropical rainforests. Leeches are predators or parasites on other animals including humans. The parasites attach temporarily to a host and secrete a local anesthetic before making an incision to draw blood. It then secretes an anticoagulant to maintain blood flow. Once engorged, it releases from its host and drops off. One is often unaware that leeches have attached to you until you get out of the water or, in the tropics, take off your clothes.

Segmented worms have considerable economic importance, both positive and negative. Earthworms are extremely beneficial to the soil, as first pointed out by Darwin in his last book, *On the Formation of Vegetable Mould through the Action of Worms*. Earthworms turn over about two pounds of soil/m²/yr. This aerates the soil, and the fecal worm castings provide nutrients. Many worms are eaten and considered a delicacy in some parts of the world. Other worms cause significant damage. A marine oyster parasite significantly reduces oyster production during outbreaks, and shipworms bore holes in submerged timbers and wooden hulls. Fire worms, a coral reef predator, are a nuisance to divers. The numerous chaetae produce a toxin that causes severe pain and skin inflammation upon contact. Leeches, although commonly used as fish bait, also are considered a nuisance organism to humans. However, for millennia, they have had medicinal use in bloodletting—a practice that continues today in association with plastic surgery and procedures where excess swelling can be reduced in an area with a temporary reduction in venous drainage due to the surgical procedure.

■ARTHROPODS

The arthropoda is the largest of all animal phyla and includes more species than all of the other animal phyla combined. It includes the class of insects that contain 70 percent of all animal species. Arthropods are abundant in both aquatic and terrestrial ecosystems. Their most distinguishing feature is their jointed (arthro) appendages (poda). Their bilaterally symmetric segmented body has three distinct regions: head, thorax, and abdomen.

These animals have a distinctive exoskeleton composed of multiple laminated layers containing chitin. This provides protection against predators and waterproofing for terrestrial forms. It can be specialized to form wings, hairs, and grinding parts. As the name suggests, it also provides the attachment points for muscles. The muscles are composed of striated cells, similar to vertebrates, that permit rapid contractions. The exoskeleton does not grow as the animal ages. Instead, molting occurs. The old exoskeleton splits open and, for a short time, the animal is vulnerable as it grows a new, larger exoskeleton. In addition to the periodic vulnerability to predators inherent in this growth pattern, it is a metabolically expensive life history.

Arthropods have an open circulatory system in which blood is pumped through a hemocoel, a blood cavity. For respiration, marine forms use gills, while terrestrial species have tracheae, a network of branching tubules within the body. Specialized malpighian tubules are used for excretion. The nervous system has a double chain of ventral segmented ganglia that join in three fused pairs of dorsal ganglia (the brain).

Arachnids

The arachnids include spiders, mites, ticks, and scorpions. These are mostly terrestrial predators and are recognized by having four pairs of legs. They ingest only liquids; therefore, to feed, they secrete digestive enzymes into a dead or immobilized prey animal, wait for digestion to occur, and then suck up the juices. Although most arachnids prey on animals, several mites are plant parasites.

Scorpions are well known as poisonous animals, paralyzing their prey with a stinger from the tip of their abdomen (tail). Over a twenty-year period, more that sixty deaths from scorpion stings were

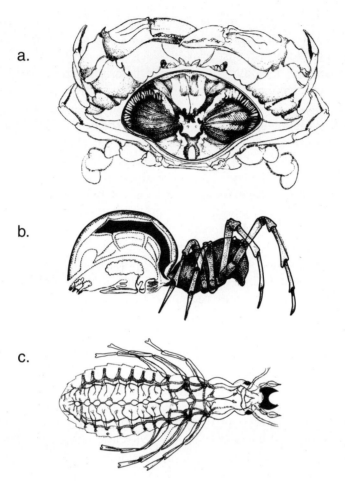

a.

b.

c.

Figure 32-9. Arthropod. The characteristic feature of arthropods is jointed appendages. In crustaceans (a), the head and thorax are joined, and there are typically two pair of antennae and many appendages. Crustacea are aquatic and depend on gills for respiration. Arachnids (b) have a joined head and thorax with four pairs of legs. Respiration is through a specialized structure called a book lung. Insects (c) have a distinct head, thorax, and abdomen. There is a single pair of antennae on the head, three pairs of legs, and typically two pairs of wings attached to the thorax. Respiration is through internally branching trachea.

reported in Arizona. In the state of Durango, Mexico, there were more than 600 victims during the same time period. Some spiders also are noted for their toxicity to humans, most notably the black widow and the brown recluse. Their bites are very painful and cause localized cell death, but seldom are they fatal to adults. Ticks are notorious as vectors for Rocky Mountain spotted fever and Lyme disease.

Crustaceans

Crustaceans, including crawfish, crabs, shrimp, and lobsters, are mostly aquatic animals. Their distinguishing features are two pairs of antennae on the head and various types of appendages on both the abdomen and thorax.

Copopods, small crustaceans, are the most abundant species on earth (individuals per species) and are critical in the marine food web. They serve as intermediate hosts for several human parasitic worms.

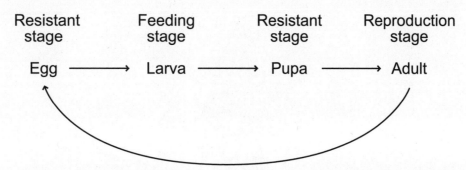

Figure 32-10. Metamorphosis. In complete metamorphosis, the insect alternates between two resting stages: a feeding stage and a reproductive stage. During these stages, the insect feeds on different, often very specific, foods that minimize competition between stages.

We are most familiar with crustaceans as seafood. In order of economic importance these are shrimp, crabs, lobster, and crawfish.

Insects

As previously mentioned, 70 percent of all animal species are insects. These are mostly terrestrial animals capable of flight. They are recognized by having a single pair of antennae, three pairs of legs, and two pairs of wings.

A major reason for their success appears to be a life history strategy of **metamorphosis,** a change in body form and feeding behavior during development.

Both the egg and pupa stages are dormant and resistant to environmental extremes. The larvae and adults have different feeding strategies and, therefore, do not compete. The diets of each are often very specialized and may be restricted to a single prey species.

Other factors contributing to their success are their small size, flight, and keen sensory perception. Insects have a compound eye that is sensitive to motion and may be sensitive to colors. Insects have touch, sound, and taste receptors; respond to pheromones (chemicals released by an animal into the air); and are capable of learning. A number of insect species have evolved complex social interactions, including communication and division of labor between individuals.

Beneficial insects include domesticated bees that produce honey and wax, but are most important for pollinating many of our commercial fruit and vegetable crops. Predatory insects, particularly beetles, are important in controlling insect pests.

Plant pests, usually the larval stages of insects, have a significant impact on agriculture, causing more than $4 billion damage to crops, forests, and stored foodstuffs in the United States per year. Animal pests include lice, roaches, ants, mosquitoes, and so on that not only are a nuisance, but also are important vectors of many bacterial and viral diseases (recall Chapter 27).

■ ECHINODERMS

The echinoderms are the only major group of invertebrate animals that have deuterostomic development. They are marine organisms with bilaterally symmetric juvenile stages but pentamerous radially symmetric adults.

These animals have an internal skeleton consisting of plate-like segments of calcium carbonate. The skeleton is covered with a thin skin that, in many species, are covered with knobs or spines. Within the body is a **water vascular system,** a system of hydraulic tubes and **tube feet** that function in movement.

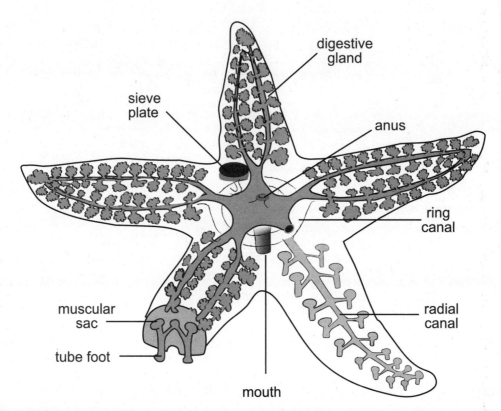

Figure 32-11. Echinodermata. The echinoderms are the only deuterostomic invertebrate animals. They are characterized by a five-parted symmetry and a spiny skin over internal shell-like plates. A water vascular system consists of a ring canal connecting radial canals associated with each segment. Tube feet along the radial canals provide locomotion. The best known members of the group are sea stars (starfish), sea urchins, and sand dollars.

Each body segment has a central radial canal connected to a ring canal in the central disk. A muscular sac, associated with each foot, controls attachment and movement of the foot. The central disk has a single opening into the digestive system, which functions both as a mouth and an anus.

Echinoderms are of major ecological importance in intertidal communities and on coral reefs. Sea stars are a major predator, often the top carnivore in the community, and, therefore, have a major impact on the community structure (recall Chapter 17). They can become a pest species in commercial oyster beds and on reefs. Sea stars attach their tube feet to each side of the bivalve prey and apply constant hydraulic pressure to pull the valves open far enough so that the predator can evert its stomach into the bivalve and digest the visceral mass in place.

A few species have economic importance as a food species. Sea cucumbers are a food source in some countries, and sea urchin gonads are considered to be a delicacy. Sea urchin sperms and eggs are one of the classic model systems for studying fertilization.

Test Yourself

1) In which of the following phyla does the mouth form after the anus in the developing embryo?
 a) annelida (segmented worms)
 b) nematoda (round worms)
 c) echinodermata (echinoderms)
 d) mollusca (molluscs)
 e) porifera (sponges)

2) Which of the following has a true coelom?
 a) nematoda (roundworms)
 b) platyhelminthes (flatworms)
 c) annelida (segmented worms)
 d) cnidaria (corals and jellyfish)
 e) porifera (sponges)

3) Cnidarians are named after their numerous
 a) sensory receptors.
 b) stinging cells.
 c) tentacles.
 d) tissue layers.

4) The exoskeleton of insects is
 a) made of chitin.
 b) self-supporting and rigid.
 c) impermeable to water and oxygen.
 d) a and b only.
 e) a, b, and c.

5) Arthropods are
 a) radially symmetrical and segmented.
 b) radially symmetrical and non-segmented.
 c) bilaterally symmetrical and segmented.
 d) bilaterally symmetrical and non-segmented.
 e) none of the above.

6) What three germ layers appear during the following stage in development.
 a) fertilization
 b) gametogenesis
 c) blastogenesis
 d) endogenesis
 e) gastrulation

7) The following organ(s) or structure(s) is/are *not* present in a flatworm such as planaria.

 a) digestive gut

 b) cilia

 c) nerve cells

 d) blood vessels

 e) sensory cells

8) Which characteristic of flatworms is *not* found in cnidarians?

 a) cephalization

 b) acoelomate

 c) incomplete digestive system (one opening)

 d) nervous cells

 e) at least two body layers

9) From which of the embryonic layers of animals do the intestine and digestive organs arise?

 a) endoderm

 b) mesoderm

 c) ectoderm

 d) mesoglea

 e) mesenchyme

10) An animal is found that is an active marine predator, has a foot modified into a series of tentacles, has a highly developed nervous stem, and has elaborate eyes. To which class of mollusks would the animal belong?

 a) gastropoda

 b) cephalopoda

 c) arachnida

 d) insecta

 e) crustacea

Test Yourself Answers

1) **c.** The echinoderms are deuterostomes, organisms in which the anus forms from the embryonic blastopore and the mouth develops later. All of the other invertebrates are protostomes in which the mouth develops from the blastopore.

2) **c.** Annelids are protostomic animals that have a true coelom. Nematodes have a pseudocoelom. All the other groups listed have no true coelom.

3) **b.** The stinging cells of cnidarians are cnidocytes, which do line the tentacles of most members of the group.

4) **e.** An insect exoskeleton is made of rigid chitin that provides support, blocks water loss, and is impermeable to oxygen.

5) **c.** Arthropods, including crustacean, insects, and arachnids, are bilaterally symmetric animals with segmented bodies.

6) **e.** The three germ layers form during and immediately following gastrulation. During gastrulation, the blastula infolds, forming an inner endoderm with the outerlayer forming the ectoderm. The mesoderm forms immediately afterward between the inner and outer layers.

7) **d.** Flatworms do not have a circulatory system with blood, blood vessels, or a heart. Instead, the digestive gut in prolifically branched internally so that all body cells are near a source of nutrition and waste removal. The bottom surface cells are lined with cilia for locomotion. Sensory cells are located at the head end of the animal where nerve cells congregate.

8) **a.** Although cnidarians do have nerve cells, they are not concentrated in the head region.

9) **a.** The digestive system develops from the endoderm, beginning at the blastopore and connecting through to complete a one-way system.

10) **b.** In the cephalopods, numerous arms of tentacles are attached to the head of the animal. In gastropods, there is a single foot. Arachnids, insects, and crustacean are arthropods, not mollusks.

Chordates

The chordates are deuterostomic animals with bilateral symmetry. Although they include all of the animals most familiar to people, their total number is less than 1 percent of all known animals. They have several distinctive features. First, is the formation of a **notochord,** a firm but flexible axis between the dorsal nerve and the digestive tract. The chordates also have a dorsal hollow nerve cord that differentiates at the anterior end into a brain. Gill slits and a post-anal tail are present during at least some stages of development.

■ INVERTEBRATE CHORDATES

The most primitive chordates are small marine animals whose adult form may be more similar to other invertebrate animals than to the rest of the chordates. The juvenile forms, however, have the distinctive chordate characteristics that implicate them as ancestral to the vertebrate groups.

Tunicates

Except for the gill slits, most chordate features are not evident in adult tunicates, or sea squirts. The sessile adult animal resembles some mollusks in having an internal and external siphon that passes water over the gills, which trap and filter plankton that is then diverted to the stomach.

The juvenile, however, is a motile animal with all the feature of chordates, including a rod-like notochord extending through the tail that allows the animal to swim.

Lancelets

Adult lancelets resemble the tunicate larval form but with more specialized mouthparts that aid in food gathering and a notochord that extends the full length of the body

These animals have an open circulatory system in which the tissues are bathed with blood. It spends most of its time burrowed into sandy substrate, where it filter-feeds on passing plankton. It is capable of swimming to new locations, where it will re-burrow into the substrate. The anterior region of the nerve cord shares the same basic developmental gene control as vertebrate embryos, the so-called *Hox* genes. These genes are responsible for differentiation of the forebrain, midbrain, and hindbrain.

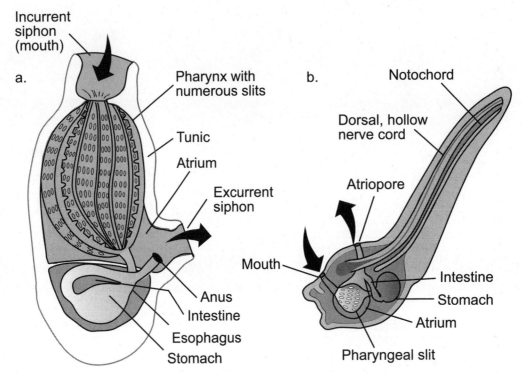

Figure 33-1. Tunicates. a) The adult tunicate is a sessile animal whose sole remaining chordate character is gill slits. b) The juvenile also has a distinct notochord and hollow nerve cord that extends down the post-anal tail.

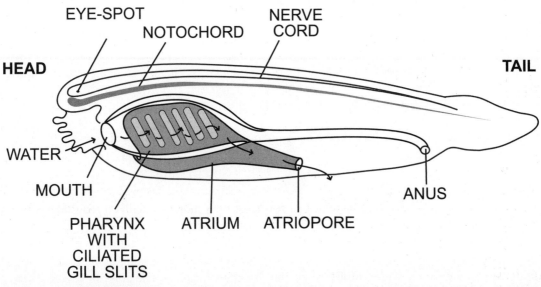

Figure 33-2. Lancelets. The mature lancelet resembles the juvenile tunicate, but with a more highly differentiated head region with light receptors and specialized mouth parts. It grows to about five centimeters long.

■VERTEBRATES

Most chordates form a flexible, segmented backbone around the notochord and spinal cord. Each segment is a **vertebra;** these animals are the vertebrates. In vertebrate animals, the brain, like the spinal cord, also is surrounded by a bony covering, the skull.

Jawless Fish

The jawless fish include lampreys and hagfish.

They are mostly marine, but lampreys survive in freshwater. Jawless fish retain the notochord in the adult animal, but lampreys have it and the spinal cord surrounded by cartilaginous vertebrae. There are no lateral fins; the flattened tail of the body is the only locomotive organ. Like other fish, they have a two-chambered heart and a closed circulatory system. Their mouth is cup-shaped suction disk with a ring of rasping teeth. Lamprey larvae look and act like lancelets, burrowing into sediments and filter-feeding.

Hagfish are either scavengers or predators; lampreys are parasites. They attach to swimming fish with their mouths, and then rasp a hole through the side of the fish to feed on blood and body fluids. When first introduced into the Great Lakes, lampreys decimated the commercial fishing industry. In Europe, lampreys are caught and eaten.

Cartilaginous Fish

The cartilaginous fish include sharks, rays, and skates. They are found almost exclusively in marine waters and are distinguished by their **cartilaginous skeleton.** Adult animals do not retain the notochord. Most members of the group are carnivores and have movable jaws for biting and tearing. Skates and rays generally lie on the sea floor and ambush their prey. Sharks are active feeders and hunt their prey in open water. A few particularly large species are plankton feeders. They are the first of the fish with paired fins, which help to stabilize the animal while swimming. The skin of most species is covered with small teeth, making it very rough. Simply brushing against shark skin can cause severe abrasions.

Most cartilaginous fish have internal fertilization. The fertilized eggs may be shed into the water or retained within the mother's body. The embryos of some sharks with live birth are attached to their mothers by a specialized placenta-like organ.

Sharks and rays are negatively buoyant. They must swim continuously to avoid sinking. Sharks are becoming increasingly important as a food species for humans. Shark fins for soup are a traditional Oriental delicacy, and many sharks are netted solely for their fins. Shark steaks are becoming more common on restaurant menus.

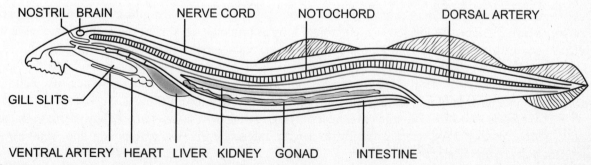

Figure 33-3. Jawless fish. Jawless fish resemble enlarged lancelets, up to one meter long. The mouth functions as a suction disk to attach the animal to prey. Rasp-like teeth surround the mouth opening. In lampreys, cartilage forms around the notochord and dorsal nerve tube.

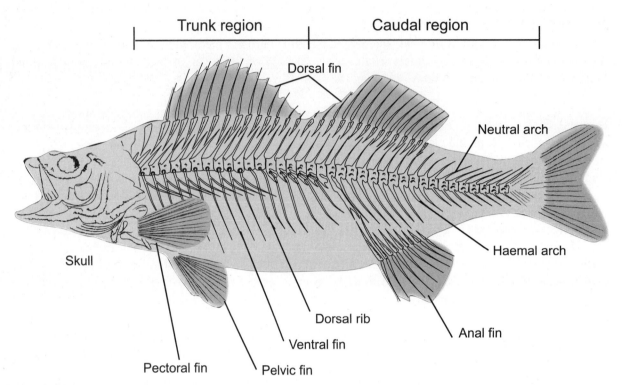

Figure 33-4. Bony fish. Bony fish have a bony skeleton and bony ribs extending into the fins. Each fin rib is connected to its own set of muscles that allow for fine movements of the fins. Fins are paired.

Bony Fish

The bony fish are the largest of all vertebrate classes and include both freshwater and marine forms. Their most distinguishing feature is a bony skeleton; they are the most ancient group of bony animals.

A notochord is present only in the embryo. Bony rays extend into the fins. Because each fin ray is attached to its own body muscles, this allows for precise swimming movements. The fins of an ancient group, the lobed-fin fishes, grow from fleshy lobes containing bones and muscles similar to the legs of land animals. They are considered to be the fish most closely related to tetrapod land animals.

Bony fish also contain a **swim bladder,** which is a gas-filled sac that allows the animal to alter its buoyancy. As a result, the fish can float effortlessly at any position in the water column. They also have a bony flap of tissue, the **operculum,** covering their gills. Movements of the operculum, along with contraction of muscles in the mouth cavity, allow the fish to pump water over the gills even while stationary. Pressure sensing organs are located in a horizontal **lateral line** on each side of the animal. These allow the fish not only to sense both their rate and direction of movement, but also the presence of other objects.

Bony fish may be either herbivores or carnivores. Their mouth parts and teeth are adapted to their feeding mechanisms. In general, carnivores have longer, sharp-pointed jaw teeth and blade-like teeth in their pharyngeal jaws. Herbivores frequently have broad teeth used for crushing and grinding.

Reproduction is mostly external with females laying egg masses that are fertilized by sperm from the males. A few species have internal fertilization with external embryo development and some have embryos that are born live.

Bony fish are important food and game species as well as major components of the aquatic food web. Many smaller fish are useful predators of mosquito larvae and are used in mosquito control programs.

Amphibians

Amphibians are semiaquatic freshwater animals that include frogs and salamanders. They rely on water for reproduction and for some or all of their subsequent life cycle. Similar to many fish, eggs are laid in a mass in the water and fertilized enmasse by the male. The young go through a tadpole juvenile stage, in which they have gills and other fish-like characteristics. During development, they go through metamorphosis in which legs grow and the tail is frequently reabsorbed.

In the adult, the skin is smooth, thin, slimy, and lacks any scales. It must be kept moist because it is the major respiratory organ for the animal, even though more-or-less well developed **lungs** may be present. Amphibians have a closed circulatory system and a three-chambered heart with two atria and a ventricle.

Amphibians are a minor group today, but during the Carboniferous Period, when ferns and fern allies were the dominant terrestrial plants, amphibians were the dominant animals. Today, they remain important insect predators in the food web, and a few find their legs on restaurant menus.

Reptiles

Reptiles include snakes, turtles, lizards, alligators, and so on. Their major evolutionary innovation was the **amniotic egg,** which is fertilized internally, but then develops structures that allow it to continue development externally on land.

With this innovation, terrestrial vertebrates were freed from the necessity of free water for fertilization. In the egg, the **amnion** is a special membrane that surrounds the embryo and suspends it within a

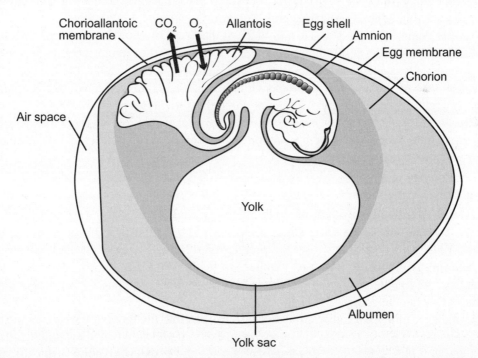

Figure 33-5. Amniotic egg. The amniotic egg contains several membrane systems that allow the embryo to survive and develop outside of water. The amnion covers the embryo and is filled with a saline solution. The allantois is specialized for gas exchange. A leathery or calcium carbonate shell provides physical protection.

saline solution. Stored food is contained in the **yolk,** and most of the volume of the egg consists of the protein albumen, water, and minerals in the "egg white."

The most visible characteristic of reptiles is dry, scaly skin. The skin is no longer a respiratory organ, but instead is adapted to minimize dehydration when exposed to air. The lungs are well developed. Most reptiles have a three-chambered heart similar to amphibians, but the crocodilian heart has four chambers. Although all living reptiles are cold-blooded, we hypothesize that some fossil forms were capable of generating metabolic heat to control their body temperature.

[The dinosaurs were reptiles and the dominant vertebrate terrestrial animals at the time when cycads dominated plant cover.] Today, reptiles remain major predators on insect pests and rodents. A few, mostly turtles, are eaten by humans, and some people also eat alligators and rattlesnakes. In the United States, one lizard species and nineteen snake species are considered poisonous and cause between ten and twenty-five human deaths per year. Alligator and snake skins are tanned to make leather products.

Birds

Technically, birds now are considered to be a class of reptiles, but traditionally, they were considered to be in a phylum of their own. Because of the large number of amateur birders around the world, they are probably the best known of any animal group.

Birds are characterized by flight. Their **feathers,** originally used for thermal insulation, adapt these animals to flight. Their hollow bone structure minimizes weight to facilitate flight and their large, keeled breastbone provides an extended surface area for attachment of the large flight muscles. They are warm-blooded and have a four-chambered heart. These features suggest a close relationship with dinosaurs. Recently, feathered dinosaur fossils have been discovered in China and several other anatomical features suggest that at least some dinosaurs were warm-blooded.

Most birds are omnivores, but the size and shape of the beak correlates with the animal's typical diet. Flightlessness has evolved several times. Some birds, well adapted to the terrestrial environment, have large, well developed legs and can run rapidly for long distances. Others are adapted to the aquatic environment. Waterfowl have webbed feet to aid in swimming. More specialized birds, like penguins, are better adapted to swimming in water than walking on land; they are incapable of flight.

Birds are important predators of insects, and several species are commercial sources of meat and eggs. Feathers of many species are used for decoration, and goose down is still the most efficient thermal insulator for cold-weather clothing.

Mammals

Ask anyone to quickly name ten different living things, and the majority of the organisms listed will be mammals. Yet, the mammals are a small class with fewer than 5,000 total species worldwide. Mammals most distinguishing features are the production of **hair** over most of the body and the development of **mammary glands** to nurse the young. Like feathers in birds, hair in mammals insulates the body, which is endothermic, producing metabolic heat. Like birds, mammals have a closed circulatory system with a four-chambered heart.

All mammals have internal fertilization, but primitive forms (the monotremes) continue to lay eggs and a few (the marsupials) carry immature young in an external pouch, where they attach to the mothers' mammaries and complete embryonic development outside the body. The young of most mammals are born alive after a prolonged period of internal development.

Test Yourself

1) The most probable ancestor of the amphibians was the
 a) lamprey.
 b) tadpole.
 c) bony fish.
 d) shark.

2) Which sensory organ in bony fishes permits the animal to detect pressure waves in surrounding water?
 a) eyes
 b) ear bones
 c) electro receptive organs
 d) sensory scales
 e) lateral line system

3) How are the fins of bony fishes better suited for complex swimming maneuvers than those of cartilaginous fishes?
 a) They are more muscular.
 b) They are larger.
 c) They are more flexible and under greater muscular control.
 d) They contain more cartilage.

4) To which animals are birds thought to be most closely related in an evolutionary sense?
 a) turtles
 b) lizards
 c) snakes
 d) mammals
 e) dinosaurs

5) Besides having no jaws, another feature of jawless fishes is
 a) the lack of paired fins.
 b) well developed scales.
 c) rough, sandpapery skin.
 d) a spiral-valve intestine.

6) External fertilization occurs
 a) only in aquatic animals.
 b) only in terrestrial animals.
 c) in aquatic and terrestrial animals.
 d) only in invertebrates.
 e) only in vertebrates.

7) The vertebrate animal class that was first able to reproduce successfully on land is
 a) amphibians.
 b) reptiles.
 c) birds.
 d) mammals.

8) Internal development of the young first arose in
 a) amphibians.
 b) reptiles.
 c) birds.
 d) mammals.
 e) cartilaginous fishes.

9) The *most significant* result of amniotic eggs was that
 a) larger numbers of young could be produced.
 b) they freed reptiles from depending on water for reproduction.
 c) they could be laid so the sun would incubate them.
 d) they were easier to hide.
 e) they provided stored food for the embryo.

10) About what percent of the total number of animal species are vertebrates?
 a) 1 percent
 b) 10 percent
 c) 20 percent
 d) 50 percent
 e) 75 percent

Test Yourself Answers

1) **c.** The lobed-fin fishes are bony fish with thickened, fleshy fins whose movements resemble the walking movements of amphibians and reptiles.

2) **e.** The lateral line system is a series of pressure-sensitive organs that permits the fish to sense water movements.

3) **c.** The fins of bony fish contain bony extensions between flexible webbing. Each bony extension is connected to its own muscles so that the fin movement can be finely controlled.

4) **e.** Recent discoveries of feathered dinosaur fossils confirms that birds are most closely related to the dinosaurs.

5) **a.** The jawless fish have no fins other than their flattened tails. Scales are characteristic of bony fish, and rough, sandpapery skin characterizes cartilaginous fish.

6) **a.** External fertilization requires a liquid medium through which the sperm can swim. This is available only in aquatic environments.

7) **b.** Reptiles, with internal fertilization and amniotic eggs that resist desiccation, were the first vertebrates to be able to reproduce independent of free water.

8) **e.** Some shark species have internal development of their young and give birth to live offspring.

9) **b.** Evolution of the amniotic egg allowed the embryo to develop, protected, in a terrestrial environment until it was capable of survival on its own. Amniotic eggs are relatively large and complex and, therefore, energetically expensive. For this reason, relatively few are produced at one time. They can be buried underground or laid in open air. All eggs provide stored food for the developing embryo.

10) **a.** Virtually all the commonly known animals are vertebrates, including mammals, and birds, yet this accounts for fewer than 1 percent of all animal species.

Vegetative Plant Structure and Function

This and the next five chapters focus on the biology of flowering plants, the dominant plants on earth today. Recall from Chapter 30 that flowering plants have vascular tissues (xylem and phloem) and the tissues are organized into several distinct organs, such as roots, stems, and leaves. This chapter describes the mature structure and function of the vegetative flowering plant.

■ ROOT

Roots are the underground axis of flowering plants that serve several critical functions. One function is to absorb water and nutrients from the soil. To aid in this function, specialized cells near the root tips (**root hairs**) extend into the spaces between soil particles, increasing the surface area for absorption. As mentioned in Chapter 31, mycorrhizal fungi associate with root cells to assist with the absorption function.

A second function, support, is optimized by the same structural adaptations that optimize absorption. If you have ever uprooted a young seedling, you will have noticed that soil particles "stick" to the root. By penetrating the soil spaces, the root hairs anchor the root in place on a microscopic scale. This turns out to be critical for root growth, as will be explained in Chapter 35. The overall structure of the root is also important for supporting the upright portion of the plant. There are two basic forms of root architecture. Many plants, including all woody plants, have a main **taproot** from which branch roots arise. The taproot can penetrate deep into the soil to tap subsurface water sources. This taproot also provides a deep anchor for the upright stem. Taproots are characteristic of **dicots,** one of two classes of flowering plants. Alternatively, roots may branch profusely just beneath the soil surface, forming a **fibrous,** interconnected mass. Fibrous roots are typical of **monocots.** Fibrous roots not only provide a solid foundation for the plant, but they also are very effective at holding the soil in place, minimizing soil erosion.

A third function of roots is storage. Root crops, such as carrots and sweet potatoes, were originally cultivated because of their specialized storage function. Biennials and perennials, plants surviving for two or more than two years, respectively, depend on storage tissues, often in the root, to supply the nutrients necessary to survive through a dormant season before resuming growth the following year.

A final function is reproduction. Many roots are capable of generating new **shoots** (stems and associated leaves). In nature, this results in a clone of a single plant that can cover large areas. Commercial nursery workers take advantage of this ability to propagate some species by making root cuttings.

An even more common method of propagating clones of plants is to make stem or leaf cuttings. In easy-to-root plants, such as *Coleus,* a shoot segment can be stripped of its lowest leaves (leave the smaller leaves at the tip) and simply placed with the bare stem in a glass of water. **Adventitious roots** will form from the submersed stem, and the rooted cutting can be transplanted. Regardless of whether a root is a taproot, fibrous root, or even an adventitious root, the mature structure will be predictable and characteristic of monocots or dicots.

Monocot Root

A cross-section of a typical monocot root is illustrated in Figure 34-1.

The outer layer of cells, **epidermis,** covers all parts of the plant, including the roots. Especially near the root tip, specialized epidermal cells differentiate into root hairs that extend laterally into the soil. Root hairs, though large enough to be seen with the naked eye, are single epidermal cells.

Beneath the epidermis is a more-or-less thick region of **cortex.** Root cortex is composed of large, relatively undifferentiated cells, with huge central vacuoles, called **parenchyma** cells. Parenchyma cells typically serve a storage function, filled with water and/or food reserves, particularly starch. The innermost layer of cortex is a distinctive ring of cells called the **endodermis.** In monocots, all but the outer wall of each endodermal cell is thickened by deposition of a waxy material that forms a cup-shaped **Casparian thickening,** making it impermeable to water. When the tissue is cut in a thin section, the

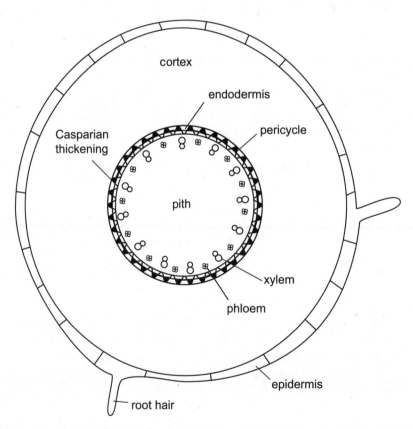

Figure 34-1. Monocot root cross-section. The outer layer of epidermis, containing root hairs, surrounds a cortex of storage parenchyma cells. Inner endodermis contains prominent Casparian thickenings except for occasional passage cells. The layer under the endodermis is pericycle, which surrounds an alternating ring of xylem and phloem bundles. Pith is in the center.

Casparian thickenings have a distinctive C-shaped appearance, and the entire endodermis resembles a circular crown. Occasional endodermal cells lack the thickening and are called **passage cells.**

The very center of the monocot root is also filled with parenchyma cells in a region called the **pith.** Pith also has a storage function. Between the endodermis and the pith are the vascular tissues. In roots, xylem and phloem occur in separate bundles. The xylem cells have a large diameter and thick walls; the phloem is smaller, similar to small parenchyma cells. In monocot roots, the xylem and phloem bundles alternate with each other in a single ring inside of the endodermis. The parenchyma-like cells immediately beneath the endodermis is a special tissue, the **pericycle.**

Dicot Root

The outer layers of a dicot root are similar to those of monocot roots. An epidermal layer, which may include root hairs, surrounds the storage parenchyma of the cortex. The inner-most layer of cortex is an endodermis, but it is much less distinctive than its monocot counterpart. Endodermal cells of dicots have a simple band of waxy material around the radial side walls of each cell. Both the inner and outer walls are thin and permeable to water; water cannot pass between adjacent cells. The presence of an endodermis is a common pattern for roots.

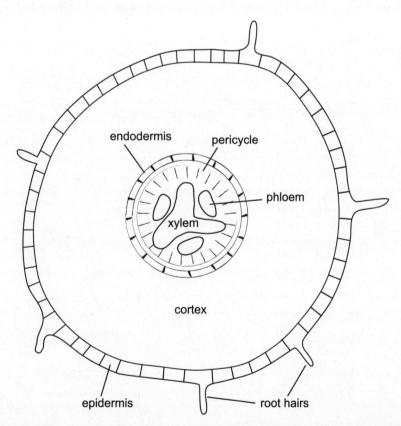

Figure 34-2. Dicot root cross-section. The outer layer of epidermis, containing root hairs, surrounds a cortex of storage parenchyma cells. Every endodermal cell is surrounded by a band of Casparian strip, most noticeable as a thickening in the middle of each side wall. Pericycle underlies the endodermis and surrounds the vascular bundles. Xylem forms a solid core with extending arms. A bundle of phloem alternates with each xylem arm.

The vascular tissues form a distinct pattern inside the endodermis. Xylem forms a star-shaped pattern in the center of the root. The number of arms varies, depending on the species and size of the root. Between each pair of xylem arms is a small bundle of phloem. Moving in a circle under the endodermis, the xylem arms alternate with phloem bundles; alternating xylem and phloem are a common pattern in roots.

■ STEM

The stem is the above-ground axis of the plant. A primary function of stems is to support the leaves. Stems are divided into repeating segments called **nodes** and **internodes.** Nodes are the stem segments where leaves are attached. The elongated stem segments between nodes are internodes.

Although leaves are the major photosynthetic organs in plants, many stems are also green because of layers of photosynthetic cells. Stem photosynthesis is particularly important in dry environments, where leaves are reduced in size or persist for only a short period following a rainy season. Stems are also important storage organs, particularly in dry environments.

As mentioned previously, stem cuttings are a commercial means of propagating plants. Some specialized stems, called runners, grow horizontally over the ground with long internodes. At each node, adventitious roots form, and a new upright stem forms. Strawberries are a commercial crop that naturally spreads in this way.

Monocot Stem

In cross section a typical monocot stem has an almost homogeneous appearance.

The outer layer, epidermis, is distinguishable from the root epidermis because of a layer of waxy **cuticle** covering the stem. Epidermal cells of all above-ground plant parts secrete this layer to help min-

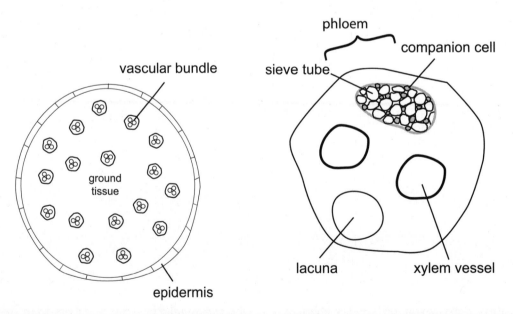

Figure 34-3. Monocot stem cross-section. The epidermis, with a waxy outer cuticle, forms an outer boundary to the stem. Most of the interior is ground tissue composed of storage parenchyma cells. Vascular bundles, containing xylem toward the inside of the stem and phloem toward the epidermis, are precisely arranged throughout the ground tissue.

imize water loss. On some plants, certain epidermal cells may differentiate into **trichomes** or hairs. Unlike root hairs, the cells forming trichomes may divide to form multicellular structures.

The parenchyma cells under the epidermis frequently are not differentiated into any distinct layers. It forms a homogeneous **ground tissue.** Arranged within the ground tissue are vascular bundles that contain both xylem and phloem in the same bundle. Monocot stem bundles are frequently described as being scattered or even randomly arranged; however, they are in a very precise and predictable pattern. An individual bundle has a mask-like appearance. The two large "eyes" are large xylem vessel cells. The "mouth" is an opening, or lacuna, where the original xylem cells were torn apart as the stem enlarged during growth. Connecting these cells are additional xylem. In the "forehead" region is a patch of phloem with large sieve tube cells interspersed with small, square companion cells. Depending on the size of the bundle, there may be a ring of thick-walled fibers surrounding the bundle. Vascular bundles are smaller and more densely packed around the periphery of the stem and larger and more widely spaced toward the center. Regardless of where an individual bundle is located, it is always oriented so that the xylem is toward the center and phloem is toward the outside.

Dicot Stem

The arrangement of tissues in a dicot stem also has a characteristic pattern.

Two stem characteristics are similar to what is found in the monocot stem—xylem and phloem are together in the same vascular bundle, and there is no endodermis. In the dicot stem, however, there are both a distinctive pith and cortex region composed of parenchyma cells. As in roots, these cells function primarily in storage.

In the stem, however, there may be some additional specialization in the cortex. In green stems, the outer layer of cortex contains **chlorenchyma** cells—parenchyma cells packed with chloroplasts that undergo photosynthesis. The chlorenchyma layer is directly beneath the cuticle-covered epidermis. Epidermal cells in above-ground parts are not packed with organelles, so the cytoplasm appears clear and functions like a window to allow light to pass while providing a barrier to water loss and pathogen entrance. In many stems, especially ridged stems with definite corners, specialized files of strengthening cells, **collenchyma,** are packed beneath each ridge. Collenchyma cells are elongated with irregularly

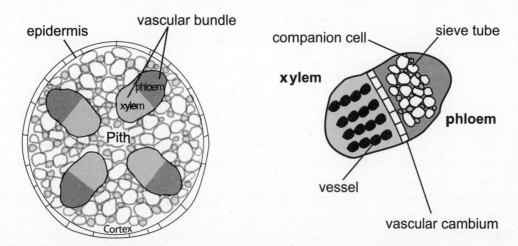

Figure 34-4. Dicot stem cross-section. The epidermis, with a waxy outer cuticle, forms an outer boundary to the stem; a pith of storage parenchyma cells fills the center. Vascular bundles, containing xylem toward the inside of the stem and phloem toward the epidermis, are arranged in a single ring between the pith and the cortex, a layer of parenchyma beneath the epidermis.

thickened primary walls. Thick bundles of strengthening cells in the corners provide maximum architectural support with a minimum of material.

The vascular bundles are arranged in a single ring around the pith. Each bundle has files of xylem cells toward the pith and a patch of phloem cells toward the cortex. In many plants, a cap of phloem fibers covers the outside of the bundle. As in monocots, xylem is always toward the inside of the stem with phloem toward the outside. In most dicots, there will be a band of residual **procambium** cells immediately between the xylem and phloem. The xylem and phloem in the bundles form from procambium cells. In monocots, the procambium is completely used up forming xylem and phloem. In dicots, some potential remains for further growth from the residual procambium. The parenchyma cells in between each bundle are **pith rays** that connect the pith to the cortex.

■ LEAF

Leaves are the primary photosynthetic organs in most plants. They are lateral appendages attached at nodes in precise and predictable patterns (called **phyllotaxy**) that are arranged to maximize exposure to light. Occasionally, three or more leaves are attached at a single node in a **whorled** phyllotaxy. More often, leaves are paired at a node, **opposite** each other. Most commonly, single leaves attach in an alternate pattern from one node to the next.

Alternate leaves are arranged in a pattern that can be described by a phyllotactic fraction. The simplest pattern has leaves alternating at 180 degrees. Beginning with any leaf on the stem, it will only require one turn around the stem, passing through two successive leaves, to be exactly above or below the starting leaf. This is a one-half phyllotaxy. Slightly more complex is a one-third phyllotaxy, in which one turn around the stem goes through three leaves. Other patterns are two-fifths, three-eights, five-thirteenths, and so on.

Most leaves are broadly flattened so numerous veins—bundles of vascular tissue—are required to supply water and nutrients and to transport sugars out of the leaf. In monocots, the leaf has parallel veins. The veins of dicots form an interconnecting network.

Monocot Leaf

Like roots and stems, leaves have a characteristic internal pattern of cells and tissues. All leaves have a lining of upper and lower epidermal cells.

Specialized epidermal cells, **guard cells,** regulate the opening and closing of pores called **stomata.** Depending on the species, stomata may be located on one or both surfaces of the leaf. A large substomatal chamber is associated with each stomate. The photosynthetic tissue within the leaf is mesophyll. In monocots, the **spongy mesophyll** is homogeneous and loosely surrounds numerous intercellular spaces. Gas exchange between mesophyll cells and their internal air spaces is critical for respiration and also for photosynthesis (recall Chapters 7 and 8, respectively).

Vascular tissue runs through the center of the leaf. The pattern of a leaf bundle is exactly the same as in stem bundles. In monocots, the bundle has a face-like appearance, with the phloem on the bottom side of the leaf and the xylem toward the top. This orientation is because leaf bundles originate as a stem bundle that moves outward out of the stem to supply the leaf. The xylem that was on the inside of the stem becomes the upper side of the leaf. In many leaves, the leaf bundles are surrounded by a conspicuous **bundle sheath** of surrounding cells.

Dicot Leaf

The dicot leaf has two distinctive differences from the monocot leaf.

First, there are two distinctively different layers of mesophyll. A layer of compacted **palisade mesophyll** occurs on the upper side of the leaf; spongy mesophyll is restricted to the lower side. Second, the

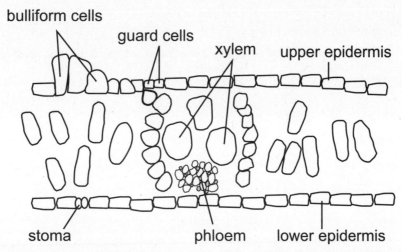

Figure 34-5. Monocot leaf cross-section. An upper and lower epidermis, with a waxy outer cuticle, forms an outer boundary to the leaf. Occasional pairs of guard cells form a stomatal opening through the epidermis for gas exchange. The interior ground tissue is spongy mesophyll with large intercellular spaces. Vascular bundles resemble stem bundles with xylem toward the top of the leaf.

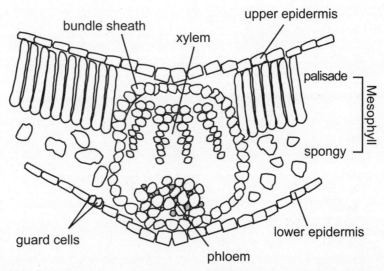

Figure 34-6. Dicot leaf cross-section. An upper and lower epidermis, with a waxy outer cuticle, forms an outer boundary to the leaf. Occasional pairs of guard cells form a stomatal opening, particularly through the lower epidermis. The interior ground tissue has spongy mesophyll with large intercellular spaces on the lower side and densely packed palisade mesophyll on the top side. Vascular bundles resemble stem bundles, with xylem toward the top of the leaf.

vascular bundles of dicot leaves resemble those of the dicot stem bundles. Files of xylem cells occur on the upper side of each bundle, with a patch of phloem on the lower side. Leaves of temperate dicots frequently have more stomata on their lower surface.

Test Yourself

1) What tissue is most responsible for photosynthesis in most monocot and dicot leaves?
 a) mesophyll
 b) cortex
 c) epidermis
 d) vascular bundle
 e) pith

2) In plants, most gas exchange occurs in
 a) stems.
 b) roots.
 c) flowers.
 d) leaves.
 e) None of the above; plants do exchange gasses.

3) Root cells that store starch are primarily located between
 a) the xylem rays within the vascular cylinder.
 b) xylem and phloem.
 c) epidermis and root hairs.
 d) epidermis and endodermis.
 e) endodermis and pith.

4) A root hair is
 a) a multicellular extension of the root epidermis.
 b) an extension of the endodermis of roots.
 c) an extension of an epidermal cell.
 d) a structure designed to absorb water from soil.
 e) both c and d.

5) Which of the following characteristics is/are typical of monocots?
 a) net-like leaf venation
 b) presence of pith in the stem
 c) secondary growth
 d) solid core of xylem in the center of a root
 e) None of the above; all the characters listed are typical of dicots.

6) The structure(s) that provides the greatest strength to an upright herbaceous stem is/are
 a) cortex.
 b) vascular bundles.
 c) endodermis.
 d) epidermis.
 e) pith.

7) An anatomical characteristic of dicots is
 a) a fibrous root system.
 b) a palisade mesophyll in the leaf.
 c) an endodermis in the root.
 d) C-shaped Casparian thickenings in the endodermis.
 e) xylem and phloem in the same bundle of stems.

8) Which of the following adjectives *best* describes the arrangement of the vascular bundles in a dicot stem?
 a) scattered
 b) ring
 c) central
 d) criss-crossed
 e) random

9) The Casparian thickening
 a) directs water movement.
 b) builds up root pressure.
 c) transports ions across membranes.
 d) absorbs water.
 e) is composed of cutin.

10) Which structure is present is a root but not in a stem?
 a) xylem
 b) phloem
 c) pericycle
 d) ground tissue
 e) pith

Test Yourself Answers

1) **a.** Mesophyll, which may be distinguished as spongy and/or palisade, is the primary photosynthetic tissue in the leaf and is composed of chlorenchyma cells. The outer layers of stem cortex may also be photosynthetic. The only photosynthetic cells of epidermis are guard cells. Neither pith or vascular bundles are photosynthetic.

2) **d.** Gas exchange is necessary both for respiration and photosynthesis. The latter is particularly important in plants, in terms of total volume of exchange, and occurs mostly in the leaves.

3) **d.** Cortex is the primary storage tissue in all roots. It is located between the epidermis and endodermis.

4) **e.** Root hairs are lateral outgrowths of individual root epidermal cells that increase surface area for absorption and anchorage. Although they may be quite long, they are unicellular.

5) **e.** Monocots have parallel leaf venation, a pith in the root only, and no secondary growth.

6) **b.** Vascular bundles, including phloem fibers and xylem, are arranged in a ring around the periphery of the stem. The fibers and xylem are lignified sclerenchyma cells that are very strong. Their arrangement in bundles around the periphery provides the optimum strength per weight.

7) **b.** Dicot leaves have both palisade and spongy mesophyll in the leaf. Fibrous roots and C-shaped Casparian thickenings are both characteristic of monocots. Both dicots and monocots have an endodermis in the root and xylem and phloem together in the same bundle in stems.

8) **b.** In the dicot stem, the vascular bundles are arranged in a single ring between the pith and the cortex.

9) **a.** The Casparian thickening, a layer of suberin within the radial cell walls of endodermis, blocks water movement through the cell walls and directs it through the cell membrane.

10) **c.** Pericycle is the cell layer immediately below the endodermis in roots. It is the tissue that gives rise to branch roots. Xylem, phloem, and ground tissue are present in all roots, stems, and leaves. Pith is found in monocot roots and dicot stems.

Plant Development

Cell division in plants is concentrated in regions called **meristems** that occur in specific parts of the plant. The actual dividing cells may be referred to as initials. Apical meristems occur at the tips of growing organs and are responsible for **primary growth** (growth in length). Growth in width, called **secondary growth,** is due to the action of a lateral meristem called cambium.

■ PRIMARY GROWTH

All apical meristems contain three primary meristems that produce the tissue regions of roots or shoots. **Protoderm** gives rise to epidermis, **procambium** forms vascular tissues, and **ground meristem** produces the remaining tissue. The organization of primary meristems in the apical meristem determines the mature tissue patterns described in Chapter 34.

Roots

The root apical meristem is relatively simple because it produces only an elongating axis. An examination of a longitudinal section through a root tip shows a pattern of cells radiating from the tip of the apical meristem.

Continuous with vascular tissues on the interior of the root are files of darkly staining procambium cells. Mature tissues can be recognized by the spirally thickened secondary walls of xylem cells. Surrounding the vascular tissue are enlarged parenchyma cells of ground tissue. Following these cells toward the tip, cell size decreases and the cytoplasm appears more darkly stained as one moves gradually into the ground meristem. Mature epidermis can be identified by the presence of root hairs. If the epidermis is followed toward the root tip, it grades imperceptibly into protoderm, the primary meristem that forms epidermis. Near the tip, the protoderm of many roots appears to move toward the center and form a boundary between the root tip proper and the root cap.

Root Cap

Because the root apical meristem is constantly being driven through the soil, there is a protective covering, the **root cap.** Root cap cells are produced by a unique primary meristem, the **calyptrogen** that is located at the boundary between the root proper and the root cap. Every time a calyptrogen cell divides, the inner daughter cell remains meristematic to divide again, while the outer cell differentiates into a root cap cell. Constant production of new root cap cells forces older cells toward the periphery of the root cap,

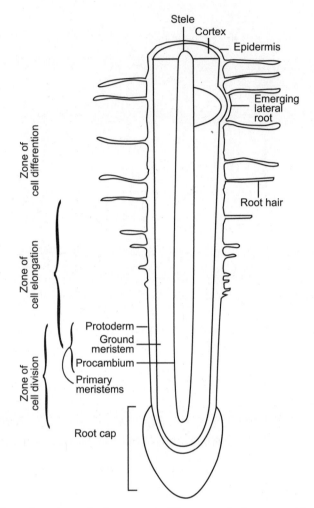

Figure 35-1. Longitudinal section through the root tip. The root tip is covered by a root cap with cell division concentrated near the common boundary. Protoderm produces epidermis, including root hairs. Procambium produces vascular tissues of xylem and phloem. Ground meristem produces cortex and, if present, the pith. Lateral root arise from pericycle beneath the endodermis.

where they continually abrade away. Root cap cells secrete a mucilaginous material that, together with the cytoplasm of crushed cells, helps lubricate the way for the root tip to penetrate through the soil.

The root cap also has another important function for root growth. Everyone knows that roots tend to grow downward. But how does the root perceive direction? If the root cap is removed from a growing root, the root will continue to grow in the direction it is pointed, regardless of the pull of gravity. If the root cap is replaced, the root will once again respond to gravity by growing downward. The root cap is the site of gravity perception.

Quiescent Center

The pattern of cell files evident in the longitudinal section, first described in the late 1800s, suggested that the tip of the meristem, where the files come together, must be the center of most active cell division. It was not until the 1950s that actual dividing cells were analyzed, and it was then discovered that the sup-

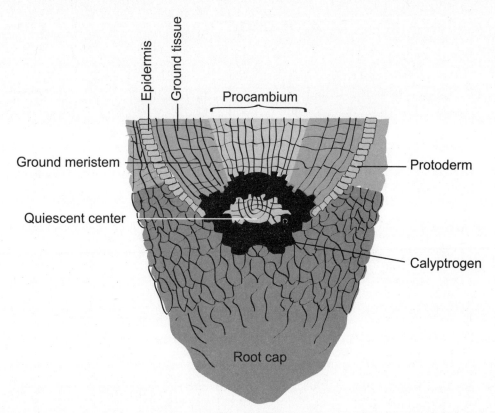

Figure 35-2. Quiescent center. The region of most active cell division (apical initials) surrounds a quiescent zone of infrequently dividing cells. The primary meristems of protoderm, ground meristem, procambium, and calyptrogen arise in the apical intials.

posed region of highest meristematic activity actually had few, if any, dividing cells. This region was termed the **quiescent center.**

The size and activity of the quiescent center depends on the species, the size of the root, and how actively the root is growing. The quiescent center serves as a reservoir of potentially meristematic cells. If the root tip is damaged, the quiescent center cells become activated and repair and re-form the apical meristem. If the quiescent center itself is destroyed, further growth in length of that axis ceases.

Root Elongation

Elongation of the root is due to a combination of cell division producing new cells, and elongation of existing cells pushing the meristematic cells forward. Protoderm, procambium, and ground meristem cells surround the quiescent center at the tip of the root. Each of these primary meristem cells divides like the calyptrogen cells. One daughter cell remains meristematic, and the other begins to differentiate into a mature cell. Because the existing root is already composed of mature cells, every round of cell division pushes the tip slightly forward through the soil. Cell division contributes the most to root elongation near the tip of the root and gradually decreases in importance as you move toward more mature tissues.

Mitotic index (rate of cell division) is highest (IB) just behind the quiescent zone (IA) and rapidly decreases as you move into older tissues. Cells are shortest in the meristematic zone (I) and gradually increase until a maximum length is reached in the mature regions. Regions of cell division, elongation, and maturation overlap.

ROOT GROWTH

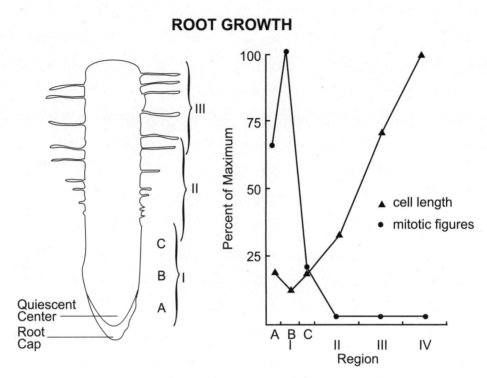

Figure 35-3. Relative contributions of cell division and cell elongation to root growth.

Most of the forward movement through the soil is due to cell elongation. Even in the meristem, when a cell divides, it must elongate back to its original size before it divides again. Cell elongation in plants is due primarily to loosening the bonds between cellulose molecules in the cell wall and increasing the size of the vacuole through water uptake. The water builds hydrostatic pressure that stretches the loosened cell walls. Daughter cells that will no longer divide continue to elongate until they reach their mature size and differentiate into mature tissues. Differentiation of vascular tissues from the procambium and root hairs from the protoderm occur at about the same distance behind the apical meristem in the region of maturation. These tissues are important to root growth because they provide resistance to cell expansion. Root hairs anchor the growing root firmly in the soil so that force generated by cell expansion can be directed only forward toward the tip. Hydraulic pressure generated by the elongating cells forces the tip through the soil. The region of elongation overlaps with the meristematic region of cell division near the root tip and gradually merges into the region of maturation in older tissues.

Branch Root Formation

As the root ages, branch roots are initiated by the primary root in regions of mostly mature cells. The first evidence of branch root initiation is cell divisions in the pericycle opposite arms or bundles of xylem. These early cell divisions are oriented so that the new cell wall between daughter cells is parallel to the surface of the root. This orientation, **periclinal**, is commonly associated with initiation of new tissues.

Subsequent cell division produces a mass of cells that begins to bulge through the endodermis and cortex. The solid xylem core of the primary vascular bundles underlying the growing tissue permits only outward expansion through the softer parenchyma of the cortex. As the mass continues to enlarge, it organizes a typical pointed apical meristem that penetrates through the cortex and bursts through the epidermis to grow laterally into the soil. Branch roots are initiated internally in the pericycle and penetrated through living tissues until they emerge from the primary root.

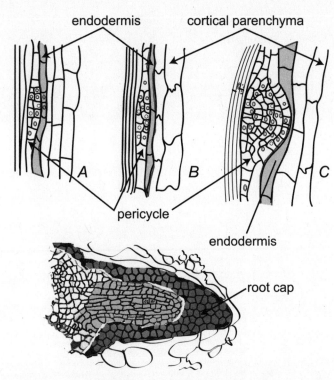

Figure 35-4. Branch root initiation and development. Branch roots are initiated by periclinal divisions in the pericycle layer. Continued cell division produces a mass of cells that forms a lateral root apical meristem that penetrates through the cortex to emerge through the epidermis.

Shoot Apical Meristem

The shoot system, consisting of the stem and associated leaves, has a common origin in the shoot apical meristem. At the tip of the axis, the meristem is divided into a core of cells, the **corpus,** surrounded by one or more sheets of covering cells, the **tunica.**

The layers of tunica are maintained as the apex grows because cell divisions are **anticlinal**—the new cell walls always form perpendicular to the surface. Occasionally, a periclinal division will occur on the flank of the meristem in either the surface layer or slightly deeper. This periclinal division near the surface of the tissue is the first indication of leaf initiation. The position of leaf initiation on the apical dome determines the ultimate phyllotaxy of the shoot. Subsequent cell divisions produce a mass of cells that bulge from the surface and are recognized as a leaf **primordium.** The layer of cells covering the leaf primordium and adjacent young stem is protoderm. As the leaf primordia continue to enlarge, strands of elongated, darkly staining procambium cells form in the center of the primordium. These are continuous with similar strands in the growing stem. The remaining cells in the leaf primordium that eventually form mesophyll are ground meristem. Ground meristem in the stem forms ground tissue, including cortex and pith.

Intercalary Meristem

Near the tip of the young shoot, successive nodes are close together. A layer of cells remains meristematic either at the top or bottom side of a node to become an **intercalary** meristem. An intercalary meristem is a group of dividing cells between already mature tissue. In the case of internodes, the meristematic cells are between two nodes. The meristem on one side of the internode continues to produce new cells as the daughter cells elongated to form an internode. In woody plants, this occurs simultaneously at

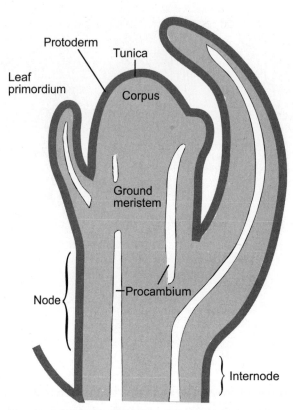

Figure 35-5. Young shoot and shoot apical meristem. The tip of the shoot (the shoot apical meristem) consists of a corpus surrounded by one or more layers of tunica. Tunica layer is contiguous with protoderm that forms epidermis. Periclinal cell divisions in protoderm or lower layers form a bulging mound of tissue, a leaf primordium. Procambium, which forms vascular tissues, is initiated in the center of the leaf primordium and within the stem. Ground meristem produces cortex and pith in stem and mesophyll in leaves.

every internode as the dormant bud begins growth in the spring. As a result, the new shoot can grow to a length of a foot or more in a matter of one or two weeks.

Branch Shoots

Also evident near the shoot tip are mounds of densely-staining cells in the upper angle where the leaf attaches to the stem. These **axillary buds** are the early initials of branch shoots. The bud is initiated from residual cells from the apical meristem at and just under the surface layer. As the initials divide and form a protruding mound of tissue that soon develops into an apical meristem with surrounding leaf primordial. The bud remains dormant until stimulated to grow by a change in hormonal concentrations (see Chapter 38).

■ SECONDARY GROWTH

Many dicots have the capability to undergo secondary growth and increase in girth by forming woody tissues. The prerequisite is that residual procambium remains between the xylem and phloem when primary growth is completed. When a residual procambium cell divides, it undergoes a periclinal division forming two daughter cells. By definition, this is now **vascular cambium.** One of the two daughter cells will always remain vascular cambium.

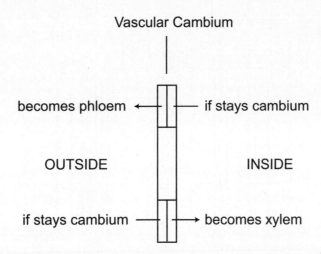

Figure 35-6. Development of secondary xylem and phloem. Vascular cambium is a layer of cells between xylem and phloem that undergo periclinal divisions. One daughter cell remains cambium, while the other differentiates either into xylem, on the inside, or phloem, on the outside.

The other daughter cell differentiates. If the inner cell stays cambium, the outer cell becomes secondary phloem. If the outer cell stays cambium, the inner cell becomes secondary xylem. Most of the time, the inner cell becomes secondary xylem and the vascular cambium is pushed slightly toward the outside.

Vascular cambium that forms between the primary xylem and phloem within the original vascular bundles is called **fascicular vascular cambium** (*fascicle* is an old term for "bundle"). If this were the only vascular cambium to form, the stem or root would start to become ridged instead of round. Ridges would grow in line with each bundle and there would be deep grooves in between in line with the pith rays. Except for some tropical vines, this does not occur. Instead, when the fascicular vascular cambium begins to function, it stimulates the adjacent pith ray parenchyma cells to differentiate into new vascular cambium. These, in turn, affect the cells immediately lateral to them, and so on, until a line of **interfascicular vascular cambium** connects one bundle to the next and there is a complete ring of vascular cambium entirely around the stem.

Growth Rings

Secondary xylem, formed by the vascular cambium, is wood. As you probably know, wood is laid down in concentric rings that relate to the age of the tree and the growing conditions each season. Early in the growing season, the environment is usually optimal for growth. There is plenty of water, and temperatures are warm but not hot. The tracheids and especially the vessels formed during these good conditions are generally large. Vessel diameter is often large enough to see individual vessels with the naked eye. Foresters use the term "pores" to describe the appearance of the vessels. If they occur only on one side of a growth ring, the wood is said to be **ring porous.** If vessels are scattered throughout, the growth ring it is a **diffuse porous** wood.

The wood formed early in the growing season is called early wood or **spring wood.**

Later in the growing season, the temperature frequently gets hot and the days become drier. Xylem cells formed at this time do not grow as large as during the spring; however, their cell walls are just as thick. As a result, the cells are packed closer together and appear darker. This is the late wood or **summer wood.** At the end of the growing season, the vascular cambium is adjacent to the last-formed layer

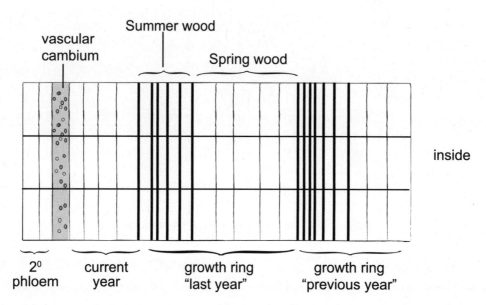

Figure 35-7. Spring and summer wood. Xylem cells formed early in the growing season (spring wood) are larger than later-formed summer wood. The boundary between one season's summer wood and the following season's spring wood is conspicuous and allows growth rings to be determined. Larger growth rings correlate with good growing seasons. The conditions "last year" were better than the conditions the "previous year."

of summer wood cells, and it goes dormant through the winter. The following spring, when growth conditions again are optimal, large-celled spring wood will be formed, and the process will be repeated. The contrast between the dense summer wood of one year and the more open spring wood of the following year appears like a line. In a piece of wood, the distance between two successive lines is a **growth ring** for that year. During droughts or unseasonably cool years, the growth rings are narrow. Years with good growing seasons produce wide growth rings. Thickness of the growth ring can be a useful indicator of weather conditions in seasons past.

In temperate areas, there is only one growing season per year. Under these conditions, there will only be one growth ring per year, and it may be called an **annual ring.** Counting the rings is an accurate index of the age of the tree. If there are not distinct seasons, however, growth rings may be ambiguous.

Rays

If you examine a tree branch or trunk that has been cut in cross-section, the growth rings are apparent as concentric circles that get wider each successive year. However, if you look closely, you will notice dark lines radiating out from the center along radii of the circular stem. Recall that the conducting cells of xylem are dead when they are mature and that they transport materials only in an upward direction. Similarly phloem conducts in an up-or-down direction. Yet all along the trunk, from the soil surface to the top-most leaves, there are living cells in the stem that must be supplied with water and nutrients. Rays are parenchyma cells that transport materials laterally from the xylem or phloem at any level in the stem.

As the stem gets wider, the space between existing rays also becomes wider so new rays must be formed in between existing ones. Rays are also formed by the vascular cambium. Most vascular cambium cells are elongated and pointed at each end, a shape called **fusiform.** Fusiform initials are vascular cambium cells that produce conducting cells of secondary xylem or secondary phloem. **Ray initials** begin as fusiform initials, but divide from top to bottom to form a stack of squarish cells with the overall shape of

the original fusiform initial. Each ray initial in the stack contributes to one row of xylem or phloem ray parenchyma.

Periderm and Bark

As the vascular cambium produces new secondary xylem and phloem, the stem gets thicker and the old primary phloem, cortex, and epidermis gets pushed farther and farther toward the outside as the internal woody layer gets thicker and thicker. Phloem and cortex get crushed, but the epidermis stretches and begins to break apart. If the epidermis is not replaced, excessive water loss will occur when the epidermis cracks, and this will provide an entry for pathogens.

Fortunately, the mechanical stress on the outer cortex cells stimulates a layer of cells to begin to divide periclinally to form a new cambium layer, the **cork cambium.** Cork cambium functions just like the vascular cambium. Every time a cambium cell divides, one cell will remain cambium and the other daughter cell will differentiate either into **cork** or into **phelloderm.** If the outer cell stays cambium, the inner cell becomes phelloderm, a thin layer of living cells. If the inner cell stays cambium, the outer cell becomes cork. Usually, the latter occurs, and cork forms thick layers of dead cells with waxy cell walls that are impervious to water.

The cork cambium and its derivative cells are called **periderm.** Multiple layers of cork cambium may be initiated, with the youngest inside the oldest. As the stem continues to increase in width, the original layers of periderm begin to fissure into plates or ridges characteristic of the species. These are the outer layers of **bark,** which includes the phloem and extends in as far as the vascular cambium. Bark may be defined as everything outside of the vascular cambium while wood is everything inside.

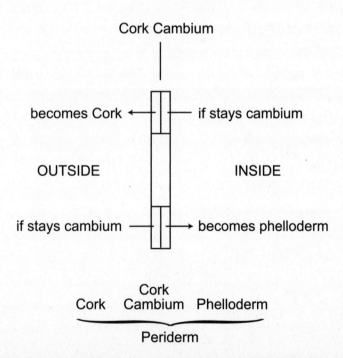

Figure 35-8. Periderm. Periderm consists of the cork cambium and its derivatives, the outer cork and the inner phelloderm. Cork cambium functions like vascular cambium. This single layer of cells divides periclinally, and one daughter cell remains cambium while the other daughter cell differentiates into either cork (outer) or phelloderm.

Test Yourself

1) New shoot growth on a tree during the spring arises from
 a) the quiescent center.
 b) an apical bud.
 c) procambium.
 d) vascular cambium.
 e) the cotyledons.

2) Growth in width of woody plants is
 a) primary growth.
 b) secondary growth.
 c) sexual reproduction.
 d) growth in apical meristems.

3) A tall ponderosa pine was cut down near Kamela, Oregon. "Tied by a shriveled leather thong, high in the treetop was a bronze cattle bell, inscribed with the date 1878 . . . The people of Kamela guessed that a pioneer had tied it to a sapling that grew into a towering pine" (*Time* magazine). Which of the following is the best explanation for the last sentence in this story?
 a) It's logical, because a tree elongates from the ground up.
 b) It's logical, because this particular tree could have attained great height since 1878.
 c) It's illogical, because no one know with certainty when the bell was tied to the sapling.
 d) It's illogical, because branch production occurs behind the shoot apical meristem.
 e) There is no basis for appraising the concluding sentence of the report.

4) A vascular cambium cell divides. If the outer daughter cell remains cambium, then
 a) the outer cell becomes xylem.
 b) the outer cell will divide again at the later time.
 c) the outer cell becomes cork cambium.
 d) the inner cell becomes cork.
 e) the inner cell becomes phloem.

5) Which of the following is a function of the root cap?
 a) produce new cells for the growing root
 b) protect the root tip
 c) cover a dormant root
 d) provide strength for the root
 e) limit water absorption by the root tip

6) After five years of drought, a woody plant goes through five additional years of good growth due to excellent growing conditions. The xylem cells formed during the last five years

 a) will be larger in diameter than those of the first five years.

 b) will be still alive while the earlier formed cells will be dead.

 c) will form smaller growth rings than during the previous five years.

 d) are imaginary because no xylem will be formed during years of inadequate moisture.

 e) both a and b.

7) Which of the following is *never* formed by vascular cambium?

 a) secondary xylem

 b) secondary phloem

 c) cork cambium

 d) vascular cambium

 e) wood

8) Branch roots in both angiosperms and gymnosperms are initiated by cell divisions in the

 a) vascular cambium.

 b) endodermis.

 c) cortex.

 d) lateral meristems.

 e) pericycle.

9) A plant cell grows longer primarily by

 a) making the wall thicker.

 b) synthesizing more cytoplasm.

 c) taking up water as the wall becomes less rigid.

 d) increasing the number of vacuoles.

 e) fusing with neighboring cells.

10) Primary phloem in the root develops from the

 a) protoderm.

 b) endoderm.

 c) procambium.

 d) ground tissue.

 e) vascular cambium.

Test Yourself Answers

1) **b.** An apical bud is a dormant shoot with no internode elongation. In the spring, each of the internodes simultaneously elongate to produce rapid shoot growth. The quiescent center is located in roots, and vascular cambium is associated with growth in width of woody plants. Procambium is the primary meristem that forms vascular tissues and cotyledons are part of the embryo in a seed.

2) **b.** Secondary growth, due to vascular cambium and cork cambium, results in the growth in width of wood plants. Primary growth is growth in length due to apical meristems.

3) **d.** Shoot elongation, primary growth, is due to the shoot apical meristem and elongation of the internodes produced by that shoot. Lateral branches, from axillary meristems, do not begin growth for at least another year. If the bell was tied to a sapling, it would stay at the level it was tied as the apical meristem continued to produce new growth above it.

4) **b.** If the outer cell remains cambium, the inner cell will differentiate into xylem, but the outer cambium cell will divide again at a later time.

5) **b.** The root cap provides a protective covering over the root apical meristem and is the site of gravity perception in the root.

6) **a.** The diameter of growth rings is proportional to the climate conditions during growth. Better growing conditions produce wider rings. Regardless of the conditions, all xylem cells are dead when they are mature.

7) **c.** Vascular cambium produces secondary xylem (wood) and phloem as well as additional vascular cambium. It does not produce cork cambium.

8) **e.** Branch roots are initiated internally in the pericycle of the primary root.

9) **c.** Cell elongation in plants is due primarily to increasing the size of the vacuole by water intake, which stretches the loosened primary cell walls. Relatively little additional cytoplasm is needed because it is a thin layer pressed by the central vacuole against the cell wall.

10) **c.** Primary phloem (phloem produced during primary growth) is always derived from procambium along with primary xylem. Vascular cambium produces secondary xylem and phloem.

Transport in Plants

Plants include both the tallest and most massive of all living things. It is therefore critical to be able to transport water, minerals, photosynthate, and other molecules from one part of the plant to another in order to keep all the cells alive.

■ XYLEM TRANSPORT

One of the major problems associated with the transition of plants to the land habitat was obtaining and transporting water (see Chapter 29). In vascular plants, **xylem** is specialized for the transport of water and the specialized organs (roots, stems, and leaves) each have a vital role. The transport system is extremely effective. It is able to provide water to living cells more than 360 feet above the soil surface in redwood trees and, in theory, could transport water much higher.

To understand how water is transported, it is first necessary to review some critical concepts covered in earlier chapters. First is the cohesive property of water. Because of hydrogen bonding (see Chapter 2) water molecules tend to bind to each other. Each hydrogen bond is weak, but the large numbers of hydrogen bonds between liquid water molecules are additively a strong force. Secondly, cellulose primary cell walls are permeable to water flow (see Chapter 5). Water moves in and through cellulose cell walls with almost no resistance. Third, water diffuses from a region of high free energy toward a region of lower free energy (see Chapter 6). In general, the fewer the molecules dissolved in water, the higher its free energy.

Root

Recall from Chapter 34 that root hairs from the epidermis grow through the spaces between soil particles.

If the soil is well watered, individual soil particles are coated with water, and many or all of the spaces between particles are filled with water solution. Thus the root hairs are in direct contact with soil water. If the free energy of water is higher in the soil water, water will diffuse into the cell walls. At this point, there are two alternative pathways.

Some of the water can simply diffuse through cell walls from one cell to the next, from the epidermis through the cortex until the endodermis is reached. The water never enters the cytoplasm of a cell, it travels through the **apoplast** (without cytoplasm). At that point, the Casparion strip (or thickening in monocots) blocks further flow through the wall, so water must pass by osmosis into the endodermal cell. The alternative pathway is to enter the cytoplasm of the root hair cell by osmosis, and then move through the cytoplasm of adjacent cells, the **symplast,** until the endodermis is reached. Recall from Chapter 31

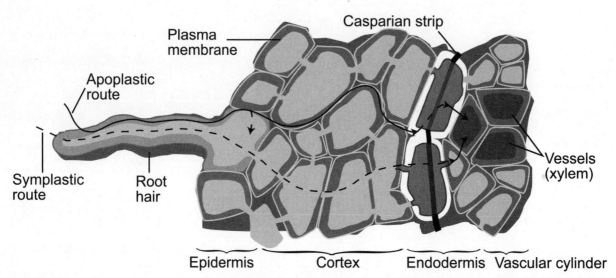

Figure 36-1. Pathway of water in the root. Water enters the root through the root hairs and moves either through adjacent cell walls, or into the cytoplasm of the root hair and through the contiguous cytoplasm, until it reaches the endodermis. The Casparian strip in endodermis cell walls ensures than any movement into the vascular tissues moves through and is regulated by the cytoplasm of endodermis cells. From the endodermis, water passes into the xylem.

that mycorrhizal fungi also are significant in absorbing water and minerals for the host plant. These also pass by way of the symplast into the endodermis.

In either case, a concentration gradient is established from the soil solution to the endodermis. For example, assume that the cytoplasm of all the cells from the epidermis, through the cortex to the endodermis are at equilibrium and at lower free energy than the soil water. Water will flow from the soil into the first cell. This automatically raises the free energy of water in the first cell relative to the second cell, so water will now flow from the first to the second. As water moves from the first cell to the second, more water is drawn into the first cell from the soil. This process is repeated from cell to cell until the endodermis is reached.

At the endodermis, the plant can control movement of water into the vascular tissues. The endodermal cells essentially function like a valve to allow more or less water to pass. Once water moves through the endodermis by osmosis, it flows into the xylem to be transported up the plant.

Leaf

The same processes responsible for water movement into the root also occur in the leaf, but in the opposite direction. The leaf is essentially a sack with a waterproof covering, called the cuticle (see Chapter 34).

Much of the internal volume of the leaf is air space surrounding water-filled mesophyll cells. Because of this construction, the air in the intercellular spaces is saturated and at equilibrium with the water in the cell cytoplasm.

The air outside the leaf is usually much drier than the air inside the leaf. As a result, when the stomata in the leaf epidermis open, water vapor diffuses from inside the leaf to outside the leaf, from higher to lower free energy. Solar heating and wind increase the rate of water movement out of the leaf—a process called **transpiration.** As water diffuses out of the leaf, a concentration gradient is established between the intercellular space and the first adjacent cell. Water now moves out of the cell into the air

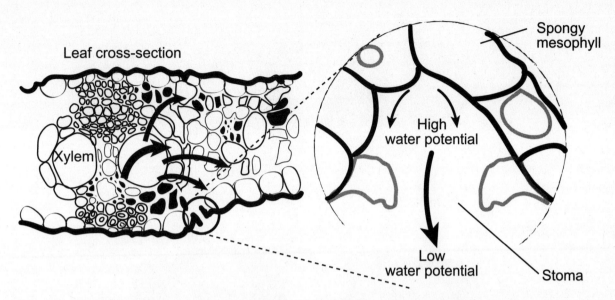

Figure 36-2. Pathway of water in the leaf. Water vapor diffuses out of the leaf through stomata. This sets up a concentration gradient from the xylem in the vascular bundles, through the mesophyll cells, and into the intercellular spaces within the leaf.

space to replace some of the water vapor that was lost. The first cell now contains less water than the adjacent second cell, so water moves from the second to the first, only to be lost again to the intercellular space. This concentration gradient moves all the way, cell to cell, and back to the xylem in the vascular bundle.

Stomata

The stomatal apparatus consists of paired guard cells with or without subsidiary cells in the epidermis. The guard cells are typically the only epidermal cells that contain chloroplasts and undergo photosynthesis. Their inner walls, adjacent to the stomatal pore, are more heavily thickened than the other walls and frequently have ridge-like ornamentation toward the opening.

The thickened walls act like leaf springs whose normal position is straight, closing the stomatal pore. The adjacent ridges function like weather stripping on a door to tightly seal the pore when closed, minimizing water loss.

When the adjacent guard cells become turgid, their thinner walls swell, causing the thicker inner walls to bow apart creating an opening. The more turgid the cells, the wider the opening. As the cells lose water, turgor pressure is reduced, and the thicker walls spring back to their original shape, closing the stomatal pore.

A variety of factors decrease the free energy of water within guard cells that causes water to move into the cells. Photosynthesis produces sugars that dissolve in the cytoplasm to lower free energy. The membranes may become more permeable to ions, which will also decrease free energy of water in the cytoplasm.

Stem

Xylem in the stem forms continuous columns of thick-walled cells of relatively small diameter. Vessel elements, joined end to end, create continuous tubes with thick walls and narrow diameter. By themselves they function like a capillary tube. Water molecules bind to themselves by hydrogen bonding, a process called **cohesion.** They also form hydrogen bonds with the wall (a process called **adhesion**),

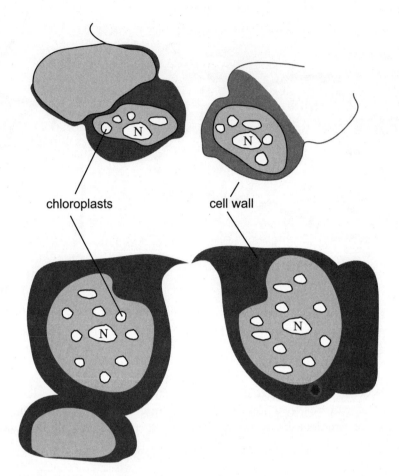

chloroplasts cell wall

Figure 36-3. Guard cells. Paired guard cells with irregularly thickened walls and ridge-like outgrowths. The top pair create an open stoma; the lower pair are closed.

which causes a film of water to creep up the wall, forming a meniscus across the diameter of the tube. If a force (such as suction) is applied to the column of water, it will flow up the tube as long as the column of water is continuous. This is what occurs when you suck on a straw.

If there is a break in the column that might be caused, for example, by injury (or a pinhole in the straw) air can enter, cohesion is broken, and the flow of water will cease. The lateral pits on xylem cell walls provide an alternative route for water flow, should any particular column be damaged. The side-by-side columns of xylem provides redundancy to minimize the possibility of breaking the continuous column of water.

The narrow diameter of the xylem tubes is also critical for water flow in the plant. Imagine a three-foot-long straw and a three-foot-long garden hose. Which one would be easier to drink from? The weight of the fluid in the straw would be about 0.33 pounds, while the weight of the fluid in the hose would be about 1.5 pounds. The narrower the tube, the less force will be required to draw fluid to the top. Plants can easily draw water more than 300 feet up in the xylem of redwoods and, in theory, could draw it three times as high. Buildings require sets of pumps about every 100 feet to raise water to the upper floors.

In the plant, loss of water through the leaves provides the driving force to draw a continuous column of water up the xylem from the roots, in a process called **cohesion-tension.**

Xylem transport depends on the cohesive force of a continuous column of water in narrow tubes and on a tension produced by transpiration of water through the leaves. Most of the water absorbed through

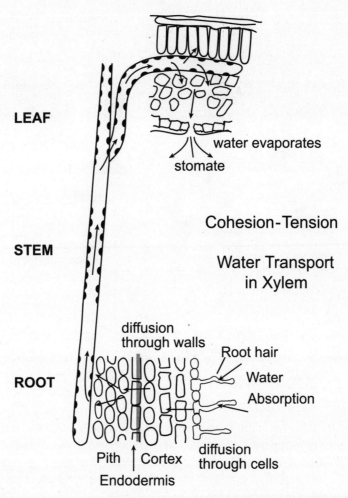

LEAF

water evaporates

stomate

Cohesion-Tension

STEM

Water Transport
in Xylem

diffusion
through walls

Root hair

Water

ROOT

Absorption

Pith | Cortex
Endodermis

diffusion
through cells

Figure 36-4. Cohesion-tension theory. Transpiration of water from the leaf creates a negative pressure (tension) on water in the xylem. The cohesive force of a continuous column of water in the narrow tubes of xylem allows water to be drawn up from the roots.

the roots simply passes through the plant and out the leaves by transpiration. This water loss is necessary because the water carries dissolved minerals and other molecules up from the roots to be distributed throughout the plant. It is a one-way transport from the roots to the leaves.

■ PHLOEM TRANSPORT

Unlike xylem, phloem transport occurs through living cells (the sieve tube members) and moves either up or down in the plant. The primary function of phloem is to carry the sugars produced by photosynthesis either directly from where they are produced in the photosynthetic tissues or from where they were stored in storage tissues.

Source

During the growing season, leaf mesophyll cells undergo photosynthesis and produce sugars. They are the source for sugar transport through the phloem. Sugars are actively transported across cell membranes of adjacent mesophyll cells and into the vascular bundles.

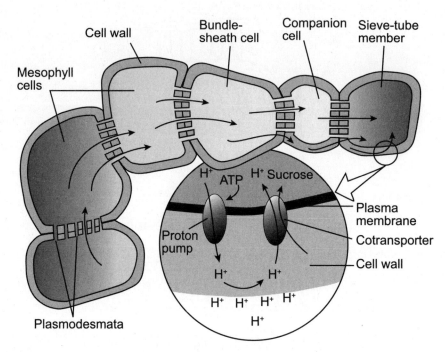

Figure 36-5. Phloem loading. Sugars, produced by photosynthesis in the leaf mesophyll, are actively transported into the phloem where companion cells load the sieve tubes.

Transport of sugar across the cell membrane involves proton pumps and special co-transport proteins (recall Chapter 4). The proton pump uses ATP to actively transport H$^+$ out of the companion cell, establishing a concentration gradient. Sugar molecules associate with H$^+$ and are cotransported into the companion cell along the H$^+$ concentration gradient through specialized transport proteins. Recall that the cytoplasm of companion cells and their associated sieve tube cells are connected. Therefore, sugar is now loaded into the phloem ready for transport.

As sugar is loaded into the phloem, the free energy of water is reduced in the phloem cells. As a result, water from the adjacent xylem cells moves into the phloem by osmosis. This builds a small pressure within the phloem that will help to carry dissolved substances, including the loaded sugars, away from the source.

Sink

Anywhere in the plant where active growth is occurring serves as a sink for the sugars loaded at the source. For example, early in the growing season, it may be apical meristems and, later in the year, it may be growing fruits. In the sink, sugar is actively unloaded from the sieve tubes by the companion cells and transported, cell to cell, to the metabolically active areas. As sugar is removed from the phloem, the free energy of water increases and water also begins to leave by osmosis. This creates a slight negative pressure at the sink. The released water can be recycled via the transpiration stream of the xylem.

Pressure Flow

Within the phloem, there is a pressure gradient from source to sink. The pressure gradient is responsible for the movement of sugars and other metabolites through the phloem. Depending on the location of the sink, relative to the source, transport may be up the stem or down to the roots. The direction of

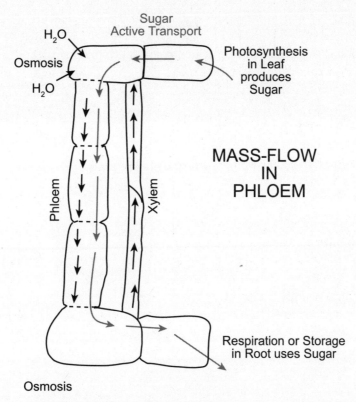

Sugar
Active Transport

H₂O

Osmosis

H₂O

Photosynthesis
in Leaf
produces
Sugar

Phloem

Xylem

MASS-FLOW
IN
PHLOEM

Respiration or Storage
in Root uses Sugar

Osmosis

Figure 36-6. Mass flow in phloem. Loading sugar into the leaves causes water to follow by osmosis, creating a positive pressure in the phloem. Unloading of sugar at the sink causes water to diffuse out of the phloem, creating a negative pressure. The pressure gradient from source to sink, along with active transport between sieve tube cells, directs the flow of sugar and dissolved metabolites.

transport may change, even during a single day, depending on the location of highest metabolic activity in the plant.

Phloem cells are not empty, and their end walls, the sieve plates, contain membranes and proteins (recall Chapter 5). In sectioned material, the sieve plates seem to be plugged with proteinaceous material, the "slime plugs." Yet transport through the phloem is even more rapid than one would expect if it were simply a series of open tubes as in the xylem. The proteins at the sieve plates are apparently involved in actively transporting metabolites through the phloem.

Test Yourself

1) Cells whose function is to regulate flow of water vapor out of the plant are
 a) guard cells.
 b) root hairs.
 c) endodermal cells.
 d) xylem.

2) Roots increase their functional absorptive surface by the presence of
 a) guard cells.
 b) stomata.
 c) cuticle.
 d) root cap.
 e) mycorrhizae.

3) In plants, gas exchange usually occurs in
 a) the stems.
 b) the roots.
 c) the flowers.
 d) the leaves.
 e) all of the above.

4) Which of the following will be most likely to occur when the guard cells of an oak leaf open more widely?
 a) Water molecules enter the guard cells.
 b) The atmosphere outside the stoma becomes less humid.
 c) Salt molecules are excreted by the adjacent guard cells.
 d) Loss of water vapor decrease.
 e) Turgor pressure in the guard cells decrease.

5) The cells chiefly responsible for moving sugars into phloem within leaves are
 a) guard cells.
 b) epidermis cells.
 c) cortex cells.
 d) endodermis cells.
 e) companion cells.

6) When endodermis cells move minerals into the vascular tissue, what happens to the water concentration in the vascular tissue, relative to that in the cortex?
 a) It says the same.
 b) It increases.
 c) It decreases.

7) The Casparian thickening
 a) directs water movement.
 b) builds up root pressure.
 c) transports ions across membranes.
 d) absorbs water.
 e) is composed of cutin.

8) Which aspect of the movement of water through the xylem is most dependent on hydrogen bonding of water molecules?
 a) absorption of water by the root hair
 b) apoplastic movement of water through the cortex
 c) cohesiveness of water moving through the xylem
 d) evaporation of water from mesophyll into intercellular spaces
 e) transpiration of water vapor through stomata

9) Which of the following aspects of transport in plants requires expenditure of chemical energy?
 a) symplast transport in the root
 b) apoplast transport in the root
 c) leaf transpiration
 d) sugar loading in the leaf
 e) all of the above

10) As sugar moves out of the phloem in a growing potato cell, water moves with it. When sugar is unloaded into the storage parenchyma cell of a potato, what is the fate of the water?
 a) It is stored in the vacuole of the potato cell.
 b) It is transported out of the potato by the xylem.
 c) It is returned to the source in the phloem.
 d) It is returned to the sink in the phloem.
 e) It is stored in the cytoplasm of the potato cell.

Test Yourself Answers

1) **a.** Guard cells, primarily in leaves, regulate the flow of water vapor out of the plant. Root hairs and endodermis are involved with absorbing water from the soil. Xylem transports water throughout the plant.

2) **e.** In addition to root hairs, mycorrhizal fungi increase the surface area for absorption of water and nutrients.

3) **d.** Gas exchange in plants occurs primarily through stomata in leaves.

4) **a.** For guard cells to open, they must become more turgid as additional water moves into the cells. As a result, additional water vapor will be lost from the leaf. This is less likely to occur if the air is drying.

5) **e.** Companion cells load sugars, produced by the leaf mesophyll, into their associated sieve tube cells in the phloem. Guard cells, epidermis, and endodermis are involved with water movement through xylem, not sugar movement through phloem.

6) **c.** If minerals are actively transported into a cell, that lowers the free energy of water in the cell, decreasing the relative concentration of water.

7) **a.** The Casparian strip, a ring of suberized material around the endodermal cells of dicots, prevents water movement through the walls into the vascular tissue and instead directs water through the cytoplasm of the endodermal cells.

8) **c.** Cohesion of water molecules is due to hydrogen bonding.

9) **d.** Sugar loading by companion cells requires active transport powered by ATP. Xylem transport depends only on the physical properties of a free energy gradient.

10) **b.** When sugar is unloaded from the phloem, the free energy of water in the phloem increases. As a result, water will diffuse into the adjacent xylem cells to be transported back up the plant toward the leaves.

Plant Nutrition

It seems obvious that as plants grow and increase in size, they must be obtaining nutrients from the soil in which they are rooted. However, this idea was tested more than 300 years ago and had to be rejected. A willow tree was weighed and planted in a known amount of soil. Five years later, the tree had gained more than 164 pounds while the soil lost 2 ounces. Clearly, most of the plant tissue was not composed of elements gained from the soil. What, then, is its source?

■ ESSENTIAL NUTRIENTS

Like animals, plants have certain nutrient requirements. Essential nutrients are elements that are necessary for normal growth and reproduction. If one or more are lacking, the plant will not be able to complete its life cycle. Some nutrients, **macronutrients,** are required in large amounts, while only small amounts of **micronutrients** are required. Some must be supplied on a regular basis or the plant will stop growing; others may be necessary only at certain stages of development or can be recycled from older parts to younger, growing tissues.

■ MACRONUTRIENTS

Macronutrients make up the bulk of the plants mass and include the elements most likely to be deficient for plant growth.

Cell Constituents

You will be able to predict six of the nine macronutrients simply by recalling the structure of the basic biological molecules (see Chapter 3). All biological molecules contain carbon, hydrogen, and oxygen, while phospholipids and nucleotides also contain phosphorous. All amino acids contain nitrogen, as do all nucleotides, and some amino acids also contain sulfur.

Carbon is the backbone of all organic molecules. In Chapter 6, you learned that the source of carbon used by plants to synthesize organic molecules is CO_2 in the atmosphere. Oxygen is incorporated into organic molecules at the same time. As long as CO_2 is available, carbon and oxygen will be in adequate supply. These nutrients enter the plant from the atmosphere through stomata. Of course, that does not mean they are in optimal supply. For example, commercial greenhouses sometimes supplement CO_2 to promote more rapid plant growth. Together, carbon and oxygen account for about 90 percent of the dry weight of a plant.

Hydrogen is the third atom required in all biological molecules. Recall from Chapter 2 that water naturally dissociates into H^+ and OH^- that are available for other reactions. As long as water is available, there will not be a shortage of hydrogen. For most plants, the ultimate source of hydrogen is water vapor in the atmosphere that falls as rain, but it is absorbed from the soil by the roots. Hydrogen accounts for about 6 percent of the dry weight of the plant.

Recall from Chapter 18 that carbon, oxygen, and water were three of the major biogeochemical cycles characteristic of ecosystems. The other major cycle involved nitrogen, which is the fourth most abundantly required nutrient for plant growth. Nitrogen is also ultimately obtained from the atmosphere, but is fixed by bacteria into nitrates that are absorbed by plant roots. Although there is not a deficiency of nitrogen in the atmosphere, the amount of fixed nitrate is limited by bacterial action and it is frequently a limiting factor for plant growth. Some intensively cultivated commercial crops, notably corn, require larger amounts of nitrogen than can naturally be provided on a sustainable basis; nitrogen fertilization is necessary. Nitrogen accounts for about 1.5 percent of the dry weight of plants.

You now have most of the answer to the question in the lead paragraph of this chapter: 97.5 percent of the mass of a plant ultimately comes from the atmosphere. Soil provides the remainder. Phosphorus is the next most important element that is a constituent of many biomolecules, accounting for about 0.2 percent of the dry mass of plants. Its ultimate source is the rock minerals that break down through weathering. Many soils become deficient in phosphorous, so it is a major component of fertilizers.

Sulfur, a component of proteins, makes up about 0.1 percent of the mass of the plant and also comes from the soil. Two other macronutrients are also constituents of certain plant cells, although they also have other metabolic functions. Calcium is a component of the middle lamella of plant cell walls (see Chapter 5) and magnesium is in the center of the cholorophyll molecule (see Chapter 6). They are responsible for 0.5 percent and 0.2 percent of the dry weight of cells, respectively.

Non-Constituent

Only one of the macronutrients, potassium, is not a component of any biological molecule, yet it accounts for 1 percent of the dry weight of cells. A primary role of potassium is to regulate osmotic function of cells, it also is a cofactor for many enzymes and is required for synthesis of many organic molecules. Potassium is frequently deficient in soils, so it is a major component of fertilizers.

■ MICRONUTRIENTS

Micronutrients are required in small amounts but are essential for plant growth. A common function of all the micronutrients is to be a cofactor for specific enzymatic reactions. For example, chlorine and manganese are both required to split water during non-cyclic photophosphorylation of photosynthesis (see Chapter 8). Iron has a coenzyme function in the synthesis of chlorophyll, but it is also a constituent of the cytochrome molecules found in electron transport chains (see Chapter 6). With the exception of iron, soils are rarely deficient in any of the micronutrients.

■ NUTRIENT UPTAKE

Mineral nutrients in the soil are available as charged ions. Negatively charged anions tend to be dissolved in the soil water and hydrogen bond to water molecules. Positively charged cations tend to bind to negatively charged clay particles or organic materials. Of the major macronutrients, nitrogen and phosphorous occur as anions, while potassium is a cation. The first two are readily available for uptake by the plant, but they are also more easily washed from the soil by leaching or runoff.

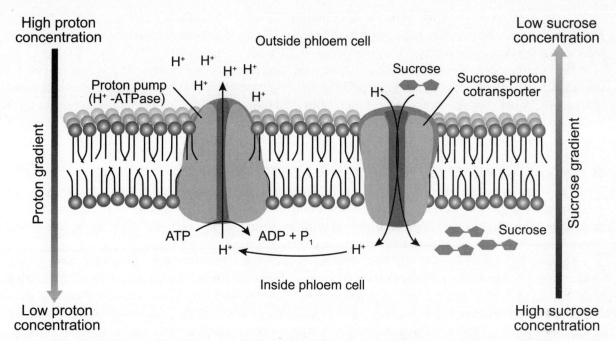

Figure 37-1. Proton pump. The proton pump is a membrane bound carrier protein that actively transports H⁺ across the membrane against a concentration gradient. The proton pump uses ATP to pump H⁺ out of the cell into the surrounding soil solution. This establishes a net positive charge on the outside of the cell and a net negative charge inside. The charge differential drives positively charge K⁺ into the cell through special channel proteins in the cell membrane, which tends to balance the charges. At the same time, anions associate with excess H⁺ to be co-transported by special carrier molecules into the cell.

Uptake of nutrients, like uptake of water, occurs through the root hairs of epidermal cells or through mycorrhizae. In either case, ions are accumulated by the cells against a concentration gradient. To do so requires energy and the action of proton pumps.

■ NUTRIENT DEFICIENCIES

The surest way to test whether plants have nutrient deficiencies is to have the soil analyzed by your state extension service. Your county extension agent can provide instructions for sampling soil and sending it for analysis. Many plants signal their deficiencies by exhibiting characteristic symptoms that relate to the function of the nutrient.

One difficulty is that several different deficiencies can produce similar symptoms. Chlorosis is a general yellowing of leaves. You must determine whether there is a specific pattern to the color change. For example, deficiencies in both iron and manganese cause chlorosis between the veins of leaves. However, with manganese, only older leaves show the symptoms, while with iron, the symptoms are seen in younger leaves. Iron is not mobile in the plant. Once it is transported into a mesophyll cell, it will remain in that cell even as the leaf ages and dies. If no additional iron is available, it is the younger, still-growing leaves that will be lacking and show the symptoms. Manganese, on the other hand, *is* mobile in the phloem. If inadequate manganese is available for new growth, it will be transported out of existing leaves and moved to the new growth. New leaves will appear healthy, while older ones become chlorotic.

General chlorosis over the entire leaf, including the veins, usually signals nitrogen deficiency, although it may indicate sulfur. Nitrogen is mobile in the plant, so the symptoms are most severe in older leaves. Sulfur is not as mobile and is most evident near the shoot tips.

Phosphorous deficiency shows some of the most characteristic symptoms. The leaves frequently become dark green on top and reddish beneath. Another characteristic symptom is the dieback of shoot tips caused by calcium deficiency. Apical meristems cannot function if calcium is not available to form the middle lamella of new cell walls.

■ ORGANIC VERSUS INORGANIC FERTILIZERS

The solution to nutrient deficiency is to add fertilizer. The problem becomes how much and what kind of fertilizer? There are basically two types of fertilizer; organic or inorganic. Both can provide the necessary nutrients, and there is no difference in the form of the nutrients taken up by the plant. Nevertheless, there are some major advantages and disadvantaged of each.

Organic fertilizers, such as compost or manure, are slow-release, which means that nutrients are made available over a long period of time. (Of course, if you are trying to grow high-nitrogen-requiring corn in a garden with severe nitrogen deficiency, slow release will not be an advantage.) Perhaps the most important benefit of organic fertilizers is that they build the structure of the soil. A good soil is porous so that gas is available to the roots (recall that all eukaryotic cells, including roots, undergo aerobic respiration and require oxygen). A porous soil also has good water-holding capacity (although soil can be too porous, as is the case with sand).

The major advantage of inorganic fertilizers is that you can apply exactly what is deficient. Commercial inorganic fertilizers always have a numerical designation such as 20-5-10. These numbers indicate, in order, the percent of nitrogen, phosphorous, and potassium. In this case, the fertilizer provides 20% N, 5% P, and 10% K. If you have your soil analyzed, you will be told exactly how much of each is required to remediate your deficiency, and you can add just what is needed. Inorganic fertilizers are also cheaper and easier to apply on a large scale than organic forms. The fertilizer can be sold in concentrated form and diluted as needed. Liquid forms can be sprayed on a field and pellets can be broadcast. Inorganic fertilizers are fast release, so the nutrients are available immediately. A disadvantage is that excessive nutrients might be released that raise the osmotic potential of the soil so that the plant dehydrates. (This is called fertilizer burn.) Because inorganic fertilizers do not build up the structure of the soil, they can easily be washed out of the soil, resulting in runoff pollution.

Test Yourself

1) The bulk of a plant's dry weight is derived from
 a) soil minerals.
 b) CO_2.
 c) the H from H_2O.
 d) the O from H_2O.
 e) uptake of organic nutrient from the soil.

2) In the nutrition of a plant, which of these elements is classified as a macronutrient?
 a) zinc
 b) chlorine
 c) calcium
 d) iron
 e) manganese

3) A mineral deficiency is likely to affect older leaves more than young leaves if
 a) the mineral is very mobile in the plant.
 b) the mineral is very immobile in the plant.
 c) the mineral is required for synthesis of chlorophyll.
 d) the soil has a long history of deficiency for that particular mineral.

4) Roots may help increase the availability of cationic minerals by secreting
 a) water.
 b) K^+.
 c) Na^+.
 d) Cl^-.
 e) H^+.

5) Which soil mineral is most likely to be leached away due to a hard rain?
 a) Na^+
 b) K^+
 c) Ca^{2+}
 d) NO_3^-
 e) H^+

6) The N-P-K numbers on a package of fertilizer refer to the

 a) total protein content of the three major ingredients of the fertilizer.

 b) percentages of manure collected from different types of animals.

 c) relative percentages of organic and inorganic nutrients in the fertilizer.

 d) concentrations of three important mineral nutrients.

 e) proportions of three different nitrogen sources.

7) Which of the following is a disadvantage of inorganic fertilizers compared to organic forms? Inorganic fertilizers are

 a) slow-release.

 b) more expensive.

 c) difficult to apply.

 d) more susceptible to runoff.

 e) all of the above.

Test Yourself Answers

1) **b.** Approximately 90 percent of the plant's dry weight is from the carbon and oxygen atoms fixed during photosynthesis.

2) **c.** Calcium, necessary for the production of middle lamella, is a macronutrient.

3) **a.** Mineral nutrients that are mobile in the plant tend to move out of older parts to supply the needs of younger growing tissue if that mineral is in short supply.

4) **e.** Root cells have proton pumps that actively secrete H^+ into the soil solution to establish an electrochemical gradient that allows uptake of ionic minerals.

5) **d.** Negative anions tend to dissolve in the soil water, making them easier for the root to absorb, but also easier to be washed away.

6) **d.** The three numbers on fertilizers refer to the available concentrations of nitrogen (N), phosphorous (P), and potassium (K), in that order, available in that product.

7) **d.** Inorganic fertilizers are more susceptible to runoff in part because they are quick-release. They are less expensive and easier to apply than organic forms over large areas.

Plant Responses

Since the time of the Greeks, it has been documented that plants grow in response to light, but it was not until Charles Darwin and his son began investigating plant movements that experiments were done to try to explain how plants sense their environments and respond to them. The classic responses are **tropisms,** movements in response to some stimulus.

■ PHOTOTROPISM

The most famous experiments in Darwin's book *The Power of Movement in Plants* (1880) relate to the bending of grass seedlings toward light, **phototropism.** The first shoot structure to appear above ground in grasses is a tubular sheath, called a **coleoptile,** which surrounds the growing leaf primordia. This simple structure bends toward light like older shoots, responds rapidly, and is easy to work with. The Darwin's question was to determine what part of the coleoptile senses light. Their first experiment was simply to cut off the coleoptile tips.

The decapitated plants did not respond to light. Although this seemed to confirm that light sensitivity occurs at the tips, Darwin realized that there was an alternative explanation. Perhaps the plant did not bend toward light because of a wound response as a result of cutting off the tip. To test this alternative, they designed a second experiment in which the tips were covered with tinfoil caps. Again the capped plants did not respond. Again it seemed that the coleoptile tip had the light receptor. But again Darwin realized there was an alternative explanation. Perhaps the caps physically restricted the bending response. To test this explanation, he drew out fine glass tubing that would just fit over the coleoptile tips. Some plants were covered with clear tubing; others had the glass tubing blackened to block light. Both treatments provided physical constriction. Plants covered with the blackened tubes did not respond but those covered by clear glass bent toward the light.

Additional experiments involved covering middle and lower portions of the coleoptiles. Plants would bend toward the light under all conditions except when light was blocked from the tips. Darwin concluded that the tip somehow perceived light. But he further predicted that as a response to light perception, the tip produced a substance that moved farther down the coleoptile to cause bending in the lower region (physical bending always occurred just below the tip).

It took thirty-eight years for Darwin's hypothesis to be tested. In a preliminary experiment, Paal (1918) surgically removed the tips from coleoptiles, and then set the tips back in place. As long as the tips were replaced, they coleoptiles would respond by bending toward unilateral light. The critical experiments were next done in complete darkness. Paal removed the coleoptile tips but then replaced them,

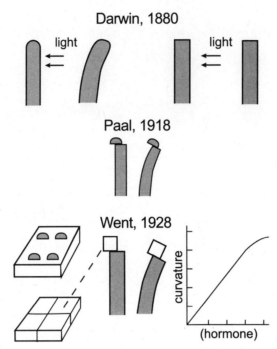

Figure 38-1. Experiments on phototropism. The first of several experiments by Darwin demonstrated that if the tip of a coleoptile is removed, the coleoptile will not respond to unilateral light. Paal demonstrated that if the tip is excised, and then set back to one side in the dark, the coleoptile will bend toward the side away from the tip. Went demonstrated that a diffusible chemical from the coleoptile tip, infused into small blocks of agar, will substitute for a tip and cause bending in the dark. Degree of bending is proportional to the concentration of chemical.

slightly askew, on top of the coleoptile. In complete darkness, the coleoptiles bent away from the side in contact with the excised tips. If some growth-promoting substance was being transported out of the tips, that substance could only move down the side in contact with the tip so only those cells should respond by growing.

Paal's experiments seemed to confirm Darwin's hypothesis of a mobile growth-promoting substance, but again there are alternative interpretations. For example, the cut cells would tend to dehydrate on the exposed side, and presumably shrink, while those covered by the replaced tip would lose less water and stay larger. Or perhaps the physical contact or addition weight of the tip on one side of the coleoptile axis triggered a growth response resulting in bending.

The presence of a mobile chemical growth promoter was finally confirmed in some elegant experiments by Fritz Went in 1928. Went excised the tips from growing coleoptiles and placed them on small sheets of agar, the jelly-like material extracted from red algae (recall Chapter 29). After a time, agar blocks cut from beneath the tips, or control blocks of plain agar, were replaced onto decapitated coleoptiles. Coleoptiles with the control blocks did not respond, but coleoptiles under treated blocks behaved as if the coleoptile tip were still in place. A chemical produced by the tips must have diffused into the agar, and then diffused back out of the agar to affect growth in the lower coleoptile.

Went took his experiment one critical step farther. What if two or three tips were placed onto a single agar block? One would expect that two or three times as much of the substance would diffuse into the agar. Now, what if these blocks were placed askew on a decapitated coleoptile? One would expect that the amount of bending would be greater than if a single block was used. Went invented the bioassay—

using living material to measure the quantity of some unknown. In this case the unknown was "growth stuff," later to be named **auxin** and identified as the chemical indoleacetic acid (IAA). Went demonstrated that Darwin was correct. The coleoptile tips produced a chemical (auxin) that diffused out of the tips and affected growth in other cells lower down. Such chemical messengers are known as hormones. Not only did Went demonstrate the occurrence of a plant hormone, but he also developed a method (the bioassay) of measuring the quantity of hormone produced.

■ GRAVITROPISM

Like phototropism, the response of plants to gravity, **gravitropism,** has been known since ancient times. Roots and shoots have very different responses to gravity that is obvious from the way plants grow. The shoot bends away from the pull of gravity—it is **negatively gravitropic.** Soon after auxin was implicated in phototropic stem bending, a similar interpretation was applied to negative gravitropism in shoots. If a shoot is laid on its side, the pull of gravity would cause more auxin to diffuse on the lower side of the stem than the upper side. Cells on the lower side would be stimulated to grow more, and the shoot would bend upward. Only when it was growing upright would the auxin concentrations on opposite sides of the stem respond equally to gravity.

Roots respond in the opposite way: They are **positively gravitropic** and bend down toward the pull of gravity. A part of the explanation for this pattern is that roots are more sensitive to auxin. The same concentration that might stimulate stem growth actually inhibits root growth. As a result, a higher concentration of auxin on the lower side of a root tip would inhibit growth, while cells exposed to lower concentrations on the upper surface would grow more, causing the root tip to bend downward.

■ THIGMOTROPISM

A third common tropism is bending in response to touch, called **thigmotropism.** Growth of cells in contact with an obstacle is inhibited while cells on the opposite side of the axis continue to grow. As a result, the stem or tendril begins to twist around the obstacle. This mechanism is important in most climbing plants and like other tropisms involves auxin.

■ AUXIN

As Darwin predicted, auxin is produced at the tip of the growing shoot, but not just the tip of the coleoptile of grasses. It is produced by the youngest leaf primordia of the shoot apical meristem of all plants. From the shoot tip, it diffuses out to the rest of the plant, but in a special way called facilitated diffusion

To begin with, auxin diffusion occurs primarily through the xylem parenchyma, not all cells of the plant. The membranes on the lower side of each xylem parenchyma cell has special transport proteins that permit auxin to diffuse out of that membrane, but not back in. As a result, transport of auxin is polar, from the shoot tip toward the root.

The role of cell membranes in auxin transport is important for many of its responses. In unilateral light, auxin diffuses preferentially toward the shaded side, and then moves by polar transport down the stem. Higher concentrations of auxin promote cell elongation, and the differential elongation from one side of the organ to the other results in bending. In a similar manner, mechanical stimulation stimulates movement of auxin away from the source of stimulus in thigmotropism, and gravity moves auxin preferentially toward the lower side.

In addition to promoting cell elongation, auxin is also necessary to initiate branch root formation, particularly of adventitious roots in stem cuttings (see Chapter 34). The active ingredient in commercial

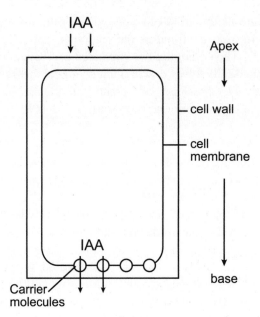

Figure 38-2. Facilitated diffusion. Xylem parenchyma cells have special transmembrane proteins on their lower surface that permit only outward flow of IAA across this memmbrane. This ensures a polarity from the hormone source at the apex toward the base of the plant.

rooting powers is a synthetic auxin called indolebutyric acid (IBA). The role of polar transport in rooting cuttings can be easily demonstrated with dormant woody stems. Willow cuttings root easily. Like many herbaceous plants, you can simply cut off a six- to eight-inch segment of stem and stick it in a glass of water. If your cutting is right-side-up, roots will form at the lowest one or two nodes. If you put it in the glass upside down, no roots form. For roots to be initiated, auxin must accumulate on the bottom side of cells.

In much the same way that root cells are more sensitive to auxins than stem cells, dicots are more sensitive than monocots. As a result, synthetic auxins are frequently used as weed killers in lawns and for cereal crops (grasses are monocots, but most weeds are dicots). The chemical 2,4-dichlorophenoxyacetic acid (2,4-D) is a selective herbicide (the "weed" of "weed and feed" fertilizers) that, at the recommended dosage, kills dicot weeds without harming grasses. A more-powerful, related chemical, 2,4,5-trichlorophenoxyacetic acid (2,4,5-T), is a broad-spectrum herbicide that kills all plants.

Axillary buds are also sensitive to auxin concentrations; high concentrations inhibit growth and the buds remain dormant. As the plant ages and the shoot grows, the earliest formed buds become farther and farther removed from the source of auxin, and concentration levels decrease. When the auxin source at the apical meristem is far enough away, growth inhibition is released, and the axillary branch begins to grow. The inhibitory effect of auxin on axillary buds is called **apical dominance.**

■ CYTOKININS

Apical dominance is actually a more complex phenomenon than was originally believed. Like most plant responses, it is actually due to a balance between two hormones—in this case, auxin and cytokinin.

As the name suggests, cytokinins are involved with cell division. They were discovered in the 1950s after years of efforts to grow single cells or small plant tissues into complete plants. Earlier botanists discovered that if coconut milk (liquid endosperm of coconut seeds) was added to the medium, cells would

divide mitotically to form larger masses of tissue. The active ingredient, named kinetin, is derived from the nucleotide adenine and is required to stimulate cell division. As you might expect, a balance between auxin and cytokinin is necessary to control plant growth. By varying the relative concentrations of these hormones, it is possible to take single cells from many plants, grow them into masses of tissue, and ultimately cause both roots and shoots to be initiated. In 1952, the first entire plant was grown from a single cell isolated from the pith of marigold. This demonstrated the **totipotency** of cells—that all the cells of a multicellular organism are basically alike and each, in theory, has the potential to form an entire new organism.

Cytokinin also associates with auxin in controlling apical dominance. Cytokinin is produced in the root tips of vegetative plants and moves upward through the xylem. Moving from the root tip toward the shoot tip, the concentration of cytokinin decreases while simultaneously the concentration of auxin increases. The correct ratio of these two hormones is necessary for axillary buds to grow. If a drop of cytokinin is placed on an axillary bud normally inhibited by auxin from the shoot tip, the axillary bud will grow out anyway.

■ OTHER PLANT HORMONES

In addition to auxin and cytokinin, a number of other plant hormones have been identified and these, too, often have interrelated function. **Gibberellins** (GA) have many effects similar to auxins, including the promotion of cell elongation. However, gibberellins are always involved with straight growth, while auxins are usually associated with unequal, bending growth. The rapid growth of flower stalks from the center of biennial rosette plants, such as cabbage, is a common example. Auxins and gibberellins are also involved in fruit growth (see Chapter 39).

Abscissic acid (ABA) is an unusual plant hormone in that it is primarily an inhibitor, whereas the other hormones are primarily stimulators. ABA works in conjunction with gibberellin to control seed germination. Relatively high concentrations of ABA promote dormancy, while high concentrations of GA induce seed germination. Abscisic acid is also involved with the proper functioning of stomata (see Chapter 37). ABA causes changes in the cell membranes of guard cells, which rapidly lose water, thereby closing the stomata.

Ethylene is a most unusual hormone because it is a gas that diffuses through the air around the plant. One of its earliest studied functions is in promoting fruit ripening. This has major commercial importance in the fresh produce industry. Many fruits and vegetables are picked before they are ripe because unripe fruit is usually firmer and, thus, can be shipped more easily. Prior to sale, the fruits are exposed to ethylene, which speeds some of the ripening processes prior to delivery to market. Ethylene is also critical to successful seed germination. The ethylene produced by growing seedlings is trapped by the soil and causes the seedling to become etiolated. Etiolated seedlings have rapid shoot elongation with little growth of leaf primordia. The seedlings are white or yellow because no energy is spent on producing chlorophyll. Once the seedling breaks the surface of the soil, the gas dissipates and normal growth ensues. Stem elongation slows and the stems begin to thicken. Leaves expand and chlorophyll is synthesized.

Closer study has shown that ethylene production is closely associated with auxin production. This explains why the two hormones appear to have many of the same effects.

■ PHOTOPERIODISM

The role of light in phototropism has been known for thousands of years and its role in photosynthesis has been known for hundreds of years. A third major role of light in plant growth and development was not even suspected until early in the twentieth century. Around 1910, Wightman Garner and Henry

Allard, plant breeders for the U.S. Department of Agriculture at Beltsville, Maryland, produced a hybrid tobacco plant with gigantic leaves growing in their field of tobacco plants. This was exciting because the leaves of tobacco are the economically important organ of the plant, and they were hoping to use it to improve their standard varieties. Unfortunately, later in the summer when all the other tobaccos came into flower and breeding crosses could be made, the Maryland Mammoth continued to grow vegetatively and did not flower. By fall, the other tobaccos had all produced seeds, but the Maryland Mammoth had not yet flowered. In order not to lose the plant, it was transplanted and brought into the greenhouse for the winter. That winter, it flowered.

Why did the mutant flower in the winter instead of during the growing season like the other tobacco varieties? Did it need a longer growing season? Did it need cooler temperatures? Did it need a shorter day length? Among the experiments carried out the next year to try to induce earlier flowering was to artificially shorten the daylength by covering the plants with light-tight boxes every afternoon and uncovering them the next morning. These short-day-grown plants flowered, while the control plants (given normal daylength) remained vegetative. To verify the role of daylength, the vegetative plants were brought back into the greenhouse for winter. Some were grown under normal daylength, while others had the days artificially extended by turning on the lights. The short-daylength plants again flowered, but the light extended plants remained vegetative.

For the next ten years, Garner and Allard experimented with several of the other crop species being bred at Beltsville. In 1920, they published a paper that described three different flowering response types in plants. Short-day plants (SDP), like Maryland Mammoth, require less than a critical daylength in order to flower. Long-day plants (LDP) require greater than a critical daylength to flower. The absolute daylength is not important; rather, is the length of day shorter or longer than some critical period. For example, both cultivated rice and scarlet pimpernel have critical daylengths of 12 hours, but rice is a short-day plant and flowers only with days shorter than 12 hours, and the pimpernel is a long-day plant

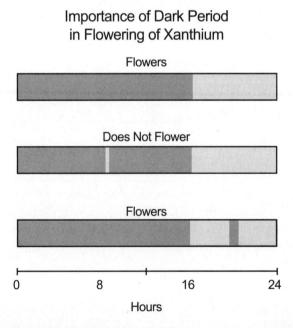

**Importance of Dark Period
in Flowering of Xanthium**

Flowers

Does Not Flower

Flowers

Figure 38-3. Day length and flowering. Xanthium (cocklebur) is a short-day plant with a critical daylenth of 8.5 hours; it actually requires nights longer than 15.5 hours. If a 16-hour night is interrupted, it will not flower, but a dark break during an 8-hour day has no effect.

needing more than 12 hours to flower. The third category, day-neutral plants, do not have a critical daylength.

After publication of Garner and Allard's paper, research on photoperiodism exploded, and breeders and commercial growers experimented to find the critical daylengths of virtually all the varieties of crop and ornamental plants. Six additional categories were discovered, and the critical daylength often depends on other conditions such as temperature, age of the plant, particular varieties, and so on. The economic impact of this discovery was tremendous. It now became possible to grow crops and have them in flower at specific times—for example, poinsettias at Christmas and Easter lilies at Easter.

■ DAYLENGTH PERCEPTION

While researchers in applied botany were busy determining the critical daylengths for a wide variety of plants, other botanists were interested in determining where and how plants perceive length of day. What pigment is involved and how does timing work?

The Role of Darkness

One approach, not so obvious, was to examine whether the dark period is really more important than the light. In nature, a "long day" is always paired with a "short night." Our bias presumed that the light period must be the triggering condition, but could it not instead be the corresponding dark period? One interesting set of experiments treated plants with their inductive short daylength but interrupted the corresponding long night with a light break. If the dark period was interrupted by light, becoming two short dark periods, the plant would not flower, regardless of how short the daylength was made. A short-day plant was really a long-night plant. This surprising result also held true for long-day plants—they are really short-night plants. Unfortunately, by this time, there was a mountain of literature using the old, incorrect, terminology, so rather than confuse the issue, they decided to keep the old names but change the definitions. Short-day plants require nights longer than a critical night length, and long-day plants require nights shorter than a critical night length.

Phytochrome

The discovery of critical night length and the effect of light break provided a necessary tool to discovering the pigment involved in perceiving light. Different colors of light could be applied during the light break. By determining the effective color, one would know the type of pigment that absorbed the light. Red light provided the effective wavelength but again there was a surprise. Far-red light, with slightly longer wavelengths, could negate the effect of the red light night interruption. In fact, alternating red and far-red light seemed to work like an on-off switch. Whichever color of light was last on would determine the effect.

The red, far-red effect helped to pinpoint the sensory pigment. Phytochrome is a pigment that has two forms. One form, phytochrome red (Pr), absorbs only red light. The other form, phytochrome far-red (Pfr), absorbs only far-red light. When Pr absorbs red light, the energy converts the pigment into the Pfr form.

Likewise, when Pfr absorbs far-red light, the energy converts it back into the Pr form. More importantly, in complete darkness, any Pfr is slowly converted into Pr. For researchers, here was at least part of the timing mechanism. During the day, both red and far-red light strikes the plant, and there is a balance of the two forms of pigment. After sunset, any Pfr begins slowly to convert back into Pr. If the night period is long enough, the conversion will be complete, and Pr will be the only form present in the plant. If the night is too short, either naturally or because of a light interruption, some Pfr will always be present. The presence of Pfr throughout the night promotes flowering in long-day plant and inhibits flowering in short-day plants.

Effect of Red or Far-red Light
on Dark Period

Treatment	Stage of Floral Development (Cockelbur - S.D.P.)
Dark Control	6.0
R	0.0
R, Fr	5.6
R, Fr, R	0.0
R, Fr, R, Fr	4.2
R, Fr, R, Fr, R	0.0
R, Fr, R, Fr, R, Fr	2.4
R, Fr, R, Fr, R, Fr, R	0.0
R, Fr, R, Fr, R, Fr, R, Fr	0.6

Figure 38-4. Red, far-red effects. Sixteen hours of darkness (dark control) causes cocklebur to flower. A night break of red light completely blocks flowering, but a night break of red followed by far-red flowers almost as well as the control. Red and far-red light breaks, respectively, turn off or turn on flowering, depending on which color is shown last.

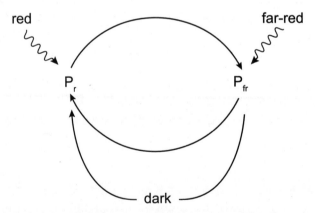

Figure 38-5. Phytochrome conversions. Phytochrome red (Pr) absorbs red light and is converted into phytochrome far-red (Pfr). Pfr absorbs far-red light and is converted back into Pr. Pfr converts into Pr slowly during the dark.

■ OTHER PHYTOCHROME MEDIATED RESPONSES

Phytochromes were first discovered because of their involvement in seed germination. Instructions for planting some seeds say to just barely cover them with one-quarter inch of soil. These seeds require exposure to light in order to germinate. Red light promotes germination, but far-red light reverses this effect.

When sunlight passes through a leaf, the ratio of red to far-red light is shifted, so that there is more far-red light in the shade. This shade effect is responsible for the different structure of sun and shade leaves. Shade leaves are broader and thinner with reduced palisade mesophll and relatively more spongy tissue.

In addition to timing the duration of the day/night cycle for flowering, photochrome also is involved with the daily resetting of the internal biological clock of plants that controls circadian rhythms and seasonal changes.

Test Yourself

1) Which of the following events in a vegetable garden is never directly affected by light?

 a) seed germination

 b) flowering

 c) food manufacture

 d) fertilization

 e) transpiration

2) You are interested in determining what part of a plant is actually sensitive to light for photoperiodism, the induction of flowering. A good first experiment would be to

 a) remove the apical meristem and replace it with auxin before beginning light treatments.

 b) shine light from one side only, and then measure the auxin diffusing down the stem on the light and the shaded sides.

 c) cover one part (for example, leaves, stems, apex) before beginning light treatments.

 d) spray auxin on just one part of the plant at a time to see which one stimulates flowering.

 e) try light treatments of different colors—first blue, then yellow, then green—to see which promotes flowering fastest.

3) At the end of the growing season, you have some green tomatoes that you want to pick and allow to ripen in the house. In order to ripen them as quickly as possible you should

 a) put them on the kitchen window sill.

 b) wrap them in foil and put them in the refrigerator.

 c) place them in a plastic bag with a ripe banana, and then seal the bag.

 d) place them in a microwave, on low power, for five minutes.

4) One way to stimulate branching in a plant is to

 a) apply auxin to the axillary buds.

 b) remove the apical meristem and young shoot tissue.

 c) give short-day light treatments.

 d) apply ethylene.

 e) add extra fertilizer.

5) Plants bend toward the light due to

 a) gibberellins causing cell elongation on the side toward the light.

 b) gibberellins causing cell elongation on the side away from the light.

 c) auxins causing cell elongation on the side toward the light.

 d) auxins causing cell elongation on the side away from the light.

 e) uneven distribution of starch granules.

6) Which of the following is synthesized in the roots and travels upward to other regions of the plant?

 a) gibberellin

 b) cytokinin

 c) auxin

 d) abscisic acid

 e) ethylene

7) The plant hormone that promotes the onset of dormancy is

 a) abscisic acid.

 b) auxin.

 c) cytokinin.

 d) ethylene.

 e) gibberellin.

8) A short-day plant is one that

 a) requires more than 12 hours of light in order to flower.

 b) increases in height when it flowers.

 c) needs a certain minimum length of photoperiod in order to flower.

 d) is not affected by temperature in its flowering response.

 e) will not flower if its dark period is interrupted by a flash of light.

9) Charles and Francis Darwin concluded from their experiments on phototropism in grass seedlings that the part of the seedling that detects the direction of light is the

 a) tip of the coleoptile.

 b) part of the coleoptile that bends during the response.

 c) root tip.

 d) cotyledons.

 e) both a and b.

10) If a short-day plant has a critical night length of 15 fifteen hours, which of the following 24-hour cycles will prevent flowering?

 a) 8 hours light; 16 hours dark

 b) 4 hours light; 20 hours dark

 c) 6 hours light; 2 hours dark; short light flash; 16 hours dark

 d) 8 hours light; 8 hours dark; short light flash; 8 hours dark

 e) 2 hours light; 20 hours dark; 2 hours light

Test Yourself Answers

1) **d.** Phytochrome absorbs light for seed germination and flowering. Chlorophylls and other photosynthetic pigments absorb light for photosynthesis, and sunlight is involved with the opening and closing of stomata during the day. Only fertilization is not directly affected by light.

2) **c.** Photoperiodism is the response of plants to day (night) length; therefore, any experiment to study this effect must involve varying the duration of light to some part of the plant. Auxin, diffusing from the shoot apical meristem, as affected by light, is involved with phototropism. Blue, yellow, and green light are not absorbed by phytochrome and are, therefore, not involved with photoperiodism.

3) **c.** Ethylene gas, produced by ripening fruits, promotes more fruit ripening. Placing the unripe tomatoes in a gas-tight bag with a ripe banana will hasten ripening because of the ethylene given off by the banana.

4) **b.** Removing the primary apical meristem will release lateral buds from apical dominance, allowing axillary buds to grow out to form branches.

5) **d.** Tropisms are due to unequal distribution of auxins. Auxin diffuses preferentially toward the side away from light, causing those cells to elongated more than the cells on the side toward light. As a result, the tissue bends toward light.

6) **b.** Cytokinins are produced in the root tip and travel up the xylem to the other parts of the plant.

7) **a.** Abscisic acid, primarily a growth inhibitor, is responsible for the onset of dormancy in seeds.

8) **e.** A short-day plant, really a long-night plant, requires more than a critical night length to flower. Interruption of the dark period by a flash of light with block flowering.

9) **a.** The tip of the grass coleoptile is sensitive to light for phototropism.

10) **d.** A short-day plant, really a long-night plant, has a critical night length of 15 hours. In order to flower, it must have a constant dark period of at least 15 hours, which occurs in each case except d, where the longest dark period is only 8 hours.

Plant Reproduction

As described in Chapter 30, flowers are a specialized reproductive shoot characteristic of angiosperms. The concept that the flower is a modified shoot dates to the German philosopher, Goethe, who hypothesized that all appendages growing off the stem of a plant were various modifications of a basic leaf. The flower was an example of serial homology—homologous but changing structures in series along the stem.

■ CLASSICAL CONCEPT OF THE FLOWER

The basic plan of a flower consists of four series of modified leaves: sepals, petals, stamens, and carpels attached to a modified stem, called the receptacle (see Chapter 30). It is not difficult to conceive of the sepal as a modified leaf. Sepals are usually green and frequently thick and fleshy. Stomata are present, and there may be a mesophyll layer. Likewise, petals are flattened, leaf-like structures that also are occasionally green, and thick. Stamens and carpels, however, are typically not very leaf-like in appearance.

But not all flowers are typical. Several primitive tropical plants do have flowers with flattened, blade-like stamens, and comparison of different species produces a series illustrating a gradual transition from leaf-like to typical morphology.

Perhaps even more compelling is to observe the gradual transition in form in a single flower. Figure 39-2 illustrates representative "petals," picked off in series from the outside to the inside of a single white water lily flower.

There is a gradual transition from typical petal to typical stamen as the blade narrows and anthers form, initially parallel to the edges of the blade. Carpels also are not typically very leaf-like. However, a transition series is again evident when some primitive tropical flowers are examined.

In some *Drimys* species, the carpel looks like a miniature clam shell, with ovules attached in a line on either side. The edges are not connected except by a hairy margin that functions as a broad stigma. The carpel, opened with dissecting needles, resembles a leaf with ovules attached to the lower surface. A comparative series illustrates gradual fusion of the edges and the restriction of the stigmatic surface to a small area at the tip of a style on top of the ovary.

■ TRANSITION OF THE APICAL MERISTEM

In Chapter 38, we discussed the conditions necessary to induce a vegetative plant to begin flowering. If the flower is indeed a modified shoot, the first physical effects of floral induction should be

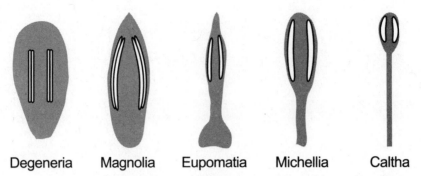

Figure 39-1. Variation in stamen form. From left to right is a transition from petal-like stamens to typical filament and anthers. Degeneria is a tropical species from New Caledonia. Magnolia is a common tree in the southern United States; Caltha is the marsh marigold from the eastern United States.

Degeneria Magnolia Eupomatia Michellia Caltha

Figure 39-2. Water lily petal-stamen transition. Transition from definite petal, left, to definite stamen, right, from a single water lily flower. Note tiny anther regions at tip of center petaloid structure.

evident at the shoot apical meristem. Inductive conditions do cause specific morphological and physiological changes in the apical meristem. The first indication of the transition to flowering is a rapid enlargement in the apical dome. Depending on the species, the apical meristem may get longer, wider, or both.

Increase in meristem size is due to an increase in the rate of cell division throughout the apical meristem (both the tunica and corpus—see Chapter 35), and these cells appear uniformly darkly staining. With an increase in cell division, primordia also are initiated at a faster rate, and with a larger apical dome, multiple primordia may be produced almost simultaneously—typically in threes in monocots and fours or fives in dicots.

■ FLORAL DEVELOPMENT

Young floral primordia resemble leaf primordia arising as a mound of tissue initiated in the surface or subsurface layer of the apical meristem. Why do specific primordia differentiate as sepals, petals, sta-

Hypothetical

Winteraceae

D. winteri

Drimys piperata unfolded

D. piperata

D. piperata

Magnolia sp.

Caltha sp.

Figure 39-3. Variation in carpel form. Top row: hypothetical folding of fertile leaf to form a carpel. Bottom row: diagrams of carpel structure of various Drimys species from the tropical family Winteraceae. The left two figures are diagrammatic cross-sections of dissected open and normal folded carpel. Hairs from inner surface form a stigmatic layer along margin. The four right-hand figures illustrate the gradual reduction in size of stigmatic area and migration toward the top of the carpel.

mens, or carpels? The ABC model predicts that three genes are involved in determining the developmental fate of a floral primordium.

Each floral part is specified by one or two of the three genes. If only gene A is "on," sepals will be produced. Genes A and B specify petals. Stamens are specified by genes B and C, and C alone results in carpel primordia. Mutants of these three genes have been identified in several plant species.

■ POLLINATION

The purpose of flowers is to ensure that the male gametes (sperm) of one flower fertilize the egg and polar nuclei of another (or the same) flower. The male gametes are carried in the tiny gametophyte plant, the pollen grain, and the egg and polar nuclei are within the embryo sac of an ovule within the ovary of a carpel (see Chapter 30). The process of transferring pollen from an anther to the stigma of a carpel is **pollination.**

The simplest method of pollination is to rely on wind to blow the pollen from one flower to another. Many temperate trees, such as oaks, maples, ashes, and willows, are wind pollinated. Their flowers lack petals and appear early in the spring, often before the leaves emerge. With wind pollination, petals not only are not necessary, but like leaves, they would obstruct the free flow of pollen in the air currents. Grasses are also wind pollinated and raise their petal-less flowers high above the leaves on elongated, flowering stalks. Wind-pollinated species produce huge amounts of pollen, increasing the probability that successful pollination will occur.

Most flowers are pollinated by animals, especially insects, although birds and mammals may also be recruited to carry pollen. Animal pollination provides many examples of often complex co-evolutionary

Figure 39-4. ABC model. The diagram on the left illustrates the four whorls of parts in a typical flower. On the right, the whorls are represented from left to right in developmental sequence: sepals, petals, stamens, carpels. Below that are represented the three organ-identity genes responsible for organ formation. Gene A alone produces sepals; A and B produce petals, B and C produce stamens, and C alone produces carpels.

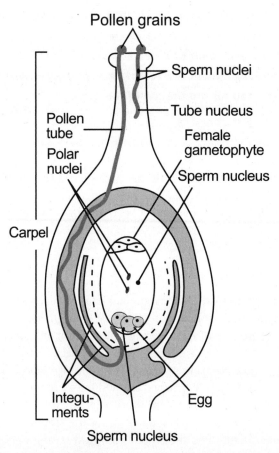

Figure 39-5. Pollination. Pollination involves the transfer of pollen grains to the stigma. Pollen germination and growth depends on chemical and physical compatibility of the pollen grain and the stigma and stylar tissues.

adaptations benefiting both the plant and its pollinator. Many flower species are specialized for pollination by a single pollinating species, and elaborate mechanisms have evolved to ensure that only a particular animal pollinator can transfer pollen from anther to stigma.

Pollen grains have a distinctive morphology, with an outer wall that is frequently highly sculptured. Many plants can be identified to species from a single pollen grain. Some pollen grains are smooth or only slightly dimpled, while others have protruding spikes in a variety of patterns. The pollen surface is coated with proteins that function in recognition.

The stigmatic surface of a carpel is adapted to catch its pollen. Flowers with smooth pollen grains secrete a sticky liquid on their stigmas to trap the pollen. Flowers with spiked pollen have tangles of hairs covering their stigmatic surfaces, which catch the pollen, Velcro-like. The stigma also produces recognition molecules. Compatible pollen will germinate and grow; non-compatible pollen frequently does not.

The pollen tube, stigma, and style interact biochemically and physically to regulate pollen tube growth. Pollen grains of different species will not germinate on the stigma or will grow slowly through the style. Length of the style can be a barrier to incompatible pollen. Many species are self-incompatible. Even though the flower is bisexual, self-pollination is prevented because it is incompatible on the stigma of flowers of the same plant. Other species freely self-pollinate.

■ FRUIT DEVELOPMENT

Germinating pollen produces a pollen tube that grows down the style. The pollen tube is a single cell that elongateds rapidly due to the production of auxin and/or gibberellin, depending on the species. The hormones stimulating pollen tube elongation also diffuse into the carpel tissue and initiate cell enlargement, the first step in fruit development.

By definition, fruits are the ripened ovary walls of the flower, with or without accessory tissues. As the fruit enlarges, three more-or-less distinctive layers develop in the fruit wall, the **pericarp.** The outer wall is the **exocarp,** the middle layer is the **mesocarp,** and the inner layer is **endocarp.**

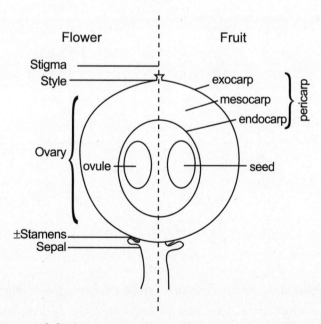

Figure 39-6. Fruit development. A fruit is a ripened ovary containing seeds. The fruit wall, or pericarp, consists of an outer exocarp, middle mesocarp, and inner endocarp.

In some fruits, such as a peanut or maple "seed," the entire pericarp is dry and either hard or papery. (The winged maple "seed" is actually a fruit with a single seed enclosed within the swollen end of the fruit wall.) Other fruits have at least one of the wall layers fleshy. Berries, such as grapes, tomatoes, or peppers, are fleshy throughout. If the exocarp is leathery, like the outer peel of an orange, it is a hesperidium. If the exocarp is hard, like a squash or pumpkin, it is a pepo. A stony endocarp, the pit, is characteristic of drupes such as olives, peaches, or avocados (the pit is not a seed; the seed is inside the pit).

As mentioned in Chapter 30, soon after pollen tube growth is initiated, the second nucleus in the pollen grain undergoes mitosis to produce two sperm, which migrate down the growing pollen tube. Each pollen tube grows toward an ovule and enters through the micropyle. The pollen tube fuses with the embryo sac, and the sperm are released to initiate double fertilization.

Seed Development

During double fertilization, one sperm unites with the egg to become a $2n$ zygote, while the second sperm unites with both polar nuclei to become a $3n$ primary endosperm cell (see Chapter 30). Both fusion cells begin to grow and undergo repeated mitotic divisions. As with the growing pollen tube, growth of these tissues produces auxin and/or gibberellin, which not only controls growth of the embryo and endosperm, but also diffuses into the developing fruit to stimulate further growth.

The endosperm cells divide and enlarge but do not differentiate into specific tissues. As mentioned in Chapter 30, initial growth of the embryo produces a short filament by always dividing with the new walls perpendicular to the axis.

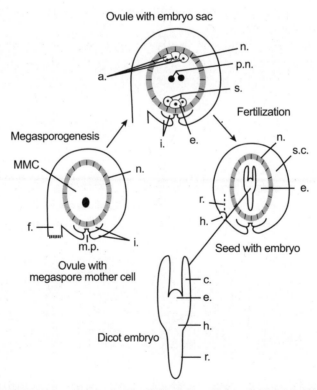

Figure 39-7. Seed development. A seed is a ripened ovule containing an embryo and stored food, the endosperm. The seed coat (s.c.) forms from the integument layers (i) that surrounded the ovule. The endosperm formed by fertilization of both polar nuclei (p.n.). The embryo resulted from fertilization of the egg. The embryo consists of a radicle (r), hypocotyls (h), cotyledons (c), and epicotyl (c).

After a short period of growth, there is a shift in polarity so that orientation of new cell walls becomes random and a spherical mass (the proembryo) differentiates on the end of the filament. Polarity of the embryo is already established, and the attached end differentiates into the **radicle,** the embryo root. The opposite pole becomes the **epicotyl,** the embryonic shoot apical meristem. The first appendages produced are the **cotyledons,** the seed leaves. Monocots have a single cotyledon; dicots have two. The epicotyl between the cotyledons may remain dormant, or it may produce a series of leaf primordia, the plumule. Connecting the radicle to the cotyledons and epidotyl is the **hypocotyl,** the transition region. These structures may easily be seen the next time you eat a whole peanut. The shell you crack open is the fruit wall. Inside, the peanuts are covered with a papery layer, the seed coat. The peanut has two main halves, each is an enlarged cotyledon that absorbed all the nutrients from the endosperm as the embryo matured. Carefully separate the two cotyledons. Between them is the tiny axis, radicle, hypocotyl, and plumule.

Most seeds must go through a dormancy period before they will germinate. For example, the seeds of any garden vegetable (any seed-containing vegetable is actually a fruit) should be dried over winter before planting the next season. There are some notable exceptions. Citrus fruit seeds, such as oranges, grapefruits, lemons, or limes, must be planted immediately after they are removed from the fruit.

Floral Evolution

Floral evolution is closely tied to the pollinator. For example, tubular flowers with a distinctively broad petal that acts as a landing platform tend to be bee pollinated, while red tubular flowers that hang upside down are hummingbird pollinated. There are other, more general trends, however, that mark distinctive patterns of floral evolution.

One common trend is to change the number of parts, either multiplying or reducing the number. The number of parts is not increased one at a time; rather, multiples are added. For example, an ancestral species might have three sepals and three petals, while one derived species might have six sepals and three petals, and another has three sepals but six petals. This accounts for monocots having floral parts in threes or multiples of three, while dicots have floral parts in fours or fives or multiples of four or five.

A second common trend is fusion of parts. Frequently, similar parts are fused. A common example is the fusion of petals to form a floral tube. With petals, you can usually tell how many original primordia fused because the tips are still separate. A very common fusion of like parts is fused carpels to form a compound **pistil.** A pistil is a female structure consisting of one or more carpels. Any fruit with multiple segments was formed from a compound pistil; each segment was a carpel.

Fusion can also occur to unlike parts. Many tubular flowers have stamens fused to the petals inside the tube. In some flowers, like the apple, the stem-like receptacle grows up around the compound pistil and fuses with it. The sepals, petals, and stamens attach above the ovary.

Reduction of parts or whole flowers is another common trend. The sunflower looks like a single gigantic flower, but, in fact, it is a collection of hundreds of individual flowers. What look like petals around the periphery are actually complete flowers, with the yellow petals fused to one side (count the tips). Below, they are fused into a tiny tube with stamens and carpel inside. The dark center of the "flower" are hundreds of tiny tubular flowers whose petals do not expand beyond the tips of the tube.

Finally, many species produce unisexual flowers. Either stamens or carpels are not initiated, or they abort soon after initiation, so that the mature flower produces only one type of gamete. Flowers producing only pollen are **staminate;** those producing only eggs are **pistillate.** In **monoecious** species, the same plant bears both staminate and pistillate flowers. **Dioecious** species have staminate and pistillate flowers on separate plants.

Test Yourself

1) Sexual reproduction
 a) is a reproductive process unique to animals.
 b) produces variation through genetic recombination.
 c) requires mitotic nuclear division (mitosis) to produce gametes.
 d) Both a and b are correct.
 e) Choices a, b, and c are all correct.

2) Pollen is released from the
 a) anther.
 b) stigma.
 c) carpel.
 d) sepal.
 e) pollen tube.

3) In the life cycle of an angiosperm, double fertilization refers to
 a) fertilization of the egg by sperm nuclei from two different pollen grains.
 b) fertilization of the egg by two sperm nuclei released from a single pollen tube.
 c) a pollen tube releasing two sperm nuclei—one fertilizing the egg, and the other combining with the polar nuclei.
 d) fertilization of two different eggs within the embryo sac.

4) A true fruit is a ripened
 a) seed.
 b) ovule.
 c) embryo sac.
 d) ovary.
 e) stigma.

5) The embryo contained within a seed
 a) is derived entirely from the tissues of the plant that bears the seed.
 b) is produced as complex carbohydrates, and proteins become more organized within the seed.
 c) results from the fusion of a sperm and an egg.
 d) is derived entirely from the pollen grain that pollinated the plant.

6) As flowers develop, all of the following transitions occur *except* that
 a) the microspores become pollen grains.
 b) the ovary becomes a fruit.
 c) the petals are discarded.
 d) the pollen tube nucleus becomes a sperm nucleus.
 e) the ovules become seeds.

7) According to the ABC model of floral development, a plant with a recessive mutation for A will produce

 a) sepals, petals, stamens, and carpels.

 b) petals, stamens, and carpels only.

 c) stamens and carpels only.

 d) stamens only.

 e) carpels only.

8) Flowers bear seeds in protective chambers called

 a) cones.

 b) stamens.

 c) sepals.

 d) ovaries.

 e) antheridia.

9) The parts that protect the developing flower bud are

 a) sepals.

 b) petals.

 c) stamens.

 d) carpels.

 e) receptacles (flowering stems).

10) The first indication that a plant is beginning to flower is that

 a) ethylene production goes up.

 b) the shoot apex enlarges.

 c) photosynthesis increases.

 d) the stem stops elongating.

 e) petals are produced by the floral apex.

Test Yourself Answers

1) **b.** Sexual reproduction can occur an any organism having cells that undergo meiosis (not mitosis) and having gametes that undergo fertilization to produce a new individual with a new combination of genes from both parents.

2) **a.** The anther, on the end of a stamen, is the site of pollen production.

3) **c.** Two sperm are produced within the growing pollen tube. One will fertilize the egg to form a zygote, and the other fertilizes both polar nuclei to form endosperm.

4) **d.** The fruit wall develops from the ovary of the carpel after pollination and fertilization have occurred.

5) **c.** The embryo results from the zygote, which is formed by fusion of an egg and a sperm.

6) **d.** The pollen tube nucleus functions throughout the growth of the pollen tube. It is the second nucleus in the pollen tube (called the generative nucleus) that divides by mitosis to produce two sperm nuclei.

7) **c.** A by itself is necessary to form sepals. A and B result in the formation of petals. If A is missing or mutated and non-functional, only stamens and carpels will form.

8) **d.** Seeds are formed from ovules, which are contained within an ovary, which forms the protective fruit.

9) **a.** Sepals are the protective outer covering of a bud that protects the other floral parts as the flower bud develops.

10) **b.** The first indication of floral induction is enlargement of the shoot apical meristem, which becomes the floral meristem. Then, instead of producing vegetative leaves, it begins to produce, in sequence, the sepals, petals, stamens, and carpels of the flower.

Animal Cells and Tissues

L ike plants, animals are multicellular organisms with hierarchical organization of cells into tissue, organs, and systems. In this unit, the major systems of the human body illustrate the typical structure/function of animals. Each of these systems is composed of cells of four tissue types: epithelial, connective, muscle, and nervous.

■ EPITHELIAL TISSUE

Epithelial tissue forms various types of linings in the body.

The cells are tightly compacted, which allows the layer to form a barrier to mechanical penetration and permits regulation of the uptake or excretion of chemicals. In areas where mechanical injury is possible, the epithelium is frequently in **stratified** layers, in which outer cells can be abraded away, with new cells constantly being formed in deeper layers. In areas where absorption or excretion occurs, there is often a single layer of **simple** squamous cells. A common secretion is mucus, a proteinaceous liquid that lubricates and moistens surfaces.

Squamose

Squamose epithelium is composed of flattened cells that fit tightly together like paving blocks. Simple squamous epithelium lines organs of the body where high rates of diffusion are a critical function. This includes blood capillaries and the lining of the air sacs in lungs. Gasses and/or nutrients must diffuse quickly through the cell from one side to the other, so the distance between the outer membrane and inner membranes must be small.

The skin is an organ whose outer layer, the epidermis, is composed primarily of thick layers of stratified epithelium. The outermost layers eventually dry and slough off, but they are continually replaced by cell division in deeper layers. Other organs where constant abrasion occurs, such as the esophagus and the anus, are also covered with stratified squamose epithelium.

Columnar

Cell of **columnar** epithelium are taller than they are broad. They also pack tightly together to form specialized layers. The cells lining the airways to the lung have specialized columnar epithelium that not only secretes mucus, but also have numerous cilia on the outer membrane. The mucus traps particles in the air, and the beating cilia remove them from the airway to be collected and excreted.

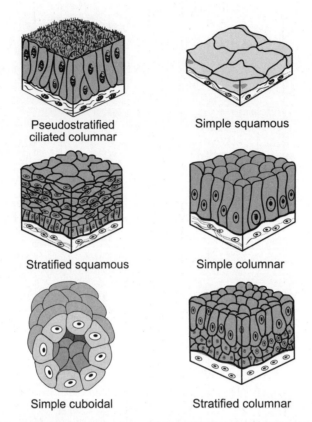

Figure 40-1. Epithelial tissue. Epithelial tissue is classified based on shape—flat (squamous), elongated (columnar), or isodiametric (cuboidal)—and layering—simple (single layer) or stratified (layered). Ciliated epithelium contains cilia on the outer surface.

The simple columnar epithelium lining the intestines is also highly specialized on the surface in contact with the environment. Numerous invaginations of the membrane surface increase the surface area necessary for rapid uptake of nutrients following digestion.

Stratified columnar epithelium lines the tubes through which urine passes from the bladder to the body. Although the outer layer is definitely columnar, the cells of the lower layers generally have not expanded and are more-or-less cuboidal.

Cuboidal

Cuboidal epithelial cells are equal-sided and typically line secretory glands. In the kidneys, these are the cells of the tubules that concentrate excretory products while conserving water. In excretory glands, such as the salivary glands, they produce and release specific molecules such as digestive enzymes. In endocrine glands, they line tubules and secrete hormones into these tubules and the blood vessels.

■ CONNECTIVE TISSUE

A common feature of many connective tissues is that they secrete an extracellular matrix of material that holds individual cells of the tissue together. The nature of the matrix defines the type of connective tissue.

Blood and adipose tissue (fat) are connective tissues that do not secrete matrix material.

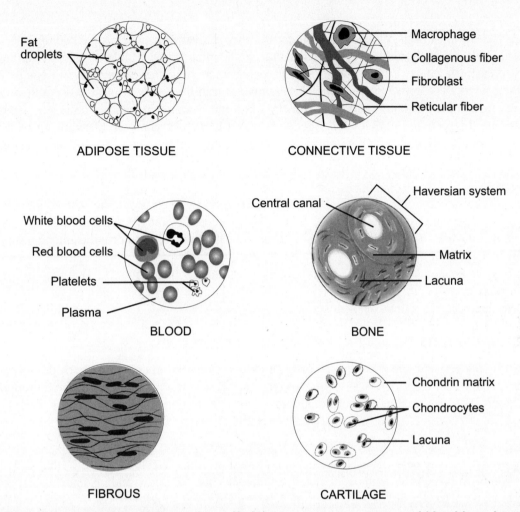

Figure 40-2. Connective tissue. Adipose tissue (fat), loose connective tissue, and blood have large spaces between individual cells. Dense connective tissue includes bone, cartilage, and fibrous.

Loose

Loose connective tissue resembles a thick, loosely woven sweater made with several types of yarn. Loose connective tissue is flexible and binds epithelial tissue to underlying layers and holds other organs in place in the body. The tissue consists primarily of three types of fibers consisting of elongated, tough strands of protein that are loosely woven with much interstitial space. **Elastic fibers** are able to stretch and return to their original shape. **Collagenous fibers,** composed of the strong glycoprotein collagen, are thick and non-elastic. They resist tearing. **Reticular fibers,** also composed of collagen, are very thin and branched and interweave with the other fibers.

Between the fibers are fibroblasts and macrophages. **Fibroblasts** are the cells that secrete the fiber proteins and are unique to the connective tissue. **Macrophages** are a type of white blood cell that can migrate out of the blood vessels and through the other tissues and spaces of the body.

Dense

In dense connective tissue, there is little, if any, interstitial space between the matrix material, and the matrix itself is firm, even mineralized.

Bone

Bone is a complex tissue composed of numerous units, **Haversian** systems, packed together. In the center of each Haversian system is a central canal that contain blood vessels and nerves. Surrounding each canal are concentric rings of bone-forming cells, **osteoblasts,** that first secrete a collaginous matrix around themselves. The collagen functions like the fiber mat in fiberglass. It is strong, yet flexible. The osteoblasts then deposit calcium and other minerals into the spaces between the collagen, where they harden around the proteins, similar to fiberglass resin that hardens around the glass fibers. As a result, bone is a living tissue that is hard, but not brittle, and can withstand both compression and tension.

Cartilage

Cartilage has some similarities with bone. In fact, in developing embryos, the skeletal system is initially composed of cartilage that is gradually replaced by bone as the embryo matures. In adults, cartilage is still found at the end of movable bones where it cushions the joints. It also provides flexible support to structures such as the nose.

Cartilage is formed by **chondrocyte** cells, which secrete a collagen matrix. The chondrocyte then secretes a rubbery protein-carbohydrate complex, **chondrin,** that embeds the tough proteins in a flexible binder. Cartilage is an excellent shock absorber.

Fibrous

Fibrous connective tissue is composed of large numbers of parallel collagen fibers, densely packed in bundles around scattered fibroblasts. These tough fibers resist stretching and form the **ligaments** that connect adjoining bones and the **tendons** that connect muscles to bones.

Adipose

Adipose tissue is a loose connective tissue composed of **adipose** cells, "fat cells" that store lipids. The function of adipose tissue is to pad the body against mechanical injury and insulate against cold. Of course it also stores food reserves as fat. Dieting can shrink the size of adipose cells by reducing the size of the stored fat drop, but it does not remove the cell. Excessive food intake not only increases the size of existing adipose cells, but also stimulates production of additional cells.

Blood

Blood is an unusual connective tissue because the matrix is a fluid (plasma) not secreted by the blood cells themselves. Plasma consists of water, salts, and a variety of proteins. It also serves as a carrier for other molecules secreted into the blood as well as its cellular components, the blood cells

There are two classes of blood cells. Red blood cells, **erythrocytes,** and white blood cells, **leucocytes**. In humans, red blood cells lack nuclei and have a double-concave disk shape. Filled with the molecule hemoglobin, they are specialized for transport of oxygen. More will be said of them in Chapter 42. There are a variety of specialized white blood cell types, but all are involved in protecting the body against foreign cells. These and special cell fragments called **platelets** will be discussed further in Chapter 42.

■ MUSCLE TISSUE

Muscle is composed of cells containing specialized contractile proteins. As a result, muscles are involved with various kinds of movements. The nature of the movement and the source of stimulus relate to which of the three types of muscle cell are involved—smooth, skeletal, or cardiac.

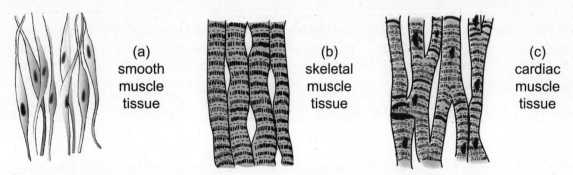

Figure 40-3. Muscle types. Smooth muscle consists of individual spindle-shaped cells. Both skeletal and cardiac muscles contain dark striations. Cardiac muscles branch and interconnect.

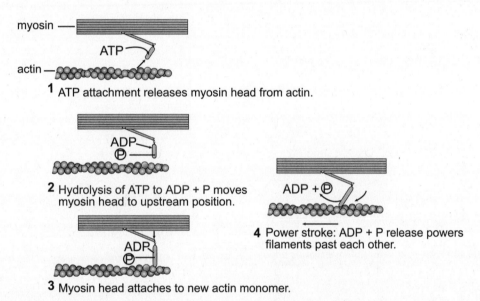

Figure 40-4. Muscle contraction. Muscle contraction moves the thick filaments of myosin relative to the thin filaments of actin, using energy from ATP.

Two types of proteins are involved in muscle contraction. **Myosin** occurs on thick filaments running either the length of the entire cell or the length of subunits of muscle cells. Thinner filaments, consisting of the protein **actin,** run parallel to the myosin filaments.

The head of each myosin molecule is a ratcheting assembly that associates with ATP/ADP and the actin filament. ATP attaches to the myosin head and the energy released as it converts to ADP + P changes the shape of the actin, causing it to rise from the resting position and reattach, via the phosphate, to a new actin monomer farther "upstream." The ADP and phosphate are released, causing the power stroke shape change that moves the myosin forward relative to the actin. As this process is repeated, the two proteins ratchet past each other.

Smooth

Smooth muscle consists of elongated, spindle-shaped cells that line the walls of many internal organs. Smooth muscles around the organs of the digestive system (see Chapter 41) contract in rhythmic

waves (called peristalsis) to move material through the digestive tract. Specialized rings of smooth muscle, called **sphincters,** between organs serve as valves to regulate the flow of material through the system. In a similar way, smooth muscle around blood vessels control blood flow to or from various parts of the body. Smooth muscle normally is under autonomic control (see Chapter 44); that is, it functions without conscious effort.

Skeletal

Skeletal muscles are the most familiar type of muscle to most people. One common name is meat. Anyone familiar with a cut of meat will recognize that it consists of one or more large bundles with a tough outer sheath. Each bundle is composed of multiple muscle cells, and each muscle cell consists of multiple myofibrils. The myofibrils have alternating light and dark bands, each of which is a unit of contraction called a **sarcomere.** The banded appearance is the reason skeletal muscles are also called striated muscles. Each sarcomere has its own set of actin and myosin molecules.

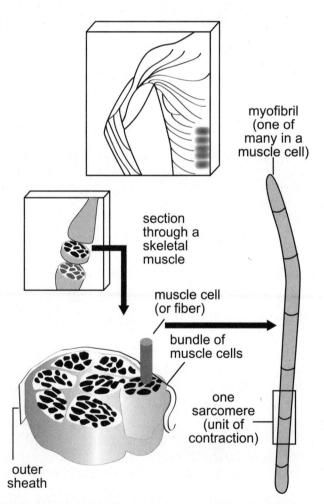

Figure 40-5. Skeletal muscle. Muscle cells are composed of many myofibrils. Muscle cells are further bundled into groups surrounded by connective tissue that, in turn, is bundled with other groups to form a muscle.

Cardiac

The **cardiac muscle** is unique to the heart. It has some characteristics in common with both skeletal and smooth muscle. Like skeletal muscles, it is striated, with individual units contracting, but like smooth muscle, it is under autonomic control. Cardiac muscle fibers branch and interconnect and are able to relay contraction stimuli from one cell to the next to help regulate heartbeat.

■ NERVOUS TISSUE

Nervous tissue consists of **neurons** and various types of supporting cells.

The neuron consists of a central cell body and numerous processes. Short, multi-branching processes are called **dendrites** because of their tree-like appearance. An elongated process that serves to connect with more distant cells is the **axon.** Neurons, like many of the supporting cell types, have membranes specialized for conducting electrical impulses from one end of the cell to the next. Specialized accessory cells—**oligodendrocytes** in the central nervous system or **Schwann cells** in the peripheral nervous system—wrap themselves around axons like a rolled-up jelly roll, so that many layers of lipid membrane function as an electrical insulator around the axon (see Chapter 44).

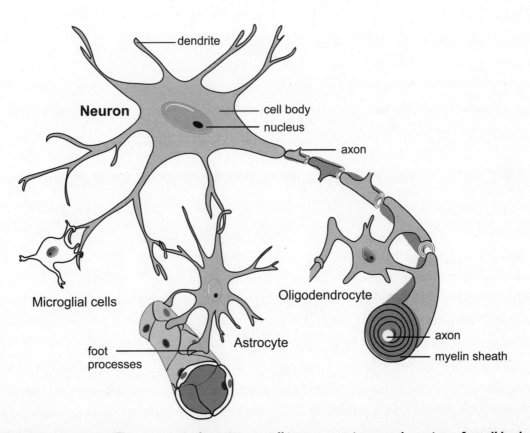

Figure 40-6. Nervous tissue. The neuron is the primary cell in nervous tissue and consists of a cell body with branching dendrites and an elongated axon tipped with synaptic endings. The axon may have a myelin sheath of Schwann cells.

Test Yourself

1) Stratified layers of epithelium are expected to be thickest in areas of skin where
 a) there is much exposure to sunlight.
 b) there is a lot of mechanical contact.
 c) waterproofing is most essential.
 d) insulation from fat is lacking.

2) The basic cell type of the nerve tissue is the
 a) axon.
 b) dendrite.
 c) Schwann cell.
 d) neuron.
 e) nerve.

3) Which of the following types of connective tissue is *not* composed of living cells?
 a) adipose tissue
 b) bone
 c) cartilage
 d) fibers
 e) All of the above contain living cells.

4) You jump from the back of a truck and land on your feet. Which of the following tissues provides the most shock absorption for your body?
 a) muscle
 b) bone
 c) cartilage
 d) collagen fibers
 e) ligaments

5) In humans, which type of living cell lacks a nucleus?
 a) adipose cell
 b) red blood cell
 c) condrocyte (cartilage cell)
 d) white blood cell
 e) All of the above contain nuclei.

6) Which of the following cells does *not* have an adaptation to maximize surface area to volume?
 a) columnar epithelium of intestine
 b) red blood cell
 c) squamose epithelium
 d) adipose cell
 e) All of the above cell types have adaptations to maximize surface area to volume.

7) Muscle cells lacking sarcomeres are
 a) skeletal muscle.
 b) smooth muscle.
 c) cardiac muscle.
 d) both a and b.
 e) both b and c.

8) All substances passing into or out of the body must go through
 a) adipose tissue.
 b) blood.
 c) connective tissue.
 d) dense connective tissue.
 e) epithelial tissue.

9) A tissue is made up of cells, no two of which are in contact with each other. This tissue must be
 a) loose connective tissue.
 b) smooth muscle.
 c) blood.
 d) skeletal muscle.
 e) cardiac muscle.

10) Most sphincters are composed of
 a) smooth muscle.
 b) elastic fibers.
 c) skeletal muscle.
 d) collagen.
 e) ligaments.

Test Yourself Answers

1) **b.** Mechanical contact will abrade surface cells, so the thickness of layers must be greater.

2) **d.** Axons and dendrites are parts of neurons. The long axons are covered by Schwann cells and multiple neurons aggregated into a single bundle make up nerves.

3) **e.** Even bone, the hardest of the connective tissues, is composed of living cells, called osteoblasts.

4) **c.** Cartilage is a rubbery connective tissue covering the ends of long bones, such as leg bones. They help to cushion the bones from shock and prevent bones from grinding against other bones at the joints.

5) **b.** Human red blood cells lack a nucleus when they are mature.

6) **d.** Columnar epithelium of the intestine have microscopic invaginations, called microvilli, to increase surface. Red blood cells are disk-shaped and concave to maximize surface area. Squamose epithelium is broad but thin to minimize volume, thus maximizing the surface area to volume ratio. Adipose cells are large and more-or-less isodiametric, which is the least favorable shape to maximize surface area/volume.

7) **b.** Sarcomeres are the light/dark striations found in both skeletal and cardiac muscle, but lacking in smooth muscles.

8) **e.** Epithelial tissue lines all organs of the body; therefore, to get anything into or out of an organ, it must pass through epithelium.

9) **c.** The cellular components of blood (red and white bloods cells) are all unicellular and independent in the plasma.

10) **a.** Sphincters are rings of smooth muscle around a hollow organ that function as a valve.

Digestive System

The digestive system is involved with ingestion, digestion, absorption, and excretion of nutrients through a one-way **alimentary canal**. Different portions of the digestive system are specialized for one of more of the activities listed above. The entire length of the canal is exposed to the environment, which is why it is lined with epithelial cells and tissues. The structure of the epithelial lining varies, depending on which part of the canal it is located. Likewise, with the exception of the mouth, smooth muscles surround each organ of the alimentary canal to aid in moving materials through the system as the various activities proceed.

■ MOUTH

The mouth is the first organ of the digestive system. Its primary function is the ingestion of food. The long, relatively sharp front teeth, incisors, and canines, are used to bite off small chunks of food. Large, flat teeth (the molars) grind the particles to smaller pieces. Technically, this chewing is called mastication. The muscular tongue moves food pieces around in the mouth to ensure that all particles have been ground to an appropriate size before swallowing.

In addition to ingesting food and breaking it down mechanically, saliva is added from three pairs of **salivary glands** located behind and below the lower jaw. The glands are connected to the mouth by ducts through which the digestive enzyme **amylase** and other secretions move. The amylase begins digestion of carbohydrates into disaccharides. Note that if you continue to chew bread or crackers after they are moistened and crushed, they begin to taste sweeter as starch is converted into sugar. The fluid helps the food pieces stick together as they are moved about by the tongue to form a single mass ready to swallow, the food **bolus.** When it is ready, the tongue contracts to push the bolus to the back of the mouth, into the esophagus, where peristaltic contractions of smooth muscles aid in transporting the bolus to the stomach.

■ STOMACH

At the entrance of the esophagus to the stomach is a special ring of smooth muscle, the **cardiac sphincter.**

The sphincter relaxes to allow the bolus to enter the stomach, but then closes to keep stomach contents from regurgitating (although, occasionally, this happens anyway). The stomach contents are acidic (hence, sour-tasting) and can damage the endothelial lining of the esophagus if there is repeated exposure. The pain associated with this condition is called heartburn or acid reflux.

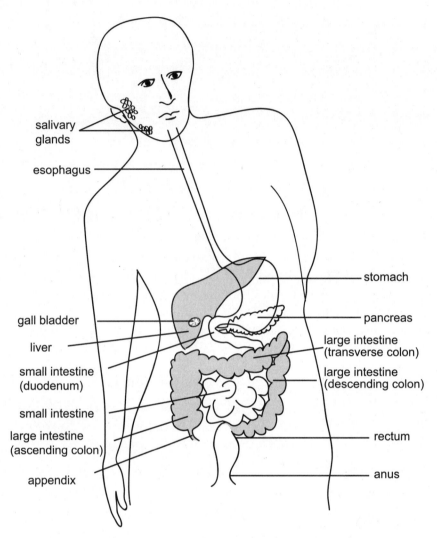

salivary glands

esophagus

stomach

gall bladder

pancreas

liver

large intestine (transverse colon)

small intestine (duodenum)

large intestine (descending colon)

small intestine

large intestine (ascending colon)

rectum

appendix

anus

Figure 41-1. Digestive system. The digestive system is a one way-tube, with accessory organs, that ingests, digests, and absorbs, and excretes non-digested waste. The main organs are the mouth and salivary glands, stomach, small intestine, pancreas, liver, and large intestine.

The stomach has several roles, including storage, mechanical churning, and digestion of proteins. The stomach lining is somewhat pleated internally to allow for expansion as additional food boli enter. There are also numerous gastric pits that increase the surface area of secretory cells. The endothelium of stomach consists primarily of mucous producing cells, the **gastric mucosa.** Mucous is a proteinaceous substance that protects the stomach from autodigesting itself. Mucous cells are especially prominent near the cardiac and pyloric sphincters.

The gastric pits are lined with mucous cells as well and they also contain two cell types specialized for the digestive function of the stomach. **Parietal cells** produce hydrochloric acid, HCL, which denatures proteins and begins their digestion. **Chief cells** secrete pepsinogen, which is converted into **pepsin** in the presence of HCL. Pepsin further digests proteins.

In the stomach, the partially digested food mass is called **chyme.** Chyme is released gradually into the small intestine through a second sphincter, the **pyloric sphincter.** Contractions of smooth muscles around the stomach continually mix the chyme to ensure complete digestion. Although absorption is

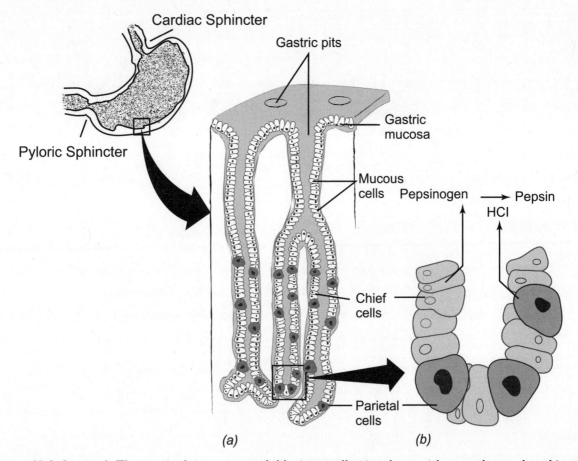

Figure 41-2. Stomach. The stomach is an expandable, internally pitted sac with smooth muscle sphincter valves at each end. It is lined with mucous producing cells, including the surface of gastric pits. Within the pits are enzyme- and acid-producing cells.

not a primary function of the stomach, alcohol, water, and some drugs are absorbed through the stomach lining.

■ SMALL INTESTINE

The small intestine is subdivided into three regions: the duodenum, the jejunum, and the ileum.

The divisions are somewhat arbitrary as one grades into the next along the continuum. The lining of the small intestine has pleated folds, and each fold is further elaborated into finger-like projections called **villi.** Each villus is supplied with a lymph vessel and a blood supply. The epithelial lining contains specialized columnar cells with microscopic invaginations, called microvilli, on the exposed surface. The microvilli, villi, and intestinal folds all serve to increase the surface area for absorption of nutrients, a major function of the small intestine. Rhythmic contractions of smooth muscles move the food mass the length of the organ.

Duodenum

The first segment of the small intestine is the duodenum. Absorption of nutrients plays a minor role in this part of the intestine. Instead, this is the site of most digestion in the system. Several enzymes are

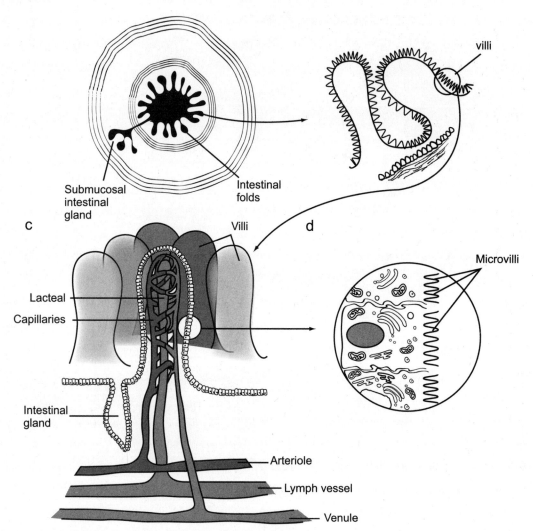

Figure 41-3. Small intestine. The internal lumen of the small intestine has longitudinal ridges covered with finger-like invaginations called villi. The columnar epithelial cells lining the villi further increase membrane surface area with microvilli on the side adjacent to the lumen.

secreated by the intestinal mucosa itself. These include disaccharidases to complete digestion of carbohydrates, aminopeptidase to continue digestion of protein, and intestinal nucleases to digest nucleic acids. More important, however, are enzymes and bicarbonate produced by the pancreas and secreted through a duct into the duodenum near the pyloric sphincter.

The pancreas is a complex organ that has both exocrine and endocrine function (see Chapter 45). The exocrine products promote further digestion of all biological molecules in the small intestine and help to protect the intestine from stomach acid. As chyme is released into the small intestine, sodium bicarbonate neutralizes the acid. Pancreatic amalase completes digestion of polysaccharides, while trypsin, chymotrypsin, and carboxypeptidase complete digestion of proteins into amino acids.

Lipids are difficult to digest because they are not water soluble. Bile, from the liver, is stored in the gall bladder and released via a duct into the small intestine, as it is needed to emulsify fats. Once emulsified, they may be digested by lipase enzymes from the pancreas. Pancreatic nucleases, along with those

from the intestine, complete the breakdown of nucleotides into their component bases and monosaccharides. As digestion is completed, absorption can begin.

Jejunum and Ileum

Most of the length of the small intestine is composed of the jejunum and ileum, which together are responsible for most of the nutrient absorption in the body.

■ LARGE INTESTINE

The large intestine also is divided into three sections, each with different function: the cecum, the colon, and the rectum.

Cecum

In humans, the cecum is mostly a vestigial structure below the insertion point of the small intestine. The terminal portion is the appendix. In ruminant animals, the cecum is the site of major digestion by symbiotic bacteria.

Colon

Most of the length of the large intestine consists of colon. The colon is where digestion and nutrient absorption is completed. It is also where salts and water are absorbed. The colon is a habitat for the normal intestinal flora of humans—symbiotic bacteria that are important for continuing food digestion and producing several essential vitamins.

Rectum

The final segment of the large intestine is the rectum, which stores the semi-solid feces until they are eliminated. Fecal material consists of mostly cellulose and bacteria, along with other undigested food material and excess minerals. Between the rectum and the anus are two sphincters. One is under autonomic control, like those associated with the stomach. The other is under voluntary, conscious control.

Test Yourself

1) The liver and pancreas add their secretions to chyme at the level of the
 a) lower stomach.
 b) upper small intestine.
 c) appendix.
 d) upper large intestine

2) A chief function of the large intestine is
 a) the absorption of water.
 b) the absorption of foods.
 c) the digestion of foods.
 d) the production of gases.

3) Pepsin, secreted by the _____, works along with _____ to chemically digest _____.
 a) stomach, amylase, fats
 b) stomach, HCl, proteins
 c) stomach, bicarbonate, proteins
 d) pancreas, bicarbonate, proteins

4) Many of the bacteria living in our large intestines provide us with
 a) carbohydrates.
 b) vitamins.
 c) minerals.
 d) calories.

5) Herbivores have proportionately longer intestines than do similarly sized carnivores. What other feature should you expect to be associated with the intestines of herbivores?
 a) cellulase-containing bacteria
 b) evapotranspiration
 c) spiral valves
 d) increased number of sphincter muscles

6) Heartburn occurs when
 a) the pH of blood in the coronary arteries decreases.
 b) the pH of blood in the coronary arteries increases.
 c) the stomach lining becomes ulcerated.
 d) chyme moves into the esophagus.
 e) a full stomach pushes against the heart.

7) In order for the products of digestion to benefit an organism, they must be

 a) ingested.

 b) digested.

 c) absorbed.

 d) excreted.

 e) defecated.

8) Which of the following organs of the digestive system does not produce any secretions that aid in digestion?

 a) large intestine

 b) small intestine

 c) stomach

 d) pancreas

 e) liver

9) Chemical digestion of carbohydrates begins in the

 a) mouth.

 b) stomach.

 c) esophagus.

 d) small intestine.

 e) large intestine.

10) The main site for digestion is the

 a) mouth.

 b) esophagus.

 c) stomach.

 d) small intestine.

 e) large intestine.

Test Yourself Answers

1) **b.** Bile from the liver and bicarbonate and numerous enzymes from the pancreas enter the duodenum, the upper portion of the small intestine, near its junction with the stomach.

2) **a.** Although some nutrient absorption occurs in the large intestine, a major function is to absorb water.

3) **b.** Pepsin is a protein-digesting enzyme secreted by the stomach that is activated by another stomach secretion, HCl.

4) **b.** Symbiotic bacteria living in the large intestine produce essential vitamins.

5) **a.** Cellulose, a major component of plant tissue, is indigestible by animals. Herbivores rely on the digestive enzymes of symbiotic bacteria to digest cellulose. This often occurs in the cecum, the first section of the large intestine, which is much enlarged in herbivores.

6) **d.** Heartburn is the irritation caused by stomach acid in chyme, damaging the epithelial lining of esophagus cells.

7) **c.** Ingestion and digestion precede absorption in the sequence of making nutrients available to animal cells. Both must occur before the nutrient products of digestion are available for uptake.

8) **a.** The liver produces bile, which emulsifies fats, making them easier to digest. The pancreas, stomach, and small intestine all produce digestive enzymes. Only the large intestine does not produce digestive secretions.

9) **a.** Salivary amylase is produced in salivary glands and secreted into the mouth, where digestion of carbohydrates begins.

10) **d.** Most foods undergo or complete their digestion in the duodenum, the upper portion of the small intestine.

Respiratory and Circulatory Systems

L̲ike the digestive system, the respiratory system gives internal body cells access to the environment, in this case, for gas exchange with the atmosphere in the lungs. The circulatory system supplies virtually every cell in the body with access to both the digestive and respiratory systems.

■ RESPIRATORY SYSTEM

Cellular respiration, a characteristic of all living things, requires constant gas exchange, O_2 availability, and removal of CO_2 (see Chapter 7). At the cellular level, gas exchange is completed by the process of diffusion from higher free energy to lower free energy. In large terrestrial animals, **ventilation** (movement of air into and out of lungs) is a related process. In this chapter, the pathway and process of ventilation are reviewed, along with the biophysics of gas exchange.

Nasal Cavity

The **nasal cavity** is an elaborate air conditioner that filters, humidifies, and modulates the temperature of the external air supplied to the body. The epithelial lining contains cilia and produces mucous that traps dust and foreign particles and removes them from the body by sneezing, swallowing, and so on. Nasal hairs filter larger particulates.

Like any good heat exchanger, the internal surfaces of the cavity are folded and elaborated to increase surface area. The tissues lining the cavity are well supplied with blood vessels, which warms the air to body temperature and raises its humidity. Warm, moist air facilitates diffusion within the lungs.

Pharynx and Larynx

The **pharynx** is the connection between the nasal cavity and throat before the separation of the esophagus (food tube) and trachea (wind pipe) at the **larynx.** The **glottis** is a flap-like valve that is normally open for breathing but folds closed as a bolus of food is swallowed. The **vocal cords** are two ligaments stretched across the opening of the larynx that vibrate as air passes through, thus producing sound of various pitch that depend on how tightly the ligaments are stretched. Laryngitis is inflammation of the vocal cords that become swollen and, therefore, do no vibrate properly—resulting in voice loss.

Trachea

The wind pipe, or **trachea,** is a flexible tube held open by rings of cartilage. These function like the reinforcement rings in the hose of a vacuum cleaner. Air is drawn in and out by a combination of suction

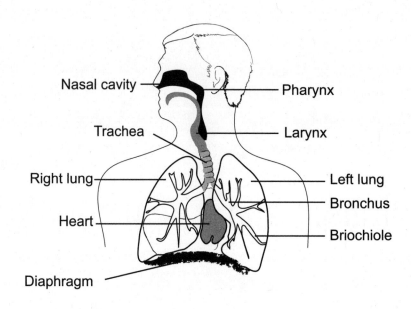

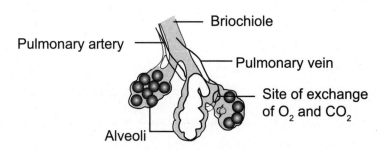

Figure 42-1. Respiratory system. The major organs of the respiratory system are the nasal cavity, trachea, bronchi, lungs, and diaphragm. Within the lungs, bronchi branch repeatedly into ever smaller bronchioles that are terminated in alveoli, thin-walled sacs associated with capillary networks.

tension and positive pressure. A flexible tube would collapse under tension, blocking the airway. The cartilage rings prevent such collapse. Ciliated columnar epithelium lines the trachea and secretes mucous. The mucus traps particles, and the beating cilia move them toward the larynx, where they are discharged into the esophagus and periodically swallowed. At the base of the trachea, the tube bifurcates to form two **bronchi,** one supplying each lung.

Lungs

The lungs are flexible sacs with large internal surface areas that can be kept moist for diffusion without excessive water loss. Within the lungs, the bronchi divide repeatedly into numerous **bronchioles.** Like the trachea, the bronchi and bronchioles are lined with ciliated cells that secrete mucous, trap particles, and sweep them up to the larynx to be discharged into the esophagus. Excessive irritation of the membranes results in increased production of mucous and "bronchial congestion" that elicits a cough response to clear large amounts of mucous that can be expelled through the mouth.

At the end of the smallest bronchioles are sac-like **alveoli,** surrounded by a bed of capillaries, which are blood vessels comprised of a single layer of cells. The oxygen in the air within the alveoli is separated

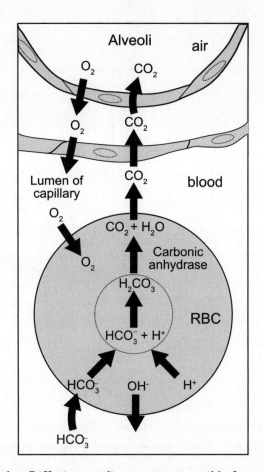

Figure 42-2. Diffusion in alveolus. Diffusion gradients are responsible for moving gases between the alveoli and the blood across two layers of epithelial cells. Oxygen has higher partial pressure in the air and diffuses into the blood to be picked up and carried by the red blood cells (RBC). Carbon dioxide, dissolved in water as carbonic acid, has its highest free energy in the blood and diffuses out into the air after reassociating as CO_2.

from the red blood cell by only two cell layers: the epithelium of the alveolus and the endothelium of the capillary. A total of five membrane surfaces must be crossed.

■ DIFFUSION OF GASES

In gases, the free energy of one gas in a mixture is defined in terms of **partial pressure.** For example, at sea level, atmospheric pressure is about 760 mmHg. Oxygen makes up about 21 percent of the air, so the partial pressure of oxygen is approximately 155 mmHg (0.21 × 760 = 155).

Within the alveolus, the partial pressure is about 100 mmHg, which is still considerably higher than that in the returning venous blood coming from the body (about 38 mmHg). As a result, there is a steep free-energy gradient between the alveolar air and the incoming blood, and oxygen diffuses rapidly into the blood, where it is taken up by the hemoglobin of red blood cells (refer to Figure 42-2). The influx of oxygen raises the partial pressure of oxygen in the outgoing arterial blood to about 90 mmHg, nearly the concentration in the adjacent air spaces of the alveoli. Body cells, which use the blood oxygen for respiration, continually lower the partial pressure of oxygen in their cytoplasm, thus continuing the decreasing concentration gradient in the body to the level of the returning venous blood entering the lungs.

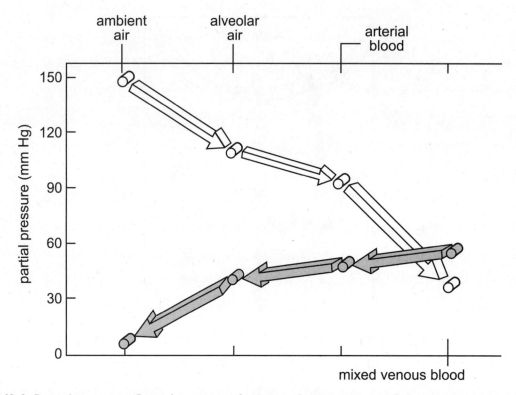

Figure 42-3. Partial pressures. Partial pressure of a gas is the percentage of that gas versus total gases. Partial pressure of O_2 (light arrows) is highest in the air and decreases as it moves through the body and is used by living cells. Partial pressure of CO_2 (dark arrows) is highest in the tissues, where it is produced as a byproduct of respiration, and is lowest in the air into which it diffuses in the lungs.

The principle of CO_2 diffusion in the lungs is similar to that of O_2. The partial pressure of CO_2 in ambient air is very small (0.2 mmHg). It is much higher in the alveoli (40 mmHg), but this is still lower than the incoming venous blood (45 mmHg). As a result, there is a diffusion gradient from the blood into the alveolar air.

Diffusion of CO_2, however, is not quite so straightforward. When CO_2 dissolves in water, it reacts to form carbonic acid, H_2CO_3. The carbonic acid further dissociates into bicarbonate and hydrogen ions, HCO_3^- and H^+. This process is reversed in the lungs as CO_2 diffuses from the plasma into the alveolar air (refer to Figure 42-2).

Concentration of CO_2 in the blood is inversely proportional to blood pH because of the carbonic acid formed. The higher the partial pressure of CO_2, the lower the pH. This relationship is critical because pH sensors are the primary way the body regulates breathing. If blood pH drops, the body responds by taking deeper and/or more frequent breaths to increase ventilation and decrease CO_2 concentrations in the alveolar air and, consequently, the blood.

■ MECHANICS OF BREATHING

Ventilation is increased by controlling expansion of the chest cavity. The lungs are two-way structures. New air must be introduced and old air expelled through the same passages. Thus, force must be exerted to drive these air movements. The lungs are sealed within a closed chest cavity, and a layer of fluid between the epithelium of the lungs and the inner epithelial lining of the chest cavity provides adhesive

force. If the cavity enlarges, the lungs will expand proportionally, drawing air into the lungs and simultaneously reducing the resistance to normal air pressure inflating the lungs.

The volume of the chest cavity is defined by the position of the ribs and the **diaphragm,** a sheet of muscle separating the chest from the abdomen.

The ribs are hoop-like bones with a rotating attachment at the spine. Pairs of muscles connect each rib to the next. One set of muscles contracts to raise the ribs; the second pair contract to lower them. In the relaxed position, the ribs angle downward, collapsing the volume of the chest. Contraction raises the ribs to achieve full volume. Simultaneously, contraction of the diaphragm, which at rest is dome shaped, flattens the floor of the chest cavity, again increasing its internal volume.

During heavy breathing, both the expansion of the chest cavity and its contraction are taken to their full extent to maximize air exchange in the lungs. Normally, only about 10 percent of the air in the lungs is exchanged with each breath. With deep breathing, as much as 80 percent exchange can occur. Ambient atmosphere also affects the mechanics of breathing. At sea level, atmospheric pressure is about 760 mmHg, which is the force that will drive air into the lungs. At high elevation, atmospheric pressure decreases because the layer of air above is much thinner. As a result, less air is forced into the lungs, and you must work harder to draw in a breath. Of course, with reduced total pressure, the partial pressure of O_2 is also reduced, making it more difficult to supply adequate oxygen to the tissues.

■ CIRCULATORY SYSTEM

The circulatory system includes the blood, heart, and blood vessels used to circulate blood between the heart and the body. It transports the nutrients obtained from the digestive system, gases used in the respiratory system, and other molecules from specialized organs to metabolizing cells, throughout the body.

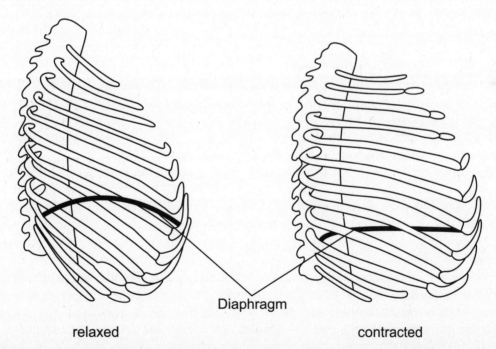

Diaphragm

relaxed contracted

Figure 42-4. Driving ventilation. Ventilation is the movement of air into and out of the lungs. The lungs are in contact with and adhere to the inside of the chest cavity. Increasing the volume of the chest by raising the ribs and contracting the diaphragm draws air into the lungs, assisted by ambient air pressure. Lowering the ribs and relaxing the diaphragm forces air out of the lungs.

Blood

Blood consists of about 55 percent plasma and 45 percent cells. Water is the single largest component, serving as a solvent and carrier for all other substances. A variety of dissolved salts help to maintain osmotic balance of the cells, help regulate membrane permeability, and buffer against pH change. The most common protein is **albumen** (the same protein in egg white). Other proteins include **fibrogens** that function in blood clotting and antibodies involved in the immune system (see Chapter 46). A variety of other substances are also transported by the plasma including dissolved gases, nutrients, waste products, and hormones.

As mentioned in Chapter 40, the most common blood cells are red blood cells, with more than 4 million contained in each mm^3 of blood. These cells contain the red pigment hemoglobin that binds oxygen. Red blood cells transport both oxygen and carbon dioxide and live for three to four months. These cells must continually be produced. In a normal adult, approximately 2 million red blood cells die every second.

White blood cells number from 4,000 to 11,000 per mm^3 of blood and survive from hours to weeks, depending on the specific type of cell. White blood cells protect the body as part of the immune system (see Chapter 46). Several types of white blood cells engulf and destroy bacteria in a process called **phagocytosis.** These cells exhibit amoeboid movement and can migrate out of the circulatory system into the fluids bathing the tissues. From 250,000 to 500,000 cell fragments, **platelets,** also occur per mm^3 of blood. Platelets initiate blood clotting, stimulated by rough tissue such as torn cells. Fibrogen from the plasma forms a meshwork that traps platelets and red blood cells to form a clot.

Heart

The human heart is a four-chambered organ composed of cardiac muscle (see Chapter 40). Two smaller chambers, **atria,** accept blood from the outside the heart and pump it into larger chambers, the **ventricles.**

The walls of the ventricles are thicker and force the blood out of the heart to circulate to the tissues.

Pathway of Blood through the Heart

Blood from the body enters the heart at the right atrium (think of an atrium, the entry way into a large house). Blood from the upper body arrives via the **superior vena cava;** the **inferior vena cava** collects blood from the lower body. Contraction of the atrium moves a volume of blood through a valve into the right ventricle. Contraction of this chamber pushes blood through the pulmonary arteries into the lungs. These vessels are the only arteries in the body that carry deoxygenated blood.

Blood returning from the lungs in pulmonary veins reenters the heart through the left atrium. Contraction of this chamber moves a volume of blood into the left ventricle. The strong contractions of this chamber pump blood out through the aorta, the largest artery in the body, to supply the blood to the rest of the body.

Heartbeat

A special section of the heart wall in the right atrium, the **sinoatrial node,** serves as the pacemaker. The pacemaker initiates the impulse to contract, and this impulse spreads rapidly to both atria. When the impulse reaches the **atroventricular node,** the electrical impulse travels across to the ventricles, where the impulse spreads, causing these muscles to contract. The slight time delay as the impulse passes over the atroventricular node delays contraction of the ventricles relative to the atria. As each chamber contracts, back flow is prevented by one-way valves. The "lub-dub" sound of the heart beating is the sequential closing of the atrial and ventricular valves.

Typically, the heart beats sixty to seventy times per minute. When the ventricles contract, blood is forced into the arteries with a **systolic pressure** of 100 to 140 mmHg.

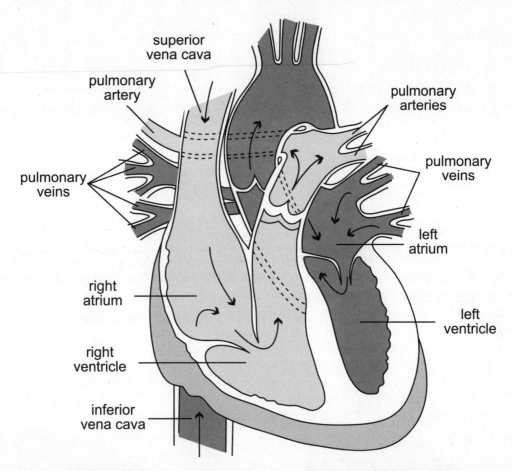

Figure 42-5. The heart. The heart is a four-chambered pump. Two chambers, the atria, receive blood from body tissues and fill the ventricles, which pump blood out of the heart into tissues. The right side receives blood from the body and pumps it to the lungs. The left side receives blood from the lungs and pumps it to the rest of the body. The pulmonary arteries to the lungs are the only arteries in the body to carry low-oxygenated blood; the pulmonary veins from the lungs are the only veins in the body to carry fully oxygenated blood.

As the ventricles relax, blood pressure in the arteries drop to their **diastolic pressure** of 70 to 90 mmHg.

Vascular System

The vascular system consists of **arteries, veins,** and **capillaries.**

Capillaries have the simplest structure, a single layer of **endothelium** separating the blood from the tissue. Capillaries perfuse through all the tissues of the body and are the site of diffusion of gasses, nutrients, waste materials, and other molecules. No cell in the body is farther than about 130 μm from a capillary.

Arteries carry blood from the heart to capillary beds. Coming from the heart, the artery must withstand pulsating pressure and swell under systolic pressure every time the heart beats, and then return to its original shape during diastole. A thick elastic layer of connective tissue around the endothelium lin-

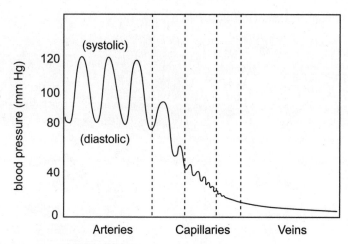

Figure 42-6. Blood pressure. Blood pressure in the arteries is higher than that in the veins and shows a rhythmic fluctuation of high systolic pressure and low diastolic pressure that corresponds to the pumping and refilling stages of the left ventricle of the heart.

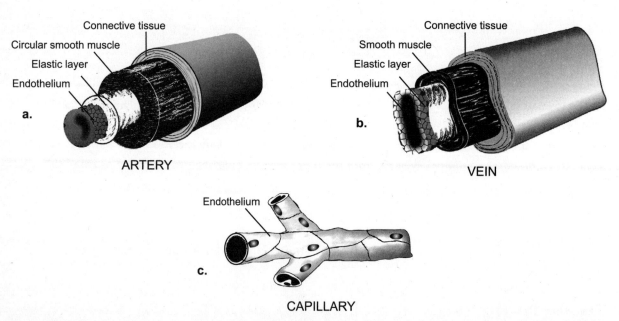

Figure 42-7. Structure of blood vessels. Thick walled arteries withstand high blood pressure from the heart, while the large-thin-walled veins minimize resistance to blood flow back to the heart after passing through the capillaries that connect arterioles to venules. All blood vessels have an endothecium lining of epithelial cells. Arteries and veins surround the endothecium with concentric layers of elastic fibers, smooth muscle, and additional connective tissue.

ing functions like an Ace bandage, providing firm but elastic support. Around the elastic layer is a thick layer of smooth muscle (see Chapter 40). Contraction of these muscles constricts the diameter of the artery restricting blood flow through that vessel. In this way, some direction of blood flow can be affected. Reducing flow to some organs makes more available for others. Finally, an outer sheath of connective tissue encases the artery.

Veins have a structure similar to arteries, except that the diameter of the lumen is much larger and the individual layers are thinner and more flexible. The larger diameter minimizes resistance to flow, which is important because blood pressure on the venous side of capillaries is low. Larger veins also contain one-way valves to prevent back flow of blood toward the capillaries. Contraction of skeletal muscles around large veins during normal movement helps force blood through the veins back toward the heart.

Test Yourself

1) Normal, unforced exhalation is the result of
 a) diaphragm relaxation.
 b) rib muscle relaxation.
 c) muscular contraction.
 d) a and b only.
 e) b and c only.

2) When the brainstem receives stimuli indicating decreased blood pH levels, it responds by
 a) increasing heart rate.
 b) initiating the vomiting reflex.
 c) decreasing breathing rate.
 d) dilating arterioles in the skin.
 e) increasing breathing rate.

3) What structural feature of capillaries is important for their function as the sites of exchange between blood and tissues?
 a) lack of smooth muscle layer
 b) lack of connective tissue sheath
 c) lack of elastic membranes
 d) all of these

4) What structures common to veins are *not* found in arteries or capillaries?
 a) endothelium
 b) elastic fibers
 c) smooth muscle
 d) valves

5) Gas exchange in the lungs is enhanced by
 a) the thinness of the alveolar walls.
 b) the great number of alveoli.
 c) the large proportion of each alveolus in contact with capillary endothelia.
 d) all of the above.

6) What is the most logical reason for blood having to return to the heart from the lungs before being pumped out to the systems?
 a) so that oxygenated blood can diffuse through the ventricular walls and nourish the heart muscle
 b) to increase the blood pressure so that an adequate supply of oxygenated blood can reach all organ systems
 c) so that natural selection will act to maintain and strengthen the interventricular septum
 d) so it can mix with deoxygenated blood in three-chambered heart

7) Platelets are
 a) a special type of leukocytes.
 b) a special type of red blood cells.
 c) involved in blood clotting.
 d) involved in immune reactions.
 e) a special type of white blood cells.

8) Blood returning from the body first enters the heart through the
 a) aorta.
 b) left atrium.
 c) right atrium.
 d) left ventricle.
 e) right ventricle.

9) Which of the following is *not* a function of the circulatory system?
 a) creating mucus
 b) transporting nutrients
 c) fighting disease
 d) moving wastes
 e) maintaining body temperature

10) Most of the oxygen in the blood is transported by
 a) plasma.
 b) hemoglobin.
 c) platelets.
 d) serum.
 e) leucocytes.

Test Yourself Answers

1) **d.** During exhalation, the volume of the chest cavity decreases by allowing the diaphragm muscle to relax, thereby resuming a dome-shape in the chest cavity. The rib muscles relax, allowing the ribs to rotate downward, reducing the chest volume.

2) **e.** With inadequate ventilation, CO_2 (which dissociates into carbonic acid) builds up in the blood, lowering blood pH. This stimulates the brain to increase breathing rate.

3) **d.** Capillaries are blood vessels consisting only of the endothelial lining, thus facilitating diffusion of gases and other molecules between the blood and body tissues.

4) **d.** Only larger veins have valves to prevent back flow of blood toward the capillaries.

5) **d.** Each of the choices either increases surface area for diffusion or minimizes the distance over which diffusion must occur. Both of these enhance gas exchange.

6) **b.** Blood passing through the lungs goes through capillaries; therefore, the blood pressure in the pulmonary veins returning to the heart is low. It must be repumped into arteries to be able to circulate through the body.

7) **c.** Platelets are fragments of blood cells circulating in the blood that assist in forming blood clots.

8) **c.** Blood returning from the body through either the superior or inferior vena cava enters the heart through the right atrium.

9) **a.** The circulatory system does not create mucus, but it does transport nutrients and waste materials, help to maintain body temperature, and carry WBC and other factors that help control disease.

10) **b.** Hemoglobin is the molecule in RBC that has an affinity for oxygen, binding it for transport throughout the body.

Excretory System

The two-fold function of the excretory system is to regulate the osmotic concentration of the body fluids bathing the cells and to filter and remove waste materials from the blood. Cells function only within a narrow range of conditions, including water and salt concentrations; thus, osmoregulation is essential. Removal of waste materials, especially toxic nitrogenous wastes, is also essential to maintain cell function in the body. Osmosis (see Chapter 4) drives proper function of the excretory system.

The excretory system consists of two primary organs, the **kidneys** and **bladder,** and associated connecting tubes, the **ureters** and **urethra.**

■ KIDNEY

The kidneys connect to the circulatory system with blood supplied directly from the aorta shortly after leaving the heart, and return flow directly into the inferior vena cava. There is constant and significant blood flow through this filtering organ. Each kidney connects to the bladder through a tubular ureter. The bladder is a muscular collection sac, which expands to hold several hundred milliliters of urine. A sphincter at the base of the bladder regulates excretion through the urethra, the tubular passage to the outside.

Each kidney is roughly the size of a fist. Sliced lengthwise, three distinct regions are visible.

The tough inner core, the **renal pelvis,** funnels the urine produced by individual **nephrons** into the ureter. The outer tissues, the **cortex,** appear densely homogeneous, while the inner **medulla** appears more fibrous. Blood vessels are scattered throughout the tissues. The textures of the cortex and medulla relate to the structure of individual nephrons and their degree of packing. They also correlate with the salt concentration of the surrounding cells. From the outer cortex to the inner medulla is a steep concentration gradient with the highest concentration of salts on the inside. (When cooking beef or pork kidneys, they must often be soaked for an hour or two in water to remove salts.)

Nephron

The functional unit of the kidney is a nephron.

Each nephron has four essential functions: 1) to collect filtrate from blood capillaries; 2) to reabsorb water back into the blood; 3) to secrete salts back into the surrounding tissue; and 4) to excrete filtered and concentrated waste materials.

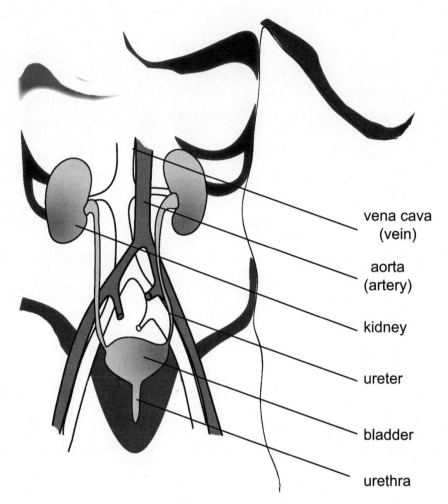

vena cava
(vein)

aorta
(artery)

kidney

ureter

bladder

urethra

Figure 43-1. Organs of the excretory system. The excretory system consists of the kidneys, ureters, bladder, and urethra.

Bowman's Capsule

Blood filtration occurs in **Bowman's Capsule** near the periphery of the cortex. Within the capsule is a capillary network called a **glomerulus.** The glomerulus consists of interconnected arterioles that reconnect to form a smaller arteriole network. As a result, pressure builds within the vessels, and water and dissolved materials are forced out of the glomerulus and collected by the surrounding Bowman's Capsule. Kidney cells in this region are isoosmotic with the blood plasma with a total solute concentration of about 300 milliosmoles/L (mosm/L). Nearly fifty gallons of liquid is expressed daily by the kidney nephrons. This raises a major problem for the body—how to reabsorb most of this water, the essential ions, and nutrients that were lost with it.

Tubule

Reabsorption, secretion, and excretion are the functions of the nephron tubule and collecting duct. The tubule consists of three anatomically and physiologically distinct regions—the **proximal tubule, Loop of Henle,** and **distal tubule** that function in consort.

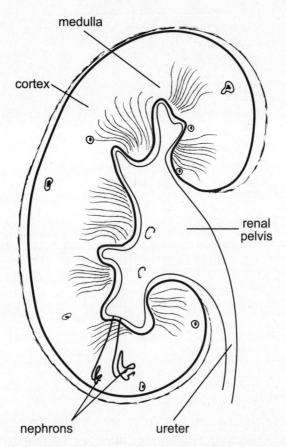

Figure 43-2. Kidney structure. The kidney consists of an inner medulla embedded within a surrounding cortex. Individual nephrons run through these tissues and empty into collecting ducts that feed into the renal pelvis, which funnels urine into a ureter.

Both the proximal and distal tubules are located in the outer cortex of the kidney, where salt concentrations are low and the free energy of water is high. In both, some reabsorption of ions and nutrients occurs.

Loop of Henle

The Loop of Henle descends from the cortex in to the inner medulla, where it turns and reverses course, ascending back into the cortex. The descending and ascending arms are structurally and functionally distinct. The membranes of the descending arm do not contain specialized carrier molecules. Instead, water is reabsorbed by the tissues by passive osmosis. As filtrate in the tubule moves deeper into the medulla, the surrounding tissue becomes ever saltier. Total solute concentration at the loop approaches 1,200 mosm/L, producing a concentration gradient. Within the tubule, free energy of water is much higher than in the surrounding tissue, so water diffuses out of the tube and into the surrounding tissues by osmosis.

As concentrated filtrate moves around the loop and begins ascending back toward the cortex, it is moving into regions where the osmolarity of the surrounding tissue is decreasing (and the free energy of water is increasing). The normal tendency would be for water to return to the filtrate by osmosis. Instead,

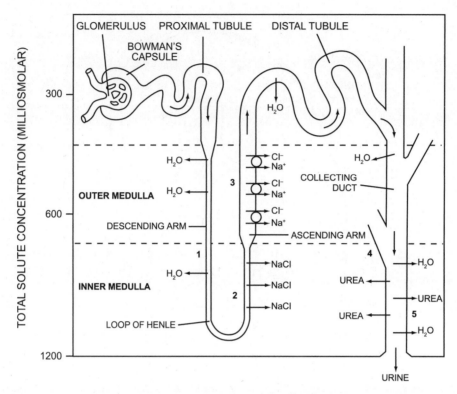

Figure 43-3. The nephron. The nephron consists of Bowman's Capsule, wrapped around a capillary glomerulus, and a long tubule that descends into the saltier medulla, does a hairpin turn to ascend back into the cortex, and finally descends back into the medulla in a collecting duct. The descending segments are permeable to water, which tends to diffuse into the more concentrated surrounding tissue. The ascending segment is impermeable to water and pumps ions out of the filtrate, which effectively dilutes the filtrate.

the membranes of the ascending arm are less permeable to water and more permeable to salt, and salt diffuses out of the filtrate, keeping the filtrate isoosmotic with the surrounding tissues. In the outer medulla, passive salt diffusion is no longer effective, but the membranes now contain ion pumps that actively pump salts out of the filtrate and into the surrounding tissues. Even though the tubule is now passing through tissue as the same osmotic concentration as the original Bowman's capsule, and even though the filtrate contains concentrated waste products originally filtered from the blood plasma, water does not diffuse into the filtrate because enough salt was excreted to make the filtrate isoosmotic.

From the distal tubule, filtrate passes into a collection duct, connected to other nephrons. As the duct descends through the medulla, it functions in the same way as the descending arm of the Loop of Henle. Water diffuses from higher free energy to lower free energy and is reabsorbed by the kidney tissues, concentrating the filtrate even more. As water is lost from the filtrate, the relative concentration of urea in the filtrate increases and begins to diffuse into the inner medulla tissue, helping to maintain the high osmolarity of the tissue.

The collecting ducts empty urine into the renal pelvis for transport out of the kidney through the ureter for storage in the bladder until it is periodically eliminated from the body through the urethra.

Test Yourself

1) Digestive wastes are eliminated by _____, whereas cellular wastes are eliminated by _____.
 a) absorption, excretion
 b) defecation, secretion
 c) defecation, excretion
 d) absorption, defecation

2) Which of the following structures empties directly into the bladder?
 a) Loop of Henle
 b) ureter
 c) urethra
 d) renal pelvis

3) The functional units of kidneys are
 a) neurons.
 b) glomeruli.
 c) ureters.
 d) nephrons.

4) Diffusion across cell membranes is an essential process for the proper function of which system?
 a) respiratory
 b) digestive
 c) excretory
 d) endocrine
 e) all of the above

5) Which of the following is removed from the filtrate in the descending loop of the nephron?
 a) glucose
 b) NaCl
 c) water
 d) ammonia
 e) proteins

6) Which part of the nephron is *least* permeable to water?
 a) proximal tubule
 b) descending arm
 c) turn of the Loop of Henle
 d) ascending arm
 e) distal tubule

7) The filtrate within the nephron is *most* concentrated in the
 a) proximal tubule.
 b) descending arm.
 c) turn of the loop of Henle.
 d) ascending arm.
 e) distal tubule.

8) Fluid moves from the glomerulus into Bowman's Capsule because
 a) beating cilia set up a current flow.
 b) blood pressure is high in the glomerulus.
 c) smooth muscles in Bowman's Capsule contract to "milk" the glomerulus.
 d) suction created by flow of urine out of the collecting ducts.

Test Yourself Answers

1) **c.** Digestive wastes, stored in the colon, are indigestible material and bacteria. Metabolic waste products are carried by the blood from the cells, where they are produced, to the kidneys, where they are filtered from the blood and excreted in the urine.

2) **b.** The ureter is a tube connecting a kidney to the bladder.

3) **d.** Nephrons are the functional units of kidneys, running from the outer cortex to the inner medulla. Glomeruli are surrounded by Bowman's Capsule at the beginning of the nephron.

4) **e.** Diffusion of substances across a cell membrane is essential to each of the systems listed.

5) **c.** In the descending loop, water diffuses out of the filtrate as the tube moves toward the loop of Henle.

6) **d.** The ascending arm is least permeable to water to prevent inflow of water as it moves into tissue with higher concentrations of water.

7) **c.** The filtrate is in highest concentration at deepest levels in the medulla, the hairpin loop of the loop of Henle.

8) **b.** The glomerulus is a network of arterioles that connects to a smaller network of arterioles, thus constricting flow and building blood pressure, which causes plasma to leak out of the vessels into Bowman's capsule.

Nervous and Sensory Systems

The nervous system provides for rapid coordination of activities in the body involving sensory perception and response. It consists of a central nervous system (the brain and spinal cord), that receive and process information, and a peripheral system of sensory perception and motor response. The neuron is the basic cell type (see Chapter 40).

■ NEURON STRUCTURE

A typical neuron (see Chapter 40; specifically, Figure 40-6) has the nucleus and most of the cytoplasm concentrated in the cell body. A variety of processes extend from the cell body. Branched dentrites receive stimulation, either directly from the environment, from a receptor, or from another neuron. In response to the stimulation, an impulse is set up that proceeds along the membrane toward the cell body. An elongated axon carries the impulse away from the cell body toward either another neuron or an effector cell such as a muscle or gland cell. The terminal end of the axon may branch profusely with each branchlet, ending in a terminal synaptic knob. A single axon in humans can be up to two meters long! The axon is usually insulated by a series of ensheathing cells.

■ NERVE IMPULSE

A nerve **impulse** is an electrochemical phenomenon that depends on establishing an electrical potential across the cell membrane. The neuron membrane contains several specialized transmembrane transport channels. Open Na^+ and K^+ channels allow diffusion of both cations, but K^+ diffuses much more quickly. At the same time, the Na^+/K^+ pump actively co-transports three Na^+ out of the cell for every two K^+ in.

The pump, along with more rapid diffusion of K^+ back out of the cell, establishes a polarized resting potential, with the outside of the membrane positively charged relative to the more negative interior.

In addition to the open channels, there are special chemically **gated channels** in the receptive regions of dendrites, and charge-gated channels along the entire length of the neuron that respond either to chemical neurotransmitters or to sudden depolarization of the membrane. Stimulation opens the gated channel allowing Na^+ to rush into the negatively charged cells, momentarily reversing the membrane potential in that localized region of the membrane and creating an **action potential.**

Resting Potential

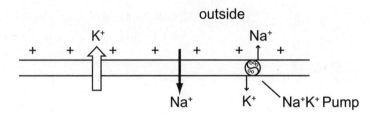

neuron interior

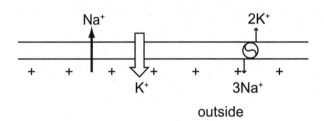

outside

Figure 44-1. Resting potential. The neuron membrane is more permeable to K⁺ (thicker arrows) than Na⁺, so more K⁺ diffuses out of the cell than Na⁺ moves in. Simultaneously, Na⁺/K⁺ pumps move more Na⁺ out than K⁺ in. As a result, total positive charge is greater outside the membrane, while the inside has negative charge.

The influx of positive charge opens charge gated K⁺ channels, allowing K⁺ to rush out of the cell, repolarizing the membrane. The entering positive ions spread laterally toward the still-polarized membrane, attracted by the negative charge. This opens new charge-gated Na⁺ channels that establish a new action potential, and the process propagates the length of the membrane from the point of initial stimulus to the synaptic knobs on the end of the axon. At the synapse, the impulse causes release of chemicals, either noradrenaline or acetylcholine, which pass across the synaptic cleft to stimulate in impulse in the next cell.

■ CENTRAL NERVOUS SYSTEM

The central nervous system consists of the brain and spinal cord. Both consist of massed neurons. Areas composed primarily of cell bodies and small connecting neurons are called **gray matter.** Areas consisting primarily of axon fibers, and their associated myelin sheaths, are **white matter.**

Brain

The brain has three major regions, the **brain stem,** the **cerebellum,** and the **cerebrum.** The brain stem is an extension of the spinal cord and controls primitive functions such as heartbeat and respiration. All nerve fibers passing through to the higher regions of the brain cross over from the left side of the body to the right side of the brain, either in the spinal cord itself or in the brain stem. The primary function of the cerebellum is coordination of muscular activity. The cerebrum receives sensory stimuli and is involved in mental functioning. In the brain, the gray matter is on the outside around the periphery, while the white matter is in deeper tissue.

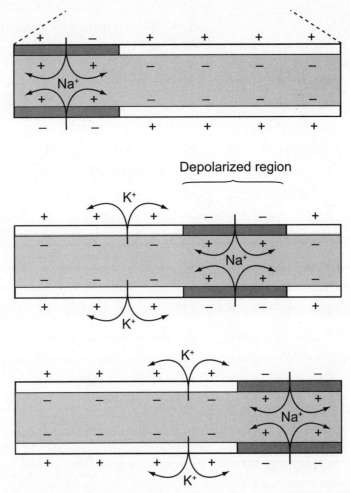

Figure 44-2. Action potential. A sudden inrush of Na⁺ locally reverses polarity of the membrane, establishing an action potential. Lateral movement of Na⁺ causes K⁺ to diffuse outward on the rear side of the direction of propagation and depolarizes the region in the direction of propagation.

Spinal Cord

The spinal cord is an extension of the brain stem, with the white matter surrounding the gray matter.

In addition to transmitting nerve impulses from the peripheral system to the brain, the spinal cord functions in coordinating **reflex responses.** Sensory neurons from certain areas of the body synapse directly with motor neurons back to the effected area. Stimulation of that area produces an automatic reflex response. The synapse also connects to the central nervous system, so that you are conscious of the stimulation, but only after you reflexively respond.

■ PERIPHERAL NERVOUS SYSTEM

The **peripheral nervous system** consists of incoming sensory nerves and outgoing motor nerves connected to the central nervous system. A nerve consists of bundles of neurons running parallel to each other from the same area, sheathed with a wrapping of connective tissue. **Cranial nerves** connect to the brain. **Spinal nerves** connect to the spinal cord. **Sensory nerves** either directly respond to stimulus or

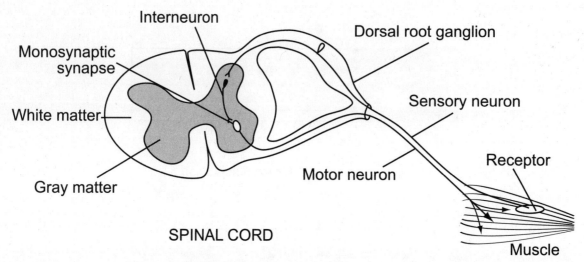

Figure 44-3. Spinal cord. The spinal cord has a butterfly-shaped region of gray matter surrounded by white matter. Incoming sensory neurons have their cell bodies concentrated in a dorsal root ganglion outside of the spinal column. They synapse with internerons and motor neurons in the gray matter, providing a rapid reflex response.

synapse with specialized sensory cells in sense organs. The direction of nervous impulse in sensory nerves is always toward the central nervous system.

Motor nerves from the central nervous system are either somatic or autonomic. **Somatic** nerves are under voluntary control of the central nervous system and supply skeletal muscles. Nerves of the **autonomic** system also are controlled by the central nervous system, but they are involuntary and supply smooth muscle and cardiac muscle. The autonomic system has two antagonistic components, both of which supply each major organ system. Nerves of the **parasympathetic** system arise either as cranial nerves or sacral nerves from the most distal region of the spinal cord. The cranial nerves innervate all the major organs of the body except the genital organs; the sacral nerves innervate the genitals. Parasympathetic neurons secrete acetylcholine, which slows or inhibits all the organs except those of the digestive system. The **sympathetic** system has the opposite effect. Sympathetic nerves arise from the rest of the spinal cord and stimulate all the body organs except the digestive system, which is inhibited. Sympathetic neurons typically release noradrenaline.

■ SENSORY PERCEPTION

Sensory neurons are either directly or indirectly affected by a specific environmental stimulus. This stimulus initiates an action potential that travels to the central nervous system.

Touch

The simplest receptors are free nerve endings that are sensitive to pain or temperature. Such receptors are concentrated in the finger tips and around body openings. Pressure is perceived by specialized receptor cells that synapse with sensory neurons. The nerve endings associated with hair follicles are also sensitive touch receptors. Mechanical movement of the hair is transmitted to the associated nerve endings.

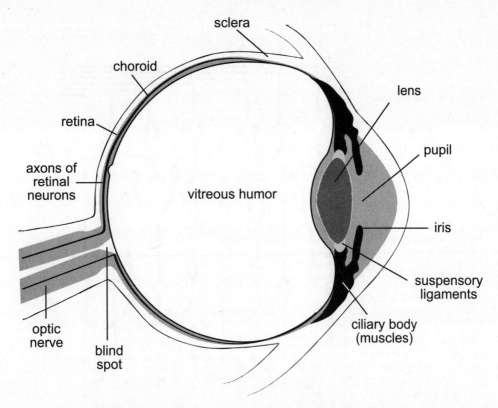

Figure 44-4. Eye. Light passes through the clear cornea and enters the eye through the variable opening defined by the iris, the pupil. The flexible lens focuses light on the retina at the back of the eye.

Light

Light is perceived by a complex organ, the eye.

The outer covering of the eye, the **cornea,** is a clear tissue lacking blood supply. Its cells depend entirely on diffusion over large distance for nutrition. This is why it is slow to heal, if damaged. The shape of the cornea is maintained by pressure from the **aqueous humor,** a secreted fluid that fills the space beneath the cornea.

The **iris,** is a large sphincter muscle with pigmented cells. It serves as a movable opaque diaphragm that regulates the amount of light entering the eye. In dim light, the muscles contract and the **pupil** enlarges. In bright light, the muscles relax and the pupil narrows.

Behind the iris a crystalline but flexible **lens** is suspended by a ring of muscles. Contraction of these muscles changes the shape of the lens, which permits focusing. The relaxed lens is flattened and optimized for distant vision. Contraction of the muscles thickens the lens to accommodate near focus.

Light passing through the lens is focused on the **retina,** the inner lining of cells at the back of the eye. The retina consists of multiple layers of cells.

At the very back of the retina is a **pigmented epithelium** that serves as a reflective layer. Some of the pigments are carotenoids, yellow pigments that are not synthesized by animals but must be obtained in the diet from plants. Incoming light passes through all the layers and is reflected from the epithelium onto the photoreceptor cells. Camera "red eye" is the light reflected off the pigmented epithelium that passes through the cell layers (including capillaries) and back out the pupil straight into the camera lens. Avoid red eye by moving the camera flash away from the lens so that light will not reflect directly back to the lens.

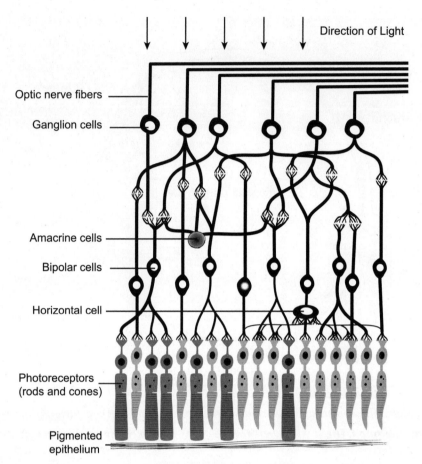

Figure 44-5. Retina. The retina is a cellular layer at the back of the eye, where light is perceived. A pigmented epithelial layer at the rear surface acts as a light reflector. The rods and cones are light receptors oriented toward the pigmented epithelium. The energy absorbed by pigments establishes an action potential that is transmitted to internerons and, ultimately, to the neurons of the optic nerve.

There are two types of photoreceptor cells. **Rods** are more elongated and sensitive to black and white. They are also more sensitive in low-light conditions and are in greater concentration off center. At night, you are more likely to see shape or movement by not looking directly at the object. **Cones** are shorter cells with pigments sensitive to color. Cone cells also provide greater resolution and are concentrated directly back of the pupil.

The light absorbed by rods or cones sets up an action potential in the membrane of those cells that migrates to synapse with intermediate neurons that, in turn, synapse with neurons of the optic nerve.

Chemical

The chemical receptors are taste buds and smell receptors. Receptor membranes are sensitive to particular chemicals, associated with a primary taste or odor, that initiate an action response. The primary tastes are sweet, sour, salty, and bitter, which are all associated with taste buds in specific locations on the tongue. The seven primary odors are camphoric, musky, floral, minty, ether-like, pungent, and putrid. Because the mouth and nasal cavity are connected, tastes of food in the mouth also produce odors sensed

in the nose. We associate a taste with both stimuli. This is why food doesn't taste the same when you have a cold and your nose is full of mucous.

Sound

Like the eye perceiving light, the ear is a complex structure for perceiving the sense of sound.

The outer ear funnels sound waves toward the **tympanic membrane** (ear drum), which vibrates in synchrony with the sound waves as long as the auditory tube (**eustachian tube**) is open. The auditory tube connects the middle ear cavity to the pharynx at the back of the throat. Swallowing will sometimes relieve partial blockage to relieve pressure on the eardrum. This connection to the mouth is also the source of bacteria that cause middle ear infections, especially in children.

In the middle ear, movement of the tympanic membrane is amplified mechanically by a series of three bones: the **hammer,** the **anvil,** and the **stirrup**. Additional amplification is due to the fact that the eardrum has a larger surface area than the **oval window,** the membrane of the inner ear to which the stirrup attaches.

The inner ear (**cochlea**) is a coiled, tubular structure divided down the middle by a **Basilar membrane,** with two fluid-filled chambers above and one below.

The upper chamber, bounded by the oval window, is continuous around the end of the cochlea to the lower chamber, which is bounded by the flexible membrane of the **round window.** Mechanical vibrations of the stirrup produce sympathetic waves in the fluid of the canals.

On the upper surface of the basilar membrane in the **Organ of Corti** are receptor cells, the hair cells. Cilia-like hairs project from the hair cells and contact the **tectorial membrane.** The basilar membrane varies in stiffness along its length. It is stiffest close to the oval window and looser the farther you move along its length. Like a stringed instrument, short, tight strings produce a high pitch, while long, loosely vibrating strings produce a low pitch. Fluid sound waves in the canals put pressure on different regions

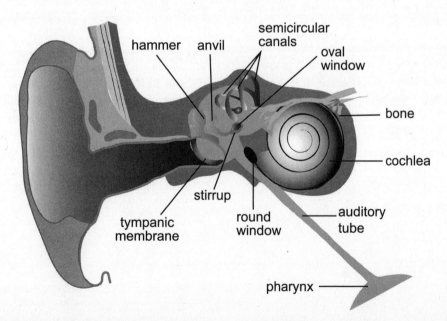

Figure 44-6. Ear. The outer ear funnels sound waves to the tympanic membrane, which vibrates in synchrony. Movement of the ear drum is mechanically transferred to the oval window of the cochlea by three small bones: the hammer, the anvil, and the stirrup.

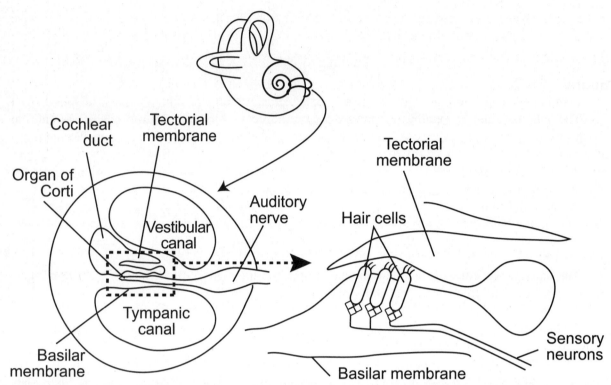

Figure 44-7. Cochlea. *The spiral-shaped cochlea is a fluid-filled organ divided into three canals. The vestibular and tympanic canal are connected. The Organ of Corti, containing hair cells, is located within the middle chamber, the cochlear duct. Fluid movement in the outer canals put pressure on the basilar membrane at different positions, depending on the wavelength of moving fluid.*

of the basilar membrane, which, in turn, presses different hair cells against the tectorial membrane. Hair cells in the stiff region are sensitive to high pitch, while those in the looser region are sensitive to low pitch. The hair cells are mechanoreceptors and, when stimulated, produce an action potential in their associated auditory neurons. With age and use, hair cells begin to wear out. Typically, we begin to lose our ability to hear higher frequencies in middle age.

Test Yourself

1) Hair cells in the semicircular canals and in the cochlea are examples of
 a) chemoreceptors (responsive to chemicals).
 b) photoreceptors (responsive to light).
 c) thermoreceptors (responsive to temperature).
 d) mechanoreceptors (responsive to motion).

2) Rod cells are adapted for
 a) vision in full sunlight.
 b) vision in dim light.
 c) underwater vision.
 d) color vision.

3) An action potential is generated when
 a) Na^+ ions rush into the cytoplasm at the trigger zone.
 b) K^+ ions rush into the cytoplasm along the axon.
 c) Ca^{++} ions rush into the cytoplasm at the dendrites.
 d) K^+ ions rush out of the cytoplasm at the trigger zone.

4) Higher brain functions, like creativity and analytical skills, are centered in the
 a) brain stem.
 b) hypothalamus.
 c) cerebrum.
 d) cerebellum.

5) Sound waves are transmitted from the eardrum to the cochlea via the
 a) anvil, hammer, and stirrup.
 b) external auditory canal.
 c) eustachian canal.
 d) semicircular canals.

6) Nervous transmission in a single neuron typically proceeds along which sequence of structures?
 a) terminal synaptic knobs, axon, cell body, dendrites
 b) dendrites, cell body, axon, terminal synaptic knobs
 c) dendrites, axon, terminal synaptic knobs, cell body
 d) terminal synaptic knobs, cell body, axon, dendrites

7) Dimly lit objects are best observed out of the corners of the eyes because
 a) rod cells cannot sense color.
 b) cone cells are located mostly around the retina's periphery.
 c) rod cells are located mostly around the retina's periphery.
 d) where the optic nerve leaves the retina, there are no rod or cone cells.

8) Cell bodies and dendrites make up
 a) interneurons.
 b) white matter.
 c) gray matter.
 d) ganglia.
 e) meninges.

9) The term for *all* nerves leading to and from the spinal cord is
 a) sympathetic nervous system.
 b) autonomic nervous system.
 c) somatic nervous system.
 d) central nervous system.
 e) peripheral nervous system.

10) The type of neuron that receives impulses from the central nervous system and transmits these impulses to body cells is
 a) sensory neuron.
 b) interneuron.
 c) motor neuron.
 d) dendritic neuron.

Test Yourself Answers

1) **d.** The hairs of hair cells are mechanically stimulated when sound waves in the cochlea vibrate the basilar membrane, causing certain hair cells to rub against the tectorial membrane

2) **b.** Rod cells, which are sensitive to black and white, are more effective than cone cells to low intensity light levels.

3) **a.** A sudden rush of Na+ from outside the membrane, through gated channels into the cytoplasm, establishes an action potential.

4) **c.** The cerebrum, most well developed in humans, is the center of higher-order skills.

5) **a.** The anvil, hammer, and stirrup mechanically connect the eardrum to the oval window of the cochlea.

6) **b.** An action potential is initiated in the dendrite, and then propagates the length of the neuron, through the cell body, axon, and terminal synaptic knobs.

7) **c.** Rod cells are not located directly behind the lens (cone cells are); therefore, dimly light objects, which are best seen using rods, are most visible when not looking directly at an object.

8) **c.** Concentrations of cell bodies and dendrites are dark and make up gray matter. Concentrations of axons surrounded by fatty myelin sheaths make up white matter.

9) **e.** All neurons not part of the brain or spinal cord make up the peripheral nervous system.

10) **c.** Motor neurons are the component of the peripheral nervous system that carry nerve impulses from the central nervous system to body cells.

Endocrine System

The endocrine system provides chemical control of the body. The chemicals (called hormones) are produced in small amounts in specialized tissues called glands that affect growth in other parts of the body. Most hormones are formed from amino acids, but those produced by the gonads (testosterone, estrogen, and progesterone) and the adrenal cortex are steroids derived from cholesterol.

The chemicals secreted by endocrine glands are transported in the blood. As a result, endocrine control is not as rapid as nervous control, but the effects may be longer lasting. In addition, hormones transported in the blood come in contact with all cells in the body and may have widespread effect—for example, on smooth muscles throughout the body. Nervous control is limited to the specific cells that are hardwired to the neuron.

■ MAJOR ENDOCRINE GLANDS

The major endocrine glands are distributed throughout the body.

Some glands produce a single hormone with a single specific effect. Others produce two or more different hormones. Some glands are composite structures with additional, other-than-hormonal, function.

■ HYPOTHALAMUS AND PITUITARY GLANDS

The hypothalamus, which is actually a portion of the brain, is sometimes called the master gland.

Specialized neurosecretory cells in the hypothalamus coordinate nervous and endocrine control in the body. They have synaptic connection with other neurons in the brain and are directly stimulated by them. Some of these secretory synaptic endings extend farther into the posterior lobe of the pituitary, where they release hormones into the blood. Others are associated with capillary nets in the base of the hypothalamus, which carry blood and neurosecretions into the separate anterior lobe of the pituitary gland. For example, gonadotropin-stimulating hormones (GSH) is released into these capillaries and target specific pituitary tissues to release hormones targeted to the gonads (ovaries in women and testes in men).

The posterior lobe of the pituitary is an extension of the hypothalamus, where neurosecretory cells release antidiuretic hormone (ADH) and oxytocin into the blood stream. In women, oxytocin release stimulates milk expression by the mammary glands and uterine contractions. In males, oxytocin stimu-

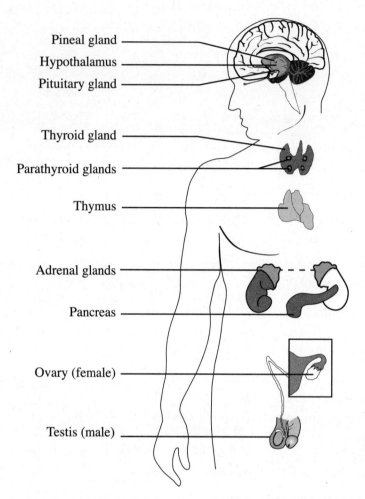

Figure 45-1. Endocrine glands. Endocrine glands are secretory tissues located throughout the body. Ovaries and testes are the female and male gonad/endocrine glands, respectively.

lates sperm release. ADH uses negative feedback to regulate uptake of water by the kidneys. ADH causes the collecting ducts of the kidney nephrons to become more permeable to water (see Chapter 43). As a result, more water is reabsorbed, and the urine becomes more concentrated. Increased hydration of the blood is sensed in the hypothalamus and ADH production ceases. As ADH levels in the blood decrease, the collecting duct becomes impermeable, less water is reabsorbed, and more is expelled in the urine. Water levels in the blood decrease and the cycle is repeated.

The anterior lobe of the pituitary consists entirely of endocrine tissues that receive their blood supply via the hypothalamus. Six different hormones are secreted by this gland. Four of these are **tropic hormones** that act on other endocrine glands. They include follicle-stimulating hormone (FSH) and lutenizing hormone (LH) that will be discussed in the following sections. Thyroid-stimulating hormone (TSH) and acrenocorticotropic hormone (ACTH) act on the thyroid and adrenal glands, respectively. Two non-tropic hormones produced by the anterior pituitary are prolactin and growth hormone. Prolactin stimulates milk production by the mammary glands, while growth hormone has an overall effect on cell division and enlargement of cells throughout the body through adolescence. Growth spurts during puberty are in response to increased levels of growth hormone.

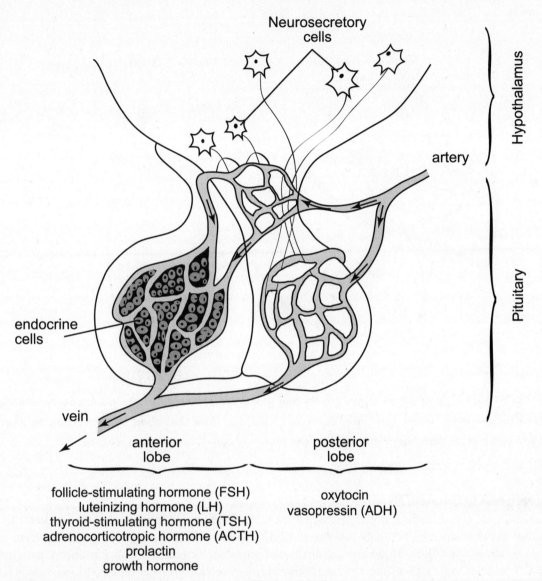

Neurosecretory
cells

Hypothalamus

artery

Pituitary

endocrine
cells

vein

anterior
lobe

posterior
lobe

follicle-stimulating hormone (FSH)
luteinizing hormone (LH)
thyroid-stimulating hormone (TSH)
adrenocorticotropic hormone (ACTH)
prolactin
growth hormone

oxytocin
vasopressin (ADH)

Figure 45-2. Hypothalamus and pituitary glands. The hypothalamus and posterior pituitary are composed of neural tissue. The anterior pituitary, whose blood supply comes through the hypothalamus, is endocrine tissue. The hypothalamus coordinates the nervous and endocrine systems.

■ THYROID AND PARATHYROID

The butterfly-shaped thyroid gland is located in the neck region above the pharynx and is the target of TSH released from the anterior pituitary. When stimulated, thyroid cells produce the hormone thyroxin, which regulates body metabolism and growth. Overproduction of thyroxin (hyperthyroidism) results in nervousness, insomnia, high blood pressure, and high heart rate. Hypothyroidism symptoms, on the other hand, include low metabolic rate, constipation, lethargy, and edema (accumulation of body fluids).

The parathyroids are four small glands attached to the underside of the thyroid. The parathyroids produce parahormone that helps regulate calcium balance in the blood.

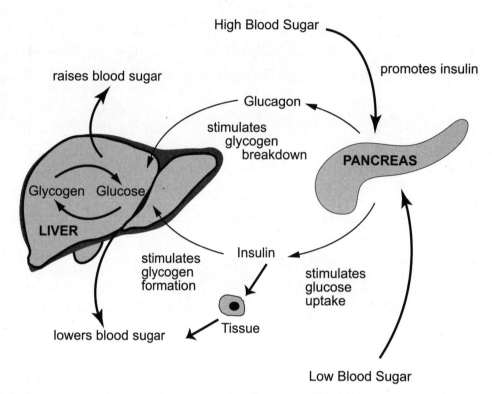

Figure 45-3. Regulation of blood sugar. Insulin and glucagon, produced in the pancreas, have opposing influence on the liver. Insulin stimulates removal of glucose from the blood by conversion to glycogen. Glucagon stimulates secretion of glucose into the blood by conversion from glycogen.

■ ADRENAL GLANDS

The adrenal glands, sitting atop each kidney, are composite glands composed of two different tissues. The outer adrenal cortex produces numerous corticosteroids that are involved in long-term stress response, such as controlling blood volume and blood pressure, blood sugar concentrations, and the conversion of proteins and fats into sugar. The anterior pituitary releases ACTH into the blood, which targets the adrenal cortex.

The adrenal medulla is actually nervous tissue of the autonomic nervous system whose synapses release hormones directly into the capillaries of the adrenal gland. Its sympathetic neurons (see Chapter 44) release epinephrine and norepinephrine into the blood as part of the fight-or-flight syndrome.

■ PANCREAS

Both the pituitary and adrenal gland are composites of endocrine and neural tissue. The pancreas is also a mixed gland, but of endocrine and exocrine cells. Most cells of the pancreas are exocrine and are involved in the digestive process (see Chapter 41). Scattered throughout this tissue are patches of endocrine cells called the Islets of Langerhans. Islets contain two types of cells. Alpha (α) cells produce glucagons, while beta (β) cells produce insulin. The hormones insulin and glucagons have opposing effects on the liver to regulate levels of blood sugar.

High concentrations of sugar in the blood promote insulin production by the pancreas. Insulin is carried to all cells of the body, stimulating them to take up glucose, thereby lowering blood sugar. Just as important, insulin stimulates liver cells to convert glucose in the blood into glycogen which is then stored.

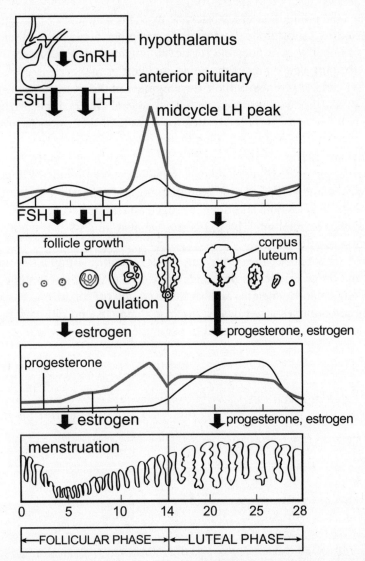

Figure 45-4. Hormonal control of menstrual cycle. The hypothalamus produces a gonadotropin-releasing hormone, which stimulates secretion of a lutenizing hormone and a follicle-stimulating hormone by the anterior pituitary. These stimulate follicle development, which produces estrogen. Rising estrogen levels have a positive feedback of LH and FSH, eventually causing a peak of LH that stimulates ovulation. The corpus luteum continues estrogen production and production of progesterone, both of which stimulate development of the uterine lining but also shut down GnRH.

This also lowers blood sugar concentration. If blood sugar concentrations are low, the pancreas produces glucagons, which stimulates glycogen breakdown in the liver, converting it into glucose, which is released into the blood, raising blood sugar concentration.

■ GONADS, TESTES, AND OVARIES

GSH released by the hypothalamus promotes production and release of FSH and LH by the anterior pituitary. Although these hormones were named with reference to the female gonads, they also affect the

testes. LH stimulates the production of testosterone by the testes, and FSH stimulates sperm formation, which is also affected by testosterone. Testosterone has other noticeable effects. Production of testosterone, beginning at puberty, is responsible for development of the secondary male sex characteristics including the growth spurt, deepening of the voice, and hair growth.

In women, FSH and LH promote follicle development in the ovaries (see Chapter 47).

The growing follicle produces estrogen, which has several effects. First, estrogen promotes increased follicle development, which positively feeds back to promote further estrogen production. Second, estrogen promotes growth of the uterine lining. Finally, estrogen has positive feedback to the pituitary to produce additional FSH and LH.

The peak of LH at midcycle triggers meiosis in the oocyte within the follicle. It also stimulates ovulation and the subsequent development of the remaining follicle cells to form the corpus luteum. The growing corpus luteum secretes both additional estrogen and progesterone. Both hormones promote additional thickening of the uterine lining, but progesterone also inhibits the hypothalamus and pituitary to shut down production of FSH and LH.

If fertilization does not occur, the corpus luteum degenerates within a few days, thus decreasing the levels of estrogen and progesterone. As the concentration of these hormones decrease, the uterine lining cannot be maintained, and it degenerates and begins to slough off, in the process known as menstruation. The decrease of these hormones also releases the hypothalamus and pituitary from negative inhibition, and GSH, FSH, and LH are again synthesized to begin the process anew and repeat the cycle.

Test Yourself

1) If the blood supply to the Islets of Langerhans were somehow to be severely reduced, what would be the most direct result?

 a) disturbed glucose metabolism

 b) less bicarbonate added to chyme

 c) incomplete digestion of chyme within the lumen of the small intestine

 d) failure of the posterior pituitary to secrete hormones

2) The following is an example of a steroid hormone:

 a) estrogen.

 b) glucagon.

 c) oxytocin.

 d) insulin.

 e) thyrotropin.

3) High levels of this hormone bring about ovulation.

 a) LH

 b) FSH

 c) estrogen

 d) progesterone

 e) testosterone

4) The level of this hormone increases in the blood as a means to conserve water.

 a) oxytocin

 b) insulin

 c) FSH

 d) ADH

 e) salt

5) The following is an example of a nonsteroid hormone:

 a) estrogen.

 b) aldosterone.

 c) cortisol.

 d) testosterone.

 e) insulin.

6) Insulin is

 a) an enzyme that is produced by the pancreas that serves to break down glycogen into glucose during fasting.

 b) a hormone produced by the α-cells of the pancreas to raise the blood sugar level.

 c) a polypeptide steroid produced by the β-cells of the pancreas that raises the blood sugar level.

 d) a polypeptide hormone produced by the β-cells of the pancreas that lowers the blood sugar level.

 e) a polypeptide produced by the α-cells of the pancreas that raises the blood sugar level.

7) Which of the following is an *incorrect* statement? Hormones
 a) are produced by neurons.
 b) are produced by endocrine glands.
 c) transmit fast, short-lived signals.
 d) are transported through the blood stream.
 e) affect only particular target cells.

8) In negative feedback, control mechanisms,
 a) high levels of a substance lead to an eventual decrease in that substance.
 b) high levels of a substance lead to a further increase in that substance.
 c) homeostasis is rarely maintained.
 d) low levels of a substance lead to further decreases in that substance.
 e) low levels of a substance inhibit the production of that substance.

9) The hormone that initiates development of the oocyte and associated cells in the ovaries of women and testosterone production by the testes of men is
 a) estrogen.
 b) progesterone.
 c) somatropin.
 d) FSH (follicle-stimulating hormone).
 e) LH (lutenizing hormone).

10) FSH and LH are secreted by the
 a) hypothalamus.
 b) anterior pituitary.
 c) ovary.
 d) vagina.
 e) uterus.

Test Yourself Answers

1) **a.** The Islets of Langerhans produce insulin and glucagon, which regulate glucose levels in the blood, including uptake by somatic cells.

2) **a.** Hormone produced by gonads, such as estrogen, are steroids. Other hormones are amino acid derivatives.

3) **a.** A peak of lutenizing hormone stimulates ovulation.

4) **d.** Antidiuretic hormone, produced by the hypothalamus and released in the posterior pituitary, affects the kidney tubules to control absorption of water.

5) **e.** Insulin, produced by the pancreas, is an amino acid–based hormone. Each of the others listed is a steroid produced either by a gonad or the adrenal cortex.

6) **d.** Insulin is an amino acid–based hormone (a polypeptide) produced by β-cells of the pancreas that lowers the blood sugar level.

7) **c.** Hormones, transported by the blood, are slow-moving but long-lived. Neurons in the hypothalamus and adrenal medulla release hormones, although most hormones are produced in adrenal glands. Hormones target particular cells.

8) **a.** In negative feedback, high levels of a substance lead to a decrease in its production and low levels stimulate additional production.

9) **e.** Lutenizing hormone from the anterior pituitary targets the oocyte-containing follicle in women and the testosterone-producing cells in the testes of men.

10) **b.** FSH and LH are secreted by the anterior pituitary.

Immune System

The human body provides ideal conditions not only to support its own cells and tissues, but also for a variety of parasites and pathogens. The immune system defends the body against foreign organisms.

The immune system has multiple layers of action. Innate immunity provides immediate protection against a broad range of microbes. The most effective defense is prevention, by baring entry into the body. If a barrier is breached, inflammatory response and phagocytic cells can minimize short-term damage. The final line of defense is acquired immunity, in which specific microbes are targeted for attack.

■ BARRIERS TO ENTRY

The initial line of defense against pathogens and parasites is to prevent their entry into the body. Membranes and epithelial tissues secrete antibiotics and sticky mucous that kill or immobilize microbes. Ciliary action sweeps trapped microbes away from vulnerable sites.

The skin is a specialized organ to prevent dessication and entry of microbes. The dead outer layers, the epidermis, is dry, and the cells are impregnated with keratin. Secretions from glands in deeper layers contain salts, oils, and antimicrobial chemicals. Perhaps most important is the normal microflora and microfauna resident on the surface of the skin. These symbiotic bacteria and fungi defend the body against pathogenic forms.

■ INFLAMMATORY RESPONSE

The inflammatory, or wound, response is the body's initial reaction to tissue damage and the presence of microbes.

Tissue injury, or white blood cells responding to the presence of bacteria, stimulates the release of histamine into the surrounding tissues. Histamines relax smooth muscles around arterioles, increasing blood flow to the area. Histamine also causes the capillaries become more permeable and leak plasma into the surrounding tissues. This causes the tissue to swell, redden, and warm. Histamine in the blood also stimulates a rise in body temperature. Temperatures of 100° to 102°F are beneficial, because this temperature inhibits the growth of many bacteria and viruses and promotes the activities of white blood cells (WBC), including the release of interferon. With injured tissue, a blood clot forms around the area, both internally and externally, which isolates the area from the environment and surrounding tissues. Finally, histamines stimulate the release of additional white blood cells into the blood and attracts phagocytic white blood cells to the area.

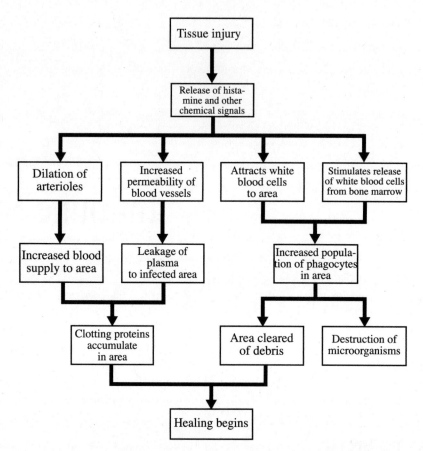

Figure 46-1. Inflammatory response. Histamines, released from injured cells, dilate arteries and increase permeability of blood cells in the affected area, eventually blocking the affected area off from the rest of the body. Simultaneously, white blood cell production is increased and white blood cells are attracted to the affected area.

■ ACQUIRED IMMUNE RESPONSE

Acquired immunity depends on two WBC classes: T-cells and B-cells. All WBCs are formed in the bone marrow of long bones. Immature WBCs will either migrate to the thymus, where they mature as T-cells, or remain in the bone and mature as B-cells. B-cells secrete antibodies that circulate in the blood and provide humoral immunity. The several different types of T-cells provide cellular immunity.

Killer T-cells function by perforating the membranes of invading cells. Helper T-cells assist B-cells in recognizing invading cells, and suppressor T-cells regulate B-cell response.

Both T-cells and B-cells contain special antigen receptor recognition sites on their membranes (see Chapter 4). The receptors on T-cells consist of two polypeptide chains with a terminal antigen binding site. B-cells have a Y-shaped receptor, consisting of four polypeptides with two identical binding sites. Each WBC contains thousands of individual antigen receptors, and each one is the same on that cell. However, the genes coding for the sites undergo rapid, random rearrangement. As a result, every WBC will carry a unique receptor. A T- or B-cell will attack a only microbe that contains an antigen complementary to its unique receptor. Given the millions of different WBCs circulating in the body at any given time, it is likely that at least one will have a recognition site matching a particular foreign invader. Although that cell by itself cannot successfully defend the body, a single cell is all that is needed to ini-

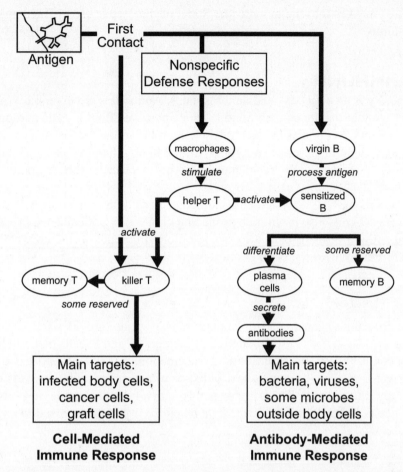

Figure 46-2. Immune response. Contact with an antigen activates killer T-cells (macrophages), which activate helper T-cells and B-cells. Activated cells begin rapid clonal production. B-cells release antibodies to establish humoral immunity. Some B-cells survive as memory cells. Killer T-cells attach to foreign cells, perforating their membranes. Some T-cells survive as memory cells.

tiate the immune response. It is important to realize that some WBCs will form with recognition sites that match the bodies own self-recognition system. These cells are recognized and destroyed during their development while they are still inactive.

■ CELLULAR IMMUNITY

One type of phagocytotic WBCs involved in the inflammatory response are the macrophages. Macrophages engulf microbes, strip off the microbial antigens, and display them on their outer membrane. Contact with a helper T-cell activates that cell, which will coordinate the activities of the cellular and humoral responses. Activated helper T-cells secrete cytokines that stimulate cell division, producing clones of the helper T-cell. Where originally, only a single cell recognized the antigens on the invading microbes, now numbers of identical cells are proliferating.

The same antigens that were displayed by the macrophage can activate T-cells directly to become killer T-cells, or they can be activated by cytokines from the helper T-cell. In either case, the killer cells target infected body cells, cancer cells, or graft cells, forming pores in the target cell membranes and

secreting proteolytic enzymes into the target cells. Some of the T-cells are retained as memory cells to provide future immunity.

■ HUMORAL IMMUNITY

Humoral immunity is an antibody-mediated response. Antibodies are essentially like the Y-shaped B-cell receptor, but without the attachment region. They are secreted by B-cells and bind to antibodies with one of several effects. Antibodies can neutralize a microbe or mark it for phagocytosis by covering the microbe. They may agglutinate several microbes, immobilizing them by binding them together. They may also mark sites on a foreign cell for complement proteins to attack by forming pores in the cell membrane.

Like T-cells, B-cells may be activated either by contact with an antigen or by cytokines from the helper T-cell. Activated B-cells also proliferate producing clones of identical cells, producing antibodies against the targeted antigen. Some B-cells also provide future immunity as memory cells. The main targets of B-cells are bacteria, viruses, and other microbes.

■ IMMUNITY

Exposure to an infectious agent that leads to an immune response provides active immunity to future infection by that agent. This is due to the production of memory T- and B-cells that will be ready to function, should a new contact occur. Immunization, or vaccination, mimics this process by presenting the body with an inactivated antigen. This may be a killed or weakened microbe, or parts of a microbe, or inactivated toxins from the microbe. The body responds with a normal immune response, resulting in a buildup of memory cells that will provide immediate response if you are exposed to an active pathogen in the future.

■ HIV-AIDS

The human immunodeficiency virus (HIV) is insidious in that it specifically attacks helper T-cells, the cells responsible for coordinating the immune response. The infected cells grow and divide, producing more viruses, which attack additional helper T-cells. This process repeats itself until, eventually, all the helper T-cells are infected, and the immune response is effectively shut down resulting in acquired immunodeficiency syndrome (AIDS). A person with AIDS is susceptible to a myriad of infections, any of which may be lethal. The protein coat of HIV mutates rapidly, making it difficult for researchers to develop an effective vaccine.

Test Yourself

1) The quickest immune response to invasion by a foreign substance/cell occurs when
 a) there are a few memory cells with the corresponding antigens in their membrane circulating.
 b) there are large numbers of antibodies corresponding to that antigen in circulation.
 rs of killer T-cells in circulation.
 corresponding to that antigen in circulation.

 ystem does HIV directly infect?

 ief obstacle to the production of an effective HIV vaccine?
 IV frequently change.
 or dead.
 odstreams of infected individuals.
 dies to HIV.

 stem that combine with foreign chemicals, especially foreign proteins,
 for later engulfment by white blood cells are called

 BCs do to help them to carry out their defensive functions effectively?

 ther cell organelles
 od vessels
 d) burst to initiate clotting

6) Nonspecific defense responses include phagocytic cells. Which of the following cells is recognized as a phagocyte?
 a) fibroblast
 b) neuron
 c) macrophage
 d) lipocyte
 e) none of the above

7) Which of the following is not a function of killer T-cells?
 a) secrete perforin to punch holes in target membranes
 b) protect the body against cells that become cancerous
 c) defend against bacteria and viruses that have already infected cells
 d) mark antigens for destruction by phagocytes

8) _____ is a macromolecule that is recognized as foreign and triggers the immune response.
 a) Platelet
 b) Antigen
 c) Antibody
 d) Lymphocyte
 e) Macrophage

9) Which one of the following symptoms of infection due to a small cut is beneficial to healing?
 a) mild fever
 b) tissue swelling
 c) tissue reddening
 d) tissue warming
 e) all of the above

10) Which one of the following is *not* a nonspecific immune response?
 a) mucous
 b) skin
 c) acid secretions
 d) histamines
 e) All of the above are nonspecific immune responses.

Test Yourself Answers

1) **b.** The most rapid immune response occurs when there are already large numbers of antibodies to the specific antigen circulating in the blood.

2) **c.** HIV selectively attacks helper T-cells, which serve to coordinate the humoral and cellular immune systems.

3) **a.** The surface antigens on the protein coat of HIV change frequently, making it difficult to develop an effective vaccine against a specific antigen.

4) **b.** One of the mechanisms by which antibodies attack foreign particles is to clump them together for later engulfment by WBCs.

5) **c.** WBCs can migrate out of the blood stream and into the tissue fluids to attach foreign substances.

6) **c.** Macrophages are one type of phagocytic cells that engulf foreign cells and diseased cells.

7) **d.** Marking antigens for destruction by phagocytes is a function of macrophages. All the other functions are accomplished by killer T-cells.

8) **b.** Antigens are foreign substances that trigger immune response.

9) **e.** Release of histamines as a wound response causes inflammation of tissues, which brings additional blood flow and white blood cells to the infected area as an immune response. Symptoms include swelling, reddening, and warming of the tissue and a general increase in body temperature.

10) **e.** Each of the above choices is either part of the first line of defense of blocking entry or of the inflammatory response that occurs prior to the acquired immune response.

Reproductive System

In Chapter 10, we discussed the basic biology of sexual reproduction, the production of haploid gametes by organisms that undergo syngamy to form a new diploid individual. In this chapter, we examine the structural and physiological human adaptations that make sexual reproduction possible

■ MALE REPRODUCTIVE SYSTEM

The male reproductive system consists of the **testes,** where sperms are produced, and a number of accessory structures that aid in transporting the sperms to the female.

Testes

The paired testes develop within the abdominal cavity, and then descend into the scrotal sac, or **scrotum,** at about the time of birth. Connective tissue in the abdominal wall grows to separate the cavity from the scrotal cavity. This remains a weak spot that is a frequent site of hernias, in which a portion of the intestine protrudes through the abdominal wall. The scrotum allows for temperature regulation during sperm development. The optimum temperature for sperm development is about 90° F, almost 10 degrees lower than normal body temperature. Smooth muscles and connective tissue raise or lower the testes within the scrotum to maintain optimum temperature (provided that clothing allows this adjustment).

The testes consist of coils of **seminiferous tubules** packed between interstitial cells. The interstitial cells are the endocrine cells that produce testosterone (see Chapter 45) that help regulate sperm production. Seminiferous tubules are the site of sperm production. The tubule wall consists of connective tissue that provides a foundation for a layer of proliferating cells. The outermost cells lining the tubule wall are diploid **spermatogonia** that undergo frequent mitotic division. One of the daughter cells remains a spermatogonium, while the other becomes a primary **spermatocyte.** It is the spermatocytes that undergo meiosis to form **spermatids,** immature haploid sperm cells. As new cells are constantly being formed at the periphery, the developing spermatids are gradually pushed toward the central duct. Every day, millions of sperm cells, structurally complete, are sloughed into the duct.

Sperm

Human sperm cells were first described in 1676 by Anthony van Leeuwenhoek, who suggested they may be the factor in semen responsible for conception. Opponents argued that sperm cells were parasites, unrelated to fertility. The structure of sperm suggests how this misconception could have arisen.

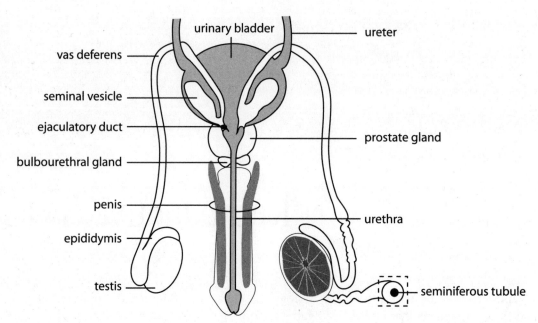

Figure 47-1. Male reproductive system. The testes is the site of sperm production in the seminiferous tubules. They, along with the epididymus, are suspended outside the abdominal cavity. Sperms are carried through the vas deferens (discussed in the "Pathway of Sperm" section) into the abdomen to join the urethra. Seminal vesicles and the prostate gland contribute seminal fluids. The bulbourethral glands temporarily store semen prior to ejaculation. The penis contains erectile tissues around the incoming arteries, which engorge during an erection.

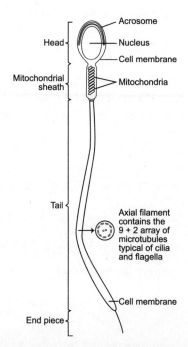

Figure 47-2. Sperm. The head of the sperm contains the nucleus and a cup-shaped acrosome. The midregion concentrates mitochondria around the base of the flagellum, which forms the tail.

The cytoplasm consists of a thin sheath covering the nucleus, packed mitochondria, and elongated flagellum. A cup-shaped vesicle, the **acrosome,** contains digestive enzymes and covers the anterior end of the nucleus in the head of the sperm. Mitochondia are packed around the basal axial filament of a single elongated flagellum, ensheathing them with the machinery for energy production. The posterior tail consists of a membrane-bound fibrous sheath around the core axial filament (see Chapter 5). There is little stored food to provide energy for movement. Instead, the sperm depends on a supply of nutrients in the bathing fluid.

Pathway of Sperm

Seminiferous tubules merge to form the **epididymis,** a tubular storage structure appressed to the testis. The tubules of the epididymis produce secretions that not only nourish the sperms but also activate them, making them motile.

The tubules of the epididymis fuse to form the **vas deferens,** a transport tube that moves the sperm back into the abdominal cavity where the two vas deferens join to the urethra. The vas deferens is lined with smooth muscles that contract to move sperm. Vasectomy, as a means of birth control, surgically cuts the vas deferens, preventing sperm from reaching the urethra. The **seminal vesicles** and **prostate gland** secrete fluids into the vas deferens and urethra that together with the sperm form **semen.** The seminal fluids perform several functions in addition to bulk transport of the sperm. They lubricate the passageways and buffer the acidic fluids of the female reproductive tract. They contain the sugar fructose to provide an external source of nutrients for sperm motility, as well as prostaglandins, which are hormones that stimulate contraction of smooth muscles in the female's uterus. Ninety-five percent of the semen is seminal fluid. Near the junction of the vas deferens with the urethra are two small sacs, the bulbourethral glands, that are surrounded by smooth muscle and temporarily store sperm during intercourse.

Penis

The **penis** is an organ that delivers sperm into the female reproductive tract, facilitating internal fertilization. Most of its volume consists of spongy **erectile tissue** surrounding two major arteries. The veins, which return blood, lie between the erectile tissues. During an erection, smooth muscles around the arteries dilate, allowing more blood to flow into the erectile tissue. Simultaneously smooth muscles around the veins contract, limiting the outward flow of blood. Arterial blood pressure causes the erectile tissue to swell and stiffen, which also helps to block out flow through the compressed veins. The penis becomes firm and erect. It is well supplied with nervous tissue.

■ FEMALE REPRODUCTIVE SYSTEM

In females, the homologue to the male testes are the paired **ovaries** that are suspended in the abdominal cavity by connective tissue.

The accessory tissues transport the released egg, facilitate fertilization, and support growth of the developing embryo.

Ovaries

At birth, each ovary contains about 1 million **oocytes,** potential egg cells that have already begun meiosis but are held in meiosis I. Many oocytes die each day, so that over the course of the woman's reproductive lifetime, only about 400 are released to potentially be fertilized. None remain when the woman reaches menopause.

Each oocyte is surrounded by a mass of smaller cells that together form the **follicle.**

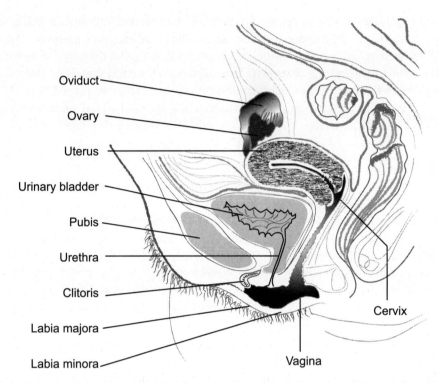

Figure 47-3. Female reproductive system. Each ovary is suspended in the abdominal cavity and partially covered by the head of an oviduct, which connects to the uterus. The head of the uterus, the cervix, protrudes into the vagina, which receives the penis during intercourse and serves as the birth canal. The clitoris and labia are the external genitalia, well supplied with blood vessels and nervous tissue.

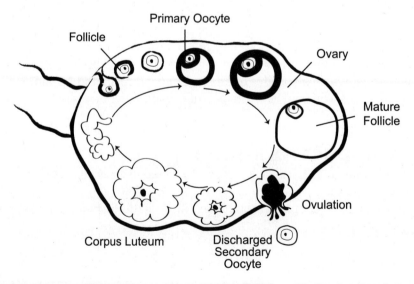

Figure 47-4. Egg development. The oocyte, surrounded by follicle cells, begins development in the ovary before birth. At the beginning of the menstrual cycle, a single follicle will continue development, and then mature, and finally burst during ovulation, releasing the oocyte into the abdominal cavity. The remaining follicle cells form the corpus luteum.

At puberty, when the menstrual cycle begins to function (see Chapter 45), one follicle per month reaches maturity. The oocyte completes meiosis I and is released as a **secondary oocyte** along with some of the inner follicle cells during ovulation.

The secondary oocyte is released into the body cavity and must be drawn into the nearby **oviduct** or Fallopian tube. The expanded opening of the oviduct partially covers one side of the ovary and is divided into numerous finger-like projections (fimbriae) that slowly sweep over the ovary. The endothelial lining of the oviduct contains ciliated cells that generate an inward current that helps propel the oocyte into and down the oviduct. A separate oviduct leads from each ovary to the uterus. A tubal ligation is a surgical procedure that ties and constricts the Fallopian tubes, preventing the oocyte from being fertilized by a sperm cell or reaching the uterus.

Uterus

The **uterus** is a thick, muscular organ whose function is to support and protect the developing fetus. The outer wall, **myometrium,** is a thick, smooth muscle that provides passive support during fetus development. At birth, rhythmic contractions of the myometrium move the infant into the birth canal. The inner layer, **endometrium,** is a blood vessel-rich spongy layer in which the embryo implants to gain nourishment. An intimate association forms between the endometrium and the fetal **placenta** to keep the maternal and embryonic blood supplies separate, but maximize diffusion between them. Development of the endometrium is under hormonal control, as described in Chapter 25. It is thickest and most receptive for only a few days after ovulation, corresponding to the time that the oocyte can be fertilized.

At the base of the uterus is the **cervix,** which is open and protrudes slightly into the birth canal or **vagina.** The smooth muscles of the cervix hold the developing fetus within the uterus until birth. When a woman goes into labor, contractions of the myometrium press the fetus against the cervix, which begins to dilate. The cervical muscles must relax and dilate sufficiently to allow the infant to pass into the birth canal.

Vagina and External Genitalia

The vagina is a muscular canal through with the infant passes from the uterus to the outside during birth. It also receives the penis during intercourse, so that sperm are deposited near the cervix. The endothelial cells lining the vagina produce secretions to lubricate the passage and to protect the body against pathogens. The vagina is maintained at a low pH to kill any microbes that may enter. Consequently, this also is an inhospitable environment for sperm cells.

The external genitalia consist of the **clitoris** and the **vulva.** The clitoris is the structural equivalent of a penis. It contains erectile tissue and is well supplied with nerve endings that are stimulated during intercourse. The vulva are two folds of skin, the labia minor and labia major, that also are well supplied with capillaries and nerve endings. They provide physical protection to the opening of the vagina.

■ PHYSIOLOGY OF COPULATION

Copulation, or intercourse, delivers the male's sperm into the female's reproductive tract. It can be divided into four physiological phases—excitement, plateau, orgasm, and resolution—that are under the control of the nervous and/or endocrine systems.

Excitement

Excitement, initiated by the nervous system, increases heart rate, breathing rate, and blood pressure. Smooth muscles relax in the genitalia and in capillaries associated with secondary sexual characteristics, such as "sex flush" in the face and in the breasts and nipples. In males, an erection occurs, and in females,

the labia and clitoris swell as the muscles surrounding the vagina relax. These responses allow the penis to be inserted into the vagina.

Plateau

During the **plateau** stage, thrusts of the penis within the vagina elicits continuous stimulation of the sympathetic nervous system, which, in turn, feeds back to the genitalia. The penis and clitoris achieve maximum erection, and the endocrine system is stimulated.

Orgasm

Orgasm is characterized by involuntary reflexive muscular contractions associated with other nervous activity and perceived as intense pleasure. In males, nerve signals from the brain stimulate **emission,** the rhythmic contraction of vas deferens and the prostate gland that moves semen to the bulbourethral gland where it is stored temporarily. Some semen may be released from the penis during emission prior to ejaculation (making withdrawal, or *coitus interruptus,* an ineffective method of contraception). Shortly afterward, violent muscular contractions around the base of the penis and the bulbourethral glands ejaculate semen through the urethra. Between three and five milliliters of fluid, containing several hundred million sperm cells, is released. If the fluid typically contains less than 20 million sperm, the male is considered functionally sterile because it is unlikely that any sperm will survive long enough in the female reproductive tract to fertilize an egg.

In the female, nervous impulses stimulate the hypothalamus to release oxytocin into the posterior pituitary. This stimulates the uterine and vaginal muscles to contract. Note that the female response is hormonal, and therefore slower to occur, but of longer duration than the neural-controlled male response.

Resolution

Resolution is a return to baseline physiological conditions. In males, there is a refractory period of about twenty minutes, during which arousal is difficult and ejaculation is nearly impossible.

■ FERTILIZATION AND DEVELOPMENT

An oocyte released from the ovary survives for about one day; sperm released into the vagina can survive about two days. Therefore, fertilization can only occur during a window of about three days around the time of ovulation.

When sperms are released into the vagina, many are killed by the acidic conditions, but many of the survivors move through the cervix into the uterus. The prostaglandins in the seminal fluid stimulate uterine contractions that, together with the sperm's swimming action, propel the sperm into the oviducts. At this point, the number of viable sperm is halved as chance determines whether a sperm that enters the oviduct that will contain an oocyte.

The oocyte that was swept into the oviduct begins to travel inward toward the uterus. Fertilization, if successful, occurs in the upper oviduct. The oocyte is surrounded by several layers of follicular cells that are a physical barrier to sperm penetration. The acrosomes of many sperms are used to gradually digest through this barrier so that, eventually, one sperm may come in contact with the oocyte.

Enzymes from the acrosome digest through the proteinaceous coating of the oocyte, and a biochemical interaction with the egg initiates growth of an **acrosomal process** that binds to the surface of the oocyte membrane. Fusion of the membranes stimulates the release of vesicle contents around the perimeter of the oocyte that raise the outer membrane of the oocyte away from the cytoplasm, making it impossible for additional sperm to fuse. Release of the sperm nucleus into the oocyte cytoplasm stimu-

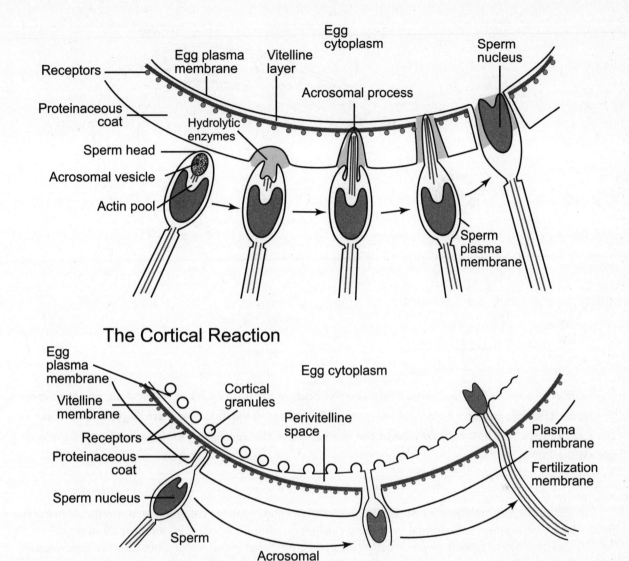

The Cortical Reaction

Figure 47-5. Fertilization. During fertilization, the acrosome of sperm digest the outer cells surrounding the oocyte and the proteinaceous covering of the oocyte. An acrosomal process contacts the oocyte membrane and syngamy occurs. This triggers completion of meiosis by the oocyte nucleus and formation of a barrier around the oocyte to prevent additional sperm from entering.

lates the oocyte nucleus to finally complete the meiotic process that was begun before birth. A single egg nucleus is formed, and the oocyte becomes the egg. Fertilization may now occur.

The fertilized egg, now a zygote, continues to pass down the oviduct, driven by ciliary action of the epithelial lining.

During this time, repeated cell divisions occur forming a blastula, gastrula, and young embryo (see Chapter 32).

The embryo secretes **chorionic gonadotropin** (the hormone checked during pregnancy tests), which prevents the corpus luteum from degenerating. As a result, it continues to secrete estrogen and progesterone (see Chapter 45).

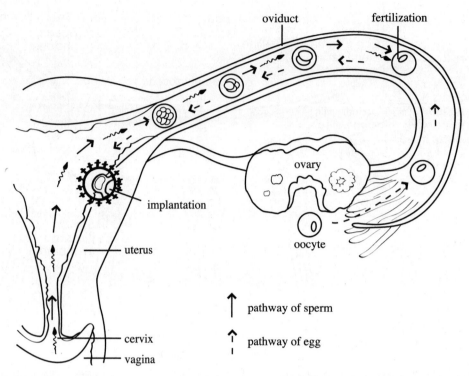

oviduct

fertilization

ovary

oocyte

implantation

uterus

cervix

vagina

↑ pathway of sperm

↑ pathway of egg

Figure 47-6. Zygote and early embryo. Fertilization occurs in the upper part of the oviduct, and the zygote undergoes cleavage to begin embryo development. The stages of blastula and gastrula formation occur as the embryo is carried down the oviduct to the uterus, where the developing embryo implants in the uterine wall.

In the uterus, the embryo embeds in the endometrium and begins to establish an intimate connection. Proliferating embryonic cells form a branching placenta within the spongy endometrial tissue.

Embryonic blood vessels never directly contact the maternal blood supply, but they are separated by only a few cells. The branching proliferation ensures a high surface area to maximize diffusion.

The first eight weeks are most critical to further embryo development.

It is during this time that early development of the central nervous and circulatory systems begins and any mutations will cause major abnormalities. Individual organs develop later, and any mutations result in relatively minor abnormalities.

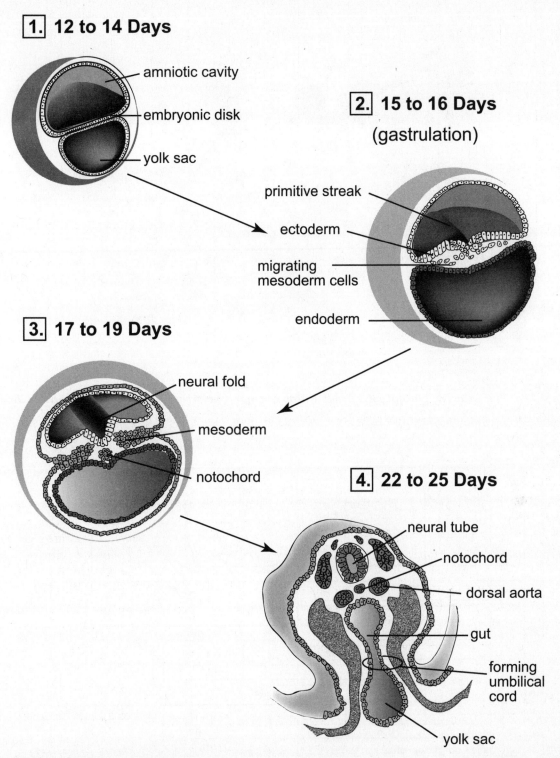

1. **12 to 14 Days**

- amniotic cavity
- embryonic disk
- yolk sac

2. **15 to 16 Days**

(gastrulation)

- primitive streak
- ectoderm
- migrating mesoderm cells
- endoderm

3. **17 to 19 Days**

- neural fold
- mesoderm
- notochord

4. **22 to 25 Days**

- neural tube
- notochord
- dorsal aorta
- gut
- forming umbilical cord
- yolk sac

Figure 47-7. Later embryo. The human embryo goes through the normal stages of tissue differentiation characteristic of triploblastic development.

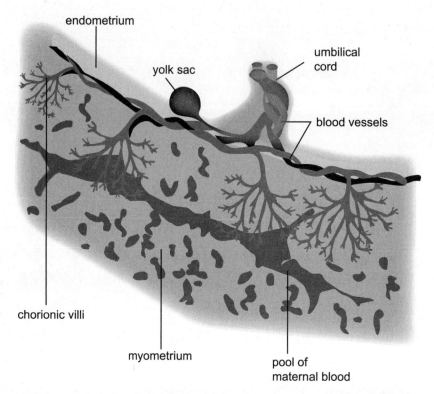

Figure 47-8. Placenta. *The placenta is a proliferation of embryonic tissue within the endometrium lining of the uterus. This maximizes surface area for diffusion between the maternal and embryonic blood supplies.*

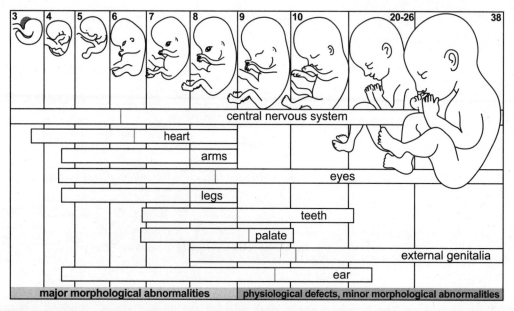

Figure 47-9. Fetal development. *The major tissues and organs begin development during the first two months of pregnancy. Later development occurs primarily in the nervous system and in the formation of the reproductive system.*

Test Yourself

1) Into which structure are oocytes directly ovulated?

 a) uterus

 b) fallopian tube

 c) ovary

 d) abdominal cavity

2) Where is one *least* likely to find complete semen?

 a) in the vagina of a woman who's trying to become pregnant

 b) in the epididymis

 c) at the junction of the bulbourethral duct and the urethra

 d) at the male urethral orifice at the end of the penis

3) If a woman ovulated on March 23, what is the earliest date at which sexual intercourse might result in pregnancy?

 a) March 16

 b) March 18

 c) March 21

 d) March 23

4) What action(s) initiate(s) and maintain(s) penile erection?

 a) constriction of smooth muscle in penile venules

 b) compression of penile veins by blood-engorged erectile tissues

 c) dilation of smooth muscle in penile arterioles

 d) both a and b

 e) both b and c

5) The acrosome of the sperm is

 a) the nucleus, containing highly condensed chromatin.

 b) a vesicle containing enzymes to help the sperm penetrate the egg.

 c) located in the midpiece, where it supplies ATP for movement.

 d) the flagellum that makes up the sperm tail.

6) Meiosis in males occurs in the

 a) epididymus.

 b) seminiferous tubules.

 c) vas deferens.

 d) prostate gland.

 e) interstitial cells.

7) Fertilization of human eggs most often takes place in the

 a) ovary.

 b) uterus.

 c) vagina.

 d) oviduct.

 e) cervix.

8) A component of the semen, which is rich in sugar fructose and prostaglandin, is produced by

 a) the sperm duct.

 b) the testis.

 c) sertoli cells.

 d) penis.

 e) seminal vesicles.

9) Meiosis in the female is initiated in the

 a) ovary.

 b) vagina.

 c) uterus.

 d) oviduct.

 e) cervix.

10) The vagina produces acidic secretions to

 a) stimulate the sperm cells on their way to the oviduct.

 b) provide the sperm cells with nutrients.

 c) prevent pathogens (bacteria and other microorganisms) from invading the female reproductive tract.

 d) immobilize the sperm.

 e) breakdown fructose, making it more easily absorbed by sperm.

Test Yourself Answers

1) **d.** Ovulation releases an oocyte, surrounded by layers of follicle cells, directly into the abdominal cavity. The ciliated fimbriae of the oviduct must sweep them into the duct before they can begin transport toward the uterus.

2) **b.** The epididymis contains formed sperm cells, but seminal fluids have not yet been added.

3) **c.** A released sperm can survive in the female reproductive tract for about two days; therefore, viable sperm released during intercourse on March 21 could still fertilize an egg that was ovulated on March 23.

4) **e.** During the excitement phase of intercourse, smooth muscles of the arteriole dilate, permitting greater blood flow into the erectile tissues while those of the veins constrict, reducing return flow, thereby engorging the erectile tissue.

5) **b.** The acrosome, at the head of a sperm, is an enzyme-containing vesicle required for successful syngamy.

6) **b.** Meiosis to produce sperm occurs in the seminiferous tubules of the testes.

7) **d.** Fertilization usually takes place in the upper oviduct, although implantation does not occur until the embryo reaches the uterus.

8) **e.** Fructose and prostaglandin are components of seminal fluid produced in the seminal vesicles.

9) **a.** In the female, meiosis is initiated in the ovary before birth, but it is not completed until years later, when a sperm enters the oocyte in the oviduct.

10) **c.** The acidic conditions of the vagina are inhospitable to microorganisms, protecting against infections.

Index

animals *(continued)*
muscle, 48, 49, 53, 71, 78, 97, 235, 237, 335, 340, 343, 345, 356, 358, 361, 425, 428–431, 434–437, 447, 448, 450, 451, 454, 463, 466, 467, 475, 483, 491, 493, 495, 496, 503
actin, 48, 49, 53, 97, 429, 430
cardiac, 429, 431, 434, 448, 466
myosin, 49, 97, 429, 430
skeletal, 71, 428–431, 434, 451, 466
smooth, 429–431, 434–437, 450, 451, 466, 475, 483, 491, 493, 495, 503
nervous, 343, 431, 434, 463–466, 468, 470, 473, 475, 478
axon, 343, 431, 434, 463, 464, 473
dendrites, 431, 434, 463, 473
neurons, 431, 434, 463–466, 468, 470, 473, 475, 478
oligodendrocytes, 431
Schwann cells, 431, 434
vertebrate, 233, 235, 237, 343, 355, 360
warm-blooded animal, 358
atomic mass, 7, 14
atomic number, 7, 14, 16
ATP, *see* phosphate group, adenosine triphosphate (ATP)

B
bacteria, 3, 44–47, 49–51, 53, 55, 70, 71, 80–82, 84, 121–123, 128, 131, 139–143, 145–152, 157, 158, 170, 178, 184, 186–191, 213, 215, 219, 271, 272–279, 282, 283, 290, 295, 329, 347, 396, 439, 440, 442, 448, 461, 469, 483, 486, 488, 502
Archaebacteria, 277, 279
Cyanobacteria, 274, 277, 279, 283, 329
fermentation, bacterial, 276
nitrogen-fixing, 186, 191, 279
photosynthetic, 44, 46, 50, 55, 81, 82, 84
blue-green, 44, 46
symbiotic, 275, 283, 439, 442, 483
bases, 15, 18, 26, 27, 30, 59, 64, 122–127, 129, 131–134, 136, 138, 143, 148, 151–153, 262
complementary, 124, 125, 129, 138, 143, 152
DNA base, 132, 136, 138, 143, 152, 262
nitrogenous, 26, 30, 59, 122
nucleotide, 123, 127, 129, 136, 138
RNA base, 138
behavior, 203– 206, 207, 210, 347
altruism, 206
anthropomorphism, 210
cognition, 204, 210

fixed action patterns, 203, 210
group behavior, 205, 206, 210, 347
communication, 205, 206, 210, 347
auditory, 205
chemical, 206, 347
pheromones, 206, 347
visual, 206, 210
kin selection, 207
learning, 203–205, 210
associative, 204, 210
classical conditioning, 204, 210
imprinting, 203, 204, 210
operant conditioning, 204
spatial, 204, 205
orientation, 204, 205
kinesis, 204, 205
migration, 205
compass orient, 205
piloting, 205
taxis, 204, 205
binary fission, *see* cell, binary fission
biochemistry, 43, 44, 85, 124
biological evolution, *see* evolutionary theory, biological evolution
biosphere, 193–197, 202
abiotic factors, 193
aquatic biomes, 197
montane effects, 195
terrestrial biomes, 194, 196, 197, 202
birds, 42, 174, 175, 182, 203–205, 211, 212, 214, 217, 218, 222, 224, 233, 253, 264–267, 358, 361, 417, 421
blood, 33, 231, 243, 244, 284, 340, 343–345, 351, 353, 355, 425–428, 430, 434, 437, 443–451, 454–456, 458, 461, 467, 475–479, 483, 484, 489, 493–495, 498, 500, 503
blood groups (types), 33, 243, 244
bloodlines, 231
capillaries, 425, 454, 455
cells, 344, 427, 428, 434, 445, 448, 483, 484, 489
clotting, 448, 483
fibrogens, 448
filtration, 456, 461
loss of, 340
parasite cells in, 284, 340, 343
pH, 454
plasma, 344, 456, 458
phagocytosis, 448
platelets, 448
pressure, 343, 450, 451, 454, 461, 477, 478, 493, 495
sugar, 478, 479
vessels, 340, 343, 351, 426–428, 430, 443, 444, 447, 450, 454, 455, 494, 495, 498
see also animals, tissues, connective, blood
bonds, 3, 24, 25, 30, 44, 134, 135
peptide, 3, 24, 25, 30, 44, 134, 135
bone, 233–235, 356, 358, 427, 428, 434, 447, 469, 484
marrow, 484

C
carbohydrates, 18, 21, 24, 30–33, 67, 85, 271, 435, 438, 442
digestion of, 438, 442
polymerizing, 18
carotenoids, 81, 82, 467
cell, 2, 3, 19, 21, 33, 41–53, 68, 71, 73, 76–78, 82, 87, 90, 91, 93–101, 103–110, 112, 114, 115, 118, 121, 124, 127, 129, 131–134, 136, 138, 139, 141, 144, 148–150, 152–154, 156, 157, 159, 188, 203, 205, 230, 239, 264, 265, 271–276, 278, 279, 281–291, 293–301, 303, 305, 307–319, 321, 323–325, 328, 329, 331–333, 335, 337, 339, 347, 348, 355–358, 361, 364–369, 372–381, 384–391, 394, 396, 398, 405, 406, 415, 417, 420, 421, 424–427, 429, 431–435, 437–439, 442, 443, 445, 446, 448, 450, 456, 458, 460, 461, 463, 468, 473, 476, 480, 483, 491–497, 501, 503
actin filaments (microfilaments), 48, 49, 53
animal cell, 33, 44, 48, 52, 53, 97, 101, 152, 425, 427, 429, 431, 433, 442
binary fission, 44, 273, 278, 279
capsule, 44, 45, 139, 271, 272, 278, 279, 288, 298, 300, 301, 305, 456, 458, 460, 461
Bowman's capsule, 456, 458, 460, 461
cell cycle, 93–97, 99, 110, 124
cell division, 3, 44, 93–99, 100, 101, 103–110, 112, 114, 115, 121, 124, 127, 129, 148, 153, 230, 250, 255–257, 259, 273, 279, 282–285, 287, 296, 298, 300, 301, 304, 305, 310–317, 321, 323–328, 331, 335, 424, 480, 491, 493, 495, 497, 498, 501–503
binary fission, 44, 273, 279
cytokinesis (cytoplasmic division), 97–99, 101, 105, 107, 127, 148, 498
cell plate, 98
cleavage, 97, 148, 498
phragmoplast, 98
interphase, 93, 95–97, 101, 105, 107, 110, 124, 127, 129, 153
meiosis, 3, 44, 103–110, 112, 114, 115, 121, 127, 129, 230, 250, 255–257, 259, 273, 279, 282–285, 287, 296, 298, 300, 301, 304, 305, 310–317, 321, 323–328, 331, 335, 424, 480, 491, 493, 495, 497, 501–503
mitosis (nuclear division), 94–99, 100, 101, 105–110, 127, 153

anaphase, 96, 97, 101, 105–107, 110
metaphase, 95–98, 101, 105, 107, 109, 127
prophase, 95, 97, 101, 105–107, 109, 110, 127, 153
telophase, 94, 96, 97, 99, 100, 105, 107–110
G-2 phase, 99
S-phase, 99, 101, 110, 124, 129
cell theory, 2, 3, 41
cell wall, 44, 47, 49, 51–53, 97, 98, 188, 271, 272, 278, 281, 282, 285–287, 289, 293, 298, 303, 305, 307, 308, 312, 313, 323, 324, 331–333, 372, 376, 377, 379, 381, 384–386, 388, 396, 398, 421
cellulose, 19, 21, 49, 278, 279, 283–285, 287, 290, 291, 296, 303, 307, 376, 385, 439, 442
centrioles, 48, 53
centrosome, 48, 95
chlorenchyma, 367, 372
collar cells, 337
collenchymas, 367
cytoplasm, 68, 78, 131, 133, 134, 144, 156, 271, 272, 324, 386, 445, 473, 496
epithelial cells, 337, 425–427, 433–435, 437, 438, 442, 443, 445, 446, 450, 468, , 483, 497
eukaryotic, 3, 44, 45, 47–51, 53, 68, 71, 78, 131, 132, 136, 138, 150, 154, 156, 157, 159, 205, 239, 271, 272, 274, 275, 279, 281, 282, 332, 333, 335, 398
flagella, 44, 45, 48, 53, 272, 281–285, 287–291, 296, 297, 301, 319, 321, 337, 339
biflagellate, 284, 285, 296, 297, 301
dinoflagellates, 281, 283, 287, 289–291, 339
Golgi bodies, 44, 47, 51, 53, 97, 98
microtubules, 33, 48, 53, 95, 96, 98, 105, 281, 287
mitochondria, 44–47, 50–53, 73, 76–78, 82, 90, 91, 278, 279, 309, 492, 493
nucleus, 2, 3, 44–46, 48, 53, 93, 95, 96, 101, 103–105, 107, 110, 124, 131, 132, 138, 273, 279, 282, 283, 291, 296, 308, 309, 324, 325, 328, 333, 420, 424, 432, 434, 463, 492, 493, 496, 497, 501
chromatids, 93
chromosomes, 45
macro, 282, 283, 291
micro, 282, 283, 291
nucleoli, 45, 53
nucleoplasm, 45
pili (fimbriae), 141, 272

Collins College OUTLINES

Fully Revised and Updated